Islamic Arms and Armor

IN THE METROPOLITAN MUSEUM OF ART

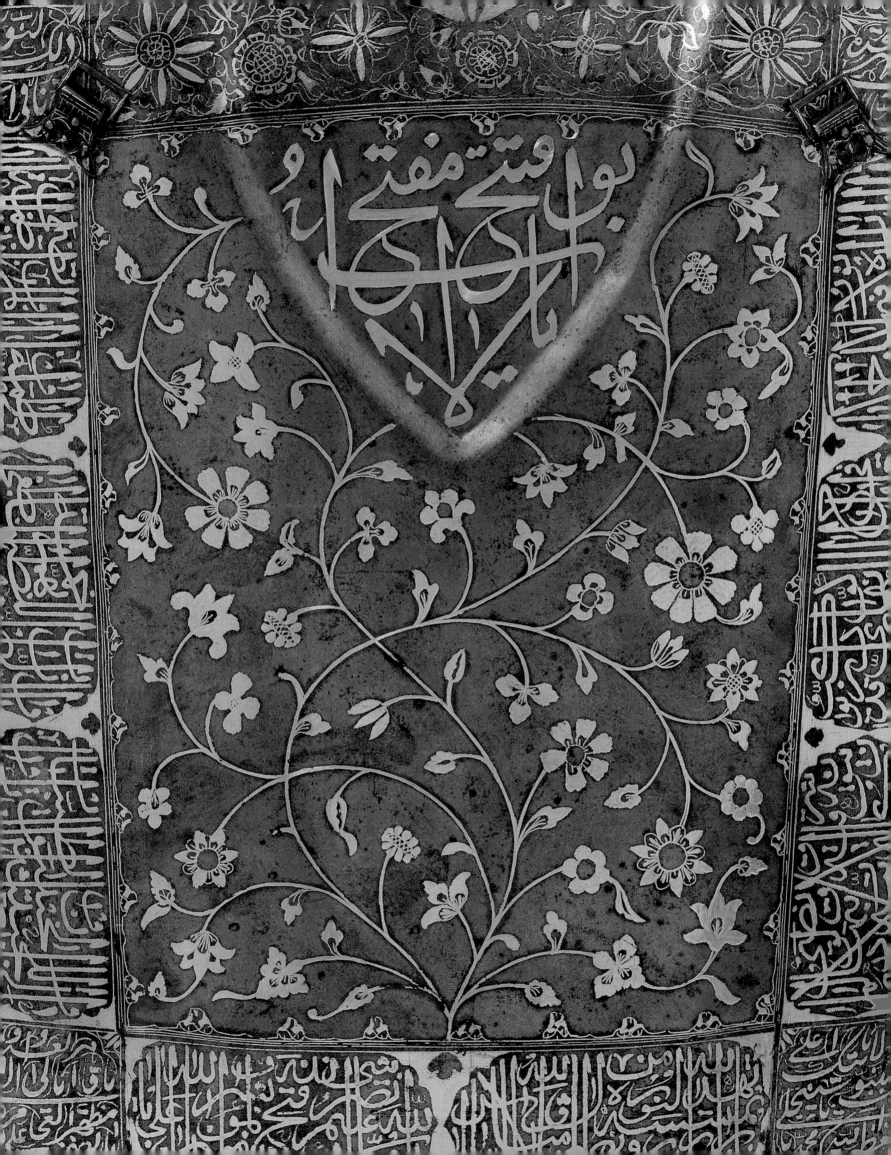

Islamic Arms and Armor

IN THE METROPOLITAN MUSEUM OF ART

David G. Alexander

With contributions by Stuart W. Pyhrr and Will Kwiatkowski

The Metropolitan Museum of Art, New York

Distributed by Yale University Press, New Haven and London

This publication is made possible by the Grancsay Fund and by The Jessica E. Smith and Kevin R. Brine Charitable Fund.

Published by The Metropolitan Museum of Art, New York

Mark Polizzotti, Publisher and Editor in Chief

Gwen Roginsky, Associate Publisher and General Manager of Publications

Peter Antony, Chief Production Manager

Michael Sittenfeld, Senior Managing Editor

Robert Weisberg, Senior Project Manager

Edited by Cynthia Clark

Designed by Steven Schoenfelder

Production by Paul Booth

Bibliography and notes edited by Amelia Kutschbach

Map by Anandaroop Roy

Image acquisitions and permissions by Jane S. Tai and Crystal Dombrow

New color photography of the objects is by Joseph Coscia Jr., Senior Photographer, The Photograph Studio, The Metropolitan Museum of Art.

Additional photography credits appear on page 336

Typeset in Alegreya and Erasmus

Printed on 135 gsm Tatami White

Separations by Professional Graphics, Inc., Rockford, Illinois

Printed and bound by Ediciones El Viso, S. A., Madrid

Jacket illustrations: (front) detail of cat. 5; (back) detail of cat. 80

Frontispieces: p. ii, detail of cat. 17; p. v, detail of cat. 90; p. vi, detail of cat. 44; p. 2, detail of cat. 58; pp. 18–19, detail of cat. 12; pp. 142–43, detail of cat. 66; pp. 256–57, detail of cat. 123; p. 302, detail of cat. 72

The Metropolitan Museum of Art

1000 Fifth Avenue

New York, New York 10028

Metmuseum.org

Distributed by

Yale University Press, New Haven and London

yalebooks.com/art

yalebooks.co.uk

Cataloguing-in-Publication Data is available from the Library of Congress.

ISBN 978-1-58839-570-2

Contents

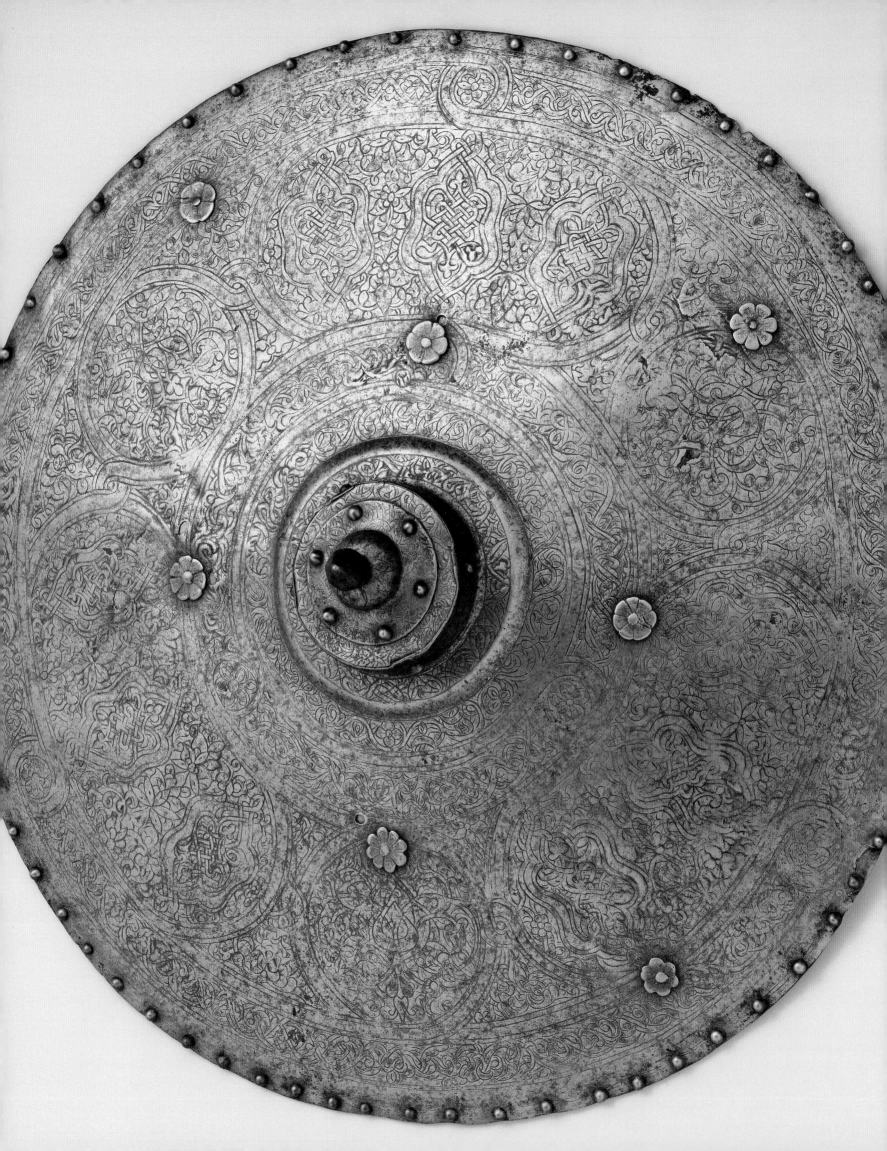

Director's Foreword

Islamic Arms and Armor in The Metropolitan Museum of Art celebrates one of the most encyclopedic collections of its kind, comprising almost one thousand objects from the Islamic world extending from Spain to India. It also marks the Metropolitan Museum's third major publication in the field of Islamic art since the opening of its Galleries for the Art of the Arab Lands, Turkey, Iran, Central Asia, and Later South Asia in 2011. The 126 armors and weapons presented here range from lavishly decorated ceremonial weapons, such as the jewel-encrusted sword for Murad V, to the earliest documented Islamic sword, a ninth-century example discovered in the Museum's excavations at Nishapur, Iran, in the 1930s. Each catalogue entry explores the work's most significant features, including its typology and use, inscriptions, ornament, and historical associations. All of the objects have been newly photographed, and most are published here for the first time. It is hoped that this publication will both enhance the appreciation of visitors to the galleries and further the scholarly study of the subject. The majority of pieces reside in the Department of Arms and Armor, most of them acquired in 1935 with the bequest of George C. Stone, whose passion for non-European armor and weapons from the Middle East, India, and Asia has so richly endowed the department in those areas; a smaller number are to be found in the Department of Islamic Art. In recent years both curatorial departments have acquired stellar works that significantly enhance the Museum's collection, many of which are featured in this volume.

David G. Alexander, the catalogue's author, is recognized as one of the leading specialists in the study of Islamic arms. Stuart W. Pyhrr, formerly Curator in Charge and now Distinguished Research Curator in the Department of Arms and Armor, and Will Kwiatkowski, an independent scholar specializing in Islamic languages and epigraphy, have contributed to the endeavor. The editor, Cynthia Clark, has ably guided this work since its inception.

The publication of this book is made possible in part by the Grancsay Fund. Named after the Metropolitan's distinguished curator of arms and armor, Stephen V. Grancsay (1897–1980), this endowed fund has over many years underwritten a number of departmental books and catalogues and is a testament to the dedication and foresight of the donor. We also extend special thanks to Kevin R. Brine for his long-standing commitment to the Department of Arms and Armor as a member of its Visiting Committee and for his generosity to the department's many initiatives. We are grateful for his kind support of this exceptional publication.

Thomas P. Campbell, DIRECTOR, THE METROPOLITAN MUSEUM OF ART

Acknowledgments

The present volume, the Metropolitan Museum's first major publication devoted to Islamic arms and armor, was begun twenty-five years ago. During that time the authors and editor have been diverted by a number of other undertakings, causing several long postponements of the project. That said, it is of great satisfaction to all the contributors that this long-awaited volume has at last been completed. It would never have appeared without the assistance and encouragement of the many individuals who, over these many years, have contributed to the final work.

We would especially like to thank two directors of the Metropolitan Museum, Philippe de Montebello, who encouraged and supported the publication from its inception, and his successor, Thomas P. Campbell, who ensured its completion. Similarly, two publishers and editors-in-chief, the late John P. O'Neill and his successor, Mark Polizzotti, have enthusiastically promoted the book and guided its development.

This publication has been the undertaking of the Museum's Department of Arms and Armor, whose curatorial, conservation, and administrative staff, past and present, have been on the "front line" for several generations. Helmut Nickel, Curator Emeritus, provided the initial access to the collection and encouraged its in-depth study. Much of the project's initial organization and clerical work was undertaken by former administrative assistant Marie Koestler. The conservators reviewed all of the objects and worked steadfastly to clean, conserve, and mount them for catalogue photography and gallery display. In some instances, particularly with recent acquisitions, the work has proved especially challenging and time consuming, but invariably the care and knowledge exercised by these skilled specialists have contributed significantly to our appreciation and better understanding of the works. We are particularly grateful to the late Robert M. Carroll, Joshua Lee, Hermes Knauer, and Edward Hunter. Collections manager Stephen Bluto has provided invaluable support, most especially in the preparation of hundreds of detailed photographs that have greatly aided Will Kwiatkowski's reading and translation of the inscriptions. We are grateful too for the support of Marilynn Doore, George Sferra III, Lindsay Rabkin, Rachel Parikh, Donald La Rocca, and the current department head, Pierre Terjanian.

The curators of the Department of Islamic Art have been enthusiastic supporters and contributors to our study of Islamic arms, assisting with the reading and translation of the inscriptions and providing expert advice on scholarly matters. We acknowledge the contributions of former members, the late Richard Ettinghausen, Stuart Cary Welch, and Annemarie Schimmel, as well as Manuel Keene, Marilyn Jenkins-Madina, and Stefano Carboni, and those of current members Sheila Canby, Patti Cadby Birch Curator in Charge, Navina Najat Haidar, Maryam Ekhtiar, and Deniz Beyazit, as well as that of Annick Des Roches and the departmental technicians.

Members of the Museum's departments of Conservation, Science, and Textile Conservation have also provided invaluable advice and technical assistance, including X-rays, XRF examination, and textile analysis. We thank Jean-François de Lapérouse, Marco Leona, David H. Koch Scientist in Charge, Mark Wypyski, Federico Carò, Florica Zaharia, Janina Poskrobko, and Olha Yarema-Wynar.

More than five hundred new digital images were taken in connection with this publication, all of them a reflection of the skill and judgment of photographer Joseph Coscia Jr. We thank other members of the Photograph Studio for facilitating this work, especially Barbara J. Bridgers and Einar Brendalen.

Many people in the Museum's Editorial Department contributed to the publication of this volume, in particular Peter Antony, Paul Booth, Jane Tai, Crystal Dombrow, Michael Sittenfeld, Anne Rebecca Blood, Elizabeth Zechella, Amelia Kutschbach, and Briana Parker. We thank Steven Schoenfelder for his elegant design that brings this wonderful selection of objects to life and for his careful typesetting, especially of the often complicated inscriptions. Robert Weisberg contributed his expertise and advice on advances in typesetting Arabic and Persian in English texts.

We are grateful to a number of academic colleagues and linguists who have advised us over the years, among them James Allen, Claude Blair, Ludvik Kalus, Michael Rogers, the late Leonard Tarrasuk, and Manijeh Bayani, Filiz Çagman, Ersin Çiçekler, Jean-Baptiste Clais, Cenap Çürük, Nejat Eralp, Sibel Erol, Ortwin Gamber, Abdullah Ghouchani, John Guy, Prudence O. Harper, Jerry Losty, Souren Melikian, Oscar White Muscarella, Tony North, Jean-Pierre Reverseau, John Seyller, Robert Skelton, Tim Stanley, Susan Stonge, Marthe Bernus Taylor, Ferenc Temesváry, Turgay Tezcan, Wheeler Thackston, and Oliver Watson, not to mention a number of colleagues at other museums, especially Christian Beaufort-Spontin, Lionello Boccia, Tobias Capwell, Francesco Civita, Simona di Marco, Simon Metcalf, Nick Norman, Thom Richardson, and Mario Scalini. We also thank Jonathan Barrett, Peter Finer, Robert Hales, David Khalili, Philippe Missillier, H.H. Prince Mukarram Jah, Howard Ricketts, and Nasser Sabah al Ahmed al-Sabah and Sheikha Hussah Sabah al-Salem al-Sabah.

We would especially like to acknowledge and thank the editor of this publication, Cynthia Clark, who has expertly guided the evolution of this work since its inception. Her dedication, professional judgment, wise counsel, diplomacy, and unflagging patience have steadily brought this work to completion. Those of us who have lived through this lengthy project particularly appreciate what a remarkable and unique person she is.

David G. Alexander, Stuart W. Pyhrr, and Will Kwiatkowsi

Preface

The armor and weaponry presented in this publication were often symbols of status, wealth, and power. The finest arms were made by master craftsmen working with the leading designers, goldsmiths, and jewelers, whose work transformed utilitarian military equipment into courtly works of art. Arms and armor of the Islamic world have only recently emerged as a subject of study by specialists, for which there is still little published information. This book attempts to address that need and to reveal the diversity and artistic quality of one of the most important and encyclopedic collections of its kind in the West.

In a recent study, the historian Clifford Bosworth delineated 186 Islamic dynasties that ruled over a period of fourteen hundred years within a geographical range covering Spain; North, West, and East Africa; Egypt; the Arabian Peninsula; Syria, Iran, and Iraq; Turkey; Crimea and the Caucasus; Central Asia; the Indian subcontinent; and Southeast Asia. Yet most surviving pieces of Islamic arms and armor come from a limited number of dynasties and geographical locations, and the majority of these objects date from the fifteenth century or later. Thus the scope of any survey of extant examples is automatically restricted. Even the most important collections of Islamic arms and armor—in terms of quality, those of the Topkapı Sarayı and Askeri Müzesi in Istanbul—are also limited geographically, chronologically, and dynastically, with most of their pieces attributable to the Irano-Turkic world of the fifteenth to sixteenth century.

The most comprehensive collections of Islamic arms and armor are those of the Furusiyya Art Foundation in Vaduz, the Khalili Collection in London, and The Metropolitan Museum of Art in New York. A published catalogue of the Furusiyya collection includes over 350 objects ranging in date from the ninth to the nineteenth century and covers a wide geographic area extending from Spain in the West to Central Asia in the East and to Mysore in southern India. Yet these pieces have been attributed to only twenty-one dynasties, with the majority given to Mughal India and the Deccan, the Ottoman Empire, and Iran. Of the more than 140 published pieces in the Khalili Collection, over half date to the seventeenth century or later, and the vast majority of objects are from Ottoman Turkey, Iran, and India. The Metropolitan Museum's collection is close in scope to those in the Furusiyya and Khalili collections; it covers a wide geographic area and includes a number of early pieces, and in totality its holdings can be attributed to fifteen distinct dynasties. However, like the Furusiyya collection, most of the Museum's pieces are relatively late in date and are mainly from the Ottoman Empire, Safavid and Qajar Iran, and Mughal India. Most of the Metropolitan's collection has heretofore been unpublished.

Other collections of Islamic arms and armor are generally smaller and tend to reflect either a colonial past or military encounters. Most British collections, such as those of the Royal Armouries and the Victoria and Albert Museum in London, for example, have a predominately Indian bias. Other important European collections, especially those in Germany, Austria, Poland, and Italy, are heavy with booty amassed during wars against the Ottomans. Yet viewed as a whole, the surviving corpus of Islamic arms and armor follows the pattern seen in the Metropolitan Museum's collection—and is certainly a statistical sample far too small to generate a definitive history of the subject.

The overall Ottoman and Indian bias combined with the lack of early pieces has created a chasm that a number of scholars have attempted to fill by recourse to representations of arms and armor in other media. Reconstructions of the history of arms and armor based upon painting, sculpture, and other media obviously cannot take into account that certain types of weapons and armor and, especially, their decoration were simply not represented in other art forms, as recent discoveries in Afghanistan and Central Asia have demonstrated.

The study of Islamic arms and armor is a developing field, the exploration of which—as with arms and armor in general—involves many other disciplines, among them painting, jewelry, sculpture, metalworking, and metallurgy. The selection of Islamic arms and armor in The Metropolitan Museum of Art presented here attempts to take these considerations into account and to place the highlights of the Metropolitan's collection within a broad historical context not limited by the imbalance of surviving objects. For further information, the reader is encouraged to refer to the bibliography.

David G. Alexander, PUYCELSI, FRANCE

Note to the Reader

The catalogue of the 126 objects published here has been organized into three broad categories: armor, edged weapons, and firearms and archery (projectile weapons), with each category further divided by type. Within the typological groupings the entries are arranged by place and date of manufacture, as seemed most appropriate.

Each of the catalogue entries consists of a description, the transcription and translation of any inscriptions, and commentary, as well as provenance and references. The descriptions, which are intended to supplement the accompanying photographs and to aid the reader in the understanding of what may be unfamiliar objects, identify the construction, materials, decorative techniques, ornament, and location of the inscriptions. In keeping with the intention that this publication should be intelligible to the general reader as well as the specialist, foreign terms have been kept to a minimum.

In the absence of specialized technical examination, mail is conventionally described as made of iron and armor plate as made of steel, although this may not always be the case. Similarly, colored gemstones are referred to as rubies, emeralds, and diamonds, whereas semiprecious stones and colored glass may also have been employed.

The frequently used term "damascening" requires comment. There are two basic methods of decorating iron or steel surfaces with soft metals like gold, silver, or copper alloy, both often confusingly referred to as "damascening" or "damascene." The first, often used for inscriptions, involves the cutting of grooves in the metal surface into which precious metal wire is hammered. This technique, which is the most exacting but most durable of the two, is here referred to as inlay. The second, far more commonly encountered technique requires the cross-hatching of the surface with a knife or file, creating a roughened area (rather like the surface of a modern nail file) onto which precious metal wire or foil is applied and burnished into the grooves. Often referred to by the Persian term "koftgari," or as "false-damascening," this latter technique is the one referred to here as damascening.

The inscriptions have been freshly read by Will Kwiatkowski. English translations of the Qur'an are taken from *The Holy Qur'an: English Translation of the Meanings and Commentary* (Medina, 1992/93). Dates are given in the Gregorian calendar unless an object carries a precise Hegira date. In that case, dates are given in both eras. *Ayn* and *hamza*, letters of the alphabet, are marked, but other diacritical signs are not used.

All of the illustrations have been oriented, first, to show the object best and, second, to allow the inscriptions to be read.

Islamic Arms and Armor

IN THE METROPOLITAN MUSEUM OF ART

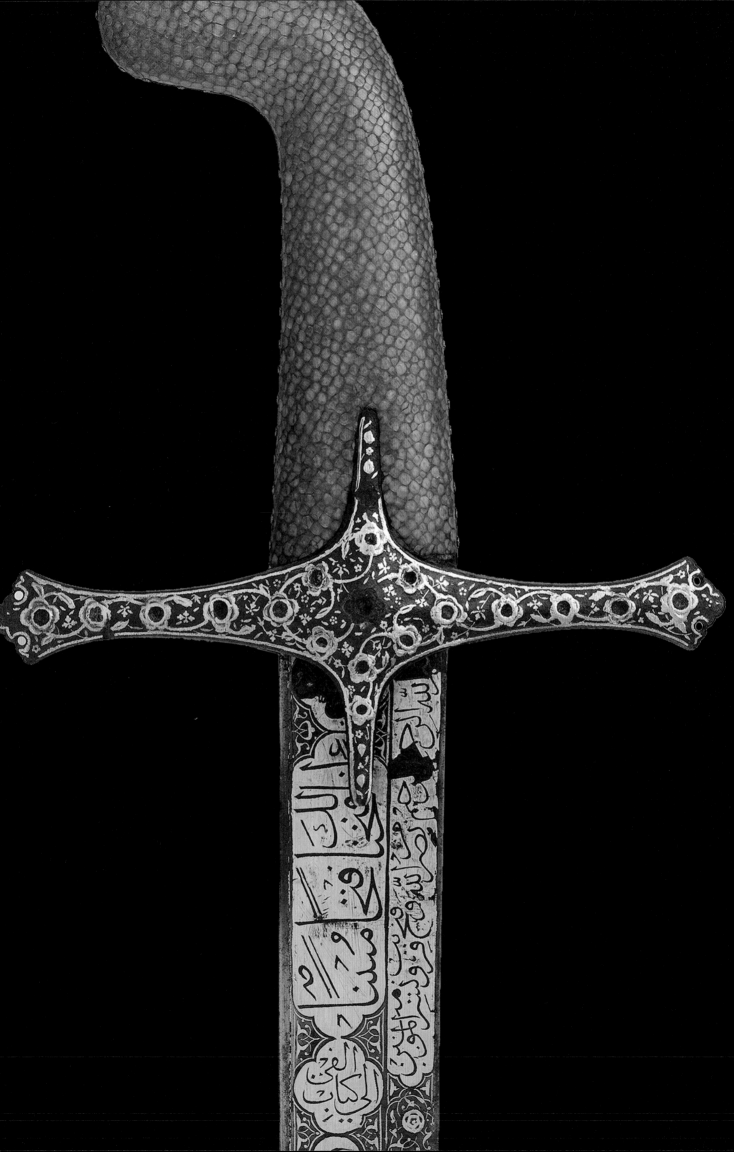

American Collectors and the Formation of the Metropolitan Museum's Collection of Islamic Arms and Armor

Stuart W. Pyhrr

The Metropolitan Museum's collection of arms and armor, begun in the late nineteenth century, is today one of the largest and most comprehensive of its kind, encompassing some fourteen thousand examples from Europe, Asia, the Middle East, and North America. Most of the collection is housed in the Department of Arms and Armor, a specialized curatorial department unique in North American art museums. The department's European and Japanese holdings, making up about two-thirds of the total, have been the principal areas of acquisition, research, publication, and display and as a consequence are well known to specialists and the public alike. The Islamic arms, on the other hand, which number fewer than one thousand items, have been exhibited only sporadically over the last century and are for the most part unpublished, remaining generally unknown. With the majority of objects coming to the Museum before World War II as gifts and bequests, the shape of the collection has largely been determined by the taste, knowledge, financial means, and collecting opportunities of those early donors. Although most of the pieces date from the eighteenth and nineteenth centuries, among them are a small but important number of early works, including a series of decorated armors and helmets dating to the fifteenth and sixteenth centuries, the earliest documented Islamic sword, and a splendid Ottoman saber from the court of Süleyman the Magnificent (r. 1520–66)

(illustrated opposite). Only in recent years has the Department of Arms and Armor had the financial means and opportunity to enhance the core collection with purchases of individual works of artistic merit and historical importance. The present catalogue, the Museum's first major publication on the subject, presents one hundred twenty-six of the Museum's most significant Islamic arms with the hope that it will make the collection better known and will encourage a deeper understanding of and appreciation for this fascinating subject.

The formation of the Metropolitan's collection of Islamic armor and weapons is rooted in a centuries-old European tradition. The West has been fascinated with so-called oriental armor and weapons since the Middle Ages, when examples arrived in Europe from the battlefields in the Holy Land and as the result of diplomatic exchange and commercial trade with the Middle East. The fall of Constantinople in 1453 opened a long chapter of contact and confrontation between Europe and the Ottomans. Due to the Turkish wars, which were fought sporadically in eastern Europe and the Mediterranean until the early eighteenth century, Ottoman and other Islamic arms were commonplace trophies in European armories; weapons of elaborate workmanship or precious materials found their way into princely treasuries and art collections, while the more commonplace examples were valued as ethnographic specimens in cabinets of curiosities, where natural and manmade objects served as an encyclopedic catalogue of the known world. Another chapter in the history of collecting began in the eighteenth century, when colonial expansion into India and North Africa brought a flood of Islamic arms of different types into Europe, particularly England and France. Apart from their obvious value as trophies of war or as exotic curios, Islamic arms were also appreciated by their owners on other levels: for their construction and use of technologies unknown in the West, such as edged weapons with blades of "watered" (crucible) steel, gun barrels of highly figured "Damascus twist" forging, and flexible bows of "composite" construction; for their elaborate embellishment that often incorporated exceptionally rich or unusual materials like hardstones, jewels, and enamel; and for novel decorative techniques, like damascening, and ornamental vocabulary, such as knot designs and arabesques. The Western fashion for Ottoman-style arms and military equipment from the

Fig. 1. Augustus Charles Pugin (1762–1832), *Armory at Carlton House, London*, 1814. Watercolor. The Royal Library, Windsor Castle (RL 17092)

Fig. 2. Oriental Armory, Wallace Collection, London, ca. 1900

sixteenth century onward testifies to the European respect and admiration for these weapons.

Arms collecting became more systematic during the nineteenth century. The Gothic Revival and the romanticized view of the Middle Ages presented in the novels of Sir Walter Scott inspired a new vogue for medieval and later European arms, just as the colonial experience, and an increasing familiarity with the Middle East and Holy Land among Western travelers, further encouraged the collecting of oriental arms. Many collectors acquired eclectically in both areas. The armory of Britain's Prince Regent (the future George IV), picturesquely arranged in his mansion of Carlton House in London, served as an early model.[1] In one of the rooms filled floor-to-ceiling with European, Indian, Asian, and African works was a fully armored equestrian figure of Tipu Sultan, ruler of the Indian state of Mysore, who died during the British siege of his capital in 1799 (fig. 1). The armory assembled by Sir Samuel Rush Meyrick (1783–1848) and published in a fully illustrated catalogue in 1830 included extensive European and oriental holdings. Meyrick displayed his Islamic and Indian pieces in a room vaguely modeled on the Alhambra and arranged his armored figures in animated poses.[2] Deemed the father of modern arms and armor collecting, Meyrick's well-publicized example inspired several later generations

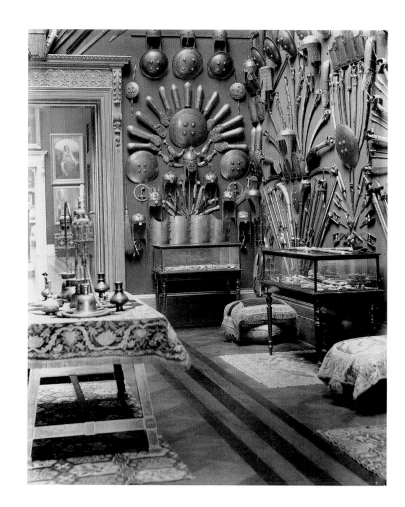

of collectors, including Sir Richard Wallace (fig. 2) and the Anglo-Florentine Frederick Stibbert.[3] The orientalist movement in France during the second half of the century inspired a new interest in Islamic art, and with it arms and armor. Jean-Léon Gérôme's *The Cairene Armorer* of 1869 (fig. 3) demonstrates the artist's fascination with the Middle East and his close observation of the costume and weapons he encountered there. Like many history painters, Gérôme (1824–1904) formed a small collection of such "props," which he incorporated into his compositions to give them added authenticity.[4] The artist's brother-in-law, the dealer and early collector of Islamic art Albert Goupil, also owned Islamic armor, including the Indian helmet—now in the Museum's collection (cat. 39)—seen in the panoply at the left of Gérôme's canvas.

It was not until the last quarter of the nineteenth century, shortly after the founding of the Metropolitan Museum in 1870, that auction sales and exhibitions began to provide evidence of a growing interest in arms and armor among a small group of New York collectors.[5] In keeping with the prevailing European taste of the day, the majority of them favored medieval and Renaissance examples. But there was also a growing interest in Japanese armor and weapons, no doubt a reflection of the current wave of Japanism that was then sweeping the West, and to a lesser degree, in Islamic and other "oriental" arms. In December 1883, for example, a number of Turkish, Persian, and North African arms were lent for display in the "Pedestal Fund Art Loan Exhibition" at the National Academy of Design in New York (fig. 4).[6] Organized to raise funds for the construction of the pedestal for the Statue of Liberty, the exhibition gave New Yorkers an opportunity to see what their fellow citizens had been collecting in recent years. Lenders to the arms and armor section included the industrialist William S. Hoyt, the painter William Merritt Chase, the society photographer Napoleon Sarony, and a future donor to the Metropolitan, John Stoneacre Ellis. The supervising committee included the financier Giovanni P. Morosini, who in this case was not a lender but whose collection would significantly enhance that of the Metropolitan's in the coming years.

The first Islamic arms to enter the Museum's collection arrived in 1891 as part of the bequest of Edward C. Moore (1827–1891).[7] A silversmith by training, Moore had a lifelong association with Tiffany and Company, becoming director of the company's silver department, its chief designer, and, ultimately, its president. Over the years Moore formed a huge collection of glass, ceramics, and metalwork, over two thousand objects, most of them from the Near and Far East. Among these were more than

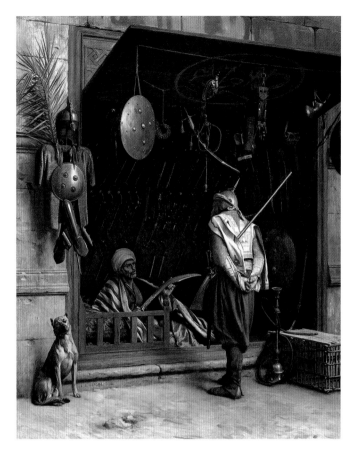

Fig. 3. Jean-Léon Gérôme (1824–1904), *The Cairene Armorer* (*Un Marchand d'armes au Caire*), 1869. Oil on canvas. Private collection

Fig. 4. Engraving of arms and armor exhibited at the "Pedestal Fund Art Loan Exhibition" at the National Academy of Design, New York, 1883. After a drawing by H. Fenn. The Metropolitan Museum of Art, New York, Thomas J. Watson Library

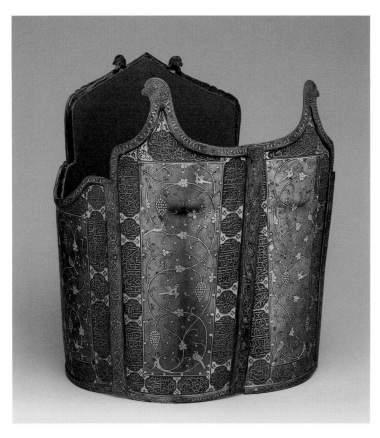

Fig. 5. Cuirass (*char-a'ina*). Iran, Qajar period, early 19th century. Steel, gold, and textile. The Metropolitan Museum of Art, New York, Bequest of Edward C. Moore, 1891 (91.1.748)

forged from crucible steel, known at the time as "Damascus" or "watered" steel, which for centuries had been highly prized for its strength, flexibility, and beautiful surface pattern. The cuirass is damascened in gold with birds amid vine tendrils, the plates framed by a series of cartouches chiseled with talismanic inscriptions from the Qur'an (Sura 48, *al-Fath*, "The Victory").[8] The armor is very similar in form and decoration to another cuirass in this catalogue (cat. 17). Moore also possessed several Qajar daggers (*kards*), each with a walrus-ivory grip and a blade of crucible steel, the best of which is decorated with Qur'anic inscriptions reserved against a flush gold background (cat. 89).

In 1896 the Metropolitan Museum was offered the gift of the small collection of arms and armor formed by John S. Ellis

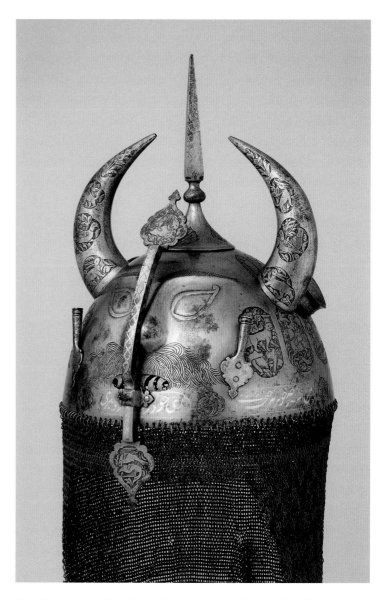

Fig. 6. Helmet. Iran, Qajar period, early 19th century. Steel, gold, and textile. The Metropolitan Museum of Art, New York, John Stoneacre Ellis Collection, Gift of Mrs. Ellis and Augustus Van Horne Ellis, 1896 (96.5.125)

four hundred works from the Islamic world, including rare examples of Mamluk painted glass and brass vessels inlaid with gold and silver dating from the thirteenth or fourteenth century that rank today among the masterpieces within the Museum's Department of Islamic Art. Moore's collection was not merely that of an *amateur*, but rather was formed to provide inspiration for the design of modern silver and other decorative art, what the literature of the time called the "industrial arts." Portions of the collection were displayed in his studio, where they served as a reference source for himself and his team of designers and apprentices. Indeed, from the late 1860s to the early 1890s, Islamic-inspired designs for silver wares were regularly introduced into the Tiffany repertory, identified variously as "Moresque," "Indian," "Persian," or "Saracenic."

Moore's small group of Islamic arms was not of comparable importance to his other Islamic metalwork. Although the majority of pieces were of fairly recent Iranian manufacture, dating to the early Qajar period (1796–1924), they are nevertheless fine examples of their kind. Among them are two elements of early nineteenth-century armor, a helmet (cat. 42) and a cuirass of four plates, called a *char-a'ina* (Persian, "four mirrors") (fig. 5). Both are

(1828–1896), who had begun collecting after the Civil War and had lent a dozen items to the "Pedestal Fund Art Loan Exhibition" in 1883.[9] While the quality of the Ellis pieces was unexceptional, the gift was of considerable importance in establishing arms and armor as a category of objects worthy of acquisition and display in an American art museum. His Eastern arms, like Moore's, were of recent manufacture and included a decorative, eye-catching helmet of Qajar origin with horns and a leonine face (fig. 6), features that allude to several heroes in the Iranian national epic, the *Shahnama* of Firdausi.[10] A Qajar dagger with a carved ivory grip, Ellis's finest weapon, is featured in this publication (cat. 90).

The bequest of the Heber R. Bishop Collection in 1902 brought to the Museum a spectacular group of more than one thousand jade objects, mostly Chinese works of the Qing dynasty that date to the eighteenth and nineteenth centuries.[11] Bishop (1840–1902) was a Gilded Age industrialist and entrepreneur whose wealth and academic interests enabled him to pursue the life of a philanthropist and art collector. His passion for jade is reflected in his extensive collection and the scholarly catalogue that accompanied it. Among his East Asian jades was a small group of Mughal works, including several dagger hilts inlaid with gemstones in gold settings. One of these has a delicately carved horsehead pommel and perhaps dates from the late seventeenth or early eighteenth century, although the decoration may be a later embellishment (fig. 7).[12] Two complete daggers with zoomorphic hilts of this type are discussed below (see cats. 82, 83). One of Bishop's most exceptional pieces, a sword guard of dark green jade carved with dragon head quillons (cat. 56), was initially identified as an Indian work of the seventeenth century but is now recognized as exhibiting strong Central Asian or Timurid characteristics and has been dated by various scholars to the fourteenth or fifteenth century.

The first truly consequential examples of Islamic armor entered the Museum with the acquisition of the duc de Dino collection in 1904.[13] A wealthy French aristocrat of ancient lineage, Maurice de Talleyrand-Perigord, duc de Dino (1843–1917), formed his collection between about 1885 and 1900, focusing principally on medieval and Renaissance arms and armor. This assemblage of about five hundred objects was hailed by specialists of the day as the most important collection in private hands. It is often forgotten, however, that among the Dino pieces are also a dozen rare examples of early Turkman and Ottoman armor, some of the most significant pieces of their kind in Western collections. Dino was not particularly attracted to Islamic art for its own sake, but rather seems to have acquired these select objects as

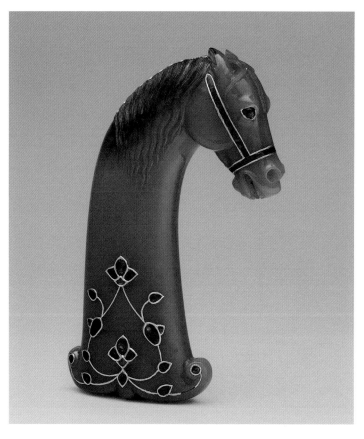

Fig. 7. Hilt of a dagger. India, Mughal period, late 17th or early 18th century. Jade (nephrite), rubies, and gold. The Metropolitan Museum of Art, New York, Gift of Heber R. Bishop, 1902 (02.18.778)

demonstrations of the armorer's art in the Middle East as a parallel to that of Europe. The collection includes an exceptional group of ten turban helmets dating from the late fifteenth or early sixteenth century and an armor of mail and plate of similar date and workmanship, all richly embellished with engraved foliate ornament and calligraphy damascened in silver or gold (cats. 5, 22–28). Given the broad geographic and cultural distribution of armor of this distinctive type, which appears to have been used by the Ak-Koyunlu, Timurids, Ottomans, and Mamluks, and in the absence of documentation identifying their place, or places, of manufacture, these works are here identified generically as Turkman style (see Appendix B). Among Dino's Ottoman works is a superb conical helmet forged of crucible steel, complete with its peak, cheek pieces, and nape defense (elements usually missing on most surviving examples) and covered with dense Arabic inscriptions in gold (cat. 33). A masterpiece of metalworking, it was undoubtedly made in the imperial workshops in Istanbul during the reign of Süleyman the Magnificent (r. 1520–66).[14]

Unlike the late works in the Moore and Ellis collections, which were essentially decorative in purpose, the Turkman and Ottoman armor in the Dino collection represent the greatest

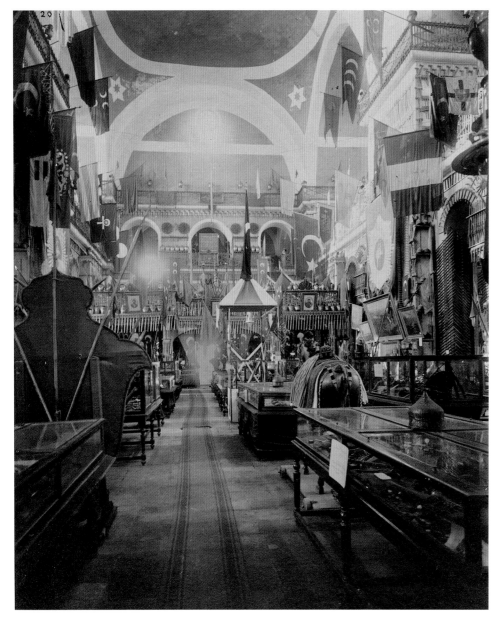

entered a number of public and private collections.[16] The arsenal mark, which provides an unimpeachable provenance for these armors, is usually incised into the steel surfaces of armor plate or stamped on a copper or lead seal applied to mail (see cat. 22 for the former and cat. 30 for the latter).

The Dino collection also includes a rare group of over one hundred small equestrian harness mounts of enameled gilt-copper, the majority of which were found in Spain and presumably date to the fourteenth and fifteenth centuries. While most of these decorative fittings are emblazoned with Spanish coats of arms, Christian symbols, or chivalric emblems, several also bear Arabic, or pseudo-Arabic, inscriptions, some based on the word *Allah*, suggesting that the same metalworking ateliers were serving Muslim clients as well (fig. 9). The Museum's Nasrid-style helmet (cat. 43) presents a similar example demonstrating the mixed cultural influences current in late fifteenth-century Spain.

period of armor manufacture and active use in the Middle East. Many of them are incised with the so-called arsenal mark, which is thought to derive from the tribal symbol, or *tamğa*, of the Kayi, one of the original Turkman tribes from which the Ottoman claim descent.[15] Essentially an Ottoman mark of possession, it seems to have been applied to the Ottoman and foreign arms that were gathered in the arsenals in Istanbul, Bursa, Edirne, and Erzurum. The majority of marked pieces in Western collections appear to have come from the arsenal in Istanbul (fig. 8), which, following the Ottoman conquest of Constantinople in 1453, was housed in the former Byzantine church of Hagia Eirene (Saint Irene), located in the first courtyard of the Topkapı Palace. About 1839, at the beginning of the reign of Sultan Abdul Mejid I (1839–61), the arsenal was reorganized, and thousands of surplus arms were disposed of. These made their way to Europe and subsequently

With the purchase of the Dino collection, arms and armor were firmly established as part of the Metropolitan Museum's core collections. A specialized curatorial department with a full-time curator was created in 1912, and a newly constructed suite of galleries for the collection's display opened in 1915. The curator's role was assumed by Bashford Dean (1867–1928), professor of vertebrate zoology at Columbia University and curator of fishes at the American Museum of Natural History, and an active private collector of both European and Japanese arms and armor. In 1904 Dean volunteered to install and publish the Dino collection, and in 1906 he was named honorary curator, a position made permanent six years later. From that time on, Dean dedicated his time, energy, and personal resources to expanding the holdings in every

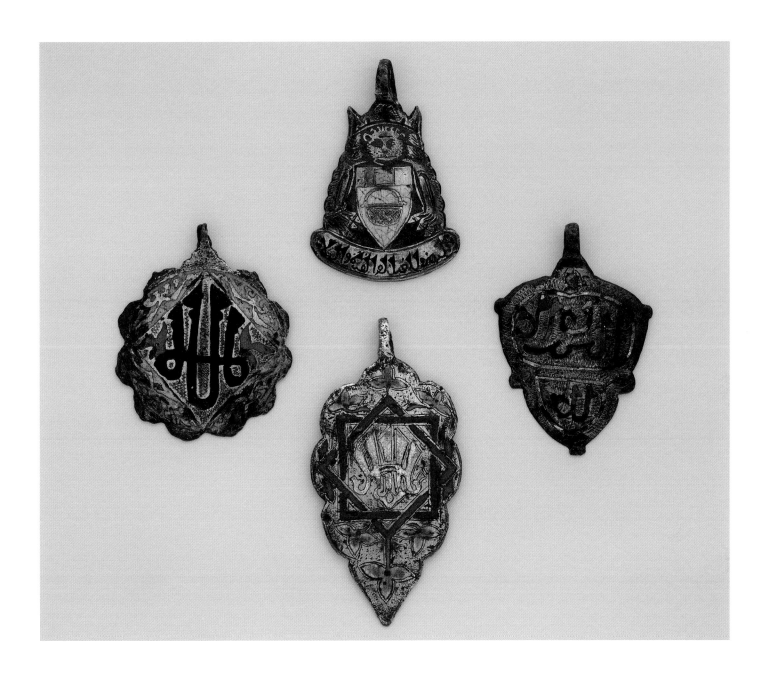

area—European, Japanese, Islamic, and North American—with the goal of creating an encyclopedic collection without rival.

Dean's efforts were encouraged and supported by the Museum's president, J. P. Morgan (1837–1913). Morgan played an active role in securing for the Museum the collection of William H. Riggs (1837–1924), an American expatriate living in Paris who had devoted his life to assembling a collection of almost two thousand examples of European arms and armor. The curator and president ultimately prevailed upon Riggs to donate his collection to the Metropolitan in 1913. Like the duc de Dino, Riggs had focused almost exclusively on European arms, yet he too possessed a few exceptional Islamic examples, which probably appealed to him because of their early date and fine condition. Among them are a fifteenth-century Mamluk lance head, a sixteenth-century

Ottoman helmet and mace, and an unusual inscribed standard head of probable fifteenth- or sixteenth-century date (cats. 93, 34, 99, and 105, respectively). Several are recorded as having been purchased in Paris in the 1890s from a Turkish dealer by the name of Beshiktash.[17]

As private collectors, Morgan and Dean would acquire an occasional Islamic piece, although neither focused in this area. Among the six thousand objects from Morgan's collection that were given to the Metropolitan Museum by his son Jack in 1917 were two nineteenth-century Turkish sabers that Morgan senior had probably picked up as curios on his frequent travels in the Middle East.[18] More important, the Morgan gift included an exquisite seventeenth-century Ottoman knife and scabbard of enameled gold set with rubies and emeralds that is published

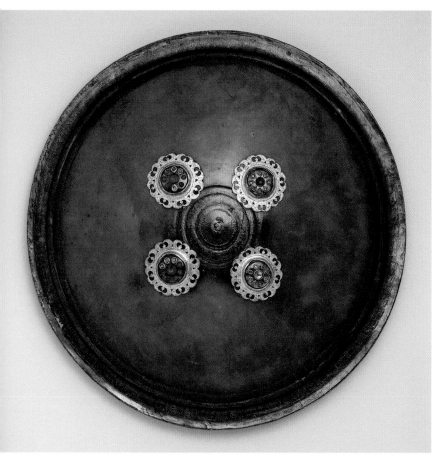

Fig. 10. Shield. India, early 19th century. Leather, gilt copper alloy, glass, lacquer, and textile. The Metropolitan Museum of Art, New York, Bashford Dean Memorial Collection, Funds from various donors, 1929 (29.158.598)

here for the first time (cat. 78). More courtly jewelry than weapon, this gem-studded work reflects Morgan's well-known affinity for small, highly finished objects of precious metal.

Bashford Dean had personally collected European and Japanese arms and armor from an early age. After his death, more than a thousand of his best pieces were acquired by the Museum by gift, bequest, and purchase; today they form one of the cornerstones of the Arms and Armor Department. Islamic arms, on the other hand, never attracted him, with the result that he owned only a random handful of examples. Among these were elements of Indian armor that he purchased while traveling in India in 1905, including a nineteenth-century shield of translucent buffalo hide set with four bosses of gilt metal, glass, and jewels (fig. 10) and a handsome anatomically formed cuirass of crucible steel that came from the armory of the nizam of Hyderabad in the Deccan (cat. 15). Commenting on these purchases at the time, Dean complained, "how rare arms and armor were in India, and what impossible prices the dealers were asking—that is for *oriental* arms."[19] Dean's lament, not an uncommon one among

collectors, also reflects the prevailing prejudice that "oriental" arms were considerably less valuable than comparable European examples. Dean's collection later came to include several mail shirts with Persian- or Arabic-inscribed rings (cat. 17) and a seventeenth-century Ottoman helmet of gilt copper (*tombak*) (fig. 11) from Istanbul.[20] Even in a field generally unfamiliar to him, Dean chose distinctive pieces.

European and Japanese pieces took pride of place when the collections of the Department of Arms and Armor were installed in the suite of specially designed galleries in 1915. One small gallery was set aside for Near Eastern arms, which was populated with the Islamic pieces from the Ellis, Dino, and Riggs collections. The display was significantly enhanced by the loan of more than forty arms of Islamic, South Indian, and Indonesian origin generously offered by a local collector and new friend of the department, George Cameron Stone (fig. 12).[21]

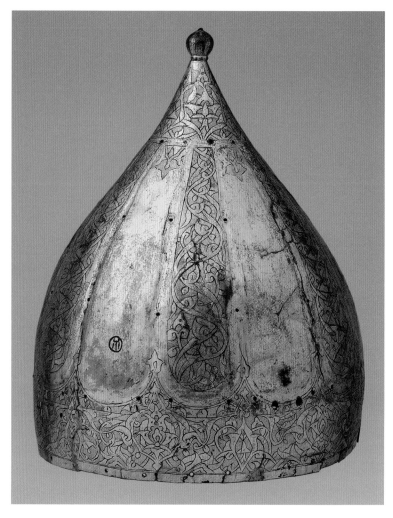

Fig. 11. Helmet. Turkey, Ottoman period, early 17th century. Gilt copper (*tombak*). The Metropolitan Museum of Art, New York, Gift of Mrs. Ruth Blumka, in memory of Leopold Blumka, 1974 (1974.118)

In 1923 that early display of Islamic arms was spectacularly enriched with the addition of nine jeweled Turkish weapons that for many years afterward were among the department's most popular and eye-catching exhibits. They were given by Giulia Morosini in memory of her father, Giovanni P. Morosini (1832–1908), one of the first American collectors in the field.[22] Morosini hailed originally from Venice, which he had to flee in 1848 following his participation in an unsuccessful uprising against the occupying Austrian government. Arriving penniless in the United States, he was eventually befriended by the financier and legendary robber baron Jay Gould, whose bodyguard, confidant, and agent he became. Working with Gould, Morosini made a fortune on Wall Street. He lived in princely style in his mansion, Elmhurst, in Riverdale (a suburb north of Manhattan), which he filled with works of art of all kinds. A well-stocked armory was the collection's centerpiece.[23]

The highlight of Morosini's extensive holdings were his Turkish arms, the most important and finest of which is the so-called saber of Sultan Murad V (cat. 66). Other items included six daggers, a flintlock pistol, and an elaborate tray on which these items could be displayed, each mounted in gilt metal and set with colored gems (fig. 13). Many of the pieces are inscribed in Arabic or Persian and several bear dates in the eighteenth century. (The workmanship of all the items appears to be the same, however, suggesting that the dates are spurious.) Similar jeweled edged weapons, apparently from the same workshops and also bearing dates between the sixteenth and the eighteenth century, are in the Walters Art Museum, Baltimore, and the Harding Collection of Arms and Armor in the Art Institute of Chicago.[24] These are known to have been acquired in Istanbul in 1903 and 1904, respectively, from the same dealer, R. S. Pardoe, proprietor of the Oriental Museum (despite its name, a commercial emporium). The Morosini weapons were probably acquired at about the same time and from the same source. Perhaps made specifically for the tourist trade, with wealthy Americans in mind, these glittering weapons were no doubt intended to play upon the Westerner's romantic notions of the lands of the *Arabian Nights* and to evoke the opulent courts of legendary sultans and shahs. Giulia Morosini's gift of 1923 was significantly augmented with her bequest of 1932, which included several dozen more Islamic arms (for example, cats. 48, 108, 111) and a complete fifteenth- or early sixteenth-century Turkish horse armor (see fig. 18).

By far the largest and most important acquisition of Islamic arms and armor came in 1935 with the bequest of George Cameron Stone's collection, which comprised over three thousand

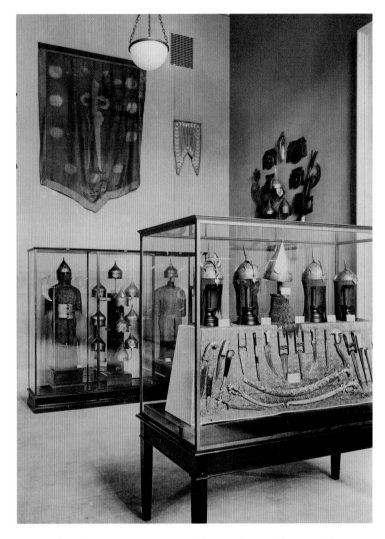

Fig. 12. Gallery of Eastern Arms, Department of Arms and Armor, The Metropolitan Museum of Art, New York, 1915

works from the Middle East, India, China, South East Asia, and Japan. A lifelong New Yorker, Stone (1859–1935) was a metallurgist who was employed most of his career at the New Jersey Zinc Company, where he eventually became its chief engineer and chief metallurgist.[25] A recognized expert in his field, he held eight patents, authored more than fifty scientific articles, and in 1935 received the James Douglas Medal, the highest honor awarded in the field of nonferrous metallurgy. Despite his many scientific contributions, Stone is principally remembered today for the collection he bequeathed to the Metropolitan Museum and for the book that essentially serves as its catalogue, *A Glossary of the Construction, Decoration, and Use of Arms and Armor in All Countries and at All Times*.[26] Published in 1934, this ambitious illustrated encyclopedia of almost seven hundred pages contains nearly nine hundred figures that picture several thousand objects, most from Stone's collection. It remains one of the fundamental

references—and probably most frequently reprinted title—in the field of arms and armor.

Fascinated with arms since childhood, Stone was unusual in his day for his early specialization in non-Western arms. His frequent business travels took him to Europe, North Africa, the Middle East, India, and the Pacific islands, providing him with unique opportunities for making acquisitions from a wide range of dealers, collectors, and other local sources. He ultimately amassed almost five thousand works that filled his townhouse at 49 West 11th Street, where every inch of wall space, and some ceilings, on the second floor were covered with the trophies of his collecting (fig. 14). He methodically recorded each purchase with a brief description, provenance (usually a dealer's name), and a coded price. The depth and range of his collection have few modern parallels.

As would be expected in so large a collection, the provenances for Stone's pieces are diverse. His principal source, however, was the English dealer William O. Oldman (d. 1949),[27] a specialist in ethnographical material and arms and armor whose shop and residence were located at Hamiliton House, 77 Brixton Hill, London. Oldman supplied museums and private collectors with African, Oceanic, Indonesian, Asian, American Indian, and Eskimo artifacts of every type and from 1903 to 1913 issued a slim monthly catalogue, often illustrated, that listed his current offerings. Stone was without doubt Oldman's best customer for arms, often buying large numbers of modestly priced works at a time. Crates of objects would be sent to Stone on approval, with the collector invited to take his pick and return the rest. Although many of Stone's pieces from Oldman were often merely acquired as representative types, some were of outstanding quality and rarity, and several were among the earliest examples of Islamic armor in his holdings (cats. 7, 38, 44).

Stone was also a regular customer of the mainstream arms and armor dealers, notably Fenton and Sons and Hal Furmage in London, Louis Bachereau in Paris, and Daniel Z. Noorian, L. A. Lanthier, Theodore Offerman, and Sumner Healey in New York. He acquired several dozen items from Dikran Kelekian (1868–1951), the leading dealer of Islamic art, who maintained shops in Paris, New York, and Cairo.[28] Kelekian supplied many American museums and private collectors, among them Henry Walters, Isabella Stewart Gardner, and the Havemeyers, with some of their finest Islamic ceramics and metalwork. Stone also attended local auctions (for example, at the American Art Association in New York), but his most important sales-room purchases came from the dispersal of the Laking collection at Christie, Manson

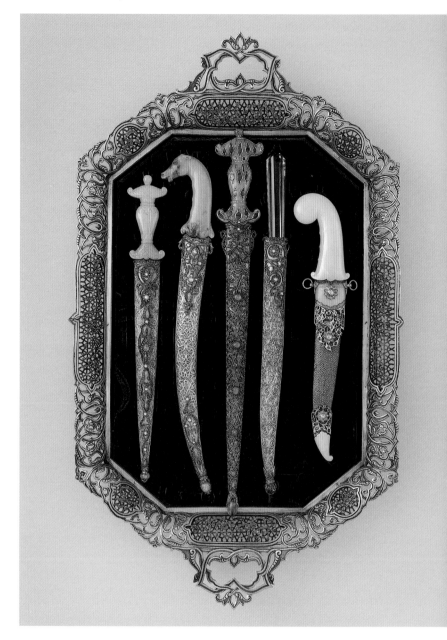

Fig. 13. Tray with five jeweled daggers. Turkey, Ottoman period, late 19th century. Steel, copper alloy, gold, jade, rock crystal, gemstones, and textile. The Metropolitan Museum of Art, New York, Gift of Giulia P. Morosini, in memory of her father, Giovanni P. Morosini, 1923 (tray, 23.232.1; left to right, 23.232.6, .7, .3, .4, .8)

and Woods in London on April 19–22, 1920, from which he acquired twenty-three pieces. Sir Guy Francis Laking (1875–1919) had been a colorful figure in the armor world who worked, often simultaneously, as the arms expert at Christie, Manson and Woods in London, the director of the London Museum, which he helped found, and the keeper of the king's works of art and arms and armor at Windsor Castle.[29] He was a passionate private collector whose holdings in both European and Islamic arms reflected his sharp eye and refined taste. Having reviewed the Laking sale catalogue with Dean, Stone entrusted the curator

with the final choice of items within his budget: Dean purchased eighteen lots for Stone (including cats. 9, 10, 35, and 40), and Old-man subsequently provided another five. Later that same year Stone also acquired through Dean several lots from the auction sale of the armory at Parham in Surrey, which had been formed in the mid-nineteenth century by Robert Curzon (1810–1873), baron Zouche of Haryngworth, who in the 1830s had been attached to the British embassy in Istanbul and who wrote an account of his travels in the Levant.[30] Zouche appears to have been instrumental in bringing to England much of the armor dispersed from Istanbul in 1839,[31] among them the inscribed pectoral plate acquired by Stone at the Zouche sale (cat. 11).

Many of Stone's best Turkish pieces came through his acquaintance with the dealer Haim in Istanbul, whom he visited in 1928 and 1932.[32] These include the only turban helmet in his collection (cat. 29) and his finest sword (cat. 58). Stone also purchased a number of items in the city's famous bazaar, among them a rare Mamluk ax (cat. 95). It is without doubt a reflection of the growing reputation of Stone's collection in these years that he was invited to lend nineteen edged weapons and firearms to the prestigious "International Exhibition of Persian Art" held at the Royal Academy of Arts in London in 1931.[33]

Through his friendship with Dean, Stone became closely involved with activities of the Department of Arms and Armor. Between 1915 and 1928 he lent more than seventy-five works to supplement the gallery displays of Eastern arms. Indeed, Dean hoped to make the arrangement permanent, and in 1926 he approached Stone to consider bequeathing his entire collection to the Museum. After some negotiation—Stone knew the Metropolitan sought only the finest examples of their kind, whereas he attempted to collect "as many of the different arms as possible, the (artistically) good and bad included"[34]—Stone bequeathed the majority of his works, over three thousand objects, to the Museum.[35] Today the Stone collection forms the bulk of the Department of Arms and Armor's non-European holdings other than Japanese, and it accounts for the more than half of the pieces featured in this publication.

As a result of Stone's transformative bequest, the Museum's collection of Islamic arms was deemed to be essentially complete. Little was acquired in this area over the next fifty years. A notable exception was the 1943 gift of ten North African and Balkan guns that were reputed to have belonged to 'Ali Pasha Tepedelenli (ca. 1744–1822), a Muslim Albanian in Ottoman service who ruled as pasha over Albania and northern Greece and became a romantic figure in the nineteenth-century history and literature (his

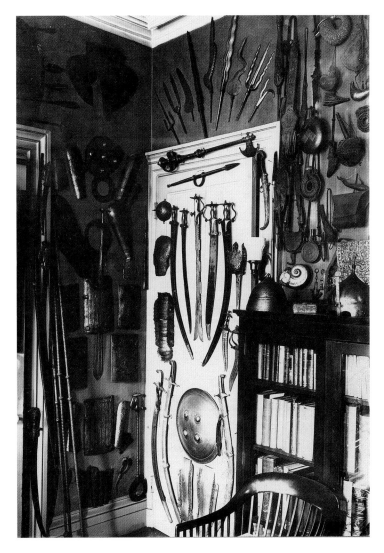

Fig. 14. Collection of George C. Stone, ca. 1930, displayed in his house at 49 West 11th Street, New York

court was described by Lord Byron).[36] Two of the 'Ali Pasha guns are discussed here (cats. 110, 114). The department made only the occasional purchase in the field, two of which are noteworthy: a superb turban helmet acquired in 1950 from the Rothschild collection in Vienna (cat. 30), a fitting complement to the eleven others in the collection, and a seventeenth-century Turkish parade saber with mounts of silver-gilt set with gem-studded jade plaques and turquoises (cat. 59), a work unlike any in Stone's collection.

In the late 1970s the author of this catalogue, David G. Alexander, then a Ph.D. candidate in Islamic art at the Institute of Fine Arts, New York University, joined the Metropolitan's Department of Arms and Armor to begin a study of its Near Eastern collection.[37] One of the rare Islamic scholars to specialize in arms and armor, Alexander focused much of his research to the two most important repositories of Islamic arms, the Topkapı Sarayı Museum and the Askeri Müsezi (Military Museum) in Istanbul,

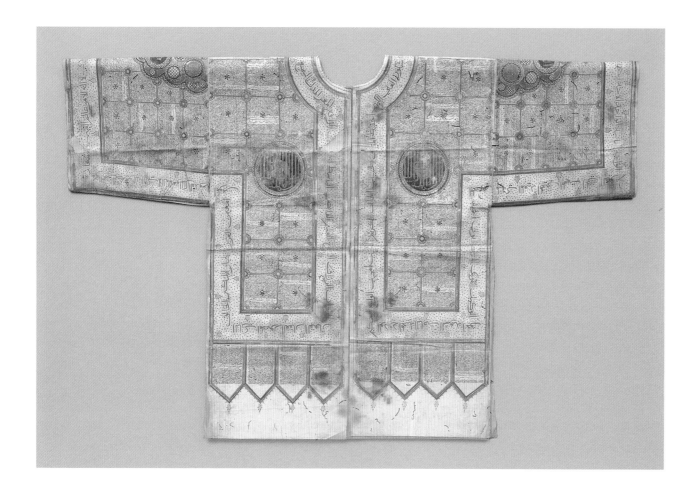

Fig. 15. Talismanic shirt. India, 15th or early 16th century. Ink, gold, and colors on cotton. The Metropolitan Museum of Art, New York, Purchase, Friends of Islamic Art, 1998 (1998.199)

Fig. 16. Dagger with zoomorphic hilt. India, probably Bijapur, ca. 1600–1650. Steel, copper alloy, gold, and rubies. The Metropolitan Museum of Art, New York, Purchase, Lila Acheson Wallace Gift, 2011 (2011.236)

Fig. 17. Detail of shirt of mail and plate before restoration (cat. 12). India, Mughal period, dated A.H. 1042 (A.D. 1632/33). Steel, iron, gold, and leather. The Metropolitan Museum of Art, New York, Purchase, Arthur Ochs Sulzberger Gift, 2008 (2008.245)

to whose storerooms he was given unprecedented access at the time. Many of his discoveries among the Iranian, Mamluk, and Ottoman armors and weapons preserved in those collections have informed his research on the Museum's collection. (Sadly, the two collections in Istanbul remain largely unpublished.) Alexander's 1985 exhibition, "The Bright Side of the Battle: Symbol and Ceremony in Islamic Arms and Armor," drew fresh attention to the range and quality of the Museum's holdings in this area, and he continued to catalogue the Museum's collection until his move with his family to France in 1988. The present publication is the direct result of this early work and his subsequent research and publication in the field.

By the late 1980s interest in Islamic arms and armor had grown to a level unparalleled since the nineteenth century. For the first time, collectors in the Middle East began to form significant collections of the art of their Muslim culture, in which armor and weapons make up a significant part.[38] The Metropolitan's departments of Arms and Armor and Islamic Art also began to acquire Islamic arms with a new enthusiasm, making select purchases of objects that complemented existing holdings and added examples of notable artistic merit and historical importance.

The Department of Islamic Art, which previously had never actively collected arms, made several significant acquisitions in this area. During the tenure of Stuart Cary Welch (1928–2008), a distinguished scholar of Indian art and special consultant

in charge of the department from 1979 to 1987, the Museum's Indian collections were considerably strengthened, including the acquisition of two outstanding seventeenth-century jade-hilted Mughal daggers of imperial quality (cats. 83, 84), which were featured in the Museum's 1985 exhibition "India: Art and Culture, 1300–1900."[39] The department subsequently acquired a rare Indian talismanic shirt, a garment with a specific arms-and-armor connection (fig. 15).[40] Embellished with ink, gold, and colors, and covered with Qur'anic inscriptions and the names of God, these cotton shirts, worn under armor, were believed to protect the warrior in battle. Similar talismanic inscriptions embellish the mail shirts and armor in this catalogue (cats. 2–4). Most recently, that department purchased one of the masterworks of Stuart Cary Welch's private collection, a rare and unusual seventeenth-century Deccani dagger with a zoomorphic hilt of cast, chased, and gilt copper set with rubies (fig. 16).[41]

The Department of Arms and Armor's Islamic holdings have grown even more significantly, with the addition of several early examples of the kind rarely found on the art market. These include a tiny but exquisitely decorated knife blade (cat. 75), possibly originally from Afghanistan and perhaps dating from the tenth to thirteenth century, and a helmet with a silver-damascened Arabic inscription that mentions Jani Beg, ruler of the Blue Horde in Russia in the fourteenth century (cat. 19). Both works appear to have been preserved for centuries in the Himalayas. Without doubt the most notable of the department's recent acquisitions is the splendid Ottoman yatagan from the court of Süleyman the Magnificent (cat. 57), which compares so closely in decoration and workmanship to the sultan's yatagan in the Topkapı that it must have been made by the same jeweler, Ahmed Tekelü, at about the same time, 1526. Two remarkable Mughal examples must also be singled out: an opulent and beautifully fashioned dagger

mounted in gold and precious stones from the court workshops of Emperor Jahangir (r. 1605–27) (cat. 80) and a shirt of mail and plate that appears to have been presented to Shah Jahan in 1632/33 (cat. 12). The shirt is not only one of the most beautiful Indian armors known but also one of the earliest securely dated examples.

The fine condition of the Museum's arms and armor is owed to the attention and skill of its conservators. Since 1909 the Department of Arms and Armor has maintained a staff of specialized armorers and conservators who have overseen the cleaning, mounting, and installation of the collection. Several examples suffice to demonstrate their recent contributions to our appreciation of the pieces in this publication.[42] The Mughal shirt of mail and plate acquired in 2008 (cat. 12) arrived at the Museum covered in active red rust (fig. 17). The thousands of mail rings, each inscribed with the names of God, had to be carefully

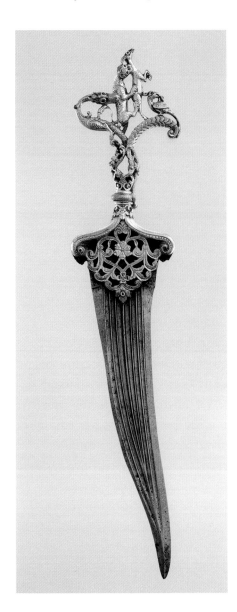
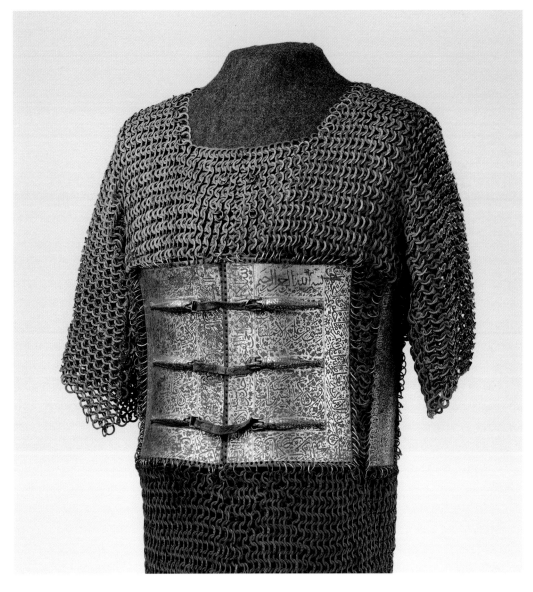

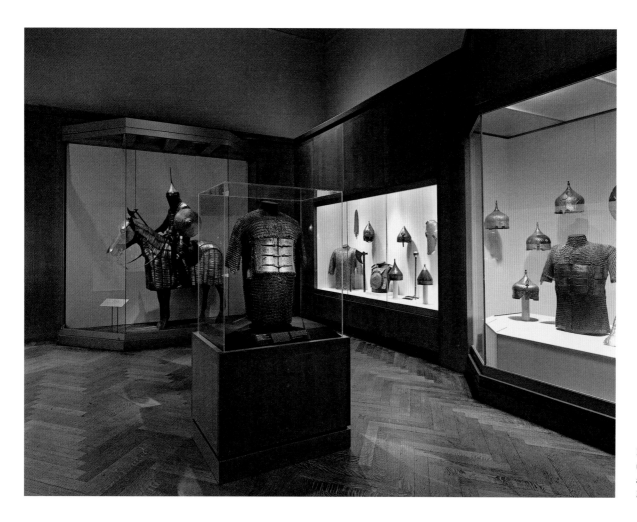

Fig. 18. Gallery of Islamic Arms
(gallery 379), Department of Arms
and Armor, The Metropolitan
Museum of Art, New York, 2012

cleaned individually, front and back, so as not to abrade the stamped inscriptions. For the steel plates, covered with gold leaf with the foliate ornament and calligraphy incised through the precious metal to the dark steel ground, every tendril, leaf, and letter had to be cleaned with tiny tools so as not to dislodge the gold or obscure the design. During the cleaning process, a third, hitherto unknown inscription came to light under the rust on the inside of one of the plates. A similar challenge was faced with the conservation and restoration of a turban helmet from the Stone collection (cat. 29), which because of its damaged and very dirty condition had never before been displayed. The helmet was in fact quite a nice specimen of its type, attractively decorated with silver ornament and inscriptions, and of particular interest because of its incised *tuğra*, which presumably incorporates its owner's name. The conservation process involved reattaching the broken apex, closing minor rust holes, and cleaning and polishing the steel and silver surfaces, resulting in the restoration of much of the helmet's original beauty. Lastly, it must be noted that even the most routine conservation work can yield exciting discoveries. This was certainly the case for our well-known Murad V saber (cat. 66), which, while undergoing a routine cleaning, was found

to harbor a secret compartment previously unknown. The emerald at the top of the scabbard was in fact fitted to a hinged mount that when raised revealed a gold coin of the sultan Süleyman the Magnificent and a pious inscription engraved on the underside of the emerald. The presence of the coin, invoking the greatest of Ottoman sultans, might be interpreted as proof strengthening the traditional but undocumented association of this sword with the unlucky Murad V (r. May 30–August 31, 1876).

The majority of works featured in this catalogue are on permanent display in the galleries of the Department of Arms and Armor. With the reinstallation of its collection in the Morgan Wing in 1991, the department created for the first time a gallery devoted exclusively to Islamic arms and armor (fig. 18). A number of other pieces (many of them on rotating loan from Arms and Armor) are presented in the Department of Islamic Art's own new galleries for the Art of the Arab Lands, Turkey, Iran, Central Asia, and Later South Asia. The Museum's holdings of Islamic arms and armor continue to grow, enhancing the displays of both departments and deepening our understanding of the cultures in which these powerful and evocative objects were produced.

NOTES

1. For the Prince Regent (1762–1830, r. 1820–30) as a collector of arms, see London 1991–92, pp. 47–50, 227. For a concise introduction to the history of collecting Islamic arms and armor, see Ricketts 1982.

2. Meyrick's "Asiatic Armoury" in his home at Goodrich Court, Herefordshire, England, is illustrated in J. Skelton 1830, vol. 2, pl. CXXXIII.

3. The oriental armory of Sir Richard Wallace (1818–1890) is briefly discussed by F. J. B. Watson in Laking 1914, pp. xi–xii, as well as in Ricketts 1982, pp. 23–24; that of Frederick Stibbert (1838–1906) has been examined in *Turcherie* 2001 and Florence 2014. Stibbert's Islamic arms were displayed in his Florentine villa in Islamic-inspired architectural settings, many of the armors arranged on posed manikins, a presentation clearly inspired by Meyrick's example. Indeed, Stibbert owned many fine Islamic and Indian arms from Meyrick's collection.

4. For Gérôme, see G. Ackerman 1986. Gérôme possessed two fifteenth-century turban helmets that were sold by the dealer Dikran Kelekian to the Baltimore collector Henry Walters in 1913. These are now in the Walters Art Museum, nos. 51.70, 51.74; see Simpson 2000, pp. 100, 101, fig. 10 (one of the helmets).

5. There were several substantial sales of antique arms in New York in the 1870s, all of which comprised a mix of European, Islamic, and Asian examples, including an anonymous collection sold at the Clinton Hall Sale Rooms (see Leavitt, New York 1873); the Carlton Gates estate sale (see Leavitt, New York 1876); and the H. Cogniat sale (see Leavitt, New York 1877).

6. New York 1883, pp. 85–88.

7. For Moore, see "Edward C. Moore Collection" 1892; Kerr Fish 1999; and Jenkins-Madina 2000, especially pp. 69–80.

8. Metropolitan Museum, acc. no. 91.1.748; see Dimand 1930, p. 122, and Dimand 1944, p. 157. Information about this and other arms discussed in this essay but otherwise not included in the catalogue is based on notes from David G. Alexander in the Department of Arms and Armor Files, The Metropolitan Museum of Art, New York.

9. The Ellis collection was displayed separately in the Museum until it was integrated with the other arms and armor collections in 1915. For an overview of the collection, see Dean 1905, pp. 177–205, display in figs. 90–101. For the subsequent growth of the Museum's collection and history of its Department of Arms and Armor, see Pyhrr 2012a.

10. Grancsay 1958, p. 244; Nickel 1974, p. 131; and Grancsay 1986, pp. 447–48, fig. 109.5. The surfaces are chiseled with cartouches filled with figures engaged in the hunt, animals, and birds, as well as gold-inlaid Persian inscriptions referring to the legendary heroes Rustam, Bahram, and Sohrab.

11. The collection is documented in the posthumously published, privately printed deluxe catalogue *Bishop Collection* 1906.

12. Ibid., vol. 2, p. 256, no. 778.

13. Pyhrr 2012b.

14. The provenance of Dino's Islamic armor is unrecorded, but it was probably supplied by the Bachereau firm in Paris, the leading French dealer in arms and armor and the principal source of the Dino collection.

15. For a discussion of the Ottoman arsenals and the mark, noting earlier sources, see Pyhrr 1989, pp. 87, 112, n. 10. A large number of similarly marked turban helmets and other Turkman armor in the State Hermitage Museum, Saint Petersburg, was taken by the Russians from the Ottoman arsenal at Erzurum in 1829; see Alexander 1983, p. 98, and Miller 2006, p. 59.

16. On the subject of the Hagia Eirene arsenal, which was later reorganized as the Askeri Müzesi, Istanbul, see Alexander 1983, p. 98; Pyhrr 1989, pp. 87–91; and Pyhrr 2007a, pp. 29–33.

17. The Riggs files in the Department of Arms and Armor, Metropolitan Museum, include original invoices from C. Beshiktash (54, rue Lafayette, Paris) dated 1892–93. The lance head and standard were acquired from this dealer.

18. The Morgan swords, acc. nos. 17.190.2101, 17.190.2102, are both in the Department of Arms and Armor, whereas the knife (cat. 78), discussed below, resides in the Department of Islamic Art.

19. Letter from Dean to William H. Riggs, December 27, 1905, written aboard the S.S. *Arabia*, off Aden (Department of Arms and Armor Files, Metropolitan Museum).

20. One of the mail shirts was included in the anonymous sale of duplicates from Dean's collection at the American Art Association/Anderson Galleries, New York 1928, lot 302, and another sold to Archer Huntington for the New York Hispanic Society and recently acquired by the Metropolitan Museum, acc. no. 2104.198. For Dean's *tombak* helmet, see David G. Alexander and Stuart W. Pyhrr in Ekhtiar et al. 2011, pp. 314–15, no. 223.

21. Dean 1915, pp. 11–13, 138–46, 147, pl. LXV (gallery H.5 plan).

22. Metropolitan Museum, acc. nos. 232.1–.9. Dean 1923a discusses the Morosini items as loans; the gift was announced shortly afterward in Dean 1923b.

23. The Morosini house and collections are described in "Elmhurst" 1902, pp. 10–13.

24. Walters Art Museum, nos. 51.48, 51.76, 51.78, 51.84, 51.87–.89, 57.620; Art Institute of Chicago, nos. 1982.2162–.2167 (formerly Harding Collection of Arms and Armor, nos. 2615–2620).

25. Stone's life and achievements are best summarized by Donald J. La Rocca in his introduction to the 1999 reprint of Stone 1934, pp. v–vi.

26. Ibid.

27. For biographical information on Oldman, with an emphasis on his activity as a dealer of ethnographic material, see Philadelphia 1986–87, pp. 15–28.

28. For Kelekian, see Jenkins-Madina 2000, pp. 69–76, and Simpson 2000.

29. For Laking, see Claude Blair's introduction to the 2000 reprint of Laking 1920–22, vol. 1, pp. v–xix.

30. I. Fraser 1986.

31. As related in Hewitt 1859, p. 116, unnumbered note.

32. Haim lent textiles, ceramics, and arms to the "International Exhibition of Persian Art" in London; see London 1931, nos. 128, 222, 298, 329, 530, 764, 831–33.

33. Correspondence and other documentation for this loan are in the Department of Arms and Armor Files, Metropolitan Museum; several of the loans are mentioned in London 1931, pp. 325–26, 330, nos. 831 J–M, 833.

34. Bashford Dean, George Cameron Stone, personal communications, October 29 and November 11, 1926, respectively, Department of Arms and Armor Files, Metropolitan Museum.

35. Additional bequests included more than fourteen hundred examples of Japanese sword fittings to the Cooper-Union Museum (now the Cooper-Hewitt National Museum of Design, Smithsonian Institution), New York, and more than three hundred works of ethnographic interest to the Peabody Museum (now the Peabody-Essex Museum) in Salem, Massachusetts.

36. Metropolitan Museum, acc. nos. 43.82.1–.10, lent by the donors since 1917 (L.1655.1–.10).

37. His dissertation focused on a study of Dhu'l faqar, the sword of the Prophet; see Alexander 1984 and Alexander 1999.

38. These include the Khalili Collection, London, the Dar al-Athar al-Islamiyya, al-Sabah Collection, Kuwait City, and the Furusiyya Art Foundation, Vaduz; see Alexander 1992, London and other cities 2001–2, and Paris 2007/Mohamed 2008, respectively.

39. New York 1985–86b, nos. 168, 177, respectively.

40. Walker 1998, p. 12.

41. New York 2015, pp. 145–46, no. 63.

42. The conservation work discussed here was undertaken by Armorer and Conservator Hermes Knauer and Conservator Edward A. Hunter, Metropolitan Museum.

Armor

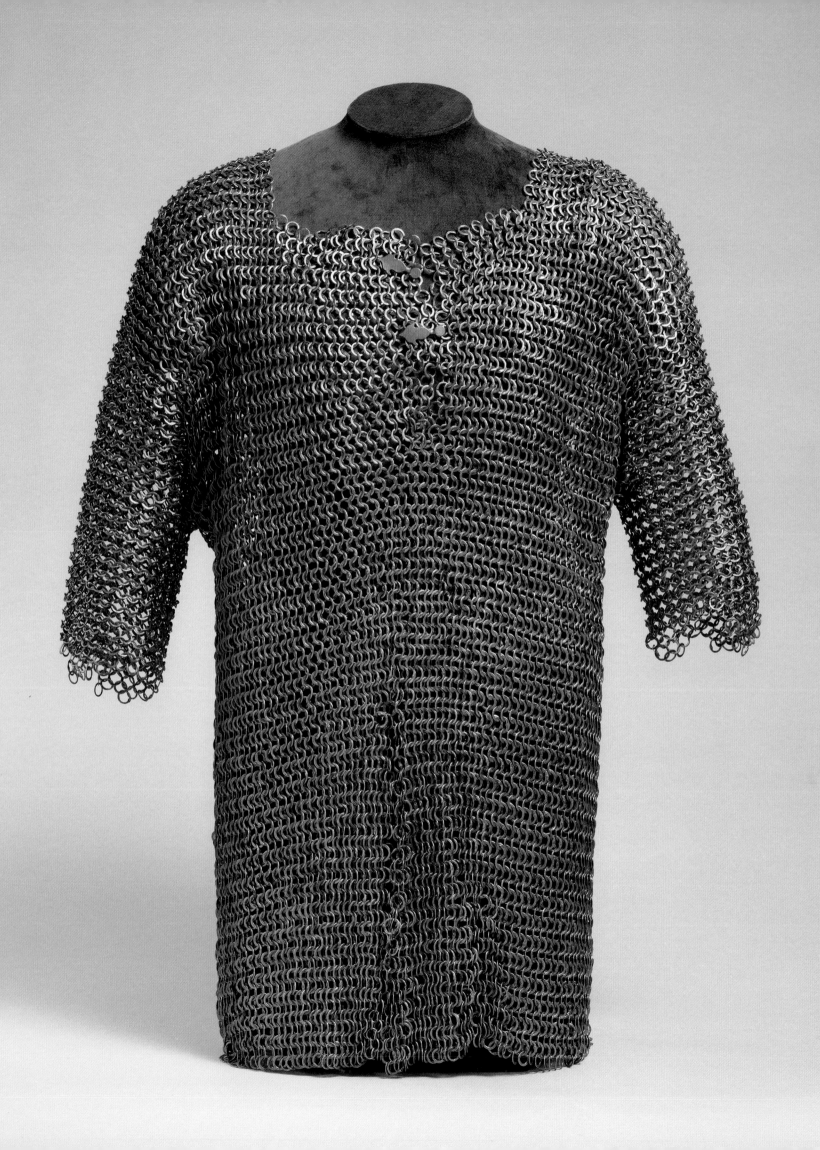

1 · Mail Shirt

Syria or Turkey, Mamluk or Ottoman period,
probably early 16th century
Iron, copper alloy
Length 33⅛ in. (84 cm); width 52 in. (132 cm);
weight 21 lbs. 12 oz. (9,869 g)
Bequest of Frederick Townsend Martin, 1914
14.99.28

DESCRIPTION: The large shirt extends to the midthigh and has elbow-length sleeves, a rectangular opening at the neck with a 9-in. (23 cm) opening down the chest, and a 12-in. (30.5 cm) opening up from the hem in the center of the front and back. The lower corners of the front opening extend into triangular panels that overlap. The mail is constructed of large riveted and solid (forge-welded) rings arranged in alternate rows, with four riveted links passing through each solid one. The riveted rings, each closed by a wedge-shaped rivet of brass, measure about ⅝ in. (16 mm) in diameter, while the solid rings are slightly smaller (14–15 mm); both types are flat and stamped on each side with slightly raised concentric lines. A row of ten brass rings of round cross section, closed by round iron rivets, extends down the left side of the chest opening, and a similar brass ring is inserted into the front of the shirt on the left sleeve and on the back near the hem. The chest opening is closed by two modern palmette-shaped buckles of cast brass.

Mail was usually formed from interlocking rings of solid or riveted wire. The wire was formed into circles, the ends flattened and overlapped and either forge-welded closed to form solid rings or pierced through and riveted closed. The rings could be arranged in a number of ways, but the most common and strongest method was to arrange them in groups of five, so that each ring was joined to four others.[1] By adding and dropping rings, the mail fabric could be shaped to form various types of body defenses: shirts, trousers, arm and leg guards, aventails, and even complete head defenses. A later form of mail, composed of butted rings, in which the links are not riveted but merely touch or abut, is not as strong as the other form but is easier to fashion into decorative patterns.

Shirts of mail such as this example were worn by the cavalrymen who formed the core of the armies in the Mamluk, Turkish, and Iranian states from the fourteenth to the sixteenth century. The split in the hem at the front and back of the shirt allowed it to drape to either side of the saddle and thus protect the bent legs of the mounted warrior. Shirts constructed from such heavy mail would not only have provided considerable protection against saber slashes but were also much more flexible than shirts made from a combination of mail and plate.

Several surviving shirts have very similar stamped rings; these include a mail-and-plate shirt, probably from Mamluk Egypt or Syria, now in Istanbul.[2] The rings of that shirt have concentric ridges on one side that are almost identical with those on the Museum's shirt, and in both examples the links are joined by a single rivet. However, it differs from the Museum's shirt in that some of the rings are stamped on the reverse with small nodules, or dots, while others are marked with a guilloche design; with two exceptions, the stampings on the Museum's shirt are the same on each side.[3] A related mail shirt, also in the Museum's collection and now much altered and shortened, is composed of riveted and solid rings stamped with concentric circles on one side and with a guilloche pattern on the other; its rings are of similar diameter, about ⅝ inch (16 mm).[4]

The present shirt would probably once have had a rigid standing collar composed of leather strips threaded through the mail around the neck. An example of approximately the same period with its original leather collar is in the Magyar Nemzeti Múzeum, Budapest.[5] The rings of the Budapest shirt are individually stamped with an Arabic slogan ("Glory is . . .") used on many armors and helmets of the late fifteenth and sixteenth centuries. Very similar brass clasps for the closing of the shirt opening are preserved on an example in the Askeri Müzesi, Istanbul.[6]

PROVENANCE: Frederick Townsend Martin, New York.

REFERENCES: C. Smith 1959, pp. 61, 63, 65, no. 11; Alexander 1985b, p. 33, fig. 6.

NOTES
1. See C. Smith 1959; Tarassuk and Blair 1979, pp. 341–42; A. Williams 2002, pp. 29–33.
2. Askeri Müzesi, Istanbul, no. 4519/2 (unpublished); the steel plates on this shirt are damascened in gold with designs and inscriptions in a style typical of the period of Sultan Qa'itbay (r. 1468–96).
3. The exceptions are two rings stamped on the reverse with a guilloche pattern. It is impossible to know whether these are original or were added to repair the shirt. Similarly, the brass rings on the Museum's shirt may also be later additions.
4. Metropolitan Museum, acc. no. 31.35.3; see Alexander 1985b, p. 33, fig. 5. Metallographic examination of links from the present mail shirt (cat. 1) and the following example (cat. 2) indicate that they are made of soft wrought iron, formed from wire cut from a thin plate (rather than pulled through a drawplate), annealed, and stamped cold; see C. Smith 1959. For a concise summary of the history and manufacture of mail, see A. Williams 2002, pp. 29–33.
5. Nemzeti Múzeum, Budapest, no. 68.9049 (unpublished); see also cat. 2.
6. Askeri Müzesi, Istanbul, no. 21491 (unpublished).

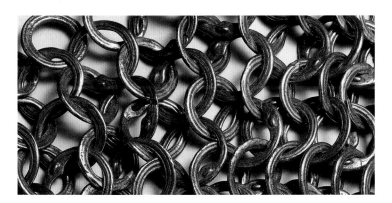

2 · Mail Shirt

Turkey, possibly Istanbul, or western Iran, 15th–16th century
Iron
Length 44⅛ in. (112 cm); width 44⅞ in. (114 cm);
weight 23 lbs. 8 oz. (10.66 kg)
Bequest of George C. Stone, 1935
36.25.33

DESCRIPTION: The shirt has short sleeves, a shallow V-shaped opening at the neck, and a wide cutout from the hem up the center of the front and back. The mail is constructed of alternating rows of solid (forge-welded) and double-riveted iron links, with four riveted links passing through each solid one. Each ring is flat, measuring about ⅝ in. (15–16 mm) in diameter, and is stamped on one side with an Arabic inscription (a) and on the other with a guilloche design. While the main body of the shirt is largely intact, rings of a different kind have been added at the collar, along the openings at the front and back, and across the bottom 4 in. (10 cm) of the shirt's length; these solid and single-riveted links are plain and round in section. The crude cutouts at the front and back are also later modifications.

INSCRIPTION:
a. (On one side of each mail ring)

العز في الطاعة الغنا في القناعة

Glory is in obedience, wealth in contentment.

The proverbial or epigrammatic inscription on the links of this shirt appears frequently on armor and helmets of the fifteenth and sixteenth centuries. The advice given refers to the proper behavior expected of a warrior and to his duties to God and to the sultan, God's earthly representative. Although the majority of objects bearing this inscription are probably Ottoman, in two important cases the helmets that it appears on might have an Ak-Koyunlu or Shirvanshah provenance.[1] The former is discussed elsewhere in the catalogue (cat. 23). While the reading of the "name" (Ya'qub?) on that helmet is uncertain, the name on the other example (now in the Furusiyya Art Foundation, Vaduz) is clearly the "amir Khalilullah."[2] There are several possible rulers and princes to whom this may refer, including the Ak-Koyunlu prince Khalil ibn Uzun Hasan (ca. 1441–1478) and the Shirvanshah Khalilullah I (r. 1418–63) and Khalilullah II (r. 1524–35). Given the use of the "obedience" inscription on Ottoman helmets of the sixteenth century and the fact that the latter Shirvanshahs solicited Ottoman help to combat the Safavids, it is possible that the inscription on the Furusiyya helmet refers to Khalilullah II when he was still a prince, before 1524.[3] This also raises the question as to whether the Furusiyya helmet was made in an Ottoman workshop for the Shirvani amir.

In summary, the inscription occurs on a number of armors and helmets that are attributed here to Ottoman workshops, to Turkmen working in Ottoman workshops, or to Turkmen working in Ak-Koyunlu or Shirvani workshops.[4] Among the large group of armor and helmets inscribed in this way are three complete mail shirts of the same type as the Museum's.[5] The same inscription, though badly worn and almost illegible, is also found on portions of a composite mail shirt in the Museum's collection.[6] In addition, it occurs on two luxuriously decorated armors in the Askeri Müzesi, Istanbul; both of these can be attributed on stylistic grounds to Turkman craftsmen working during the period of Bayezid II (r. 1481–1512).[7] Two undeniably Ottoman helmets of the sixteenth century also carry the same inscription.[8]

A shirt of mail decorated in this way becomes more than a piece of armor. Indeed, it might be more accurate to think of such a shirt in the context of a *khil'a* or *tashrif*, terms generally used to designate a robe of honor. In the case of mail shirts such as this, it is not a robe of silk given as a gift by a ruler, but a robe of steel given to a warrior.

PROVENANCE: W. O. Oldman, London; George Cameron Stone, New York.

REFERENCES: C. Smith 1959, pp. 61, 63, 65, no. 10, fig. 8; Alexander 1985b, pp. 29–31, fig. 1.

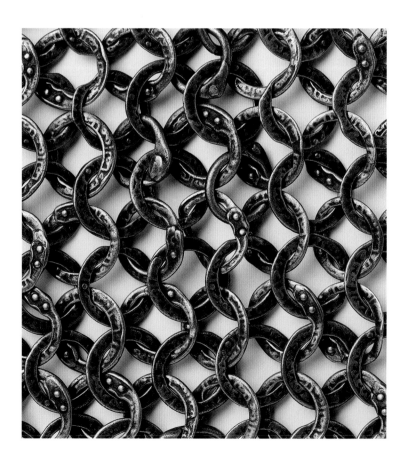

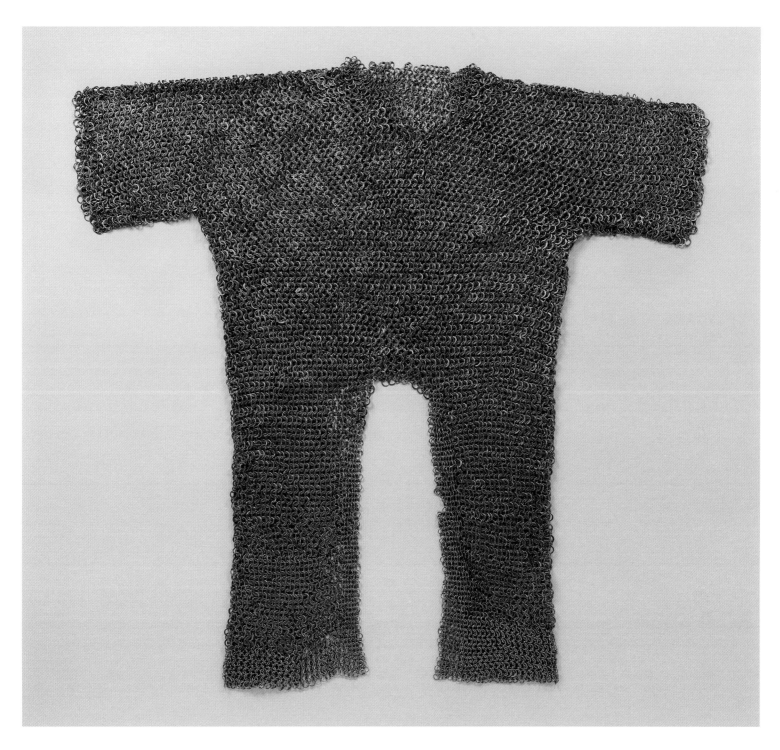

NOTES

1. A clearly Ottoman helmet is in the Musée de l'Armée, Paris, no. H.452; see Paris 1990, no. 7, and cat. 34, fig. 24.

2. Furusiyya Art Foundation, Vaduz, no. R-832; see Paris 2007/Mohamed 2008, p. 323, no. 310.

3. See Bosworth 2004 for genealogy of the second line of Shirvanshahs and for further bibliography.

4. Other pieces inscribed with the verse or parts of it include "turban" and conical helmets, mail shirts, plate-and-mail armors, and defenses for arms and legs. Among those not mentioned elsewhere in this entry, see, for example, Metropolitan Museum, cats. 6, 7, 22; Askeri Müzesi, Istanbul, nos. 4324/3, 4475/3, 4518/2, 5692, 5696, 5909, 7957, 8088, 9249, 9704, 16294, 16389, 16457 (see Istanbul 1987, no. A.160), 22163; Furusiyya Art Foundation, Vaduz, nos. R-140, R-804, R-806 (see Paris 2007/Mohamed 2008, pp. 305, 324, 322, nos. 293, 311, 309, respectively); Royal Armouries, Leeds, no. XXVIA.113 (see Hewitt 1859, p. 117, no. 553); Sheremetev Collection, Saint Petersburg (see Rose 1902–5, p. 12, fig. 5); Topkapı Sarayı Museum, Istanbul, nos. 743, 16171, 16508. The inscription is also used on a helmet that might include the name of the Ak-Koyunlu sultan Ya'qub (cat. 23).

5. Magyar Nemzeti Múzeum, Budapest, no. 68.9049 (unpublished). The others are in the State Hermitage Museum, Saint Petersburg (see Lenz 1908, pl. IV, Saltikov Collection 199), and the Khalili Collection, London, no. MTW 1156 (see Alexander 1992, pp. 72, 74–75, no. 30).

6. Metropolitan Museum, acc. no. 36.25.489; see Alexander 1985b, p. 29. The metallurgy of that shirt, as well as that of several other Islamic mail shirts in the Museum's collection (including the present example and cat. 1), is discussed in C. Smith 1959.

7. Askeri Müzesi, Istanbul, nos. 4326-2, 4518/2 (unpublished).

8. Musée de l'Armée, Paris, no. H.452; see note 1 above. Museo Stibbert, Florence, no. 6209; see Venice 1993, no. 251, ill.; Florence 2002, p. 26, fig. 9; and Florence 2014, p. 114, no. 1, where the same helmet is mistakenly catalogued as Mamluk.

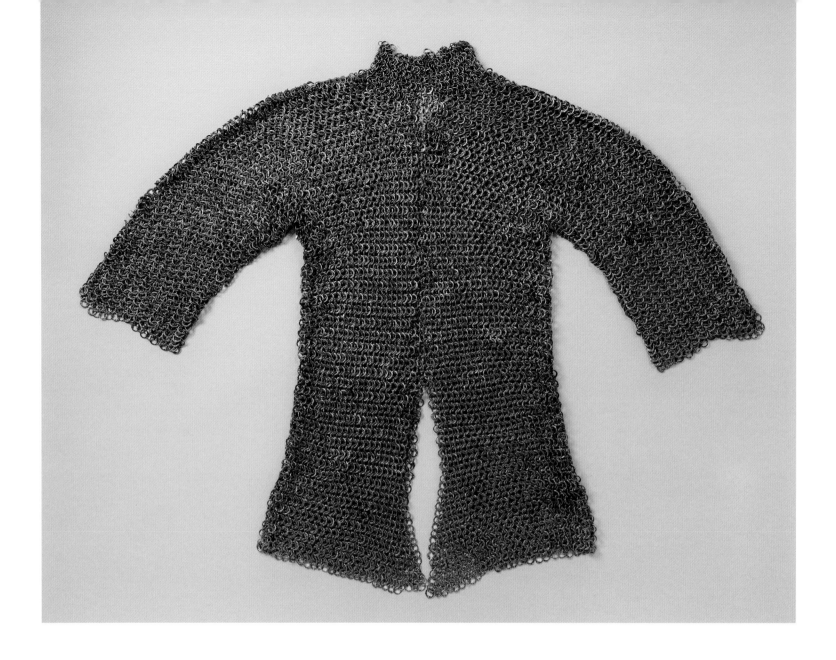

3 · Mail Shirt

Possibly Iran, Safavid period, 16th century or later
Iron
Length 31⅞ in. (81 cm); width 54 in. (137 cm); weight 12 lbs. 4 oz. (5,562 g)
Gift of Mary Alice Dyckman Dean, in memory of Alexander McMillan
Welch, 1949
49.120.4

DESCRIPTION: The shirt, which opens completely down the front, has a short collar, long sleeves, and an approximately 12-in. (30 cm) opening up the center of the back; each side of the front opening has a triangular extension near the bottom that over-laps inward. It is constructed of alternating rows of solid (forge-welded) and riveted iron links. Each ring is flat, measuring approximately ⅝ in. (14–15 mm) in diameter, and is stamped on one side only with an Arabic inscription (a); the other side is smooth but retains traces of shallow concentric lines. The collar, constructed of rows of alternating solid and riveted rings of round section, is later.

INSCRIPTION:
a. (On one side of each mail ring)

الله محمد علي فاطمة حسن حسين

Allah, Muhammad, 'Ali, Fatima, Hasan, Husayn.

Mail links of this type were made from wire cut into links on which an inscription was then stamped with a die, like coins. The inscription on these links gives the great name of God, Allah, as well as the names of the five *ahl al-kisa*, or people of the cloak, meaning Muhammad and his immediate family (his daughter Fatima and her husband, 'Ali, and their two children, Hasan and Husayn), considered by the Shi'a to be the holy family of Islam.[1] The wearing of talismanic shirts was common in the Islamic world, and a mail shirt of shiny steel links bearing the names of the *ahl al-kisa* must have been seen as a potent talisman. Indeed, it was not only a powerful prophylactic but also a veritable armor of light to be worn in the battle against darkness.

The Qur'an and the hadith of the Prophet are full of refer-ences to light (*nur*) and, in contrast, to the darkness of ignorance and evil. Annemarie Schimmel, for instance, quoted the poet Hassan ibn Thabit, "who described Muhammad as the one who brought light and truth in the darkness."[2] Islamic chronicles recorded that warriors wore highly polished armors that reflected

the light. In one such account by the court theologian Jalal al-Din Davani (1427–1502/3), an Ak-Koyunlu military parade was portrayed as a veritable festival of light, with shining armor and helmets, held before a sunlike ruler and paralleling the divine celestial order.[3]

While the Ak-Koyunlu were probably Sunni, Davani's parade report draws on both Shi'a and pre-Islamic Iranian light mysticism. The Museum's mail shirt is certainly from a Shi'a milieu and most likely was produced in Iran during the early Safavid period. The individual links are not as substantial as those on the shirts attributed here to the late fifteenth and sixteenth centuries (such as those on cats. 1, 2), which suggests that this shirt may have been produced at a time when firearms were becoming more popular on the battlefield, making heavy armor less useful.

The shirt can also be regarded as a kind of *burda*, or cloak, evoking the immediacy felt by the Safavids for the events surrounding the lives and deaths of 'Ali and his family and for the mystery of the five *ahl al-kisa*. All of this is apparent in the poetry of the first Safavid shah, Isma'il (r. 1501–24), who regarded himself as an incarnation of the divine light and as the "Shadow of God on the earth."[4] For Isma'il, the battles he fought were part of an ageless struggle against unbelievers, and it is possible that mail shirts similar to this one were worn by his followers.

In their construction, the rings of this mail shirt are notable for the extensive overlap of metal where they are riveted. And unlike the concentric lines visible on the rings of mail shirt cat. 1, the lines on the uninscribed sides of these rings are not deeply stamped and may have been produced in the process of drawing the wire to make the rings.

PROVENANCE: Bashford Dean, New York; Mary Alice Dyckman Dean (Mrs. Bashford Dean), New York.

REFERENCES: Alexander 1985b, pp. 30, 32, fig. 3; Canby 2014, pp. 55–56, fig. 100.

NOTES

1. This inscription is also found on a composite mail shirt in the Museum's collection, acc. no. 36.25.489 (see Alexander 1985b, p. 29), and on a well-preserved example recently acquired by the Museum, acc. no. 2014.198.
2. Schimmel 1985, p. 124.
3. See Minorsky 1978, especially p. 150.
4. For the *burda*, see sword cat. 63; for Isma'il, see Minorsky 1942.

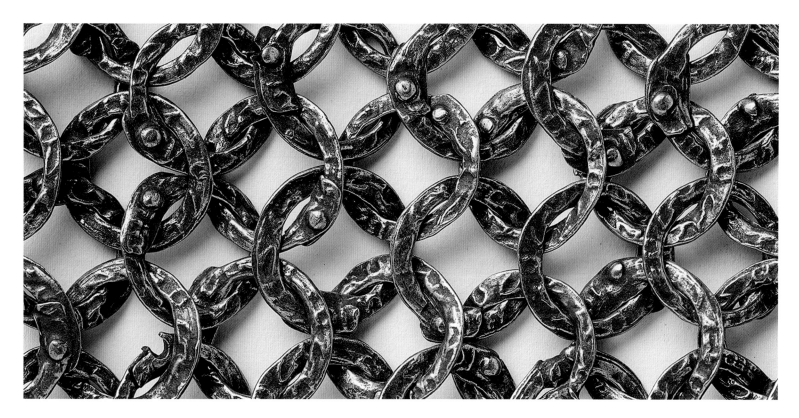

4 · Mail Shirt

Iran or India, dated A.H. 1232 (A.D. 1816/17)
Iron, copper alloys, leather
Length 34 in. (86.3 cm); width 78¾ in. (200 cm)
Bequest of George C. Stone, 1935
36.25.57

DESCRIPTION: The thigh-length shirt, which opens completely down the front, has long sleeves ending in wide, diagonally shaped cuffs and an associated collar. It is constructed entirely of small butted rings of iron patterned with butted links of brass and copper forming Arabic inscriptions over the entire surface (a, b); the characters of the inscription are in brass, the diacriticals in copper. The mail, which is round in cross section and measures about ⅛ in. (3–4 mm) in diameter, is heavier across the front and back of the shoulders and down the front of the shirt to waist level. The rectangular neck opening has been extended with an associated collar formed of larger (and probably older) iron mail in alternating rows of solid and riveted links. At the back of the collar a fragment of leather cord is woven through the mail, evidence that the collar was originally stiffened in this manner.

INSCRIPTIONS:

a. (Around the body and over the shoulders)

تجده عونا لك في النوائب ناد عليا مظهر العجائب

بنبوتك يا محمد بولايتك يا علي كل هم و غم سينجلي

يا فتاح يا غفار يا قهار يا كريم

Call upon 'Ali, the manifestation of wonders,
You will find him a comfort to you in crisis,
Every care and sorrow will pass,
Through your prophecy O Muhammad, through your guardianship O 'Ali!

O Opener! O Forgiving! O Subduer! O Generous!

b. (Up the arms)

الله محمد علي فاطمة حسن حسين سنة ١٢٣٢

Allah, Muhammad, 'Ali, Fatima, Hasan, Husayn. Year 1232 (A.D. 1816/17).

Butted mail is composed of metal links that are not riveted together but merely touch or abut; although this type of mail is not as strong as other forms, it is easier to fashion into decorative patterns. While the earliest surviving armors of butted and decorated mail are European and were made in Germany and Hungary during the fifteenth century, this does not exclude its use as a decorative technique in the Islamic world at an early date.[1] The earliest surviving Islamic examples come from Mughal India and Iran and are datable to the seventeenth or eighteenth century. The inscription with which the Museum's shirt is decorated is clearly Shi'a and includes the names of the five people of the cloak, known as the *ahl al-kisa* (see cat. 3), and some of the ninety-nine names of God, *al-asma al-husna*.

Although the shirt is dated A.H. 1232 (A.D. 1816/17), it is difficult to determine whether it is Iranian or from one of the Shi'a states in central India. If it was made for battle, its function, despite its being thickened at the front, would have been largely talismanic; however, it could equally as well have been made for use in one of the Shi'a passion plays commemorating the heroic death of Husayn, grandson of the Prophet and the third Shi'a imam, at the battle of Karbala on the tenth day of Muharram in A.H. 61 (October 10, A.D. 680). Called *Ashura*, this is a day of painful remembrance for the Shi'a, on which they reenact in graphic terms the massacre of Husayn, his baby son, and their followers. At this time Husayn is remembered by the Shi'a with sorrow over his martyrdom and with pride for his stance against tyranny and oppression.[2]

PROVENANCE: George Cameron Stone, New York.

REFERENCES: Stone 1934, p. 428, fig. 543; New York 1979, p. 106, no. 37; Alexander 1985b, pp. 33–35, fig. 8; Alexander 1992, p. 134, s.v. no. 79.

NOTES
1. A number of probably sixteenth-century butted-mail shirts of Hungarian provenance, with appliqué stars and half-moons, are preserved in the Askeri Müzesi, Istanbul, among them no. 2767 (unpublished).
2. For a detailed account of this one-sided battle, see Momen 1985, pp. 28–33.

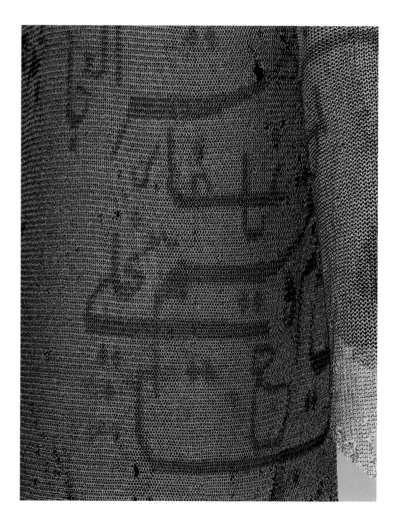

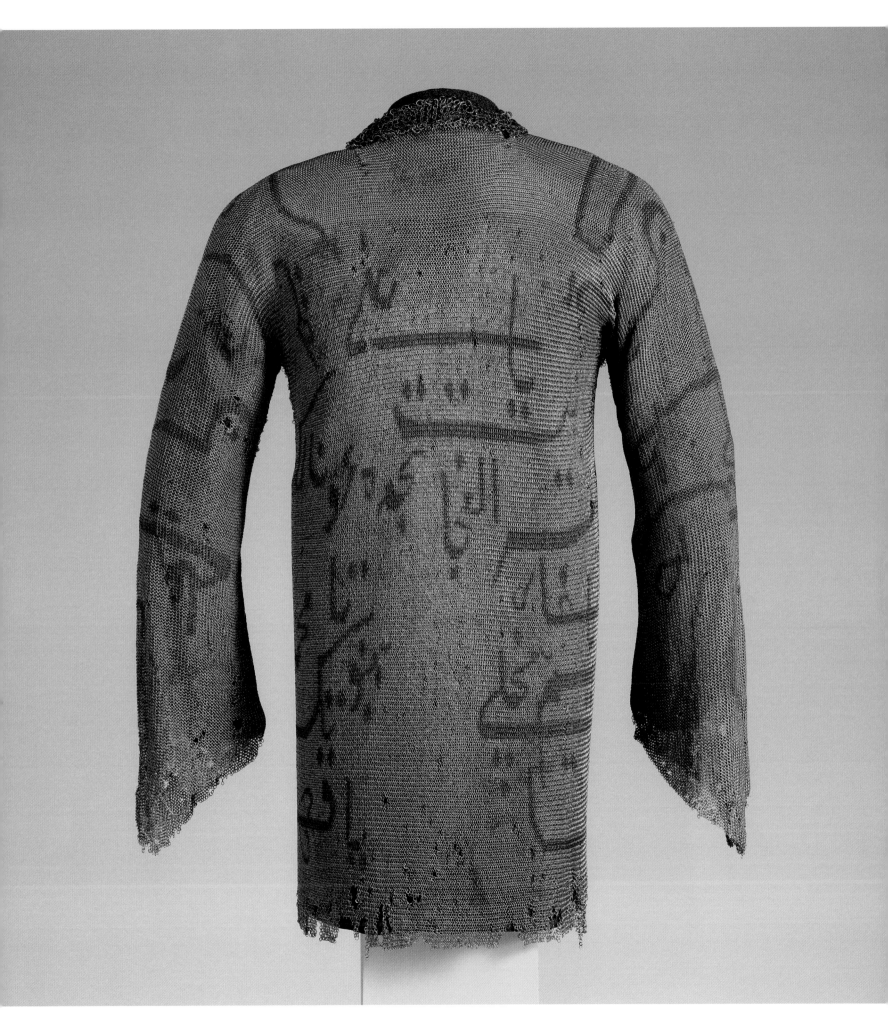

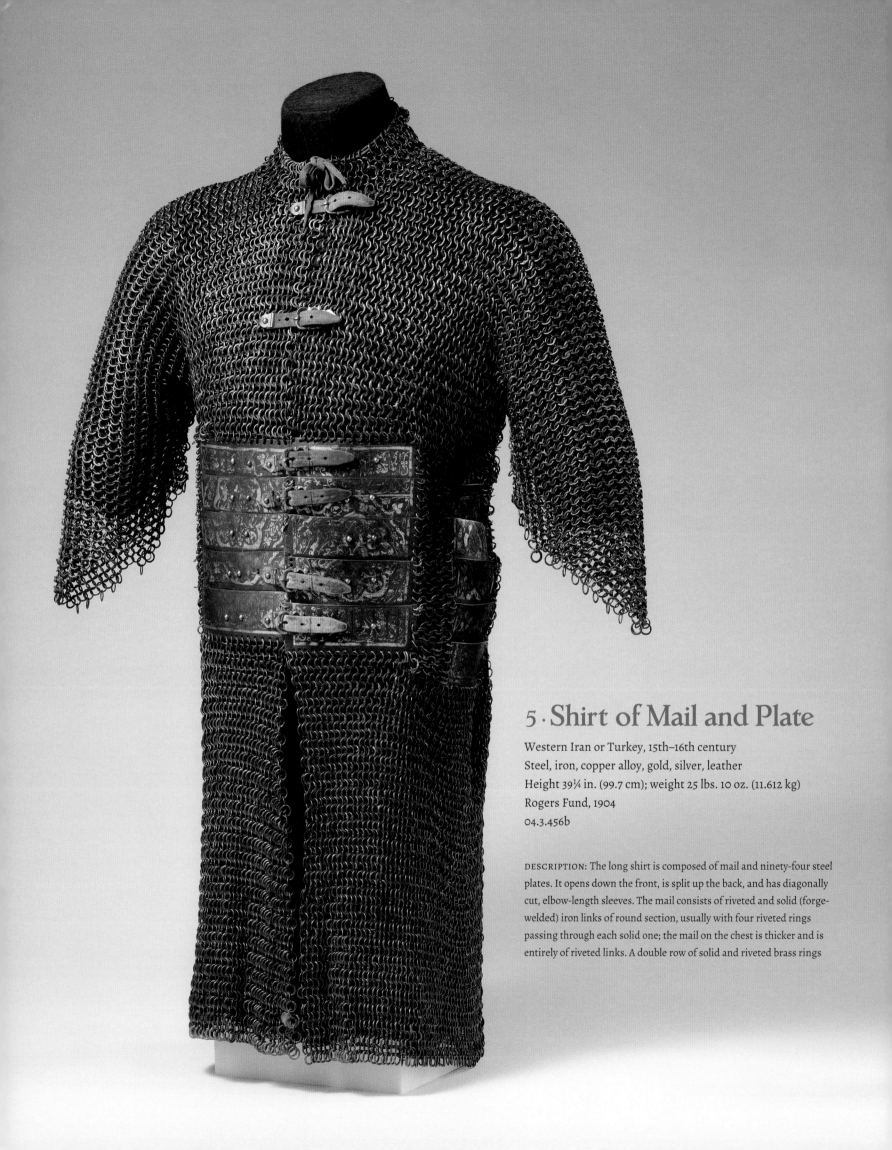

5 · Shirt of Mail and Plate

Western Iran or Turkey, 15th–16th century
Steel, iron, copper alloy, gold, silver, leather
Height 39¼ in. (99.7 cm); weight 25 lbs. 10 oz. (11.612 kg)
Rogers Fund, 1904
04.3.456b

DESCRIPTION: The long shirt is composed of mail and ninety-four steel plates. It opens down the front, is split up the back, and has diagonally cut, elbow-length sleeves. The mail consists of riveted and solid (forge-welded) iron links of round section, usually with four riveted rings passing through each solid one; the mail on the chest is thicker and is entirely of riveted links. A double row of solid and riveted brass rings

lines the right side of the chest opening, and another row of solid brass rings encircles the bottom edge. Two strap-and-buckle fittings close the mail on the upper chest. The plates, all arranged to overlap upward, are set into the mail. The front of the shirt is set with two vertical rows of five rectangular plates each, one row on each side of the center opening, and is closed by four strap-and-buckle attachments fitted to the upper and lower two plates. The buckles and hinged strap fittings are of gilt steel. The plates are pierced around the outer edges with holes through which they are secured to the mail, and they are also attached to one another vertically by internal leather straps held by rivets, the heads of which are visible on the faces of the plates. Each side of the shirt is set with two vertical rows of six rectangular plates each, the rows tapering upward. The back is set with three vertical rows of twenty rectangular plates each, the center row tapering to the base of the spine and indented down the middle. The plates are engraved with floral designs, lobed medallions containing symmetrical arabesques, and Arabic and Persian inscriptions (a, b) against a dot-punched ground; the bands framing the plates and most of the floral designs are gilt, whereas the inscriptions and minor areas of the ornament are damascened in silver. At the bottom of the shirt on the right side of the front opening is a large, irregularly shaped piece of lead, perhaps the remnants of a seal.

At some time in the nineteenth century the front plates of this shirt were removed, repaired, and refurbished. The fourth plate from the top on the right side and the fifth plate from the top on the left side have riveted-on repairs to their outer edges. The leathering is modern and is not found on shirts of mail and plate of this early type. The fourth plate from the top on the right side appears originally to have been placed, inverted, second from the top. This transposition would thus align the left and right sides, which are now asymmetrical. All rivets, leathers, and hinge-and-buckle fixtures are modern.

INSCRIPTIONS:

On the front
a. (Along the top and bottom, in Arabic, with extra letters)

العز ا لمولانا / نا سلطان ا

السلطان الا|عظم| / مالك رقاب الامم

Glory to our lord, sultan. The [greatest] sultan, possessor of the necks of the nations.

On the back
b. (Out of order, benedictions and part of a saying in Arabic and part of a benedictory couplet in Persian)

العز الدا|ن-|م / و الاقبال / و الا /قبال| / و الا|قبال| / العز / في الـ / طا /عة

نگه دار بادا جها|ن| آفرین بهر جا که با شـ|د خداوند این|

Perpetual glory and prosperity and prosperity and prosperity. Glory is in obedience.

May the Creator of the World protect [the owner of this]
Wherever he may be.

This boldly decorated armor is perhaps the most attractive of the Museum's mail-and-plate shirts. As a type it evolved from lamellar armor, which was composed of small plates, or lames, of metal, horn, or leather usually joined by cord, the horizontal rows of plates overlapping upward.[1] Whereas in many of the early examples the plates are relatively small, the later Turko-Iranian examples of the fifteenth and sixteenth centuries tend to be constructed from larger plates. The evolution of the type is best understood in a broad Turko-Iranian context,

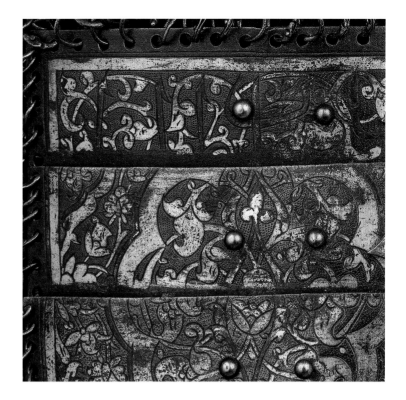

and many of the armors are decorated in a robust decorative style that can be regarded as Turkman.[2] The earliest surviving datable armor of this mail-and-plate type, now in the Furusiyya Art Foundation, Vaduz, is inscribed with the name of Ibrahim Sultan, probably Ibrahim Sultan b. Shahrukh b. Timur, who was governor of Shiraz between 1414 and 1434.[3]

The Museum's armor would originally have been worn with a so-called turban helmet and with knee and lower leg defenses (such as, respectively, cats. 8, 9), all decorated with matching ornament and inscriptions. The inscriptions on the plates of this shirt are typical of those found on the turban helmets of the late fifteenth and sixteenth centuries. Consequently, the armor, like the helmets, can be attributed to Turkey or northwestern Iran and similarly dated.

PROVENANCE: Maurice de Talleyrand-Périgord, duc de Dino, Paris.

REFERENCES: Cosson 1901, p. 111, no. N.1; Grancsay 1958, pp. 241–42, ill.; Grancsay 1986, pp. 443–45, fig. 109.1; *Islamic World* 1987, no. 65; New York 1987–88, p. 67, no. 49.

NOTES
1. Lamellar armor was used in the Near East from Assyrian and Urartian times (about the ninth century B.C.); see Gamber 1978, pls. 185, 189–91, 336. Herodotus 1942, p. 523, verse 61, described the Persians as wearing armor made of fishlike iron scales.
2. See Allan 1991; Allan and Gilmour 2000, especially pp. 468–70; and Auld 2004.
3. For the Furusiyya armor, see Riyadh 1996, vol. 2, p. 114, no. 90; Paris 2007/Mohamed 2008, pp. 300–301, no. 289. The date of the Ibrahim armor roughly coincides with the earliest datable depiction of mail-and-plate armor in miniature painting, found in the *Divan* of Khwaju Kirmani (dated A.H. 798 [A.D. 1396]), British Museum, London, Add. 18113, fol. 56v; see Riyadh 1996, vol. 2, pp. 114, 246–47, nos. 90, 206.

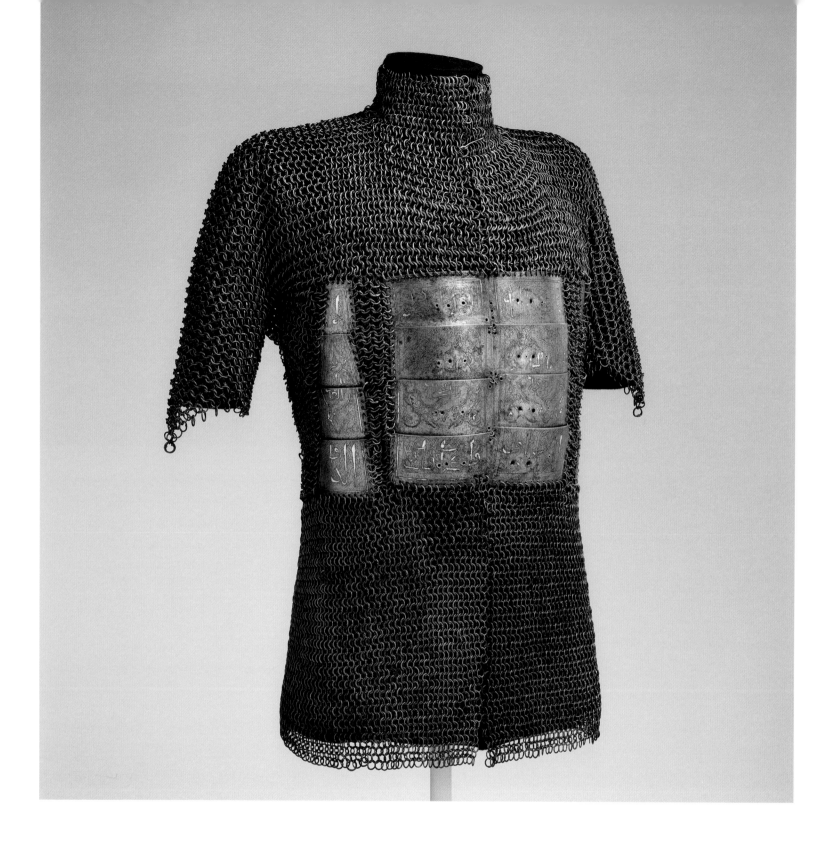

6 · Shirt of Mail and Plate

Turkey, possibly Istanbul, Ottoman period, late 15th–16th century
Steel, iron, silver
Height 32 in. (81.2 cm); weight 22 lbs. 2 oz. (10.07 kg)
Bequest of George C. Stone, 1935
36.25.54

DESCRIPTION: The shirt is composed of mail and sixty-nine steel plates. It opens down the front and is split up the back and has diagonally cut, elbow-length sleeves. The mail consists of solid (forge-welded) and riveted iron links with the usual configuration of four riveted rings passing through each welded one; the mail on the upper chest is thicker and consists entirely of riveted links. The steel plates, which overlap one another upward, are set into the mail: four rows of four large rectangular plates each cover the stomach, the lateral rows shaped to the underarm; five vertical rows of plates cover the back, with three middle rows of fifteen small plates each, the center row tapering downward and indented slightly down the middle, and two lateral rows of four larger plates each, the upper two plates of each shaped to the underarm. The plates are engraved with Arabic inscriptions (a–g), some contained within lobed medallions, amid foliate scrolls on a stippled ground; some of the framework, foliage, and inscriptions are damascened in silver. Rivet holes in the front plates denote the loss of the straps and buckles by which the shirt was closed.

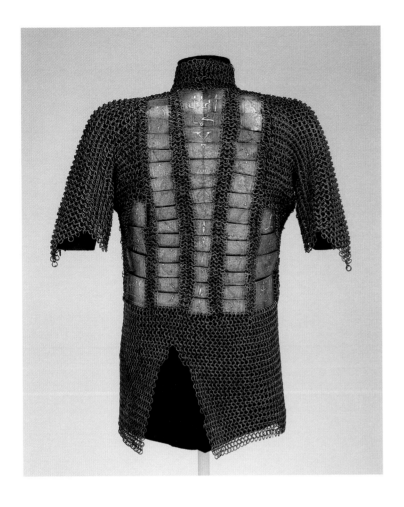

The inscriptions consist of individual letters, perhaps abbreviations, and words and phrases in praise of an unidentified ruler or prince.[1] Although they are only fragmentary, the inscriptions clearly belong to the same genre as those found on many armors and helmets of the fifteenth and sixteenth centuries.[2]

The style of decoration seen here, notably the elongated cartouches with lobed palmette shapes at each end, occurs not only on armors but also on two lamps from the mosque of Bayezid II (r. 1481–1512), one of which is now in Istanbul and the other in Qatar.[3] These elongated cartouches relate the Museum's example to a number of armors with pierced decoration now in the Askeri Müzesi, Istanbul. All of these were probably produced in Istanbul during the early sixteenth century. However, some of the words in the inscriptions create an uncertainty about the origin of this and related armors; it remains open as to whether they were produced in Istanbul during the late fifteenth to early sixteenth centuries or are from a center in Iran of the same period.

PROVENANCE: Dikran Kelekian, New York; George Cameron Stone, New York.

REFERENCE: Stone 1934, fig. 51, no. 1.

NOTES

1. Melikian-Chirvani 1982b, pp. 163–68, has suggested that such letters are abbreviations for some of the benedictory phrases often found on Iranian metalwork. A version of the same garbled inscription (e), above, is found on a very similar shirt of mail and plate in the Khalili Collection, London, no. MTW 1158; see Alexander 1992, pp. 68–69, no. 26.

2. See also the shirt of mail and plates, cat. 5.

3. For the armor in the Museum of Turkish and Islamic Art, Istanbul, no. 170, see Allan and Raby 1982, pl. 20. For the example in the Qatar National Museum, Doha, see Doha 2002, no. 21.

INSCRIPTIONS:

Front

a. (Across the top)

<div dir="rtl">

ملكه خراسان (؟) / الامرا (؟) / ...

</div>

His dominion, Khurasan (?), the amirs (?) . . .

b. (Along the bottom)

<div dir="rtl">

العز في الطا |عة| و / و اكتاف (؟) رقاب (؟)

</div>

Glory is in obedience and . . . and shoulders (?), necks (?).

c. (In the two cartouches in the middle section)

<div dir="rtl">

... العالم (؟) / ...

</div>

. . . the Wise (?) . . .

Back

d. (In large letters at the top of the center section and at the bottom of the right and left sections)

<div dir="rtl">

الجماعة / الدولة / السلام

</div>

Community, wealth, peace.

e. (Undeciphered large letters at the top of the right and left sections)

f. (An undeciphered word consisting of five letters, repeated in three cartouches, one in the center section, one in the middle of the left section, and one in the middle of the right section)

g. (In two plates across the bottom of the center section)

<div dir="rtl">

الـعـ |ـز| (؟) / الا|قبال| (؟)

</div>

Glory (?), prosperity (?).

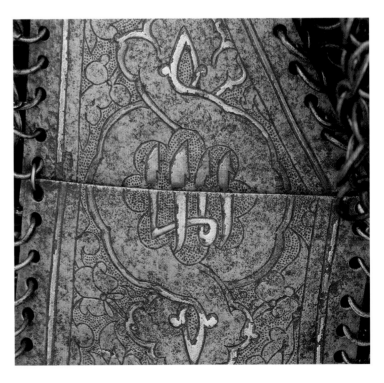

7 · Shirt of Mail and Plate

Turkey, perhaps Istanbul, Ottoman period, late 15th–16th century
Steel, iron, copper alloy, silver
Height (as mounted) 34 in. (86.4 cm); weight 20 lbs. 10 oz. (9,349 g)
Bequest of George C. Stone, 1935
36.25.362

DESCRIPTION: The shirt is composed of mail and sixty-nine steel plates. It opens down the front, is split up the back, and has diagonally cut, elbow-length sleeves. The mail consists of solid and riveted iron links of round section measuring between 7/16 and 9/16 in. (11 and 14 mm) in diameter; the mail on the upper chest is slightly heavier, with every fourth row composed of markedly thicker riveted rings. The sixty-nine steel plates are set into the mail: four rows of four large rectangular plates cover the stomach, the lateral rows shaped to the underarm; five vertical rows of smaller plates cover the back, with three middle rows of fifteen small plates each, the center row tapering downward and indented slightly down the middle, and two lateral rows of four larger plates each, the upper two plates of each shaped to the underarm. The plates are engraved and damascened in silver with a narrow frame enclosing bold Arabic inscriptions in a Kufic script (a, b); the outer edges of the larger plates are framed by an interrupted band filled with tight scrollwork suggesting a pseudo-Arabic script. Three of the four plates at each side of the front opening retain the copper rivets that once held the straps and buckles by which the shirt was closed; four copper rivets set into the mail on the upper chest served the same function. The lowermost front plate to the left of the opening is incised with the *tamğa* of the Ottoman arsenal; the same mark is incised on the inside of the second plate from the top on the right side of the opening.

INSCRIPTIONS:

a. (On the front, in the two large bands in the center)

السلطان / العالم (؟)

The wise (?) sultan.

b. (On the front, on the small bands at far right and left, and on the back, repetitions of words in Arabic, out of order and with misspellings)

... العز ...

. . . glory . . .

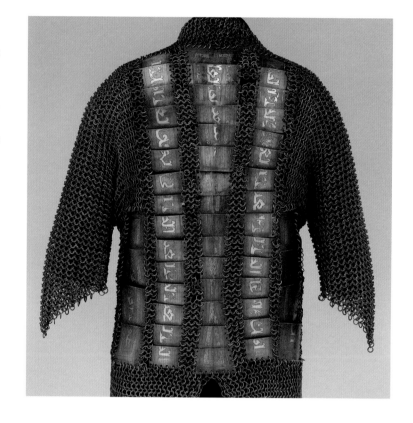

The inscriptions consist of individual letters, words, and abbreviations of phrases similar to those found on the mail-and-plate shirt cat. 6. The form of script points to an Ottoman provenance. Known as Kufic, this style of script developed during the ninth century; early examples are strong and austere and characterized by bold vertical and horizontal strokes.[1] Over the centuries numerous variations of the script developed, and by the fifteenth century a foliate variety appeared in Timurid, Mamluk, and Ottoman manuscripts. In the Timurid and Mamluk examples the foliate tips of the characters are generally more restrained than those of the Ottoman manuscripts, and the usual arabesque backgrounds are carefully delineated from the script. However, the script style used on armors and helmets is more flamboyant than anything found in the manuscripts: the long, sinuous extensions to the letters stand out against plain or punched grounds with no arabesques. The closest, but certainly not identical, comparison to the script style on the armors is that used on Iznik pottery of the early sixteenth century, as can be seen on an Iznik lamp in the Museum's collection, datable to about 1525–40 (fig. 19).[2] As with the present armor, the elongated curling tendrils sprout from the ends of the letters. (The script on this lamp has even closer parallels with that on a

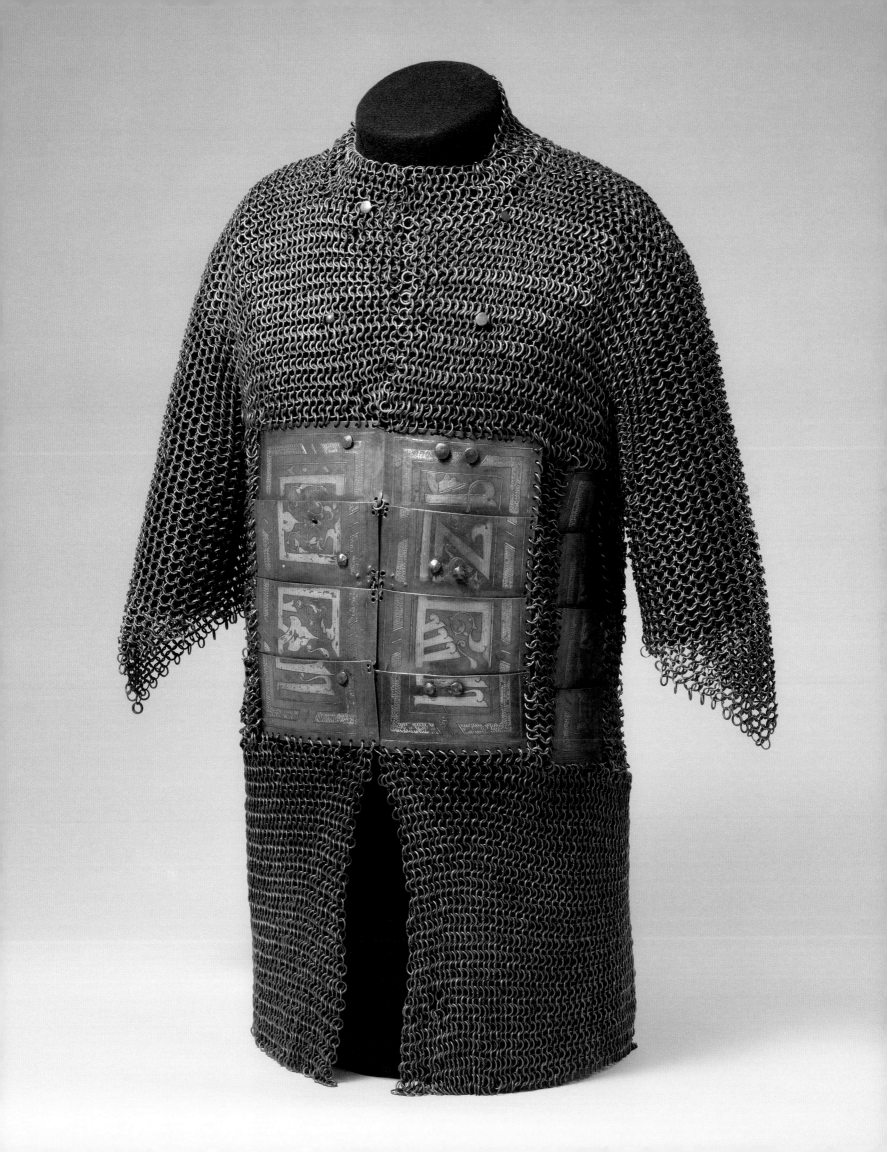

Fig. 19. Mosque lamp with Arabic inscriptions. Turkey, Iznik, 1525–40. Stonepaste, painted in blue under transparent glaze. The Metropolitan Museum of Art, New York, Harris Brisbane Dick Fund, 1959 (59.69.3)

helmet in the Museum's collection and is further discussed in the entry for cat. 24).

The overall impression given by the scripts on armor of this type is that the foliate forms invade the letters so that they also become juicy and leaflike. This exuberance is a characteristic of Turkman design, and although we do not at present know exactly where these pieces were produced, they should be attributed to a Turkman workshop in Anatolia or to Turkman decorators working in a major Ottoman center such as Istanbul.

Another type of script used on this and numerous other armors consists of tiny, meaningless squiggles or pseudo-inscriptions (see, for example, the Museum's helmet cat. 28). Why this motif was used as ornamentation is not known; the squiggles may have been modeled on the tiny but readable script on more sumptuous examples, or were thought to have a talismanic value, or were perhaps the work of illiterate craftsmen.

PROVENANCE: Ottoman arsenal, Istanbul; W. O. Oldman, London; George Cameron Stone, New York.

REFERENCES: Stone 1934, p. 38, fig. 51, nos. 2, 3; Alexander 1983, pp. 101–2, fig. 8.

NOTES

1. See, for example, Lings 1978, pls. 83, 87, 88.

2. Another Iznik lamp with similar script style is in the Çinili Köşk Müzesi, Istanbul, no. 41.4; see Atasoy and Raby 1989, fig. 293.

8 · Thigh and Knee Defense

Iran or Turkey, 15th century
Steel, iron, copper alloy, silver
Length 24 in. (61 cm); width 17¼ in. (43.8 cm);
weight 2 lbs. 9 oz. (1,175 g)
Bequest of George C. Stone, 1935
36.25.55b

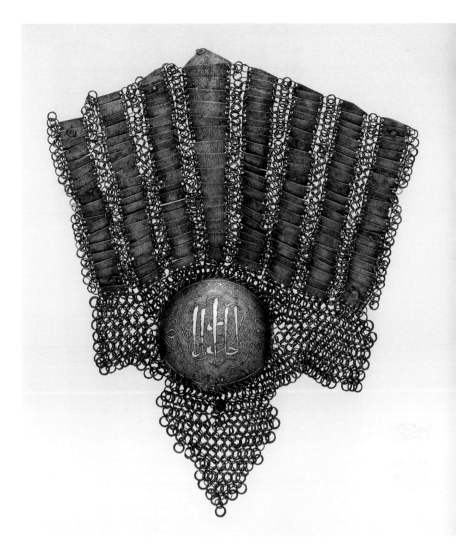

DESCRIPTION: Apparently intended for the left leg, this defense consists of eight columns of small rectangular plates, or lames, that overlap upward to cover the thigh and a large hemispherical plate to cover the knee, the plates connected by mail, and panels of mail to each side and below the knee. The thigh defense is composed of a central column of lames tapering to the knee and engraved with stylized foliate scrolls on a dot-punched ground within wide framing bands; four columns of undecorated lames cover the outer side, and three columns the inner. Iron studs fixed to the lames at the top and bottom of the outermost columns originally held the leather straps and buckles by which the defense was attached around the thigh. The knee plate is engraved with a lobed medallion formed of interlacing strapwork that contains an Arabic inscription (a) in cursive script, the background filled with floral designs on a dot-punched ground; the inscription, narrow framing bands of the medallion, and border around the knee are damascened in silver. The mail around the knee consists of a rectangular panel to each side and a triangular panel below. The mail is constructed with four riveted links passing through a solid one; the solid links, which are noticeably larger than the riveted ones, measure about ½ in. in diameter (12–14 mm) and have an irregular faceted edge with swelling on one side, an indication of their forge-welded construction. Incised inside the knee is a large *tamğa* of the Ottoman arsenal, and on the mail below the knee is a copper seal stamped with a six-petaled flower.

INSCRIPTION:
a. (On the knee plate)

Most glorious (?) . . .

… (؟) اجل

The inscription is garbled, probably part of the benedictions or titles frequently found on armor. Although its significance is not known, the flower-shaped mark on the copper seal may be of topographical import.[1]

Knee defenses such as this were usually decorated in the same styles and inscribed with the same types of inscriptions as those found on many of the Iranian, Anatolian, or Shirvani turban helmets and mail-and-plate armors in this publication.[2] In addition, there exist a number of Mamluk examples with similar decoration, and defenses of the same type also appear in Mughal miniature painting.[3]

PROVENANCE: Ottoman arsenal, Istanbul; Dikran Kelekian, New York; George Cameron Stone, New York.

REFERENCE: Stone 1934, fig. 51, no. 1.

NOTES
1. For an identical copper seal in the State Hermitage Museum, Saint Petersburg, see Lenz 1908, pp. 130, 134, and no. L.78, pl. IV.
2. For an example of such helmets, see cat. 25.
3. Several Mamluk pieces are preserved in the Askeri Müzesi, Istanbul, among them no. 16558 (unpublished). For those in Mughal miniature paintings from about 1636, see New Delhi and other cities 1997–98, pl. 36.

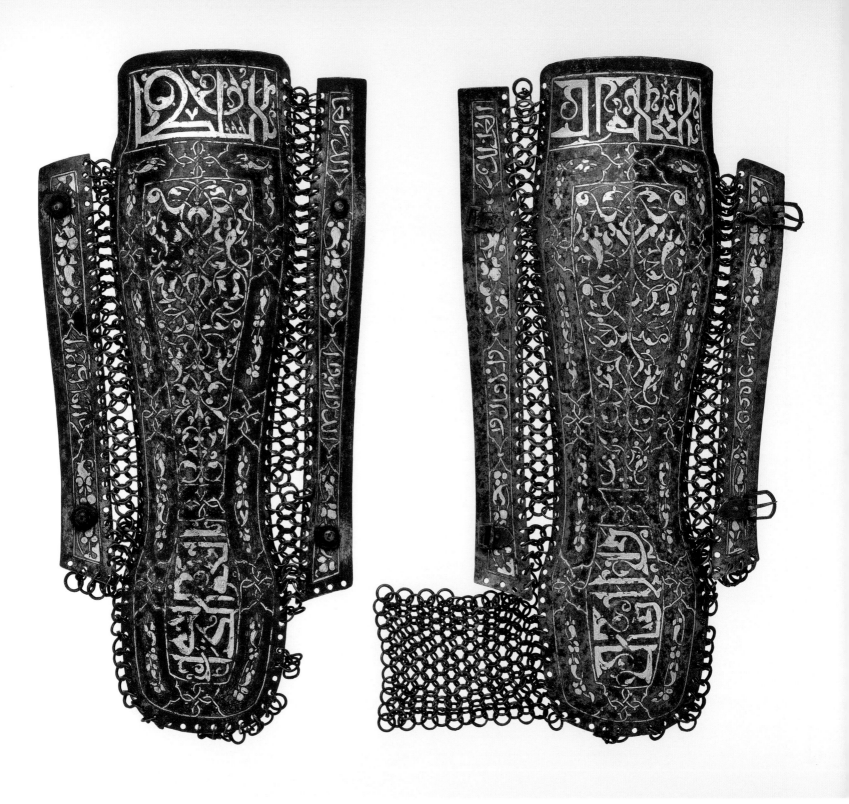

9 · Pair of Leg Defenses (Greaves)

Turkey, Istanbul (?), Turkman style, late 15th–16th century

Steel, iron, silver, gold, tin, leather

Length of each 15⅝ in. (39.7 cm); weight (of 36.25.457) 1 lb. 6 oz. (637 g) and (of 1990.229) 1 lb. 10 oz. (737 g)

Bequest of George C. Stone, 1935; Rogers Fund, 1990

36.25.457, 1990.229

DESCRIPTION: This matching pair of greaves, or defenses for the lower legs, comprises pieces for the right and left legs (36.25.457 and 1990.229, respectively) acquired more than fifty years apart. Each consists of three plates of steel connected by links of riveted and welded iron mail. The central plate of each is shaped over the calf and ankle and is engraved on a dot-punched ground with strapwork cartouches enclosing arabesques and Arabic inscriptions in foliate Kufic script (a, b). The engraved designs are damascened in silver; the remaining surfaces display traces of gilding. The inner side of each greave is tinned as a rust inhibitor and is incised at the ankle with an unusually large (¾ in., or 2 cm, in diameter) *tamğa* of the Ottoman arsenal. The narrow adjoining plates, the front plate longer than the rear, are each engraved

Right

Left

and damascened on a dot-punched ground with cartouches enclosing arabesques and Arabic inscriptions in cursive script (c, d) with traces of gilding. On the left greave the adjoining plates retain iron strap loops and buckles (mismatched but probably old) for the attachment of the leather straps; the right greave retains only domed rivets covering fragments of thick leather (modern). The left greave also preserves a section of mail in front of the ankle that originally was part of a complete foot covering.

INSCRIPTIONS:

a. (In large letters along the top, reading across both pieces, starting with the left greave)

السلطان / العالم الـ

The Sultan, the Wise, the . . .

b. (In large letters along the bottom, reading across both pieces, starting with the left greave)

العز الدائم و / الاقبال

Perpetual glory and prosperity.

c. (Down the left side of the right greave and up the right side)

العز الدا|ئم / و الاقبال و ا / ...

Perpetual glory and prosperity and wealth and . . .

d. (Down the left side of the left greave and up the right side)

السلطان|ن و الـ / الدولة ا و الـ / ...

The sultan and . . . wealth . . .

This is one of the few known pairs of matching greaves from this period and of this type. When placed next to each other, the seemingly fragmentary inscriptions on each piece of armor combine to create a coherent statement—in this case the line across the top of both would read "The Sultan, the Wise," which is the beginning of a formula commonly found on armor and helmets of this Turkman type. If the matching plate-and-mail armor and helmet for this set could be found, it is probable that a complete inscription would emerge.

The foliate Kufic script is of the same type as that found on a large number of other armors and helmets, including three in the Museum's collection, which consequently suggests a date to the late fifteenth or early sixteenth century.[1]

PROVENANCE: (36.25.457) Ottoman arsenal, Istanbul; Sir Guy Francis Laking, London; W. O. Oldman, London; George Cameron Stone, New York; (1990.229) Ottoman arsenal, Istanbul; Howard Ricketts, London.

REFERENCES: Christie, Manson and Woods, London 1920, lot 323 (one of two leg defenses; the other, cat. 10); Pyhrr 1991; Paris 2007/Mohamed 2008, p. 291.

NOTE

1. See especially cats. 7, 24, for a dating based on comparison with Iznik pottery of the early sixteenth century; the third example, a turban helmet, is acc. no. 04.3.462 (see Alexander 1983, pp. 101–2, fig. 7).

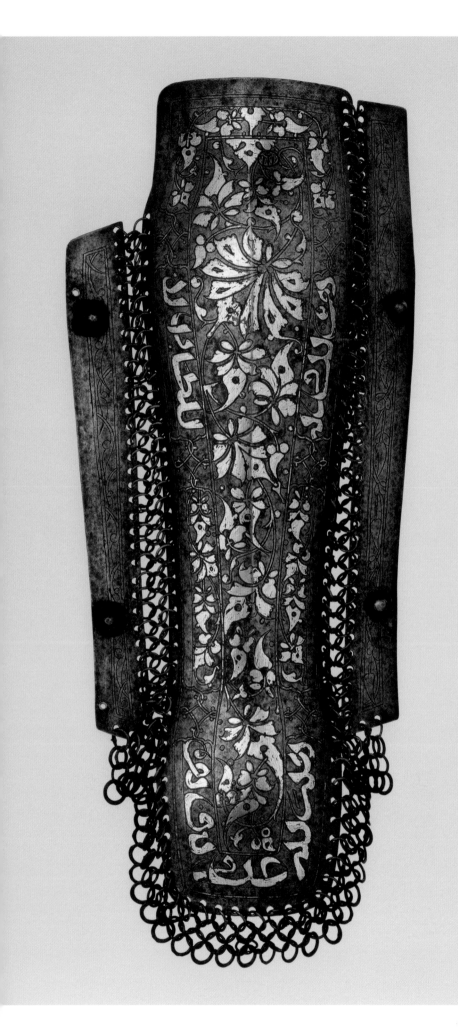

10 · Leg Defense (Greave)

Turkey, Bursa (?), Ottoman period, mid-15th century
Steel, iron, silver, gold, leather
Length 16 in. (40.8 cm); weight 1 lb. 5 oz. (593 g)
Bequest of George C. Stone, 1935
36.25.458

DESCRIPTION: The defense for the right lower leg consists of three plates of steel connected by links of solid and riveted iron mail. The central plate is shaped over the calf and ankle and has a low medial ridge along the upper two-thirds of its length. It is engraved with a long central panel filled with large-petaled floral scrolls, the leaves and petals hollowed in places. The panel is encircled by a narrow band filled with strapwork cartouches alternately enclosing foliate scrolls and Arabic inscriptions (a), the cartouches connected to one another by strapwork interlace. The engraved designs are damascened in silver, and the edges of the plate retain traces of gilding. Incised on the outer face of the center plate near the top is the *tamğa* of the Ottoman arsenal; incised on the inner face of the same plate at the ankle is a *tamğa*. The narrow adjoining plates, the front plate longer than the rear, are each engraved (but not damascened) with a narrow band of scrollwork and bear faint traces of gilding along their inner edges. Two domed iron rivets on each of the adjoining plates secure fragments of leather straps by which the defense was originally secured around the leg.

INSCRIPTIONS:
a. (Around the central plate)

... الا السلطان [ا]ا| ...

. . . the Sultan, the . . .

This leg defense belongs to a small group of armor whose decoration is characterized by large floral forms with broad leaves and petals that are pierced with holes and have a distinctly strong, solid appearance.[1] These armors must have been produced in the same workshop, and it is likely that the Museum's leg defense and a very similarly decorated helmet now in the Askeri Müzesi, Istanbul, may once have been part of the same armor.[2] Leaves of the type seen here are found in Timurid painting, ceramics, and stone carving.[3] However, there are also Ottoman parallels, chiefly from Bursa, where a group of Iranian and Iranian-trained Ottoman artisans worked for Murad II (r. 1421–51). Arthur Lane noted that the luxurious *cuerda seca* (dry cord) tilework they produced "marks the introduction of the Timurid-Persian style into Turkey."[4] A comparison of the leaf forms found on the Metropolitan's armor with those distinctive of Bursa work suggests that the Museum's leg guard and other related pieces may have been made there during the mid-fifteenth century.

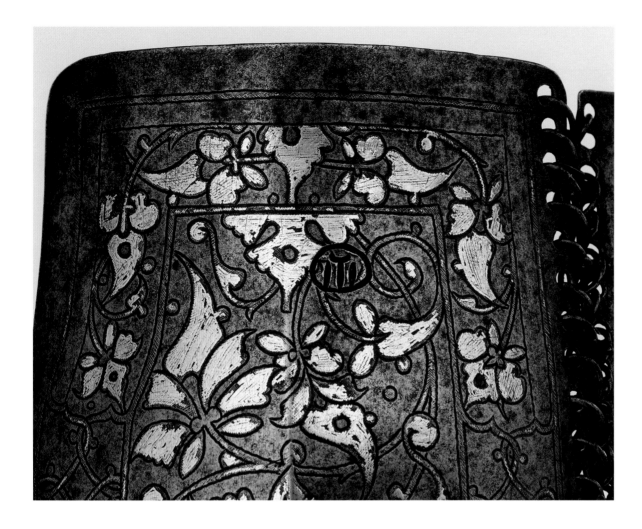

This greave typifies the difficulty in attributing many fifteenth-century armors to a specific center. Although worked in a variety of styles, these armors share a family resemblance; for this reason, many of them are described here as exemplifying a widespread Turkman aesthetic with a huge production in numerous diverse locations. One of the characteristics of this family group is that the inscriptions are often incorrectly written, leading to the assumption that in many cases they may have been executed by a non-Arabic speaker, perhaps either by an illiterate craftsman or by a Kurd, an Iranian, or a Turkman.[5] The *tamġa* engraved on the inside of this greave is the same (but reversed) as that found on two helmets in the Museum's collection, cat. 22 and acc. no. 04.3.209.[6]

PROVENANCE: Ottoman arsenal, Istanbul; Sir Guy Francis Laking, London; W. O. Oldman, London; George Cameron Stone, New York.

REFERENCES: Christie, Manson and Woods, London 1920, lot 323 (one of two leg defenses; the other, cat. 9); Alexander 1983, p. 101, fig. 6; Paris 2007/Mohamed 2008, p. 307, no. 295, n. 1.

NOTES

1. This group includes two examples in the Askeri Müzesi, Istanbul, nos. 12160 (greave), 13624 (helmet) (both unpublished).

2. Askeri Müzesi, no. 6887 (unpublished). A similarly decorated leg guard is in the Furusiyya Art Foundation, Vaduz, no. R-165; see Paris 2007/Mohamed 2008, p. 307, no. 295.

3. Washington, D.C., and Los Angeles 1989, p. 213, fig. 76; see also the floral decoration on a fifteenth-century bowl and the floral borders on a drawing from a horoscope of 1411, both in ibid., nos. 129, 36, ills., respectively.

4. Lane 1971, p. 42. Many of these artisans' works are signed; Arthur Lane lists the names of some of the craftsmen who signed a mihrab in the Green Mosque ("Made by the masters of Tabriz") and who elsewhere signed their names "'Ali ibn-Hajji Ahmed of Tabriz" and "Muhammad al-Majnun." Another master mentioned by Lane was 'Ali ibn Iyas 'Ali ("The Painter" Naqqash 'Ali) of Bursa, who was trained in Samarqand and Tabriz.

5. Annemarie Schimmel (personal communication, 1984) argued that the inscriptions must have been done by an illiterate, as the letters are connected in an impossible way.

6. For the latter, see Cosson 1901, p. 112, no. N.4, pl. 8.

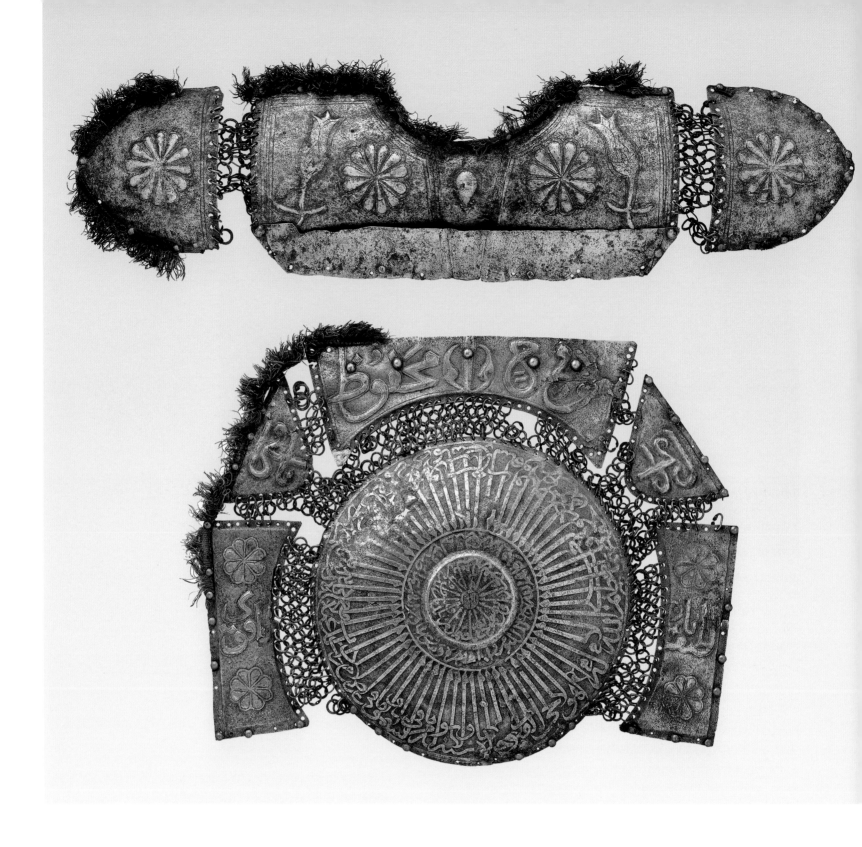

11 · Portions of an Armor

Turkey, Ottoman period, late 16th–17th century
Steel, iron, copper alloy, textile
Breastplate: 14⅛ × 18⅛ in. (36 × 46 cm); diameter of
circular plate 10⅞ in. (27.5 cm)
Shoulder defense: 4⅛ × 19⅞ in. (10.5 × 50.5 cm)
Bequest of George C. Stone, 1935
36.25.345

DESCRIPTION: The ensemble is fragmentary and composite, comprising portions of the breastplate and the shoulder and back defenses from two different armors. The breastplate consists of a slightly convex circular plate, or pectoral disk, and five plates surrounding it at the top and sides, the plates attached to one another by riveted and solid (forge-welded) links of iron mail. The decoration of the circular plate is arranged in three fields: a slightly concave central medallion surrounded by two contiguous bands, the narrow inner one slightly recessed, the wider outer one convex. All three fields are chiseled (not embossed) in low relief with three concentric bands of Arabic inscriptions, consisting of Qur'anic quotations, in a cursive

script (a–c). The three large plates at the top and sides are shaped to fit the contours of the disk and are connected to one another by two small triangular plates. The outer edges of the side plates are lined with brass-headed rivets that retain portions of an associated brown silk woven band with fringe. The five surrounding plates are embossed in low relief with Arabic inscriptions, with eight-petal rosettes on the two side plates. The plate at the top is inscribed with a Qur'anic quotation (d), while the four plates at the sides are inscribed with calls to various names of God (e, f). The shoulder defense consists of a long horizontal plate shaped to fit across the back of the shoulders and around the neck, with a narrow adjoining plate riveted below it, and two shield-shaped plates attached by mail at the shoulder ends. The backplate is outlined with engraved lines and has two grooves extending down the center of both plates; to each side of the grooves on the larger plate is an embossed twelve-petal rosette and a stylized tulip with engraved petals. The shoulder plates also have engraved outlines and are embossed in the center with a twelve-petal rosette. Associated fringed textile bands similar to those on the breastplate are riveted to the edge of the back- and shoulder plates, which also retain fragments of their original red silk edging. Engraved at the center of the pectoral disk is the *tamġa* of the Ottoman arsenal.

INSCRIPTIONS:

a. (In the central field of the circular plate)

قل هو الله احد الله الصمد لم يلد و لم يولد و لم يكن له كفوا احد

Say: He is Allah, the One; Allah, the Eternal, Absolute; He begetteth not, nor is He begotten; And there is none like unto Him. (Qur'an 112)

b. (In the narrow middle field of the circular plate)

فوقاهم الله شر ذلك اليوم و لقاهم نصرة و سرورا و جزاهم بما صبروا جنة و حريرا

But Allah will deliver them from the evil of that Day, and will shed over them brightness and a (blissful) Joy. And because they were patient and constant, He will reward them with a Garden and (garments of) silk. (Qur'an 76:11–12)

c. (In the wide outer field of the circular plate)

الله لا اله الا هو الحي القيوم لاتأخذه سنة و لا نوم له م في السموات و ما في الارض من ذا الذي يشفع عنده الا باذنه يعلم ما بين ما ايديهم و ما خلفهم و لا يحيطون بشيء من علمه الا بما شاء وسع كرسيه السموات و الارض و لا يؤده حفظهما و هو العلي العظيم

Allah! There is no god but He, —the living, the Self-subsisting, Supporter of all / No slumber can seize Him nor sleep. His are all things in the heavens and on earth. Who is thee can intercede in His presence except as He permitteth? He knoweth what (appeareth to His creatures as) Before or After or Behind them. Nor shall they compass aught of His knowledge except as He willeth. His Throne doth extend over the heavens and the earth, and He feeleth no fatigue in guarding and preserving them for He is the Most High, the Supreme (in glory). (Qur'an 2:255)

d. (On the top plate)

في لوح محفوظ

(Inscribed) in a Tablet Preserved! (Qur'an 85:22)

e. (Repeated in mirror form on the upper side plates)

يا كافي

O Self-Sufficient!

f. (On the two lower side plates, on the proper left and right side)

يا لطيف / يا قوي

O Gentle! O Strong!

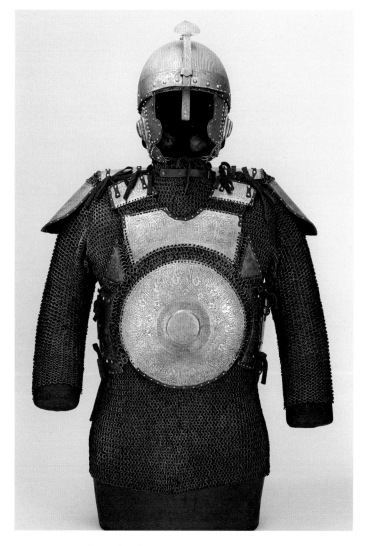

Fig. 20. Armor. Turkey, early 16th century. Steel, iron, gold, leather, and textile. Kunsthistorisches Museum, Vienna (C85).

Pectoral and dorsal disks suspended by straps in the center of the chest and at the back, many decorated with solar motifs, seem to have been first used in Iran about 1000 B.C.[1] The style spread from Iran to Assyria, where such armor appears in relief sculpture from the palace of Sargon II (r. 721–705 B.C.) at Khorsabad, and to the Steppes of Central Asia, as witnessed by a Scythian example of about the fourth century B.C. that has a disk incorporated into a lamellar breastplate.[2] Two sixth-century B.C. examples from Italy and Central Europe, decorated respectively with a sunburst design and with concentric rings, indicate that the style also traveled to these regions.[3]

During the Sasanian period armor with pectoral and dorsal disks was often depicted on silver-gilt plates[4] and can be seen in the royal hunting and investiture scenes at Taq-i-Bustan in Iran.[5] Such armors continued to be used in Central Asia; a sixth-century example from Panjikent (near Samarqand) shows a rider in the boar-drawn chariot of the god Veshparkar wearing a disk of this type. It is decorated with small circles and a triangle.[6]

The early types of pectoral and dorsal disks suspended by straps in the center of the chest and at the back evolved into a variation in which larger pectoral and dorsal disks were incorporated into an armored shirt. The earliest surviving example of these so-called pot-lid armors from the Islamic period consists of a small disk incorporated into a mail-and-plate armor that can be dated to the fifteenth century.[7] Many examples of this type of armor have been preserved, with quite a few, albeit in fragmentary condition, in the Askeri Müzesi, Istanbul, while others are in numerous public and private collections throughout the world. Of these, two with larger disks, one decorated in a style indicating a Safavid provenance and the other Ottoman datable to the early sixteenth century (although probably made in Syria after the Ottoman conquest of 1517), are in the Topkapı Sarayı Museum, Istanbul, and the Kunsthistorisches Museum, Vienna (fig. 20). This last is one of the most complete and best-preserved examples of the type.[8]

The component parts of the Museum's armor are worked in different techniques. This does not necessarily mean that they are of different dates, however, as a number of related armors have survived that apparently were produced in a large workshop with the various parts crafted by different artisans, then assembled—but sometimes with little regard as to whether the parts matched. The pectoral disk of the Museum's armor is chiseled, while the other elements are embossed.[9] The embossed decoration of the shoulder plates differs from that of the plates fitted around the breastplate (the rosettes on the former have twelve petals, rather than eight as on the latter) and includes engraved borders not matching those on the breast. Other armors of the same type indicate that embossing and chiseling were often combined; a very similar piece now in the Askeri Müzesi, Istanbul, appears to have been produced by at least three different artisans, one of whom was probably also responsible for parts of the Museum's armor.[10] Other examples, however, such as one in the Museo Stibbert, Florence, seem to have been produced—or at least decorated—by a single craftsman.[11]

The inscriptions used here are clearly intended as a talisman, praising God as lord of the heavens who will protect his servants on the Day of Judgment. The similar Askeri Müzesi armor mentioned above is also inscribed with some of the names of God and with the same Qur'anic verse (76:11–12), very appropriate for a warrior facing possible death in the jihad.[12]

Several other armors with pectoral disks now in the Askeri Müzesi, Istanbul, are worked with similar circular inscriptions or with radiating ribs (in the Museum's example, the elongated *alifs* and other letters function visually in the same way as the radiating ribs on more simply designed pieces), and they must also date to the later sixteenth or early seventeenth century. Indeed, the embossed sections on our armor relate it to a much larger group that includes cat. 34, dated here to about 1580, and numerous shaffrons with embossed frontals, among them cat. 51. Such a dating is further suggested by the calligraphic roundels and the tulip decoration.[13] A shield in the Museo Bardini, Florence, with a fringe similar to that on the Metropolitan and Stibbert armors, is also related and is a late sixteenth- or seventeenth-century type.[14]

PROVENANCE: Ottoman arsenal, Istanbul; Robert Curzon, 14th Baron Zouche of Haryngworth, Parham Park, Sussex; Robert Curzon, 15th Baron Zouche; Darea Curzon, 16th Baroness Zouche; George Cameron Stone, New York.

REFERENCES: Sotheby, Wilkinson and Hodge, London 1920, lot 29; Alexander 1989, pp. 199–200, fig. 1; Schimmel 1992, p. 46, fig. 58.

NOTES

1. For this type of armor and its solar associations, see Alexander 1989.

2. See Gamber 1978, figs. 192, 324; Alexander 1989, p. 201, fig. 3.

3. Gamber 1978, figs. 269, 271.

4. See New York 1978, nos. 3, 6, 7, 12.

5. Alexander 1989, p. 201, fig. 4.

6. Azarpay 1981, fig. 14.

7. Alexander 1989, pp. 200, 201, fig. 5, illustrating an Iranian mail-and-plate shirt in the Askeri Müzesi, Istanbul, no. 21301.

8. Topkapı Sarayı Museum, Istanbul, no. 1/596 (unpublished), and Kunsthistorisches Museum, Vienna, no. C85. For the latter, see Thomas and Gamber 1976, pp. 246–47, pl. 64, and Riyadh 1996, vol. 2, pp. 114–15, no. 90. See also Gorelik 1979, figs. 171–73, 189, 192–94, and Alexander 1983, fig. 9.

9. Calligraphic roundels such as this are common in Ottoman religious inscriptions from the mid-sixteenth century onward; see, for example, the roundels in Istanbul's Süleymaniye Mosque, dating to the mid-sixteenth century.

10. Askeri Müzesi, Istanbul, no. 16468 (unpublished). For another example in the Armeria Reale, Turin, no. B.51, see Stone 1934, p. 39, fig. 52.

11. Museo Stibbert, Florence, no. 6266; see H. Robinson 1973, p. 208, pl. 20; Venice 1993, p. 402, no. 252; Florence 2002, p. 40, fig. 11; Florence 2014, p. 119, no. 16.

12. For a discussion of the possible solar associations of pectoral disks chiseled with radiating spokes, see Alexander 1989.

13. See also Askeri Müzesi, Istanbul, nos. 17347, 18365 (unpublished). A conical helmet in the Askeri Müzesi, Istanbul, no. 896 (unpublished), also has inscriptions in exactly the same style as the Museum's example.

14. Museo Bardini, Florence, no. Bd. 2683; see Florence 2002, no. 11.

12 · Shirt of Mail and Plate

India, Mughal period,
dated A.H. 1042 (A.D. 1632/33)
Steel, iron, gold, leather
Height 32 in. (81.3 cm);
weight 23 lbs. 10 oz. (10,700 g)
Purchase, Arthur Ochs Sulzberger Gift, 2008
2008.245

DESCRIPTION: The short-sleeve shirt is composed of mail and six plates. It has a wide round opening at the neck and opens down the front to the waist, below which it is closed; there is a six-inch opening up the center of the front and back. The shirt is composed of two types of mail: the upper half, down to the bottom edge of the plates, is made up of alternating rows of solid (forge-welded) and double-riveted links of flattened section, the outer faces of each stamped with Arabic inscriptions of the ninety-nine names of god (a). The rings, which are slightly oval in shape, measure about ⅝ in. (15–17 mm) in diameter. The lower portion of the shirt is composed of similar double-riveted mail but without the stamped inscriptions. Set into the mail at the top, to each side of the center opening, are two pairs of rings, each composed of one riveted and one solid ring, set one above the other, which apparently served as closures (with leather thongs?); these rings differ from those of the main body of the shirt in being of round section, the riveted links closed by one, rather than two, rivets. Four plates are set into the mail at the front, and two plates at the back toward the sides. The plates are secured to the shirt by small links of round section, each closed by a single rivet; the difference in these rings from those that compose the shirt suggest that the plates are associated.

The plates set into the front consist of two tall rectangular plates at the center, one to each side of the opening, with a narrow plate at either side. The rectangular plates are doubly curved, being convex along the vertical axis and also concave in profile. To each of the rectangular plates is riveted a vertical row of three stylized fish-shaped fixtures in the mouths of which are held the buckles (left) and strap loop (right), in which portions of the three leather straps are retained. The narrow lateral plates are slightly convex in section and have their upper outer corners shaped to fit beneath the arm. Two similarly shaped narrow plates are also set into the back of the shirt, one at each side behind the arm.

The surfaces of the plates are covered with gold leaf (burnished onto a cross-hatched surface) into which the decoration is incised, rendering the inscriptions and ornament legible in contrasting dark steel. The decoration of each consists of wide borders around a central field, the surfaces of both covered with Arabic inscriptions (b–i) interspersed with delicate foliate tendrils and flowers. Two colors of gold are employed: a deep yellow and a paler yellow, the latter used in the centers of the four narrow plates and on the scales of the fish-shaped mounts. Incised on the inside of the large plate on the proper right side at the front are two Persian inscriptions, one contained within a cartouche, the other immediately below it, while a third inscription is found inside the right lateral plate. These as yet have only been partially deciphered (j–l).

INSCRIPTIONS:

a. (Stamped on the outer faces of the mail rings are invocations to the names of God, four to five names on each ring, the same ring repeated in columns from the top to the bottom of the shirt; each column has a different type of ring.)

On the front from proper left to proper right
b. (On the left lateral plate, in the center)

بسم الله الرحمن الرحيم قل هو الله احد الله الصمد لم يلد و لم يولد و لم يكن له كفوا احد

In the Name of Allah, Most Gracious, Most Merciful. Say: He is Allah, the One; Allah, the Eternal, Absolute; He begetteth not, nor is He begotten; and there is none like unto Him. (Qur'an 112)

c. (On the left lateral plate, around the edge)

بسم الله الرحمن الرحيم قل يا ايها الكافرون لا اعبد ما تعذدون و لا انتم عابدون ما اعبد و لا انا عابد ما
عبدتم و لا انتم عابدون ما اعبد لكم دينكم و لي دين يا حافظ يا ناصر يا معين

In the Name of Allah, Most Gracious, Most Merciful. Say: O ye that reject Faith! I worship not that which ye worship. Nor will ye worship that which I worship. And I will not worship that which ye have been wont to worship. Nor will ye worship that which I worship. To you be your way, and to me mine. (Qur'an 109). O Protector! O Victor! O Aider!

d. (On the two center plates, beginning at the top of the right plate, continuing around the border and then in the center, and then continuing in the same order on the left plate)

بسم الله الرحمن الرحيم الله لا اله الا هو الحي القيوم لا تأخذه سنة و لا نوم له ما في السموات و
ما في الارض من ذا الذي يشفع عنده الا باذنه يعلم ما بين ايديهم و ما خلفهم و لا يحيطون بشيء
من علمه الا بما شاء وسع كرسيه السموات و الارض و لا يوده حفظهما و هو العلي العظيم لا اكراه
في الدين قد تبين الرشد من الغي فمن يكفر بالطاغوت و يؤمن بالله فقد استمسك بالعروة و الوثقى لا
انفصام لها و الله سميع عليم

In the Name of Allah, Most Gracious, Most Merciful. Allah! There is no god but He, —the Living, the Self-subsisting, Supporter of all / No slumber can seize Him nor sleep. His are all things in the heavens and on earth. Who is thee can intercede in His presence except as He permitteth? He knoweth what (appeareth to His creatures as) Before or After or Behind them. Nor shall they compass aught of His knowledge except as He willeth. His Throne doth extend over the heavens and the earth, and He feeleth no fatigue in guarding and preserving them for He is the Most High, the Supreme (in glory). Let there be no compulsion in religion: Truth stands out clear from Error: whoever rejects Tagut and believes in Allah hath grasped the

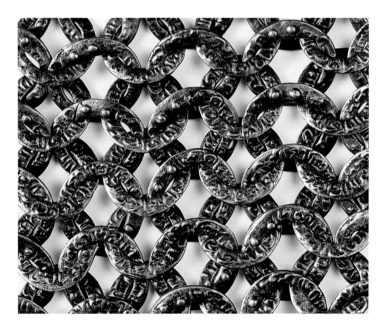

most trustworthy hand-hold, that never breaks. And Allah heareth and knoweth all things. (Qur'an 2:255–56)

e. (On the right lateral plate, in the center)

يا رحمن الدنيا و الاخرة و رحيمهما

O Compassionate One of this world and the afterlife, and Merciful One of them both.

f. (On the right lateral plate, around the border)

بسم الله الرحمن الرحيم قل اعوذ برب الناس ملك الناس اله الناس من شر الوسواس الخناس الذي
يوسوس في صدور الناس من الجنة و الناس

In the Name of Allah, the Compassionate, the Merciful. Say: I seek refuge with the Lord and Cherisher of Mankind, the King (or Ruler) of Mankind, the God (or Judge) of Mankind,— from the mischief of the Whisperer (of Evil), who withdraws (after his whisper),— who whispers into the hearts of Mankind,— among Jinns and among Men. (Qur'an 114)

On the back
g. (On the right backplate, beginning in the border and continuing in the center)

بسم الله الرحمن الرحيم قل اعوذ برب الفلق و من شر ما خلق و من شر غاسق اذا وقب و من شر
النفاثات في العقد و من شر حاسد اذا حسد

In the Name of Allah, the Compassionate, the Merciful. Say: I seek refuge with the Lord of the Dawn. From the mischief of created things; from the mischief of Darkness as it overspreads; from the mischief of those who blow on knots; and from the mischief of the envious one as he practises envy. (Qur'an 113)

h. (On the left backplate, around the border)

بسم الله الرحمن الرحيم اذا جاء نصر الله و الفتح و رأيت الناس يدخلون في دين الله افواجا فسبح بحمد
ربك و استغفره انه كان توابا

In the Name of Allah, Most Gracious, Most Merciful. When comes the Help of Allah, and Victory, and thou dost see the People enter Allah's Religion in crowds, celebrate the Praises of thy Lord, and pray for His Forgiveness: for He is Oft-Returning (in forgiveness). (Qur'an 110)

i. (On the left backplate, in the center)

نصر من الله و فتح قريب

Help from Allah and a speedy victory. (Qur'an 61:13)

On the inside of the right breastplate
j. (In the cartouche)

پیشکس سیف خان سنة ۱۰۴۲
قیمت (۲۰۰) روپیه ۲۶ (۲۶) بار (؟) ۵

Gift of Saif Khan, year 1042 (A.D. 1632/33).
Price (200 in *raqam*) rupees, 26 (26 in *raqam*) *bar* (?) *ha*.

k. (Below the cartouche)

وجوه ولی بیگ (؟) ۲۳ شوال ۳۲
(۲۲۰)
۱

In the charge of Vali Beg (?) 23 Shawwal, [regnal year] 32.
220
1

On the inside of the right lateral plate
l.

وجوه علی رضا ۲ ذی حجة سنة ۲۳

In the charge of 'Ali Riza, 2nd Dhu'l-Hijja, [regnal] year 23.

In an inscription on the inside of the right breastplate, this armor is recorded as a gift from Saif Khan in the year A.H. 1042 (A.D. 1632/33) and bears two further inventory dates recorded as regnal years 23 and 32, which, if referring to the reign of Shah Jahan (1627–58), would correspond to 1649 and 1658.[1] Saif Khan served under the Mughal emperors Jahangir (r. 1605–27) and Shah Jahan (r. 1627–58).[2] He was a son of Amanat Khan, received the title "khan" in A.H. 1025 (A.D. 1616), and was appointed reporter of the province of Gujarat.[3] In A.H. 1032 (A.D. 1623) he married a sister of Shah Jahan's wife, Mumtaz Mahal.[4] Also in that year he distinguished himself in battle, for which he was promoted to the rank of 3000/2000 and was granted the privilege of a banner and drums.[5] He died in A.H. 1049 (A.D. 1639/40).[6]

This beautiful Indian mail-and-plate shirt belongs to a very small group of high-quality objects decorated in a reverse technique, in which the entire surface was covered with gold leaf and the inscriptions and decoration incised through the gold to reveal the contrasting surface beneath. Other related examples include a plate from a cuirass in the Furusiyya Art Foundation, Vaduz, and a helmet in the Topkapı Sarayı Museum, Istanbul.[7] The floral elements accompanying the inscriptions on the Museum's armor are typical of the workmanship on other pieces almost certainly made for the emperors Jahanghir and Shah Jahan. Such characteristic individual flower forms can be seen on the gold sections of a scabbard locket in the Dar al-Athar al-Islamiyya, al-Sabah Collection, Kuwait City, and the serrated leaves on an enameled element from a *huqqa* pipe in the same collection.[8] Our armor should also be attributed to a decorator who worked for the Mughal court.

It is possible that the shirt is composite and that the plates and mail are associated, since the rings attaching the plates to the body of the shirt are unlike the surrounding links and do not seem to be as old. However, this must remain hypothetical, for it could just as easily have been put together during the seventeenth century using rings from one smith and plates from another and repaired when in the imperial arsenal.

PROVENANCE: Nagel Auktionen, Stuttgart, November 5, 2007, lot 414; Andrew Lumley, Thirsk, Yorkshire, England; Philippe Missillier, Lyon.

REFERENCES: Nagel Auktionen, Stuttgart 2007, lot 414; Pyhrr 2010, pp. 30–31.

NOTES

1. The inscriptions were read by Will Kwiatkowski; they were also referred to Manijeh Bayani and John Seyller, who concurred on all points, save that Dr. Seyller regarded the inventory inscriptions referring to the regnal years 23 and 32 as belonging to Shah Jahan's reign rather than to that of his successor, Aurangzeb (r. 1658–1707). Dr. Seyller argued that if the second date is from the period of Shah Jahan it would correspond to July 24, 1658, and he wrote that this would be "exactly a week before Aurangzeb was crowned officially. It might even make sense that a new administrator would be taking custody of such objects as Aurangzeb officially took control of the state.

Accordingly, the other date (2 Zi'l Qa'da RY 23 = A.H. 1059) would be November 7, 1649." However, he added that in the "absence of additional corroborative information, [he and Dr. Bayani] think that . . . both possibilities for the equivalents [should be given] of the two regnal dates" (Will Kwiatkowski, personal communication, February 2015). In addition, Robert Skelton and Wheeler M. Thackston have read a word in the inscription in the cartouche inside the right breastplate (j) as "bar" rather than "athar," as some have; they also think that this word signifies some kind of weight (Will Kwiatkowski, personal communication, June 2015).

2. Details of his life and service are recorded in the *Jahangirnama* (the diary of Jahangir; see Thackston 1999) and the *Ma'athir al-Umara* (biographies of the Mughal nobles, written in the eighteenth century; see Shahnavaz Khan Awrangabadi 1979, vol. 1, pp. 689–92). He is repeatedly mentioned in the *Padshahnama* chronicling the reign of Shah Jahan, and is depicted in a painting of Shah Jahan receiving Dara Shikuh; see New Delhi and other cities 1997–98, pp. 41, 168, no. 84, pl. 10, fig. 86.

3. Thackston 1999, p. 204.

4. Mumtaz is buried in the Taj Mahal. See ibid., pp. 242, 251, 278, 346, 397–400, 418, 459.

5. Ibid., p. 400.

6. Shahnavaz Khan Awrangabadi 1979, vol. 1, p. 692.

7. For the Furusiyya example, no. R-145, see Paris 2007/Mohamed 2008, p. 309, no. 297. For the Topkapi example, no. 1353, see Riyadh 1996, vol. 2, pp. 110, 113, no. 89v. The same technique is also found in Mamluk and Ottoman decoration; see cat. 58.

8. See London and other cities 2001–2, pp. 57, 67, nos. 5.1, 6.14.

13 · Shirt of Mail and Plate

India, probably Bijapur, 17th century
Steel, iron
Height 35⅝ in. (90.5 cm); weight 25 lbs. 10 oz. (11.61 kg)
Purchase, Arthur Ochs Sulzberger Gift, 2000
2000.497

DESCRIPTION: The long-sleeved shirt constructed of mail and narrow, scalelike plates opens completely down the center and has a short opening up the center of the back. A short rectangular flap of mail at the top of the shirt at the back of the neck is perhaps the remnant of the original collar. The extremely long sleeves extend over the hand and end in a diagonal cut. The mail is composed of solid (forge-welded) and riveted rings, the heaviest and most densely structured sections being reserved for the sleeves, which are attached separately at the shoulders. The plate components consist of a series of columns of small, downward-overlapping plates, each having an indented center and cusped lower edge. The columns taper slightly toward the bottom, each separated by three rows of mail. There are eight columns of plates on the front, four to each side of the center opening, and seven on the back; two narrow, vertical plates, each slightly convex and measuring about 8½ in. (21.5 cm) long, below each of which is a short row of small overlapping plates, are set side by side beneath each arm. A single row of overlapping plates extends across the top of each shoulder. The shirt is composed of almost fourteen hundred plates. The forward vertical plate beneath the right arm is incised on its face with a Hindi inscription, and an unidentified mark is stamped on the inside of each of the four large plates beneath the arms.

The Hindi inscription, only partially translated, mentions the name of Maharaja Anup Singh of Bikaner (r. 1669–98) and the date *samvat* 1774 (A.D. 1691). This shirt of mail and plate is part of a large group of arms and armor dispersed from the armory of the maharajas of Bikaner in Rajasthan within the past twenty-five years.[1] Many of the armors, helmets, and weapons have inscriptions in Hindi recording the dates and campaigns in which they were captured as booty.[2] The armor can be traced to Bijapur, the richest and most powerful Muslim state in the Deccan. Bijapur was ruled by the 'Adil Shahi dynasty—established in 1489 by Yusuf (r. 1490–1510)—until 1686, when Sikandar b. 'Ali (r. 1672–86) was defeated by the Mughal emperor Aurangzeb (r. 1658–1707). After Aurangzeb's conquest of Bijapur, Siddi Masud, a lieutenant whom Sikandar had appointed governor of Adoni, remained in power as an independent ruler until 1689, when Adoni was captured by Anup Singh.

Anup Singh, among Bikaner's most famous rulers, was one of Aurangzeb's generals and led a number of campaigns in the Deccan during the 1680s and 1690s. Appointed governor of Adoni by Aurangzeb in 1689, Anup Singh held the post until his death in 1698. Most of the arms and armor captured by him and then

placed in the armory at Bikaner were taken either at Golconda, in 1687, or Adoni, in 1689. The inscription on the Museum's armor unfortunately makes no mention of the place of capture.

The majority of armors known to have come from Bikaner are mail shirts inset with large rectangular plates at the front and rows of small plates on the back,[3] a type used throughout the Mamluk, Ottoman, and probably Iranian world since the early fifteenth century, several examples of which are in the Museum's collection (cats. 5–7). The present armor, constructed principally of small plates, is a much rarer Indian type (*zereh bagtar*). Its equivalent, known as a *bekhter*, was particularly popular in Russia and eastern Europe from the early sixteenth century.[4] A number of similar mail-and-plate shirts from Bikaner are in the Royal Armouries, Leeds. A study of the mail components indicates that, on certain examples, the link size changes abruptly, suggesting that components such as sleeves or skirts were prefabricated and assembled separately.[5] This would explain the differences in the mail found on the body and on the sleeves of the Museum's shirt. The same study found that on the majority of Indian mail shirts the links were coated with zinc (comparable to the modern industrial process of galvanization) to prevent corrosion,

although X-ray fluorescence (XRF) of the Museum's shirt found no traces of zinc on this example.

PROVENANCE: Bikaner armory; Syd Bryan, Pontyberem, Wales; Robert Hales, London.

REFERENCE: New York 2002–3, p. 41.

NOTES
1. Over the last twenty-five years a large quantity of arms and armor from the Bikaner armory has been bought and sold by a small group of British dealers and collectors, including the vendor of the Museum's armor.
2. A large group of daggers from the Bikaner armory is now in the Furusiyya Art Foundation, Vaduz; see, for example, no. RB-45 in Paris 2007/ Mohamed 2008, p. 207, no. 198.
3. The Metropolitan Museum's collection includes a Bikaner example of this type, acc. no. 2000.595, which is inscribed with the maker's or owner's name in Persian, Hassan, and Hindi inscriptions indicating its capture by Anup Singh in his campaign against the city of Adoni in 1689.
4. Bocheński 1971.
5. Bottomley and Stallybrass 2000.

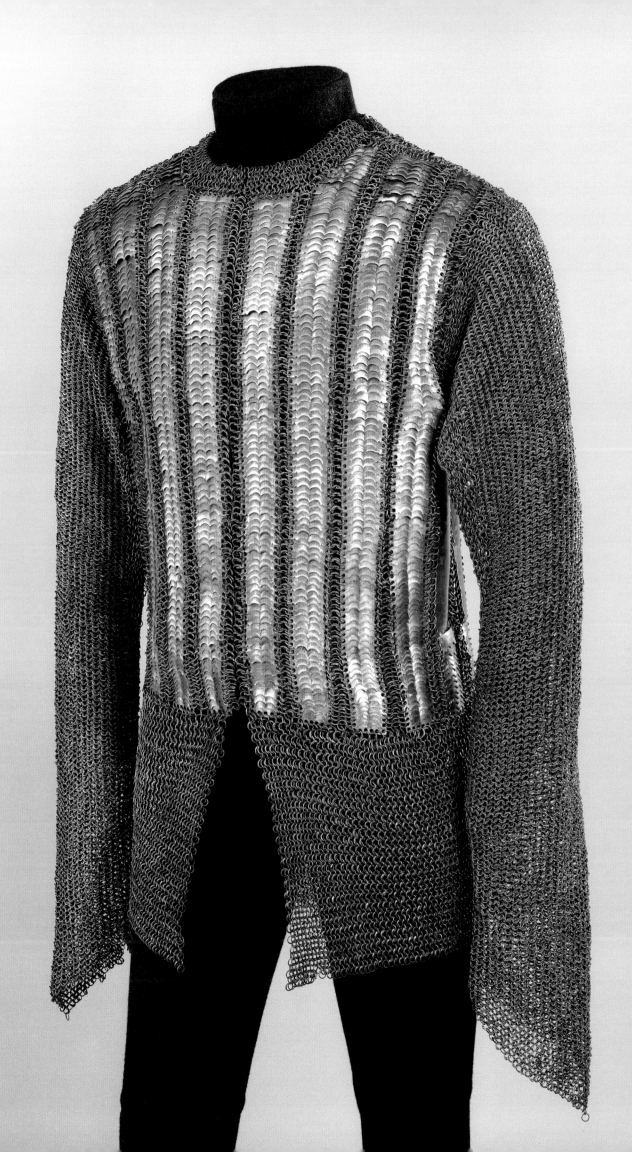

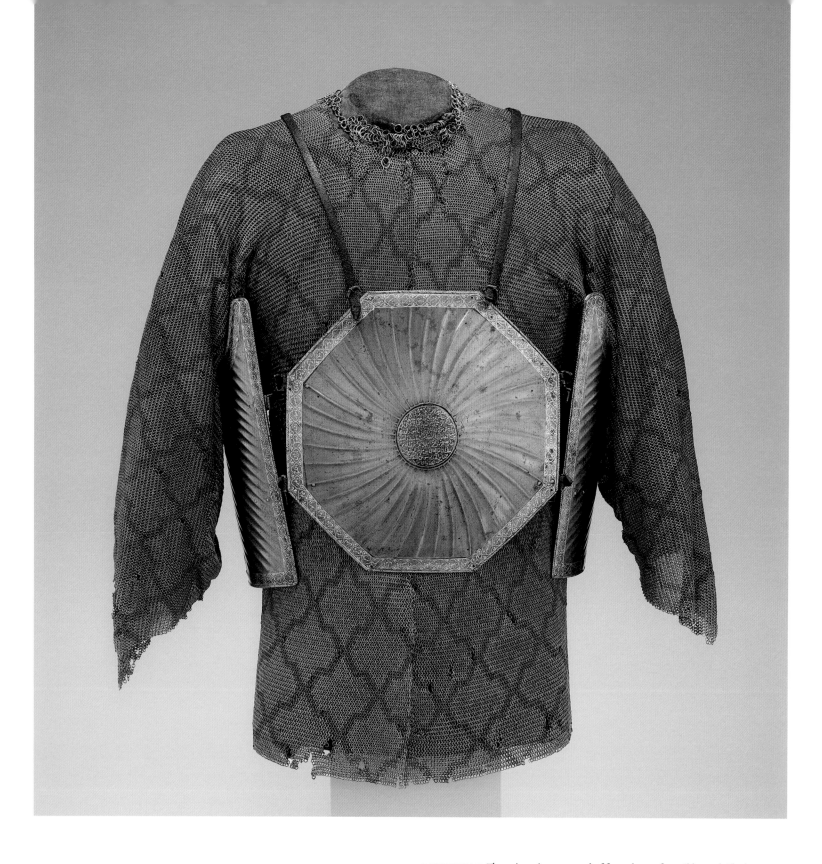

14 · Cuirass

Iran, 17th–early 18th century
Steel, iron, gold, leather
Breast- and backplates 11 × 11 in. (28 × 28 cm); side plates 11⅝ × 6⅛ in.
(29.5 × 15.5 cm); weight 6 lbs. 8 oz. (2,948 g)
Bequest of George C. Stone, 1935
36.25.18a–d

DESCRIPTION: The cuirass is composed of four plates of crucible steel. The breast-
and backplates are octagonal in shape, convex in section, and are chiseled with
radial fluting moving in a clockwise spiral. In the center of each is riveted an applied
disk damascened in gold on a dark ground with quotations from the Qur'an (a, c) in
a cursive script; around the edges is a gold-damascened border consisting of a
contiguous series of quatrefoil medallions enclosing the *bismallah* and invocations
to various names of God (b, d), the interstices between the medallions filled with
sprigs of leaves. The vertical side plates are strongly convex and expand toward the
top, which is cut out to fit under the arm; the surfaces are chiseled with chevron
fluting and are decorated around the edges with a gold-damascened band contain-
ing the *bismallah* and further invocations to names of God (e) akin to those on the
breast- and backplates. The rims of all four plates are chiseled with narrow raised

bands damascened in gold with a chevron design. Riveted to the inside of the plates are pairs of iron buckles and strap loops (several are modern replacements) for the attachment of shoulder straps and lateral straps of leather (modern). The interiors of the plates are lined with modern brown velvet. (The cuirass is photographed mounted with an eighteenth-century Indian mail shirt of butted iron and brass rings, acc. no. 36.25.22a).

INSCRIPTIONS:
a. (Breastplate, center)

<div dir="rtl">

بسم الله الرحمن الرحيم نصر من الله و فتح

قريب و بشر المؤمنين فالله خير حافظا و هو ارحم الراحمين بسم الله الرحمن الرحيم قل اعوذ

برب الفلق من شر ما خلق و من شر غاسق اذا وقب و

من شر النفاثات في العقد و من شر حاسد اذا حسد

بسم الله ارحمن الرحيم قل يعوذ برب الناس

ملك الناس اله الناس من شر الوسواس

الخناس الذي يوسوس في صدور الناس

من الجنة و الناس

</div>

In the Name of Allah, Most Gracious, Most Merciful. Help from Allah and a speedy victory. So give the Glad Tidings to the Believers. (Qur'an 61:13)
But Allah is the best to take care (of him), and He is the Most Merciful of those who show mercy! (Qur'an 12:64)
In the Name of Allah, Most Gracious, Most Merciful. Say: I seek refuge with the Lord of the Dawn, from the mischief of created things; from the mischief of Darkness as it overspreads; from the mischief of those who blow on knots; and from the mischief of the envious one as he practices envy. (Qur'an 113)
In the Name of Allah, Most Gracious, Most Merciful. Say: I seek refuge with the Lord and Cherisher of Mankind, the King (or Ruler) of Mankind, the God (or Judge) of Mankind,— from the mischief of the Whisperer (of Evil), who withdraws (after his whisper),— who whispers into the hearts of Mankind,— among Jinns and among Men. (Qur'an 114)

b. (Breastplate, border)

<div dir="rtl">

بسم / الله / الرحمن / الرحيم / يا الله / يا رحمن / يا رحيم / يا ملك / يا قدوس / ياسلام / يا مؤمن /

يا مهمين / يا عزيز / يا جبار / يا متكبر / يا خالق / يا بارى / يا مصور / يا غفار / يا قهار / يا وهاب /

يا رزاق / يا فتاح / يا عليم / يا قابض / يا باسط / يا خافض / يا رافع / يا معز / يا مذل / يا سميع / يا

بصير / يا حكم / يا عدل / يا لطيف / يا خبير / يا حليم / يا عظيم / يا غفور / يا شكور / يا علي / يا كبير /

يا حفيظ / يا مقيت / يا حسيب / يا جليل / يا كريم / يا رقيب / يا مجيب / يا واسع / يا حكيم / يا ودود /

يا مجيد / يا باعث / يا شهيد / يا حق / يا وكيل / يا قوي / يا متين / يا ولي/ يا حميد / يا محصي/

يا مبدئ / يا معيد

</div>

In the Name of Allah, Most Gracious, Most Merciful. Allah, [each of the following names of God is preceded by the vocative] the Gracious, the Merciful, the Sovereign, the Holy One, the Source of Peace (and Perfection), the Guardian of Faith, the Preserver of Safety, the Exalted in Might, the Irresistible, the Supreme, the Creator, the Maker, the Shaper, the Forgiving, the Subduer, the Bestower, the Sustainer, the Opener, the All-Knowing, the Restrainer, the Extender, the Abaser, the Exalter, the Bestower of Honors, the Humiliator, the All-Hearing, the All-Seeing, the Judge, the Just, the Gentle, the All-Aware, the Forebearing, the Magnificent, the Forgiver of Faults, the Appreciative, the Sublime, the Great, the Preserver, the Nourisher, the Accounter, the Majestic, the Generous, the Watchful, the Responsive, the Boundless, the Wise, the Loving, the Majestic, the Resurrector, the Witness, the Truth, the Trustee, the Strong, the Forceful, the Governor, the Praiseworthy, the Appraiser, the Originator, the Restorer, the Giver of Life, the Taker of Life, the Ever Living, the Self-Subsisting, the Finder, the Glorious, the Indivisible, the Eternal, the All Determiner, the Expediter, the Delayer, the First, the Last, the Manifest, the Hidden, the Patron, the Self-Exalted, the Most Kind, the Ever Relenting, the Avenger, the Forgiver, the Clement, the Owner of All Sovereignty, the Lord of Majesty and Generosity, the Equitable, the Gatherer, the Rich, the Enricher, the Preventer, the Harmer, the Benefactor, the Light, the Guide, the Originator, the Ever Enduring, the Inheritor, the Righteous Teacher, the Patient.

c. (Backplate, center)

<div dir="rtl">

بسم الله الرحمن الرحيم

الله لا اله الا هو الحي القيوم

لاتأخذه سنة و لا نوم له م في السموات

و ما في الارض من ذا الذي يشفع عنده

الا باذنه يعلم ما بين ايديهم و ما خلفهم

و لا يحيطون بشيء من علمه الا بما شاء

وسع كرسيه السموات و

الارض و لا يؤده حفظهما

و هو العلي العظيم

</div>

In the Name of Allah, Most Gracious, Most Merciful. Allah! There is no god but He, —the Living, the Self-subsisting, Supporter of all / No slumber can seize Him nor sleep. His are all things in the heavens and on earth. Who is thee can intercede in His presence except as He permitteth? He knoweth what (appeareth to His creatures as) Before or After or Behind them. Nor shall they compass aught of His knowledge except as He willeth. His Throne doth extend over the heavens and the earth, and He feeleth no fatigue in guarding and preserving them for He is the Most High, the Supreme (in glory). (Qur'an 2:255)

d. (Backplate, border)

<div dir="rtl">

بسم / الله / الرحمن / الرحيم / يا الله / يا رحمن / يا رحيم / يا ملك / يا قدوس / ياسلام / يا مؤمن /

يا مهمين / يا عزيز / يا جبار / يا متكبر / يا خالق / يا بارى / يا مصور / يا غفار / يا قهار / يا وهاب /

يا رزاق / يا فتاح / يا عليم / يا قابض / يا باسط / يا خافض / يا رافع / يا معز / يا مذل / يا سميع / يا

بصير / يا حكم / يا عدل / يا لطيف / يا خبير / يا حليم / يا عظيم / يا غفور / يا شكور / يا علي / يا كبير /

يا حفيظ / يا مقيت / يا حسيب / يا جليل / يا كريم / يا رقيب / يا مجيب / يا واسع / يا حكيم / يا ودود /

يا مجيد / يا باعث / يا شهيد / يا حق / يا وكيل / يا قوي / يا متين / يا ولي/ يا حميد / يا محصي/

يا مبدئ / يا معيد / يا محيي

</div>

In the Name of Allah, Most Gracious, Most Merciful; [each of the following names of God is preceded by the vocative] Allah, the Good, the Merciful, the Compassionate, the Sovereign, the Most Holy, the Peace, the Granter of Security, the Controller, the Most Mighty, the All-Compelling, the Proud, the Creator, the Maker, the Shaper, the Forgiving, the Subduer, the Bestower, the Sustainer, the Opener, the All-Knowing, the Restrainer, the Extender, the Abaser, the Exalter, the Bestower of Honors, the Humiliator, the All-Hearing, the All-Seeing, the Judge, the Just, the Gentle, the Magnificent, the Forgiver of Faults, the Appreciative, the Sublime, the Great, the Preserver, the Nourisher, the Accounter, the Majestic, the Generous, the Watchful, the Responsive, the Boundless, the Wise, the Loving, the Majestic, the Resurrector, the Witness, the Truth, the Trustee, the Strong, the Forceful, the Governor, the Praiseworthy, the Appraiser, the Originator, the Restorer, the Giver of Life.

e. (Sides, both identical)

<div dir="rtl">

بسم / الله / الرحمن / الرحيم / يا سميع / يا بصير / يا حكم / يا عدل / يا لطيف / يا خبير/ يا حليم /

يا عظيم / يا غفور / يا شكور / يا علي / يا كبير / يا حفيظ / يا مقيت / يا حسيب / يا جليل / يا كريم /

يا رقيب / يا مجيب / يا واسع / يا حكيم / يا ودود / يا مجيد / يا باعث / يا شهيد / يا حق / يا وكيل /

يا قوي / يا متين / يا ولي / يا حميد / يا محصي / يا مبدئ / يا معيد / يا محيي / يا مميت / يا حي / يا قيوم /

يا واجد/ يا ماجد / يا واحد / يا احد / يا صمد / يا قادر / يا مقتدر / يا مقدم / يا مؤخر / يا اول / يا اخر /

يا ظاهر / يا باطن / يا والي / يا متعالي / يا بر / يا تواب / يا منتقم / يا عفو / يا رووف / يا مالك

/ يا رب / يا مقسط / يا جامع / يا غني / يا مغني / يا مانع / يا ضار / يا نافع / يا نور / يا هادي / يا بديع

/ يا باقي / يا وارث / يا رشيد / يا صبور / يا صادق / يا ستار / يا ذال الجلال و / الاكرام

</div>

In the Name of Allah, Most Gracious, Most Merciful; [each of the following names of God is preceded by the vocative] the All-Hearing, the All-Seeing, the Judge, the Just, the Gentle, the All-Cognizant, the Slow to Anger, the Magnificent, the Forgiver of Faults, the Appreciative, the Sublime, the Great, the Preserver, the Nourisher, the

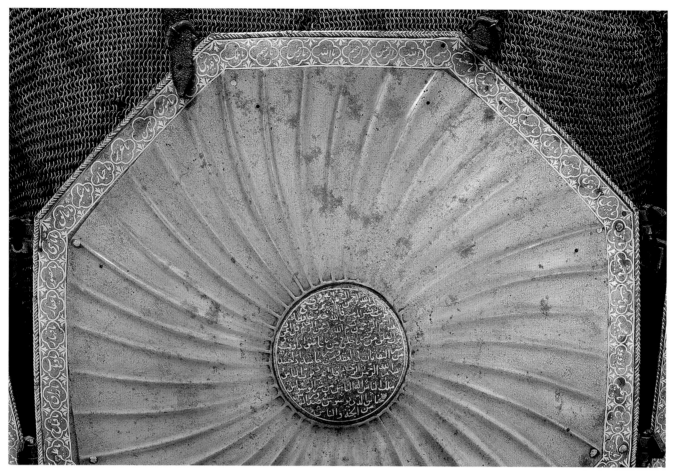

Front

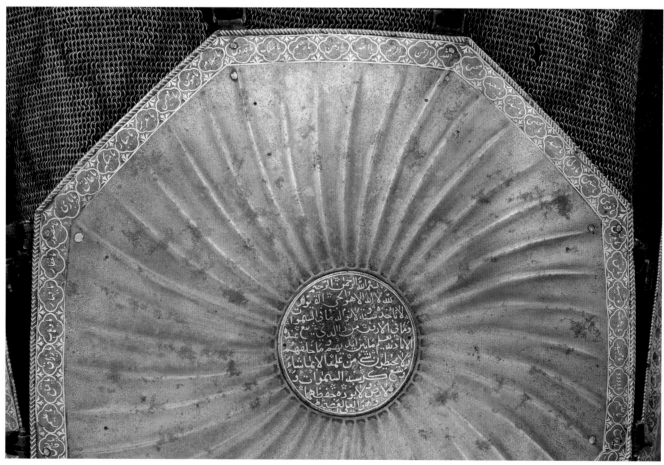

Back

Accounter, the Majestic, the Generous, the Watchful, the Responsive, the Boundless, the Wise, the Loving, the Majestic, the Resurrector, the Witness, the Truth, the Trustee, the Strong, the Forceful, the Governor, the Praiseworthy, the Appraiser, the Originator, the Restorer, the Giver of Life, the Taker of Life, the Ever Living, the Self-Subsisting, the Finder, the Glorious, the Indivisible, the Eternal, the All Powerful, the All Determiner, the Expediter, the Delayer, the First, the Last, the Manifest, the Hidden, the Patron, the Self-Exalted, the Most Kind, the Ever Relenting, the Bestower of Favors, the Avenger, the Forgiver, the Clement, the Possessor, the Lord, the Equitable, the Gatherer, the Rich, the Enricher, the Preventer, the Harmer, the Benefactor, the Light, the Guide, the Originator, the Ever Enduring, the Inheritor, the Righteous Teacher, the Patient, the Sincere, the Concealer, the Lord of Majesty and Generosity.

I n terms of construction, most surviving armors from the Islamic world consist of mail shirts set with iron or steel plates covering the central areas of the front, back, and sides of the torso. In some cases these plates are circular and have been called "armors with pectoral disks" (see cat. 11);[1] in other instances the plated area is composed from smaller rectangular plates (see cat. 5); while in yet other examples the body armor is of four large, usually rectangular plates secured by leather straps and generally worn over a shirt of mail. This latter subgroup is called in Persian *char-a'ina*, or four mirrors. In a rare variation, the Museum's armor has breast- and backplates that are octagonal with circular centers. Fluted clockwise, the plates, like many Ottoman, Iranian, and Russian examples, give our armor the character of a solar disk.[2] On the other hand, the sides of the Museum's armor are rectangular with semicircles cut for the arms and are consequently typical of Iranian *char-a'ina* of the seventeenth and eighteenth centuries.[3]

As a group, *char-a'ina* are frequently inscribed with mystical verses and also carry the longest Qur'anic inscriptions found on Islamic armor. The reason for this is that such armors, in addition to providing straightforward physical protection, were thought to have a special talismanic quality, as mirrors that could repel evil. Michael Gorelik noted that this idea persisted in Sino-Manchurian armor until the nineteenth century.[4]

The image of the mirror is used in Sufi thought to describe the way man arrives at self-knowledge and knowledge of God. In such analogies the mirror is likened to the soul, through which man becomes aware of something inexpressibly greater than himself.[5] For the Iranians, especially, armor of this kind evoked associations with the solar imagery of Zoroastrianism, which had been Islamicized in the *Shahnama* of the Persian poet Firdausi (about A.D. 1000). A *char-a'ina* in the Historisches Museum, Bern, for example, is inscribed with a Persian poem that begins, "When the King is dressed with the four mirrors, he appears as the rising sun."[6]

Such solar imagery reflects the Zoroastrian concept of the "light of glory" that surrounds the hero.[7] The ruler appearing as the rising sun can therefore be seen in an Islamic context as embodying the heavenly light on earth, and he becomes the "shadow of God" or "pole or axis of the age," *qutb al-zaman*. This concept holds that at all times there exists an individual intimately connected with the divine who is consequently the best, indeed the only, route by which others can approach God.[8]

PROVENANCE: George Cameron Stone, New York.

REFERENCES: Grancsay 1928, pp. 128–29, ill.; Stone 1934, p. 43, fig. 56, no. 2; Stöcklein 1939, pp. 2561–62, n. 4; H. Robinson 1967, pp. 36–38, fig. XXI; Grancsay 1986, pp. 26–27, fig. 7.1; Allan and Gilmour 2000, p. 136.

NOTES
1. These generally have additional plates protecting the shoulders.
2. For the solar motif, see cat. 11, Alexander 1989, and Melikian-Chirvani 1992. There are three Russian examples with clockwise fluting in the Kremlin Armory, Moscow, nos. OP-124, OP-125, OP-126; respectively, these are dated 1616, 1663, and 1670 in Bobrovnitskaia et al. 1988, pp. 155, 164–65, 174, ills. The Museum's armor was dated to the late sixteenth century by Stöcklein 1939 (see References above) and to the late sixteenth or early seventeenth century by H. Robinson 1967.
3. See also cats. 17, 18.
4. Gorelik 1979, p. 38. For Central Asian and Tibetan *char-a'ina* formed of four circular disks, see New York 2006, pp. 126, 128–31, 134–37, nos. 41–44, 46.
5. This process was described by the mystical philosopher Ibn al-'Arabi (1165–1240), who said that created man contains the knowledge of God deep within himself and must learn to recognize this divine manifestation. Although it is impossible for man to actually see God within himself, man can see his own true form, which is the "mirror" of God. And while God is like a mirror in which man sees his true self, mankind is like a mirror to God in which God contemplates his names. This knowledge hidden in man's deepest self is like a "niche of light." See Ibn al-'Arabi 1975, chap. 1, and Qur'an 24:35, which is inscribed on another *char-a'ina* in the Museum's collection, cat. 17.
6. Zeller and Rohrer 1955, p. 46, no. 3, inscriptions 1, 2 on the breastplate (no. 928).
7. For the account by Davani, see Minorsky 1978, especially pp. 17, 23, n. 33, pl. 12.
8. See, for example, Momen 1985, pp. 208–9.

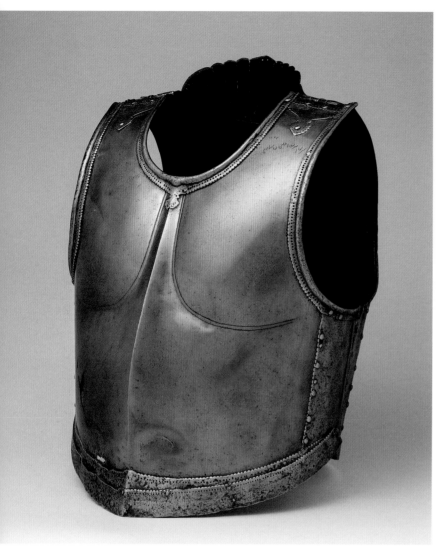

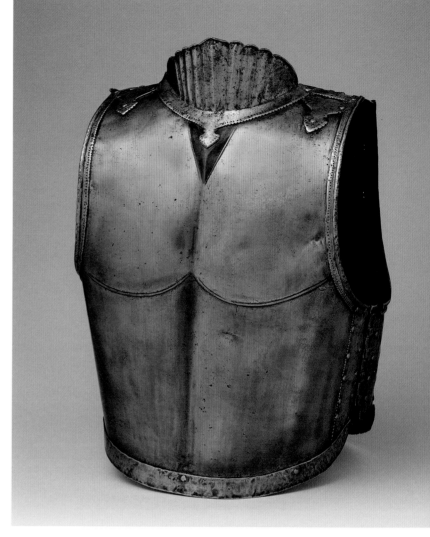

15 · Cuirass

India, Hyderabad, dated A.H. 1192 (A.D. 1778/79)
Steel, iron
Height of breastplate 18¼ in. (46.3 cm); weight 3 lbs. 13 oz. (1,733 g)
Height of backplate 18¼ in. (46.2 cm); weight 3 lbs. 9 oz. (1,620 g)
Bashford Dean Memorial Collection, Funds from various donors, 1929
29.158.165a, b

DESCRIPTION: The cuirass is composed of a breast- and backplate of crucible steel attached at the shoulders and sides with iron hinges. The breastplate is shaped as a stylized "muscled" torso, with double engraved lines accentuating the pectorals and with a sharp median ridge. The neck and arm openings have applied iron borders with an outward-rolled outer edge and a serrated inner edge decorated with a row of punched dots. The border at the neck is extended at the center with a stylized palmette (damaged). The main plate is extended at each side by an iron plate to which the hinge is riveted. Riveted to the bottom edge are two narrow, upward-overlapping waist plates, each with a serrated edge followed by punched dots. On the upper-left side of the breastplate below the shoulder is an incised Persian

inscription (a), with an Arabic number on the shoulder hinge above it (b). The backplate is shaped slightly over the shoulder blades, which are accentuated by double engraved lines, and has a shallow groove down the center, applied borders at the armholes, and extension plates at the sides matching those on the breastplate. At the center of the back near the top is a raised triangular area, above which is an applied iron upright collar, which is vertically ribbed and has an outward-angled upper edge; the base of the collar extends into a stylized palmette. A narrow iron plate (modern) is riveted at the base.

INSCRIPTIONS:
a. (Below the left front shoulder)

١١٩٢

سرکار میر نظام علیخان بهادر

1192 (A.D. 1778/79).
Sarkar Mir Nizam ʻAli Khan Bahadur.

b. (On the left shoulder hinge)

٧٢

This cuirass comes from the armory of the Nizams of
Hyderabad and is crafted in a European style. European
penetration of India began in 1510 with the establish-
ment of a Portuguese colony in Goa; subsequently the Dutch,
French, and English all vied for influence, commercial as well as
political. European artistic and military styles also had a major
impact, beginning during the reign of Akbar (1556–1605).[1]

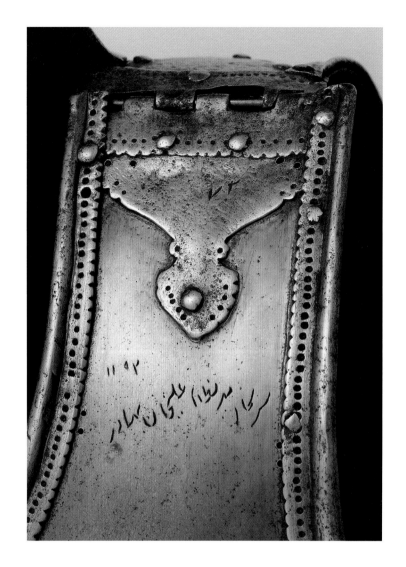

It was within this cultural ambience that our armor and those
like it were produced. Although the precise influence, whether
from representations in art or from imported armors, remains
unknown, the inscription above suggests that the piece and oth-
ers like it may have been made in Hyderabad.[2] Mir Nizam 'Ali
Khan Bahadur (1734–1803), named in the inscription, was the
fourth son of the Chin Qilich Khan, who was given the title Nizam
by the Mughal emperor Muhammad Shah and subsequently ruled
in Hyderabad in the Deccan under the name Asaf Jah; Mir Nizam
'Ali Khan Bahadur took the ruling name Asaf Jah II. During his
long rule (1762–1803), Asaf Jah II led Hyderabad through a lengthy
period of economic growth, during which the state became the
most important Muslim cultural center in the Indian subconti-
nent. Forcibly annexed by India in 1948, Hyderabad remains the
major center of Islam within India.

The same inscription, but without a date, is engraved on a
very similar armor in the Khalili Collection, London.[3] In recent
years a number of these cuirasses have appeared at public auc-
tion, all presumably coming from the former Hyderabad arsenal.
Many bear the same inscription and date, A.H. 1192, and some
have old inventory numbers, suggesting that this was a large,
specially commissioned series, perhaps for a corps of bodyguards.[4]

PROVENANCE: Bashford Dean, New York.

REFERENCE: Alexander 1992, p. 174, no. 108.

NOTES

1. The most frequently cited example of such European influence is the presentation to
Akbar in 1580 of a copy of the illustrated *Polyglot Bible*; see New York 1985–86b, p. 164,
no. 100. See also Koch 1988 and Rogers 1993, no. 3.

2. For European influences on Indian armor, see H. Robinson 1967, pp. 105–7. Other
related Indian armors in the Museum's collection are acc. nos. 36.25.346a, b, 36.25.15a–g
(see Stone 1934, p. 48, fig. 61, no. 2). Several elaborately gold-damascened cuirasses of
this anatomical type are known, but none with Hyderabad inscriptions; see Valencia
2008, pp. 180–81, no. 57, and Richardson and Bennett 2015, p. 69.

3. Khalili Collection, London, MTW 1157; the armor is published in Alexander 1992,
p. 174, no. 108, in which the inscription and date on the Museum's armor are incor-
rectly given.

4. Among the inscribed-and-dated examples are three bearing old arsenal numbers: 55
(see Hermann Historica, Munich 2013, lot 3070), 64 (see Hermann Historica, Munich
2014, lot 2936), and 71 (see Hermann Historica, Munich 2014, lot 2594; and Hermann
Historica, Munich 2015, lot 2641).

16 · Armor of Mail and Plate

India, Sind, late 18th–first half of the 19th century
Steel, iron, copper alloy, textile
Height 70¼ in. (178.5 cm)
Bequest of George C. Stone, 1935
36.25.11a–g

DESCRIPTION: The armor comprises a helmet, elbow-length jacket, a pair of
vambraces with integral gauntlets, trousers, and shoes and is constructed of
large steel plates and alternating iron and brass scales attached by links of
overlapped and solid iron mail. The large plates have applied brass decoration
consisting of raised borders enclosing quatrefoil medallions stamped with a
centralized foliate motif in low relief, the interstices filled with applied foliate
forms. The scales, which have ogival-shaped bottom edges, are arranged in
downward overlapping vertical or horizontal rows and are decorated with
raised dots created by punching the undersides; the dots outline the scales
and form a rosette in the center of each scale. The helmet, which would origi-
nally have been mounted with a thickly padded textile lining, is constructed
of rows of plates and scales and is surmounted by a large domed boss of brass
with raised lobes and a flange at the base pierced and engraved with leaves,
with a baluster-shaped finial. The cheekpieces and long nape defense are of
mail and scales, with a chin band of the same. The face is covered by a trian-
gular flap of mail with openings for the eyes. The elbow-length jacket opens
down the front and is edged at the collar, front, and bottom with a padded
red velvet border. The torso is encircled by thirteen narrow vertical steel
plates, with four shorter plates on the upper chest; the remainder of the jacket
and sleeves are covered with scales. The plates to each side of the front open-
ing are fitted with brass loops through which the jacket is laced closed; the
present red silk laces are modern. The lower arms are covered by long steel
vambraces formed of two hinged, gutter-shaped plates, the longer outer plate
extending well above the elbow and decoratively shaped at the top, with two
comma-shaped cutouts. Each of the plates is embossed near the bottom edge
with a horizontal ridge. The edges of the vambrace have applied brass borders
with punched decoration, the edges fretted in a leaf pattern. Riveted at the
base of the vambrace is a gauntlet of scales. The trousers are formed of a
similar combination of plates and scales, the plates covering the fronts of the
upper thighs and the lower legs, with a small rectangular plate at the front of
each knee. The lower legs are completely encased, whereas only the front and
outer sides of the thigh are covered. The separate shoes of butted mail and
scales, having upturned toes, are modern restorations.[1]

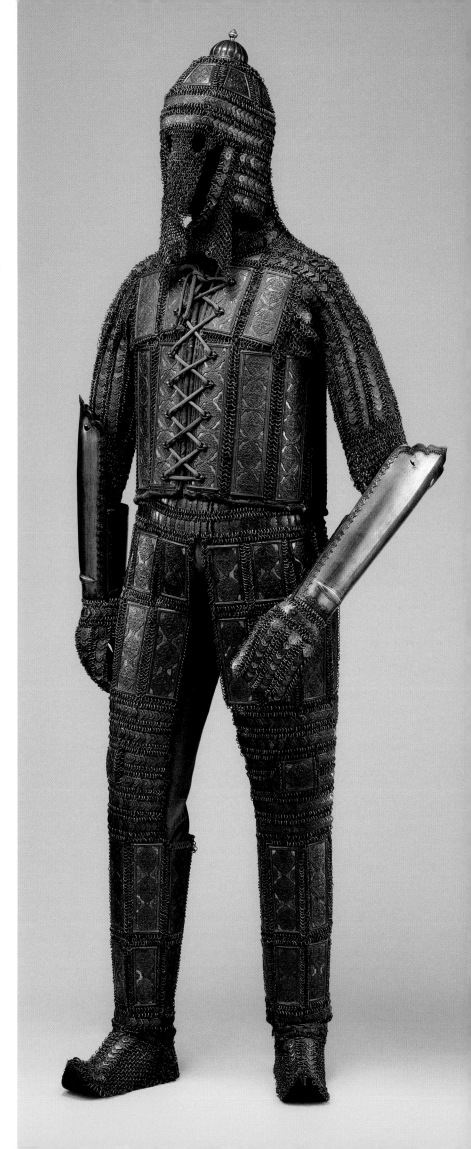

This very distinctive rare form of armor comes from Sind, an Indian border region now part of Pakistan. Wilbraham Egerton suggested that armor of this type was made in the town of Bhuj in western India.[2] Complete armors of very similar form and decoration include two in the Museum für Völkerkunde, Vienna.[3] One of them, completely covered by plates and scales, has a solid face mask of plates and retains its original thickly padded trousers; the other consists largely of mail sewn to a padded lining but with a cuirass of large plates connected by mail. A third comparably complete example, also with a solid face mask, was formerly in the collection of Sir Samuel Rush Meyrick (1783–1848) at Goodrich Court, Herefordshire, England, and is now in the Museo Stibbert, Florence.[4] Several other examples are in private collections in the United Kingdom and in the Muzeum Narodowe w Krakowie (National Museum, Kraków).[5]

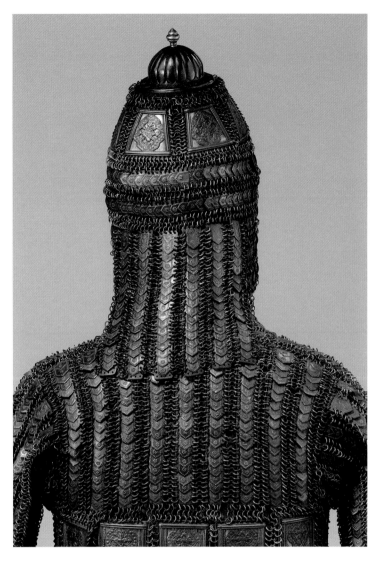

PROVENANCE: Colonel William Wetherly, London; Hal Furmage, London; George Cameron Stone, New York.

REFERENCES: Christie, Manson and Woods, London 1919, lot 284; Grancsay 1928, p. 128; Stone 1934, p. 49, fig. 63; Bullock 1947, p. 171, ill.; Indianapolis 1970–71, no. 31; Grancsay 1986, p. 26.

NOTES

1. A photograph of this armor, annotated "I restored the boots of this suit for Col. Wetherly," is pasted into an untitled album of arms and armor photographs in the Kienbusch library in the Philadelphia Museum of Art. From internal evidence, this album would appear to have been assembled by the famous London art restorer Felix Joubert (1872–1953).

2. Egerton 1896, p. 139, no. 745, pl. 14; this armor, complete, is in the Victoria and Albert Museum, London, nos. 3254 (IS)–3258 (IS), and is now on loan to the Royal Armouries, Leeds.

3. Museum für Völkerkünde, Vienna, nos. 3149-54, 31555-58; see H. Robinson 1967, pp. 95–96, pl. XIII.

4. Detailed drawings of the armor in the Museo Stibbert, Florence, are found on two unnumbered pages of the untitled manuscript third volume of Joseph Skelton's catalogue of the Meyrick Collection (see J. Skelton 1830); however, there is no indication of the armor's origin. This armor was exhibited at the South Kensington Museum (now Victoria and Albert Museum), London (see London 1869, p. 88, no. 1175) and was subsequently sold by the dealer Samuel Pratt to the Anglo-Florentine collector Frederick Stibbert (1838–1906). For this armor, no. 7544, see H. Robinson 1973, pp. 212–13, no. 168, pls. 75, 76, and Florence 1997–98, pp. 90–91, no. 54.

5. One armor now in a private collection in the United Kingdom was once on loan to the Victoria and Albert Museum, London, and was the property of a Major White; another armor, now in a private collection in London (see Paris 1988, p. 195, no. 213, ill.), came from the collection of Prince Regent Charles of Belgium (sold at Christie's London 1986, lot 240). For the half-armor in the Muzeum Narodowe w Krakowie, Kraków, see Zygulski 1982, pp. 226–27, no. 233. The Metropolitan Museum's collection also includes two vambraces with similar applied-brass ornament, each with an integral gauntlet formed of mail and brass and iron scales, acc. nos. 36.25.416, 36.25.417.

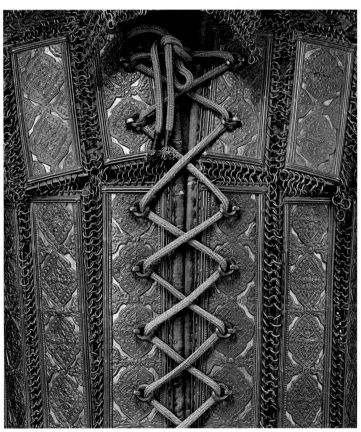

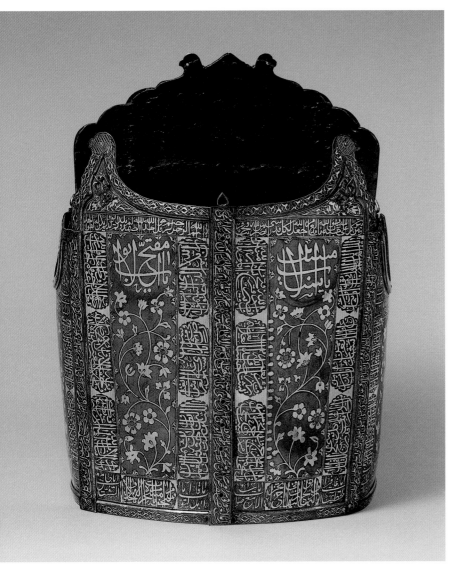

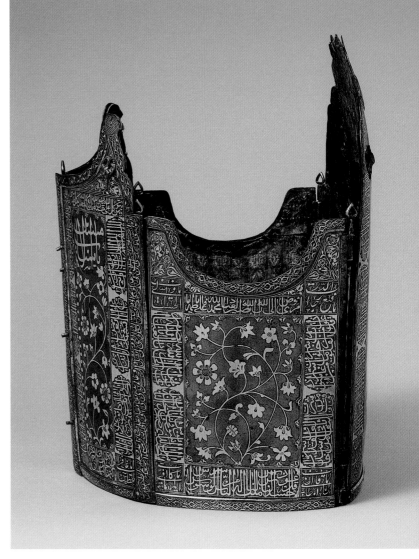

17 · Cuirass

India or Iran, late 18th–early 19th century
Steel, gold, textile
Height of breastplate 13 in. (33 cm); backplate 15⅜ in. (39 cm);
sides 9⅝ in. (24.5 cm)
Width 11¼ in. (28.5 cm); depth 9½ in. (24 cm); weight 7 lbs. (3,163 g)
Gift of Harry G. Friedman, 1948
48.92.1

DESCRIPTION: The cuirass, of *char-a'ina* type, is composed of five plates of crucible steel hinged together with long removable pins bearing inverted heart-shaped heads. The plates are slightly convex on the exterior, taper downward to straight bottom edges, and have decoratively shaped upper edges. The breastplate, formed in two halves joined at the center by a hinge, is slightly embossed at the pectorals; its concave upper edge rises at each side to bird-head finials. The tall backplate, with its high ogival pointed profile and bird-head finials, has a wide V-shaped recess between the shoulder blades. The side plates have deeply concave top edges to fit under the arms. Each plate is constructed in five riveted sections (top, bottom, sides, and middle), the seams almost invisible on the outside, and has flat applied borders (that on the proper left side of the backplate is missing); the borders at the top of the breast- and backplates end in bird heads. The border covering the hinge at the center of the breastplate is pierced with a series of holes for the attachment of spherical buttons, of which only several stems remain. Two small gold-damascened iron buckles are riveted at the shoulders of the breastplate, with two corresponding strap loops on the backplate. Each of the plates is damascened in gold in the center with scrolling vines framed by wide borders with cartouches containing Arabic inscriptions in cursive script (b–i, k–t). Large Arabic inscriptions are also found on the raised pectoral of each breast half and in the recessed area on the backplate (a, j). The top frieze on the backplate is damascened with a central medallion surrounded by floral scrolls. The right breast half and both side plates retain their linings of blue and white striped brocaded silk decorated with flowers.

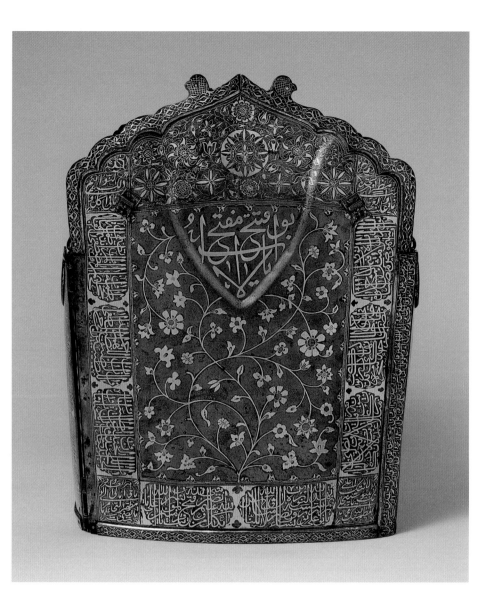

Day. And Thou causest the Day to gain on the Night; Thou bringest the Living out of the Dead, and Thou bringest the Dead out of the Living; and Thou givest sustenance to whom Thou pleasest, without measure. (Qur'an 3:26–27). Allah the Exalted, the Mighty, spoke the truth. Help from Allah and a speedy victory. So give the Glad Tidings to the Believers. (Qur'an 61:13) O Allah!

d. (On the proper right breastplate, across the top)

بسم الله الرحمن الرحيم قل هو الله احد الله الصمد لم يلد و لم يولد و لم يكن له كفوا احد

In the Name of Allah, Most Gracious, Most Merciful. Say: He is Allah, the One; Allah, the Eternal, Absolute; He begetteth not, nor is He begotten; and there is none like unto Him. (Qur'an 112)

e. (On the proper right breastplate, in the cartouches running down the right, along the bottom, and up the left)

ان ربكم الله الذي خلق السموات و الارض في ستة ايام ثم استوى على العرش يغشي الليل النهار يطلبه حثيثا و الشمس و القمر و النجوم مسخرات بامره الا له الخلق و الامر تبارك الله رب العالمين ادعو ربكم تضرعا و خفية انه لا يحب المعتدين و لا تفسدوا في الارض بعد اصلاحها و ادعوه خوفا و طمعا ان رحمت الله قريب من [المحسنين]

Your Guardian Lord is Allah, Who created the heavens and the earth in six Days, then He settled Himself on the Throne: He draweth the night as a veil o'er the day, each seeking the other in rapid succession: and the sun, the moon, and the stars, (all) are subservient by His Command. Verily, His are the Creation and the Command. Blessed be Allah, the Cherisher and Sustainer of the Worlds! Call on your Lord with humility and in private: for Allah loveth not those who trespass beyond bounds. Do not mischief on the earth, after it hath been set in order, but call on Him with fear and longing (in your hearts): for the Mercy of Allah is (always) near to [those who do good]. (Qur'an 7:54–56)

f. (Down the outer border of the proper left breastplate, part of a Shi'i prayer)

... [القائم] بالحق الذي يضرب بالسيف بحكم ازلي اجب الان دعائي و ترحم حضراني و اقض حاجات لنا الكل و ولي و تقبل بقبول حسن دعائي بنبي [كذا] العلي بعلي العلي العلي صلوات الله عليه و عليهم اجمعين الطاهرين

... [resting] on truth, who hits with the sword with eternal authority, answer now my prayer, and be merciful to my companions and see to all our needs and, O Guardian, accept my prayer with the goodness of a master. By the exalted Prophet, by 'Ali the Exalted, the Exalted, God's blessings on Him and all of Them, the Pure ones.

g. (Up the border between the two breastplates, a Shi'i prayer, partially deciphered)

يا حيدر الغضنفر ... فاطم ... الحسنين ... كاظم ... الرضا ... النقي ... الهادي

O Haydar, the lion . . . Fatim . . . the two Husayns . . . Kazim . . . al-Rida . . . al-Naqi . . . al-Hadi.

h. (Down the outer border of the proper right breastplate, a Shi'i prayer, partially deciphered)

... يا سيدم ... خاتم ذى شرف مشرف ذي ظفر مظفر ذي خطر مخطر ... كل ظالم

O my Sayyid . . . seal, possessor of nobility, made noble, possessor of victory, made victorious, the possessor of gravity, the one who risks his life . . . every tyrant.

i. (In the four squares along the bottom of the proper left and right breastplates)

يا غافر الخطيات / يا قابل التوابات / يا قابل التوابات / يا جامع الشتات

O Forgiver of erorrs! O Accepter of repentances! O Accepter of repentances! O Collector of scattered!

INSCRIPTIONS:

On the breastplate

a. (On the pectorals, in large letters, left and right)

يا مسبب الاسباب / يا مفتح الابواب

O Causer of Events! O Opener of Doors!

b. (On the proper left breastplate, across the top)

و من يتوكل على الله فهو حسبه ان الله بالغ امره قد جعل الله لكل شيء قدرا نصر من الله و فتح قريب

And He provides for him from (sources) he never could expect. And if anyone puts his trust in Allah, sufficient is (Allah) for him. (Qur'an 65:3) Help from Allah and a speedy victory. (Qur'an 61:13)

c. (On the proper left breastplate, in the cartouches running down the right, along the bottom, and up the left)

قل اللهم مالك الملك تؤتي الملك من تشاء و تنزع الملك ممن تشاء و تعز من تشاء و تذل من تشاء بيدك الخير انك على كل شيء قدير تولج الليل في النهار و تولج النهار في الليل و تخرج الحي من الميت و تخرج الميت من الحي و ترزق من تشاء بغير حساب صدق الله العلي العظيم نصر من الله و فتح قريب و بشر المؤمنين يا الله

Say: O Allah! Lord of Power (and Rule), Thou givest Power to whom Thou pleasest, and Thou strippest off Power from whom Thou pleasest: Thou enduest with honour whom Thou pleasest, and Thou bringest low whom Thou pleasest: in Thy hand is all Good. Verily, over all things Thou hast power. Thou causest the Night to gain on the

On the backplate

j. (In the center, in large letters)

<div dir="rtl">

يا مفتح الابواب افتح
</div>

O Opener of the doors! Open!

k. (In the cartouches down the right side, along the bottom, and up the left)

<div dir="rtl">

الله نور السموات و الارض مثل نوره كمشكوة فيها مصباح المصباح في زجاجة الزجاجة كأنها كوكب
دري يوقد من شجرة مباركة زيتونة لا شرقية و لا غربية يكاد زيتها يضيء و لو لم تمسسه نار نور
على نور يهدي الله لنوره من يشاء و يضرب الله الامثال للناس و الله بكل شيء عليم نصر من الله و
فتح قريب و بشر المؤمنين يا علي الخبيثات للخبيثين و الخبيثون للخبيثات و الطيبات للطيبين و
الطيبون للطيبات لي خمسة اطفي بهم حر الجحيم الحاطمة المصطفى و المرتضى و ابنيهما و الفاطمة
</div>

Allah is the Light of the heavens and the earth. The parable of His Light is as if there
were a Niche and within it a Lamp: the Lamp enclosed in Glass: the glass as it were
a brilliant star: lit from a blessed Tree, an Olive, neither of the East nor of the West,
whose Oil is well-nigh luminous, though fire scarce touched it: Light upon Light! Al-
lah doth guide whom He will to His Light: Allah doth set forth Parables for men: and
Allah doth know all things. (Qur'an 24:35) Help from Allah and a speedy victory. So
give the Glad Tidings to the Believers. (Qur'an 61:13) O Allah! O 'Ali! Women impure
are for men impure, and men impure are for women impure, and women of purity
are for men of purity, and men of purity are for women of purity. (Qur'an 24:26) I
have five [people], through whom I extinguish the fire of Hell, al-Mustafa, al-Murta-
za, their two sons [i.e., Hasan and Husayn, sons of 'Ali and Fatima], and Fatima.

l. (In the two squares at upper right and left corners and bottom right corner)

<div dir="rtl">

ناد عليا مظهر العجائب تجده [عو]نا لك في النوائب
كل هم و غم سينجلي بعظمتك يا الله بنبوتك يا محمد بولايتك يا علي
</div>

Call upon 'Ali the manifestation of wonders,
You will find him a comfort to you in crisis,
Every care and every sorrow will pass.
Through your greatness O God, through your grandeur O Muhammad, through
your guardianship O 'Ali!

m. (In the square in the bottom left corner, a couplet in praise of 'Ali)

<div dir="rtl">

يا قاهر العدو يا والي الولي يا مظهر العجائب يا مرتضى يا علي
</div>

O defeater of enemies! O trustee of the favorite!
O manifestation of wonders! O Murtaza! O 'Ali!

n. (On the applied border along the right edge, the call on God to bless the Fourteen
Innocents)

<div dir="rtl">

يا اللهم صل على المصطفى محمد و المرتضى علي و البتول فاطمة و السبطين الامامين الحسن و
الحسين و صل على زين العباد و على الباقر محمد و الصادق جعفر و الكاظم موسى و الرضا علي و
التقي محمد و النقي علي و الزكي العسكري الحسن و صل [على] ... الحجة القائم المهدي الهادي (؟)
</div>

O God, pray for Muhammad al-Mustafa (the chosen one), and 'Ali al-Murtada (the
chosen), and Fatima al-Batul (the chaste), Hasan and Husayn, al-Sibtayn (the two
grandsons) al-Imamayn (the two imams), and pray for Zain al-'Abidin (the orna-
ment of worshippers), Muhammad al-Baqir (the splitter open of knowledge), Ja'far
al-Sadiq (the truthful), Musa Kazim (the forbearing), and 'Ali al-Rida (the pleasing),
and Muhammad Taqi (the God-fearing), and 'Ali al-Naqi (the distinguished), and
Hasan al-Zaki (the pious), al-Askari (the soldier), and pray [for] . . . al-Hujja (the
proof), al-Qa'im (the one who will arise), al-Mahdi (the rightly-guided), al-Hadi (the
guide).

On the left side plate

o. (Across the top)

<div dir="rtl">

افوض امري الى الله ان الله بصير العباد محمد يا علي يا فاطمة
</div>

My (own) affair I commit to Allah: for Allah (ever) watches over His Servants.
(Qur'an 40:44). Allah, Muhammad. O 'Ali! O Fatima!

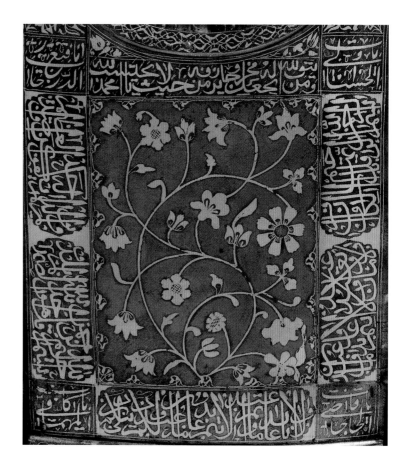

p. (In the cartouches down the right side, along the bottom, and up the left)

<div dir="rtl">

قل اعوذ برب الفلق من شر ما خلق و من شر غاسق اذا وقب و من شر النفاثات في العقد و من شر
حاسد اذا حسد قل اعوذ برب الناس ملك الناس اله الناس من شر الوسواس الخناس الذي يوسوس في
صدور الناس من الجنة و الناس افوض امري الى الله ان الله بصير العباد
</div>

In the Name of Allah, Most Gracious, Most Merciful. Say: I seek refuge with the Lord
of the Dawn, from the mischief of created things; from the mischief of Darkness as
it overspreads; from the mischief of those who blow on knots; and from the mischief
of the envious one as he practices envy. (Qur'an 113) Say: I seek refuge with the Lord
and Cherisher of Mankind, the King (or Ruler) of Mankind, the God (or Judge) of
Mankind,— from the mischief of the Whisperer (of Evil), who withdraws (after his
whisper),— who whispers into the hearts of Mankind,— among Jinns and among
Men. (Qur'an 114) My (own) affair I commit to Allah: for Allah (ever) watches over
His Servants. (Qur'an 40:44)

q. (In the four squares in the corners)

<div dir="rtl">

يا رفيع الدرجات / يا ولي الحسنات
يا قاضي الحاجات / يا كافي المهمات
</div>

O You of highest rank! O Patron of benefits! O You who takes care of neccesities!
O You who is sufficient in all important affairs!

On the right side plate

r. (Across the top)

<div dir="rtl">

و من يتق الله يجعل له مخرجا و يرزقه من حيث لا يحتسب يا الله محمد
</div>

And for those who fear Allah, He (ever) prepares a way out, and He provides for him
from (sources) he never could expect. (Qur'an 65:2–3) O Allah! Muhammad.

s. (In the cartouches running down the right, along the bottom, and up the left)

<div dir="rtl">

بسم الله الرحمن الرحيم قل يا ايها الكافرون لا اعبد ما تعذدون و لا انتم عابدون ما اعبد و لا انا عابد ما
عبدتم و لا انتم عابدون ما اعبد لكم دينكم و لي دين بسم الله الرحمن الرحيم قل هو الله احد الله الصمد
لم يلد و لم يولد و لم يكن له كفوا احد صدق الله العظيم
</div>

In the Name of Allah, Most Gracious, Most Merciful. Say: O ye that reject Faith! I worship not that which ye worship. Nor will ye worship that which I worship. And I will not worship that which ye have been wont to worship. Nor will ye worship that which I worship. To you be your Way, and to me mine. (Qur'an 109) In the Name of Allah, Most Gracious, Most Merciful. Say: He is Allah, the One; Allah, the Eternal, Absolute; He begetteth not nor is he begotten; and there is none like unto Him. (Qur'an 112). Allah the Mighty spoke the truth.

t. (In the four squares in the corners)

<div dir="rtl">
يا ولي الحسنات / يا رفيع الدرجات

يا قاضي الحاجات / يا كافي المهمات
</div>

O Patron of benefits! O You of highest rank! O You who takes care of necessities! O You who is sufficient in all important affairs!

For further discussion of armors of this type, including the symbolism that developed around armors constructed from four plates, *char-a'ina*, see the commentary for cat. 14.

A vine motif very similar to the pattern on this cuirass occurs on the painted border of a Mughal miniature signed by Hadi and dated A.H. 1169 (A.D. 1755–56); perhaps something like this was the inspiration for the design on the Museum's armor.[1] The armor itself is probably of approximately the same period and should therefore be attributed to a late eighteenth-century or early nineteenth-century workshop. Indeed, a cuirass of the same form and construction sold at auction in 2008 was dated A.H. 1197 (A.D. 1783/84), while a comparably constructed and decorated armor in the Wallace Collection, London, is inscribed with the name of the Persian owner, Fath 'Ali Shah Qajar (r. 1797–1834), and the date A.H. 1224 (A.D. 1809/10).[2]

The various inscriptions on this armor invoke Allah as the god of light and stress the rewards to come to his servants as well as the punishments to come to unbelievers and evildoers. Among the inscriptions is a verse from the "Light" sura (Qur'an 24), which has always been an inspiration to Muslims of all tendencies. As early as the eighth century this verse was regarded as a description of Muhammad, through whom the heavenly light was able to shine on earth,[3] and the great theologian Abu Hamid al-Ghazali (1058–1111) referred to the verse as one of the jewels of the Qur'an.[4]

The intercessory prayer to 'Ali (l) and the names and *kunyas* (honorific names) of the fourteen luminaries of the Twelver Shi'a—Muhammad and Fatima and the twelve Shi'a imams (n)—are also to be found among the many inscriptions here. The Shi'a can be divided into two basic groups, those who recognize seven imams and those who recognize twelve. The latter are the prevailing group; they were dominant during the Safavid period in Iran and remain the strongest and most influential group today. They believe in the occultation of the last imam, Muhammad al-Mahdi, who is said to have disappeared about 874 and to

have remained in hiding through the centuries. According to the Shi'a, he will reveal himself at the end of days and cleanse the world by defeating the anti-Christ, *dajjal*, the "one-eyed" (literally translated as the cheat or imposter, but understood as a manifestation of pure evil). Isa (Christ) will return, the dead will be raised, and the Last Judgment will be held. Until then, the hidden imam is regarded as the point of reference for mankind, the individual on earth most closely connected to the divine essence, through whom others can approach God.

PROVENANCE: M. Avigdor Galleries, Boston; Harry G. Friedman, New York.

REFERENCES: Grancsay 1958, p. 245, ill.; Grancsay 1986, p. 447, figs. 109.3, 109.4; Allan and Gilmour 2000, p. 136; Valencia 2008, p. 183, n. 2.

NOTES
1. Washington, D.C. 1981–82, p. 172, no. 17d.
2. Hermann Historica, Munich 2008, lot 433; Wallace Collection, London, no. OA1572 (see Norman 1982, pp. 10–12, 16, fig. 9). The cuirasses in the Metropolitan Museum and in the Wallace Collection have been identified among a group of five very similar examples considered to be of Iranian (possibly Isfahani) origin and dating to the late eighteenth or early nineteenth century; see Allan and Gilmour 2000, p. 136. (The Metropolitan has a second, very similar example, acc. no. 91.1.748.) Comparable gold-damascened Iranian cuirasses are discussed in Moshtagh Khorasani 2006, pp. 703–11, nos. 397–402; Valencia 2008, pp. 182–83, no. 58; and Elgood 2015, pp. 190–93, no. 132.
3. Schimmel 1985, p. 124.
4. Al-Ghazali 1983, chap. 14. The depiction of a lamp in a niche on prayer carpets also evolves from this verse; see, for example, Dimand and Mailey 1973, no. 105, fig. 68, and Rogers 1987b, nos. 7, 21.

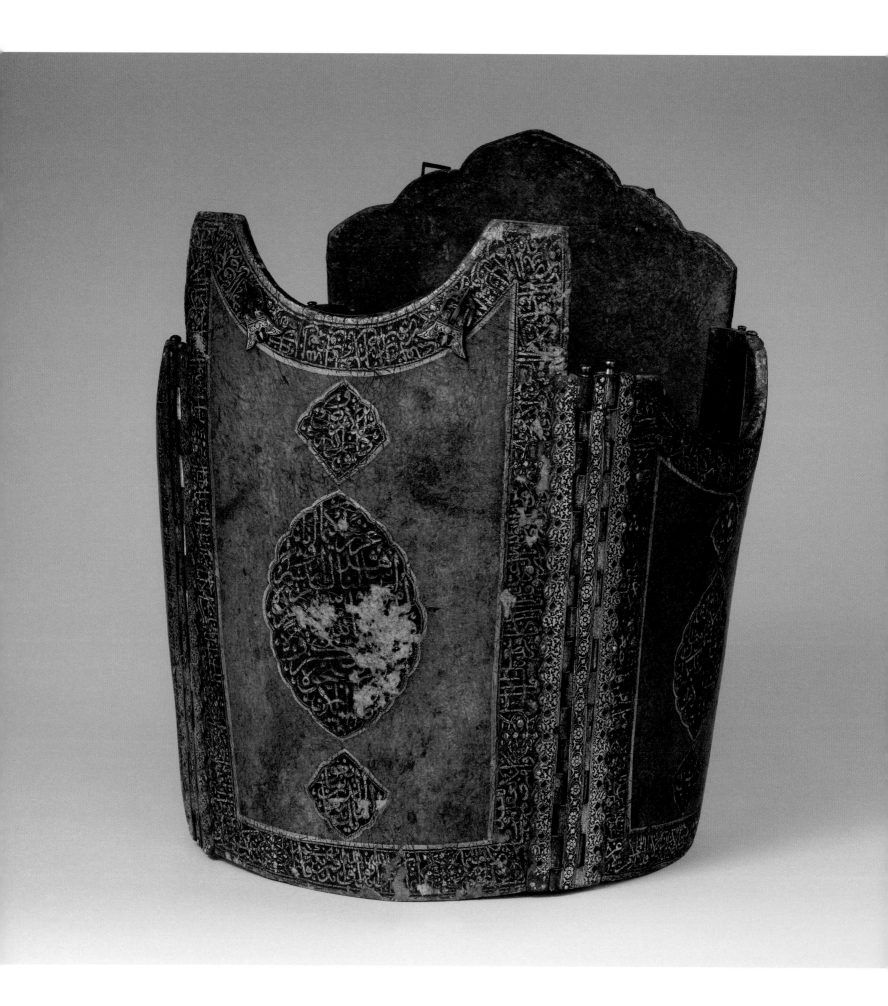

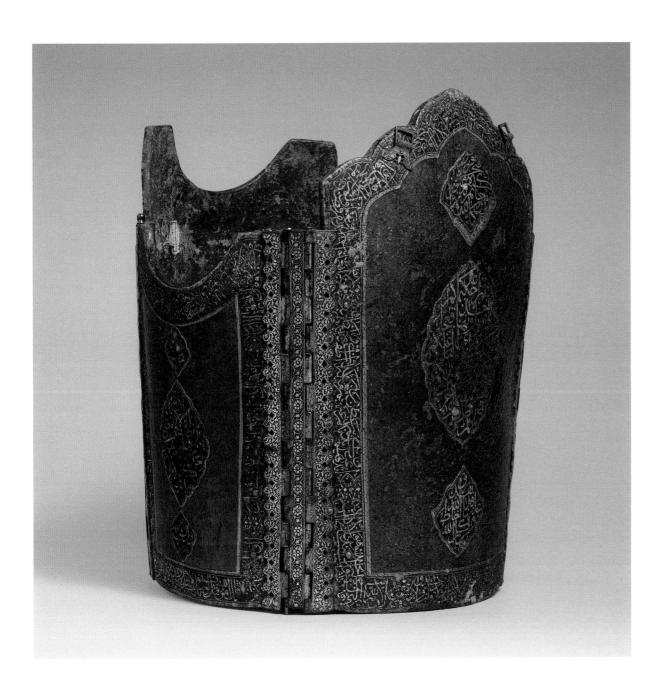

18 · Cuirass

Iran, Qajar period, late 18th–early 19th century

Leather, lacquer, iron, copper alloy, gold

Height of breastplate 14 in. (35.6 cm), backplate 15³⁄₁₆ in. (38.5 cm),

sides 11 in. (28 cm)

Width 13½ in. (34.3 cm); depth 10⅜ in. (26.5 cm);

weight 7 lbs. 14 oz. (3,566 g)

Bequest of George C. Stone, 1935

36.25.342

DESCRIPTION: The cuirass, of *char-a'ina* type, is constructed of four panels of thick rhinoceros hide connected to one another by long iron hinges with removable pins. The leather measures in thickness between ¼ and ⅜ in. (7–11 mm). Each panel is convex on the exterior, tapers slightly to the bottom, and has a straight bottom edge; the top edge of the front and side panels are concavely shaped, whereas the top of the back panel, which is higher than the front, rises to a decorative ogival point. The hinges, attached by numerous brass rivets, have shaped and pierced outer edges of petal form and are damascened in gold with arabesques and repeating leaf and flower ornament. The hinge pins have baluster-shaped heads. Two iron buckles damascened with gold arabesques are riveted to the top of the front panel, and there are two corresponding damascened iron strap hooks at the top of the back panel for the leather straps by which the cuirass was suspended from the shoulders. Numerous brass rivets that edge the inside of the plates formerly secured a textile lining, now missing. Each of the panels has a red-orange lacquered field in which three lobed medallions enclose Arabic inscriptions in gold script on a black background. A wide band outlines each of the panels and likewise encloses gold Arabic inscriptions on a black ground. There are numerous losses of color throughout.

فانزل الله سكينته على رسوله و على المؤمنين و الزمهم كلمة التقوى و كانوا احق بها و اهلها و كان
الله بكل شيء عليما لقد صدق الله رسوله الرويا بالحق لتدخلن المسجد الحرام ان شاء الله امنين محلقين
رؤوسكم و مقصرين لا تخافون فعلم ما لم تعلموا فجعل من دون ذلك فتحا قريبا هو الذي ارسل رسوله
بالهدى و دين الحق ليظهره على الدين كله و كفى بالله شهيدا محمد رسول الله و الذين معه اشداء على
الكفار رحماء بينهم تراهم ركعا سجدا يبتغون فضلا من الله و رضوانا سيماهم في وجوههم من اثر السجود
ذلك مثلهم في التوره و مثلهم في الانجيل كزرع اخرج شطاه فازره فاستغلظ فاستوى على سوقه يعجب
الزراع ليغيظ بهم الكفار وعد الله الذين امنوا و عملوا الصالحات منهم مغفرة و اجرا عظيما

[For to Allah belong the Forces of the heavens] and the earth; and Allah is exalted in Power, full of Wisdom. We have truly sent thee as a witness, as a Bringer of Glad Tidings, and as a Warner: in order that ye (O men) may believe in Allah and His Messenger, that ye may assist and honor him, and celebrate His praises morning and evening. Verily those who plight their fealty to thee plight their fealty in truth to Allah: the Hand of Allah is over their hands: then any one who violates his oath, does so to the harm of his own soul, and any one who fulfils what he has covenanted with Allah,– Allah will soon grant him a great Reward. The desert Arabs who lagged behind will say to thee: "We were engaged in (looking after) our flocks and herds, and our families: do thou then ask forgiveness for us." They say with their tongues what is not in their hearts. Say: "Who then has any power at all (to intervene) on your behalf with Allah, if His Will is to give you some loss or to give you some profit? But Allah is well acquainted with all that ye do. Nay ye thought that the Messenger and the Believers would never return to their families; this seemed pleasing in your hearts, and ye conceived an evil thought, for ye are a people doomed to perish." And if any believe not in Allah and His Messenger, We have prepared, for those who reject Allah, a Blazing Fire! To Allah belongs the dominion of the heavens and the earth: He forgives whom He wills, and He punishes whom He wills: but Allah is Oft-Forgiving, Most Merciful. Those who lagged behind (will say), when ye set forth to acquire booty (in war): "Permit us to follow you." They wish to change Allah's word: Say: "Not thus will ye follow us: Allah has already declared (this) beforehand": then they will say, "But ye are jealous of us." Nay, but little do they understand (such things). Say to the desert Arabs who lagged behind: "Ye shall be summoned (to fight) against a people given to vehement war: then shall ye fight, or they shall submit. Then if ye show obedience, Allah will grant you a goodly reward, but if ye turn back as ye did before, He will punish you with a grievous Chastisement." No blame is there on the blind, nor is there blame on the lame, nor on one ill (if he joins not the war): but he that obeys Allah and His Messenger,– (Allah) will admit him to Gardens beneath which rivers flow; and he who turns back, (Allah) will punish him with a grievous Chastisement. Allah's Good Pleasure was on the Believers when they swore Fealty to thee under the Tree: He knew what was in their hearts, and He sent down Tranquility to them; and He rewarded them with a speedy Victory; and many gains will they acquire (besides): and Allah is Exalted in Power, Full of Wisdom. Allah has promised you many gains that ye shall acquire, and He has given you these beforehand; and He has restrained the hands of men from you; that it may be a Sign for the Believers, and that He may guide you to a Straight Path; and other gains (there are), which are not within your power, but which Allah has compassed: and Allah has power over all things. If the Unbelievers should fight you, they would certainly turn their backs; then would they find neither protector nor helper. (Such has been) the practice of Allah already in the past: no change wilt thou find in the practice of Allah. And it is He who has restrained their hands from you and your hands from them in the valley of Makkah, after that He gave you the victory over them. And Allah sees well all that ye do. They are the ones who disbelieved and hindered you from the Sacred Mosque and the sacrificial animals, detained from reaching their place of sacrifice. Had there not been believing men and believing women whom ye did not know that ye were trampling down and on whose account a guilt would have accrued to you without (your) knowledge, (Allah would have allowed you to force your way, but He held back your hands) that He may admit to His Mercy whom He will. If they had been apart, We should certainly have punished the Unbelievers among them with a grievous punishment. While the Unbelievers got up in their hearts heat and cant—

INSCRIPTIONS:

(The inscriptions are continuous, beginning at the proper upper-right edge of the breastplate and encircling each plate with a complex double line of intertwined text, with additional text within the central medallions.)

[و الله جنود السموات] و الارض و كان الله عزيزا حكيما انا ارسلناك شاهدا و مبشرا و نذيرا لتؤمنوا
بالله و رسوله و تعزروه و توقروه و تسبحوه بكرة و اصيلا ان الذين يبايعونك انما يبايعون الله يد الله
فوق ايديهم فمن نكث فانما ينكث على نفسه فمن اوفى بما عاهد عليه الله فسيؤتيه اجرا عظيما سيقول
لك المخلفون من الاعراب شغلتنا اموالنا و اهلونا فاستغفر لنا يقولون بالسنتهم ما ليس في قلوبهم قل
فمن يملك لكم من الله شيئا ان اراد بكم ضرا او اراد بكم نفعا بل كان الله بما تعملون خبيرا بل ظننتم ان
لن ينقلب الرسول و المؤمنون الى اهليهم ابدا و زين ذلك في قلوبكم و ظننتم ظن السوء و كنتم قوما
بورا و من لم يؤمن بالله و رسوله فان اعتدنا للكافرين سعيرا و لله ملك السموات و الارض يغفر لمن
يشاء و يعذب من يشاء و كان الله غفورا رحيما سيقول المخلفون اذا انطلقتم الى مغانم لتأخذوها ذرونا
نتبعكم يريدون ان يبدلوا كلام الله قل لن تتبعونا كذالكم قال الله من قبل فسيقولون بل تحسدوننا بل كانوا
لا يفقهون الا قليلا قل للمخلفين من الاعراب ستدعون الى قوم اولى باس شديد تقاتلونهم او يسلمون
فان تطيعوا يؤتكم الله اجرا حسنا و ان تتولوا كما توليتم من قبل يعذبكم عذابا اليما ليس على الاعمى
حرج و لا على الاعرج حرج و لا على المريض حرج و من يطع الله و رسوله يدخله جنات تجري من
تحتها الانهار و من يتول يعذبه عذابا اليما لقد رضي الله عن المؤمنين اذ يبايعونك تحت الشجرة فعلم
ما في قلوبهم فانزل السكينة عليهم و اثابهم فتحا قريبا و مغانم كثيرة يأخذونها و كان الله عزيزا حكيما
وعدكم الله مغانم كثيرة تأخذونها فعجل لكم هذه و كف ايدي الناس عنكم و لتكون اية للمؤمنين و يهديكم
صراطا مستقيما و اخرى لم تقدروا عليها قد احاط الله بها و كان الله على كل شيء قديرا و لو قاتلكم
الذين كفروا لولوا الادبار ثم لا يجدون وليا و لا نصيرا سنة الله التي قد خلت من قبل و لن تجد لسنة
الله تبديلا و هو الذي كف ايديهم عنكم و ايديكم عنهم ببطن مكة من بعد ان اظفركم عليهم و كان الله بما
تعملون بصيرا هم الذين كفروا و صدوكم عن المسجد الحرام و الهدى معكوفا ان يبلغ محله و لو لا رجال
مؤمنون و نساء مؤمنات لم تعلموهم ان تطؤهم فتصيبكم معرة بغير علم ليدخل الله في رحمته من
يشاء لو تزيلوا لعذبنا الذين كفروا منهم عذابا اليما اذ جعل الذين كفروا في قلوبهم الحمية حمية الجاهلية

the heat and cant of Ignorance,—Allah sent down His Tranquility to his Messenger and to the Believers, and made them stick close to the command of self-restraint; and well were they entitled to it and worthy of it. And Allah has full knowledge of all things. Truly did Allah fulfil the vision for His Messenger: ye shall enter the Sacred Mosque, if Allah wills, with minds secure, heads shaved, hair cut short, and without fear. For He knew what ye knew not, and He granted, besides this, a speedy victory. It is He who has sent His Messenger with Guidance and the Religion of Truth, to make it prevail over all religion: and enough is Allah for a Witness. Muhammad is the Messenger of Allah; and those who are with him are strong against Unbelievers, (but) compassionate amongst each other. Thou wilt see them bow and prostrate themselves (in prayer), seeking Grace from Allah and (His) Good Pleasure. On their faces are their marks, (being) the traces of their prostration. This is their similitude in the Taurat; and their similitude in the Gospel is: like a seed which sends forth its blade, then makes it strong; it then becomes thick, and it stands on its own stem, (filling) the sowers with wonder and delight. As a result, it fills the Unbelievers with rage at them. Allah has promised those among them who believe and do righteous deeds forgiveness, and a great Reward. (Qur'an 48:7–29)

The first six verses to this sura (*al-Fath*, "Victory"), which relates an important statement concerning the duty of the jihad, are missing and may have appeared on a matching helmet.

The painted inscription and decoration on this leather cuirass were probably originally covered with a glossy varnish, which places the armor within the broad context of Islamic lacquerwork, while the arrangement of the central medallions recalls decoration common to book covers, illuminations (fig. 21), and textiles.[1] Leather was commonly used for armor during the early Islamic period, but few early pieces have survived.[2] At a later date leather was often used in India for shields, but rarely for helmets and body armor.

Although this piece opens at the side rather than the front, it is very similar to a steel cuirass in the Wallace Collection, London, that was made for the Qajar ruler Fath 'Ali Shah (r. 1797–1834) and to another Iranian example in the Royal Museum, Edinburgh.[3] These make use of similar decorative details, such as the split-leaf-and-petal design on the metal strips and the pierced, wing-shaped buckles. The outer edges of the metal hinges on the Museum's armor are pierced with palmette forms, which occur on numerous pieces of arms and armor from Iran and India of the eighteenth and nineteenth centuries. The same is true of the

wing-shaped buckles; in addition to the Iranian example mentioned above, they are also to be seen on a number of Indian pieces.[4]

PROVENANCE: S. Haim, Istanbul; George Cameron Stone, New York.

REFERENCES: New York 1996, pp. 32–33, 46, no. 56, pl. 22; Allan and Gilmour 2000, p. 136.

NOTES
1. A definitive work on Iranian lacquer by David Khalili, Basil Robinson, and Tim Stanley is based on the pieces in the Khalili Collection, London. A large number of the nineteenth-century Qajar pieces they discuss are related to the Metropolitan Museum's armor, especially those using a palette of gold, red, and black. For numerous examples, see Khalili, B. Robinson, and Stanley 1996–97. For the book-cover aspect of the decoration, see Allan and Gilmour 2000, p. 136.
2. The plates from a comparably decorated Iranian cuirass of leather in the Military Museum, Tehran, are dated A.H. 1203 (A.D. 1788/89); see Moshtagh Khorasani 2006, pp. 712–13, no. 403.
3. Wallace Collection, London, no. OA 1572 (see Norman 1982, pp. 10–12, 16, fig. 9), and National Museum of Scotland, Edinburgh (see Elwell–Sutton 1979, pp. 6–8, figs. 6, 7).
4. Pierced borders of this type can be seen on a vambrace and shield in the Furusiyya Art Foundation, Vaduz, nos. R–172, R–876, respectively; see Paris 2007/Mohamed 2008, pp. 311, 376, nos. 299, 356, respectively. For the same design on Iranian helmets in the Khalili Collection, London, see Alexander 1992, pp. 134, 136–37, nos. 78, 79. Wing-shaped buckles appear on numerous Indian pieces, including a vambrace dated 1690, in the Furusiyya Art Foundation, no. R–739; see Paris 2007/Mohamed 2008, p. 312, no. 300.

Fig. 21. Pages from an illuminated Book of Prayers. Iran, probably Isfahan, dated A.H. 1132 (A.D. 1719/20). Ink, opaque watercolor, and gold on paper. The Metropolitan Museum of Art, New York, Purchase, Friends of Islamic Art Gifts, 2003 (2003.239)

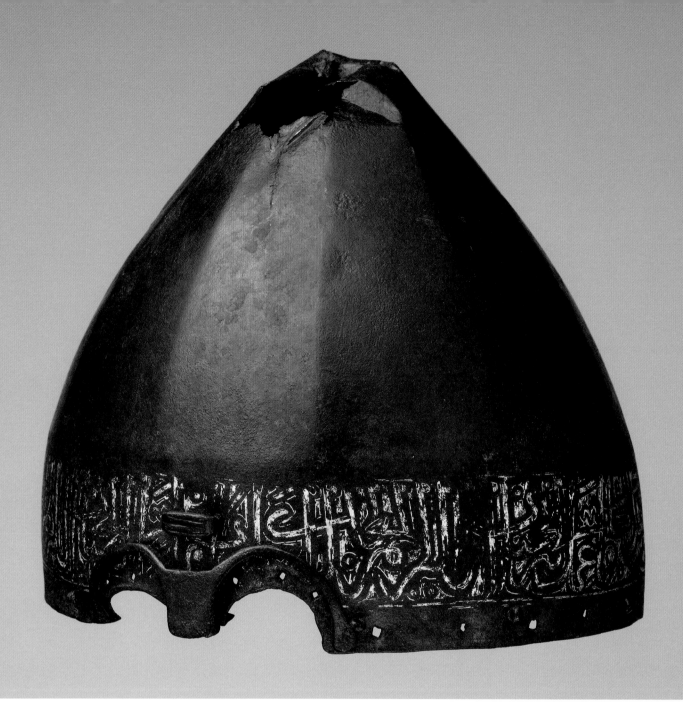

19 · Helmet

Central Asia or Russia, Blue Horde, probably ca. 1342–57
Steel, silver
Height 8 in. (20.3 cm); weight 2 lbs. 4 oz. (1,031 g)
Purchase, Arthur Ochs Sulzberger Gift, by exchange, 2007
2007.86

DESCRIPTION: The wide conical helmet is forged from a single plate of iron and is worked around its upper section with ten wide facets. The bottom edge is cut out in two semicircles over the eyes. Riveted over the cutouts and shaped to their contours is an iron stop rib, the broad center section of which is hollow to accommodate a sliding nasal bar. Directly above is a small iron staple with a horizontally filed face that originally secured the bar, now missing. The rim of the bowl is pierced with a series of holes, mostly square but some round, for the attachment of the lining, now missing. Above the lining holes is a second series of holes for the attachment of pierced lugs, or vervelles, of which six remain, used to attach a curtain of mail. The iron vervelles have split shanks that are secured inside the bowl by round iron

washers, over which the shanks are opened. The smooth rim of the helmet is encircled by a wide band damascened in silver with an Arabic inscription in cursive script that consists of one phrase repeated, with slight variations, three times (a). The band is framed by double lines along the bottom edge and by a single line above.

There is a hole at the top of the helmet just below the apex, which is partly crushed. This damage may be the result of battle or later misuse. There is an open crack on the right side of the bowl. The rim has a few small splits, and the projection over the nose is split and bent inward. The overall surface of the helmet has a brown patina owing to old corrosion, and there are extensive losses to the silver damascening.

INSCRIPTION:
a. (Around the rim, repeated three times, the final repetition missing the last four words)

مما عمل برسم الجناب الكريم العالي الغازي سلطان محمود جانيبگ خان

Made at the order of his Excellency, the noble, the exalted, the holy warrior, Sultan Mahmud Jani Beg Khan.

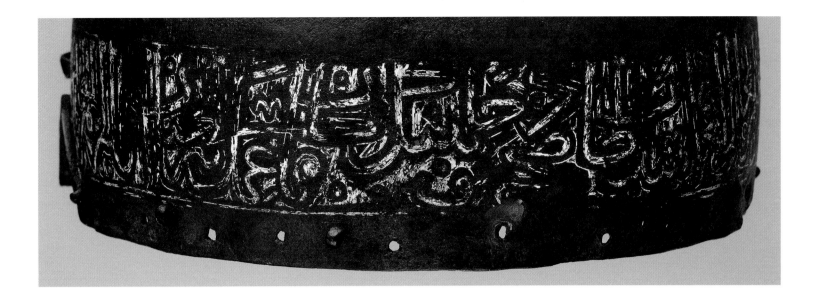

The inscription, repeated three times (with a slight variation in the last given text), includes the name Sultan Mahmud Jani Beg Khan, which almost certainly refers to the khan of the "Blue Horde," Jalal al-Din Jani Beg ibn Özbeg, who ruled from 1342 to 1357.[1] While his name is usually recorded simply as Jani Beg, on several coins found at his capital Sarai on the Volga River he is given as Mahmud Jani Beg.[2]

The inscription might seem unusual, as it is written in a style generally associated with the Mamluks.[3] However, the khans of the Golden Horde had important commercial and diplomatic relations with the Mamluks. These relations flourished at the highest level, as evidenced by a chronicle of the thirteenth century that lists a number of items, including arms and armor constituting a royal gift from the Mamluk sultan Baybars I (r. 1260–77) to Berke Khan of the Golden Horde (r. 1257–66) in 1262.[4] It is consequently not surprising that a Mamluk calligraphic style should have been used on the Museum's helmet.

When Genghis Khan (ca. 1162–1227) died, his empire was divided among his four sons, Jochi, Chagatai, Ögedei, and Tolui. The lands given to his eldest son, Jochi, extended through western Siberia and the southern Russian Steppes. When Jochi died in 1227, his empire was further divided by his sons Orda and Batu into the "White" and "Blue" *Ordu* or *Ulus* (Horde), respectively. As khan of the Blue Horde, Batu (r. 1227–56) conquered Russia and invaded Poland and Hungary. The fourth khan of the Blue Horde, Berke (r. 1257–66), converted to Islam. Jani Beg was the last ruler of the Batu'id line, and following his assassination there was a long period of instability. By 1378 the White and Blue Hordes were dubbed by the Russians the *Zolotaya Orda* or Golden Horde, perhaps because the khan's tent was topped with gold.

The wide facets around the bowl of the Museum's helmet are suggestive of the segmented construction of a spangenhelm, and the helmet may present a reworking, from a single piece of metal, of that early form of construction. The ridge of metal applied around the eyes is probably a crude version of the eyebrows and nasal guards that grace many spangenhelms as well as Russian and Crimean helmets from the eleventh to the fifteenth century.[5]

The Museum's helmet is said to be from Tibet; if so, by what circuitous route it reached such an isolated resting place is unknown. Whatever its recent provenance, the helmet is of considerable importance: it is an exceptionally early example to bear an inscription naming a ruler, and it is the only known helmet associated with the Blue Horde.[6] Furthermore, it helps place a group of similar Tartar helmets in a historical context and provides a stylistic link between Mongol, Russian, and Turkman helmets of the thirteenth to the fifteenth century.[7]

PROVENANCE: Jeremy Pine, London.

REFERENCE: La Rocca 2008, pp. 27–29.

NOTES
1. For the previous interpretations of the inscriptions, see La Rocca 2008, pp. 29, 31, nn. 21, 22.
2. See Fraehn 1826, p. 237, no. 33.I, for a *dihram* inscribed "Sultan Jelal al din Mahmud Jani Beg khan . . . minted at Sarai al-Jedid in the year A.H. 746 (A.D. 1345–46)."
3. It is interesting that the term of address used in the inscription, *al-janab*, usually translated as "his Excellency," in a nonroyal title, used mostly in inscriptions done for Mamluk amirs (personal communication, Will Kwiatkowski, February 2015).
4. Sadeque 1956, pp. 189–90.
5. A helmet of this type from the early Islamic period is in the Khalili Collection, London, no. MTW 1415; see Alexander 1992, pp. 26–27, no. 1. For Russian examples, see Kirpicnikov 1973.
6. See also La Rocca 2008, p. 29.
7. Several pieces of armor presently in the Askeri Müzesi, Istanbul, are probably also from the Blue and White Hordes. These include a knee defense set with a brass plug stamped with a rosette and possibly a greave said to be inscribed with the name of the White Horde ruler Chimtay ibn Ilbasan (1344–1374); the reading of this inscription, however, has been disputed and needs further study.

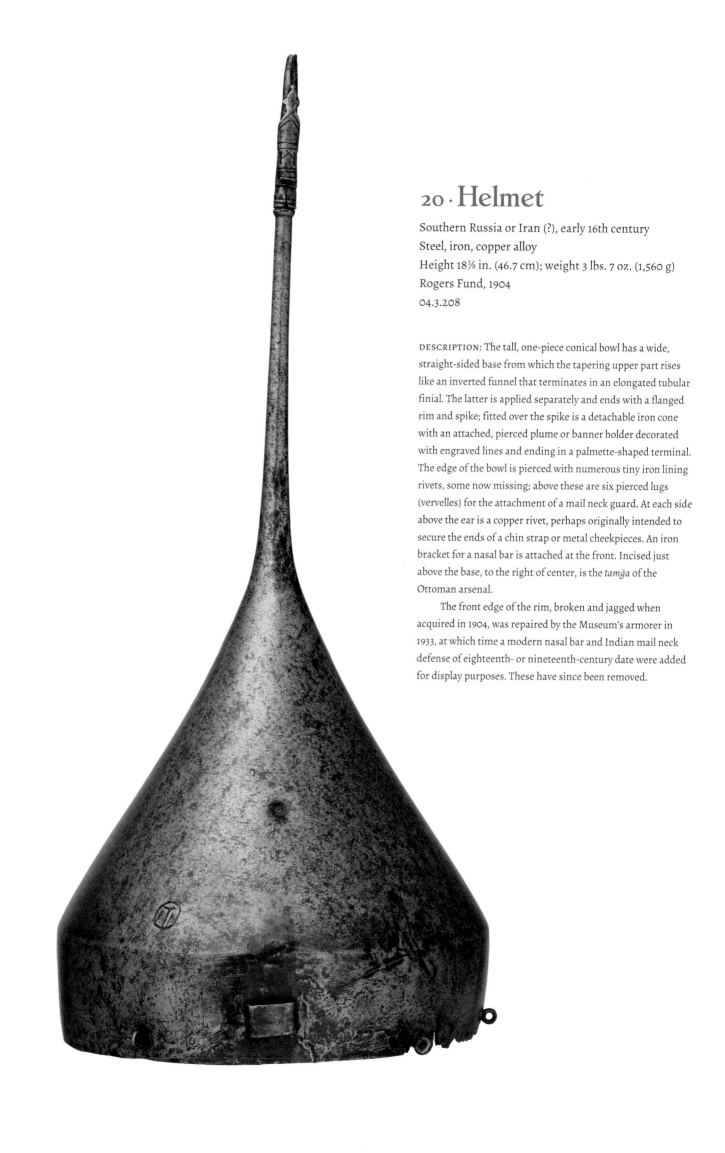

20 · Helmet

Southern Russia or Iran (?), early 16th century
Steel, iron, copper alloy
Height 18⅜ in. (46.7 cm); weight 3 lbs. 7 oz. (1,560 g)
Rogers Fund, 1904
04.3.208

DESCRIPTION: The tall, one-piece conical bowl has a wide, straight-sided base from which the tapering upper part rises like an inverted funnel that terminates in an elongated tubular finial. The latter is applied separately and ends with a flanged rim and spike; fitted over the spike is a detachable iron cone with an attached, pierced plume or banner holder decorated with engraved lines and ending in a palmette-shaped terminal. The edge of the bowl is pierced with numerous tiny iron lining rivets, some now missing; above these are six pierced lugs (vervelles) for the attachment of a mail neck guard. At each side above the ear is a copper rivet, perhaps originally intended to secure the ends of a chin strap or metal cheekpieces. An iron bracket for a nasal bar is attached at the front. Incised just above the base, to the right of center, is the *tamğa* of the Ottoman arsenal.

The front edge of the rim, broken and jagged when acquired in 1904, was repaired by the Museum's armorer in 1933, at which time a modern nasal bar and Indian mail neck defense of eighteenth- or nineteenth-century date were added for display purposes. These have since been removed.

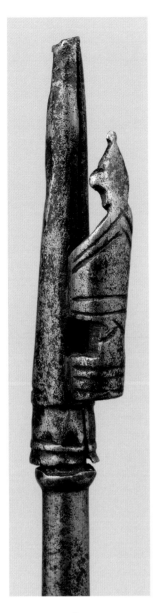

Tall conical helmets with long, attenuated finials seem to have originated in Central Asia during the sixth or seventh century and appear in frescoes of the immediate pre-Islamic period at Panjikent, near Samarqand.[1] Conical helmets with cutouts for the eyes were also used during the tenth century by the Khazars of present-day southern Russia, evidenced by a helmet found in a Khazar grave of the eighth or ninth century as well as by the representation of such a helmet on a Khazar horse trapping of about the tenth century.[2] Other examples, dated to between 1100 and 1250 and showing both Russian and Steppe nomad influences, were excavated in the region of Kiev. According to Anatolij N. Kirpicnikov, such helmets were called "Scholom" by the Moscow Rus.[3] Other early survivals include a Byzantine helmet of the thirteenth century[4] and an Islamic example probably of the fifteenth century. The latter is inscribed in Arabic and is now in the State Hermitage Museum, Saint Petersburg.[5] Similar helmets can also be seen in a number of Iranian miniature paintings, such as a battle scene of 1495 and another of 1530 by Mahmud Musavvir.[6] However, a Polish painting of not later than 1537 depicting the battle of Orsha in 1514 shows the Muscovite cavalry dressed in what is generally regarded as Oriental or Islamic fashion: plate armor, pectoral disks, and tall conical helmets, some with cheek-pieces and many with small pennons attached to the elongated finials.[7] Among the surviving Russian examples is a helmet made about 1557 at the order of Ivan the Terrible (1530–1584) for his three-year-old son, Prince Ivan Ivanovich.[8]

All of this makes the attribution of specific examples difficult, especially when they are not inscribed, and the presence of the Ottoman arsenal mark cannot be used to prove a place of manufacture. The Polish painting and the surviving Russian examples are clear evidence that helmets of this type were used in Russia; however, the Iranian paintings equally point toward an association with the Turkman warriors who formed the bulk of "Iranian" cavalry units during the rule of the Ak-Koyunlu and early

Safavids. Under the Safavids these cavalrymen were known as Qizilbash, and it is possible that the elongated spikes on the helmets were covered with a red cone, their hallmark. The paintings and surviving examples demonstrate that helmets of this type were produced as late as the sixteenth century, that the style became widespread, and that some were made to be worn with an aventail of mail while others were fitted with neck and cheek defenses and with brims. The latter include several now in the Askeri Müzesi, Istanbul, among them a helmet that is not holed around the rim for an aventail and whose neck and cheek defenses appear to be original with the bowl.[9]

Finally, two other related examples with slightly shorter finials, in the Khalili Collection, London, and Furusiyya Art Foundation, Vaduz, are said to be from the armory at Bikaner in India. If they were indeed made there, they are perhaps of the late Sultanate or early Mughal period, indicating that the style must have been truly international.[10]

PROVENANCE: Ottoman arsenal, Istanbul; Maurice de Talleyrand-Périgord, duc de Dino, Paris.

REFERENCES: Cosson 1901, p. 113, no. N.12; Miller 2006, pp. 58, 77, n. 16.

NOTES

1. Azarpay 1981, pl. 17.
2. For the helmet, see Kirpicnikov 1973, pl. 19, and Gutowski 1997, no. 21, ill. The copper-alloy pendant for a horse trapping, found in a Khazar grave in southern Russia, is in the Furusiyya Art Foundation, Vaduz, no. R-902; see Paris 2007/Mohamed 2008, p. 115, no. 83.
3. Anatolij N. Kirpicnikov 1973, especially pl. 4, nos. 1, 2, notes that all of these were found in the border regions separating the Rus of Kiev from the Steppe nomads.
4. Goncharenko and Narozhnaia 1976, p. 54.
5. State Hermitage Museum, Saint Petersburg, no. B.O. 1248; see Alexander 1992, p. 96, s.v. no. 46, and Miller 2006, pp. 57–60. Yuri Miller calls it Turkish, but the style of the inscription does not support this attribution; the term "Turko-Iranian cultural sphere" would be more appropriate.
6. For the Iranian miniature of about 1495, see Gorelik 1979, fig. 203; for the painting of about 1530, see Gray 1977, p. 135.
7. Zygulski 1979–80, figs. 34, 37, 38.
8. Kremlin Armory, Moscow, no. 4681 [4395]; see New York 1979, no. 65, and especially *Armoury Chamber of the Russian Tsars* 2002, pp. 44–45, 300, no. 2. Two richly decorated Russian examples of this type are preserved in the Livrustkammaren, Stockholm, nos. 20388 (dated to around 1500), 20389 (made for Ivan the Terrible in the 1530s); see Stockholm 2007, p. 241, nos. 3.30, 3.31, ills.
9. A number of conical helmets with elongated finials or banner shafts have been preserved. About ten of these are in the Askeri Müzesi, Istanbul, including nos. 15772, 9417, 21408, 12518 (unpublished); the latter two retain their original nasals, brims, and neck and cheek defenses. Other examples are in the British Museum, London (see H. Robinson 1967, pl. VIIB, fig. 34B); Deutsches Historisches Museum, Berlin (see Pope 1938–58, vol. 3, p. 2565, vol. 6, pl. 1411c); and Royal Armouries, Leeds (see H. Robinson 1967, p. 30, pl. IC). The group is further discussed in Miller 2006, pp. 57–62, with emphasis on examples in the State Hermitage Museum, Saint Petersburg.
10. For the former, no. MTW 1128, see Alexander 1992, p. 96, no. 46; for the latter, no. R-802, see Paris 2007/Mohamed 2008, p. 326, no. 313.

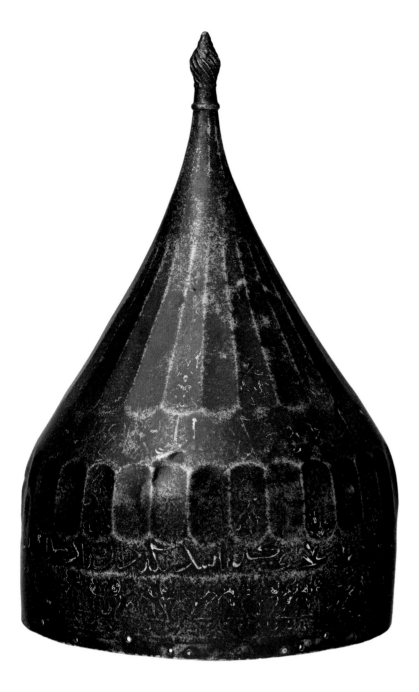

slightly concave facets alternately plain and damascened with floral designs in gold (and silver?); a smooth zone possibly originally decorated with inscriptions in silver; and a narrow terminal with nine facets. The separate pointed finial rises from a horizontal molding and has a spirally grooved head. The helmet has suffered heavy corrosion in the past, with the loss of most of its damascened decoration.

The *tamğa* of the Ottoman arsenal is incised in the lower faceted register, presumably at what was the front.

INSCRIPTIONS:

a. (Lower band around the bowl)

<div dir="rtl">... جای که باشد نگه دار باد (؟) خداوند این ...</div>

. . . wherever he might be, protect, the owner of this . . .

b. (Upper band around the bowl)

<div dir="rtl">... نگه دار بادا جهان آفرین ... خداوند ...</div>

. . . Protect, Creator of the world . . . the owner . . .

This example of an elongated and elegant helmet form was once extensively decorated in gold and silver ornament and calligraphy, of which little is now preserved. It has no direct parallels, and consequently it is very difficult to attribute.[1] Recourse can be taken to representations in miniature painting, allowing the helmet to be tentatively placed in an Iranian context of the fifteenth century.

PROVENANCE: Ottoman arsenal, Istanbul; Dikran Kelekian, New York; George Cameron Stone, New York.

REFERENCE: Stone 1934, p. 42, fig. 55.

NOTE

1. The closest parallels are a faceted but otherwise undecorated conical helmet in the Nationalmuseet, Copenhagen, no. EMB168, considered to be probably Iranian, fifteenth century, and another faceted gold-damascened example, considered to be Russian, in the Livrustkammaren, Stockholm, no. 20388. For the former, see Pope 1938–58, vol. 3, p. 2565, vol. 6, pl. 1411D; and Dam-Mikkelsen and Lundbaek 1980, pp. 102–3. For the latter, see Stockholm 2007, p. 241, no. 3.31.

21 · Helmet

Iran, 15th century (?)
Steel, iron, silver, gold
Height 12½ in. (31.7 cm); weight 2 lbs. 8 oz. (1,131 g)
Bequest of George C. Stone, 1935
36.25.106

DESCRIPTION: The one-piece conical bowl is fitted at the top with a separate finial. The bowl is pierced along its edge with small lining holes, in which several iron rivets remain; slightly above these is a second row of holes that presumably held the pierced lugs, or vervelles, for attaching a curtain of mail. The bowl is forged in an unusually complex form consisting of alternating smooth and faceted zones; it retains traces of fine gold and silver damascened ornament and Persian inscriptions (a, b) in cursive script. The bulbous lower half of the bowl is decorated in four horizontal registers: a smooth band at the rim with floral designs in gold and silver; a narrow recessed band with inscriptions in silver; a zone with thirty-two vertical facets damascened in gold with floral forms; and a smooth zone with inscriptions in silver. The narrow, tapering upper half of the bowl is decorated in three registers: a tall zone with twenty-four

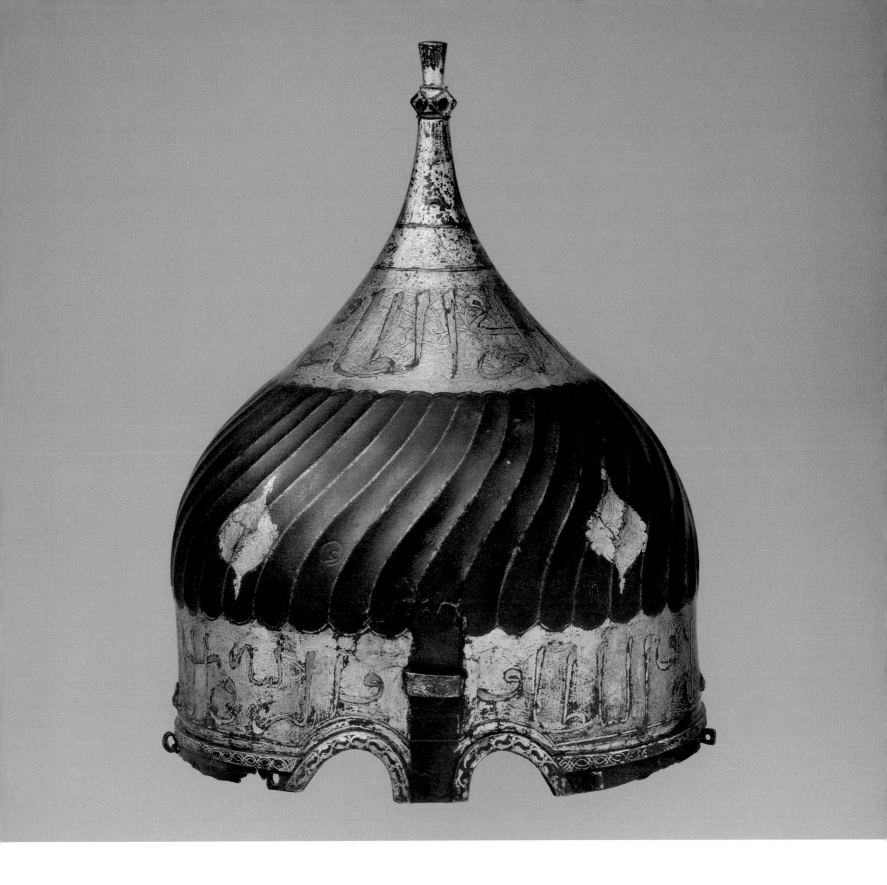

22 · Helmet

Turkey, Istanbul (?), Turkman style, late 15th–16th century
Steel, iron, silver, gold
Height 11¾ in. (29.8 cm); weight 2 lb. 13 oz. (1,271 g)
Rogers Fund, 1904
04.3.210

DESCRIPTION: This example originally had seven iron loops (vervelles), of which five remain: four are cut in triangular shape from iron sheet and pierced with a hole in the center, the fifth is formed from circular wire. At each side the bowl is pierced above the iron band set over the vervelles with a hole for a rivet that presumably secured a chin strap or metal cheekpiece. The nasal bar is missing, but its bracket remains.

The decoration is organized in five registers. The wide band around the base is engraved with Arabic inscriptions (a) in cursive script set against a background of arabesques on a stippled ground. The calligraphy is damascened in silver, the background gilded overall. The second register is spirally fluted with forty shallow

channels and has a blackened surface; it is engraved at the front, to the left and right of center, with two pointed medallions engraved with arabesque ornaments and gilt overall. The third register repeats the decoration of the first, with silver-damascened inscriptions (b) on a gilt-arabesque ground. The fourth and fifth registers, at the apex, consist of two narrow bands of arabesques, gilt overall, the bands separated by silver filets. The applied band around the rim is damascened in silver with a repeating interlace pattern, and those over the eyes are damascened in silver with a foliate pattern. The bowl is engraved on the left side with a *tamğa* of the Ottoman arsenal and on the right side with another *tamğa*.

INSCRIPTIONS:
a. (Around the base)

العز الدائم و الاقبال و الدولة و السلطاو [كذا] و البركة (؟) في الكفاية و البركة في الحلال (؟)

Perpetual glory and prosperity and wealth and sultan and there is blessing (?) in sufficiency and blessing in the lawful (?).

b. (Around the top)

... العز في الطاعة و الغنا في القناعة

Glory is in obedience and wealth in contentment . . .

This helmet and the eight that follow are examples of a distinctive form of conical helmet worn throughout much of the Islamic world from the mid-fourteenth to at least the early sixteenth century. The large size and wide spiral grooves that distinguish many of these helmets recall the folded cloth turbans commonly worn by Muslims and account for the modern appellation "turban helmet." The type is characterized by a wide bulbous bowl forged from a single plate of steel that tapers to a separately applied finial comprising a faceted cube surmounted by an inverted cone. The rim of the bowl is shaped over the eyes and is fitted around the edge with pierced lugs, or vervelles, to which a neck and lower face defense of mail, or aventail, was secured by a cord. A narrow horizontal iron band is often riveted around the rim above the vervelles, with similar applied bands around the eyes, to stop or deflect a glancing blow. An adjustable sliding nose guard, or nasal, is attached between the eyes by a bracket. Many examples are also fitted with a small hook, usually set to the proper right of the nasal, by which to hold up the aventail when not in use. Unless otherwise stated, the "turban helmets" catalogued here fit this basic description.

This particular helmet is unique in two respects: first, the fluted area, usually left plain, is decorated with two small medallions, and, second, it is engraved with what is possibly the *tamğa* of the Cavuldur tribe from eastern Turkey (see detail). This mark is used on only one other helmet known to this writer (Metropolitan Museum, acc. no. 04.3.209); it has been observed on the pectoral disk of an armor in the Askeri Müzesi, Istanbul.[1] The armor is most likely Ottoman and from a metropolitan workshop, but the disk is decorated in a completely different style and although

probably also Ottoman cannot be attributed to the same atelier. A variant of this mark, reversed (giving it the appearance of the Arabic number 2), is on a greave in the Metropolitan Museum, cat. 10.

The dramatic coloring of this helmet is noteworthy. As the gilding appears to cover pitted and damaged areas, it is likely that the helmet was regilt at a much later period; this restoration presumably follows the original coloring. The fluted section, now darkly patinated, may originally have been brightly polished.

The decoration around the rim is the knot-and-loop design also associated with Mamluk workshops; around the cusps for the eyes is a frieze of leaves whose rounded sides face one another, which seems to be specifically Ottoman. It is used on a helmet in the Askeri Müzesi inscribed with the name Orhan Ghazi (that is, the Ottoman sultan Orhan, r. 1326–60)[2] and consequently can probably be attributed to a workshop in Bursa (conquered by Orhan in 1326 and made his capital); it appears as well on tiles in the mosque of Edirne (ca. 1436) and on Iznik pottery of the early sixteenth century decorated by the "Master of the Knots" (fig. 22).[3]

The interconnection of decorative elements that define the "family resemblance" of these "turban" (or Turkman-style or Turko-Iranian) helmets is further demonstrated when the Museum's helmet is compared with another example in the Askeri Müzesi.[4] The latter has exactly the same configuration of a knot-and-loop design around the rim and a leaf frieze around the eyes, but it also has wide diagonal flutings and an overall stringy arabesque design similar to that on a greave in the Museum's collection, cat. 9. In addition, the decorative elements and inscriptions on the Istanbul helmet are set among lobed cartouches like those on another Museum helmet, cat. 28. No two helmets of this general type make use of exactly the same decorative elements; rather, they are blended from a large repertoire of stock motifs. Consequently, in the absence of a dedicatory inscription it is rarely possible to attribute them to specific geographical workshops.

PROVENANCE: Ottoman arsenal, Istanbul; Maurice de Talleyrand-Périgord, duc de Dino, Paris.

REFERENCES: Cosson 1901, p. 112, no. N.5; San Francisco 1937, p. 54, no. 180, ill.

NOTES
1. Askeri Müzesi, Istanbul, no. 4326/2 (unpublished). The mark on the helmet under discussion and that on the Askeri armor are contained within a circle; that on acc. no. 04.3.209 is not.
2. Askeri Müzesi, Istanbul, no. 15723; see Alexander 1983, pp. 97–98, fig. 1.
3. See, for example, Atasoy and Raby 1989, p. 93, fig. 90.
4. Askeri Müzesi, Istanbul, no. 5740 (unpublished).

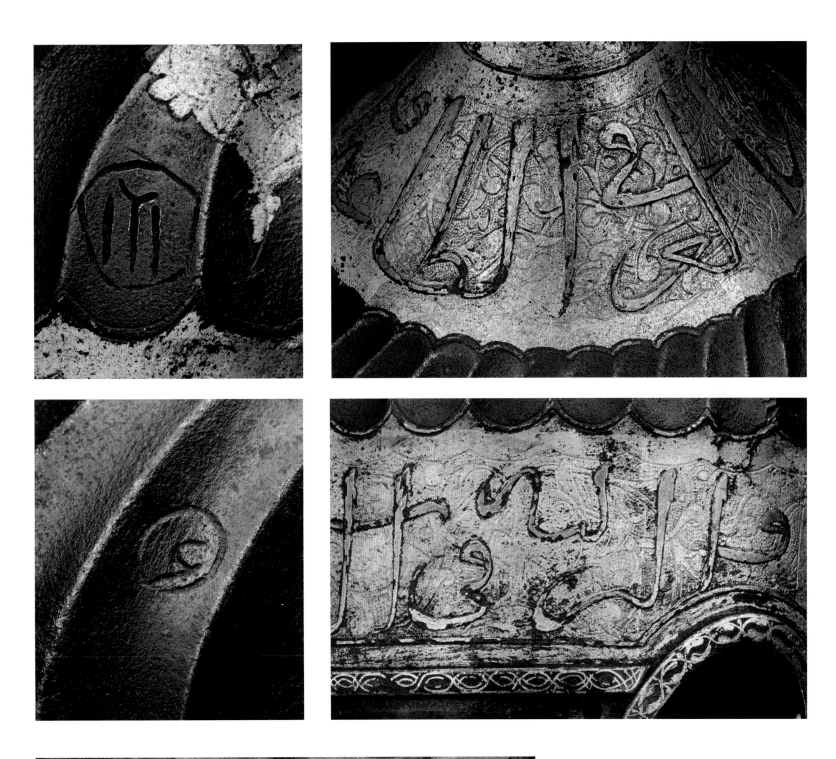

Fig. 22. Detail from a mosque lamp. Turkey, Iznik, ca. 1510. Painted and glazed ceramic pottery. British Museum, London (1983 G.5)

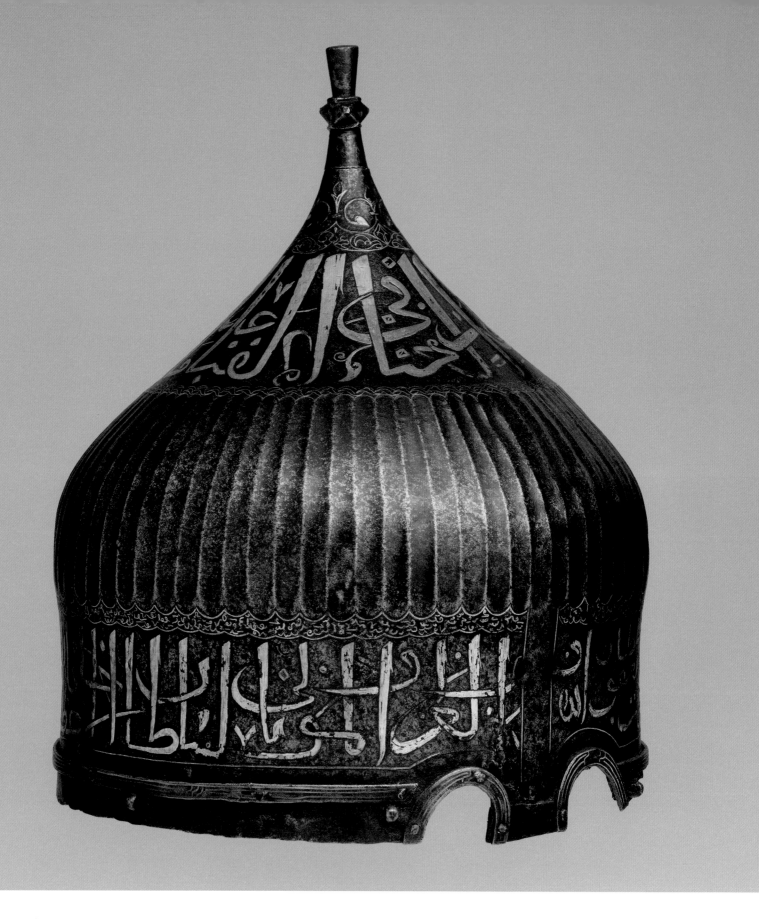

23 · Helmet

Turkey or Iran, Ak-Koyunlu period, 1478–90 (?)

Steel, iron, silver

Height 11⅛ in. (28.3 cm); weight 3 lbs. (1,372 g)

Rogers Fund, 1904

04.3.211

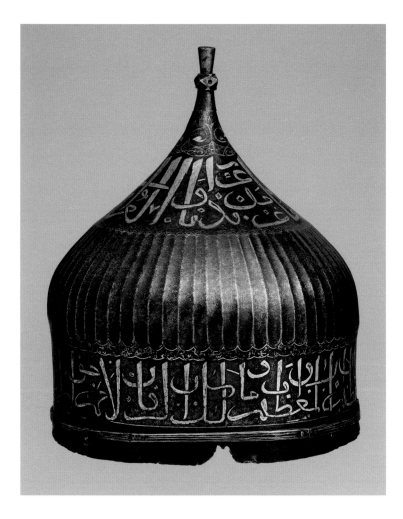

Although the decoration of this helmet includes such conventions as the design of fleurs-de-lis alternating with spearlike floral forms that is engraved below the apex, it differs from the decoration on almost all surviving helmets of this general type in its restraint and sparseness; even the inscriptions are worked without the usual foliate background. One of the inscriptions on this helmet contains a series of titles, which seems to end with the name يعقو[ب], "Yaʻqub," although it lacks a final ب. If the reading "Yaʻqub" is indeed correct, then the inscription is probably in the name of the Ak-Koyunlu sultan Yaʻqub (r. 1478–90).[1]

The Ak-Koyunlu dynasty arose from a confederation of tribes in central Anatolia whose power was consolidated in the fourteenth century by Qara Yoluk ʻUthman; they reached the height of their power under Hasan b. ʻAli b. ʻUsman (Uzun Hasan) (r. 1453–78), whose rule extended from the region of Diyarbakır and Amida in eastern Anatolia to Tabriz and Baghdad. Yaʻqub, one of Uzun Hasan's sons, acceded to the throne after the death of his brother Khalil in 1478. He is noted not only for his patronage of architecture (especially in Tabriz) and the arts as well as science and literature but also for his war against the Georgians.[2] Although initially popular, Yaʻqub eventually alienated many among the religious establishment. By the time of his death in 1490, the Ak-Koyunlu dynasty was threatened by the growing power of the Safavids, who in 1501 crushed the Ak-Koyunlus at the battle of Sharur, near Nakhchivan.[3]

DESCRIPTION: The bowl retains four of the original seven pierced lugs (vervelles) for the attachment of the mail neck defense (aventail). The sliding nasal bar and its bracket are missing. The surface of the bowl is heavily corroded, the left rim is deeply chipped, the apex is cracked, and the plug is loose. There is a modern patch at the bridge of the nose.

The decoration is organized in four registers. The wide band around the base is damascened in silver with Arabic inscriptions (a) in cursive script bordered above by a narrow, scallop-edged band enclosing pseudo-calligraphy, or squiggles. The second register is vertically fluted with seventy narrow channels; the third repeats the first with large, silver-damascened Arabic inscriptions (b) framed by narrow, scallop-edged bands filled below with pseudo-calligraphy and above with stylized foliage. The fourth register, at the apex, consists of simple foliate motifs of asymmetrical fleurs-de-lis alternating with vertical, spearlike leaf forms. The applied iron bands around the lower edge and eyes are silver damascened with parallel lines, those over the eyes interrupted by zigzag ornament. Incised on the left side of the bowl, within the lower register, is the *tamğa* of the Ottoman arsenal.

INSCRIPTIONS:

a. (Around the base of the helmet, with mistakes and extra letters)

العز ... المولى نا [كذا] [ا]لسلطان الاعظم خانان [كذا] المعظم مالك الرقاب [كذا] الامم ... ملوك العرب و العجم سلطان يعقو[ب] ...

Glory to our lord, the greatest sultan, the mighty Khaqan, master of the necks of nations . . . [the lord of] the kings of the Arabs and the Persians, Sultan Yaʻqu[b] . . .

b. (Around the top of the helmet)

العز في الطاعة الغنا في القناعة ...

Glory is in obedience, wealth is in contentment . . .

PROVENANCE: Ottoman arsenal, Istanbul; Maurice de Talleyrand-Périgord, duc de Dino, Paris.

REFERENCES: Cosson 1901, p. 112, no. N.6; Stone 1934, p. 41, fig. 54; Alexander 1983, pp. 98–99, fig. 2; Kalus 1992, pp. 161–62, fig. 7; London 2005a, pp. 209, 415, no. 155, ill.; Pyhrr 2012a, pp. 9–10, fig. 9; Pyhrr 2012b, pp. 194–95, fig. 24.

NOTES
1. An armor in the Askeri Müzesi, Istanbul (no. 16462; see Istanbul 1987, pp. 155, 203, no. A.151), has plates uniquely decorated with interlacing ropework forming soft-edged star patterns with rosettes at their centers. On the right side, the mail is fixed with a brass stamp inscribed with the name "Sultan Ya qub." The style of the decoration differs from that on the Museum's helmet, but both must be attributed to the Ak-Koyunlu ruler.
2. See Woods 1976.
3. Ibid.

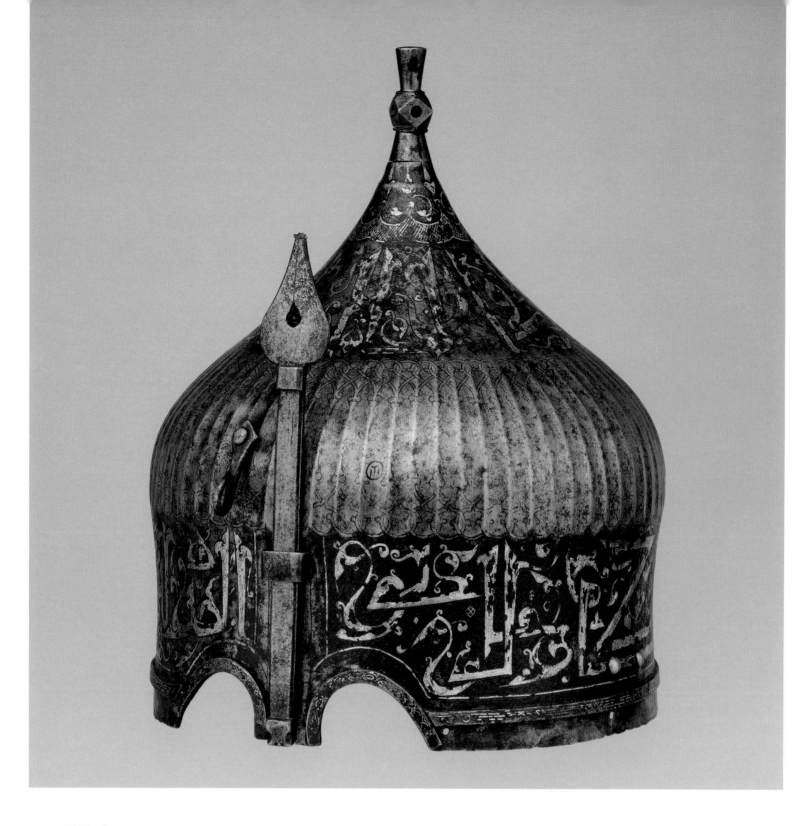

24 · Helmet

Turkey, Istanbul (?), Turkman style, late 15th–16th century
Steel, iron, silver, copper alloy
Height 11⅜ in. (29.6 cm); weight 3 lbs. 1 oz. (1,399 g)
Rogers Fund, 1904
04.3.212

DESCRIPTION: The rim of the bowl is pierced with seven holes for vervelles, now missing, and above these is riveted a narrow reinforcing band; the cusps over the eyes are similarly reinforced with applied bands. Two copper rivets at each side, secured on the inside by circular iron washers, presumably held the chin straps. Fitted at the front is a nasal bar held by a friction bracket; the nasal's finial of

flattened teardrop shape has a pierced center. Both are undecorated and therefore may be associated. To the right of the nasal is a hook for the aventail.

The decoration is organized in three registers; the calligraphy and ornament are engraved and damascened in silver. The lower register consists of a wide band with Arabic inscriptions (a) in a foliate Kufic script on a stippled ground. The middle register is vertically fluted with seventy narrow channels and is framed by repeating patterns of interlocking loops with trefoil terminals that border the calligraphic bands above and below. The upper register, like the lower one, consists of a wide band of inscriptions (b), above which is a scallop-edge band filled with crosshatching surmounted by a series of spearlike foliage. The applied band around the edge is damascened with a series of parallel horizontal lines that interlace at regular intervals; the bands around the eyes are damascened with a loop-and-knot pattern.

Incised in the middle register to the left of the nasal is the *tamġa* of the Ottoman arsenal.

INSCRIPTIONS:

a. (Around the base, garbled)

... لمو |لا|نا (؟) السلطان |ا|لعز لا المو|لا|نا |كذا| ...

... to our lord (?) the sultan, glory to our lord ...

b. (Around the top)
(Undeciphered)

As with the shirt of mail and plate cat. 7, this helmet belongs to a large group of armor inscribed in a flamboyant foliate Kufic style and is datable to the late fifteenth to early sixteenth century. This helmet is especially relevant in dating other helmets and armor of this general type, as its inscription uses an additional convention found on Iznik pottery of the early sixteenth century, specifically the apparently random distribution of annulets in the background. The reinforcing rim around the eyes is decorated with a loop-and-knot design of exactly the type used on a helmet in the Musée du Louvre, Paris, that bears a dedicatory inscription to the Mamluk sultan Barsbay (r. 1422–38).[1] This does not mean that the Museum's helmet is Mamluk, but rather reinforces the hypothesis that the form and decoration of these helmets drew upon a variety of influences.

The combination of exuberant floral forms with Mamluk elements suggests that this helmet and others like it are the work of Turkman craftsmen from a southern Anatolian or even a northern Syrian center. Turkman tribes from this region, such as the Afshar, were allied with the Ak-Koyunlu, while others, like the Döger, fought with the Mamluks.[2] The Turkman-Mamluk connection probably explains the use of Mamluk

decorative elements on many helmets of this type as well as the use of garbled or atypical Mamluk titulature on a helmet in the Askeri Müzesi, Istanbul, and another in the Dar al-Athar al-Islamiyya, al-Sabah Collection, Kuwait City.[3] Unfortunately, none of this resolves the problem of precisely where the Museum's helmet was made. It remains open whether pieces such as this were produced in Istanbul by Turkman artisans or in another Turkman center in southern Anatolia, perhaps even a center under Mamluk control.

PROVENANCE: Ottoman arsenal, Istanbul; Maurice de Talleyrand-Périgord, duc de Dino, Paris.

REFERENCES: Cosson 1901, p. 112, no. N.7; Stone 1934, p. 41, fig. 54; Mexico City 1994–95, pp. 264–65, 301, no. 110, ill.

NOTES

1. Musée du Louvre, Paris, no. 6130; see Washington, D.C., and other cities 1981–82, no. 41, and Behrens-Abouseif 2014, pl. 8.

2. For such tribes, see Woods 1999, Appendix B, "The Aqquyunlu Confederates." The Mamluk Empire extended as far north as Adana and Sis and incorporated many Turkman tribes.

3. Askeri Müzesi, Istanbul, no. 8202 (unpublished); Dar al-Athar al-Islamiyya, al-Sabah Collection, Kuwait City, no. LNS.145.M (see Baltimore and other cities 1990–92, pp. 208–9, no. 68). Both helmets are inscribed "al-malik al-Mansur al-sultan al-ashraf." The helmet in the Askeri museum is inscribed in both Arabic and Persian, is signed by the maker Ishaq, and possibly mentions the name of the Mamluk sultan Al-Ashraf Inal (r. 1453–61), whereas the helmet in Kuwait City has been attributed to the Ak-Koyunlu prince Ashraf ibn Dana Khalil Bayandur.

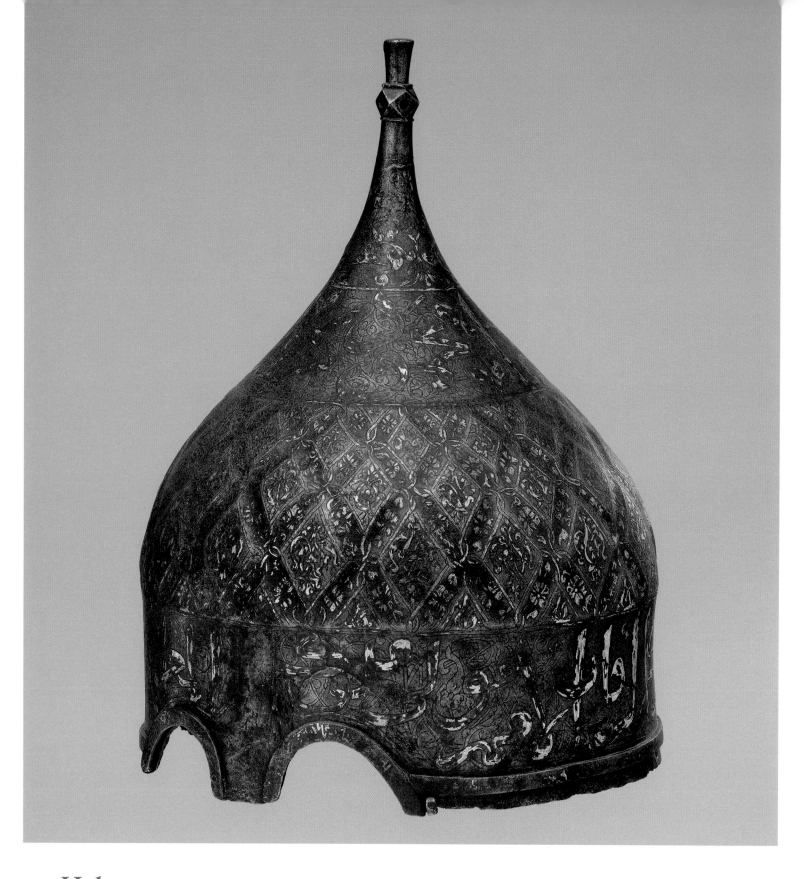

25 · Helmet

Turkey, Istanbul (?), Turkman style, late 15th century
Steel, iron, silver
Height 12⅜ in. (32 cm); weight 4 lbs. 4 oz. (1,928 g)
Rogers Fund, 1904
04.3.215

DESCRIPTION: The bowl was originally fitted around its edge with six vervelles, of which only two fragmentary ones remain. A narrow applied reinforcing band encircles the bowl above the vervelles, with two semicircular bands applied over the eyes; these are damascened in silver with pseudo-calligraphic "squiggles." The surfaces are heavily corroded, and the lower edge heavily chipped. A plug fitted into the metal over the left eye appears to have been added during the original forging of the bowl. Two slots at the front denote the missing nasal and its bracket.

The bowl is engraved and damascened in silver against a dot-punched ground, and the decoration organized in three registers. The first or lower register, a wide band at the bottom, contains Arabic and Persian inscriptions against a leafy arabesque (a); the second or middle register is embossed overall with diamond-shaped lozenges containing symmetrical floral forms separated by crisscrossed channels

outlined by knotted strapwork enclosing flowers; the third or upper register is decorated in two zones, the lower one with inscriptions (b) like those in the first register and the upper one rising to the finial with interlocking palmettes.

Incised above the right eye is the *tamġa* of the Ottoman arsenal.

INSCRIPTIONS:

a. (Around the base)

المعز |كذا| المولانا |كذا| السلطان الاعظم خاقان |كذا| المعظم مالك الرقاب |كذا| الامم مولى ملوك |العرب و العجم|

Glory to our lord, the greatest sultan, the mighty Khaqan, lord of the necks of nations, ruler of the kings [of the Arabs and Persians].

b. (Around the top)

عمل استاد حسين عاقبت خير با|د| الهى عاقبت محمود گر|دان|

Made by Master (*ustad*) Husayn. May the end be good, O God make the end a felicitous one.

This helmet is noteworthy as one of the few signed examples of its type and for the inclusion in its inscriptions of a line from one of the *mufradat* (single-line poems) of the Persian poet Saʿdi (ca. 1213–1292).[1] According to the late Annemarie Schimmel, the series of Arabic titles in the lower register (a) contains at least one word (*al-riqab*) that is grammatically incorrect, suggesting that the artisan was not familiar with this language.[2] None of this, however, proves an Iranian provenance for the piece, as the embossed lozenge design links the Museum's helmet to another example, a shield in the Royal Ontario Museum, Toronto (discussed below),[3] that is certainly Ottoman and datable to the late fifteenth century, a time at which many Iranian artists worked in various Ottoman workshops.

A number of pieces worked with embossed lozenge patterns connected by engraved and inlaid knots are known. These include the shield mentioned above, and four helmets in the Askeri Müzesi, Istanbul, one of which is inscribed in an almost identical script and all of which are probably from the same workshop.[4] (Two of the helmets in Istanbul are also inscribed with the same verse as that on the Museum's helmet.)[5] Other helmets with the same lozenge design include an example in the State Hermitage

Museum, Saint Petersburg, and another in the Oberösterreichisches Landesmuseum, Linz;[6] the Linz helmet not only is almost identical to the Museum's in decoration but also has the same Persian inscription following the maker's name, in this case *ustad* (master) Balhak, or Barani. There is also an arm guard worked in the same lozenge pattern in the Museo Nazionale del Bargello, Florence.[7]

In terms of dating, the most important object in the group is the Toronto shield. Its center and rim are engraved with floral arabesques, and the flower forms are of exactly the same type as those on an Iznik plate, datable to about 1480, in the Gemeentemuseum, The Hague.[8] These flowers have rounded petals that curl inward toward their centers, a hallmark of the so-called Baba Nakkaş style. Baba Nakkaş, possibly an Uzbek craftsman from Central Asia, was one of the most important designers in the *nakkaşhane* (royal scriptorium) of the Ottoman sultan Mehmed II (r. 1444–46, 1451–81) and later of his son Bayezid II (r. 1481–1512).[9]

Another characteristic of these lozenge-embossed pieces is the use of knots to connect the lozenge shapes. Julian Raby has identified an entire group of Ottoman ceramics decorated with similar knots and attributed the group to a "Master of the Knots" active during the reign of Bayezid II, when such designs were a favored motif. While the Museum's helmet is not as delicately decorated as the Toronto shield, the two examples have many motifs in common, especially the centrally organized arabesques engraved on the lozenge forms. The entire group should be attributed to the same period and to a group of armorers working in the same center.

PROVENANCE: Ottoman arsenal, Istanbul; Maurice de Talleyrand-Périgord, duc de Dino, Paris.

REFERENCES: Cosson 1901, p. 113, no. N.10; Stone 1934, p. 41, fig. 54; *Islamic World* 1987, pp. 85–86, fig. 64; Florence 2002, p. 50, no. 4.

NOTES

1. Will Kwiatkowski (personal communication, July 2015). Melikian-Chirvani 1982b, pp. 321, 277, n. 42, published several examples from the collection of the Victoria and Albert Museum, London, and commented that the line is "often found on Safavid metal."

2. Annemarie Schimmel (personal communication, 1984); Will Kwiatkowski (personal communication, 2015) also noted that some of the words are spelled incorrectly.

3. Royal Ontario Museum, Toronto, no. 925.49.34-M657, currently on loan to the Metropolitan Museum.

4. Askeri Müzesi, Istanbul, nos. 3004, 8091, 9558, 9624 (unpublished).

5. Askeri Müzesi, Istanbul, nos. 9558, 9624 (unpublished).

6. State Hermitage Museum, Saint Petersburg, no. N.18 (unpublished); Oberösterreichisches Landesmuseum, Linz, no. C.1993 (see Diessl 1981).

7. Museo Nazionale del Bargello, Florence, no. C 1618; see Florence 2002, p. 50, no. 4.

8. Gemeentemuseum, The Hague, no. OCI 6-36; see Atasoy and Raby 1989, fig. 279.

9. For the possible origins of Baba Nakkaş, based on a report by the seventeenth-century traveler and historian Evliya Çelebi, see Raby and Tanındı 1993, p. 60.

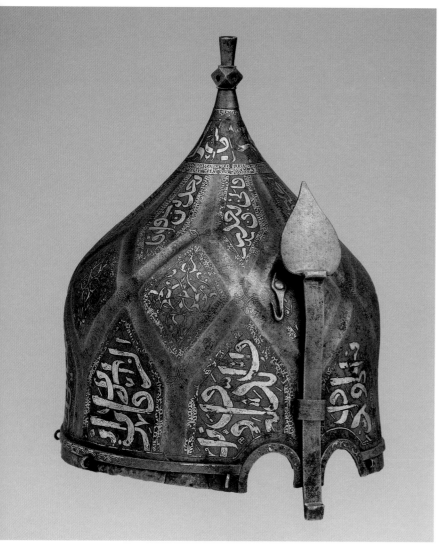
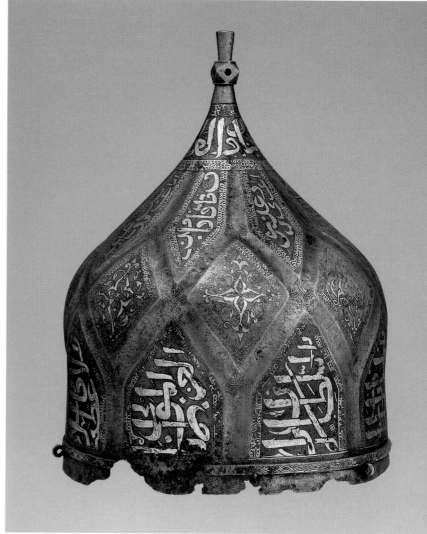

26 · Helmet

Turkey, Ottoman period, Turkman style, 16th century
Steel, iron, silver
Height 12⅝ in. (32.1 cm); weight 3 lbs. 12 oz. (1,713 g)
Rogers Fund, 1904
04.3.457

DESCRIPTION: The edge of the bowl retains four of the original seven vervelles for the attachment of the aventail, with a narrow iron reinforcing band encircling the bowl above them and similar arched bands riveted over the eyes. These applied bands are damascened in silver with a repeating loop-and-knot motif on the horizontal band and foliate motifs on those over the eyes. A pair of rivet holes is pierced on each side of the bowl, just above the applied band, presumably to hold the chin straps. The helmet is fitted with a plain iron nasal, which ends in a large, flat, teardrop-shaped finial and is held in place by a friction clamp; the undecorated nasal and clamp are later associations. To the right of the nasal is riveted a small iron hook to hold up the aventail.

The decoration of the bowl, which employs calligraphy and foliate ornament engraved against a stippled ground and damascened in silver, is organized in two registers. The lower register, which covers most of the helmet's surface, is composed of large embossed lozenges separated by crisscrossed channels engraved at the intersections with knot designs. The eight lozenges around the middle of the bowl are embellished with delicate, centrally organized arabesques, whereas the elongated lozenges below (a) and above (b) are filled with bold Arabic inscriptions in cursive script. All of the lozenges are outlined by narrow bands of pseudo-calligraphic squiggles. The narrow upper register, which is smooth, is engraved with Arabic inscriptions in cursive script framed by bands of squiggles (c). Incised on the right side of the bowl is the *tamga* of the Ottoman arsenal.

INSCRIPTIONS:

a. (Within the lower band of lozenge shapes, reading counterclockwise, with mistakes and extra letters)

العز المولى / السلطان / المالك [كذا] /الرقاب [كذا] الا[مم] / الدولة / ... / السلطان /الخا|قان الاعظم

Glory [to] the lord, the sultan, the possessor [of] the necks [of the nations], prosperity . . . the sultan, the greatest Khaqan.

b. (Within the upper band of lozenges)
(Undeciphered)

c. (Around the top, with extra letters)

العز الدائم و الاقبال

Perpetual glory and fortune.

This is the largest of the Museum's turban helmets, both in weight and mass. The decoration on the bowl includes knot designs with small nodules of the same type found on numerous other armors and helmets as well as on the work of Mahmud al-Kurdi and other craftsmen who produced what is often called Veneto-Saracenic metalwork.[1] This very specific knot style helps date such pieces to the late fifteenth or early sixteenth century and to an Ottoman workshop.

While the helmet's embossed lozenge shapes also relate it to another helmet in the Museum's collection (cat. 25), it lacks that example's delicacy of design. In addition, the pattern of embossed lozenge forms around the center with embossed V shapes above relates the Museum's helmet to two Ottoman helmets in the Askeri Müzesi, Istanbul, that are also decorated with lozenge forms.[2] The close formal correspondence between these two helmets in the Askeri Müzesi and the present helmet suggests an Ottoman attribution, in the Turkman style, of the early sixteenth century.

PROVENANCE: Ottoman arsenal, Istanbul; Maurice de Talleyrand-Périgord, duc de Dino, Paris.

REFERENCE: Cosson 1901, p. 111, no. N.2, pl. 8.

NOTES

1. See Auld 2004, pp. 71–74.
2. Askeri Müzesi, Istanbul, nos. 3004, 23958 (unpublished).

27 · Helmet

Turkey, Istanbul (?), Turkman style, late 15th–
first quarter of the 16th century
Steel, iron, gold, silver, copper alloy
Height 11³⁄₁₆ in. (28.5 cm); weight 2 lb. 6 oz. (1,092 g)
Rogers Fund, 1904
04.3.460

DESCRIPTION: The edge of the bowl is fitted with eight pierced lugs, or vervelles, for the attachment of the aventail; six of these have heads cut from rectangular sheet and pierced through the center, the remaining two (to the left of the left eye) are formed of flattened wire. A band riveted above the vervelles extends around the bowl, and similar arched bands are applied over the eyes; the bands are pierced with quatrefoils alternating with two vertically aligned circles and are engraved with simple leaf forms against a dot-punched ground that is gilt overall. On each side of the bowl, just above the band, are three rivet holes arranged triangularly, the lower two filled with copper rivets that have domed copper alloy (formerly gilt) heads, probably for the attachment of chin straps or metal cheekpieces. A gilt-iron nasal bracket is fitted between the eyes, its nasal bar missing, and a gilt-iron hook for the aventail is riveted higher up on the bowl over the right eye.

The decoration consists of engraved ornament and calligraphy, partly silver damascened on a gilt and stippled ground, and is organized in three registers. The lower register is engraved with a series of interconnected strapwork cartouches with lobed edges: the larger, rectangular-shaped cartouches contain Arabic inscriptions (a) damascened in silver against a floral ground and alternate with smaller, round cartouches enclosing a centralized arabesque partly damascened. The silver-damascened fillets outlining the strapwork cartouches form loops between the cartouches. The middle register is spirally fluted with twenty slightly concave channels, alternately plain or engraved with silver-damascened inscriptions (b) within cartouches against a foliate-engraved and gilt ground; the cartouches have distinctive, trefoil foliate terminals. The upper register, which is gilt overall, is composed of three bands: the lowest is decorated with a silver-damascened Arabic inscription (c) against a floral arabesque; the one above it with a continuous leaf-and-petal scroll; and the band at the apex, below the finial, with a pattern of upward-overlapping scales.

Incised on the right side of the bowl is the *tamǧa* of the Ottoman arsenal.

INSCRIPTIONS:
The inscriptions are garbled repetitions of words and parts of words.
a. (Around the base)

المعز |كذا| ... / اعظم العز ...

Glory . . . greatest, glory . . .

b. (Around the center, in alternate spiral flutes)

العز ...

Glory . . .

c. (Around the top)

العز ...المعز الموالاانا |كذا| ...

Glory . . . glory to our lord . . .

The decoration on this helmet has a hierarchical quality and lacks the exuberance of the fleshy leaves and flower forms on such pieces as cat. 30. Nevertheless, it includes many elements, among them lobed knots and composite leaf forms, that can be considered Turkman. This style, or group of related styles, is complex; it should be stressed that there are many decorative variations within the "Turkman" style, and that while none are exactly the same, all share a family resemblance. These armors and helmets were produced by a large number of armorers and decorators working in many different workshops and centers.

The Museum's example relates closely to several other diagonally fluted turban helmets that are engraved with cartouches having dartlike trefoils at either end. One such helmet in the Askeri Müzesi, Istanbul, also has flutings alternately engraved and plain.[1] Both the Askeri helmet and the Museum's are probably from the same workshop. Other closely related pieces in the Metropolitan's collection are a helmet[2] and greave cat. 9.

The pierced and engraved bands applied around the rim of the Museum's helmet are distinctive and relatively uncommon, although several other turban helmets are known to have them, including three in the Askeri Müzesi; one in the Musée de l'Armée, Paris; and one in the Museo Nazionale del Bargello, Florence.[3] The Bargello example is engraved around the center with a design similar to those on Ottoman textiles of the first quarter of the sixteenth century[4] and also has small clamps with large rosette-shaped heads that help secure the reinforcing band. Similar clamps are used on several hinged knee defenses set with striated rivet heads of the type found on Mamluk and Ottoman armor of the second half of the fifteenth to the sixteenth century.[5]

Unfortunately in terms of attribution, most helmets with pierced reinforcing bands are not only decorated in different styles but were also perhaps made in different workshops, with the bands then added in yet another.

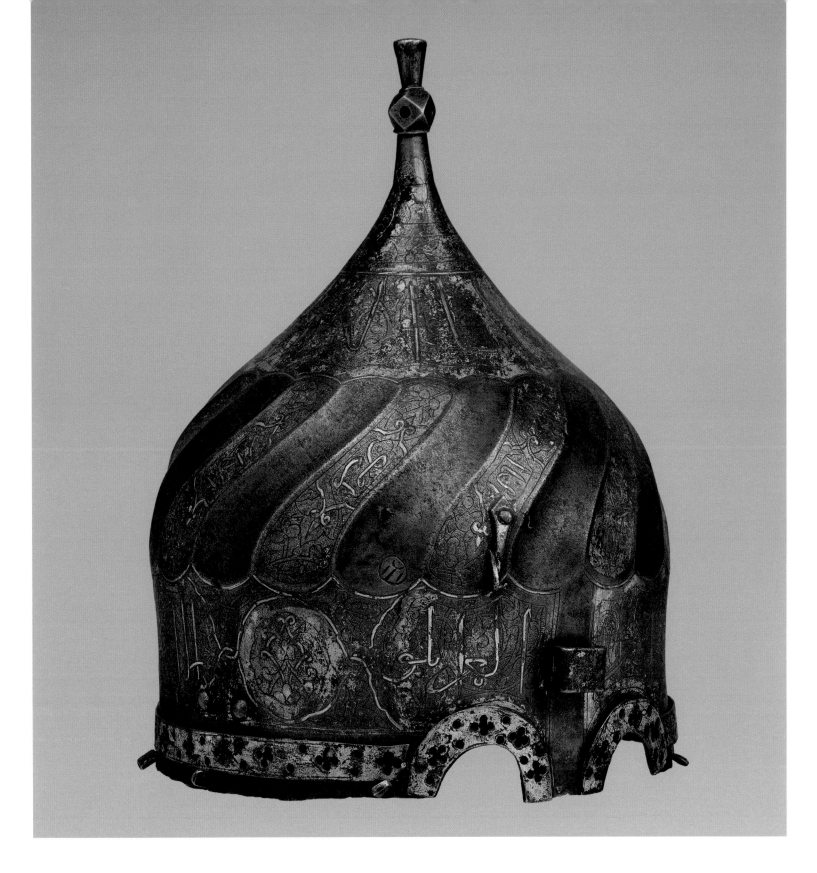

PROVENANCE: Ottoman arsenal, Istanbul; Maurice de Talleyrand-Périgord, duc de Dino, Paris.

REFERENCES: Cosson 1901, pp. 111–12, no. N.3, pl. 8; Stone 1934, p. 41, fig. 54; Katonah 1980, no. 23, ill.; Washington, D.C., and other cities 1982–83, p. 34, ill.; Florence 2002, p. 48, no. 2.

NOTES

1. Askeri Müzesi, Istanbul, no. 8084 (unpublished).
2. Metropolitan Museum, acc. no. 04.3.209; see Cosson 1901, p. 112, no. N.4, pl. 8.
3. Askeri Müzesi, nos. 6885, 8084, 72654 (unpublished); Museo Nazionale del Bargello, Florence, no. C 1645 (see Florence 2002, p. 48, no. 2). The helmet in Paris (Musée de l'Armée, Paris, no. P.O. 2668, unpublished) is inscribed with the name of its owner, Ishak Bey, and although it is not possible to identify him with certainty, it is probably either the Ottoman general Ishak Bey b. Evrenos Ghazi (d. ca. 1460?) or the Karamanid prince of the same name who ruled in Anatolia in 1464–65.
4. Such as one in the Topkapı Sarayı Museum, Istanbul, no. 13/46, said to be a tunic of Selim I (r. 1512–20); see Rogers 1986, no. 7. Later in the seventeenth century, this design can be seen on a Safavid bowl now in the Victoria and Albert Museum, London, no. M.718-1910; see Melikian-Chirvani 1982b, pp. 342–44, no. 159.
5. See, for example, Askeri Müzesi, Istanbul, no. 22517 (unpublished). This knee defense is of a structural type that, by comparison to European knee defenses, must also be of the late fifteenth to early sixteenth century.

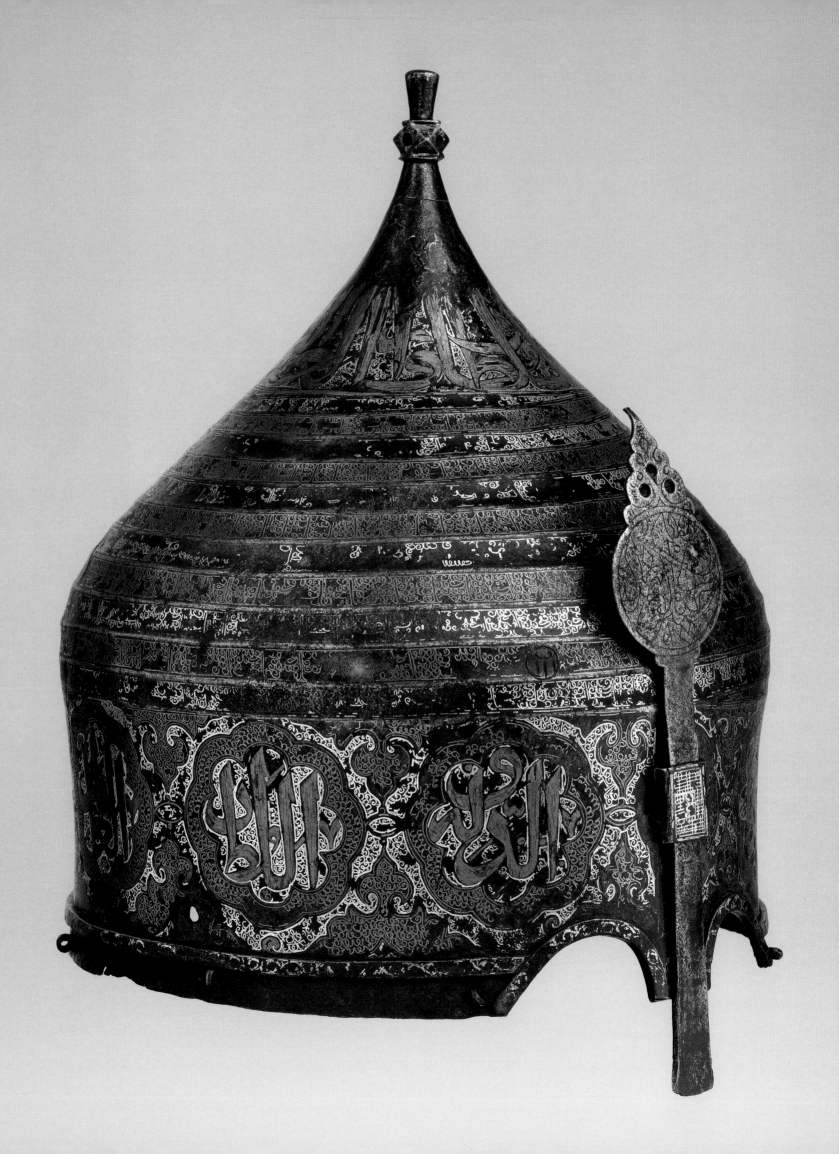

28 · Helmet

Western Iran, Turkman style, late 15th century
Steel, iron, silver, copper alloy
Height 11½ in. (29.2 cm); weight 3 lbs. 5 oz. (1,496 g)
Rogers Fund, 1904
04.3.461

DESCRIPTION: The edge of the bowl is fitted with eight vervelles for the attachment of an aventail; above these is riveted a narrow iron band that encircles the rim, with an additional applied band over each eye. The bands are damascened in brass and silver with foliate scrolls. Immediately above the band at each side are two rivet holes for the attachment of chin straps; one hole on the left side retains a rivet with a domed copper-alloy head. Set between the eyes is a nasal bar with a flat circular tip engraved with an inscription (a) and surmounted by a pierced, palmette-shaped finial; the nasal is held by a bracket, or pressure clamp, damascened overall in silver with geometric ornament.

A large rectangular patch, riveted flush into the back of the bowl in the lower register, is decorated to match the surrounding area and appears to be a repair made at the time the bowl was forged. The nasal, which lacks damascened ornament and is considerably more corroded than the rest of the helmet, may be associated.

The decoration of the bowl is organized in three registers. The lower register consists of a wide band damascened in brass with nine lobed medallions containing bold Arabic inscriptions (b); the wide strapwork bands forming the medallions are filled with tiny pseudo-calligraphic squiggles, and the medallions are connected to one another by delicate interlaced fillets. The areas between the medallions are filled with palmettes, also damascened in brass with squiggles, while the remaining ground is covered with silver-damascened squiggles. The middle register is masterfully forged with a series of narrow, almost horizontal channels that encircle the bowl in a very gradual ascending spiral; the channels are alternately damascened in brass and silver with squiggles. The upper register is damascened in brass with a continuous inscription around the apex (c), the background filled with silver-damascened squiggles, now very worn.

Incised in the middle register, above the right eye, is the *tamġa* of the Ottoman arsenal.

INSCRIPTIONS:
a. (On the nasal)
(Undeciphered)

b. (Around the base)
الدولة / السلطان / العالم / الدولة / الكامل / القائم (؟) / الجماعة / ...،/ الدنيا ...
Wealth, the sultan, the learned, wealth, the complete, the steadfast (?), the community, . . . the world . . .

c. (Around the top)
العز الدائم و الاقبال و الدولة السلطان و ...
Perpetual glory and prosperity and wealth, the sultan and . . .

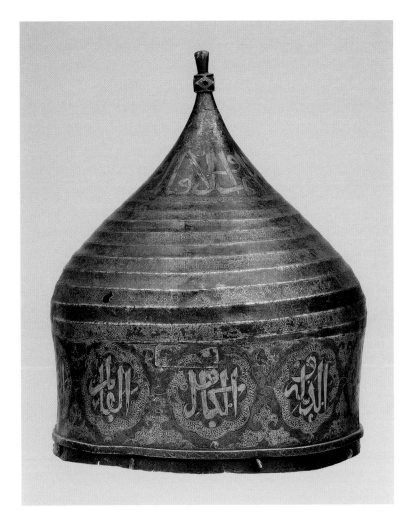

Horizontally fluted turban helmets such as this are rare. Among the many examples surviving in Istanbul, only two in the Askeri Müzesi are of this type.[1] As with most of the inscriptions on such helmets, those on the Museum's are of a general nature. However, of the examples in the Askeri Müzesi, one is inscribed with a long verse in Persian in a truncated script of the same type as that on a leg defense in the Museum's collection (cat. 10).[2] The other example in the Askeri Müzesi is inscribed in both Arabic and Persian and gives the name of Yasr (or Syar) Shah ibn Sultan Khalil,[3] which presumably refers to a son of the Ak-Koyunlu sultan Khalil. It is probable that the Askeri and Metropolitan helmets were made in Iranian workshops of the Ak-Koyunlu period during the late fifteenth century.

Much of the surface of both the Museum's helmet and the Yasr Shah helmet are covered with tiny, scroll-like "squiggles." This type of decoration is often found on Turkman helmets and armor of this period and can be characterized as pseudo-inscriptions added for decorative or perhaps even talismanic reasons. Many such helmets have nasals that must also have served as miniature alems, or standards, and probably identified tribal or dynastic groups. The nasal on the Museum's helmet, as on many others, terminates in a medallion with a palmette form at the top. The inscription, which has not been translated, is not in Arabic and is most likely a Turkish dialect. Eventually, it might provide a clue to the precise origin of helmets with nasals of this form.

PROVENANCE: Ottoman arsenal, Istanbul; Maurice de Talleyrand-Périgord, duc de Dino, Paris.

REFERENCES: Cosson 1901, p. 113, no. N.11; Stone 1934, p. 41, fig. 54.

NOTES

1. Askeri Müzesi, Istanbul, nos. 163, 5745; see notes 2 and 3 below.
2. Askeri Müzesi, Istanbul, no. 5745; see Kalus 1992, p. 164, fig. 12.
3. Askeri Müzesi, Istanbul, no. 163; see ibid., pp. 162–63, fig. 8.

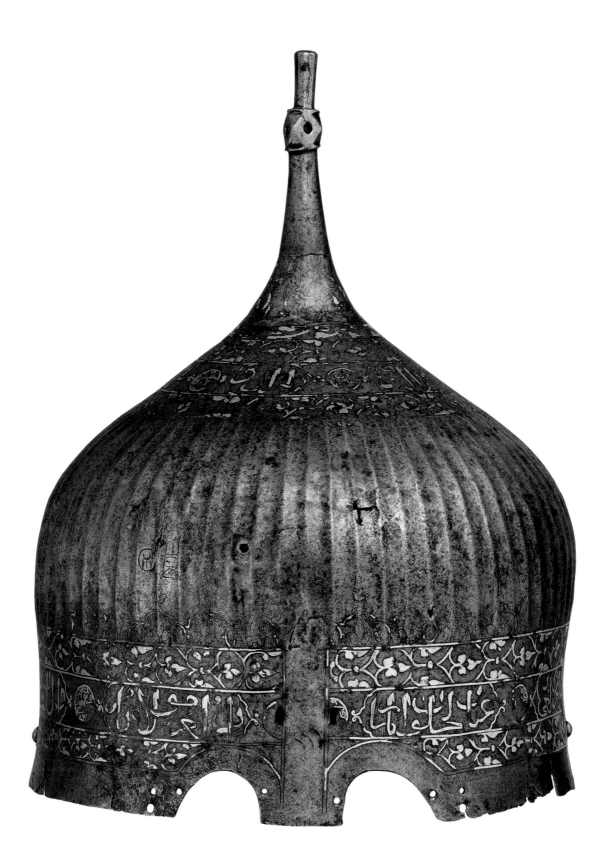

29 · Helmet

Turkey or Iran, Turkman style, 15th century
Steel, silver, copper alloy
Height: 12¼ in. (31.2 cm); weight 2 lbs. 9 oz. (1,161 g)
Bequest of George C. Stone, 1935
36.25.109

DESCRIPTION: The bowl is of typical "turban helmet" type but slightly squatter and with an unusually elongated, separately applied finial. Rivet holes around the edge indicate that it was formerly fitted with applied reinforcing bands on the cusps over the eyes and around the edge and with vervelles below this for the attachment of a curtain of mail, all of these now missing. Holes for the missing nasal bracket are pierced at the front, and a single hole higher up and to the right of center denotes the missing hook for securing the mail curtain in a raised position. Two large copper rivets at each side presumably served to attach a chin strap.

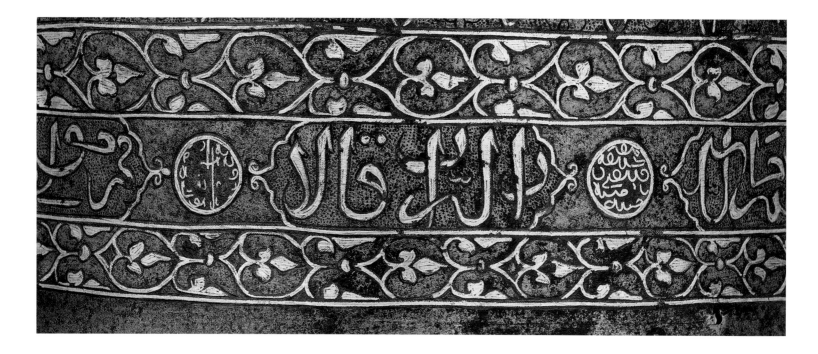

The decoration is organized in three registers, the upper and lower ones consisting of horizontal bands of engraved ornament and inscriptions damascened in silver, the middle register vertically fluted with seventy channels. The lower register has three bands, two narrow outer ones with repeating foliate ornament framing a wider band with circles enclosing pseudo-calligraphic "squiggles" alternating with elongated cartouches enclosing Arabic inscriptions (a) on a stippled ground; the upper edge of the top band is decorated with a frieze of interlocking foliate forms that project into the fluted middle area. The decoration at the top repeats that of the lower register, with Arabic inscriptions (b) and two additional bands of foliate ornament extending up to the applied finial.

Engraved on the right side is the *tamġa* of the Ottoman arsenal and a *tuğra* (c).

INSCRIPTIONS:

a. (In the middle band around the base)

العز مولانا / السلطان الا / عظم و الخا|قان| / المعظم و مالك / الرقاب |كذا| الا|مم| / مولى ملوك /
العرب و العجم / ...

Glory [to] our lord, the greatest sultan, the mighty Khaqan, master of the necks of nations, the lord of the kings of the Arabs and Persians . . .

b. (Around the top)

العز ... / السلطان|ان| / احمد (؟) / ...

Glory . . . the sultan, Ahmad (?) . . .

c. (The *tuğra*)

فرهاد (؟) ...

Farhad (?) . . .

Annemarie Schimmel noted that there are a number of missing or superfluous letters in the inscription and that it must have been copied by someone who did not know Arabic.[1]

The *tuğra* engraved on the side of the helmet is perhaps that of the owner. It is of a form that has similarities with *tuğras* of the Turkman period in Iran and Anatolia and with those of the

Ottomans.[2] Unfortunately it is very worn, but it has been tentatively read to include the name Farhad. It is possibly the same *tuğra* as that engraved on a knee defense in the Askeri Müzesi in Istanbul, and if so is certainly Ottoman.

PROVENANCE: Ottoman arsenal, Istanbul; S. Haim, Istanbul; George Cameron Stone, New York.

Unpublished.

NOTES

1. Annemarie Schimmel (personal communication, 1984).
2. For Turkman examples, see the *tuğra* of the Ak-Koyunlu ruler Uzun Hasan on a document of 1473 in Fekete 1977, no. 20, pl. 71.

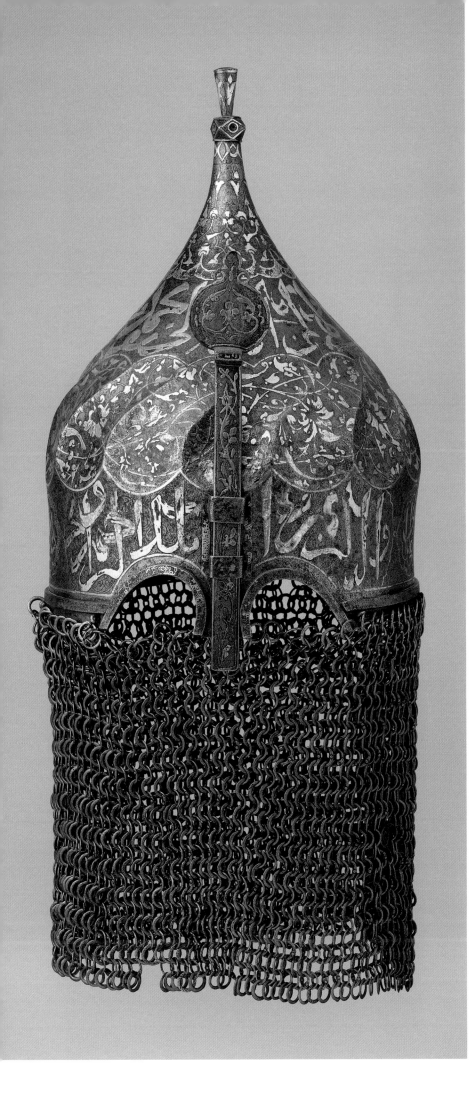

30 · Helmet with Associated Aventail

Turkey, Turkman style, late 15th–16th century
Steel, iron, silver, copper alloy
Helmet, height 13⅛ in. (33.2 cm); weight 3 lbs. 9 oz. (1,618 g)
Aventail, height 9⅝ in. (24.5 cm); weight 3 lbs. 13 oz. (1,730 g)
Purchase, Anonymous Gift, 1950
50.87

DESCRIPTION: The edge of the bowl retains its original seven vervelles for the attachment of the aventail. A narrow iron band is riveted around the rim above the vervelles, with an applied arched band over each eye. A single rivet hole is pierced in the center of each side above the band, presumably for the attachment of the chin strap; a single hole is also pierced at the back, to the left of center, for purposes unknown. At the center of the front are two friction clamps, or brackets, one over the other, to secure the nasal bar. The nasal has a flattened circular finial surmounted by a pierced palmette.

The bowl is engraved and damascened in silver against a dot-punched or stippled ground, and the decoration is organized in three registers. The lower register consists of a wide band filled with Arabic inscriptions (a) in cursive script contained within lobed medallions of alternating circular and rectangular form against a ground of engraved arabesques. The middle register is fluted with fourteen wide, spiraling channels decorated with meandering broadleaf-and-fleshy-petal arabesques. The upper register is divided into two zones by a scalloped band; the lower area is decorated with large Arabic inscriptions (b) in cursive script against a background of arabesques, the area above it with a palmette arabesque that continues up the sides of the finial. The applied bands around the edge, the lobed circular medallions in the lower register, and the scalloped border in the upper register are damascened with pseudo-calligraphic squiggles. The nasal and two brackets are damascened with foliate scrolls, the upper bracket also having what appears to be traces of damascening with copper alloy.

Incised over the right eye is the *tamġa* of the Ottoman arsenal.

Associated with this helmet at the time of acquisition is a heavy aventail constructed of alternating solid and riveted links, the latter closed by round rivets; the solid (forge-welded) rings are slightly heavier and wider than the riveted ones (just over ½ in. versus just under ½ in. [13–14 mm versus 12 mm]). A single row of solid copper-alloy rings encircles the bottom edge (some of them missing), of which seven have a guilloche design stamped on each side. Set into the mail is a copper seal stamped with the *tamġa* of the Ottoman arsenal.

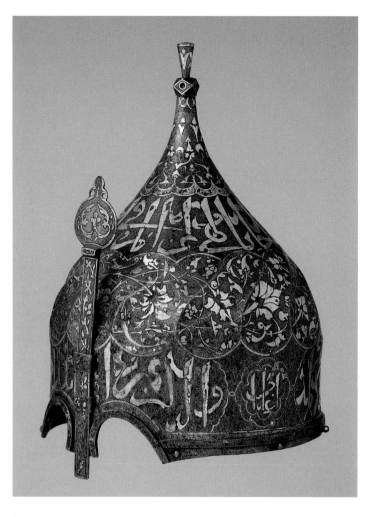

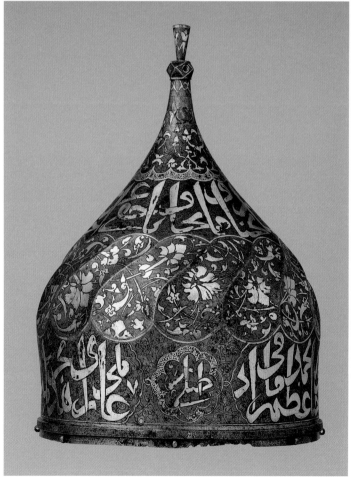

INSCRIPTIONS:

a. (Around the base, various words can be made out)

ملك الرحيم ... |ا|عظم ما في ... عالمي ...

King/dominion, the Compassionate . . . greatest, what is in . . . learned . . .

b. (Around the top, with mistakes and interspersed among words that do not belong, a prayer in Arabic)

يا خفي |الا|لطاف نجنا مما نخاف

O You whose acts of beneficence remain hidden, conceal us from what we fear.

The fluted section of this helmet is decorated with a plethora of floral forms, creating a carpetlike surface. Among these elements are carnation-like blossoms and long, spearlike flowers composed of lobed petals, as well as split, trefoil, and palmette-shaped leaves. Certain of the floral forms have wide stems that flare toward the base of the flower; on each side of the stem are tiny ovular leaves, in between which is a circle. While very similar but not identical floral forms occur on Mamluk and Ottoman metalwork of the late fifteenth century and early sixteenth century, a number of other decorative details places the Museum's helmet firmly within a Turkman context. Foremost among these are the long, spearlike leaves, which decorate a large number of helmets and armors, including comparable turban helmets in the Philadelphia Museum of Art, the Victoria and Albert Museum, London, the Louvre Abu Dhabi, and the Askeri Müsezi, Istanbul.[1] The latter has been published several times, most recently by Michael Rogers, who read the text as including the name "Farrukhyasar," probably the last

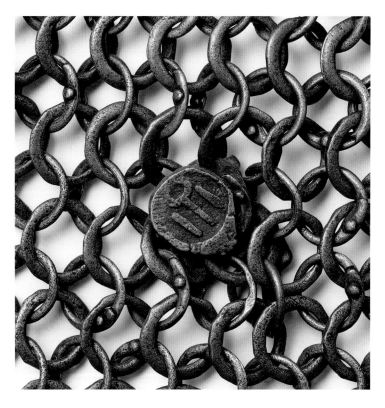

Fig. 23. Dish. Turkey, Iznik, mid-16th century. Stonepaste, painted in turquoise and two hues of blue under transparent glaze. The Metropolitan Museum of Art, New York, Bequest of Benjamin Altman, 1913 (14.40.727)

Shirvanshah Farrukhyasar (r. 1462–1501).[2] He noted, however, that the "arrangement and ungrammatical construction make it difficult to suggest the order and parts of words"—exactly the problem found with the Museum's helmet, where the inscriptions are certainly in Arabic but the words are jumbled and contain mistakes and must have been copied by a craftsman who did not understand their meaning. Another helmet with carnation-like forms similar to those on the Museum's helmet is in the Furus-iyya Art Foundation, Vaduz, and is inscribed with the name "Khalilallah," possibly the Shirvanshah Khalilullah I (r. 1418–63) but more probably the Ak-Koyunlu Khalilullah II (r. 1524–35) while still a prince.[3] The decoration on the Museum's helmet is not exactly the same as those on the "Farrukhyasar" group, but the common elements mentioned above suggest a close relationship and a dating for the armor and helmets in this group to between the last years of the fifteenth century and about 1525.

The Sunni rulers of Shirvan had a close and usually warm relationship with the Ottomans,[4] and the existence of the Iznik dish (fig. 23) decorated with flowers of the same type as those on the "Farrukhyasar" helmet would seem to prove that this artistic style was popular over a wide area. All of this raises once again the problem of where the Museum's helmet was made: the style is certainly Turkman, but was it crafted by a Turkman working in Azerbaijan or by a Turkman working in Anatolia or Istanbul?[5]

PROVENANCE: Ottoman arsenal, Istanbul; Nathaniel de Rothschild, Vienna; Albert de Rothschild, Vienna; Alphonse de Rothschild, Vienna; Blumka Gallery, New York.

REFERENCES: Migeon 1907, p. 245, fig. 200; Migeon 1926, pl. LI; Grancsay 1958, pp. 243–44, ill.; [Nickel] 1968, p. 219, ill.; Nickel 1969, p. 91, ill.; Nickel 1974, p. 83, ill.; Alexander 1983, p. 100, fig. 5; Grancsay 1986, pp. 446–47, fig. 109.2; Nickel 1991a, p. 50, ill.

NOTES

1. These four helmets, like the Museum's, are forged with large bowls and broad spiral flutings. For the Philadelphia (no. 1977-167-953) and Istanbul (no. 5911) examples, see Alexander 1983, pp. 98–100, figs. 4, 3, respectively; for the Istanbul helmet, see also Washington, D.C. 1991–92, p. 195, no. 84. For the Victoria and Albert helmet (no. 399-1888), see North 1976, pp. 274–76. The helmet now in the Louvre Abu Dhabi was acquired in June 2015 and previously published in Paris 1988, no. 2. The large splayed floral forms on all these helmets are almost identical to those on an Iznik dish in the Metropolitan's collection (fig. 23).

2 This might be a generic reference to the Shirvanshah dynasty of eastern Transcaucasia, present-day Azerbaijan. The verse on the "Farrukhyasar" helmet is also found on three others in the Askeri Müzesi, Istanbul, nos. 163, 5745, 9488; these include the phrase "Yasr or Syar Shah" and in one case "Yasr or Syar Shah ibn Sultan Khalil." The interpretation of these names remains elusive, but when and if this problem is solved, the origin of a large group of these helmets should become clear.

3. Furusiyya Art Foundation, Vaduz, no. R-832; see Paris 2007/Mohamed 2008, p. 323, no. 310 (the possibility that this refers to Khalilullah II was not included there).

4. After their incorporation into the Safavid Empire in 1538, the Sunni rulers of Shirvan sought Ottoman help to regain their independence. In 1590 Shirvan became an Ottoman province.

5. There is even the possibility that some of the armors and helmets of this type were made in Azerbaijan for the Ottoman market; see Geneva 1995, p. 137, no. 80, for the importation of "Derbendi" armor in 1500–1501.

31 · Helmet

Egypt or Syria, Mamluk or post-Mamluk period, ca. 1515–20
Steel, iron, copper alloy, gold
Height with mail 24¾ in. (63 cm), without mail 12⅜ in.
(31.5 cm); weight (without mail) 5 lbs. 1 oz. (2,319 g)
Bequest of George C. Stone, 1935
36.25.116

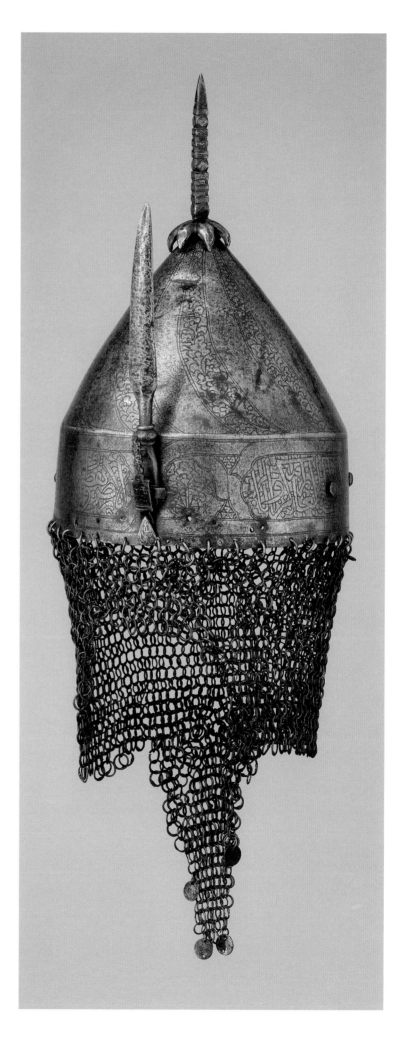

DESCRIPTION: The helmet is composite and consists of an early bowl to which were
later added the apical spike, spearlike fixtures at the brow, and a curtain of mail. The
squat, conical bowl has a stepped profile, with a wide rim from which the upper part
tapers to a blunt apex. The bowl was originally fitted with a peak and sliding nasal at
the brow, plate cheekpieces, and a plate neck defense, now missing but for which
the rivets or rivet holes remain. The edge of the rim is pierced with numerous closely
set holes for the lining rivets. Rivet holes across the brow denote the placement of
the peak, above which is the original nasal bracket. Two large copper rivets at each
side formerly secured the leather straps for the cheekpieces, and three iron loops at
the back retain portions of the copper hinges by which the neck guard was attached.
The rim is engraved with interlaced strapwork forming alternating round and
rectangular lobed cartouches, the former containing symmetrical foliate forms
against a stippled ground, the latter Arabic inscriptions (a) in a cursive script, also
on a stippled ground. The tapering upper part of the bowl is engraved with nine
spiral bands containing thick foliate scrolls. Minute traces of gilding around the rear
copper rivet on the right side suggest that at least portions of the engraved decora-
tion were formerly gilt.

Incised on the right side is the *tamğa* of the Ottoman arsenal.

The later additions to the bowl, all of iron, are of much cruder workmanship
and are undoubtedly of later date. The apex was fitted with a faceted iron spike
seated on a six-petaled foliate base; the facets of the spike are inlaid with brass and
engraved with simple geometric ornament. Three fixtures are applied to the brow.
A long, spearlike fixture was set into the nasal bracket, its slightly convex blade
engraved in Arabic (unread). In front of the nasal bracket was riveted a smaller
fixture consisting of a flat, rectangular panel from which rises a tall, irregularly
notched finial, the face of this plate damascened with gold, possibly with remnants
of an Arabic inscription. Riveted in front of that fixture was a smaller one in the
shape of an inverted heart, damascened in gold with an Arabic inscription. Attached
to the rim is a curtain of mail shaped over the face, long at the sides and with an
added triangular extension at the center of the back to which four circular gilt-
copper medallions are attached. The rings are alternately solid and riveted and
measure approximately ½ in. (11 mm) in diameter.

INSCRIPTION:
a. (In the rectangular lobed cartouches around the rim)

قل اللهم مالك المـ|ـلـ|ـك التوتى |كذا| الملك |من| تشا|ء| و تـ|ـنـ|ـزع الملك ممن تشاء| / الحكيم
العالم ... / الارض و فى نقطة (؟) الاقلام (؟) و السلام على ...

Say: "O Allah! Lord of Power (and Rule) Thou givest Power to whom Thou pleases,
and Thous strippest off [Power from whom Thou pleasest]." (Qur'an 3:26).
. . . the Wise, the All-Knowing . . . earth and in the point (?) of pens (?) and peace be
upon . . .

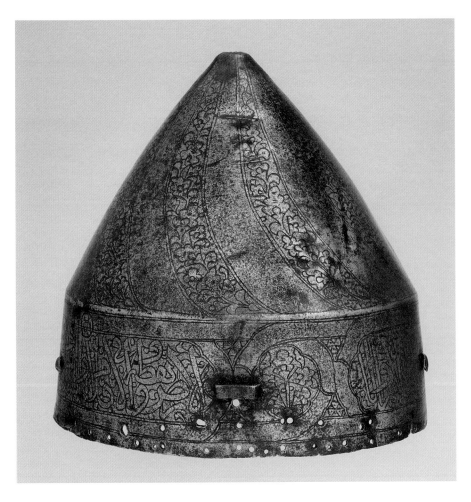

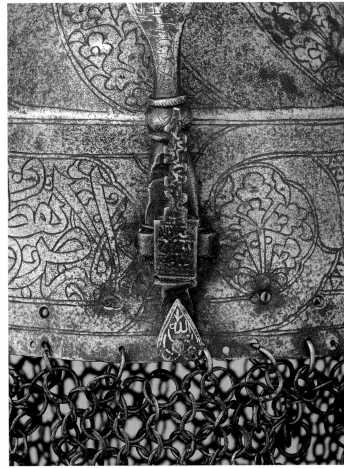

The shape of this helmet is unique, making it difficult to place on that basis alone. Fortunately, the wide rim is embellished with an alternating design of cartouches enclosing leaf forms and inscriptions that is very similar to a Mamluk example in the Topkapı Sarayı Museum, Istanbul.[1] That helmet also bears a Mamluk blazon and is inscribed with the name of Kha'ir Bey (d. 1522), the last Mamluk governor of Aleppo. The Kha'ir Bey helmet is pivotal to the attribution of the Museum's helmet and several other related examples, including helmets in Istanbul, Bologna, and Stockholm,[2] and a shaffron made for the Ottoman sultan Selim I (r. 1512–20).[3] That comparable decorative and structural elements can be found on both Mamluk and Ottoman pieces should not be surprising, especially on those that relate to Kha'ir Bey. As the Mamluk governor of Aleppo who defected to the Ottomans, he played a major role in the pivotal Ottoman victory at Marj Dabiq in 1516, after which he was rewarded with the governorship of Egypt under Selim I. At that time Mamluk craftsmen also began to work for the Ottomans, and it is this milieu into which the Museum's helmet falls.[4] It must have been produced during the last years of the Mamluk Empire or during the years immediately after the Ottoman conquest, although whether it is Mamluk or Ottoman remains uncertain.

The inscription on the Museum's helmet is curious, as it is executed in a beautiful thuluth script and begins with a sentence from the Qur'an, yet continues with a series of fragmentary words and sentences.

The apical spike, fittings at the brow, and mail are later additions, probably North African, suggesting that the helmet may have been refitted for use during the Mahdi uprising in the Sudan in the late nineteenth century.

PROVENANCE: Ottoman arsenal, Istanbul; W. O. Oldman, London; George Cameron Stone, New York.

Unpublished.

NOTES

1. For the helmet in the Topkapı Sarayı Museum, Istanbul, see Stöcklein 1934, pp. 213–14, fig. 13, and Mayer 1943, fig. 9. Another Mamluk helmet with similar decoration is in the Furusiyya Art Foundation, Vaduz, no. R-807; see Lexington 2010, p. 171, no. 229, ill.
2. Topkapı Sarayı Museum, Istanbul, no. 822 (unpublished); Museo Civico Medievale, Bologna (see Boccia 1991, p. 208, no. 472); Livrustkammaren, Stockholm, no. 9659 (see Stockholm 1985, p. 20, no. 18).
3. Askeri Müzesi, Istanbul, no. 208-82; see Güçkıran 2009, pp. 36–37. This is one of several shaffrons inscribed with the name and titles of Selim that probably date to the years after he conquered the Mamluks (1517), as the inscriptions include the title "guardian of the Holy Shrines."
4. For Mamluk craftsmen working for the Ottomans, see cat. 32.

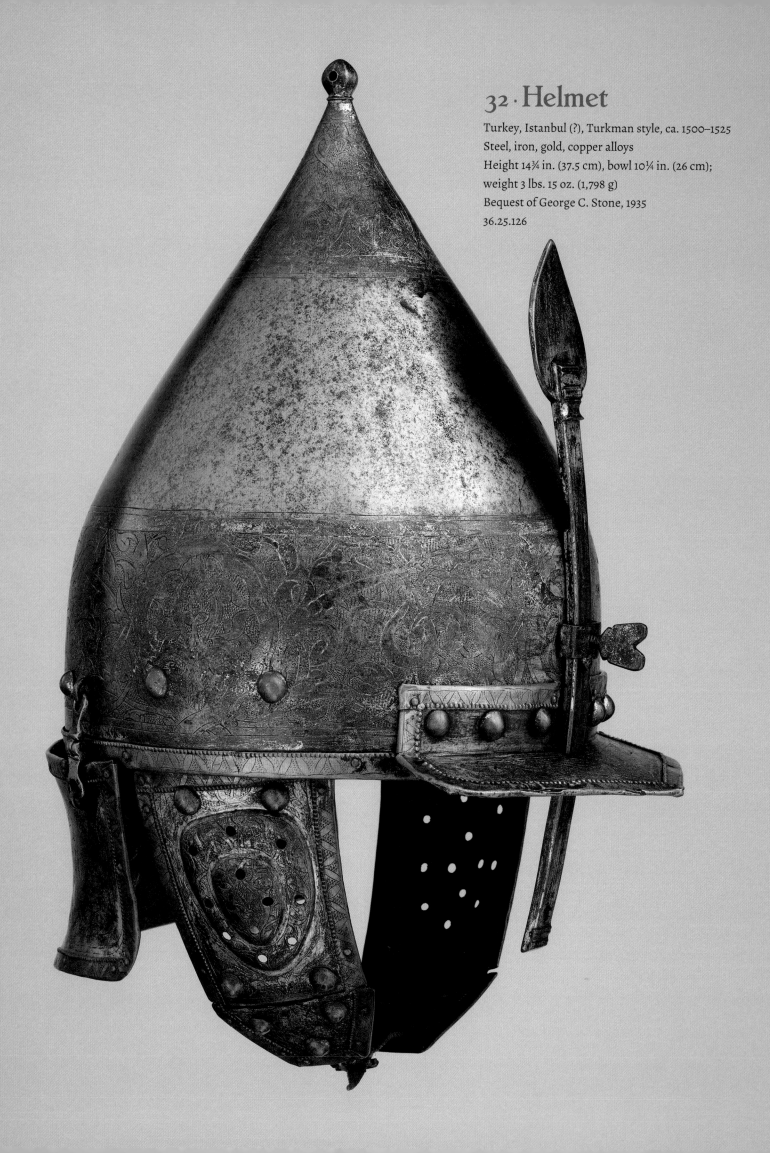

32 · Helmet

Turkey, Istanbul (?), Turkman style, ca. 1500–1525
Steel, iron, gold, copper alloys
Height 14¾ in. (37.5 cm), bowl 10¼ in. (26 cm);
weight 3 lbs. 15 oz. (1,798 g)
Bequest of George C. Stone, 1935
36.25.126

DESCRIPTION: The helmet is constructed of a bowl to which are applied a peak and sliding nasal, cheekpieces, and neck defense. The tall, conical bowl is forged from a single plate of steel and is set at the apex with a pointed, eight-sided finial drilled through the center, presumably for the attachment of a streamer. The decoration is arranged in three registers: the wide lower register around the rim is engraved and gilt on a stippled ground with four lobed medallions, those at the back and front containing an undeciphered inscription in Arabic letters and those at the sides containing symmetrical foliate ornament, with an intertwining floral arabesque between; the middle register is of bright polished steel; and the upper register is engraved and gilt with an intertwining floral arabesque. The rim of the bowl is fitted with a gilt brass border held by tiny gilt-copper rivets; the border's upper edge is beaded, its surface engraved with simple leaves arranged in zigzag patterns against a tooled zigzag ground. The peak, cheekpieces, and neck defense are similarly trimmed with gilt brass and are etched and gilt to match the bowl. The peak is held rigid to the bowl by six rivets with large domed gilt-copper heads and is pierced at the center to accommodate a sliding nasal. The nasal bar of gilt steel has a flattened, spear-shaped finial and is held by a gilt-iron bracket with a setscrew that is riveted above the peak. The narrow cheekpieces are attached to the bowl by internal leather straps held by rivets with large gilt-copper heads. Each cheekpiece is now formed of only two plates: a larger upper one embossed with a pointed oval panel pierced for hearing, and a smaller triangular one to which a leather strap (left) and bronze buckle (right) are affixed for securing the helmet beneath the chin. Each would originally have been wider, with a shaped plate on either side (as on cat. 33). The neck defense is composed of a single plate, concave in profile and pointed at the bottom, and is secured to the bowl by three two-part brass hinges attached through steel loops; it retains portions of the original canvas lining. The engraved medallion in the center of the neck defense also contains an undeciphered inscription matching those on the bowl. Two lining rivets with large gilt-copper heads are set at the back, above the neck guard.

Much of the gilding on the decorative bands and on the copper trim and rivets has been lost; the internal leathers on the cheekpieces are modern.

INSCRIPTION:
On the neck
(Undeciphered)

This is one of only two complete early Islamic helmets in the Museum's collection to retain its original peak, cheek, and neck defenses and nasal.[1] These elements encompass decorative and formal features that are found on Mamluk, Ottoman, and Turko-Iranian objects.[2] Helmets of this conical shape were used at one time or another throughout the Islamic world from at least as early as the Umayyad (661–870) era, but the form—especially with peak, cheek, and neck defenses and nasal—was later common in the Mamluk and Ottoman empires. Details on this helmet such as the applied brass border engraved with a zigzag motif occur on both Mamluk[3] and Ottoman helmets of the late fifteenth to early sixteenth century, while the fragmentary inscriptions (frequently just single letters) and the fleshy floral forms are characteristic of an eastern Turkman influence.

From the fifteenth and sixteenth centuries on, the Ottoman Empire, and especially Istanbul, was the recipient of a multitude of diverse cultural influences—often, but not always, as the result

of conquests in southern Europe, Syria, Egypt, and Iran. Artists and artisans from these various regions, among them Urban the cannon maker, Baba Nakkaş the designer, and the swordsmiths Haji Sunqur, Haji Murad Khuskadam, and Ibrahim al-Maliki, were recorded as working in the Ottoman capital.[4] Consequently, it is not surprising that a helmet such as this example would exhibit a range of elements with wide-ranging sources.

In addition to the applied brass border engraved with a zig-zag motif (stylized lotus petals),[5] other Mamluk features on this helmet include the large rivet heads and the small projection on the nasal clamp.[6] Ottoman helmets similarly fitted with peaks, nasals, cheekpieces, and neck defenses are numerous (see cat. 33).

An important feature regarding attribution is the style of the inscription and of the arabesque decoration encompassing it. The inscriptions, made up of individual letters and parts of words, also belong to the large corpus of inscriptions seen on many turban helmets and associated armors that suggest a Turkman

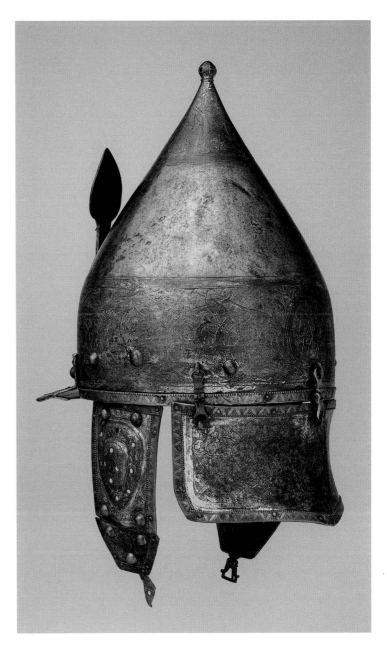

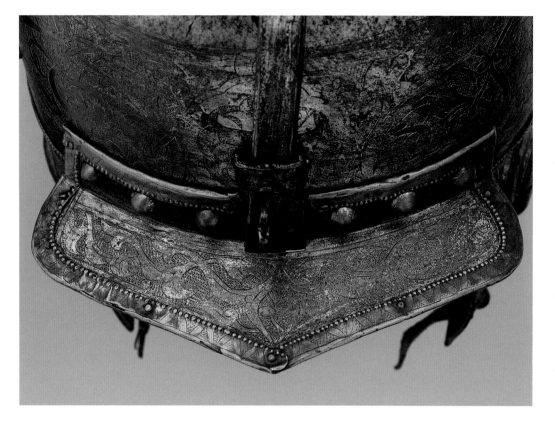

NOTES

1. The other complete early Islamic helmet is cat. 33.

2. Of the major influences on this helmet, the Turkman style can be the most confusing, especially when considering contemporary geographical labels. The Turkman, originally from Central Asia, spread throughout the Near and Middle East. Their specific influence in the present context was via the Ak-Koyunlu ("White Sheep" Turkman) Empire, which covered large parts of present-day southern Caucasus, Iran, Iraq, Turkey, and parts of north-eastern Syria.

3. One early Mamluk example, with an exceptionally high bowl, was made for Sultan al-Ashraf Sayf al-Din Barsbay (r. 1422–38) and is now in the Musée du Louvre, Paris, no. OA. 6130; see, for example, Washington, D.C., and other cities 1981–82, pp. 112–13, no. 41, and Behrens-Abouseif 2014, pl. 8. Another Mamluk example, which is inscribed with the name of Sayf al-Din al-Ashraf Kha'ir Bey (governor of Aleppo in 1504/5) and has a small, almost hemispherical bowl, is in the Topkapı Sarayı Museum, Istanbul; see Stöcklein 1934, pp. 213–14, fig. 13, and Mayer 1943, p. 8, fig. 9.

influence.[7] The use of individual letters and single words on a turban helmet in the Oberösterreichisches Landesmuseum, Linz, has been carefully analyzed by Wilhelm Diessl, and his drawing of a section of the inscription succinctly demonstrated the way these inscriptions were constructed.[8]

An eastern Turkman influence in the decoration of the Museum's helmet is seen in the type of leaves comprising the arabesque; fleshy and elongated, they have a secondary leaf growing from their tips. This type of fleshy leaf form belongs to what has been called the Turkman style, of which there are many examples in this catalogue.[9] The leaf forms on the Museum's helmet are almost identical to those depicted on an ornament from the Qur'an by the Ottoman calligrapher Seyh Hamdullah dated 1491, on an Ottoman shaffron inscribed with the name of Selim I that can be dated to between 1517 and 1520, and on an Ottoman silver jug of the late fifteenth to early sixteenth century in the Khalili Collection, London.[10]

The possible attributions for the production of this helmet range from a non-Arabic-speaking craftsman working in a Turkman style in an Ottoman workshop to a Mamluk workshop in southern Anatolia or a Turkman craftsman in northern Syria, or even to a Turkman craftsman transplanted to Istanbul after the Ottoman conquests in 1517.[11]

PROVENANCE: Louis Bachereau, Paris; George Cameron Stone, New York.

REFERENCE: Stone 1934, pp. 38, 42, fig. 51, no. 1, fig. 55.

4. Urban, probably a Hungarian or Transylvanian, constructed a huge weapon (named *bogaz kesen*, the "throat cutter") in 1452 for Mehmed II (r. 1444–46, 1451–81); see Babinger 1978, pp. 78–96. Baba Nakkaş, possibly an Uzbek from Central Asia, was one of the most important designers in the *nakkaşhane* (royal scriptorium) of Mehmed II and later of his son Bayezid II (r. 1481–1512); see Raby and Tanındı 1993, p. 60. Haji Sunqur was probably Egyptian; see Yücel 2001, p. 161. Haji Murad Khuskadam was probably Syrian. Ibrahim al-Maliki was probably Egyptian and worked first for the Mamluk Qansawh al-Ghauri (r. 1501–16) and then for Selim I (r. 1512–20) after the Ottoman conquest in 1516.

5. This motif can be clearly seen on a Mamluk helmet in the State Hermitage Museum, Saint Petersburg, no. 38, which has a nasal inscribed with the name of the Mamluk sultan Qa'itbay (r. 1468–96); see Miller 1976. Similar brass rims/borders engraved with a zigzag motif occur on a helmet in the Furusiyya Art Foundation, Vaduz, no. R-803 (unpublished), and on another in the Museo Stibbert, Florence, no. 3518 (see Herz 1910, no. 2, pl. VII; Florence 1997–98, p. 88, no. 52; Florence 2014, p. 114, no. 2).

6. The helmet of Sultan Barsbay is another example with a small projection on the nasal clamp and large rivet heads (see note 3 above).

7. See, for example, the armors cats. 6, 7. A similar treatment of an inscription appears on a helmet with a small bowl-shaped skull—related to the Museum's example by a number of details, such as its brass trim and hinges—now in the Livrustkammaren, Stockholm, no. 9659; see Stockholm 1985, p. 20, no. 18. At first glance, its inscription looks to be correct, but in fact it merely repeats part of a phrase.

8. Oberösterreichisches Landesmuseum, Linz, no. C1993/II; see Diessl 1981, fig. 25.

9. For the Turkman style, see, especially, Allan 1991; for examples in the Metropolitan Museum, see cats. 7, 24, 44.

10. For the Qur'an ornament, Topkapı Sarayı Museum, Istanbul, no. Y. 913, fol. 4a, see Atasoy and Raby 1989, p. 92, fig. 92. The shaffron is in the Askeri Müzesi, Istanbul, no. 208-82; see Güçkıran 2009, pp. 36–37 (the inscription refers to Selim as guardian of the two holy shrines and can therefore be dated to after his conquest of the Mamluks in 1517). For the Khalili Collection jug, no. MW 312, see Geneva 1995, pp. 175–76, no. 115.

11. The same difficulty in attribution resulting from the movement of craftsmen during the early sixteenth century is further discussed in cat. 31.

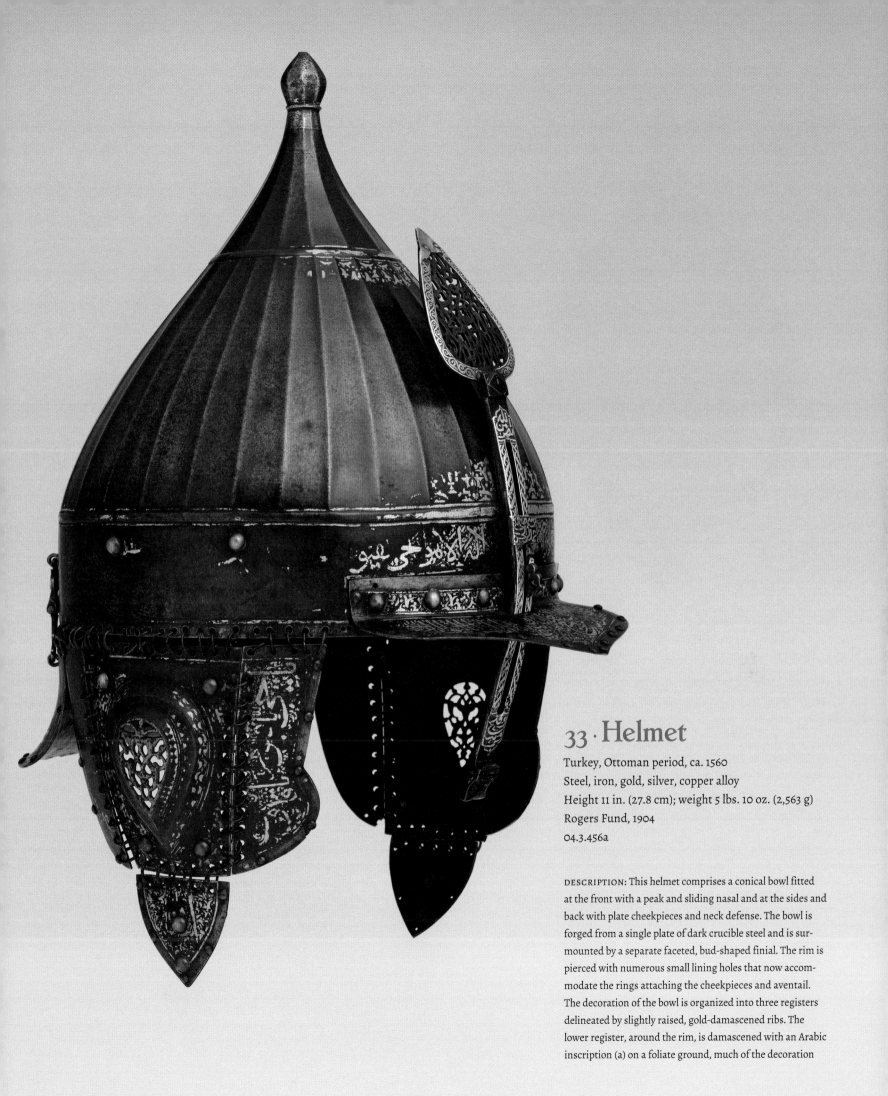

33 · Helmet

Turkey, Ottoman period, ca. 1560
Steel, iron, gold, silver, copper alloy
Height 11 in. (27.8 cm); weight 5 lbs. 10 oz. (2,563 g)
Rogers Fund, 1904
04.3.456a

DESCRIPTION: This helmet comprises a conical bowl fitted
at the front with a peak and sliding nasal and at the sides and
back with plate cheekpieces and neck defense. The bowl is
forged from a single plate of dark crucible steel and is sur-
mounted by a separate faceted, bud-shaped finial. The rim is
pierced with numerous small lining holes that now accom-
modate the rings attaching the cheekpieces and aventail.
The decoration of the bowl is organized into three registers
delineated by slightly raised, gold-damascened ribs. The
lower register, around the rim, is damascened with an Arabic
inscription (a) on a foliate ground, much of the decoration

now effaced on the right side and at the back. The middle register is fluted with twenty-eight shallow vertical channels and is damascened in gold with a split-leaf arabesque around the upper and lower edges. The upper register is fluted with fourteen vertical channels and bears faint traces of gold damascening, which include three horizontal lines that divide this area into four uneven zones. The applied finial, now polished brighter than the bowl, also retains traces of gold damascening. Riveted to the front of the bowl is a pointed peak damascened in gold on its upper face with an Arabic inscription (b) against a floral ground. The peak is pierced to accommodate a sliding nasal bar, which is held by a friction clamp that is damascened in silver with an Arabic inscription (c). The iron nasal bar has a slot down the center and is surmounted by a teardrop-shaped finial pierced with an openwork Arabic inscription (d) and framed by an applied silver border engraved with floral scrolls. The tip of the finial is broken off and has been crudely repaired with a modern silver plate riveted in place. Directly below the finial the nasal is thicker and is chased in relief with a raised diamond within a square. Applied to the face of the nasal bar is a silver plate engraved with a braided design, with Arabic-inscribed cartouches at the top and bottom (e) and with traces of gold damascening on the raised moldings at each end.

Suspended now from rings (but originally from internal leather straps) at the sides of the bowl are two cheekpieces, each of four plates: the central trapezoidal-shaped plate covering the ear is embossed with a pointed oval panel pierced with arabesques and is flanked by shaped plates at the front and back, with a small triangular plate below (that on the left cheek is modern) to which a chin strap is attached. The surfaces of the cheekpieces are damascened in gold with floral designs and, on

the plates surrounding the central one on the right cheek, Arabic inscriptions (f). The neck defense is attached at the back of the bowl by three two-part silver hinges; the plate is deeply concave and ends in a blunt point and is damascened in gold with an Arabic inscription (g) against a floral ground, the center area now completely effaced. A rectangular notch has been cut out at the point of the neck defense. The peak, cheekpieces, and neck defense are outlined in small brass lining rivets, which presumably also once secured an applied border of brass, or perhaps even silver gilt (see also cat. 32).

A long mail face and neck defense, or aventail, formerly attached by butted rings to the rim of the bowl, has since been removed.

INSCRIPTIONS:
a. (Around the rim of the bowl)
بسم الله الرحمن الرحيم الله لا اله الا هو الحي القيوم [لاتأخذه سنة و لا نوم له ما في السموات و ما في الارض من ذا الذي يشفع عنده الا باذنه يعلم ما بين ايديهم و ما] خلفهم و لا يحيطون بشيء من علمه الا بما شاء وسع كرسيه السموات و الارض و لا يؤده حفظهما [و هو العلي العظيم]

In the Name of Allah, Most Gracious, Most Merciful. Allah! There is no god but He, —the Living, the Self-subsisting, Supporter of all / No slumber can seize Him nor sleep. His are all things in the heavens and on earth. Who is thee can intercede in His presence except as He permitteth? He knoweth what (appeareth to His creatures as) Before or After or] Behind them. Nor shall they compass aught of His knowledge except as He willeth. His Throne doth extend over the heavens and the earth, and He feeleth no fatigue in guarding and preserving them for He is the Most High, the Supreme (in glory). (Qur'an 2:255)

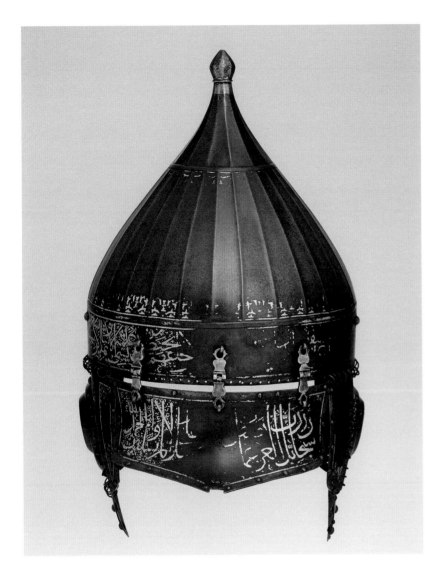

This magnificent helmet, the finest and most complete in the Museum's collection, belongs to a small group that can be attributed to the palace workshops of Süleyman I (r. 1520–66) and his successors in the second half of the sixteenth century. Some of these helmets reflect the highest level of design and workmanship achieved by Ottoman armorers, goldsmiths, and jewelers. The helmets in this group all have bud-shaped finials, and most, but not all, have sides that are vertically faceted or fluted. The conical bowls are always divided into three registers separated by horizontal ribs and have analogous peaks and nasals, cheekpieces and neck guards (the cheekpieces usually having teardrop-shaped bosses with pierced arabesque ornament). Most have nasals with central slots and chiseled, diamond-shaped elements below the large, usually openwork finial. Almost all incorporate within their inscriptions the *ayat al-Kursi*, or "Throne" verse, from sura 2 of the Qur'an.[1]

The decoration on these helmets falls into two distinct groups. Helmets in the first group are covered entirely with a combination of gold damascening and gold plaques in high relief set with precious stones; these opulent examples must have been made for the sultan.[2] Helmets in the second group are damascened in gold with inscriptions and palmette friezes, the decoration rich but more restrained. The Museum's helmet belongs to this second group, which is more numerous and includes two examples in the Hofjagd- und Rüstkammer of the

b. (On the peak)

ربنا تقبل منا انك انت السميع العليم و تب علينا انك انت التواب الرحيم

Our Lord! Accept from us (this prayer), for you are the All-Hearing, the All-Knowing, And forgive us, for you are the Forgiving, the Merciful.

c. (On the friction clamp)

نصر من الله و فتح قريب

Help from Allah and a speedy victory. (Qur'an 61:13)

d. (Pierced work on the nasal)

لا اله الا الله محمد رسول الله

There is no god but God, and Muhammad is the messenger of God.

e. (On the nasal bar)

برسم صفي الدين احمد ابن الحسن

By order of Safi al-Din Ahmad Ibn al-Hasan.

f. (On the right cheekpiece)

يا حي يا قيوم يا قدوس

O Living One! O Self-Subsisting! O Holy One!

g. (On the neck, very worn)

سبحان ربك رب العزة عما يصفو[ن و] سلام [على] المرسلين و الحمد لله [رب العالمين]

Glory to thy Lord, the Lord of Honour and Power! (He is free) from what they ascribe

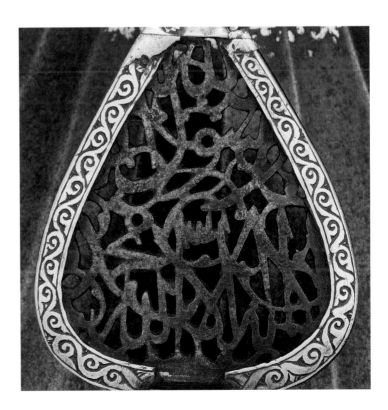

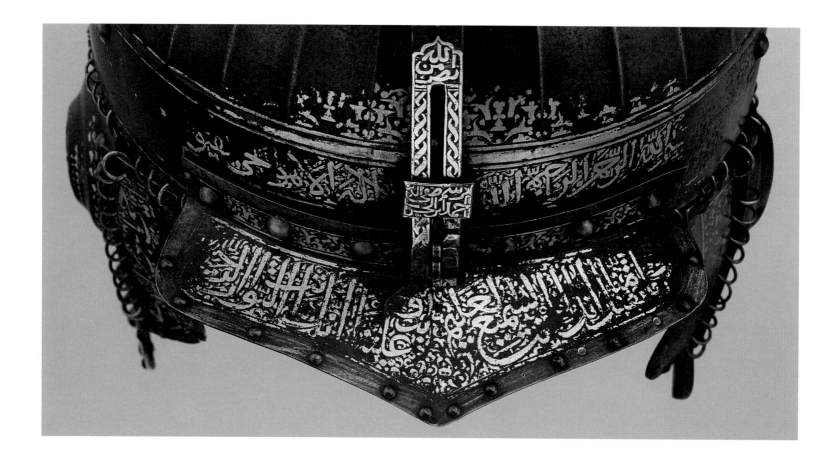

Kunsthistorisches Museum, Vienna, one made for Sokollu Meh-met Paşa (d. 1579), governor of Bosnia and grand vizier to Süley-man the Magnificent, the other for Stephan Báthory (1522–1586), prince of Siebenbürgen and later king of Poland.³ Additional examples in this group include two helmets each in the Topkapı Sarayı Museum, Istanbul;⁴ the State Hermitage Museum, Saint Petersburg;⁵ and the Kremlin Armory, Moscow.⁶

Decoration aside, the Topkapı helmet mentioned above (no. 2/1187) was probably made for Süleyman I and is of exactly the same form as the Museum's: both are similarly fluted, and both have the same type of finial and horizontal ribs between the various decorative elements. The Topkapı helmet would therefore corroborate a dating of the Museum's helmet to this period and to the same workshop.

This helmet appears to have been refurbished in the nine-teenth century. The multiplate cheekpieces would originally have been held together and suspended from the bowl by leather straps, which would have been attached by the pair of rivets at the side of the bowl over the ears and by the corresponding rivets near the top of the central cheek plate. The central plate of the left cheekpiece has two riveted repairs at the top edge and upper-rear corner, and the bottom plate of that cheekpiece is a modern replacement. The iron links attaching the cheekpieces, and indeed the aventail itself, are subsequent restorations. All of the brass rivets are modern substitutions, indicating that the helmet was dismantled, probably for cleaning and restoration. Some of

the silver facing on the center of the nasal has been restored, as has the tip of the nasal.

PROVENANCE: Maurice de Talleyrand-Périgord, duc de Dino, Paris.

REFERENCES: Cosson 1901, p. 111, no. N.1, pl. 8; Grancsay 1958, pp. 241–42, ill.; Nickel 1969, p. 90, ill.; Nickel 1974, p. 83, ill.; Grancsay 1986, pp. 443–45, fig. 109.1; Washing-ton, D.C., Chicago, and New York 1987–88, p. 67, no. 49; Miller 2006, pp. 30, 63–64; Pyhrr 2012b, p. 195, fig. 25.

NOTES

1. Muhammad is said to have called this sura the sovereign of all the verses in the Qur'an.
2. The best-known example is in the Topkapı Sarayı Museum, Istanbul, no. 2/1187 (see Washington, D.C., Chicago, and New York 1987–88, p. 148, no. 84), and is decorated in a style attributable to the period of Süleyman I. A Turkish helmet of similar style and workmanship but with a hemispherical bowl is in the Kremlin Armory, Moscow, no. OP-165; see Tumanovskii 2002, pp. 46–49, 301, no. 3.
3. Hofjagd- und Rüstkammer, Kunsthistorisches Museum, Vienna, nos. C159, A609; see Gamber and Beaufort 1990, pp. 209–10, 213–14, figs. 125, 124, respectively. For the inscriptions on no. C159, see Sydney and Melbourne 1990, p. 62, no. 48. Another exam-ple, structurally from the same group but decorated and inscribed in a different style, was taken from Admiral Ali Baja, one of the Ottoman naval commanders at the battle of Lepanto (1571), and is now in the Real Armería, Madrid, no. M19; see Valencia de Don Juan 1898, pp. 369–72, and Madrid 2003, p. 48, fig. 11.3.
4. Topkapı Sarayı Museum, Istanbul, nos. 1/798, 2/1192; see Aydın 2007, pp. 106, 108.
5. State Hermitage Museum, Saint Petersburg, nos. B.O. 1258, B.O. 1556; see Miller 2006, pp. 28–34, 62–65, figs. 10–12.
6. Kremlin Armory, Moscow, nos. OR-118, OR-163; see Tumanovskii 2002, pp. 60–67, 307–8, nos. 7, 8, respectively. The same collection includes a very similar helmet made in Moscow by Nikita Davydov in 1621, in obvious imitation of these Ottoman examples; see ibid., pp. 56–59, 305–7, no. 6.

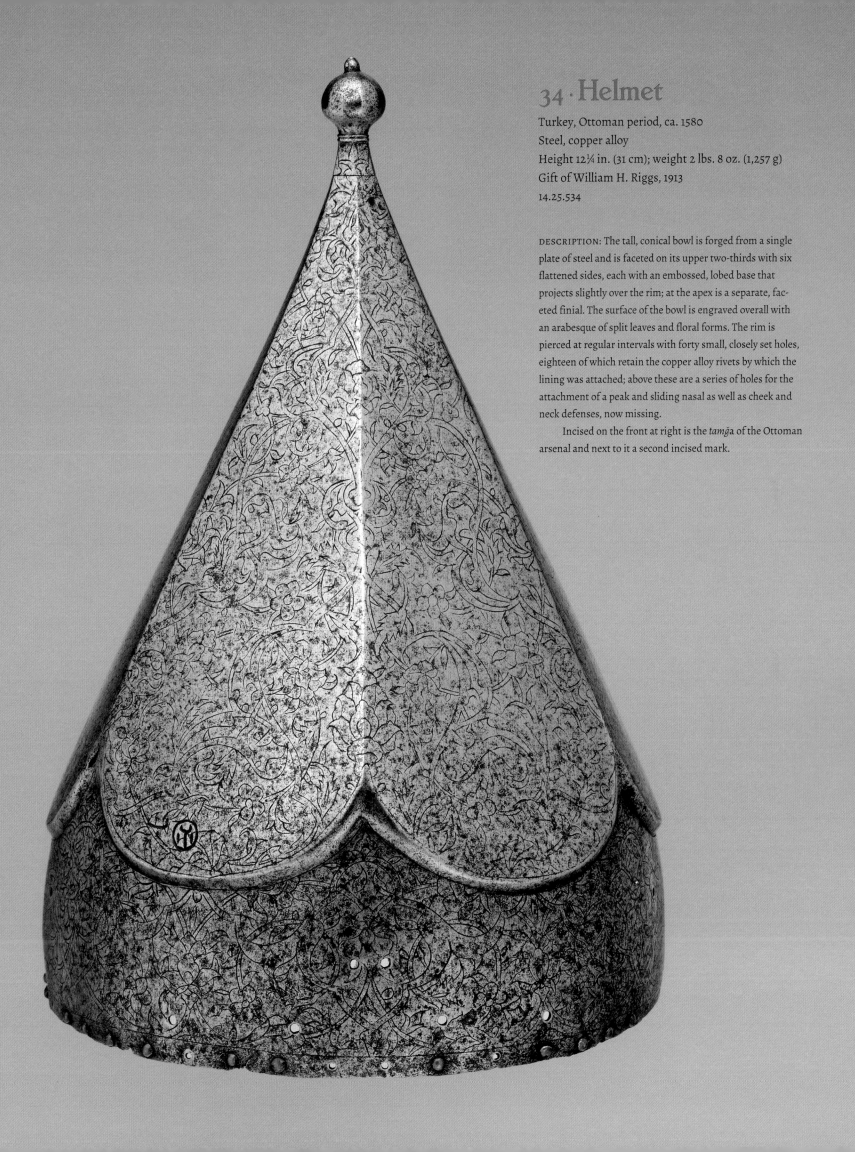

34 · Helmet

Turkey, Ottoman period, ca. 1580
Steel, copper alloy
Height 12¼ in. (31 cm); weight 2 lbs. 8 oz. (1,257 g)
Gift of William H. Riggs, 1913
14.25.534

DESCRIPTION: The tall, conical bowl is forged from a single plate of steel and is faceted on its upper two-thirds with six flattened sides, each with an embossed, lobed base that projects slightly over the rim; at the apex is a separate, faceted finial. The surface of the bowl is engraved overall with an arabesque of split leaves and floral forms. The rim is pierced at regular intervals with forty small, closely set holes, eighteen of which retain the copper alloy rivets by which the lining was attached; above these are a series of holes for the attachment of a peak and sliding nasal as well as cheek and neck defenses, now missing.

Incised on the front at right is the *tamğa* of the Ottoman arsenal and next to it a second incised mark.

PROVENANCE: Ottoman arsenal, Istanbul; Michel Boy, Paris; William H. Riggs, Paris.

REFERENCE: Bloomington 1970, no. 289.

NOTES

1. See, for example, Kalmár 1971, p. 276, figs. 49, 50.
2. Musée de l'Armée, Paris, no. H.452; see Paris 1990, no. 76. The inscriptions on this helmet were translated by Ludvik Kalus.
3. Esterhazy collection at Forchtenstein Castle, Austria; see Szendrei 1896, pp. 267–69, no. 827.
4. See, for instance, Atasoy and Raby 1989, chap. 3.
5. An Iznik dish in the Musée Nationale de la Renaissance—Château d'Ecouen, for example, has a cypress tree in exactly the same style as that on the helmet in Paris; see ibid., no. 694.
6. Musée du Louvre, Paris, no. 4048; see ibid., no. 536. A further confirmation of this dating is provided by the engraved decoration on a helmet in the Askeri Müzesi, Istanbul, no. 12228 (unpublished), which closely resembles that on both the Museum's helmet and the Louvre pen box. The Askeri helmet is not faceted but rather has lobed sides similar to another helmet in the Museum, acc. no. 04.3.213 (unpublished), that is datable to about 1580–90 when compared to an almost identical helmet in the Askeri Müzesi, Istanbul, no. 8349, that is inscribed with the name of the vizier Hasan Pasha and bears the date A.H. 997 (A.D. 1588/89).

Conical helmets with broad, faceted sides such as this are extremely rare. Most of the surviving examples are Ottoman or eastern European (in imitation of Ottoman fashion) and can be dated to the second half of the sixteenth century.[1] The original appearance of our helmet can be judged by another Ottoman example in the Musée de l'Armée, Paris, which is engraved and partly gilt and retains its peak, nasal, and cheek and neck defenses (fig. 24).[2] The form of the Museum's helmet and of that in Paris are so similar that it is likely that both were forged by the same smith. Their decoration, however, differs in many respects despite common elements, suggesting that they were probably engraved by different masters in the same workshop. A third example, engraved with similar foliage and arabesques, with traces of gilding, is in the Esterhazy collection at Forchtenstein Castle, Austria.[3]

The chronological development of Ottoman decoration through the sixteenth century is well documented in Iznik ceramics;[4] by comparing these patterns with the designs on the helmet in Paris and the present example, it is possible to arrive at a fairly precise dating. The split leaves in the decoration are composed of smaller leaves that together form a composite leaf with an open center. The engraved design on the upper section of the helmet in Paris consists of alternating panels of cypress trees and elongated hyacinth plants. While the hyacinth style is commonly dated to the mid-sixteenth century, the combination of stylized cypress trees and hyacinths occurs somewhat later and is datable to about 1560–75.[5] A further clue is provided by what is called a late development of the *saz*-leaf style that is datable to the 1580s. On the Museum's helmet the flowers framed by split leaves closely parallel those on a pen case in the Musée du Louvre, Paris, that belongs to a group dated to the 1580s.[6] When all the details of construction and decoration are taken together, a dating of the present helmet to about 1580 is appropriate.

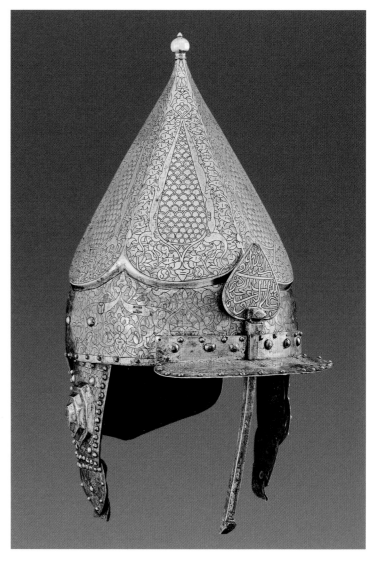

Fig. 24. Helmet. Turkey, ca. 1580. Steel and gold. Musée de l'Armée, Paris (H.452)

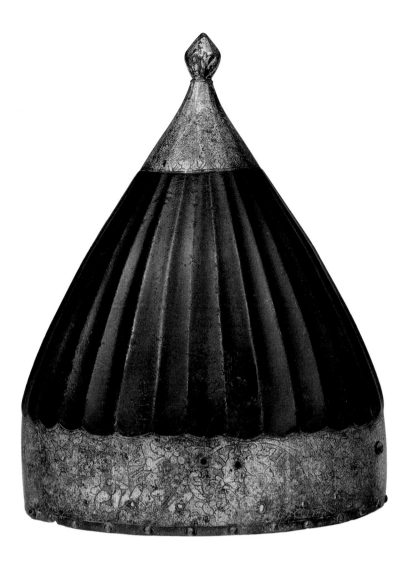

35 · Helmet

Turkey, Ottoman period, before A.H. 997 (A.D. 1588/89)
Steel, copper alloy, gold
Height 11 in. (28 cm); weight 3 lbs. 7 oz. (1,569 g)
Bequest of George C. Stone, 1935
36.25.107

DESCRIPTION: The tall conical bowl is forged from a single plate of steel worked around the central section with thirty-two shallow vertical channels and is set at the apex with a separate faceted finial. The decoration of the bowl is organized in three registers: the straight-sided rim, or lower register, is engraved and gilt on a stippled ground with an interlocking arabesque of split leaves and luxuriant flowers (roses?); the middle, fluted register has a dark (originally brightly polished?) finish; and the upper register has eight facets engraved and gilt with a network of flower buds on a stippled ground. The applied finial is also gilt. Around the rim are numerous close-set copper-alloy rivets (some missing) to secure the lining, and above these are various rivet holes for the attachment of the peak and nasal, cheek and neck defenses, all missing.

Incised at the front, to the (proper) right of the missing nasal, is the *tamğa* of the Ottoman arsenal and an Arabic inscription (a).

INSCRIPTION:
a. (On the front, to the right of the missing nasal)

وزير حسن پاشا سنة ٩٩٧

Vizier Hasan Pasha, year 997 (A.D. 1588/89).

The word "pasha" derives from the Persian term *padishah*, thought to have originally meant "lord who is a royalty,"[1] and was used by both the Seljuqs and Ottomans. For the Ottomans it was the highest title that could be awarded to an individual, and from the fourteenth century onward its award was confined to regional governors and viziers.[2]

The Museum's helmet is inscribed with the name of the vizier Hasan Pasha and the date A.H. 997 (A.D. 1588/89); it is not clear whether this is an inventory inscription or whether it designates the piece as the personal property of Hasan Pasha. Whatever the case, the inscription provides a terminus ad quem for its date. Several other helmets are also inscribed with his name, including five in the Askeri Müzesi, Istanbul.[3] While the identity of Hasan Pasha is uncertain, he is possibly the Bosnian vizier of that name who died in battle in Croatia in 1593.[4]

A number of helmets, shaffrons, armors, and shields are engraved with, or carry seals bearing, the names of other pashas.[5] In some cases the name is preceded by the formula "owned by," but in other instances it is not known whether these are owner's marks or inventory markings of the vizier or pasha responsible for the armories at that time, or if they indicate that the helmets were worn by men under the vizier's command.

PROVENANCE: Ottoman arsenal, Istanbul; Sir Guy Francis Laking, London; George Cameron Stone, New York.

REFERENCES: Christie, Manson and Woods, London 1920, lot 329; Stone 1934, p. 42, fig. 55; Grancsay 1937a, p. 56, fig. 2; Bloomington 1970, no. 292; Grancsay 1986, p. 167, 170, fig. 63.8; Alexander 1992, p. 86, s.v. no. 39.

NOTES
1. Babinger and Bosworth 1995, p. 237, quoting M. Bittner in Oberhummer 1917, p. 105.
2. Deny 1995, pp. 279–81.
3. Askeri Müzesi, Istanbul, nos. 16585, 23958, 8349 (similarly dated A.H. 997), 15675, 13542 (unpublished).
4. Inalcık 1970.
5. Among the names recorded are those of Ahmad Khan Pasha (Askeri Müzesi, shaffron no. 177); Al-Fakir 'Ali Pasha (Askeri Müzesi, Istanbul, shaffron no. 24145, armor no. 3088; Livrustkammaren, Stockholm, helmet no. 9659); Al-Fakir Hafiz Pasha (Askeri Müzesi, helmets nos. 167, 23956, shaffrons nos. 14221, 9427, shield no. 17402); Al-Fakir Hasan Pasha (Askeri Müzesi, helmet no. 8349); Al-Fakir Mehmed Pasha (Askeri Müzesi, shaffron no. 208-54); Bayram Pasha (Askeri Müzesi, helmets nos. 9707, 9725); Hafiz Ahmed Pasha (Askeri Müzesi, shield no. 451/6, shaffrons nos. 208-39, 208-83); Hasan 'Ali Pasha (Museo Stibbert, Florence, shaffron no. 6703); Husain Pasha (State Hermitage Museum, Saint Petersburg, helmet no. 27); Kh(oca?) Sinan Pasha (Askeri Müzesi, no. 7951); Muhammad Pasha (Askeri Müzesi, no. 165).

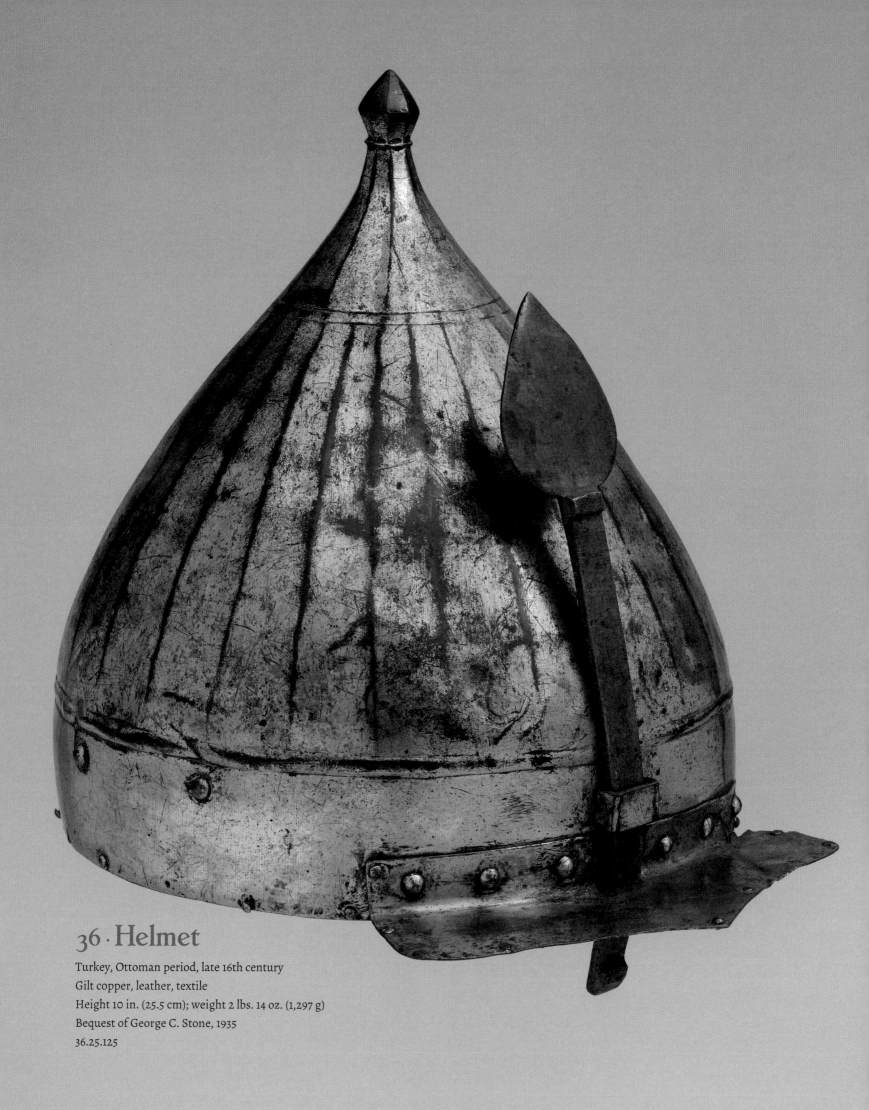

36 · Helmet

Turkey, Ottoman period, late 16th century
Gilt copper, leather, textile
Height 10 in. (25.5 cm); weight 2 lbs. 14 oz. (1,297 g)
Bequest of George C. Stone, 1935
36.25.125

DESCRIPTION: The conical bowl of gilt copper is decorated in three registers: a smooth rim; a middle zone with twenty-four vertical facets; and an apex with eight facets and set with a similarly faceted pointed finial. A raised rib separates the rim from the faceted middle zone, and a pair of engraved lines divide the middle and upper zones. The edge of the bowl is set with a series of small gilt-copper lining rivets. A pointed peak is riveted at the brow and is set around its edge with small gilt-copper lining rivets. The peak is pierced to accommodate the sliding brass nasal bar with pointed finial, held by a friction bracket. Two large gilt-copper rivets at each side formerly secured cheekpieces, those on the right retaining fragments of their leather suspension straps and, below the leather, traces of the original textile lining. Three holes at the back formerly secured the nape defense.

Incised on the left side of the bowl is the *tamğa* of the Ottoman arsenal.

As with most *tombak* armor, the helmet shows numerous dents and fractures, with considerable loss of gilding; the brass nasal, which appears never to have been gilt, is probably a replacement.

Most Ottoman armors were made for use on the battlefield; others, however, were intended primarily for ceremonial usage. During the sixteenth century Ottoman craftsmen developed a completely new and distinctive type of parade armor made of gilt copper, called *tombak*.[1] These gilt armors were relatively flimsy, and although inadequate in military terms were ideal for ceremonial purposes. The use of gilt copper was clearly a technological innovation. Such armors were handsome, comparatively inexpensive, light in weight, and easily fabricated.[2] Prior to this development, decorated steel armor was usually engraved and then damascened with other metals, predominantly silver; such armor derived its visual impact from the contrast of the various metals as they delineated the weave of an arabesque or the strokes of an inscription. *Tombak* armor relied on a different aesthetic, drawing its visual power from the brilliance of an unbroken golden surface. Ranks of soldiers and cavalry seemingly clad in gold, bearing golden shields, their horses adorned with golden shaffrons and trappings, must have presented a dazzling spectacle never adequately rendered in miniature painting.[3] This use of massive blocks of a solid-surface color is a prime example of what has been called the Ottoman plain style.[4]

Some *tombak* armor was also decorated, usually with engraved floral designs and inscriptions or stippled ornament

(cats. 37, 51, and fig. 11). These embellished pieces are sometimes of exceptional quality and include a series of helmets made for high-ranking officers, among them one now in Istanbul that is decorated with large floral forms in the style of the second half of the sixteenth century.[5] Further variety was achieved through the use of different shapes: the Ottomans distinguished military ranks and units from one another by the color or some peculiarity of their costume and especially by the shape of their helmets.[6]

There are many examples of *tombak* helmets in Ottoman miniature painting, including those worn by the imperial guards in the *Süleymanname* of 1558 (A.H. 966). One miniature in this manuscript depicts two *bostançı*, or imperial gardeners, who served as guards and as executioners;[7] in the painting they carry axes and walk ahead of the sultan.[8] As the subject of this painting is largely ceremonial, it seems plausible that the *bostançı* are wearing helmets of lightweight *tombak* rather than gilt steel.[9]

The present helmet is very similar to several preserved in the Askeri Müzesi, Istanbul, all of which have a broad horizontal rib separating the faceted area of the bowl from the rim and relatively squat top sections. One of the Askeri helmets of this type is inscribed with the name of the vizier Al-Fakir Hasan Pasha and dated A.H. 997 (A.D. 1588/89); this inscription, a version of which is also found on cat. 35, thus provides a terminus ad quem for our *tombak* example.[10]

PROVENANCE: Ottoman arsenal, Istanbul; Clapp and Graham, New York; George Cameron Stone, New York.

Unpublished.

NOTES

1. كبادمة, from the Malay *têmbaga*, for copper; the earliest reference to this in English is in a traveler's account of 1602 describing "gold and brasse together" (Oxford English Dictionary).

2. Allan 1979, p. 11, notes that the easiest metal to gild is silver, followed by copper (which was plentiful in Anatolia), and then iron and steel. For a discussion of the technique, see Batur 1984, pp. 19–27.

3. See, for example, Akurgal 1980, pl. 173.

4. See Allan and Raby 1982.

5. Askeri Müzesi, Istanbul, no. 1092; see Riyadh 1996, vol. 2, no. 89, fig. i. Another extremely finely decorated arm guard was offered on the art market in 2000 (see Christie's London 2000, lot 212, ill.); although badly corroded, traces of the surviving design indicate that it must be one of the earliest surviving *tombak* armors, perhaps from the first quarter of the sixteenth century.

6. See, for example, Esin 1970, pp. 110–16.

7. See Uzunçarşılı 1960.

8. Atıl 1986, pp. 226–27, pl. 62.

9. A *tombak* helmet of this type is in the Askeri Müzesi, Istanbul, no. 7925 (unpublished). Another *tombak* parade helmet in the Museum's collection, acc. no. 1974.118, is also of conventional military form (fig. 11).

10. For further discussion of examples with this and other closely related inscriptions, see cat. 35.

37 · Helmet

Turkey, Ottoman period, early 17th century
Gilt copper
Height 8¾ in. (22.2 cm); weight 2 lbs. 8 oz. (1,139 g)
From the Collection of Nina and Gordon Bunshaft,
Bequest of Nina Bunshaft, 1994
1995.68

DESCRIPTION: The conical bowl of gilt copper is divided into three zones, the smooth rim and apex being slightly inset from the low-relief middle section, which is embossed to suggest overlapping vertical plates. A hole at the apex formerly accommodated a separate finial, now missing. The edge of the rim, now broken in many places, is encircled by a series of small gilt-copper lining rivets. Above these are circular holes at the brow for an applied peak (brim) and, above these, holes for a nasal bracket, with two holes at each side for cheekpieces and three square holes at the back for a nape defense, these appendages now lost. The smooth surfaces at the rim and apex are embellished with stippled decoration: at the apex there is a band of zigzag ornament and another of interlace and leaves; the base is similarly punched but includes at the back an Arabic inscription (a). The gilt surface is considerably worn.

INSCRIPTION:

a. (Around the rim, at the back)

مما عمل برسم الجناب العالي الامير عثمان امير الوا [كذا] ابن الامير علي

Made at the order of his exalted excellency, the amir ʿUthman (Osman), Amir al-Liwa, ibn Amir ʿAli.

This helmet is decorated with exactly the same motif as that on a pectoral-disk armor now in the Askeri Müzesi, Istanbul, and another almost identical helmet with the same dot-punched inscription that recently appeared on the art market.[1] All were perhaps produced in the same workshop.

A small but distinctive group of gilt-copper (*tombak*) armor can be formed around the Museum's helmet. This includes not only the pieces noted above, but also a helmet and shield in Istanbul similarly punched with floral designs.[2] According to Fulya Bodur Eruz, the shield belonged to the Ottoman grand vizier Hafiz Ahmed Pasha (ca. 1570–1632).[3] Appointed to that position in 1625 by Murad IV (r. 1623–1640), he was assassinated by the Janissaries in 1632. If the shield was indeed made for him, this would

place the group in the early seventeenth century. Unfortunately, there is nothing inscribed on the shield to support this attribution. Nevertheless, a seventeenth-century dating for these punch-decorated pieces is probably correct. Also belonging to this *tombak* group are two shaffrons in the Museum's collection, one of which is inscribed with the name of Amir Yusuf (cat. 51); the other is punched with the same zigzag-and-dot design.[4]

The Museum's helmet is inscribed with a name using a formula that is not typically Ottoman—the individual is referred to as "amir, (ibn) son of an amir" and not as a pasha, aga, or vizier as might be expected. He is also called "Amir al-Liwa." This term might be interpreted either as referring to a governor of a province (*sanjak* or *liwa*) or to someone in charge of a banner. The terms *sanjak* and *liwa* were often used synonymously to designate a province, and the use of the latter word may indicate that the helmet was made at the order of a governor from an Arab rather than a Turkish or Balkan province. A second possibility is that the helmet was made at the order of an officer in charge of a banner (*mir alem*). It has been suggested that several lavishly decorated shaffrons, such as one in the Khalili Collection, London, might have been used by participants in the hajj.[5] If the inscription on the helmet refers to a flag rather than to a province, perhaps it was made at the order of the officer in charge of the banner that accompanied the *mahmal* (litter)—a palanquin carried by a camel on the annual pilgrimage to Mecca.[6]

PROVENANCE: Nina and Gordon Bunshaft, New York (acquired in Istanbul in 1971).

REFERENCE: New York 2002–3, no. 35.

NOTES
1. Askeri Müzesi, Istanbul, no. 166 (unpublished); and Sotheby's London 2007a, lot 158.
2. Askeri Müzesi, Istanbul, nos. 6894 (helmet), 4519/6 (shield; see Istanbul 1987, no. A. 173). The shield is both punched and engraved; the punched areas are on the pierced and lobed cartouches.
3. Askeri Müzesi, Istanbul, no. 4519/6; see Istanbul 1987, no. 173.
4. The Museum's punch-decorated shaffron is acc. no. 32.25.507; see Stone 1934, p. 170, fig. 214, no. 4.
5. For the shaffron in the Khalili Collection, London, no. MTW 995, see Alexander 1992, pp. 120–21, no. 65.
6. A pilgrim writing in about 1575 reported that the camel carrying the Mahmal was "The fairest which may be found within the dominions of the Grand Signor. This camel is also decked with cloth of gold and silk, and carrieth a little chest. . . . Within this chest is the Alcoran all written with great letters of gold, bound between two tables of massy gold, and the chest during their voyage is covered with silk, but at their entering into Mecca it is all covered with gold, adorned with jewels, and the like at the entrance to Medina. . . . After this follow fifteen other most fair camels, each one carrying one of the aforesaid vestures, being covered from top to toe with silk. Behind these go twenty other camels which carry the money, apparel and provisions of the Amir al-Hajj, captain of the caravan. After followeth the royal standard of the Grand Signor, accompanied continually with the musicians of the captain and five and twenty Sipahi archers"; anonymous pilgrim, Hakluyt 1927, 3:180–82, as quoted in F. Peters 1994, p. 171.

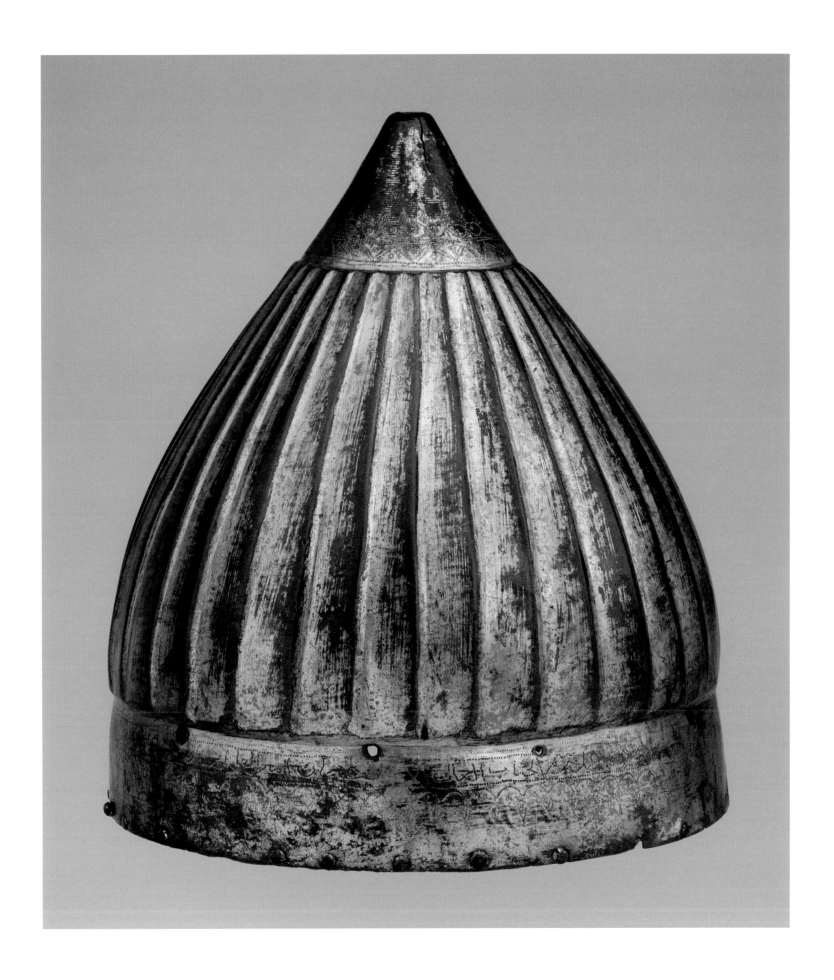

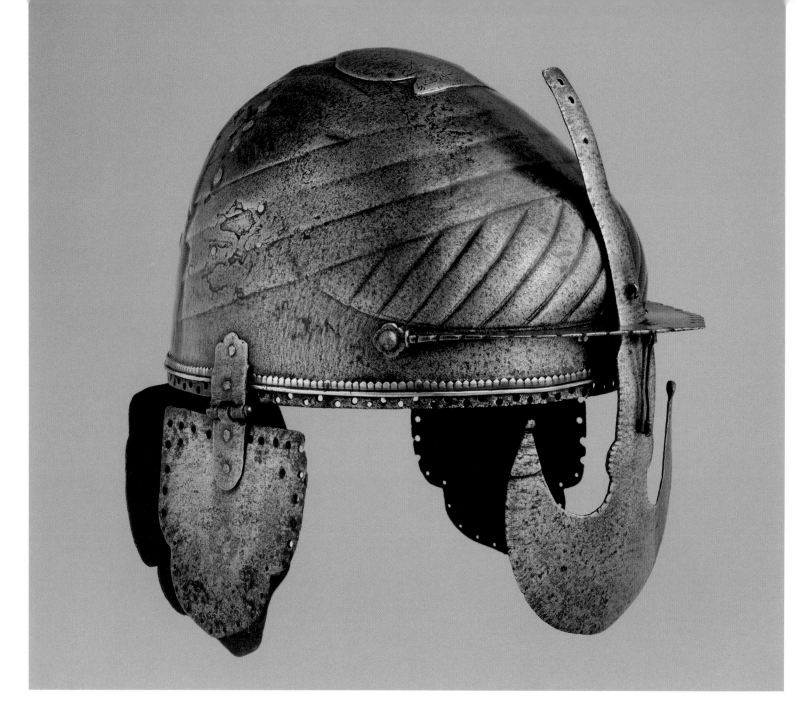

38 · Helmet

India, Deccan, probably Bijapur, 17th century
Steel, iron, copper alloy
Height overall 11⅜ in. (29 cm), bowl 5⅞ in. (14.8 cm);
weight 3 lbs. 14 oz. (1,759 g)
Bequest of George C. Stone, 1935
36.25.99

DESCRIPTION: The helmet comprises a one-piece bowl to which are attached a fixed peak (brim) with sliding nasal, two cheekpieces, and a neck defense. The bowl is forged to suggest a compact, tightly wrapped turban, high and rounded toward the back and swelling at the front over the peak, the folds slightly convex and delineated by engraved lines. The rim is pierced with numerous small holes arranged in a zigzag pattern through which the lining was attached. Above these holes and completely encircling the edge of the bowl is riveted a narrow copper-alloy band with notched upper edge. The right side and back of the bowl show old, crude repairs consisting of large plates riveted inside to close breaks in the metal; a small hole over the left eye has also been repaired. Attached by rivets at the apex, but apparently not

as a repair, is a wide, leaf-shaped iron plate engraved with an Arabic inscription (a), now heavily worn and only partly decipherable. Riveted at the brow is a shallow pointed peak with a decoratively cusped and pierced front edge; the peak is pierced at the back edge in the center to accommodate the nasal bar. The nasal, forged of flat plate, is slightly convex to the outside and has a long stepped arm terminating at the bottom in a wide, crescentic face guard. The arms of the crescent terminate in thickened knobs, the right one an old replacement. The arm of the nasal is pierced near the top with three vertically aligned holes and is fitted in the middle with two widely separated hooks that engage in the elongated wire swivel loop riveted to the underside of the peak and by which the nasal was adjustable in two positions. The sides of the nasal arm above the face guard are notched. The flat, one-piece cheekpieces are trefoil shaped with straight upper edges and are pierced around the edges with lining holes, those at the bottom smaller than the ones above; the cheekpieces are attached to the bowl with crude, two-part iron hinges fastened by iron rivets. The large neck defense, of lobed and pointed shape, is suspended from the bowl by a single hinge in the center, which is attached by copper-alloy rivets; the upper edge of the hinge is crudely fashioned as a trefoil leaf (fleur-de-lis). Portions of a double engraved line near the bottom of the plate suggest that it has been cut from a large decorated plate and therefore may be a replacement.

The iron surface shows overall corrosion and what appears to be several generations of repairs and adaptations. The repairs to the bowl and even its inscribed plaque are evidence of its later use, as are the crudely applied cheekpieces and even later neck defense. The nasal is old, but the holes at the top of its arm, which serve no purpose at present, suggest that this piece too has been reused.

INSCRIPTION:
a. (On the plate at top)

<div dir="rtl">

بسم الله الرحمن الرحيم

ناد علي [كذا] مظهر العجائب تجده

عونا لك في النوائب كل هم

و غم سينجلي بنبوتك (؟) يا محمد (؟) بولا

بتك يا علي

يا علي يا علي لا سيف الا ذالفار [كذا]

</div>

Allah. In the Name of Allah, Most Gracious, Most Merciful.

Call upon 'Ali, the manifestation of wonders,
You will find him a comfort to you in crisis,
Every care and sorrow will pass,
Through your prophecy, O Muhammad . . . O Muhammad, through your guardianship, O 'Ali, O 'Ali! O 'Ali!

O 'Ali! There is no sword except Dhu'l faqar.

Indian helmets in the form of fabric turbans are rare. Recorded examples are all slightly different in shape, unsurprising as in India during the seventeenth century a great variety of turban forms were worn. Artists of the period frequently depicted numerous variations within a single miniature painting, as seen in the *Padshahnama* in the Royal Collection, Windsor, in which a painting by Payag of about 1640 depicts at least twelve different forms.[1] Two of the surviving helmets of this type are traditionally associated with warriors who served under the Mughal emperor Aurangzeb (r. 1658–1707). One opulent example, delicately damascened in gold overall with fine foliate ornament, now in the Maharaja Sawai Man Singh II Museum,

Jaipur, has been attributed to Raja Jai Singh of Amber (r. 1625–67), with a tentative suggestion that it was made in Agra.[2] The other, now in the Khalili Collection, London, is said to have been presented by Aurangzeb to Chin Qilich Khan (Asaf Jah I of Hyderabad) after his bravery at Golconda in 1686.[3]

Most turbans illustrated in Mughal miniature paintings wrap around the head, with the top tending to rise toward the back and protrude beyond the line of the central wrap; both the Jaipur and Khalili examples are of this form. The Museum's helmet differs in that it is rounded and represents a less common type of turban, one that is generally associated with the Deccan. The plaque on the Museum's helmet is inscribed with Shi'a slogans, which would seem to narrow the origin of the helmet to one of two Deccani states, either Vijayangara or Bijapur. Bijapur, the richest and most powerful Muslim state in the Deccan, was strongly Shi'a, and if the helmet was made there, it should be dated prior to the fall of the ruling 'Adil Shahi dynasty to the Mughal emperor Aurangzeb in 1689. The other, far less likely possibility is that it is booty captured from the Hindu state of Vijayangara, against which the 'Adil Shahi were in an almost constant state of war. A dating to before 1689, however, seems certain.

PROVENANCE: W. O. Oldman, London; George Cameron Stone, New York.

REFERENCES: Stone 1934, p. 50, fig. 64, no. 4; H. Robinson 1967, p. 106, fig. LIIIB; Pant 1978–83, vol. 3, fig. 225; Elgood 2015, pp. 284, 273, n. 420.

NOTES
1. Royal Library, Windsor, fol. 214b; see New Delhi and other cities 1997–98, pp. 104–5, 206–7, pl. 43. See also Pant 1978–83, vol. 3, pp. 44–45, for renderings of turban types.
2. New York 1985–86b, pp. 351–52, nos. 233a, b, for this helmet and its reputed matching shield. Elgood 2015, p. 185, disputes the earlier attribution and dating and dismisses the notion that the helmet and shield match one another.
3. Alexander 1992, pp. 168–69, no. 104; Elgood 2015, p. 184, addresses the Khalili helmet and other Deccani helmets of turban type.

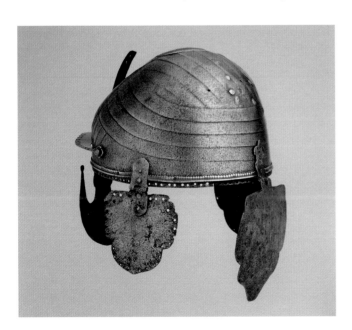

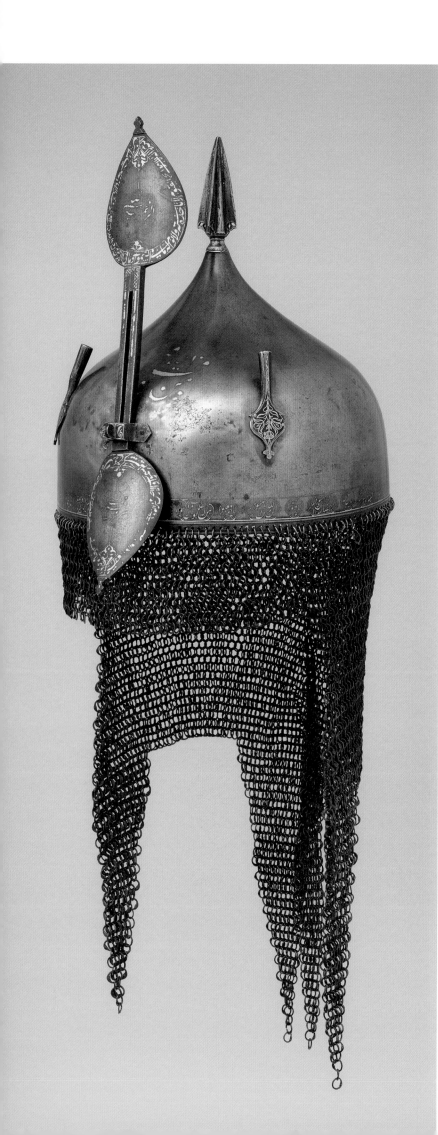

39 · Helmet

India, Deccan, possibly Golconda, 17th century and later
Steel, iron, gold
Height with mail 24⅛ in. (61.3 cm), bowl 9⅝ in. (24.3 cm);
weight 3 lbs. 11 oz. (1,665 g)
Bequest of George C. Stone, 1935
36.25.127

DESCRIPTION: The conical bowl of squat, bulbous form is forged from a single plate of crucible steel and is set at the apex with an acutely pointed finial with four radiating edges pierced at their bases with leaves. The upper surface of the bowl bears traces of four large lobed cartouches, one each at the front, back, and sides, damascened in gold with Arabic inscriptions, now very faint (a–d). Just above the rim is a narrow border damascened in gold with thirty-two lobed cartouches of alternating shape containing Arabic inscriptions (e, f). Riveted at the front of the bowl is a screw clamp that secures a sliding nasal formed of a slotted bar ending in large pointed leaf-shaped tips; the surfaces are damascened in gold, the decoration of the tips including inscribed borders (g) around a central inscribed medallion (h). Riveted to the bowl at each side of the nasal is a small tubular plume holder with palmette-shaped base damascened in gold with flowers. The rim, which has an applied, molded border, is pierced at regular intervals with a series of close-set holes, originally to secure the lining, through which the mail neck defense, or aventail, of riveted iron links is attached. The mail is shaped straight across the forehead and has four long points.

INSCRIPTIONS:
On the bowl, in four cartouches, clockwise from front
a.

نصر من الله و فتح قريب

Help from Allah and a speedy victory. (Qur'an 61:13)

b.

افوض امري الى الله

My (own) affair I commit to Allah. (Qur'an 40:44)

c.

و من يتوكل على الله

If anyone puts his trust in Allah. (Qur'an 65:3)

d.
(Not legible)

Around the rim
e. (In the large cartouches, worn and not all legible)

بسم الله الرحمن الرحيم الله لا اله الا هو الحي القيوم لا تأخذه سنة و لا نوم له ما في السموات و ما
في الارض من ذا الذي يشفع عنده الا باذنه يعلم ما بين ايديهم و ما خلفهم و لا يحيطون بشيء من
علمه الا بما شاء وسع كرسيه السموات و الارض و لا ...العظيم ... فمن يكفر بالطاغوت و يؤمن
بالله فقد استمسك بالعروة و الوثقى لا انفصام لها و الله سميع عليم الله ولي الذين آمنوا يخرجهم من
الظلمات الى النور

In the Name of Allah, Most Gracious, Most Merciful. Allah! There is no god but He, —the Living, the Self-subsisting, Supporter of all / No slumber can seize Him nor sleep. His are all things in the heavens and on earth. Who is thee can intercede in His presence except as He permitteth? He knoweth what (appeareth to His creatures as) Before or After or Behind them. Nor shall they compass aught of His

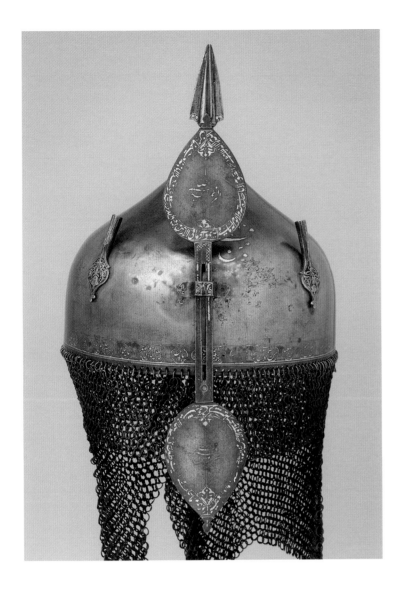

Helmets of this compact shape, probably a later development of the bulbous turban type, were worn in India from the sixteenth to the eighteenth century. Although surviving examples can be assigned to the sixteenth century, their existence is also demonstrated in miniature painting, as can be seen in the *Akbarnama* of about 1590 and in a mid-sixteenth-century painting from Tabriz or Bukhara.[1] The Museum's helmet is very similar in shape to one in the Khalili Collection, London, that probably dates to the seventeenth century.[2] The latter is missing its aventail but is holed around the rim for such an attachment, and it has a similar spearlike finial. It has been suggested that the Khalili helmet was one of three known examples from Golconda, the others being in the Museum of the Tombs in Golconda and in the Archaeological Museum, Hyderabad.[3] If this is correct, then the Museum's helmet should probably also be attributed to the Deccan and perhaps more specifically to Golconda.

The bowl of this helmet appears to have had long, continuous use, as it shows a number of repairs and alterations. The spear-shaped finial at the top, the nasal clamp, and the two plume holders seem to be later, probably nineteenth-century additions: their surfaces do not show the same degree of wear as does the surface of the bowl, and they are crudely attached. In addition, the gold-damascened ornament on the clamp and plume holders is less sophisticated and less worn than the rest of the decoration. The nasal bar, on the other hand, shows wear

knowledge except as He willeth. His Throne doth extend over the heavens and the earth, and . . . the Supreme (in glory). . . . Whoever rejects Tagut and believes in Allah hath grasped the most trustworthy hand-hold, that never breaks. And Allah heareth and knoweth all things. Allah is the Protector of those who have faith: from the depths of darkness He leads them forth into light. (Qur'an 2:255–57)

f. (In the smaller cartouches, the names of God, worn and not all legible)

يا احد / يا صمد / يا وتر / يا حي / يا قيوم / يا رحمان / يا رحيم / ... / يا محمود / يا معبود / ...

O One! O Eternal! O Single! O Living! O Self-Subsisting! O Compasionate! O Merciful! . . . O Praised! O Worshipped! . . .

On the finials of the nasal
g. (Around the borders)

بسم الله الرحمن الرحيم الله لا اله الا هو الحي القيوم لاتأخذه سنة و لا نوم له ما في السموات و ما في الارض من ذا الذي يشفع عنده الا باذنه يعلم ما بين [ايديهم و ما خلفهم] ...

In the Name of Allah, Most Gracious, Most Merciful. Allah! There is no god but He, —the Living, the Self-subsisting, Supporter of all / No slumber can seize Him nor sleep. His are all things in the heavens and on earth. Who is thee can intercede in His presence except as He permitteth? He knoweth what [(appeareth to His creatures as) Before or After or Behind them]. (Qur'an 2:255) . . .

h. (In the central medallions)

بسم الله الرحمن الرحيم

In the Name of Allah, Most Gracious, Most Merciful.

PROVENANCE: Albert Goupil, Paris; Bachereau, Paris; George Cameron Stone, New York.

REFERENCES: Hôtel Drouot, Paris 1888, lot 231; Stone 1934, p. 38, fig. 51, nos. 2, 3; Katonah 1980, no. 24, ill.; Paris 1988, no. 121.

NOTES

1. For the image in the *Akbarnama*, see New York 1985–86b, no. 90; for the painting ascribed to Tabriz or Bukhara, see B. Robinson 1976, p. 54.
2. Khalili Collection, London, no. MTW 1126; see Alexander 1992, p. 164, no. 101, ill.
3. Paris 1988, p. 176; for a similar helmet, but with a different finial, see Pant 1978–83, vol. 3, fig. 231. See also Paris 2007/Mohamed 2008, pp. 330–31, nos. 317, 318, for two helmets with similarly shaped bowls attributed to the Deccan, sixteenth century.
4. A Safavid example dated 1677 is in the Furusiyya Art Foundation, Vaduz, no. R-830; see Paris 2007/Mohamed 2008, p. 334, no. 321.
5. One such finial is depicted in a Mughal painting of ca. 1633; see New Delhi and other cities 1997–98, no. 18 (fol. 102b).
6. See also Lavoix 1885. Two turban helmets from the Gérôme collection are in the Walters Art Museum, Baltimore, nos. 51.70, 51.74.
7. G. Ackerman 1986, no. 194, and G. Ackerman 2000, no. 194; sold at Sotheby's New York 1994, lot 78, and again at Christie's London 1994, lot 54.

comparable to the bowl and may be contemporary. The nasal is clamped to the bowl slightly off center from the frontal medallion, and the bowl evidences several repairs in that area. The interior reveals a number of blind rivets, some of which probably patch small holes, although two rivets at each side of the bowl may originally have held a chin strap or cheekpieces. If the latter is the case, the provision for the aventail may be of more recent date.

Spiked finials such as the one on this helmet are common features on Iranian helmets of the Safavid and Qajar periods,[4] but they were found as well on Mughal helmets of the first half of the seventeenth century.[5] Although nasals lobed at the base and finial appear on Iranian and Indian helmets, the large type, as seen here, is exclusively Indian. Indeed, such nasals seem to have originated in the Deccan, and numerous similar examples have been preserved. These were often set with small rounded knobs—like those on the Museum's nasal lobes—or with bird or snake heads.

The helmet was acquired by George C. Stone from the French dealer Bachereau and had previously been included in the 1888 sale of the collection of the art dealer Adolphe Goupil (1806 or 1809–1893). Goupil was the father-in-law of the French artist Jean-Léon Gérôme (1824–1904), and both men were fascinated by Islamic art. Many of the arms depicted in Gérôme's paintings belonged either to the artist or his father-in-law,[6] and this helmet (in its present state) was the one depicted by Gérôme in his *Un Marchand d'armes au Caire* of 1869 (fig. 25).[7]

Fig. 25. Detail of fig. 3, Jean-Léon Gérôme (1824–1904), *The Cairene Armorer (Un Marchand d'armes au Caire)*, 1869. Private collection

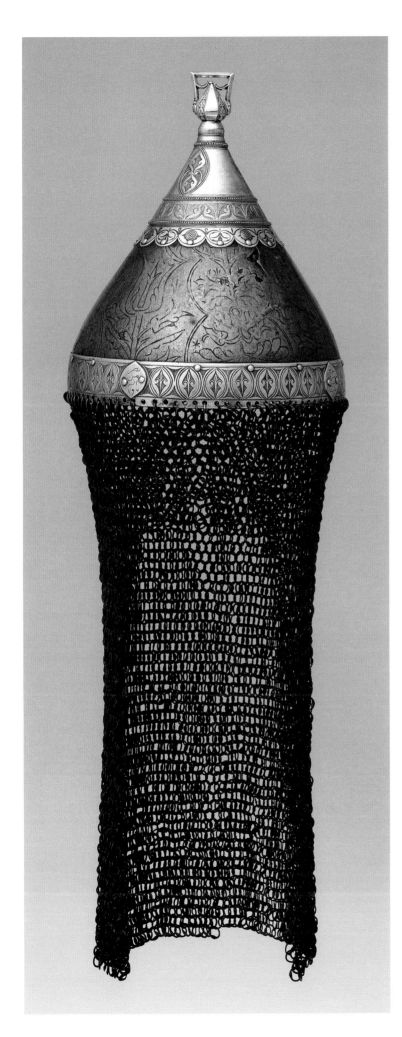

40 · Helmet

Bowl, Turkey, Ottoman period, 17th century; mounts,
Crimea, dated A.H. 1196 (A.D. 1781/82)
Steel, iron, silver, gold, niello
Height with mail 24 in. (61 cm); bowl 8⅝ in. (22 cm);
weight 3 lbs. 14 oz. (1,751 g)
Bequest of George C. Stone, 1935
36.25.115

DESCRIPTION: The conical bowl is forged from a single plate of steel. It is engraved around the sides with four vertical panels with lobed edges that enclose a stylized plant design incorporating tulips; the areas between the panels are engraved with larger tulip designs. The bowl, which apparently had a long working life, is considerably worn, showing delamination, dents, rivet holes, and old riveted repairs. It has been extended at the top by a short steel cone, riveted on, which has been threaded to receive the finial. The tapering upper part of the bowl is encased in silver consisting of three sections: a horizontal band with scalloped bottom edge, nielloed with alternating stylized flowers and tendrils, which is attached by silver rivets; a conical mount with raised, beaded borders enclosing a gilt horizontal band of stylized plant forms on a punched ground, the area above that embossed and gilt with three elliptical panels enclosing plant designs on a punched ground; and a screwed-on finial of faceted bud shape, the facets alternately plain and engraved with leaf forms, to which is riveted a swivel buckle for the attachment of a streamer or pennons. The conical mount is positioned on the bowl by means of a guide pin that fits into a hole in the bowl and is held in place by the finial. Applied to the rim is a border of silver, formerly gilt, that is engraved and punched with a repeat pattern of elliptical fields containing stylized plant motifs. Applied with silver rivets around this band are four medallions, also elliptical in shape, engraved with Arabic inscriptions in a cursive script (a–d). The rim of the bowl is pierced with numerous close-set holes through which is attached a long mail face and neck defense, or aventail, of riveted iron links. The mail is shaped to hang straight over the face and around the bottom and is closed low in the front with two hooks.

 Incised near the top of the bowl, concealed beneath the conical mount, is the *tamǧa* of the Ottoman arsenal.

INSCRIPTIONS:
On the medallions, clockwise from right front
a.

<div dir="rtl">نصر من الله ١١٩٦</div>

Help from Allah. (Qur'an 61:13) 1196 (A.D. 1781/82).

b.

<div dir="rtl">منصور من الله بكمرن (؟) بگ</div>

Made victorious by God, Bekmurun (?) Beg.

c.

<div dir="rtl">لا اله الا الله محمد رسول الله صلى الله عليه و سلم</div>

There is no god but God, and Muhammad is the messenger of God, God's blessings and peace upon Him.

d.

<div dir="rtl">موسوسن (؟) بگ ابن حاطو (؟) خشوقه (؟)</div>

Mawsusun (?) Beg ibn Hatu (?) Khishiqwa (?)

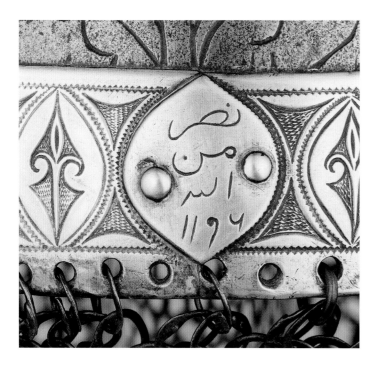

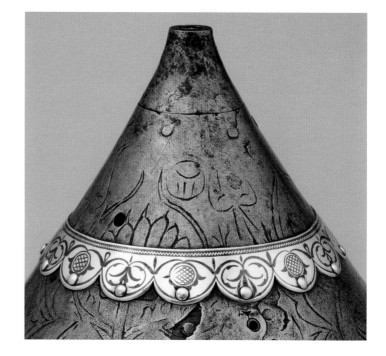

The tulip decoration on the bowl is typically Ottoman and probably of the seventeenth century, whereas the decoration on the silver sections at the top and base is characteristic of the Caucasus and the Crimea. Although the names in the inscription are not completely clear and cannot at present be localized, they are most likely of Krim (Crimean) Tartar origin. However, there were many Circassians in the Crimea serving in the armies of the Krim Tartars, and it is likely that two of the names on the helmet, Hatu and Khishiqwa, are Circassian.[1]

The silvered decoration must have been added to the earlier Ottoman bowl in 1781/82 by a craftsman in the Crimea or the Caucasus. The buckle at the tip would have been used to secure a colored streamer, a feature that is documented on helmets from at least the sixteenth century.[2]

Other formal features, especially the placement of the silver mounts at the top and rim of the bowl, the swivel buckle at the tip, and the very long aventail, are typical of the Krim Tartars.[3] The combination of Tartar and Ottoman styles also occurs on a sixteenth-century helmet and war mask now in the Kremlin Armory, Moscow.[4] The lower decorative band on that helmet represents tulip and carnation plants, and it is set at the top with a bulblike form that is very similar to that on the Museum's helmet. It should not be surprising that these helmets combine Ottoman and Tartar features; the Krim Tartars often allied themselves with the Ottomans and participated in many of their campaigns. Bosworth even reports that there was "a vague feeling that, should the Ottoman dynasty die out, . . . the Girays [a ruling Krim family] would have a claim on the succession in Turkey."[5] The Krim Tartars also fought with the Poles and Lithuanians against

the Russians, and the numerous helmets and arm guards of this type now in Polish collections resulted either from these campaigns or from the Ottoman siege of Vienna in 1683.[6]

PROVENANCE: Ottoman arsenal, Istanbul; Sir Guy Francis Laking, London; George C. Stone, New York.

REFERENCES: Christie, Manson and Woods, London 1920, lot 325; Stone 1934, p. 37, fig. 50, no. 1.

NOTES
1. Will Kwiatkowski, personal communication, February 2015.
2. For example, on a probably Ottoman helmet in the Khalili Collection, London, no. MTW 776; see Alexander 1992, p. 108, no. 55.
3. For a generally similar Tartar helmet inscribed with the name of a member of the ruling Giray family, see cat. 41. For Crimean Tartar helmets, see also Chirkov 1971, especially pls. 35–44; Gutowski 1997, nos. 31–33; and Miller 2000, especially pp. 192–200, 323–30, figs. 85–96.
4. See Tumanovskii 2002, pp. 72–73, no. 11.
5. Bosworth 2004, p. 257. A number of other earlier pieces of armor with similar and much later Tartar fittings are preserved in various collections. In the Topkapı Sarayı Museum, Istanbul, there are a pair of engraved steel arm guards bearing the name of the penultimate Mamluk sultan Qansawh al-Ghauri (r. 1501–16) that are fitted with silver mounts inscribed with the name of Khan Selim Giray and the date A.H. 1173 (A.D. 1759/60); see Stöcklein 1934, p. 213, fig. 11. Examples in other collections include two arm guards in the Museum's collection, acc. nos. 36.25.397a, b, 36.25.296 (see Stone 1934, p. 108, fig. 140, nos. 1, 3), and two arm guards in the Furusiyya Art Foundation, Vaduz, nos. R-170 (see Paris 2007/Mohamed 2008, p. 308, no. 296), R-738 (unpublished). The reused guard of the latter is decorated with an Iznik-style design and can be dated to the mid-sixteenth century. A similarly decorated arm guard is in the Museum's collection, acc. no. 36.25.395; see Stone 1934, p. 108, fig. 140, no. 2. For other reused arm and leg defenses, see Gutowski 1997, nos. 41–49. Many of these pieces are engraved with the *tamğa* of the Ottoman arsenal.
6. For example, Muzeum Wojska Polskiego, Warsaw, no. 2710x, inscribed with the name of Khan Adil Giray (r. 1666–71); see Gutowski 1997, no. 31.

41 · Helmet

Crimea or southern Russia, dated A.H. 1223 (A.D. 1808/9)
Steel, iron, silver, gold, niello, leather
Height 21⅝ in. (55 cm); bowl 6⅛ in. (15.5 cm); weight 3 lbs. 13 oz. (1,740 g)
Bequest of George C. Stone, 1935
36.25.119

DESCRIPTION: The steel bowl of low, ogival shape rises to a point in the center and is formed from four segments overlapped and riveted together. Each of the four exposed sections of the bowl is inlaid in gold with a teardrop-shaped cartouche inscribed in Arabic (a–d). The bowl is overlaid in silver with a wide brow band and a conical upper mount that are connected by four vertical bands that hide the construction seams of the bowl. At the apex is a screwed-on, nielloed silver mount with a swivel buckle for the attachment of a streamer or pennons. The silver mounts, partly gilt and nielloed, have raised beaded borders and leafy scrolls and circular medallions of geometric ornament against a ring-punched ground. The conical upper mount is decorated in two registers, the lower one with circular medallions connected by foliate scrollwork, the upper one with similar motifs arranged in a spiral. The wide silver-gilt bands are outlined by narrow silver borders with niello dots. Around the brow band at the front, back, and sides are four applied teardrop-shaped cartouches of nielloed silver containing Arabic inscriptions (e–h). The rim is pierced with numerous close-set holes by which the long mail face and neck defense, or aventail, of riveted iron links is attached. The helmet retains its woven-textile chin strap with two nielloed silver fittings, a rectangular slide, and a circular pendant.

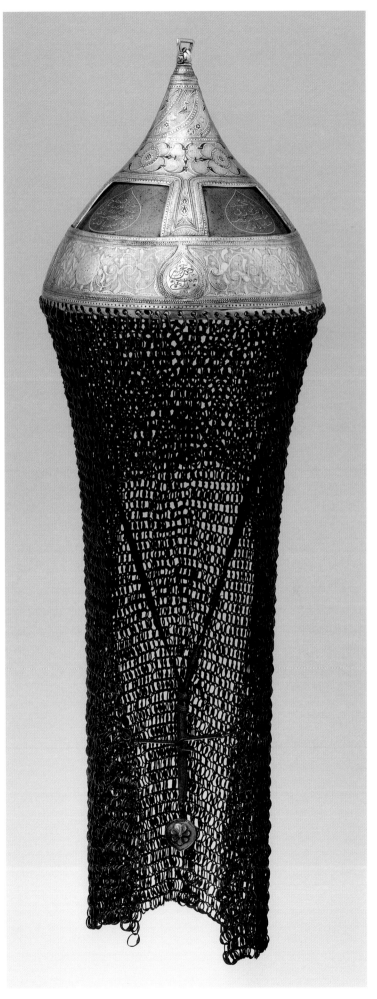

INSCRIPTIONS:

In the four gold-inlaid teardrop-shaped cartouches on the bowl, clockwise from right front

a.

يا فتّاح
... المولى
حسبي الله نعم النصير يا احد
يا صمد يا فرد/ ق‍ـ]‍‍ا[در (؟)

O Opener! . . . the Master. Allah is enough for me, the best supporter. O One and Only! O Eternal! O Unique / All-Powerful (?).

b.

يا ابا بكر
و تعز من تشاء
و تذل من تشاء
يا حي يا قيوم

O Abu Bakr! And Thou enduest with honour whom Thou pleasest. (Qur'an 3:26). O Ever-Living! O Self-Subsisting!

c.

يا عمر
يا عثمان فرد
حي قيوم حكم عدل
قدوس الفاروق بين [الحق و الباطل]

O 'Umar! O 'Uthman! Unequalled, Ever-Living, Self-Subsisting, Judge, Just, Holy. Distinguisher between [the truth and the false].

d.

يا محمد
علي و ترزق
من تشاء بغير
حساب يا حي

O Muhammad! 'Ali. And Thou givest sustenance to whom Thou pleasest, without measure. (Qur'an 3:27). O Ever-Living!

In the four silver teardrop-shaped cartouches on the rim, clockwise from right front

e.

بسم الله الرحمن الرحيم توكلت على الله

In the Name of Allah, the Compassionate, the Merciful. I put my trust in God.

f.

صاحب ابات بسلنايى ابن الحاج قريمگرايى زيد عمره

Owner, Abat Besleney ibn al-Hajj Qirim-giray, may [God] prolong his life.

g.

عمل قلوبات زاده حاجنك اوستاسي خانفوغ/جانفوغ (؟) ١٢٢٣

Made by Qalubat-zade Haji's master, Khanfugh / Janfugh (?), 1223 (A.D. 1808/9).

h.

يا رفيع الدرجات

O Raiser of Dignity!

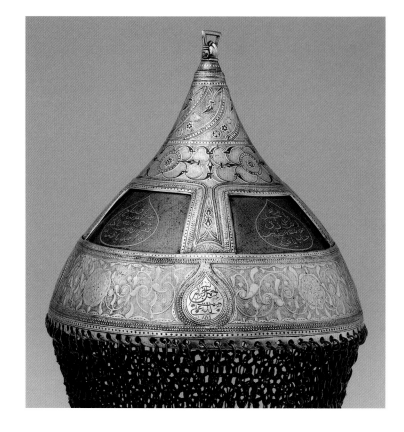

The inscription includes the names of both maker and owner, the latter apparently a descendant of the ruling house of the Crimean, or Krim, Tartars. The Krim Tartars were a branch of the Mongol Golden Horde who controlled the Crimean Peninsula from 1239. With the demise of the Great Horde, the Khan of the Krim Tartars, Hajji Giray, proclaimed an independent state in 1449. By the late sixteenth and seventeenth centuries they ruled in the Crimea, southern Ukraine, the lower Don-Kuban, and Kazakhstan. They were in almost continual conflict with the rising power of Russia and, in their need to find powerful Muslim allies, became increasingly dependent upon the Ottomans. Nothing, however, could halt Russian encroachment, and their lands were gradually conquered, culminating with the annexation of the Crimea by Russia in 1783.[1] The inscription on the Museum's helmet dates therefore to the period when the Girays were Russian vassals. The process of subjugating the Muslim Tartars continued into the Soviet era, ending in a mass expulsion in 1944 under Stalin. In 1992 the Krim Tartars, a minority in their homeland, voted for independence from the new Russian state.

The reading of the place-names in the inscription remains tentative, especially the name rendered here as "Khanfugh/ Janfugh." As recorded in the inscription, the owner of the helmet, Abat Besleney, was a member of the Besleney, a Circassian (Adyghe) tribe, with connections to the ruling Giray.[2] The name "Giray" also occurs on several stylistically related helmets with silver mounts, including one in Poland inscribed with the name

of Adil Giray (r. 1666–71);[3] two in the State Hermitage Museum, Saint Petersburg, one dated A.H. 1158 (A.D. 1745/46) that mentions Muhammad Giray, son of Islam Giray, the other dated A.H. 1200 (A.D. 1785/86) and inscribed with the owner's name, Inajat Krim Giray Bek;[4] and another, now in the Topkapı Sarayı Museum in Istanbul, dated A.H. 1180 (A.D. 1766/67) and inscribed "Sultan 'Ali ibn Muhammad Giray."[5] The "Qirim-Giray" (father of the owner) referred to on the Museum's helmet is possibly Qirim-Giray b. Dawlat, who ruled in 1758–64 and then again in 1768–69. Another helmet of this same type, dated A.H. 1196 (A.D. 1781/82), is also in the Museum's collection (cat. 40).

The prototype for helmets with silver mounts such as this is the early medieval spangenhelm, whose metal frames were used to hold together the various segments of the bowl. In discussing Russian helmets of the early Middle Ages, Anatolij N. Kirpicnikov illustrates a number of varieties, among them one found at Babitschi, near Kiev, which he dates about A.H. 544–647 (A.D. 1150–1250); it has a bowl almost identical in shape to that of the Museum's helmet, as well as mounts of silver niello clearly decorated with stylized leaf forms.[6]

This decorative style relies on the use of large stylized floral forms that sometimes look as though they have been cut out and placed onto a lighter ground. The style developed from the

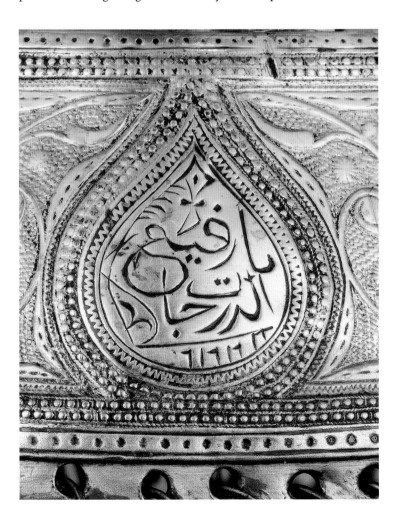

leatherwork and appliqué decoration used by Central Asian nomads on their most basic equipment of everyday life, particularly their ox-drawn tents.[7] The French missionary Willem van Ruysbroeck, who was part of an embassy to Batu and then to Möngke, the great khan of all the Mongols between 1253 and 1255, described their tents as follows: "They cover it [the tent] with white felt: quite often they also smear the felt with chalk or white clay and ground bones to make it gleam whiter . . . and they decorate the felt around the neck at the top with various fine designs. Similarly they hang up in the front of the entrance felt patchwork in various patterns: they sew onto one piece others of different colors to make vines, trees, birds and animals."[8] Equipment decorated in this nomad style has been observed over a large area. It occurs on a belt fitting found during the Museum's excavations at Nishapur in Iran;[9] on a group of quivers and bow cases, many from archaeological excavations of Golden Horde sites in southern Russia; and on belt fragments found in Afghanistan.[10]

PROVENANCE: W. O. Oldman, London; George C. Stone, New York.

Unpublished.

NOTES
1. See especially Bosworth 2004, pp. 255–57, no. 135.
2. The owner of the helmet, Besleney Abat, was tentatively identified by Will Kwiatkowski, who noted that "an Abat Besleney is mentioned as one of two brothers who helped the Russians compile a report on the Adyghe tribes in 1829, and a Besleney Abat is mentioned as going on a mission to the sultan in Istanbul, along with a Horeliko Hamirz, to present the cause of the Adyghe peoples, who were being displaced by the Russians" (personal communication, February 2015). For the Circassians in the Crimea, see B. Williams 2001, pp. 198–99; for the "Circassian genocide" after the Russian conquest of the Caucasus, see Richmond 2013.
3. Muzeum Wojska Polskiego, Warsaw, no. 2710x; see Gutowski 1997, p. 54, no. 31, ills. p. 94, cover.
4. For the two helmets in the State Hermitage Museum, Saint Petersburg, see Miller 2000, pp. 160–61, 163, 328, figs. 85–86.
5. According to Hilmi Aydın 2007, p. 168, this helmet is inscribed "Owned by Sultan 'Ali Bin Muhammad Giray Oglu Mansur." Aydın also includes a group of helmets, firearms, and sabers all inscribed with the names of various members of the Giray family or clan; see ibid., pp. 166–72. For a listing of the Giray Khan dynasty from the fifteenth century to the Russian annexation of the Crimea, see Bosworth 2004, pp. 255–57, no. 135.
6. Kirpicnikov 1973, especially fig. 3; see also cat. 40.
7. Richard Ettinghausen 1952 has called this type of Turkic nomad decoration "the beveled style."
8. Ruysbroeck 1990, p. 73. A modern example of this appliqué technique can be seen on a felt hanging in the State Central Museum, Ulaanbaatar, Mongolia, on which strong pseudo-vegetal forms in brown and red felt contrast against a white ground; see Uray-Köhalmi 1989, p. 49.
9. National Museum of Iran, Tehran; see Allan 1982b, p. 66, no. 35, ill.
10. For the bow cases, see Malinovskaya 1974. The belt fragments found in present-day Afghanistan are now in the Furusiyya Art Foundation, Vaduz, no. R-573; see Paris 2007/Mohamed 2008, p. 117, no. 86. For later Turkman examples of this widespread style, see, for example, Hasson 1987, nos. 176, 177, 180, 184, and cat. 40.

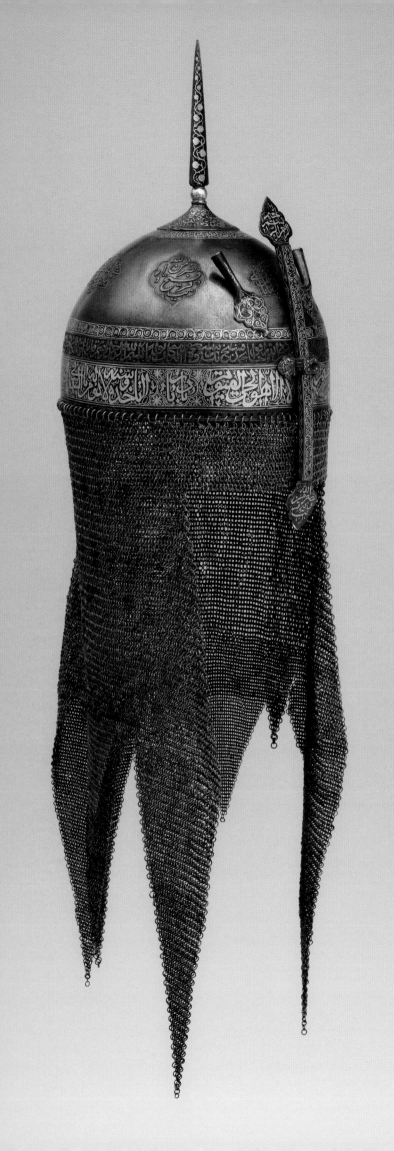

42 · Helmet

Iran, Qajar period, 18th–early 19th century
Steel, iron, gold, copper alloys, textile
Height 27⅜ in. (69.4 cm), without mail 9¾ in. (24.8 cm);
weight 4 lbs. 3 oz. (1,913 g)
Edward C. Moore Collection, Bequest of Edward C. Moore, 1891
91.1.749

DESCRIPTION: The hemispherical bowl is constructed of three plates: one of
crucible steel that forms the upper half, and two applied concentric bands of dark
iron or steel that encircle the rim and form the two lower registers of decoration;
the joins and numerous rivets that secure them are visible beneath the lining. The
upper half of the bowl is chiseled with six lobed cartouches of alternating round and
rectangular shape containing Arabic inscriptions (a, b); it is damascened in gold
around its lower edge with a band of scrollwork and at the top with a band contain-
ing an Arabic inscription (c). The two applied bands at the rim are decorated with
Arabic inscriptions, the upper one chiseled in relief (d), the lower one damascened
in gold and divided among cartouches of alternating shape (e, f). Riveted at the apex
is a low conical mount fitted with a four-sided spike that rises from a globular knob;
the spike and its base are damascened with foliate scrolls. Riveted at the front of the
bowl is a screw bracket that secures a sliding nasal of rectangular section with flat-
tened, lobed finials. Above the bracket and to each side are riveted two small plume
holders with flattened, lobed bases. The nasal and plume holders are damascened
with foliage and scrolls, and the finials of the nasal contain Arabic inscriptions (g,
h). Attached through holes around the rim of the bowl is a long mail neck defense,
or aventail, of small butted rings of iron, brass, and copper arranged in geometric
patterns; the mail has a dagged lower edge, with four long triangular points (one at
each side and two at the back) and six shorter ones. The lining of red textile glued
into the bowl is modern.

INSCRIPTIONS:

a. (Around the upper section of the bowl in the three round cartouches)

بسم الله الرحمن الرحيم / نصر من الله و فتح قريب / و بشر المؤمنين هو و محمد علي

In the Name of Allah, Most Gracious, Most Merciful. Help from Allah and a speedy
victory. So give the Glad Tidings to the Believers. (Qur'an 61:13). He (Allah), and
Muhammad, ʻAli.

b. (Around the upper section of the bowl in the three rectangular cartouches)

ناد عليا مظهر العجائب تجده عونا لك في النوائب

كل هم ش غم سينجلي بعظمتك يا الله بنوبتك [كذا] يا [محمد] بنو[بتك] يا محمد بولايتك يا علي يا علي

عمل علي

Call upon ʻAli the revealer of miracles,
You will find him a comfort to you in crisis,
Every care and every sorrow will pass
Through Your greatness, O Allah, through your prophecy O [Muhammad], through
your Prophecy O Muhammad, through your guardianship, O ʻAli, O ʻAli!

Made by ʻAli.

c. (Around the top of the bowl)

بسم الله الرحمان الرحيم قل هو الله احد الله الصمد لم يلد و لم يولد و لم [يـ]كن له كـ[فـ]وا احد ...

In the Name of Allah, Most Gracious, Most Merciful. Say: He is Allah, the One; Allah,
the Eternal, Absolute; He begetteth not, nor is He begotten; and there is none like
unto Him. (Qur'an 112) . . .

d. (Around the upper band on the rim)

بسم الله الرحمن الرحيم قل يا ايها الكافرون لا اعبد ما تعبدون و لا انتم عابدون ما اعبد و
لا انا عابد ما عبدتم و لا انتم عابدون ما اعبد لكم دينكم و لي دين يا سبحان الله ان الله قوي
عزيز يا باقي بسم الله الرحمن الرحيم اذا جاء نصر الله و الفتح و رأيت الناس يدخلون في
دين الله افواجا فسبح بحمد ربك و استغفره انه كان توابا

In the Name of Allah, Most Gracious, Most Merciful. Say: O ye that reject
Faith! I worship not that which ye worship, nor will ye worship that
which I worship. And I will not worship that which ye have been wont to
worship nor will ye worship that which I worship. To you be your Way,
and to me mine. (Qur'an 109). O Glory be to Allah, for Allah is strong and
mighty. O Ever-Lasting! In the Name of Allah, Most Gracious, Most Mer-
ciful. When comes the Help of Allah, and Victory, and thou dost see the
People enter Allah's Religion in crowds, celebrate the Praises of thy Lord,
and pray for His Forgiveness: for He is Oft-Returning (in forgiveness).
(Qur'an 110)

e. (Around the lower band on the rim in the long cartouches)

بسم الله الرحمن الرحيم الله لا اله الا هو الحي القيوم لاتأخذه سنة و لا نوم له ما في السموات
و ما في الارض من ذا الذي يشفع عنده الا باذنه يعلم ما بين ايديهم و ما خلفهم و لا يحيطون
بشيء من علمه الا بما شاء وسع كرسيه السموات و الارض و لا يؤده حفظهما و هو العلي
العظيم نصر من الله و فتح قريب

In the Name of Allah, Most Gracious, Most Merciful. Allah! There is
no god but He, —the living, the Self-subsisting, Supporter of all / No
slumber can seize Him nor sleep. His are all things in the heavens and
on earth. Who is thee can intercede in His presence except as He permit-
teth? He knoweth what (appeareth to His creatures as) Before or After
or Behind them. Nor shall they compass aught of His knowledge except
as He willeth. His Throne doth extend over the heavens and the earth,
and He feeleth no fatigue in guarding and preserving them for He is the
Most High, the Supreme (in glory). (Qur'an 2:255). Help from Allah and a
speedy victory. (Qur'an 61:13).

f. (Around the lower band on the rim in the small cartouches)

يا حنان / يا منان / يا ديان

O Ever-Yearning! O Ever-Bestowing! O All-Requiting!

g. (At the top of the nasal)

بسم الله الرحمن الرحيم

In the Name of Allah, Most Gracious, Most Merciful.

h. (At the base of the nasal)

نصر من الله وفتح قريب

Help from Allah and a speedy victory. (Qur'an 61:13)

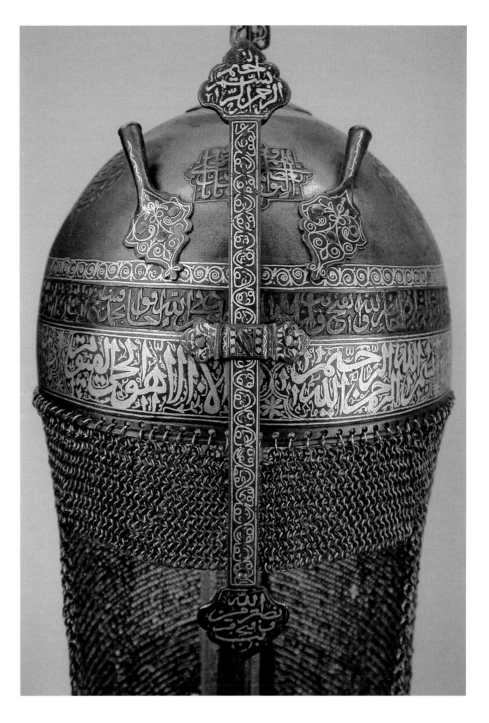

Iranian helmets of this form, with a hemispherical bowl
surmounted by a spike, have often been described, with little
proof, as Safavid and of the seventeenth century. Yet most
are decorated in styles that seem much later and are probably of
the Zand (1751–94) and Qajar (1779–1925) periods. Safavid helmets
of the sixteenth and probably most of the seventeenth centuries
seem to have had tall conical bowls, often fluted, and were
frequently illustrated in miniature paintings.[1] The Safavids
appear to have adopted helmets with small hemispherical bowls
set with spear-shaped finials later in the seventeenth century,

several dated examples of which survive, including one dated
A.H. 1088 (A.D. 1677/78) in the Furusiyya Art Foundation, Vaduz.[2]
Other examples are of the eighteenth century, such as one now in
the State Hermitage Museum, Saint Petersburg, dated A.H. 1146
(A.D. 1733/34), during the reign of 'Abbas III (1732–36).[3]

The Museum's helmet is inscribed and decorated in two dif-
ferent techniques: gold damascening over a crosshatched ground
and chiseling. The damascened work is typical of the late eigh-
teenth to early nineteenth century,[4] but the chiseled inscriptions
and ornament are more difficult to date and could be placed any-
where between the seventeenth and the nineteenth century.
Dated examples include a finely chiseled saddle ax of 1735/36 now
in the Museo Poldi Pezzoli, Milan.[5] Although James Allan and oth-
ers have tried to establish a chronology for this chiseled style, the

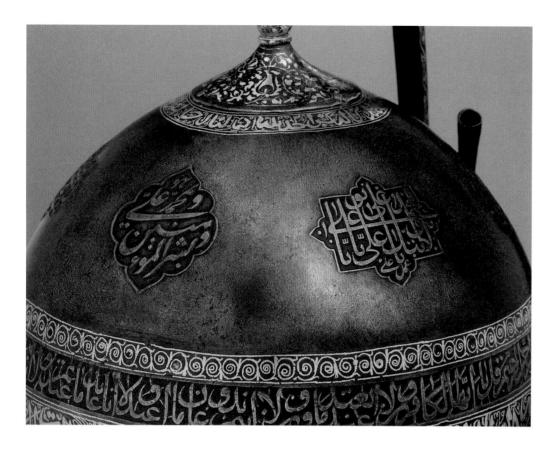

existence of numerous objects made during the "Safavid revival" of the Qajar period has hitherto prevented a satisfactory conclusion to this problem.[6] Certainly, helmets of this form were commonly worn by Qajar cavalrymen as late as the mid-nineteenth century, and the vast majority of the surviving helmets are of this period.[7]

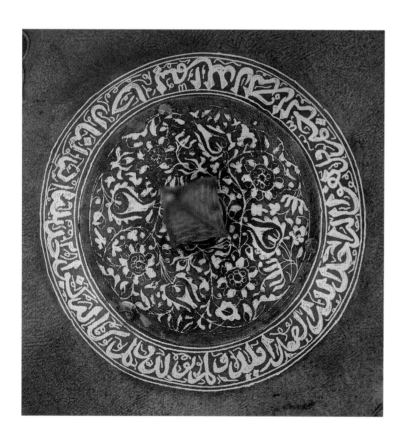

PROVENANCE: Edward C. Moore, New York.

REFERENCES: Dimand 1930, p. 122; Dimand 1944, p. 157; Dimand 1958, p. 157.

NOTES

1. One such miniature painting is in the Metropolitan Museum, "The Besotted Iranian Camp Attacked by Night," from the *Shahnama* (Book of Kings) of Shah Tahmasp, fol. 241r (acc. no. 1970.301.36); see Canby 2014, p. 207.

2. Furusiyya Art Foundation, Vaduz, no. R-830 (the date falls within the reign of the Safavid shah Sulaiman, 1666–94); see Paris 2007/Mohamed 2008, p. 334, no. 321. A helmet in the British Museum, London, is inscribed with the name of Shah ʿAbbas I (r. 1587–1629) and dated A.H. 1033 (A.D. 1625/26) (see Barrett 1949, pp. xx, xxiv, pl. 38a), and another in the Topkapı Sarayı Museum, Istanbul, no. 1/897, is dated A.H. 993 (A.D. 1587/88) (see Munich 1910, no. 343, pl. 230, and Istanbul 2010, p. 214); both are probably of Qajar manufacture.

3. For the example in the State Hermitage Museum, Saint Petersburg, see *Musée de Tzarskoe-Selo* 1835–53, vol. 1, pl. 33, and Egerton 1896, p. 53, pl. V. An example in a private collection in Los Angeles, although undated, is also most probably of the late Safavid period; see Soudavar 1992, no. 54.

4. For example, floral forms such as those on the apical spike are of the same type as those in the work of the bladesmith Muhammad Hadi (active ca. 1800); see Zeller and Rohrer 1955, nos. 177, 178. Another example previously in the Holstein collection is dated 1798/99; see Mayer 1962, p. 60. A dating to the late eighteenth century is also suggested by the decoration, which includes leaves with open centers that are very similar to those on a dagger in the Freer Gallery, Washington, D.C., no. 39.442–6, dated 1777; see Washington, D.C. 1985–86, no. 35.

5. Museo Poldi Pezzoli, Milan, no. 2198; see Boccia and Godoy 1985–86, vol. 2, pp. 531–32, no. 1023, and cat. 96.

6. See Allan 1982a, no. 26, for a beggar's bowl (*kashkul*) chiseled in this style, signed by Haji ʿAbbas, and spuriously dated 1606/7.

7. An example of such a helmet can be seen in a painted detail from a nineteenth-century lacquered Iranian casket in the Khalili Collection, London, no. LAQ 356; see Khalili, B. Robinson, and Stanley 1996–97, vol. 1, no. 125.

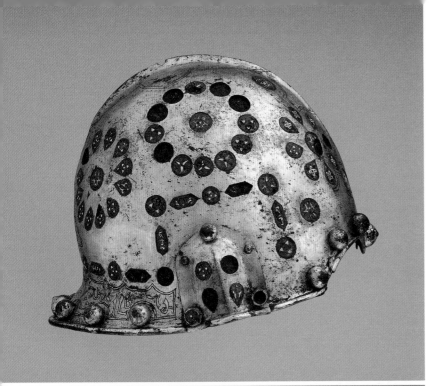

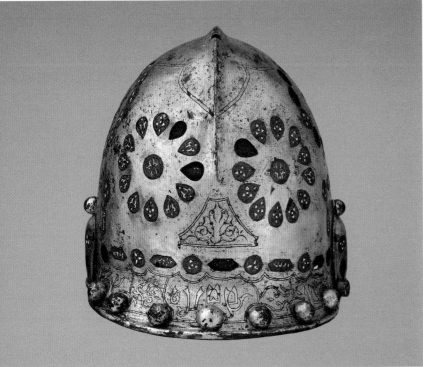

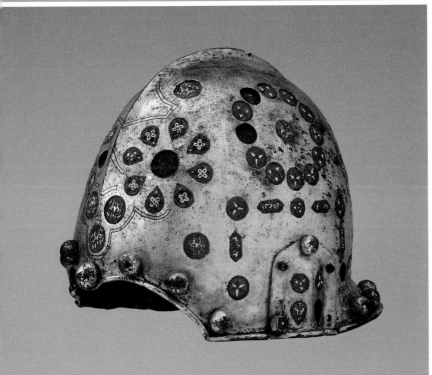

43 · Helmet

Spain, Granada (?), late 15th or early 16th century
Steel, silver, gold, cloisonné enamel
Height 7⅞ in. (20 cm); weight 3 lbs. 12 oz. (1,702 g)
From the Lord Astor of Hever Collection, Purchase,
The Vincent Astor Foundation Gift, 1983
1983.413

DESCRIPTION: The one-piece bowl is forged with a low comb pierced at the apex with a circular hole for a plume, semicircular cusps over the eyes, and a short flanged tail at the back, the edge rolled outward. The bowl is cut at the sides with the slots for the ears, each slot measuring 1½ in. (3.8 cm) wide at the base and tapering slightly upward, with the top cut in a flattened ogival shape. The slots are covered by arched plates boxed out over the ears and secured by five rivets of different design: the large pair of gilt-iron rivets at the bottom are hexagonal in shape and inset with cloisonné enamel; the small pair of silvered iron rivets above them are of domed shape; and the rivet at the top has a large domed head of gilt iron. The ear covers have an outward-rolled lower edge that continues the line of the bowl's bottom profile. The edges of the bowl are encircled by rivets with large domed heads of gilt iron, the rivets at the center of the brow and tail being of slightly pointed form. The surface of the bowl is hatched and covered with gold leaf, the rolled edges covered with hatched silver. The gilt surface is punched with dots and guilloche patterns around the enamels and rivet heads and is engraved with disconnected double lines at the front and on each side of the comb; at the base of the comb at the back is an engraved triangular panel, the points concave, filled with engraved, stylized foliage. The surface of the tail is engraved with pairs of lines that follow the irregular edges of the enamels and rivet heads and form a cartouche that encloses decorative pseudo-Arabic inscriptions against a background of dense, incised foliate scroll-work. The bowl is pierced to accommodate 116 inlaid cloisonné enamels (22 missing) of round, pointed-oval, or hexagonal shape set flush into the surface. The designs on the enamels—in foil-backed translucent green, opaque red, blue, black, and white—include hexagrams, rosettes, knots, interlacing foliate forms, and pseudo-Arabic inscriptions. The enamels are distributed over the surface, arranged in three circles on each side, in a rectilinear design outlining the ear covers, and in a straight line across the back of the bowl above the tail; three enamels (two over one) are also placed at the center of the brow, with two additional enamels high up on the skull, one to each side of the comb, and one at either side over the eyes. Each ear cover is inset with four enamels in addition to the enamels set into the lower two rivet heads. The interior is fitted with six large, crudely cut steel plates that act as supports for the enamels; the ends of the rivets that secure these plates to the bowl have been filed flat to the outer surface but are occasionally visible beneath the gold leaf. The ear covers are lined with a woven silk textile, now very worn. Rivets around the front of the bowl retain fragments of the original leather lining strap; beneath the lower rivet at the front of each ear cover are remnants of what was probably the chin strap of leather covered with bright yellow silk.

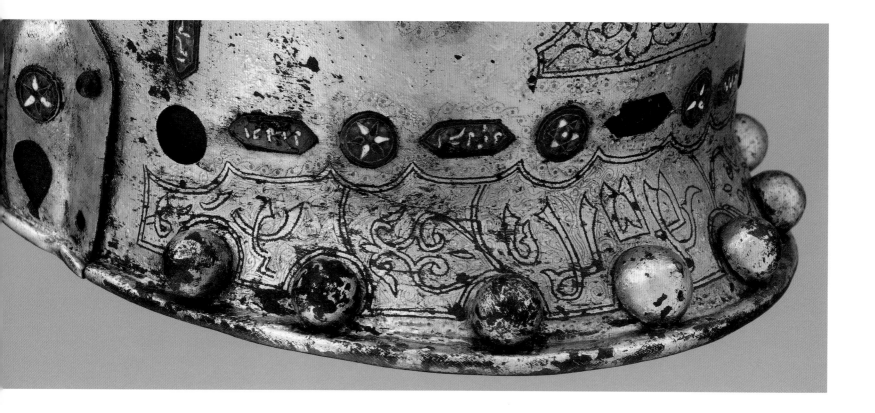

A unique piece, this helmet is perhaps the only surviving example of armor from Muslim Spain under the rule of the Nasrids (r. 1232–1492), yet its very uniqueness makes it almost impossible to place it in an unambiguous historical context. The bowl, which is of European manufacture, is generally close in form to two types of open-faced infantry helmets, or sallets, worn in Spain in the late fifteenth century, both distinguished by cutouts over the eyes. Some of these are struck with a mark traditionally associated with Calatayud, near Saragossa, Spain, a center noted for its production of gilded helmets set with precious stones.[1] That it is a European style of helmet should not be surprising; wall paintings in the Torre de las Damas in the Alhambra palace confirm that the Nasrids were influenced by the weapons and armor of their Christian neighbors and adversaries.[2]

The decoration on this helmet can certainly be related to other pieces of the Nasrid period. Similar cloisonné enamels can be seen in the hilts of Nasrid swords; in a set of mounts for a bridle in the British Museum, London; and in belt fittings in the Metropolitan Museum's medieval collection.[3] The guilloche-and-dot design punched into the gilt ground of the sallet is also found on the hilt of the sword attributed to the Nasrid general 'Ali 'Attar, who died in 1483.[4]

The European parallels for this type of helmet might lead to the suggestion that since most of the pseudo-Arabic inscriptions on the helmet are apparently meaningless it could not have been decorated in a Muslim workshop and that it is perhaps a commemorative piece produced for the Christian conquerors of the Nasrids.[5] However, in light of the large number of Ottoman or Turkman helmets and armor that also bear unintelligible or incorrect inscriptions, this argument loses strength. One example of this type of pseudo-inscription appears on a sword from Islamic Spain now in the Musée de l'Armée, Paris, and though not enameled the inscription is surrounded by tight foliate scrolls comparable to the inscription on the neck of the Museum's sallet.[6] An additional example is found on the grip of a Nasrid sword in the Museo Arqueológico Nacional, Madrid.[7]

A tangential problem is the possible relationship of the Museum's helmet to several other pieces that contain both Nasrid and Mamluk components. These include a sword of Mamluk type now in the Topkapı Sarayı Museum, Istanbul, whose guard is decorated with filigree of the same style as that on two Milanese helmets in the Real Armería, Madrid,[8] and a Nasrid or perhaps North African sword with a German blade in the Topkapı Sarayı Museum.[9] The common element in this array of diverse pieces that bear a connection to the Museum's helmet remains elusive. It may eventually be explained by a historical analysis of the complex interrelationships between the Nasrids and their Christian neighbors in Spain and their Muslim counterparts in North Africa and in the Mamluk Empire.[10]

PROVENANCE: Baron Pierre-François Percy; Monsieur Durand; Marquis de Perignon, Château de Perignon; Lord Astor of Hever, Hever Castle, Kent.

REFERENCES: Dubois, Paris 1825, lot 53; Lebrun, Paris 1830, lot 62; Laking 1920–22, vol. 2, pp. 15–18, fig. 356; Mann 1933, p. 301, pl. 90; Sotheby Parke Bernet, London 1983, lot 34; Pyhrr and Alexander 1984, ill.; *Islamic World* 1987, pp. 66–67, no. 48; Nicolle 1989, p. 33, fig. E; Gonzalez 1990, pp. 198–99; Nickel 1991a, p. 55; Granada and New York 1992, pp. 294–95, no. 65; Gonzalez 1994, pp. 134, 140, 146–47, figs. 96, 101; Pyhrr 2001, pp. 626, 639, fig. 9; Pyhrr 2007b, p. 116, fig. 9; Washington, D.C. 2009, pp. 56–57, no. 5.

NOTES

1. The Museum's helmet appears to be an amalgam of two types of sallet worn in Spain at this time, both with cutouts over the eyes: one with flaring sides and a short tail, the other more close-fitting, with straight sides and cutouts for the ears. Both types are discussed and illustrated in Mann 1933, p. 301, fig. 8, and pl. 88, no. 5. Neither typically has a rolled edge, a feature found on the Museum's example and in general on better-quality helmets of European manufacture. For Calatayud, see Bruhn de Hoffmeyer 1981, pp. 144–45, where it is noted that, in the thirteenth century, Calatayud was a center for gilded and jeweled helmets; this does not prove, however, that this center was still producing that type of work during the fifteenth century, nor that our helmet was decorated there.

2. Illustrated by a drawing by David Nicolle in Bruhn de Hoffmeyer 1981, p. 281, fig. 121. In the same publication there are a number of illustrations from the Cantigas de Santa Maria of Alfonso X (1221–1284), a manuscript of poetry set to music, showing that by the thirteenth century Christians and Muslims in Spain used similar armor.

3. For the swords, see Granada and New York 1992, nos. 61–63; for the bridle in the British Museum, London, no. 1890, 10-4, 1, see ibid., no. 68; for the belt fittings in the Metropolitan Museum, acc. no. 17.190.962, see ibid., no. 72.

4. Museo del Ejército, Madrid, no. 22.904 (formerly 1097); see, especially, Ferrandis Torres 1943, pp. 156–57, fig. 13; Seville 1992, p. 160, no. 75.

5. See the discussions by Alvaro Soler, who considers the helmet to be the work of Christian craftsmen influenced by Nasrid metalwork, in Granada and New York 1992, pp. 294–95, and Washington, D.C. 2009, pp. 56–57.

6. Musée de l'Armée, Paris, no. J PO 680; see Ferrandis Torres 1943, p. 163, fig. 21. For an image that includes the inscribed guard, see "Epée dite 'de Boabdil,'" Musée de l'Armée, Paris, accessed July 28, 2015, www.musee-armee.fr/collections/base-de-donnees-des-collections/objet/epee-dite-de-boadbdil.html.

7. Museo Arqueológico Nacional, Madrid, no. 51056; see Ferrandis Torres 1943, pp. 154–55, fig. 11, and Seville 1992, p. 159, no. 74.

8. For the sword in the Topkapı Sarayı Museum, Istanbul, see Alexander 2004, no. 12. For a detailed discussion of this type of granulation, see Hildburg 1941 and New York 1983, p. 92. For the sallets in the Real Armería, Madrid, nos. D 12, D 13, see Valencia de Don Juan 1898, p. 140, and New York 1998–99, pp. 5–6, figs. 4, 5, respectively.

9. Topkapı Sarayı Museum, Istanbul, no. 1/111 (unpublished).

10. While the helmet's opulent and unusual decoration indicates that its purpose was exclusively ceremonial, for whom it was made, as well as when, where, and for what occasion, are not known. Its provenance, unfortunately, tells nothing of its early history. It is first recorded in Paris in 1825 in the posthumous sale of the collection of Baron Pierre-François Percy (1754–1825), chief surgeon to the French army under Napoleon I; see Dubois, Paris 1825. Like many of his fellow officers, Percy assembled a substantial collection of antique arms and armor that were taken as booty or souvenirs during French military campaigns in Europe. Percy presumably acquired this helmet during his sojourn in Spain in 1809. By the time the helmet reappeared on the art market in Paris about 1900 it had acquired a new and fanciful provenance as having belonged to Muhammad XII, called Boabdil, the last Nasrid king of Granada.

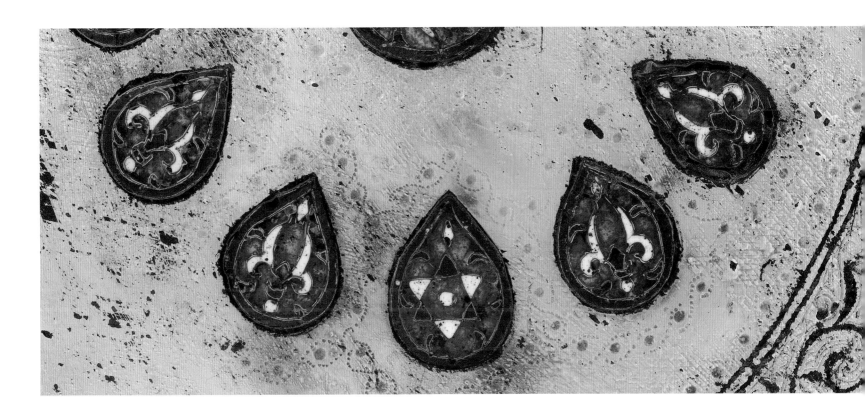

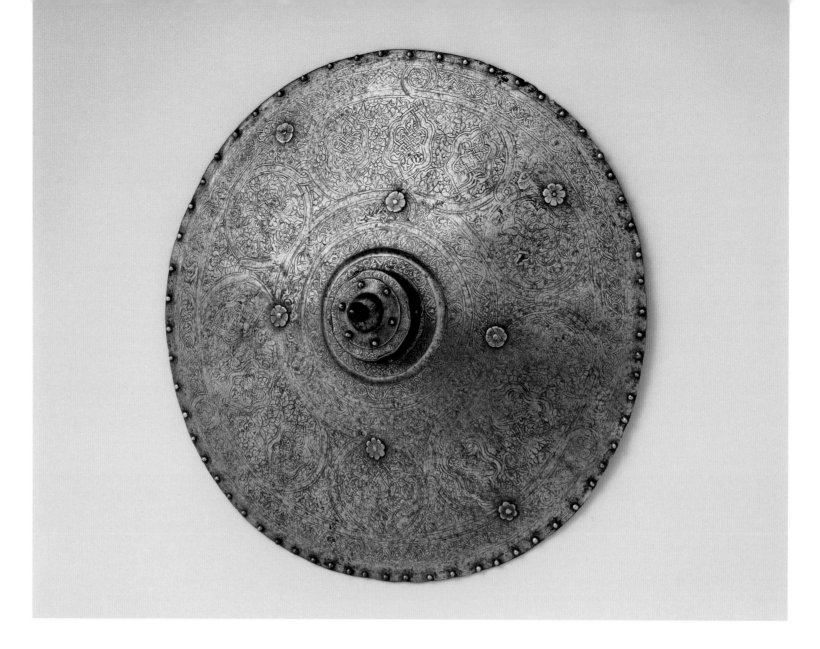

44 · Shield

Turkey, Ottoman period, or Syria, Mamluk period, late 15th century
Steel, copper alloys
Diameter 18⅜ in. (46.7 cm); weight 3 lbs. 7 oz. (1,546 g)
Bequest of George C. Stone, 1935
36.25.610

DESCRIPTION: The round shield has a shallow convex face and is embossed with a slightly raised circular area in the center from which rises a straight-sided, drumlike umbo. The top of the umbo is a separately applied flat disk attached inside the drum wall by four turned-down tabs secured by brass rivets. Applied to the center of the disk and held by six brass rivets is another, smaller circular plate, domed in the center, with a squat, faceted spike. The surface of the shield between the rim and the raised center is engraved with strapwork that frames four concentric registers filled with dense, fleshy-leafed floral arabesques. The first, third, and fourth registers from the rim are engraved with continuous foliate scrolls, the first and third interrupted by three round strapwork cartouches filled with a centralized flower. The second, and widest, register is filled with six interconnected cartouches, alternately oval and round, the former each containing three lobed medallions filled with strapwork knots, the latter filled with symmetrical arabesque ornament. The raised center and face of the umbo are engraved with dense foliage to match the shield. The rim is encircled by sixty-two small copper rivets with domed heads that

originally secured the lining, now lost. On the interior are seven iron loops with circular washers, six of them retaining their rings by which the arm straps and shoulder strap were attached; the stems of the loops are secured on the exterior by flat, rosette-shaped iron washers engraved with petals. Engraved near the center, in the band separating the third and fourth registers, is the *tamğa* of the Ottoman arsenal.

The shield's surface appears to have been chemically cleaned in the nineteenth century, and there are a number of small patches filling rust holes. Some of the engraving appears unusually deep for the worn surface and may reflect a restorer's attempt to reinforce the design, presumably when the shield entered the art market around 1839–40. The spike and its base plate may be a later European addition.

The type of engraved arabesque and knot designs on this shield belongs to a widespread Turko-Iranian style that draws upon Syrian, Iranian, and Anatolian influences.[1] The designs here bear resemblances to both Mamluk and Iranian decorative styles, as seen in the use of similar large, rounded cartouches and centrally organized arabesque designs on a Mamluk shield of the late fifteenth century in the Askeri Müzesi, Istanbul, and, more generally, in the rounded and lobed cartouches and similar leaf forms in Timurid decoration of the

fifteenth century.[2] Rosette-shaped washers like those on this shield are found on a number of all-metal shields, including one attributed to an Ottoman workshop, now in the Royal Ontario Museum, Toronto; the Mamluk example mentioned above; and a Turkman shield in the Royal Armouries, Leeds.[3] The Ottoman and Mamluk examples are both decorated in easily identifiable styles, but the shield in Leeds illustrates yet again the difficulty in attributing much of the armor of this period. In addition to rosette-shaped washers similar to those on the Museum's shield, it too is entirely of steel. While the engraved design on the Leeds shield is comparable to that used on many so-called turban helmets, its central boss is decorated in a different style and is inscribed الو غ بك مرز.[4] This inscription has been tentatively read as the name of the Timurid ruler Ulugh Beg (1393–1449); as Ludvik Kalus has noted, however, Ulugh is usually written الغ and not الو غ. The Leeds inscription might therefore not be Timurid and should perhaps be read as a reference to a guardian of a frontier province. Consequently, the Leeds shield cannot be used as proof that the Museum's shield is Iranian, nor can the rosette-shaped washers clinch the attribution, as versions of these are found on a number of shields from apparently diverse centers. Decoratively, the closely packed knots and arabesques are similar to those on Ottoman armors and metalwork, such as a shoulder defense from a pectoral armor and a jug in the Khalili Collection, London,[5] and a helmet in the Askeri Müzesi, Istanbul.[6]

Another all-metal shield of this general type, called Ottoman of about 1500, was sold by Sotheby's, London, in 2003. It is decorated and inscribed in a style often found on turban helmets of the late fifteenth to sixteenth century.[7] However, the Ottoman and Mamluk pieces have much in common and belong to a shared cultural sphere stretching from Istanbul to northern Syria; although the Museum's shield is probably Ottoman, it cannot be attributed here to a specific location.

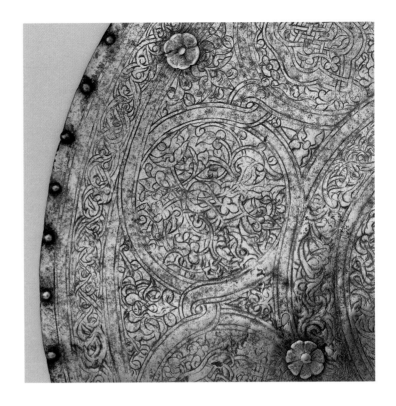

As with so many pieces coming from the imperial Ottoman arsenal, this shield probably left Istanbul about 1839 and entered the European art market. A number of pieces purportedly coming from Istanbul were sold at auction in London in the early 1840s, including, for example, "a fine Turkish engraved shield."[8] It is likely that its subsequent owner John Beardmore (1816–1861) acquired this shield from this or a similar source not long before it was engraved for illustration in his collection catalogue of 1845.

PROVENANCE: Ottoman arsenal, Istanbul; John Beardmore, Uplands, near Fareham, Hampshire, England; W. O. Oldman, London; George Cameron Stone, New York.

REFERENCES: Beardmore 1845, p. 23, no. 383, pl. 17; Christie, Manson and Woods, London 1921b, lot 43; Stone 1934, p. 37, fig. 5, no. 1; Bloomington 1970, no. 290.

NOTES
1. Unless this mélange of influences can be attributed to a specific metropolitan center, it is here described as Turkman.
2. For the Mamluk shield in the Askeri Müzesi, Istanbul, no. 17410, see Istanbul 1987, p. 152, no. A.145, and Riyadh 1996, vol. 2, no. 86i. For Timurid decoration between 1424 and 1431, see Lings 1978, nos. 81, 82.
3. Royal Ontario Museum, Toronto, no. 925.49.34 (unpublished), and Royal Armouries, Leeds, no. XXVIA.127. The latter, illustrated in H. Robinson 1967, pl. XA, has a central boss decorated in a style that differs from the rest of the shield.
4. See Kalus 1980, especially p. 24.
5. Khalili Collection, London, nos. MTW 1153, MTW 312; see Geneva 1995, pp. 144–45, 175–76, nos. 86, 115.
6. Askeri Müzesi, Istanbul, no. 13892 (unpublished).
7. Sotheby's London 2003, lot 73, ill. The inscription includes the Arabic poem, "May there be happiness and well-being and long-life to the owner, as long as the dove coos," which is used on numerous fifteenth-century helmets. For its relevance to Turkman metalwork, see Allan 1991.
8. Oxenham and Son, London 1842, lot 237. The sale catalogue description might equally apply to the shield in the Royal Armouries (see note 3 above).

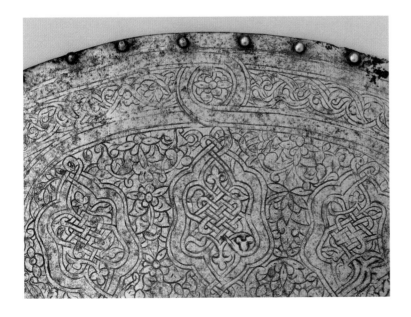

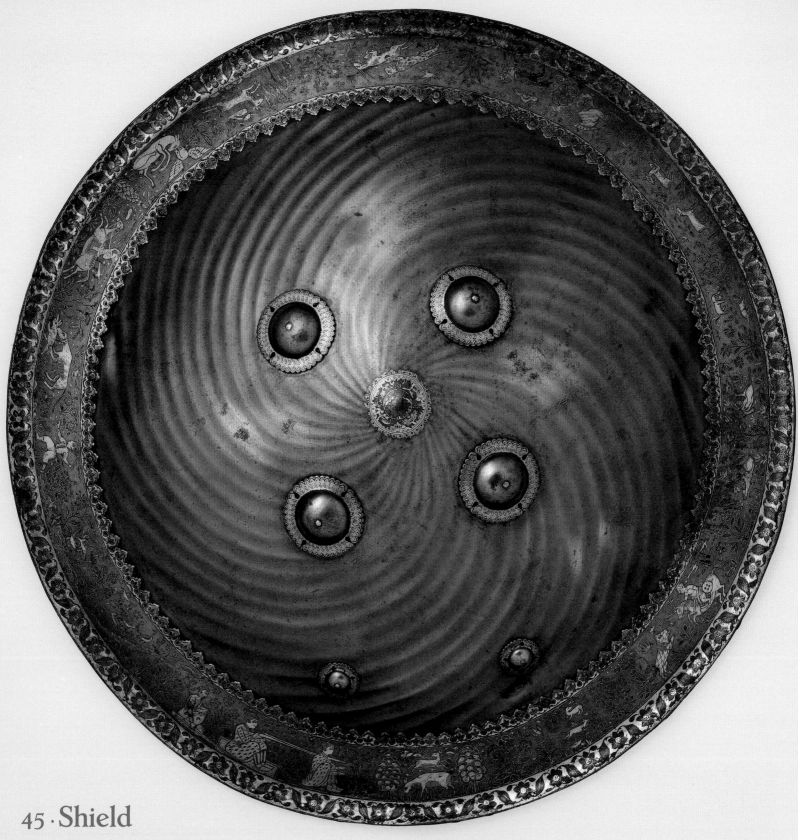

45 · Shield

India, Mughal period, 18th century

Steel, iron, gold, copper, leather, textile

Diameter 20¾ in. (52.8 cm); weight 5 lbs. 12 oz. (2,617 g)

Fletcher Fund, 1976

1976.176.3

DESCRIPTION: The round shield is strongly convex and slightly pointed in the center. The main plate is of crucible steel forged with narrow spiral flutings and is damascened in gold at the center with a roundel framed by an aureole of feathers or leaves and enclosing a landscape of hillocks and water occupied by aquatic birds and a pavilion. Riveted around the center are four domed bosses with pierced rims damascened in gold with a design of leaves or feathers; two smaller bosses of similar design are set to the edge of the main plate. The wide rim of iron is separately applied to the main plate. It is engraved and damascened in gold with a landscape populated by hunters and animals, the naive drawing style suggesting a somewhat later date of manufacture. The rim's inner edge is pierced with palmette shapes and is engraved with a repeating leaf motif on a gold ground; the turned-out outer edge has a repeating leaf-and-petal scroll reserved against a gold ground. The landscape scenes on the rim include vignettes of grazing and cavorting deer, lolling lions, mounted riders, feasting birds of prey, a trained cheetah attacking an antelope, a

hunting dog followed by his trainer grasping a small quadruped, a seated prince aiming a matchlock gun that rests on the shoulder of his attendant, and a rushing elephant mounted by a mahout trampling a man who has fallen off his mount. The interior is lined with layers of leather and paper (?) covered with a red, yellow, and blue cotton and silk brocade woven with a repeating geometric pattern; the lining is edged with braided, metallic thread and secured by numerous copper rivets with gilt heads. In the center of the interior a square pad covered with bands of cut-and-stitched leather applied over green and red velvet is edged with metal braid. The thickly padded grip straps are covered with a woven tan cotton and are secured by heavy iron rings to pierced lugs with rosette washers damascened in gold with petals. The rosette-shaped washers, which correspond to the two small, offset bosses on the exterior, are also damascened in gold; these presumably once secured a shoulder strap.

The spiral fluting on this shield is unusual, as Indian shields of either steel or leather generally have a smooth surface.[1]

Some of the guns in the hunting scenes around the rim, such as that held by the seated prince leveling his weapon on the shoulder of an attendant, have a stock shaped with a protruding rim behind the barrel. This feature seems to have first appeared on Mughal guns during the seventeenth century.[2] A later example of this generic Indian type, of the eighteenth or early nineteenth century, is in the Metropolitan's collection (cat. 115). Vignettes of hunters, warriors, and animals such as those depicted on this shield appear to derive from Mughal miniature painting (fig. 26).

PROVENANCE: Howard Ricketts, London.

REFERENCES: Los Angeles and other cities 1989–91, p. 162, no. 177; Mexico City 1994–95, pp. 266–67.

NOTES

1. For a comparable example, the main plate of crucible steel, spirally fluted, and damascened in gold at the center, see Paris 2007/Mohamed 2008, p. 374, no. 355.
2. A miniature painting of 1635 depicts the emperor Shah Jahan (r. 1628–58) with such a gun (Chester Beatty Library, Dublin, Ms. 7, no. 28); see cat. 115, fig. 40.

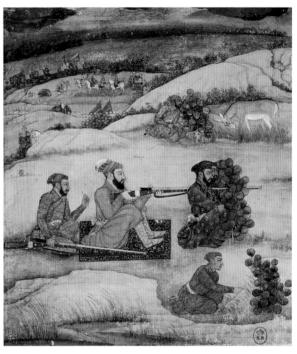

Fig. 26. "Bahadur Shah Hunting," folio from an album. India, Mughal period, first half of the 18th century. Gouache on paper. Bibliothèque Nationale de France, Paris, Département des Estampes (Rés. Od. 44, fol. 1)

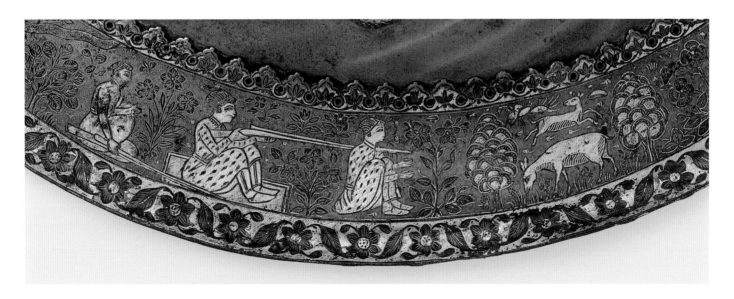

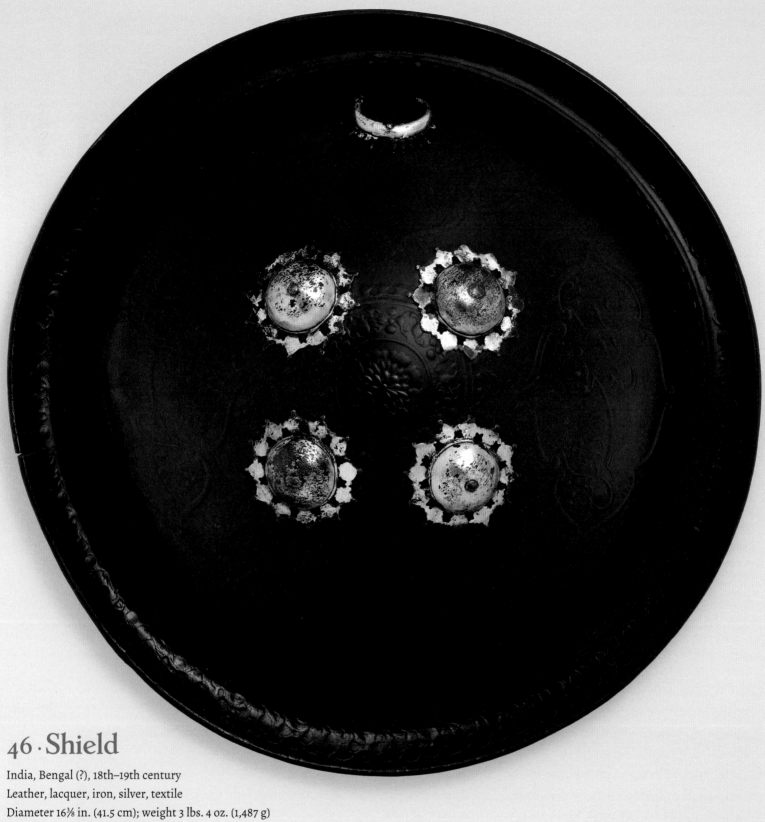

46 · Shield

India, Bengal (?), 18th–19th century
Leather, lacquer, iron, silver, textile
Diameter 16⅜ in. (41.5 cm); weight 3 lbs. 4 oz. (1,487 g)
Bequest of George C. Stone, 1935
36.25.649

DESCRIPTION: The round shield of thick, stiff hide has a pronounced convex exterior, almost half round in profile, with a recurved edge. The surface is covered in black paint and shellac, often called "lacquer," and has raised designs: at the center is a circular medallion enclosing a symmetrical flower, surrounded by a band of scrolling foliage and an outer border of foliated cusps; between the center and the rim are four quatrefoil medallions containing a Persian quatrain (a); and the rim is decorated with a band of scrolling foliage with a foliate-cusped inner edge. Set around the center are four domed bosses of silvered iron with pierced foliate edges affixed over a red textile that shows through the piercings. Set at the top between center and rim is a raised crescent moon of silvered iron, its lower edge filed with flames. On the interior, also black, is a small rectangular cushion and two handgrips, covered in red velvet and secured by iron rings to four faceted iron loops set on quatrefoil washers, the loops secured to the exterior beneath the bosses. The edge at top is pierced with two later holes, presumably for hanging.

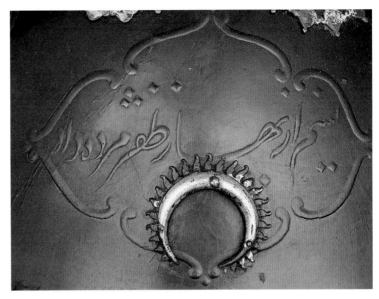

Inscription, line 1

Inscription, line 3

INSCRIPTION:

a. (In the four quatrefoil medallions between the center and the rim)

چو شد دل ز بستان بنگاله شاد نسیم از بهار ظفر مژده داد
شنیدم که مرغ سحر دوش گفت گل فتح بدست تو دایم باد

When the heart became joyful by [seeing] the garden of Bengal,
The Spring breeze brought good news of victory,
I heard last night the nightingale say,
"May the flower of victory be always in your hand."

The most interesting feature of this typical Indian shield is the poem, which seems to indicate that it was made in Bengal in northern India. The other decorative device used on this and numerous other Indian shields is the crescent, an ancient Eastern symbol that eventually became intimately associated with Islam.[1] Like the majority of the many hide shields in the Museum's collection, it is probably of the eighteenth or nineteenth century.

Leather shields have a long history in the Islamic world. During the time of the Prophet, the Arabs used shields of either leather, wood, or metal; those of leather were made of bull, elephant, or oxhide.[2] In the Islamic West some of the finest and strongest shields were made from the skin of the Saharan oryx (antelope), or *lamt*, and were, according to the Arab historian and geographer al-Ya'kubi (d. 897), white in color. Later medieval accounts say that these shields, cured in milk, became so hard that "a sabre rebounds off them, and if it does manage to penetrate, it sticks so hard that no-one can pull it out";[3] furthermore, if the shields were damaged by arrows or spears, the holes would "close up again by themselves . . . so they never lose their value as defensive weapons."[4]

PROVENANCE: W. O. Oldman, London; George Cameron Stone, New York.

Unpublished.

NOTES

1. See Ettinghausen 1971.
2. Ibn Ishaq records the use of leather shields in several passages: "And a round shield of bull's hide" (Ibn Ishaq 1982, p. 356, pt. 3, verse 535); "With a shield of smooth ox-hide I'm safely arrayed" (ibid., p. 427, pt. 3, verse 639); and "You could see the long mail upon the warriors and their strong leather shields" (ibid., p. 470, pt. 3, verse 700). He also records the use of iron shields: "Our sharp swords . . . cut through iron shields" (ibid., p. 489, pt. 3, verse 723). According to a hadith collected by al-Bukhari, the Prophet had two shields, one of leather and another maybe of wood or metal.
3. Ibn al-Fakih al-Hamadhani, as quoted in Viré 1986, p. 651.
4. Zunbul al-Mahalli, as quoted in Viré 1986, p. 652. Among the earliest surviving leather Islamic shields is a richly embroidered fifteenth-century Nasrid *adarga* (bilobed shield) made from oryx, which is now in the Kunsthistorisches Museum, Vienna, no. C.195; see Thomas and Gamber 1976, pp. 128–29, fig. 63.

47 · Shaffron

Turkey or Iran, early 16th century
Steel, copper alloy
Length 20 in. (50.8 cm); weight 1 lb. 11 oz. (753 g)
Bequest of George C. Stone, 1935
36.25.510

DESCRIPTION: The shaffron is flanged at the ears and around the eyes and tapers slightly down the nose, flaring at the tip, which ends in a rounded point. The sides below the eyes are angled inward and are cut out toward the tip of the nose. Wide, shallow flutings or channels, one on each side, follow the contours around the ears and eyes and continue in straight lines down the nose, forming a diamond-shaped area at the forehead, which is intersected by a shallow median ridge that extends down the center to the nose. The center and sides of the shaffron are engraved with split-leaf arabesques. The fore-head and the sides below the eyes are engraved with cartouches containing Persian inscriptions (a, b), with smaller cartouches, not inscribed, engraved on the eye flanges. The engraving is now very worn. The edges are pierced with small, widely spaced holes for the attachment (with mail rings) of side plates and a lining, both now missing. A single copper-alloy lining rivet, miss-ing its domed head, remains at the tip of the nose.

Incised below the left ear is the *tamğa* of the Ottoman arsenal.

INSCRIPTIONS:
a. (On the forehead)

جهانت بكام و فلك يار باد

May the world comply with your wishes and Heaven be your friend.

b. (On the sides below the eyes)

جهان افرينت [نگهدار باد]

May the Creator of the World [be your guardian].

The inscriptions, which begin on the brow and continue on the sides, are from the preface to the *Bustan* of the Persian poet Sa'di (ca. 1213–1292).[1] The verse, written for an Iranian ruler, is ideal for use on an armor.[2]

As with most other similarly fluted shaffrons, this example can be dated to the early sixteenth century, and a number of such shaffrons with diamond-shaped reserves at the brow have been preserved. Of these, two are Ak-Koyunlu, another is probably Kara-Koyunlu, and others are Mamluk, Ottoman, and Persian; consequently, the type can be said to

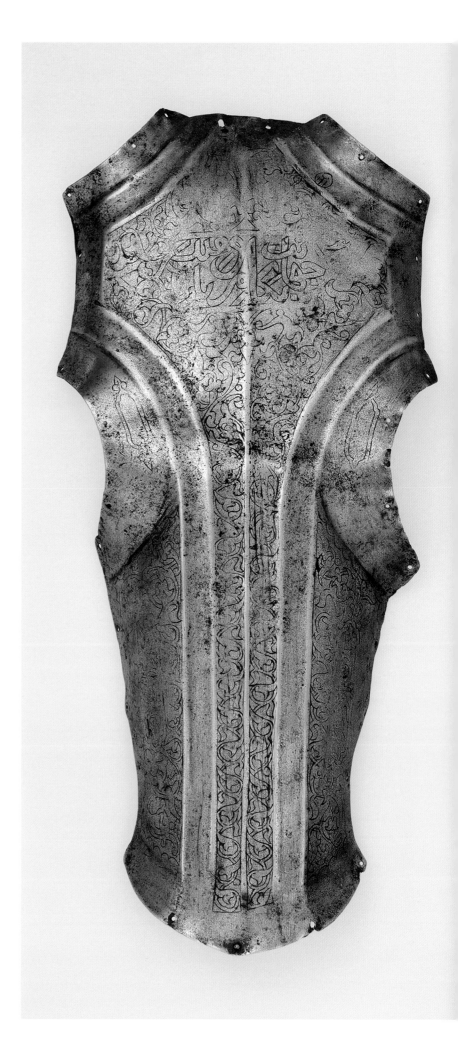

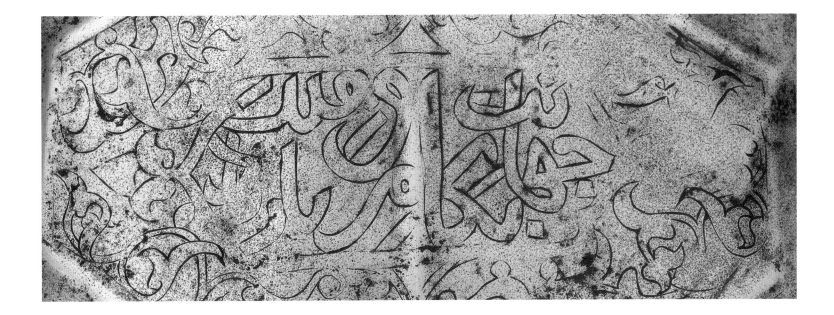

represent an international style. One Ak-Koyunlu example, in the Khalili Collection, London, is inscribed with the name Husayn b. Alikhan Jahangir.[3] Husayn, an Ak-Koyunlu prince from the house of Jahangir and the brother of Uzun Hasan (r. 1453–78), was killed in 1497 during the Ak-Koyunlu war of succession. The Kara-Koyunlu example has small diagonal flutings on each side and is inscribed with the name of Sultan Yusuf, perhaps Abu-Nasr Qara Yusuf, who ruled in eastern Anatolia, Iraq, and northwest Iran between 1388 and 1419, but more likely his son Jahan Shah Qara Yusuf (r. ca. 1438–67).[4] One of the Mamluk examples is inscribed with the name of Qa'itbay (r. 1468–96);[5] an Ottoman shaffron of this type bears the name of Selim I (r. 1512–20).[6] Among the Persian examples are two engraved with a lion and sun, a Persian emblem.[7]

PROVENANCE: Ottoman arsenal, Istanbul; Sir Guy Francis Laking, London; George Cameron Stone, New York.

REFERENCES: Christie, Manson and Woods, London 1920, lot 357; Stone 1934, p. 170, fig. 214, no. 2; Alexander 1992, pp. 86–89; Paris 2007/Mohamed 2008, p. 340.

NOTES

1. Sa'di 1964, p. 10.

2. Will Kwiatkowski (personal communication, February 2015) noted that a correct translation of the verses that follow, which are not included in the inscriptions on the shaffron, would be along the lines of "Thy lofty star has illumined a world; the declination of thy star has burned the enemy" (translation by Captain Wilberforce Clarke, London, 1879).

3. Khalili Collection, London, no. MTW 928; see Alexander 1992, pp. 86–89, no. 40. This shaffron, signed by Kamal b. Amir al-Janahi, was probably made in Tabriz, where Husayn died in 1497. The other Ak-Koyunlu example is also in the Khalili Collection, no. MTW 778; see ibid., pp. 93, 95, no. 45. Although not as finely decorated, it is engraved on the brow with a cartouche almost identical to that on the Husayn shaffron and is probably from the same workshop. It is signed ". . . al-Din ibn Amin al-Din al-Janahi (?)."

4. Furusiyya Art Foundation, Vaduz, no. R-157; see Paris 2007/Mohamed 2008, p. 340, no. 326. For Yusuf, see, for example, Fekete 1977, doc. no. 10.

5. For the Mamluk shaffron, Askeri Müzesi, Istanbul, no. 208-84, see Riyadh 1996, vol. 2, pp. 104–5, no. 87i, and Güçkıran 2009, pp. 44–45. This shaffron is also inscribed with the names of an amir, Qansuh al-Yahyawi, and the maker, Mahmud.

6. The Ottoman example is in the Askeri Müzesi, Istanbul, no. 208-85; see Güçkıran 2009, p. 43. Other shaffrons of similar form are in the Museo Poldi Pezzoli, Milan, nos. 1949, 1882 (see Boccia and Godoy 1985–86, vol. 2, pp. 524–25, nos. 989, 992, respectively, figs. 1376, 1381, 1382). Another shaffron of this type that can be attributed to an Ottoman milieu is inscribed with the phrase "for the ghazis and the Jihad in the cause of Allah"; Askeri Müzesi, Istanbul, no. 208-137 (see Güçkıran 2009, p. 130).

7. Deutsches Historisches Museum, Berlin, no. AB 8904 (see Pope 1938–58, vol. 3, p. 2561, vol. 6, pl. 1407B); Museo Poldi Pezzoli, Milan, no. 2116 (see Boccia and Godoy 1985–86, vol. 2, p, 524, no. 991, figs. 1372–75; and Riyadh 1996, vol. 2, pp. 104, 107, no. 87vii).

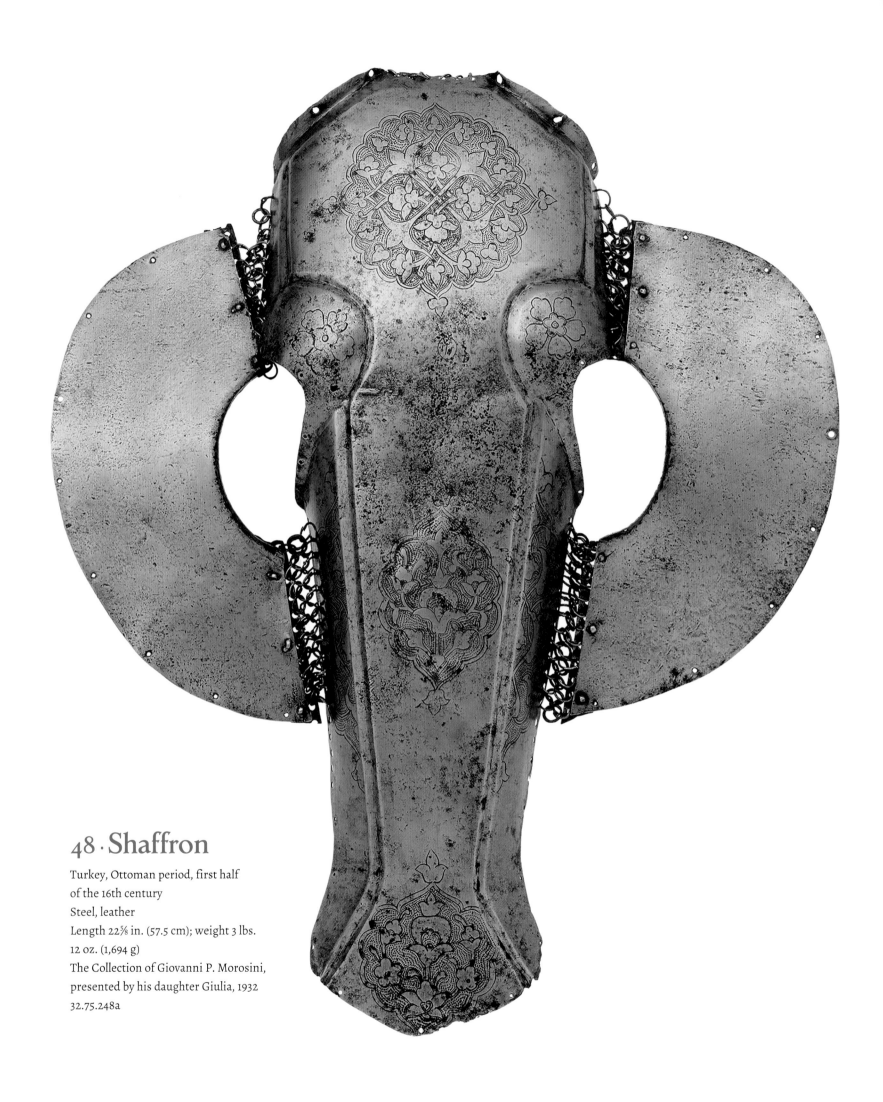

48 · Shaffron

Turkey, Ottoman period, first half
of the 16th century
Steel, leather
Length 22⅝ in. (57.5 cm); weight 3 lbs.
12 oz. (1,694 g)
The Collection of Giovanni P. Morosini,
presented by his daughter Giulia, 1932
32.75.248a

DESCRIPTION: The shaffron consists of a long frontal plate to which are attached by rows of mail links two cheekpieces and a small triangular poll plate. The frontal plate is flanged around the ears and is embossed with semicircular moldings around the eyes and tapers toward the nose, where it flares out to a rounded tip. A narrow channel extends around the ears and eyes and down each side to the nose. It is engraved on the brow with a lobed medallion containing a centrally organized arabesque of trilobed leaves and petals against a punched ground; on the bridge of the nose and nostril with lobed medallions containing composite floral forms against a punched ground; on the sides with a split-leaf arabesque against a punched ground; and on the cusped eyes with five-petal rosettes. The semicircular cheekpieces are flanged around the eyes. The present cheekpieces, which are of different metal from the frontal plate, are associated. Modern leather straps are fitted to the cheekpieces and poll plate for mounting on a horse manikin.

Incised below the brow is the *tamğa* of the Ottoman arsenal.

This shaffron was acquired by the Museum as part of a composite horse armor (acc. no. 32.35.248). In terms of construction and form, it is similar to another shaffron in the Metropolitan's collection (acc. no. 29.158.621). Both have flattened fronts, sunken bands around their edges, embossed forms around the eyes, and flared tips. Another example almost identical to the present shaffron, and evidently from the same workshop, is in the Deutsches Historisches Museum, Berlin.[1] Solid cheekpieces such as those here were first documented on a Mamluk shaffron dated between 1412 and 1421, now in Lyon.[2]

The motif on the forehead of the Museum's example is formed from a central knot composed of four interlocking split leaves and four flowers; at the point where the split leaves touch there is a trilobate bud, while the tips of the flowers divide and usher forth two smaller floral forms. This design can be traced back to manuscript illustrations produced in the imperial Ottoman *nakkaşhane* (royal scriptorium) during the fifteenth century, as seen in the treatise on law *Ghurar al-ahkam* by the legal scholar Molla Hüsrev (d. 1480), dated A.H. 878 (A.D. 1474) and dedicated to Mehmed II (r. 1444–46, 1451–81).[3] The popularity and longevity of the motif is demonstrated by its occurrence, in triskelion form, on Iznik ceramics of about 1530–40.[4] Together these decorative features indicate an Ottoman origin for the shaffron.

PROVENANCE: Ottoman arsenal, Istanbul; Giovanni P. Morosini, Riverdale, New York; his daughter Giulia P. Morosini, Riverdale, New York.

REFERENCE: Nickel 1974, p. 131, ill.

NOTES
1. Deutsches Historisches Museum, Berlin, no. AB. 8907. Very similar solid cheekpieces occur on a group of gilt-copper Ottoman shaffrons of the sixteenth century now in the Askeri Müzesi, Istanbul, nos. 208-6, 208-8, 208-63, 208-69, 208-101, 208-103, 208-118; see Güçkıran 2009, pp. 63, 54, 69, 85, 84, 59, 95, respectively. As with the Museum's shaffron, these all are worked with deep grooves on either side of the face. In addition, another comparable shaffron was sold at Christie's London 2013, lot 211.
2. Musée des Beaux-Arts, Lyon, no. D. 377-1; see Meinecke 1996, fig. III,iii, and Paris 2002–3, p. 108, no. 38.
3. Topkapı Sarayı Museum, Istanbul, Ms. A. 1032; see Raby and Tanındı 1993, no. 20.
4. See Carswell 1982, no. 84.

49 · Shaffron

Turkey, Ottoman period, 16th century (?)
Steel, copper alloy
Length 21 in. (53.5 cm); weight 1 lb. 14 oz. (847 g)
Fletcher Fund, 1921
21.102.4

DESCRIPTION: The shaffron is unusually complex in form, surface articu-
lation, and decoration. It is shaped around the ears, and tapers upward to
a wide, rounded point. The edges below the ears are flanged inward,
whereas those around the eyes are flanged outward, and the plate below
the eyes tapers slightly toward the nose, which ends in a rounded point.
The edges are pierced all around with a series of holes for the lining rivets
and for cheekpieces or other harness attachments. The upper half of the
plate is essentially flat and continues down the center of the nose, while
the sides, below the eyes, are steeply angled inward. The flat area is
embossed with a series of designs, from top to bottom, consisting of an
inverted triangle and a T-shaped form whose vertical element continues
down the bridge of the nose as a raised pyramidal ridge; the ridge expands
to a diamond-shaped ornament in the center and a triangular one at the
tip of the nose. Embossed across the width of the plate between the eyes
are three semicircular swags, whose upper points end in inverted trian-
gles. A diamond-shaped motif is embossed at the center of each of the
inverted sides. The centers of the triangular and diamond-shaped areas
are inlaid with thin copper-alloy sheet embellished with crudely engraved
ornament; the crossbar of the T-shaped ridge is similarly inlaid and
engraved with a quotation from the Qur'an (a) in cursive script on a stip-
pled ground (the inlays in the center of the nose and at its tip are missing).
Applied near the top, between the inverted triangle and T-shaped motifs, is
an upright plate of flattened semicircular form.

INSCRIPTION:
a. (On the crossbar of the T-shaped ridge)

نصر من الله و فتح قريب

Help from Allah and a speedy victory. (Qur'an 61:13)

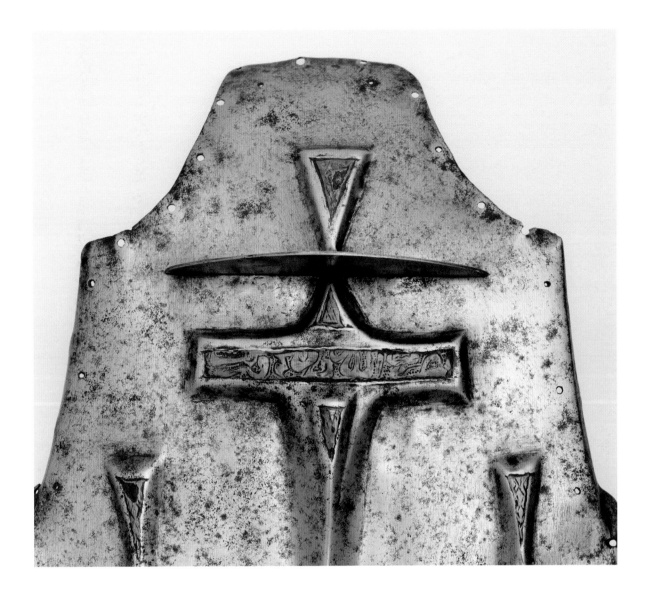

Shaffrons of this general type, with sharply cutaway semicircular sides and embossed with large T-shaped forms along the forehead and down the nose, seem to have originated in the Ottoman Empire, probably during the sixteenth century. Large numbers of these, many with inscriptions, have been preserved in the Askeri Müzesi, Istanbul, and in the Museo Stibbert, Florence. (As a group they are discussed in cat. 51.)

The present example is one of several shaffrons embossed with both a T-shape and semicircular forms; one of these (also with brass inlay) is in the Askeri Müzesi, Istanbul, and another is in the Museo Stibbert, Florence.[1] The shaffron in the Museo Stibbert, like the Museum's, has an upstanding horizontal brow plate. It is fitted with copper rivet heads engraved with radiating spokes, a type frequently used on Mamluk and Ottoman armor of the sixteenth century, including an Ottoman "turban" helmet and a horse armor both probably of that century.[2]

PROVENANCE: Robert Curzon, 14th Baron Zouche of Haryngworth, Parham Park, Pulborough, Sussex; Robert Curzon, 15th Baron Zouche; Darea Curzon, 16th Baroness Zouche.

REFERENCE: Sotheby, Wilkinson and Hodge, London 1920, lot 33.

NOTES

1. Askeri Müzesi, Istanbul, no. 208-142 (see Güçkıran 2009, p. 101); Museo Stibbert, Florence, no. 6708 (see Florence 1997–98, p. 100, no. 62; and Florence 2014, pp. 43, 120, no. 19). Both of these examples carry the same inscription on the crossbar as that on the Museum's shaffron: "Help from Allah and a speedy victory" (Qur'an 61:13).

2. The Ottoman helmet is in the Askeri Müzesi, Istanbul, no. 13892 (unpublished); for the horse armor, also in the Askeri Müzesi, no. 208-145-3, see Güçkıran 2009, p. 160. For similar rivets, see, for example, a Mamluk knee defense in the Askeri Müzesi, no. 3000 (unpublished), and a *khazagand* of Sultan Jaqmaq (r. 1438–53) now in the Museo Nazionale del Bargello, Florence, no. M 1244 (see Florence 2002, p. 18, fig. 1).

50 · Shaffron

Turkey, Ottoman period, first half of the 16th century
Copper alloy, gold, iron
Length 23⅞ in. (60.5 cm); weight 4 lbs. 4 oz. (1,917 g)
Bequest of George C. Stone, 1935
36.25.496

DESCRIPTION: The shaffron of gilt copper is shaped around the ears and eyes and tapers slightly down the nose, expanding at the tip with a decoratively scalloped edge. A deep groove extends across and along each side at the top, arching over the eyes and continuing down either side of the nose, where it fans out in three branches. The eye region on each side is embossed slightly with semicircular grooves. A wide triangular plate of gilt copper with lobed edges is set across the forehead at right angles to the main surface. Through this plate passes a long, tubular plume holder, also of gilt copper, with pierced and lobed edges and a palmette-shaped terminal at the base; the plume holder is secured to the main plate by gilt-copper rivets. The edges of the shaffron are pierced with holes of two sizes, small ones around the ears, eyes, and nose for the attachment of the lining, and larger ones at the top for the attachment of a poll plate; those at the sides are filled with links of riveted iron mail by which four narrow gilt-copper side plates are attached. The surfaces retain much of their original gilding.

Incised at the forehead is the *tamğa* of the Ottoman arsenal.

Among the many surviving gilt-copper (*tombak*) shaffrons, this example belongs to a small and early group.[1] These are all relatively large, have an upright horizontal lobed ridge that secures a plume holder, and flare toward their lobed tips over the nostrils. The deep grooving seen on this example is commonplace on the lavishly decorated Ottoman shaffrons of gilt copper preserved in Istanbul.[2] Certain of these formal features relate the Museum's shaffron to the steel shaffrons made for the Ottoman sultans Selim I (r. 1512–20) and his son Süleyman I (r. 1520–66) as well as to several others with flaring, lobed tips that are datable to the later fifteenth or early sixteenth century.[3] Ottoman miniature paintings, such as one in the Topkapı Sarayı Museum, Istanbul, frequently show the military escort of the sultan mounted on horses wearing golden shaffrons, and it seems likely that the Museum's example was used in that way.[4]

PROVENANCE: Ottoman arsenal, Istanbul; Clapp and Graham, New York; George Cameron Stone, New York.

REFERENCES: Katonah 1980, no. 27, ill.; *Islamic World* 1987, p. 124; David G. Alexander and Stuart W. Pyhrr in Ekhtiar et al. 2011, pp. 314–15, no. 224.

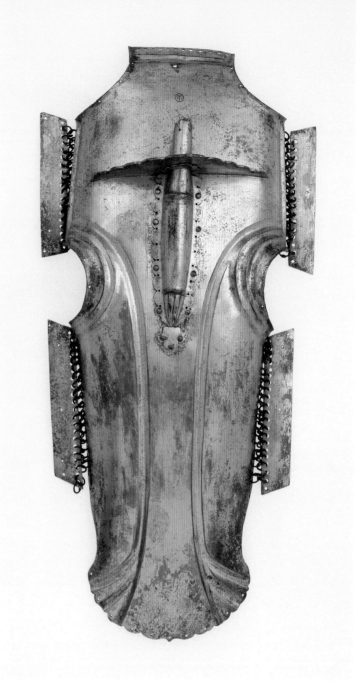

NOTES
1. There are three other gilt-copper examples of this group in the Askeri Müzesi, Istanbul, nos. 208-38, 208-72, 208-96; see Güçkıran 2009, pp. 65, 78, 70, respectively.
2. One such example is in the Askeri Müzesi, Istanbul, no. 208-130; see Istanbul 1987, p. 176, no. 180, and Güçkıran 2009, pp. 56–57.
3. While the examples in steel do not have the deep grooving characteristic of the gilt-copper shaffrons, they often have engraved lines delineating a similar design feature. Examples include shaffrons made for the sultans Selim I and Süleyman I that are both large and long, with an upright frontal plate between the eyes, now in the Askeri Müzesi, Istanbul, nos. 208-75, 208-77; see Güçkıran 2009, pp. 39, 40. The flaring tip with scalloped edge on the Museum's shaffron is not unusual and also occurs on a number of shaffrons in the Askeri Müzesi, including most of those with solid cheekpieces (see cat. 48, n. 1), as well as on two others datable to the late fifteenth to early sixteenth century now in the Khalili Collection, London, nos. MTW 928, MTW 896 (see Alexander 1992, pp. 86–90, nos. 40, 41). The former shaffron is inscribed with the name of the Ak-Koyunlu prince Husayn b. Alikhan Jahangir, who died in 1497; the latter is decorated in a Turkman style.
4. For the Topkapı Sarayı Museum, Istanbul, miniature painting, no. B.200, fol. 101v, see Akurgal 1980, pl. 173. See also Güçkıran 2009, pp. 15, 19, figs. 2, 4.

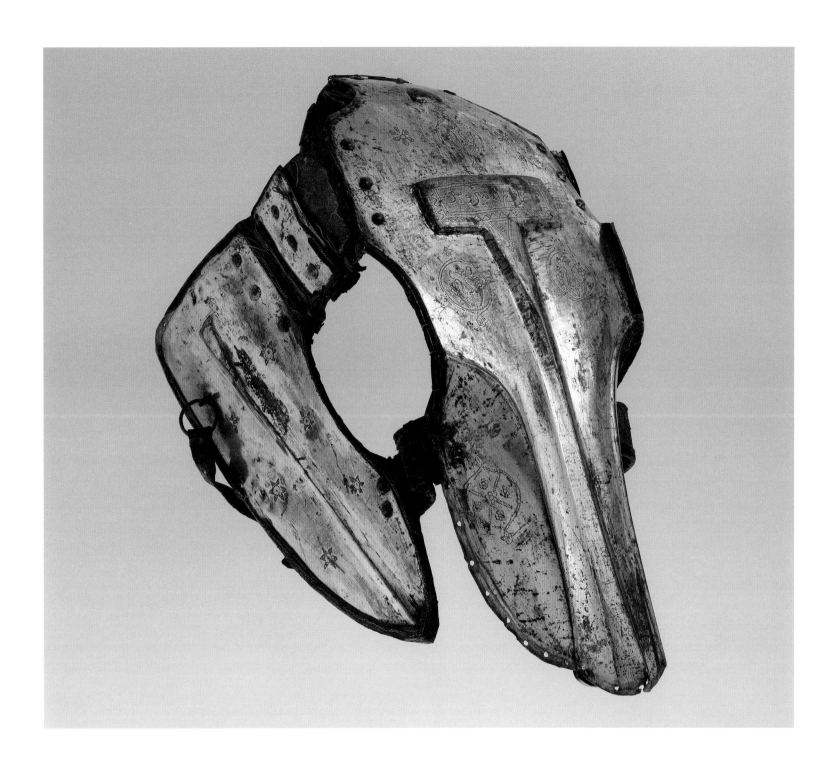

51 · Shaffron

Turkey, Ottoman period, 17th century
Copper alloy, gold, leather, textile
Length 17⅝ in. (44.7 cm); weight 3 lbs. 11 oz. (1,684 g)
Fletcher Fund, 1921
21.102.3

DESCRIPTION: The shaffron of gilt copper is unusually complete, retaining its main plate, poll plate, and cheek plates, as well as most of its lining. The front plate is shaped around the base of the ears and around the eyes (where the edge is flanged outward) and tapers down the nose, the sides of which are angled sharply inward. It is embossed in high relief at the top with a small triangle and in the center of the forehead with a large T-shaped ridge, the bottom of the T extending down the center

of the nose as an inverted V-shaped ridge. The horizontal stroke of the T is dot punched, or stippled, with an Arabic inscription (a) framed by geometric ornament. The surrounding surfaces are also stippled with circles containing stylized tulips and other flowers (one circle above the T and one to each side), six-petaled flowers, and pointed-oval medallions containing flowers (one on each side of the nose). The edges are pierced with lining holes at regular intervals, with a fragment of the original leather binding for the lining still preserved around the right eye, where it is held in place by fine, twisted brass wire. The shaffron is lined throughout with brown leather enclosing a stuffing of cotton and horsehair. Attached at the top of the front plate by a textile-covered leather hinge is a triangular poll plate with a bronze strap loop at the apex. The lining of the front plate extends upward to line the poll plate as well. Attached to each side of the front plate by two wide leather straps covered on the outside with brownish red velvet, the upper strap reinforced with a rectangular plate of gilt copper, is a curved cheek plate of gilt copper, pointed at the bottom and flanged around the eye, with a raised vertical ridge down the center; the surface is

stippled with stars. The leather-lined cheek plates have leather bindings secured with twisted copper wire around the edges and are fitted with copper-alloy rings retaining portions of their leather straps.

INSCRIPTION:
a. (On the crossbar of the T-shaped ridge)

مما عمل برسم الامير يوسف

Made at the order of the amir Yusuf.

This shaffron belongs to the group of ceremonial armor of gilt copper discussed elsewhere in this publication (see helmets cats. 36, 37, and shaffron cat. 50).[1] More specifically, it can be related to a number of shaffrons in both iron and gilt copper that are characterized by a flat forehead area with an embossed T-shaped design in the center and deeply angled sides.[2] Examples of this type have been dated from the sixteenth to the nineteenth century, indicating that the style was long lived, although most examples can be dated to the sixteenth to seventeenth century. Dating these shaffrons depends on the study of individual details; the punched decoration and floral forms on the Museum's shaffron, for example, suggest an earlier, seventeenth-century date, confirmed by the presence of similar punched decoration on a *tombak* helmet in the Museum's collection (cat. 37).[3]

Another significant feature of many of these shaffrons is that they are inscribed with the names of various amirs and pashas, including (in addition to Amir Yusuf on this example) Hafiz Ahmed Pasha, 'Ali Pasha, and Al-Fakir Mehmed Pasha.[4] The *tombak* helmet in the Museum's collection mentioned above (cat. 37) also bears an amir's name; if these *tombak* shaffrons were used for the horses involved in accompanying the *mahmal* (litter) to Mecca during the Ottoman period, then these names could very well be those of the amirs *al-hajj*, the caravan commanders who were the pashas responsible for this aspect of the pilgrimage.[5] This is not to say that all the shaffrons with T forms were used in this way; one gilt-copper example inscribed "for the *ghazis* and the jihad in (the cause of Allah)" was most likely intended for a military use,[6] as is probably also the case for the many surviving steel shaffrons.

PROVENANCE: Robert Curzon, 14th Baron Zouche of Haryngworth, Parham Park, Pulborough, Sussex; Robert Curzon, 15th Baron Zouche; Darea Curzon, 16th Baroness Zouche.

REFERENCE: Sotheby, Wilkinson and Hodge, London 1920, lot 20.

NOTES
1. Ceremonial armors of gilt copper are discussed in the commentary for cat. 36. In addition, Güçkıran 2009 catalogues and illustrates forty-three gilt-copper shaffrons now in the Askeri Müzesi, Istanbul.
2. The Metropolitan Museum's collection includes six such shaffrons: two of *tombak* (the present example and acc. no. 36.25.507) and four of iron (cat. 49 and acc. nos. 36.25.503, 36.25.505, 36.25.508); see Stone 1934, p. 170, fig. 214, nos. 4, 6, 9, 8, respectively. Güçkıran 2009 publishes twenty-eight shaffrons of this T-embossed type now in the Askeri Müzesi, Istanbul, of which six are of *tombak*. Another similar example is in the Victoria and Albert Museum, London, no. 579-1927 (see North 1976, p. 276, fig. 5).
3. A comparable *tombak* helmet, also with punched decoration, was sold at Christie's, London 2013, lot 210.
4. Respectively, Askeri Müzesi, Istanbul, nos. 288-39, 208-83 (Hafiz Ahmed Pasha; Güçkıran 2009, pp. 68, 141); no. 208-100 ('Ali Pasha; ibid., p. 93); no. 208-54 (Al-Fakir Mehmed Pasha; ibid., p. 123). Other similar examples are in the Museo Stibbert, Florence, nos. 6643, 6703, 6705, 6708; for the latter, see Florence 1997–98, pp. 100–101, no. 62.
5. For further discussion of this aspect of these inscribed *tombak* elements, see cat. 37.
6. Askeri Müzesi, Istanbul, no. 208-139; see Güçkıran 2009, p. 60.

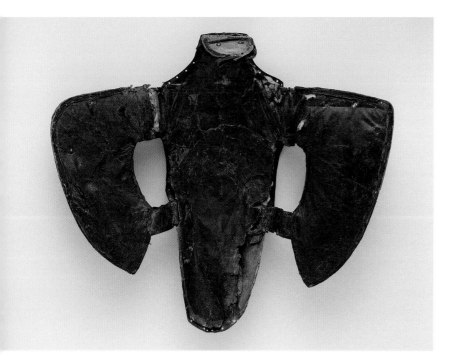

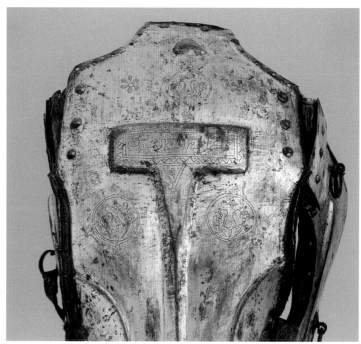

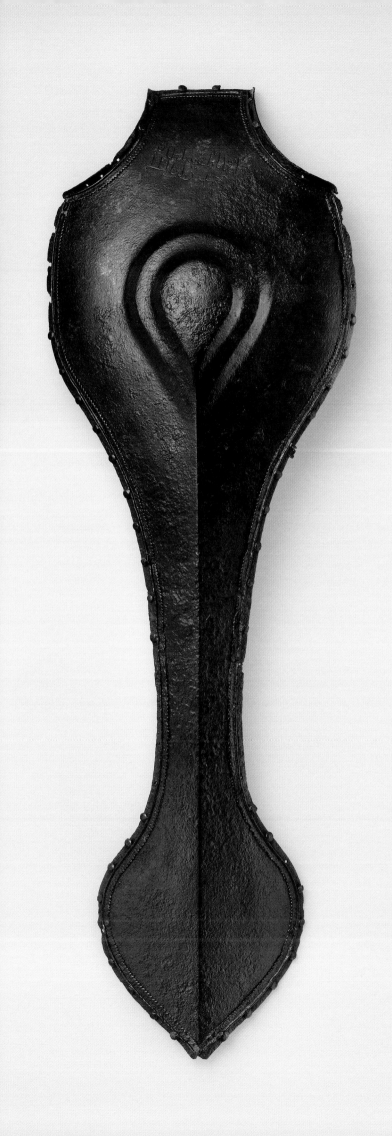

52 · Shaffron

India, Deccan, Golconda, dated A.H. 1026 (A.D. 1617/18)
Steel, brass
Length 23⅞ in. (60.7 cm); weight 1 lb. 13 oz. (820 g)
Purchase, Arthur Ochs Sulzberger Gift, 2008
2008.197

DESCRIPTION: The slightly curved plate of elongated, waisted form is wide at the top, where it is shaped around the ears, tapers at the center, and expands to a heart-shaped terminal over the tip of the nose. A sharp medial ridge extends upward from the nose to a drop-shaped, stepped, raised panel in the center of the brow. The edge of the plate is set all around with dome-headed iron lining rivets, many now missing, and is followed by a narrow iron reinforcing band applied just inside the rivets. Traces of textile under the rivet heads suggest that the rivets also secured a lining band. The applied band is of L-shaped section, the outer edge formed as a raised ridge, the flat inner edge notched and decorated with a row of punched dots. Above the raised panel on the brow is a later incised Arabic inscription (a).

The shaffron, probably originally polished bright, now has an even brown corrosion patina, inside and out, and is lightly pitted overall. It has cracked through at the narrowest point and has been repaired on the inside with a thin brass plate held by rivets, the repair now masked with paint. The shaffron was presumably originally fitted with ear defenses of plate, now missing, as is the lining.

INSCRIPTION:

a. (Above the raised panel on the brow)

<div dir="rtl">

ابو المظفر سلطان

محمد قطبشا[ه] سنة ٢٦٢ [٠] ١

</div>

Abu'l Muzaffar Sultan Muhammad Qutb, Sana (year) 1026 (A.D. 1617/18).

This shaffron is the only Indian example in the Museum's collection and, thanks to its inscription, provides important documentation for the date and cultural context for similar shaffrons. The inscription, presumably added in a princely armory, perhaps long after the shaffron was made, indicates that it was used in the service of the Qutb Shahi ruler of Golconda, Muhammad b. Muhammad Amin b. Ibrahim (r. 1612–26) (fig. 27). At least two other shaffrons bearing fragmentary inscriptions of the same type are known, one in the Furusiyya Art

Foundation, Vaduz,[1] and another in the Royal Armouries, Leeds.[2] The former is inscribed with the name مظفر سلطان محمود.و (Muzaffar Sultan Mahmud *waw*); while the titulature in that inscription appears similar to that of the Metropolitan's shaffron, the name of the ruler on the Furusiyya example is Mahmud rather than Muhammad, and it is uncertain to whom it refers. The inscription on the Royal Armouries example appears to read "Muhammad Zaman . . . Rashid Quli," which may refer to Muhammad Quli of Golconda, the fifth Qutb Shah (r. 1580–1612).[3] At least two shaffrons of the same type, apparently not inscribed but retaining their textile linings, are preserved in the National Museum, New Delhi.[4]

Golconda, one of the five empires that made up the Deccan sultanate in central India, was regarded as the most important center for the diamond trade in Asia and is mentioned by Marco Polo in 1292 and then in 1651 by the French jeweler Jean Baptiste Tavernier.[5] The first decades of the seventeenth century were difficult for Golconda's Qutb dynasty: it was in constant conflict with its neighbors in the Deccan and eventually came into conflict with the Mughals, who in 1636 demanded and received tribute from them, thereby acknowledging Mughal suzerainty. The Qutb Shahi dynasty continued to rule as Mughal tributaries until 1687, when they were definitively conquered by the Mughals.

PROVENANCE: Acquired at Christie's London, April 8, 2008, lot 273.

REFERENCES: Christie's London 2008, lot 273; New York 2015, p. 229, no. 121.

NOTES

1. Furusiyya Art Foundation, Vaduz, no. R-154 (see Paris 2007/Mohamed 2008, p. 344, no. 330); acquired at Sotheby's London 1989, lot 311, it is one of a group of at least four that appeared on the London art market.

2. Royal Armouries, Leeds, no. xxvɪʜ.36; acquired at Sotheby's London 1993, lot 415. See Richardson and Bennett 2015, pp. 62, 64.

3. As suggested by Thom Richardson, personal communication, April 2010.

4. National Museum, New Delhi; see Pant 1997, pls. xxxvɪɪ, xxxvɪɪɪ.

5. Sherwani 1965.

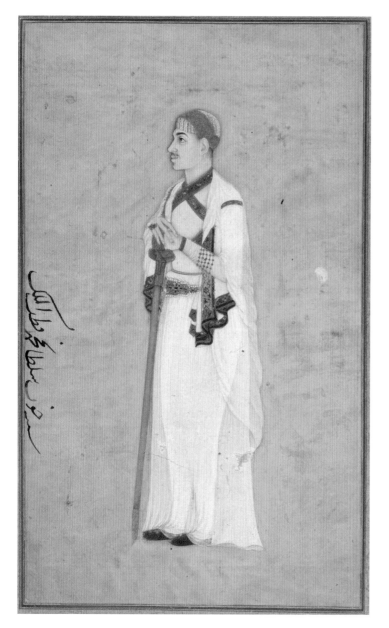

Fig. 27. "Sultan Muhammad Qutb Shah of Golconda," from the Minto Album. Signed by Hashem. India, ca. 1624–25. Painting, watercolor, and gold on paper. Victoria and Albert Museum, London (IM 22-1925)

53 · Saddle

Turkey, Ottoman period, late 16th–17th century
Wood, staghorn, bark, leather, textile, iron
Length 24 in. (61 cm); height 22¾ in. (57.8 cm);
weight 9 lbs. 2 oz. (4,130 g)
Gift of William Henry Riggs, 1913
14.25.1651

DESCRIPTION: The saddle is constructed with a laminated wood frame lined on the underside with bark; the front, rear of the cantle, and long sides of the frame are covered with leather painted with gold foliate motifs on a black ground, and the edges are outlined and reinforced with thin strips of white staghorn with engraved lines filled down the center with black color. The seat, which has a deep concave

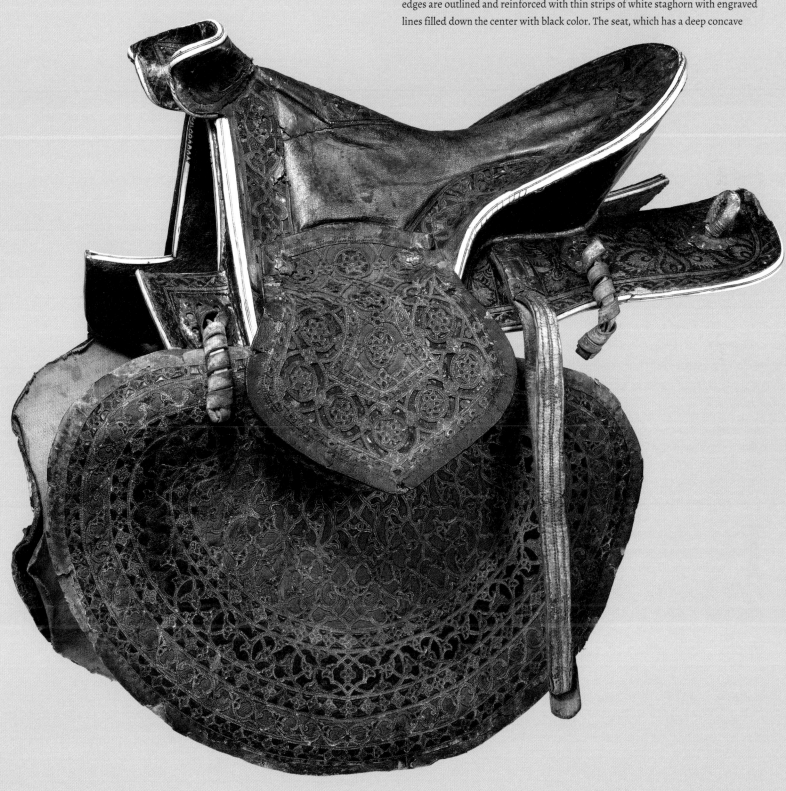

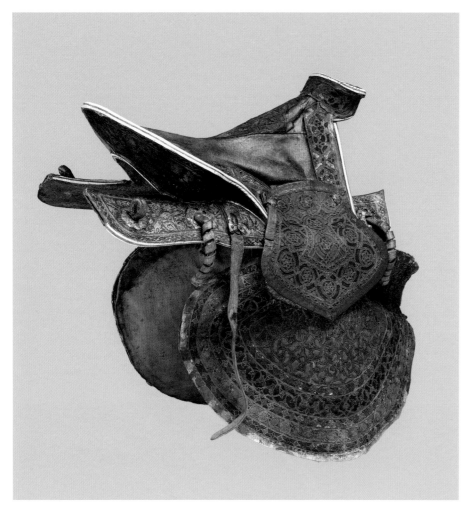

knightly prototypes, as they can be documented in European art from at least the time of the Bayeux Tapestry (completed ca. 1077). This type continued to be used throughout the Islamic world well into the eighteenth century and beyond, even after the widespread use of firearms had irrevocably changed cavalry tactics. With its large flat back-plate, this type of saddle provided a sizable and highly visible space for embellishment; no doubt many of the small plaques often described as horse trappings were originally mounted on saddles like these.[3]

The Museum's saddle appears to be the only preserved sixteenth-century Ottoman example of a type that seems to have developed from the thir-teenth to the fourteenth century, as can be seen in the illustrations of Rashid al-Din's encyclopedic *Compendium of Chronicles* of 1314.[4] These early saddles are characterized by their open pom-mels and broad, arched backs, which were often embellished with bone or set with decorated metal plaques.[5] Saddles of this type were used throughout the Near East, India,[6] and in Russia[7]

horn and a raised semicircular cantle, is upholstered with a padded brown (formerly red?) leather framed by applied bands of green-dyed openwork leather stitched over a backing of alternating red velvet and blue (black?) leather, with some inserts of gilded leather for contrast. At each side is riveted a heart-shaped flap of similar pierced-and-colored leatherwork, the ornament composed of symmetrical interlac-ing strapwork and geometric patterns; the flap is backed with canvas and lined with leather. Secured by straps below the flap at each side is a larger semicircular pad similarly decorated with leather and fabric openwork in concentric bands, the decoration consisting primarily of split-leaf arabesques, the pad lined with canvas. The iron rivets, washers, and fastenings for straps and girths are engraved with geometric ornament; the rear strap on the left side is dyed green. The surfaces are worn overall, the once brilliant-colored leather and textile now faded.

I n the immediate pre-Islamic period saddles with low-arched cantles and sometimes simple padded blankets were widely used. They are seen in Sasanian art and also in sculptured representations of horsemen from Palmyra in Syria.[1] Similar devices were current in Central Asia immediately before the Arab conquest; saddles represented in Soghdian painting appear to have low cantles and pommels and have a padded rather than a clearly defined structural form.[2] During the thirteenth or four-teenth century cantles and pommels became more pronounced and gave added support to a fully armored warrior using a long lance. Such saddles were almost certainly based on European

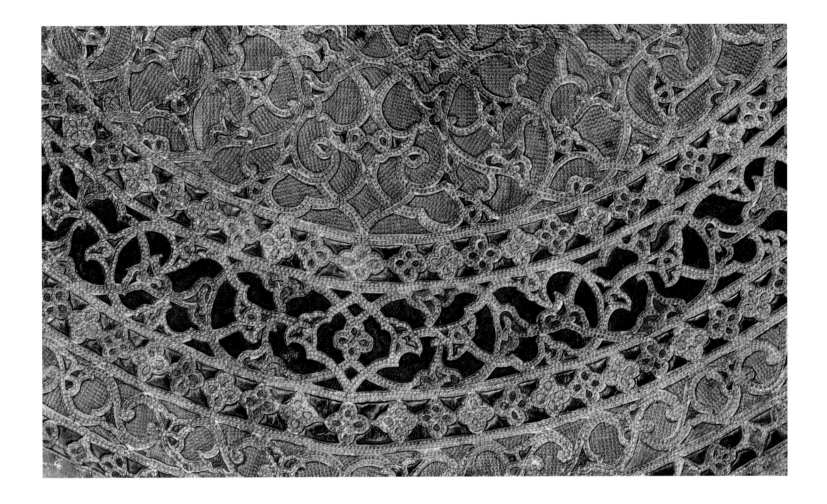

through the sixteenth century, and four surviving examples, captured by Stephen Báthory, king of Poland (r. 1576–86), at the conquest of Pleskau in 1581 during a war with Ivan the Terrible (r. 1547–84), are in the Kunsthistorisches Museum, Vienna.[8] The Vienna group is very similar to the present example in shape and staghorn trim, as well as the painted surfaces on the saddle frame, but the simple stitched leather fittings are altogether different from the elaborate and colorful fittings of the Museum's saddle.

The decorative use of pierced leather against different-colored grounds occurs on a small number of Ottoman luxury objects of the sixteenth century. These include a full-length war coat in the Szépművészeti Múzeum, Budapest; a pair of boots made for Selim II (r. 1566–74) in the Topkapı Sarayı Museum, Istanbul; and a bow case, quiver, and water bottle in the Kunsthistorisches Museum, Vienna.[9] The Real Armería in Madrid also preserves a group of twenty-five Turkish quivers and bow cases, many of which are decorated with similar pierced-leather appliqué over colored textile.[10]

PROVENANCE: Albert Denison, 1st Baron Londesborough, Grimston, Yorkshire; William Denison, 2nd Baron and 1st Earl of Londesborough; William H. Riggs, Paris.

REFERENCES: London 1875, p. 40, no. 1050; Christie, Manson and Woods, London 1888, lot 456; Louisville 1955, no. 57.

NOTES

1. Riyadh 1996, vol. 2, pp. 56–57, no. 51.

2. Azarpay 1981, pls. 6–9, 17, 20. As with almost every category of Islamic arms and armor, only a few saddles or parts of saddles that can be dated to before the fifteenth century have survived.

3. Several complete sets of plaques for the backs of saddles are published in Esin 1968, figs. 3, 4, and Riyadh 1996, vol. 2, pp. 156–57, nos. 124, 125. See Kramarovsky 1996 for a discussion of excavated Mongol horse trappings of this type dating to the thirteenth and fourteenth centuries.

4. Gray 1978, no. 2, fol. 7r.

5. Esin 1968, figs. 3, 4.

6. An Indian example of a saddle with an open-curved pommel can be seen in a Mughal miniature of about 1580; British Museum, London, no. OA 1948 10-9 066 (see Riyadh 1996, vol. 2, p. 180, no. 149, ill.).

7. They are depicted in a woodcut labeled "Arms and Armour of the Muscovites" from Herberstein's 1567; see Miller 1982, p. 120.

8. See Gamber and Beaufort 1990, pp. 232–37, nos. D210, D211, D331, D334, pl. 143. A fifth saddle from the group, formerly C143, was transferred after World War I to the Magyar Nemzeti Múzeum, Budapest (unpublished).

9. For the war coat in the Szépművészeti Múzeum, Budapest, see Fehér 1975, pl. 3, figs. 2–10; for Selim II's boots in the Topkapı Sarayı Museum, Istanbul, no. 2/4447, see Washington, D.C., Chicago, and New York 1987–88, pp. 166, 315, no. 106; for the bow case, quiver, and water bottle in the Kunsthistorisches Museum, Vienna, nos. C.5, C.5a, C.28, see ibid., pp. 164–65, 315, nos. 104a, b, 105.

10. Real Armería, Madrid, nos. J.160–J.184; see Valencia de Don Juan 1898, p. 295. These are thought to be booty from the battle of Lepanto in 1571 and to have entered the Spanish royal collection as inheritance from Don Juan of Austria (1547–1578), the natural son of Charles V.

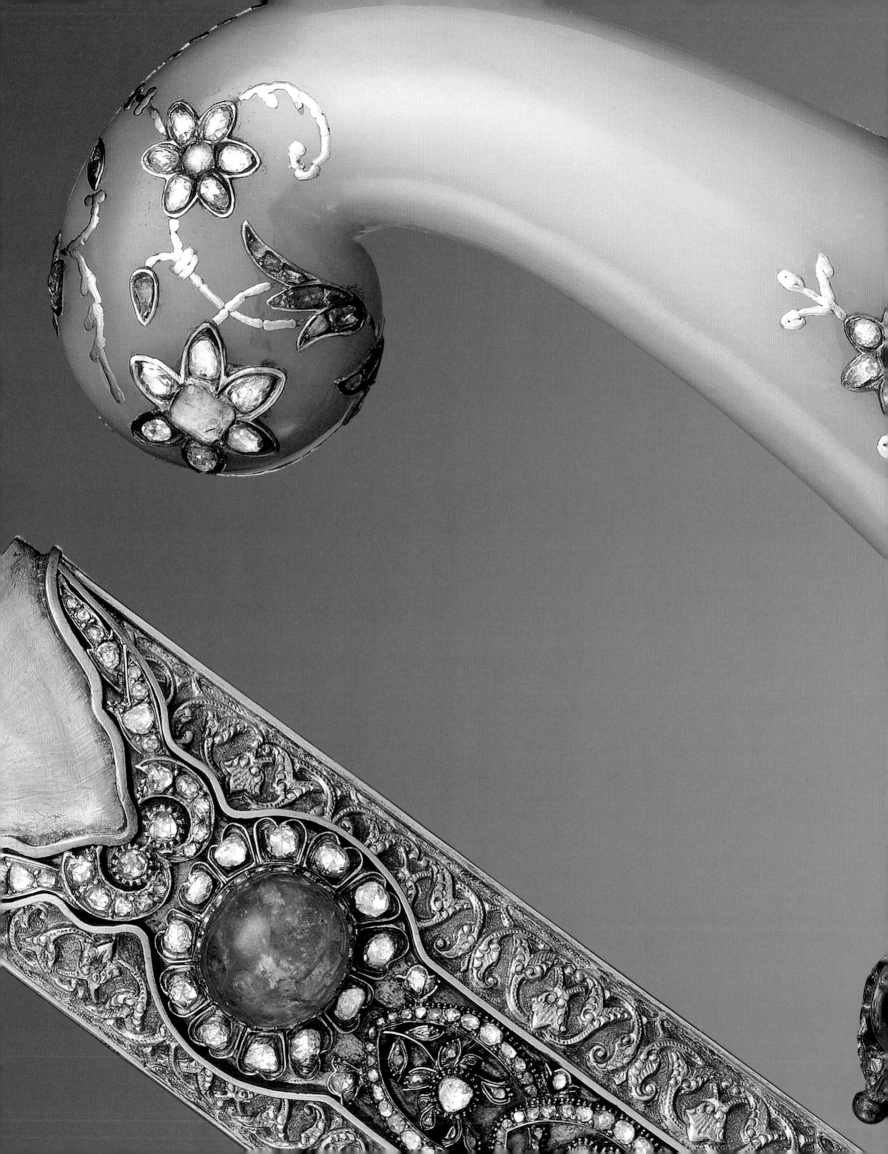

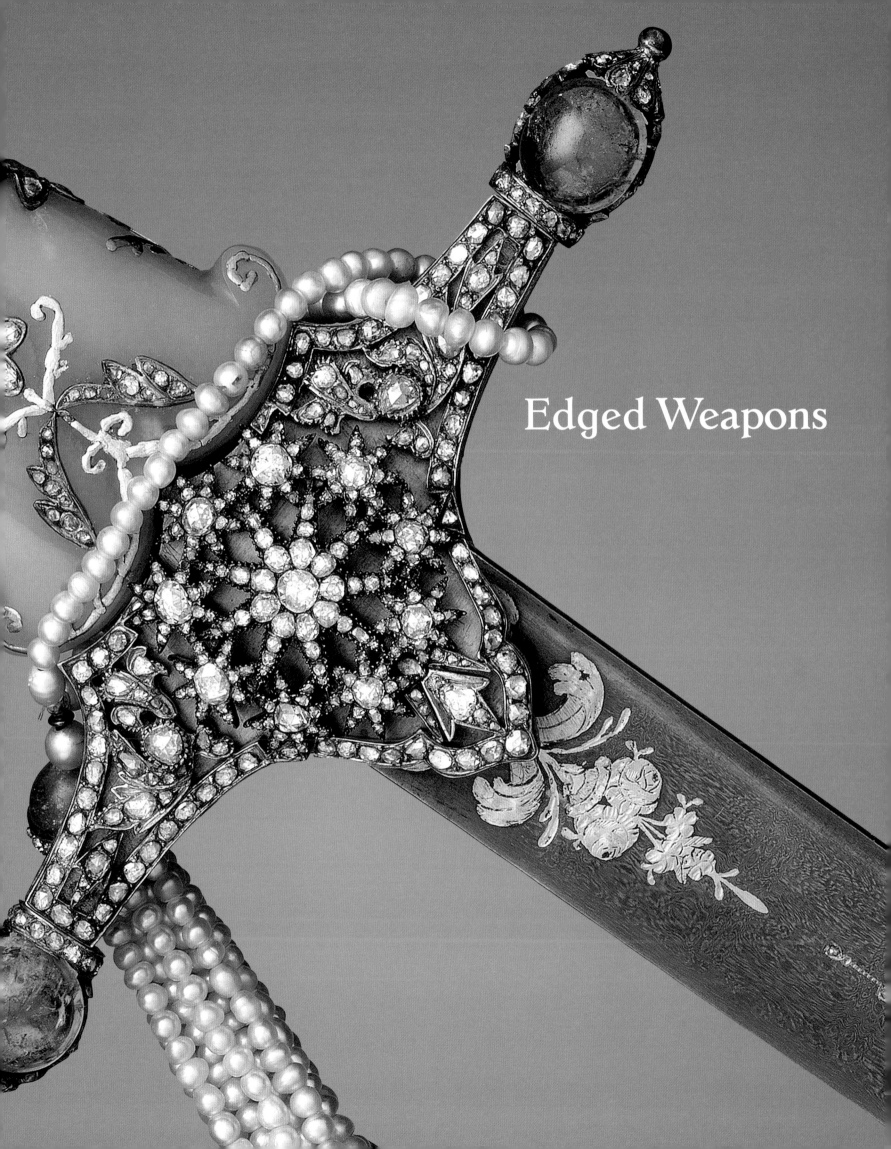

Edged Weapons

54 · Saber

Iran, Nishapur, Samanid period, 9th century
Steel, copper alloy, gold, wood
Sword: length overall 29 in. (73.7 cm); length of blade 28⅛ in. (71.5 cm);
width of blade 1⅜ in. (3.5 cm); width of guard 3⅞ in. (9.7 cm)
Pommel/chape: length with wood fragments 2⅞ in. (7.4 cm), without
wood 2⅛ in. (5.5 cm); width 1⅜ in. (3.6 cm)
Rogers Fund, 1940
40.170.168

DESCRIPTION: The sword is in excavated condition and now fragmentary; it retains portions of its scabbard. The hilt consists of a guard and possibly a pommel (see below), both of gilt bronze. The guard is formed of two identical halves, presumably once riveted together, that fit around the tang of the blade. A portion of the tang projects above the guard and may retain fragments of the original wood (and probably leather-covered) grip. The quillons are straight, of rectangular section, and taper toward the cinquefoil palmette-shaped tips. The faces of the guard have raised edges, with raised leaf forms in the center and within the tips. The heavily corroded blade is broken into six pieces. Now obscured by the remains of the wood scabbard that cling to it, the blade has been described as straight or possibly very slightly curved, single edged, and perhaps with a sharpened back edge. Portions of the two upper scabbard mounts remain. Each consists of a gilt-bronze sheet with raised

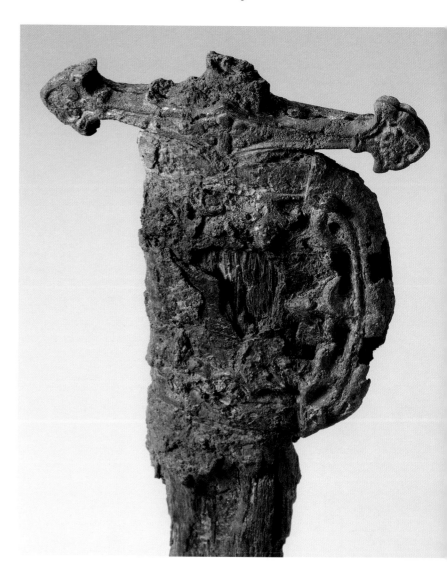

trefoil decoration around its inner edges that is riveted between two bronze bands that encircle the scabbard and to which is riveted along the back edge a bracket of ogival shape. The band at the mouth of the scabbard is shaped to accommodate the pointed center of the guard. Of the lower mount only a small portion remains attached to the blade, while a larger section, including the riveted-on bracket, is now broken away. Found with the sword was a separate mount that is identifiable either as the pommel or, more likely, the chape (end) of the scabbard. It is of flattened oval section formed of two identical plates of cast and gilt bronze seamed along the edges; the edges are straight, the end of flattened ogival shape. Each face is decorated with trefoils facing inward, one of them (the top one, if a pommel, or the bottom one, if a chape) a double trefoil with raised scrolls at the sides. The mount retains fragments of the wood grip or scabbard. Also found with the sword was a ring (now lost) held by a plate raised as a (gorgon's?) face, which may have served as a mount at the end of the grip to secure a wrist strap.

T his important saber was excavated by the Metropolitan Museum in 1939 from Tepe Madrasa at Nishapur, located in the eastern Iranian province of Khurasan and one of the major commercial centers of the Samanid dynasty. It was found beneath a piece of tenth-century pottery and therefore can most likely be dated to the ninth century.[1] Although large numbers of early sabers of the eighth and ninth centuries have been discovered at various sites in Russia and Central Asia, the Museum's is the earliest surviving Islamic example.[2] It may have belonged to a Turkic warrior in the employ of the Samanids, who controlled Nishapur from 874 to 999. Recent metallurgical studies suggest that it is also one of the earliest documented Iranian blades forged of crucible steel.[3]

A wall painting also discovered during the Museum's excavations at Nishapur depicts a fully armed warrior of the period, whose high rank is indicated by his belt with six pendant straps (fig. 29).[4] The Samanids made extensive use of Turkic slave warriors, and as early as the late ninth century they were promoted to the highest ranks in the Samanid army.[5] The figure depicted in the fresco, perhaps one of these warriors, is girded in the Hunnic fashion with two blades—one a short and very slightly curved saber and the other a long, thin straight sword with a rounded pommel.[6] The latter might be a *qarachur*,[7] a type of long sword that, according to the Seljuq vizier Nizam al-Mulk (1018–1092), was given to Turkic slave warriors in their third year of training.[8] A thirteenth-century account by the historian Fakhr-i Mudabbir indicates that the ability to use both weapons was a highly regarded skill.[9]

Sabers were used on the fringes of the Islamic world during the early Islamic period, and, apart from the surviving excavated material, we see evidence of them in painting, as on a shield of about 722 found at a castle on Mount Mugh near Samarqand.[10] Slightly later the 'Abbasid caliph al-Mu'tasim (r. 833–42) employed Turkic warriors from Transoxiana, and it is logical to assume that

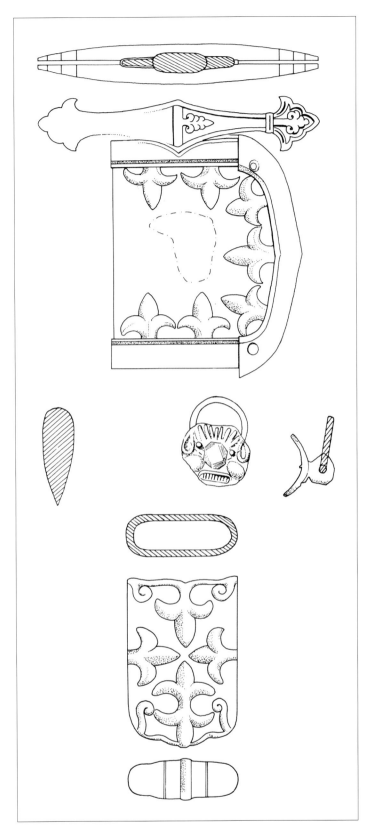

Fig. 28. Line drawings of the Nishapur sword (after Allan 1982b)

at this time they introduced the saber into the heartland of the Islamic world, which is supported by both paintings and accounts of the period. Fragments of period paintings from Samarra bear representations of these warriors, among them a soldier depicted wearing a belt with hanging straps of the kind designed to support a saber.[11] Other early examples have been found in Khazar

Fig. 29. Huntsman in a wall painting from Nishapur. Iran, early 9th century (after Hauser and Wilkinson 1942)

graves in present-day southern Russia. One of these is said to have been found in the Caucasus near Adygea in the same grave, *kurgan*, as an identical saber now in the National Museum of Adygea, Maykop.[12] Numerous horse trappings were also found in the tomb, suggesting that the ensemble must have belonged to an important member of the Khazar aristocracy.[13]

A distinguishing feature of these early sabers is the way the hilt is bent or crooked just below the pommel.[14] This kind of bend is partly a result of the manner in which the pommel is riveted to the tang and, more important, partly a functional feature intended to increase the ability of the mounted warrior to swing his weapon at an opponent. Eventually, and perhaps by direct descent, this kind of crooked hilt became a hallmark of Tartar sabers datable to the sixteenth century and later. The P-shaped or hemispherical scabbard mounts that are another characteristic of these early sabers indicate that the weapons were intended to be worn slung from a belt around the waist. Thin leather straps would have been attached to the top of these mounts and then to the warrior's belt.

The blade of the Museum's saber is apparently straight or very slightly curved, and although it is heavily corroded and encrusted, it retains traces of a sharpened back edge, which is consistent with the numerous early sabers found over a wide area that ranges from Poland and Hungary to Japan.[15] The supposition that the Museum's saber was probably worn by a Turkic slave warrior of the Samanids is consistent with the view that sabers of this type were developed by the nomadic Avar or Turkic warriors

of Central Asia.[16] It is also possible that the *gladius huniscus* referred to by the Anglo-Saxon theologian and scholar Alcuin (ca. 735–804) was in fact a saber, suggesting that the weapons may have been introduced into Europe by the Huns.[17] Among the many excavated pieces are a saber found at Koban in the northern Caucasus, which on numismatic evidence found in the grave is datable to the late eighth or early ninth century, and a saber from the grave of a Turkic chieftain excavated at Srotzki in the Altai, which is datable to the early tenth century.[18] The latter's blade and the general shape of its gilt-bronze fittings are remarkably similar to our Nishapur saber, and provide additional evidence that the Museum's weapon may have belonged to a Turkic slave warrior of the Samanid dynasty.

A large number of these early sabers are luxuriously decorated with fittings of either precious metal or gilt bronze. They were highly prized by the warriors who wore them and often had a symbolic value, as demonstrated by the fact that one such saber was used as part of the regalia of the Holy Roman Emperors. This so-called saber of Charlemagne is now preserved in the Schatzkammer of the Kunsthistorisches Museum, Vienna.[19]

The remnants of the wrist-strap ring found with the Museum's saber are set with a faceted knob sculpted with a gorgon's face. The gorgon motif was used frequently in Soghdia during the

Cat. 54 pommel/chape

pre-Islamic period.[20] Wrist-strap rings are a common feature on early sabers and were quickly adopted by the Arabs. A comparable ring can be found on a sword hilt, perhaps Fatimid, of about 1025, and such rings are often encountered on later Anatolian and Mamluk swords and sabers.[21]

PROVENANCE: 1939, discovered at Tepe Madrasa, Nishapur, Iran, by the Metropolitan Museum's expedition under a concession granted by the Council of Ministers, Iran, upon the recommendation of the Ministry of Education of Iran; title transferred to The Metropolitan Museum of Art pursuant to the concession.

REFERENCES: Allan 1982b, pp. 56–58, 108–9, no. 208; Allan 1988, pp. 5–6, fig. 19; Nicolle 1988, vol. 1, p. 556, vol. 2, figs. 1557A–G; Allan and Gilmour 2000, pp. 52–55, 194–95, figs. 5a, b; Alexander 2001, pp. 214–15, fig. 14; al-Sarraf 2002, pls. XII-26a, b, XII-103; Lebedynsky 2008, p. 170.

NOTES

1. Discovered in 1939 at Tepe Madrasa, Nishapur, Area Y2, field no. 353; Wilkinson personal communication 1978, dish no. 39N166, 7 (Department of Islamic Art Files, The Metropolitan Museum of Art, New York). For an overview of the Nishapur excavations, see Hauser and Wilkinson 1942. For the sword, see Allan 1982b, pp. 56–58, 108–9, no. 208, where he described the blade as straight and identified the separate mount with trefoil ornament as the pommel, and Allan and Gilmour 2000, pp. 52–55, 194–95, where James W. Allan identified the blade as being of crucible steel and slightly curved rather than straight. He also maintained that the trefoil mount was the pommel based on the angled grain of the wood within it.

2. For examples of these early sabers, see Arendt 1935; Kirpicnikov 1972; Augustin 1993, no. 123; and Paris 2007/Mohamed 2008, pp. 30–36, nos. 1–7.

3. See note 1 above.

4. The fresco is now in the National Museum of Iran, Tehran; see Hauser and Wilkinson 1942, fig. 45, and Alexander 2001, p. 216, fig. 15.

5. Bosworth 1973, p. 99, mentions that under Isma'il Ahmad (r. 892–907) the commander-in-chief of the Samanid army was a slave warrior.

6. In the tenth-century version of the Germanic epic poem *Waltharius*, the hero Walther "arms himself in the Hunnish fashion . . . with a double-edged long sword, *spatha*, belted to his left hip . . . and a single-edged half-sword, *semispatha*, at his right"; see Nickel 1973a, p. 138.

7. It is difficult to match surviving blades to early terminology. While it might be argued, for just one example among many, that the short sword is a *qaljuri* (which, according to al-Kindi, was a type of sword made in the Yemen that was light in weight and about three handspans long), Allan 1979, pp. 86, 137, calls the *qaljuri* a long, curved sword. In addition, al-Kindi's use of the word itself is unclear, as surviving manuscripts of his work variously call it *uri*, *quyuri*, *unuri*, and *qubuzi*, all of which were rendered by al-Kindi 1952, p. 17, n. 8, as *qaljuri*. Although a *qarachur* was defined by Nizam al-Mulk as a long sword given to a Turkish slave warrior at the Samanid court after his third year of service (see note 8 below), it might possibly instead refer to the belt from which the sword was suspended, indicating that Nizam was in fact referring to a form of investiture.

8. Nizam al-Mulk reported that in their first year the trainees served on foot and were not permitted to mount a horse; in their second year they were given a Turkish horse and plain harness; in their third year, a long sword called a *qarachur/qalachur*; in their fourth year a better saddle, clothing, and a mace; and in their fifth year, parade dress. See Bartol'd 1958, p. 227.

9. According to Fakhr-i Mudabbir, Sultan Mahmud of Ghazna fought with both sword and *qarachur*; see Bosworth 1973, pp. 119–20, and Allan 1979, p. 90. Although there is some disagreement as to whether a *qarachur* was in reality a sword or saber, there is

no doubt that the early reports refer to two distinct types of weapon (see also note 7 above).

10. State Hermitage Museum, Saint Petersburg, no. CA-9093; see Vienna 1996, p. 296, no. 162, ill.

11. Herzfeld 1927, pl. LXVI. Until the appearance of the Museum's saber it was thought that these weapons had not been used in the Islamic world until at least the eleventh century; see Mayer 1952, pp. 43–44, and Allan 1979, p. 90.

12. For the saber in the National Museum of the Republic of Adygea, Maykop, see Ditler 1961 and Bálint 1989, p. 34, pl. 13. Another example is in the Furusiyya Art Foundation, Vaduz, no. R-645; see Paris 2007/Mohamed 2008, pp. 30–31, no. 1. Both pieces must have been cast from the same molds and are the work of the same craftsman.

13. A number of these pieces are also in the Furusiyya Art Foundation, Vaduz, and some are decorated with representations of Khazar warriors, including warriors holding axes of the type generally associated with the Scandinavians and the Rus'; see Paris 2007/Mohamed 2008, especially p. 113, no. 80. The Khazars were a confederation of mainly Turkic tribes, and during the eighth century A.D., the royal bodyguard seems to have been composed of Khwarazim Turkish Muslims; see Bartol'd and Golden 1978, p. 1174. Yet during the same period the ruling elite converted to Judaism, while the majority seems to have remained pagan (shamanistic). The recent finds from Khazar graves were not excavated under controlled conditions, which might have established the religious orientation of the deceased; the inclusion of weapons and horse trappings in the graves, however, probably indicates that these warriors were not Muslims.

14. The present condition of the Nishapur sword does not allow us to determine with certainty that its grip was bent.

15. See, for example, Arendt 1935.

16. The origins of the saber have been extensively discussed in Nickel 1973a and Sinor 1981. Sinor 1981, p. 141, for example, quotes from *The Russian Primary Chronicle*, in which a Turkic Khazar is reported to have contrasted the Khazars' use of the saber with the Slavs' dependence on the sword.

17. See Schlosser 1892, p. 19, as quoted in Hampel 1897–99, p. 45.

18. For the Koban saber, see Arendt 1935, pp. 49–50, no. 3, pl. VI, figs. 12, 12a, b; the saber found at Koban was in a grave that also contained Umayyad and 'Abbasid coins dating to between A.D. 740 and 799, dates that roughly correspond to the reigns of Charlemagne (742–814) and the 'Abbasid caliph Harun al-Rashid (766/763–809). For the Srotzki saber, which is now in the Bilsk Museum, see ibid., pl. XXXI, and Zacharov 1935, p. 28. The grave of a Turkic chieftain at Srotzki in the Altai contained, along with a saber, Tang dynasty (618–907) coinage of the tenth century; see ibid.

19. Some of the most important publications include Arendt 1935, Fillitz 1971, and Kirpicnikov 1972. According to one tradition, the saber was found in A.D. 1000 by the emperor Otto III (980–1002) in the tomb of Charlemagne; according to another, it was captured by Charlemagne during his war against the Avars. In yet another account, it is said to have been one of the gifts sent to Charlemagne by Harun al-Rashid; for some of these gifts, see Sourdel 1978, p. 118.

20. See, for example, the standard from Samarqand in Iakubovskii and Diakonov 1954, fig. 22.

21. For the former, see Schwarzer and Deal 1986 and Schwarzer 2004. For later Anatolian and Mamluk examples, see Copenhagen 1982, pp. 70–71, no. 24, and Alexander 1985c, nos. 64–75.

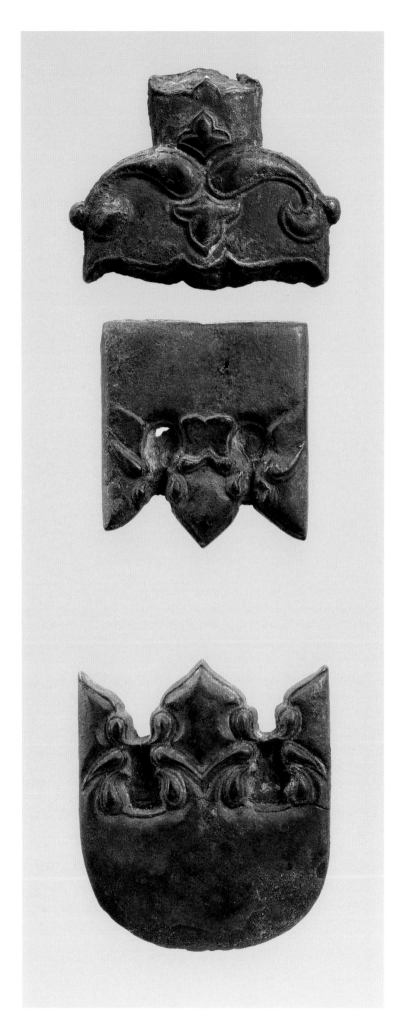

55 · Matrices for Sword Mounts

Iraq or Iran, 10th–11th century
Copper alloy
Sword guard (.1): 2¼ × 2⅞ in. (5.8 × 7.2 cm); weight 6 oz. (162 g)
Locket (.3): 2⅜ × 2¼ in. (5.9 × 5.6 cm); weight 4 oz. (119 g)
Chape (.2): 3 × 2⅝ in. (7.5 × 6.7 cm); weight 7 oz. (206 g)
Purchase, Rogers Fund and Anonymous Gift, 1980
1980.210.1, .2, .3

DESCRIPTION: These three cast-bronze matrices served as the master molds for the manufacture of a sword guard (.1) and for the upper and lower mounts for its scabbard (.3 and .2, respectively). The mold for the guard, which includes a sleeve for the base of the grip and another for the mouth of the scabbard, is decorated with raised scrolling leaves at the quillons and with palmettes at the center. The molds for the scabbard mounts, that is, the locket (.3) and chape (.2), have openwork edges formed of wide leaves and are decorated with raised teardrop forms.

Molds of varying types were widely used by metalworkers and other craftsmen during the early Islamic period.[1] The shoulder-shaped mold here (.1) would presumably have been used to fashion a sword guard of gold or silver, which would be made of two identical plates joined along the edges; the faces might then have been further decorated, perhaps with niello, as was a hilt in the Furusiyya Art Foundation, Vaduz.[2] A hilt with a compact guard of this shape reflects an Islamic adaptation of the Roman *gladius*; with minor changes such hilts were used in the Islamic world until the early twentieth century.[3]

The softly cut edges of the various decorative elements are reminiscent of beveling found on woodwork. The origin of this type of craftsmanship, called the "beveled style" by Richard Ettinghausen, has been traced to the wood- and leatherwork produced by Turkish artisans and introduced into the Islamic world during the eighth century.[4] While the beveled-style decorative motifs seen here have some parallels in the metalwork excavated at Nishapur, they are not exactly similar, and the origin of the Museum's molds could be anywhere in Iran or Greater Syria.

A number of related sword fittings and the molds used to make them are preserved. These include three sword guards in the Furusiyya Art Foundation, Vaduz, all datable to between the eleventh and thirteenth century;[5] a gold sword guard in the Saint Louis Art Museum;[6] and a bronze sword hilt dating to about 1025 that was found in the wreck of a (Fatimid?) ship in the Aegean.[7] In addition, a bronze mold for a sword guard of almost the same shape as the Museum's but decorated with lions and probably dating to the Artuqid dynasty, which ruled in Greater Syria (ca. 1101–1408), is in the Furusiyya Art Foundation.[8] The mold for that guard is accompanied by one for the pommel, also decorated with lions, and is of much the same shape as a rounded pommel of silver gilt with nielloed decoration that probably dates to the ninth or tenth century, also in the Furusiyya Art Foundation.[9]

The Furusiyya collection also preserves a scabbard chape decorated with teardrop forms similar to those on the Museum's molds.[10] Assadullah Souren Melikian-Chirvani has called such teardrop forms "lotus buds" and noted that they are characteristic of metalwork of the Samanid period (874–999) in Iran.[11] However, the decoration and style of inscription on the Furusiyya chape are also very close to that on a group of cast-bronze mirrors attributable to Syria and the Jazira and usually dated to the thirteenth century.[12] Another lower scabbard mount, cast from a similar matrix, is in the Kuwait National Museum.[13] Finally, in the Furusiyya Art Foundation there is a mold made of schist from Iran or Afghanistan, dated to the tenth century, that would have been used to cast scabbard mounts.[14] That mold is very similar to a Samanid example from Nishapur now in the Metropolitan's collection.[15] Due to the variation in dates and attributions of the relevant examples, the dating for the Museum's matrices should remain tentative.

PROVENANCE: Sotheby Parke Bernet, New York, May 16, 1980, lot 132.

REFERENCES: Alexander 1980; Sotheby Parke Bernet, New York 1980, lot 132; Alexander and Ricketts 1985, p. 300, s.v. no. 306; Nicolle 1988, no. 1560A–C, vol. 1, p. 556, vol. 2, p. 949; Nickel 1991b, p. 125, fig. 9 (acc. no. 1980.210.1); Paris 2007/ Mohamed 2008, p. 108, s.v. no. 73.

NOTES

1. Allan 1979, pp. 59–65.

2. Paris 2007/Mohamed 2008, p. 108, no. 74.

3. A seventeenth-century Ottoman example of a complete hilt of this type is in the Museum's collection, acc. no. 1987.42; see Hales 2013, p. 240, no. 591.

4. Ettinghausen 1961.

5. Furusiyya Art Foundation, Vaduz, nos. R-603–R-605; R-604 is said to have been found in present-day Afghanistan. See Paris 2007/Mohamed 2008, pp. 108–9, nos. 74–76.

6. Saint Louis Art Museum, no. 45.1924; Pope 1938–58, vol. 6, pl. 1428, fig. B.

7. Schwarzer and Deal 1986; Schwarzer 2004, p. 382, no. WP64, figs. 21-4, 21-15, 21-16.

8. Furusiyya Art Foundation, Vaduz, no. R-574; see Paris 2007/Mohamed 2008, p. 108, no. 73, in which it is attributed to Central Asia or Khorasan, whereas this author maintains that it should be attributed to Syria or the Jazira.

9. Furusiyya Art Foundation, Vaduz, no. R-623; see ibid., p. 106, no. 68. The pommel is inscribed with the name of the amir Abi al-Ghanaim Mansur bil-Allah. Another example of this type of pommel is now in a private collection in Qatar.

10. Furusiyya Art Foundation, Vaduz, no. R-548; see ibid., p. 109, no. 77.

11. Melikian-Chirvani 1982b, p. 28.

12. Ibid., no. 58; Kuwait 1990, no. 41.

13. Kuwait National Museum, Kuwait City, no. LNS 143m.

14. Furusiyya Art Foundation, Vaduz, no. R-631; see Paris 2007/Mohamed 2008, p. 129, no. 118.

15. Metropolitan Museum (acc. no. 41.170.211); Hauser and Wilkinson 1942, p. 101, fig. 32.

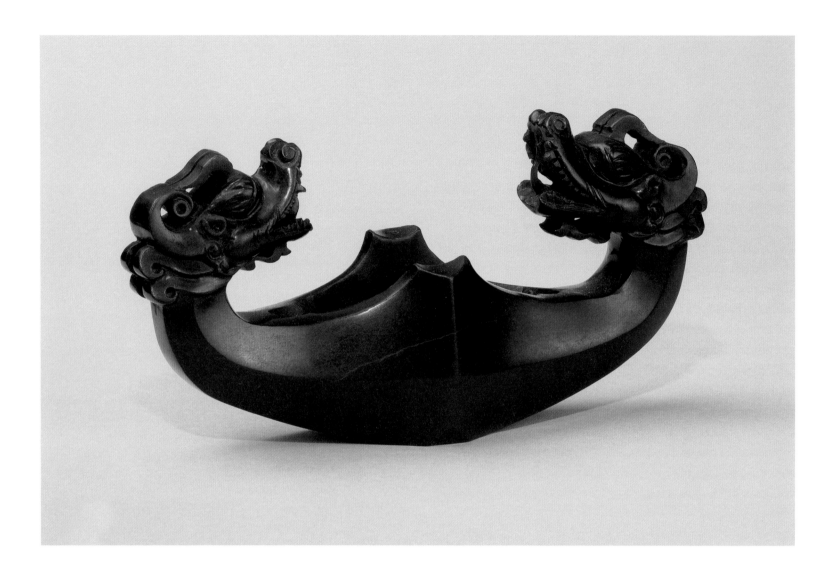

56 · Guard for a Saber

Iran or Central Asia, Timurid period, 15th century
Nephrite (jade)
2 × 4 in. (5.1 × 10.2 cm)
Gift of Heber R. Bishop, 1902
02.18.765

DESCRIPTION: The guard is carved from a single piece of dark green nephrite. The quillons are hexagonal in section, tapering toward the tips, which curve downward and terminate in elaborately carved dragon heads; the lower prongs (langets) are broken off and have been filed down to the present concavely shaped stems.

This guard belongs to a group of guards on sabers very probably made in Samarqand in the court workshops of the Timurid prince Ulugh Beg (r. 1447–49).[1] In 1419 Ulugh Beg sent an embassy to China, which included a number of artists, among them the painter Ghiyas al-Din Naqqash.[2] As a result of this journey Chinese influences on Iranian art became especially pronounced, and the finely carved Chinese-like dragons on the saber hilts of this group are probably a direct consequence of this contact. An attribution to the court workshops of Ulugh Beg is rendered all but certain by comparison with a cup now in the Museu Calouste Gulbenkian, Lisbon, inscribed with

the prince's name; on its handle is carved an almost identical dragon.[3] Two sabers with carved nephrite hilts from this workshop are now preserved in the Topkapı Sarayı Museum, Istanbul.[4] Another hilt from the same group but with reworked quillons is in the Furusiyya Art Foundation, Vaduz.[5] The latter is inscribed in Persian with a verse by the poet Sa'di (ca. 1213–1292). Sabers with luxurious mountings of precious and fragile materials like nephrite must have been used as ceremonial weapons. In miniature painting they often appear in distinctly nonmilitary contexts, as can been seen in a Jalayirid miniature dated A.H. 798 (A.D. 1395/96) depicting Prince Humay at the gate of Humayun's Castle.[6]

Dragon heads were a common form of imagery on many objects from the Islamic world, but it is curious that the dragon seems to have been associated with the Prophet's sword, Dhu'l faqar, which represents an entirely non-Arab metamorphosis in the history of that weapon. That is not to say that a sword or saber with dragon imagery—decorating the blade, or more frequently as quillons formed as dragon heads—was always intended as a representation of Dhu'l faqar. Yet from the fourteenth century onward it appears that "dragon swords" were regarded as having a connection with the sword of the Prophet; examples were produced in every part of the Islamic world, from Spain to India, as well as under numerous dynasties: Nasrid, Mamluk, Ottoman, Timurid, Safavid, and Mughal.[7] Indeed, one of the swords preserved in the Treasury of the Prophet in the Topkapı Sarayı Museum, Istanbul, has a hilt with dragon quillons.[8]

The earliest specific connection between a sword blade and a dragon is encountered in literature from the eleventh century, when the Isma'ili philosopher, traveler, and poet Abu Mu'in Nasir-i Khusrau (1004–ca. 1078) wrote that "the sword of 'Ali is a dragon held in the hands of a lion."[9] Later, the Ottoman sultan Mehmed II (r. 1444–46, 1451–81) was described by his court poet and historian Ibn Kamal (ca. 1468–1534) as "the victorious panther at whose side hung a dragon sword."[10] And, an Iranian blade dated A.H. 1163 (A.D. 1749/50) in the State Hermitage Museum, Saint Petersburg, is inscribed, "The blade, even in its sheath, is terrible. It is a dragon hid in its cavern."[11] Dragon imagery was merged with the symbolism of Dhu'l faqar in three ways: first, by associating a bifurcated blade with dragon quillons on the hilt; second, by inscribing a blade—especially one decorated with a dragon-and-phoenix combat—with verses about the Dhu'l faqar;[12] and third, by engraving a dragon on the blade of a bifurcated sword. Examples of the third type include several made by the swordsmith Muhammad ibn Abdullah.[13] Examples of the first type are found on Ottoman banners of the sixteenth and seventeenth centuries (see the banner cat. 107).

PROVENANCE: Heber R. Bishop, New York.

REFERENCES: *Bishop Collection* [1902], no. 765; Grube 1974, p. 254, pl. lxxxiv, fig. 109; Alexander 1984, no. 34; *Islamic World* 1987, pp. 88–89, no. 67; Washington, D.C., and Los Angeles 1989, pp. 143, 340, no. 51; Melikian-Chirvani 1997, pp. 159–61; London 2005b, pp. 235, 425, no. 194; Paris 2007/Mohamed 2008, p. 177, no. 165, n. 1; James C. Y. Watt in Ekhtiar et al. 2011, pp. 195–96, no. 133.

NOTES

1. See also Melikian-Chirvani 1997, pp. 159–61, who argues on stylistic evidence that the hilt is from the first half of the fourteenth century and discusses the significance of jade, "the royal stone," and the dragon heads as "the invincible king's symbol." James C. Y. Watt in Ekhtiar et al. 2011, pp. 195–96, no. 133, also gives it an early date, tentatively to the fourteenth to early fifteenth century.

2. See Roxburgh 2005, p. 160.

3. Museu Calouste Gulbenkian, Lisbon; see London 1976, pp. 123, 129, no. 114, ill., and Washington, D.C., and Los Angeles 1989, pp. 143–44, fig. 46. See also ibid., no. 51, where this guard is published as having been made for a dagger hilt. Its dimensions, however, are almost exactly those of the hilts of the Topkapı sabers (see note 4 below), making such an identification virtually impossible.

4. Topkapı Sarayı Museum, Istanbul, nos. 1/219, 1/220; see Pope 1938–58, vol. 6, pl. 1428, figs. C, E, and Alexander 1984, nos. 33, 32, respectively. For no. 1/220, see also London 2005b, pp. 211, 416, no. 158; Istanbul 2010, p. 100.

5. Furusiyya Art Foundation, Vaduz, no. R-331; see Alexander and Ricketts 1985, p. 302, no. 308; and Paris 2007/Mohamed 2008, p. 177, no. 165.

6. By the artist Junayd al-Sultani, in a *Diwan of Khwaju Kirmani* that is dated A.H. 798 (A.D. 1395/96), British Library, London, no. Add. 18113, fol. 56v; see Riyadh 1996, vol. 2, pp. 246–47, no. 206.

7. The prototype for the dragon sword can probably be traced back to the Chinese type described in Grancsay 1930, pp. 194–95 (reprinted in Grancsay 1986).

8. Topkapı Sarayı Museum, Istanbul, no. 21/129; see Yücel 2001, pp. 15–16, no. 1.

9. Esin 1974, p. 205.

10. Ibid., p. 211.

11. Egerton 1896, p. 53, n. 2, citing (in translation) *Musée de Tzarskoe-Selo* 1835–53, pl. 92, no. 6, in which the text mistakenly converts the date A.H. 1163 to A.D. 1740.

12. The finest and best preserved of these is a blade traditionally ascribed to Jafar ibn Tayyar and now in the Treasury of the Prophet, Topkapı Sarayı Museum, Istanbul, no. 21/143; see Yücel 2001, pp. 38–39, no. 16; and Aydın 2007, p. 200.

13. For examples by this smith, see Alexander 1984, no. 15; Alexander 1999, pp. 177, 181, fig. 8; Yücel 2001, pp. 30–32, no. 10; and Aydın 2007, pp. 194–95.

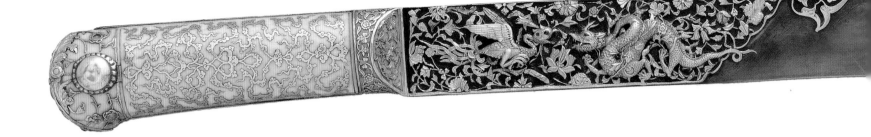

57 · Yatagan

Turkey, Istanbul, Ottoman period, ca. 1525–30
Steel, gold, ivory, silver, turquoise, pearls, rubies
Length 23⅜ in. (59.3 cm); blade 18⅜ in. (46.6 cm);
weight 1 lb. 8 oz. (691 g)
Purchase, Lila Acheson Wallace Gift, 1993
1993.14

DESCRIPTION: The grip and pommel are formed of a single piece of walrus ivory fitted around three sides of the tang of the blade (leaving the top edge exposed), the pommel end rounded and extended asymmetrically downward. The respective sections of the grip and pommel are outlined in gold. The gold-inlaid decoration is in two registers: on each side of the grip are symmetrically arranged cloud bands; on the pommel are floral scrolls with three raised gold flowers enclosing turquoises. Each face of the pommel was originally set with a raised silver-gilt boss with beaded edge, the one on the inner face now missing; at the top of the pommel is another boss, surrounded by gold-inlaid floral scrolls set with two rubies. The exposed edge of the tang along the top of the grip is covered by a gold shim worked in low relief with scrolls and peonies on a matted ground. The tapered collar, or ferrule, at the base of the grip is of gold cast and worked in relief with floral scrolls on a recessed matted ground. The blade of crucible steel is of typical double-curved, single-edged yatagan type that widens toward the point. It is decorated on both faces within 6 in. (15 cm) of the hilt with an asymmetrical half-palmette-shaped panel enclosing designs, different on each side, in high-relief gold set into the blade, the background darkened for contrast. The decoration on each panel consists of a scaly dragon attacking a phoenix (or in Persian mythology, a *senmurv*). The dragon has a ruby eye and silver teeth, the phoenix a ruby eye and a seed pearl at the back of its head (the pearl on the outer side is missing). The two creatures, which are rendered differently on each side of the blade (those on the inner side are upside down), appear to have been made separately, of iron covered with gold, and riveted to the blade. They inhabit a forest of raised gold foliage of Chinese type, the vines wrapping around the undulating body of the dragon. The gold work on these mythical creatures and foliate designs has engraved and chiseled detail. Along the back edge of the blade is a gold-inlaid Persian inscription, now very worn and almost illegible.

This luxuriously decorated sword, a superb example of the Ottoman goldsmith's art, ranks among the Museum's finest Islamic works of art. It belongs to a group of three comparably embellished yatagans[1] produced in the royal workshops of the Ottoman sultans in Istanbul, of which it is the smallest. In addition to the Museum's example the group includes another very similar yatagan in the Topkapı Sarayı Museum, Istanbul, and a larger and even more beautifully crafted one in the Furusiyya Art Foundation, Vaduz.[2] The Topkapı example is almost identical in workmanship to the Museum's and is inscribed with the titulature of Süleyman I (r. 1520–66), the date A.H. 933 (A.D. 1526/27), and the name of the maker, Ahmed Tekelü.

According to Michael Rogers, this master is recorded only once in the registers of the Topkapı, in an undated list of rewards and gratuities offered to craftsmen by the sultan, which suggests that he may have been listed in the registers under another name, perhaps as Ahmad Gozcu or Gurci (the Georgian).[3] Another possibility is that he was a member of the Turkman tribe or clan called Takkalu, who originally followed the Ak-Koyunlu and later were part of the Qizilbash confederation who served the Safavids.[4] Whatever his origin, he was very likely also the master who crafted, or more probably decorated, the Museum's sword. Indeed, it is often difficult to know whether a signature on a blade refers to the swordsmith or to the decorator; the clear exceptions are those in which a name is stamped on the tang.[5]

The hilts of all three yatagans are of ivory inlaid with gold arabesques or cloud bands; with the exception of the Museum's example, the ornament is set against a subsidiary floral design. In addition, the two smaller examples, the Museum's and the Topkapı's, are set with rubies and turquoises. Ivory worked with a juxtaposition of gems set within a field of split-leaf floral arabesques is typical of the Ottoman court workshops of the first half of the sixteenth century.[6] The blades of all three yatagans are

decorated with floral designs and scenes of combat between dragons and phoenixes. This style developed in Iran during the late Timurid period (late fifteenth century), and the decorative workmanship is very similar to that on metalwork made for the early Safavid shahs, as can be seen on a set of belt fittings crafted for Shah Isma'il in 1507.[7] Although differing slightly in quality, the decoration on the blades can be attributed to the same hand—the variations perhaps resulting from being produced at somewhat different stages in the craftsman's career. It is most likely that the person responsible for the decoration, Tekelü, was trained in Iran and later moved, either voluntarily or as a prisoner, to Istanbul.[8]

Widely popular in Iranian and Ottoman art during the fifteenth and sixteenth centuries, the theme of combat between dragon and phoenix is found in a variety of mediums, including miniature paintings, textiles, and metalwork. Yet it seems to have had a special significance for weaponry, as it also occurs (with slightly less opulence than on these three luxury blades) on a large number of blades apparently created as presentation pieces.[9] These examples, decorated with the same motif of dragon-and-phoenix combat, are worked not in relief but are damascened in gold and silver on the blade and in most cases include an inscription comparing the weapon to Muhammad's sword, Dhu'l faqar. The most finely worked of these presentation blades, traditionally said to have belonged to Jafar al-Tayyar, cousin of the Prophet and brother of 'Ali, is now in the Treasury of the Prophet in the Topkapı Sarayı Museum, Istanbul.[10] Whatever the sequence, the three yatagans discussed here must then have served as the models for the next generation of damascened dragon-and-phoenix blades, of which the sword ascribed to Jafar is most likely the earliest.[11]

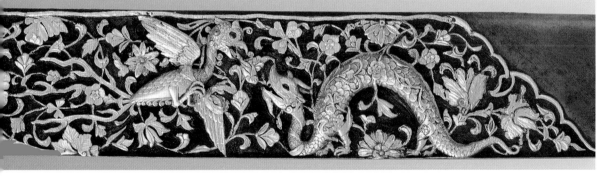

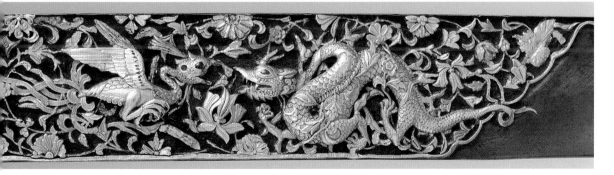

The inscription on the large yatagan in the Furusiyya Art Foundation, Vaduz, has been read by Michael Rogers as giving the name of "Ahmad b. Hersek Khan, the Rustam of the age, the aid of the armies, the Alexander of generals." Hersekzade Ahmad (1456–1517) was a younger son of the grand duke of Herzegovina. He served under Mehmed II and Bayezid II, holding various posts, including sancakbeg of Bursa, beglerbeg of Anatolia, vizier, and admiral of the fleet. Later he served Selim I as a general and grand vizier. If the Furusiyya yatagan was made for him, it could not

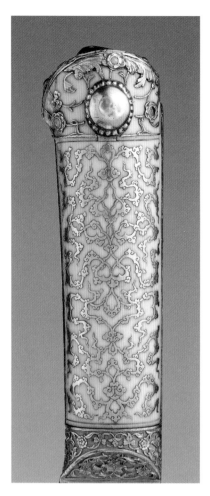
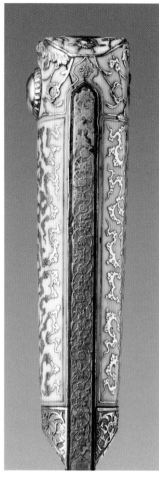

date later than 1517 and consequently would be the earliest in the group. However, this reading of the inscription has been disputed,[12] leaving the chronology of the three weapons unresolved.

PROVENANCE: Rex Ingram, Los Angeles; Anonymous [Ingram estate] sale, A. N. Abel Auction Company, Los Angeles, 1989 (no catalogue).

REFERENCES: Pyhrr 1993; David Alexander and Stuart W. Pyhrr in Ekhtiar et al. 2011, pp. 312–13, no. 221.

NOTES

1. Long knives or swords with incurving blades are known in Turkish as *yatagans*. Though blades such as these were not an Ottoman invention, they must have been used by the Turks from an early date, as shown in a Tang painting probably from the ninth century (now in the National Palace Museum, Taipei), which depicts a Turkish chieftain girt with a long yatagan-like knife; see Ettinghausen 1963.

2. For the yatagan in the Topkapı Sarayı Museum, Istanbul, no. 2/3776, see Washington, D.C., Chicago, and New York 1987–88, pp. 151–54, 313, no. 86; London 1988, pp. 146–47, no. 83; Rogers 1988; and Ward 1990. For the yatagan in the Furusiyya Art Foundation, Vaduz, no. R-944, see Sydney and Melbourne 1990, pp. 64–65, no. 50;

Washington, D.C. 1991–92, no. 89; Paris 2002–3, p. 147, no. 102; Paris 2007/Mohamed 2008, pp. 56–57, no. 21; and H. Lowry 2011, pp. 10–12.

A fourth example, now in the Museum of Islamic Arts, Doha, is decorated not with the dragon-and-phoenix motif but rather with raised gold calligraphy, which includes the name and titles of Sultan Bayezid II (r. 1481–1512). It is the earliest surviving example from this group of yatagans. Like the Metropolitan's example, the Furusiyya and Qatar yatagans were formerly in the collection of the film director Rex Ingram (1892–1950). For the Qatar example, see Jodidio 2008, pp. 55–154, no. 26, and Los Angeles and Houston 2011–12, pp. 44–45, 230, no. 68, fig. 37.

3. Tekelü received 3,000 *akçes* and a robe of honor; Gurci was given as a present to Bayezid II. See Rogers 1988.

4. Woods 1999, p. 163.

5. For examples of names stamped on the tang, see Yücel 2001, p. 90, no. 47. The very rubbed gold-inlaid inscription on the spine of the Museum's blade, the same location in which Tekelü's name occurs on the Topkapı yatagan, has so far defied a convincing reading. According to Maryam Ekhtiar, Associate Curator of the Department of Islamic Art at the Metropolitan Museum, "the inscription is in a *nasta'liq* script which indicated that [it] is most probably in Persian. It appears to be in the form of [a poem], as it has a rhyming repeat. It seems to contain the remnants of a date (written out)." Professor Abdullah Ghouchani has also observed that it seems to be a poem in Persian and that the first word could refer to "phoenix" (Department of Arms and Armor Files, The Metropolitan Museum of Art, New York, the former view from September 20, 2011, the latter recorded on October 9, 2008).

6. See, for comparison, Washington, D.C., Chicago, and New York 1987–88, nos. 76, 77, 93.

7. Pope 1938–58, vol. 6, pl. 1394; New York and Milan 2003–4, pp. 202–3, 205, figs. 8.1, 8.3.

8. While craftsmen often moved from one court to another, they were also frequently taken as prisoners after a military campaign. If the latter applies here, this artist may have been taken prisoner by Selim I, following his defeat of Isma'il at the battle of Chaldiran and capture of Tabriz in 1514. On this question, see also H. Lowry 2011, p. 12, n. 43.

9. These blades are discussed as a group in Melikian-Chirvani 1982a.

10. Topkapı Sarayı Museum, Istanbul, no. 2/143; see Yücel 2001, pp. 38–39, pl. 16. The fittings of this sword are certainly Ottoman and are chiseled with palmettes of exactly the same form as those on the guard of an Ottoman dagger now in the Kunsthistorisches Museum, Vienna, no. C 152 (see Grosz and Thomas 1936, p. 95, no. 7). The inlaid ivory hilt of the Vienna dagger is worked in a decorative style datable to between about 1525 and 1550.

11. Such a sequence would account for the fact that in this entire corpus of damascened blades (perhaps fifty in all) none has fittings predating the mid-sixteenth century and most can be attributed to the late sixteenth or early seventeenth century. If the decoration on the Jafar sword blade is roughly contemporary with its fittings—and there is no reason to suppose otherwise—a chronology begins to emerge for the entire group.

12. Maryam Ekhtiar read the inscription as "the unrivaled Rustam of the age is grateful to this weighty mace of the owner and by the order of Ahmad ibn Umar Beyg Khan" (*Rustam-I asr tak-seffat shukr an gurz-I geran ze sahib va hukm-I Ahmad ibn Umar Beyg Khan*) (Department of Arms and Armor Files, The Metropolitan Museum of Art, New York).

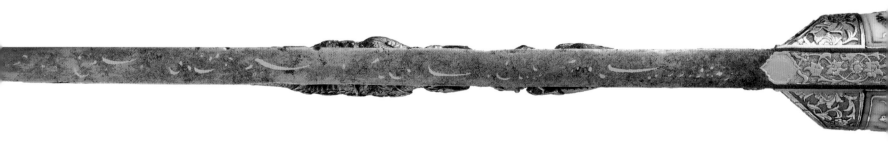

58 · Saber

Turkey, Ottoman period, 1522–66
Steel, gold, fish skin
Length 37⅝ in. (95.6 cm); blade 31¾ in. (80.5 cm);
weight 2 lbs. 5 oz. (1,037 g)
Bequest of George C. Stone, 1935
36.25.1297

DESCRIPTION: The present grip, incorporating a right-angled bend in place of a pommel, is a replacement for the lost original. It is of green-stained fish skin over a wood core, the seams closed by tiny gold rosette-headed nails. The cruciform guard of blackened steel has straight tapered quillons expanding toward pierced palmette-shaped tips; each face is chiseled and damascened in gold with petaled rosettes, whose recessed centers formerly held gemstones, against a subsidiary arabesque design inlaid flush with the surface. The blade of dark steel is curved and single edged, with a slightly enlarged double-edged section toward the point. Each face is covered over its entire length with a series of lobed cartouches containing quotations from the Qur'an (a–f) in cursive script, the background being cut away and filled with gold foil. The interstices between the cartouches are inlaid in gold with delicate arabesque scrolls. The decoration is flush to the surface throughout. The inscriptions are arranged in two horizontal registers on each side: the upper one, along the back of the blade, consists of three long panels, whereas the lower register, along the edge, includes twenty cartouches of alternating rectangular and quatrefoil shapes. The spine of the blade is also inlaid with arabesques.

INSCRIPTIONS:

On the outer face

a. (In the rectangular cartouches along the edge of the blade)

انا فتحنا لك فتحا مبينا / ليغفر لك الله ما تقدم / من ذنبك و ما تأخر و يتم نعمته / عليك و يهديك صراطا / مستقيما و ينصرك الله نصرا عزيزا / هو الذي انزل السكينة / في قلوب المؤمنين ليزدادوا / ايمانا مع ايمانهم و لله جنود / السموات و الارض و كان الله / عليما حكيما

Verily We have granted thee a manifest Victory: That Allah may forgive thee thy faults of the past and those to follow; fulfil His favour to thee; and guide thee on the Straight Way; And that Allah may help thee with powerful help. It is He Who sent down Tranquility into the hearts of the Believers, that they may add Faith to their Faith;– for to Allah belong the Forces of the heavens and the earth; and Allah is full of Knowledge and Wisdom. (Qur'an 48:1–4)

b. (In the quatrefoil cartouches along the edge of the blade; the first cartouche is damaged and only partially visible beneath the hilt)

[قالت يا ايها الملؤا انى]/ القى الي كتاب / كريم انه من / سليمان و انه / بسم الله / الرحمن / الرحيم / الا تعلوا / علي و اتوني / مسلمين

[(The Queen) said: "Ye chiefs! Here is]—delivered to me—a letter worthy of respect. It is from Solomon, and is (as follows): 'In the Name of Allah, Most Gracious, Most Merciful: Be ye not arrogant against me, but come to me in submission (to the true Religion).'" (Qur'an 27:29–31)

c. (In the three narrow cartouches along the back of the blade)

[بس]م الله الرحمن الرحيم نصر من الله و فتح قريب و بشر المؤمنين / الله لا اله الا هو الحي القيوم لا تأخذه سنة و لا نوم له ما في السموات و ما في الارض من ذا الذي يشفع عنده الا باذنه يعلم ما بين ايديهم و ما خلفهم و لا يحيطون بشيء من علمه الا بما شاء وسع كرسيه السموات و الارض و لا يؤده حفظهما و هو العلي العظيم / و حشر لسليمن جنوده من الجن و الانس و الطير فهم يوزعون صدق الله العظيم

In the Name of Allah, Most Gracious, Most Merciful. Help from Allah and a speedy victory. So give the Glad Tidings to the Believers. (Qur'an 61:13)

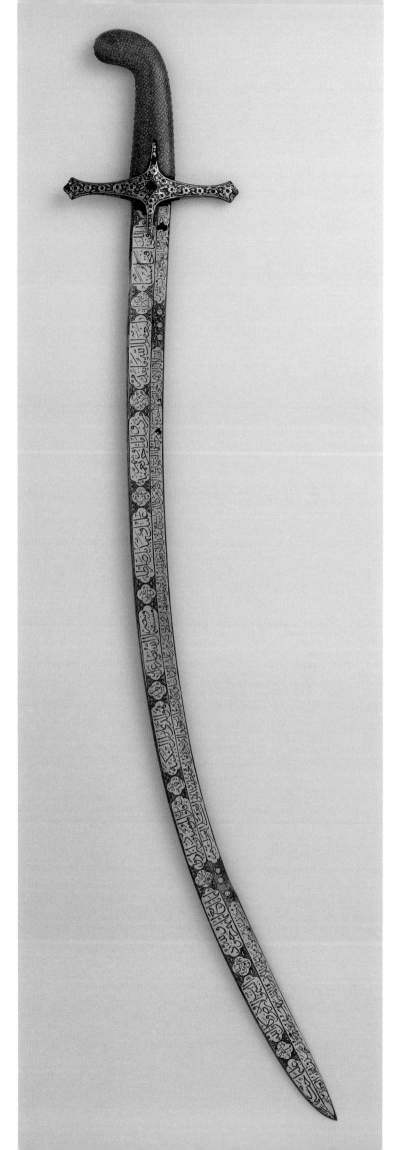

Allah! There is no god but He, —the Living, the Self-subsisting, the Supporter of all. No slumber can seize Him nor sleep. His are all things in the heavens and on earth. Who is there can intercede in His presence except as He permitteth? He knoweth what (appeareth to His creatures as) Before or After or Behind them. Nor shall they compass aught of His knowledge except as He willeth. His Throne doth extend over the heavens and the earth, and He feeleth no fatigue in guarding and preserving them for He is the Most High, the Supreme (in glory). (Qur'an 2:255)

And before Solomon were marshalled his hosts, —of Jinns and men and birds, and they were all kept in order and ranks. (Qur'an 27:17). God, the Supreme, spoke the truth.

On the inner face of the blade

d. (In the rectangular cartouches along the edge of the blade)

ليدخل المؤمنين و المؤمنات / جنات تجري من تحتها الانهار / خالدين فيها و يكفر عنهم / سيئاتهم و كان ذلك عند الله / فوزا عظيما و يعذب المنافقين / و المنافقات و المشركين / و المشركات الظانين بالله / ظن السوء عليهم دائرة السوء / و غضب الله عليهم و لعنهم و اعد لهم / جهنم و ساءت مصيرا

That He may admit the men and women who believe, to Gardens beneath which rivers flow, to dwell therein for aye, and remove their sins from them; —and that is, in the sight of Allah, the grand triumph, and that He may punish the Hypocrites, men and women, and the Polytheists, men and women, who think an evil thought of Allah. On them is a round of Evil: the Wrath of Allah is on them: He has cursed them and got Hell ready for them: and evil is it for a destination. (Qur'an 48:5–6)

e. (In the quatrefoil cartouches along the edge of the blade; the first cartouche is partially obscured by the hilt)

[حتى اذا اتوا] على [واد] النمل / قالت نملة يا ايها النمل / ادخلوا مساكنكم / لا يحطمنكم سليمان و جنوده / و هم لا يشعرون فتبسم ضاحكا / من قولها و قال رب اوزعني / ان اشكر نعمتك التي انعمت / علي و على والدي و ان اعمل / صالحا و ترضه و ادخلني / برحمتك في عبادك الصالحين

At length, when they came to a valley of ants, one of the ants said: "O ye ants, get into your habitations, lest Solomon and his hosts crush you (under foot) without knowing it." So he smiled, amused at her speech; and he said: "O my Lord! so order me that I may be grateful for Thy favours, which Thou has bestowed on me and on my parents, and that I may work the righteousness that will please Thee: And admit me, by Thy Grace, to the ranks of Thy Righteous Servants." (Qur'an 27:18–19)

f. (In the three narrow cartouches along the back of the blade)

[و لله] جنود السموات و الارض و كان الله عزيزا حكيما / انا ارسلناك شاهدا و مبشرا و نذيرا لتؤمنوا بالله و رسوله و تعزروه و توقروه و تسبحوه بكرة و اصيلا ان الذين يبايعونك انما يبايعون الله يد الله فوق ايديهم فمن نكث فانما ينكث على نفسه و من اوفى بما عاهد عليه الله فسيؤتيه اجرا عظيما سيقول لك المخلفون من الاعراب شغلتنا / اموالنا و اهلونا فاستغفر لنا يقولون بالسنتهم ما ليس في قلوبهم قل فمن يملك لكم من الله شيئا ان اراد بكم ضرا او اراد بكم [نفعا بل كان الله بما تعملون خبيرا]

For to Allah belong the Forces of the heavens and the earth; and Allah is exalted in Power, full of Wisdom. We have truly sent thee as a witness, as a Bringer of Glad Tidings, and as a Warner: In order that ye (O men) may believe in Allah and His Messenger, that ye may assist and honour him, and celebrate His praises morning and evening. Verily those who plight their fealty to thee plight their fealty in truth to Allah: The Hand of Allah is over their hands: Then any one who violates his oath, does so to the harm of his own soul, and any one who fulfils what he has covenanted with Allah, —Allah will soon grant him a great Reward. The desert Arabs who lagged behind will say to thee: "We were engaged in (looking after) our flocks and herds, and our families: Do thou then ask forgiveness for us." They say with their tongues what is not in their hearts. Say: "Who then has any power at all (to intervene) on your behalf with Allah, if His Will is to give you some loss or to give you some [profit? But Allah is well acquainted with all that ye do.] (Qur'an 48:7–11)

The inscriptions unite a series of verses from the Qur'an that stress the sovereignty of God, the majesty of his throne, the duties demanded by the jihad, and the wisdom and power of his servant Solomon, all of which are invoked in an especially clever form that metaphorically refers to a contemporary ruler, the Ottoman sultan Süleyman I the Magnificent (r. 1520–66).

Among the Qur'anic inscriptions on the Museum's saber are verses from suras 2, 27, and 48. The quotation from sura 2 is the "Throne" verse, *ayat al-Kursi*, which occurs with great frequency on Islamic arms and armor, especially those from the Ottoman period.[1] Sura 27 deals with the story of Solomon and Sheba and makes special reference to Solomon's majesty and power and his use of these gifts in the service of God. Solomon's power was not just over men but also over jinns, birds, and ants; it has been

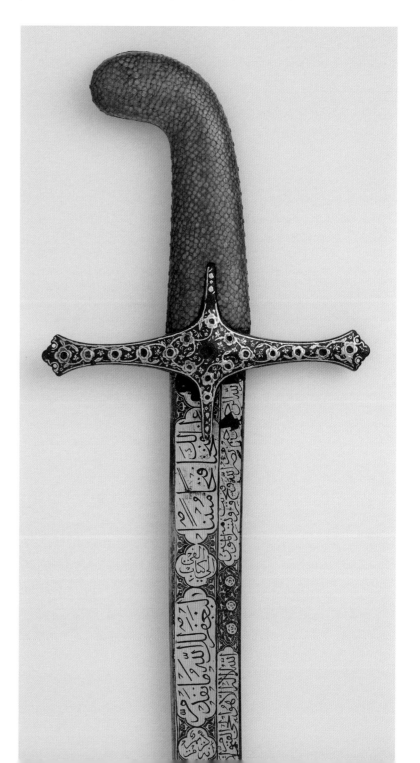

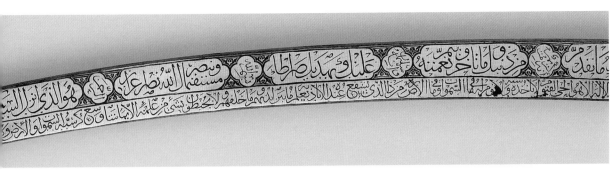

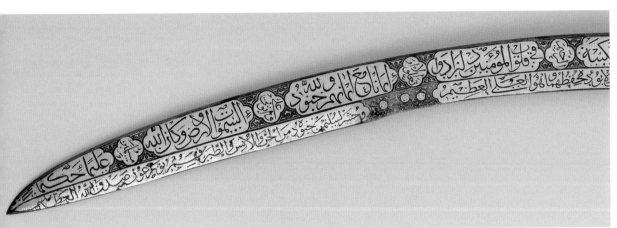

crafted for the Ottoman sultan Süleyman I, whose name and widespread conquests, especially in Iran, made him a worthy claimant to the inheritance of Solomon.

It is instructive to compare this saber and its iconographic program to a painting in the *Süleymanname* that shows Süleyman the Magnificent receiving the ruby cup of the ancient Iranian hero Jamshid, symbolic of authority over Iran, at the outset of his campaign against the Safavids in 1553.[5] The saber's inscriptions, with their multiple references to Solomon, victory, and royal power, are chiseled in relief in a style common in Iran but not used in Turkey. It thus seems reasonable to propose that the blade was crafted by an Iranian master working for Süleyman to commemorate, as does the *Süleymanname* painting, his victories over the Safavids.

The grip, but not the guard, is a later addition, for hilts of this period did not have right-angle bends at their pommels. This is confirmed by X-rays, which show that the tang has been drastically shortened and is pierced with a number of rivet holes, indicating that the blade has been rehilted on several occasions. The guard is of a type and is decorated in a style with a number of parallels in Ottoman sabers of the mid-sixteenth century, most being weapons preserved in the Topkapı Sarayı Museum, Istanbul.[6]

argued that these terms refer to various tribes over which he ruled. However, Solomon was commonly held to have had miraculous powers, and stories about him are frequent in Islamic literature.[2] The calligrapher for our saber probably interpreted the verse (27:17) in this way. Sura 48, *al-Fath*, the "Victory" verse, is significant because it refers to one of the Prophet's greatest victories, achieved through a peace treaty with the Meccans in A.D. 628, as well as to the duties the jihad placed upon the believer and the rewards that flowed from fulfilling them.

In Islamic thought Solomon is regarded as a model for kingship; emphasis is always made of his power, wisdom, and justice. When a ruler used this kind of iconography or used a title such as "heir to the kingdom of Solomon," he was laying claim to a divinely sanctioned reign. At least two Muslim rulers, the Ottoman sultan Süleyman I and the Safavid shah Sulaiman (r. 1666–94),[3] so identified with Solomon that they used the verse "It is from Solomon, and is (as follows): 'In the Name of Allah, Most Gracious, Most Merciful'" (Qur'an 27:30) as a personal slogan. Süleyman I used it in many contexts, including as the introduction to the historical manuscript known as the *Süleymanname*.[4]

Our saber is fitted with one of the most exquisitely decorated Islamic blades in existence and must have been made for a sultan; the inclusion of sura 27:30 was probably intended as a subtle allusion to the ruler who commissioned it. The shape of the blade, slightly curved and with a straight tang, and the nature of its decoration suggest a date in the sixteenth century, which precludes the Safavid shah Sulaiman. It seems very likely that the saber was

PROVENANCE: S. Haim, Istanbul; George Cameron Stone, New York.

REFERENCES: Grancsay 1937b, p. 168, fig. 2a; Grancsay 1958, p. 246, ill.; New York 1979, pp. 94–95, no. 30, ill.; Grancsay 1986, pp. 178–79, 451–52, figs. 63.17, 109.10; Alexander 1987, no. 95; *Islamic World* 1987, pp. 124–25, no. 95; Nickel 1991a, pp. 52–53, ill.; David Alexander and Stuart W. Pyhrr in Ekhtiar et al. 2011, pp. 313–14, no. 222.

NOTES

1. For further discussion of this and other suras often inscribed on Islamic arms and armor, see Appendix A.
2. For an eighth-century account, see al-Tabari 1988–89, vol. 1, p. 66.
3. For the use of this verse on Shah Sulaiman's coinage, see Rabino 1945.
4. See Atıl 1986, p. 87.
5. Ibid., p. 216, pl. 57.
6. Topkapı Sarayı Museum, Istanbul, nos. 1/290, 1/293, 1/294, 1/474; see Alexander 2003, nos. 7, 4, 12, fig. 5, respectively. The quillon tips of the Museum's sword match those of no. 1/294; see Washington, D.C., Chicago, and New York 1987–88, p. 156, no. 89, and Alexander 2003, pp. 231–32, no. 12, ill.

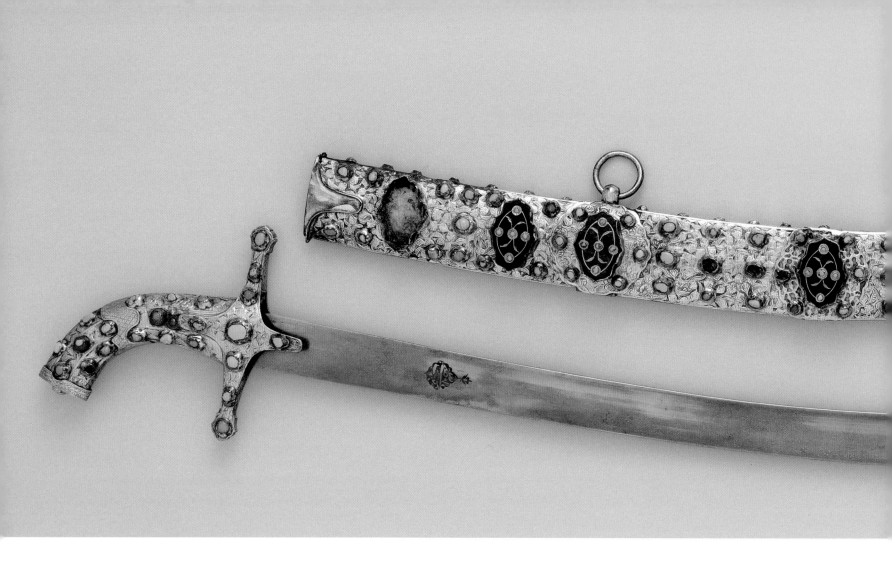

59 · Saber with Scabbard

Hilt and scabbard, Turkey, Ottoman period, late 16th–17th century;
blade, Iran, late 16th–17th century
Steel, silver gilt, wood, nephrite, turquoise, gold, copper
Sword: length 39⅞ in. (101.3 cm); blade 34⅝ in. (87.8 cm);
weight 2 lbs. 3 oz. (990 g)
Scabbard: length 36⅞ in. (93.5 cm); weight 2 lbs. (906 g)
Rogers Fund and Pfeiffer Fund, 1978
1978.145a, b

DESCRIPTION: The hilt is covered entirely with silver gilt over a wooden core. The arched grip is of flattened octagonal section, the facets on the outer face chiseled and engraved with carnations and set with turquoises on high, rosette-shaped collets. The grip's inner face is engraved overall with a diaper pattern, the center engraved with a band of strapwork knots and a cartouche chiseled with carnations. Narrow herringbone bands separate the two faces. The flat, caplike pommel, set with a turquoise in the center, is engraved with a diaper pattern, the low sides with stylized leaves. A silver-gilt band encircles the grip at the center, its outer face shaped around the collets. The cruciform guard, with straight tapering quillons ending in palmette-shaped tips and short rounded langets, is decorated en suite with the grip, the inner face of the guard engraved at the center with a lobed circular cartouche containing carnations. The blade of crucible steel is curved and single edged; on the outer face near the hilt is a cartouche containing an Arabic inscription (a) in cursive script reserved against a gold ground. The scabbard is constructed and decorated en suite with the hilt with the addition of seven (originally nine) black and gray-green nephrite plaques set in high collets and arranged alternately; these are inlaid in gold with simple symmetrical leaf and flower forms and set with numerous turquoises. The five plaques in the center are fitted to lobed circular silver-gilt mounts attached by bands that encircle the scabbard and mask the seams of the scabbard sections. Suspension rings are attached to two of these mounts. A row of mounted turquoises is set along the scabbard's back edge.

This saber has suffered considerable damage in the past and is extensively repaired, the restorations sensitively made. The grip was cracked or broken through and has been repaired by the addition of a band around the center. The pommel cap is also a replacement. The transverse rivets at the center of each face, most likely added to fix the hilt to the blade, are crude and perhaps even later repairs. The scabbard, in addition to the two missing plaques, has a new chape. Of the five applied mounts, only the fourth from the top exactly matches the chased-and-engraved ornament of the scabbard face; the first and third mounts and second and fifth mounts are of different workmanship in two different styles. Although of slightly different design, these mounts appear to be contemporary. The bands attaching the first and third mount, and therefore the two suspension rings, are also replacements; the band on the second mount is missing.

INSCRIPTION:
a. (On the outer face of the blade, near the hilt)

<div dir="rtl">توكلت على الله</div>

I put my trust in God.

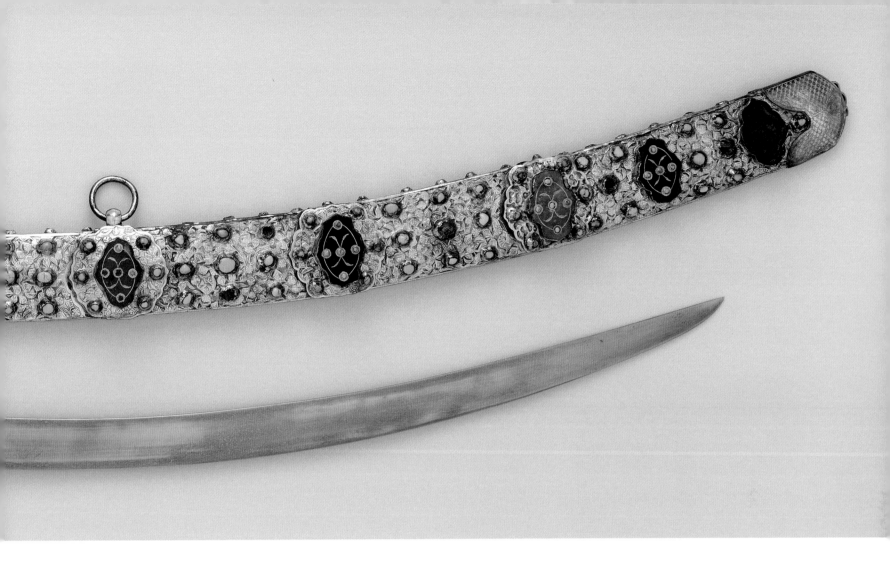

This is a typical Ottoman presentation saber of a type
dating from the late sixteenth through the early
seventeenth century. Many similar examples are
preserved in various European collections, which they entered
either as diplomatic gifts—among them examples now in the
Kremlin Armory, Moscow, received as presents from the Ottoman
sultans between 1623 and 1658—or as booty after the siege of
Vienna in 1683.[1] It was common in Turkey at that time to decorate
objects with this type of nephrite (jade) plaque,[2] and large num-
bers of Ottoman edged weapons are decorated with silver
scabbards embossed with floral forms and set with jade plaques,
although only a few are stamped with silver marks. One of these
rare weapons is an estoc, or thrusting sword, in the Furusiyya Art
Foundation, Vaduz.[3] It has a hilt and scabbard decorated with
fittings much like those on the Museum's saber and is stamped
with a *tuğra* in the name of "Sultan Murad," probably Murad III
(r. 1574–95). The decorative style was certainly not confined to the
period of his rule, as is indicated by the pieces mentioned above,
and our saber should consequently be dated to the late sixteenth
or early seventeenth century.

Swords, sabers, and estocs with scabbards and hilts of this
type are fitted with a remarkable variety of blades from widely

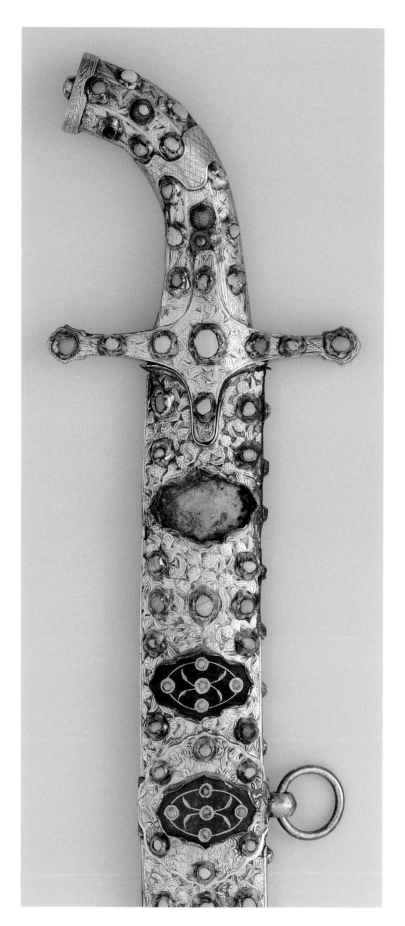

different sources, including Mamluk, Ottoman, and Iranian examples, most of high quality.[4] The blade on the Museum's saber is probably Iranian; it is likely that whoever made the fittings did so with the blade at hand and that both blade and fittings are contemporary.[5]

PROVENANCE: Prince Alexei Ivanoviti Sachovskoys [Alexander Sachovskoy], Saint Petersburg; General Count Theodor Keller, Saint Petersburg; Count Alexander Keller, Saint Petersburg; sold at Bukowskis, Stockholm, March 5, 1920, lot 185; Bukowskis, Stockholm, December 15, 1937, lot 1063; Christie's London, October 13, 1975, lot 14; Sotheby Parke Bernet, London, April 3, 1978, lot 132.

REFERENCES: Bukowskis, Stockholm 1920, lot 185; Bukowskis, Stockholm 1937, lot 1063; Christie, Manson and Woods, London 1975, lot 14; Melikian-Chirvani 1978; Sotheby Parke Bernet, London 1978, lot 132; Pyhrr 1979.

NOTES

1. This group of objects includes not only sabers and straight-bladed swords but also maces, shields, quivers, saddles, and related equestrian fittings. Polish and Russian collections are particularly rich in this equipment. For the former, see Zygulski 1982, nos. 108, 109, 112–14, 117, 121, 125, 129; for the latter, see *Armoury Chamber of the Russian Tsars* 2002, nos. 32, 36, 37, 40, 43.

2. See Alexander 1984, nos. 37–43. For jade plaques, see also Miller 1972, pp. 66–68.

3. Furusiyya Art Foundation, Vaduz, no. R-243; see Paris 2007/Mohamed 2008, p. 67, no. 31. For a similar estoc in a miniature painting of around 1639, which depicts Sultan Murad IV (1612–1640), see Stchoukine 1966–71, vol. 2, pl. XII (Topkapı Sarayı Museum, Istanbul, no. H. 2134, fol. 1); see also Alexander 2003, fig. 2.

4. See, for example, a saber in the Magyar Nemzeti Múzeum, Budapest, no. 55 3335, which has a Mamluk blade of the early sixteenth century (see Szendrei 1896, pp. 515–16, no. 3045, and Sárvár 1971, p. 51); a sword in the treasury of Mons Clara, Czech Republic, has an Ottoman blade probably made in the Balkans (see Zygulski 1972, fig. 30); and a saber in the Kremlin Armory, Moscow, no. 5713, has an Iranian blade (see *Opis' Moskovskoi Oruzheinaya palata* 1884–93, p. 98, no. 5713, pl. 383).

5. Melikian-Chirvani 1978 corrected the reading of the inscription on this saber, which had been misread and published incorrectly in the then-recent sale catalogue (Sotheby Parke Bernet, London 1978, lot 132), and further suggested that the calligraphy had "a 19th-century look."

60 · Saber

Turkey, Ottoman period; grip and guard, second half
of the 17th century; blade, late 18th–19th century
Steel, gold, nephrite
Length 37⅝ in. (95.5 cm); blade 32½ in. (82.5 cm);
weight 1 lb. 15 oz. (889 g)
Bequest of George C. Stone, 1935
36.25.1298

DESCRIPTION: The grip, formed of a single piece of pale green nephrite, is carved to
simulate one constructed of two plaques attached to the tang of the blade by three
transverse rivets with rosette-shaped washers on each side, with flat shims filling
the joins between the plaques, and with a rounded pommel cap with lobed upper
edge at the sharply downturned end. The main surfaces on each side are carved with
a wavelike pattern of rippling flutes, the pommel carved with four rosettes matching
the grip washers, one on each lobe, with plant forms between. At the base of the
pommel is a rosette with a rounded knob. The cruciform guard is of gold, cast in two
halves (front and back), joined along an almost invisible center seam. Each face is
delicately chased in low relief with different foliate designs against a recessed stip-
pled ground, the quillon tips, in stepped relief, of palmette shape with symmetrical
foliate designs. The blade of dark gray crucible steel is curved and single edged, with
a wide double-edged section toward the point and a flat T-shaped back edge. It is
paneled and chiseled below the hilt on the outer face with a bright split-leaf ara-
besque against a stippled gold ground interrupted with three cartouches inlaid in
gold with Arabic inscriptions in cursive script (a). Forward of this is another inscrip-
tion, consisting of an Arabic quatrain (b) interspersed with five engraved, copper-
inlaid rosettes set with faceted diamonds, that runs along the shallow groove down
the length of the blade below the back edge. There are three inscribed cartouches (c)
connected by linear knotwork designs inlaid on the back edge near the hilt. The
inner face is inlaid in gold with a lobed-arch form below the hilt enclosing the mak-
er's signature (d) and with a hexagram containing an inscription (e). The back edge
near the tip is chiseled on each side with a split-leaf panel against a stippled gold
ground and, toward the tip, two narrow parallel grooves.

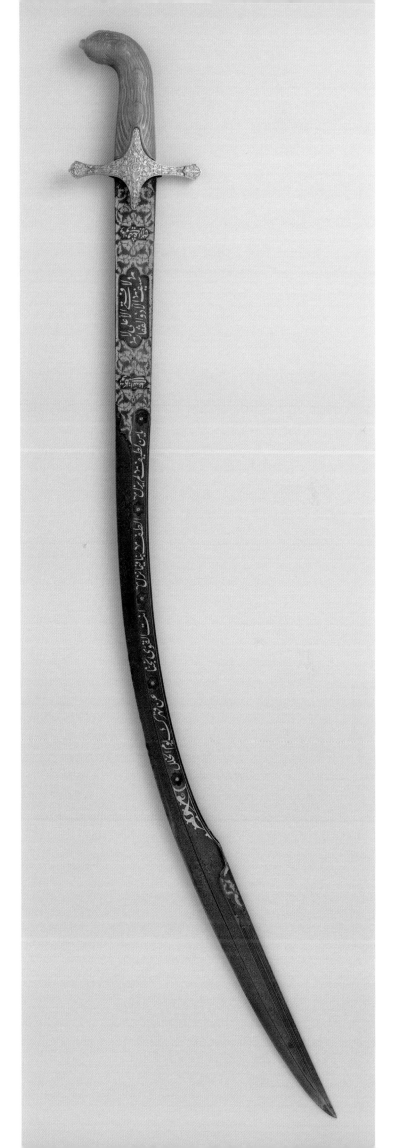

INSCRIPTIONS:

On the outer face

a. (In three cartouches below the hilt)

<div dir="rtl">و ما توفيقي الا بالله</div>

My success is through God alone.

<div dir="rtl">لا فتى الا علي لا سيف الا ذو الفقار</div>

There is no hero but 'Ali and no sword but Dhu'l faqar.

<div dir="rtl">توكلت على الله</div>

I put my trust in God.

b. (Along the back edge of the blade)

<div dir="rtl">يا من لطيف لم يزل الطف بنا فيما نزل</div>
<div dir="rtl">انت القوي نجنا عن قهرك يوم الخلل</div>

O you who are gentle and who are infinite,
Be gentle to us in all that comes to us,
You are the Powerful, so save us
From your wrath on the day of disturbance (Day of Judgment).

c. (In three cartouches on the back edge near the hilt)

<div dir="rtl">يا مفتح الابواب / افتح لنا خير الباب / الله و نعم الوكيل</div>

O Opener of doors! Open for us the best door. God is sufficient for me and the best Disposer of affairs.

On the inner face

d. (In a lobed arch below the hilt)

<div dir="rtl">عمل عجم اوغلي [كذا] (اوغلو)</div>

Made by Acem Oğli [sic].

e. (In a hexagram below the lobed arch)

<div dir="rtl">ما شاء الله</div>

As God wills.

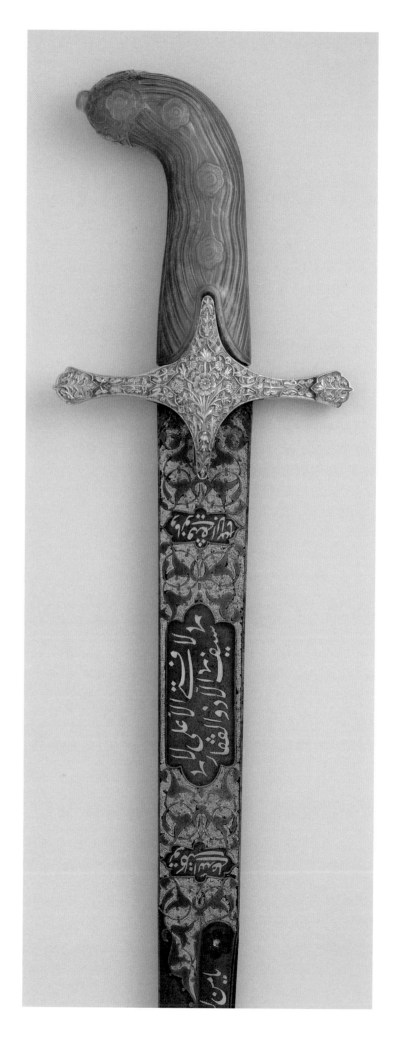

The grip is a rare and particularly fine example of Ottoman jade carving. Such work probably developed under the influence of Timurid and Turkman artisans captured during the course of the various battles fought by the Ottomans during the fifteenth and early sixteenth centuries. These craftsmen were organized under the *Cemaat-i Hakkakin*, or guild of gemstone carvers, and produced many fine objects for the imperial court; they are best known for the inlaid plaques of nephrite that were used on a number of different objects, notably sword fittings.[1] Ottoman saber and sword hilts of nephrite were often modeled on Iranian and Mughal prototypes, but Ottoman carving is usually stronger and less naturalistic.[2]

Four saber grips of ivory carved with similar ripple patterns are known; one was formerly in the collection of Helge Brons Hansen, Denmark, and three others are in the Topkapı Sarayı Museum, Istanbul.[3] The cross guards of all four are of the same general form and all are decorated in a style similar to that on the Museum's saber. Characteristic of this are the rounded quillon

tips terminating, in most cases, with a slight point at the center. All are decorated with a central plant form spreading out to reveal a series of flower heads, with each head separated by a sprig of leaves. The Museum's cross guard of gold is the most painstakingly and most delicately worked and must represent a luxury example of the type. The same is true for the grip, which in addition to the ripples is carved with a series of flowers that echo the decorative theme of the guard. The shape of the guard and the scabbard fittings on a number of sabers of this type date the Museum's grip and guard to the second half of the seventeenth century.[4]

The associated blade is later in date than the hilt and is signed by Acem Oğlu, a swordsmith who appears to have been active from the reign of Sultan Abdülhamid I (r. 1774–89) to that of Mahmud II (r. 1808–39).[5] Other blades inscribed with his name include three in the Museum's collection, cat. 63 and acc. nos. 36.25.1610 and 36.25.1294, the last being almost identical in decoration to the present example and bearing the same inscription, its silver-gilt mounts struck with the *tuğra* of Mahmud II.[6]

Blades of T-shaped section were first documented among the scores of examples captured at Vienna following the Ottoman defeat in 1683. The decoration of the Museum's blade, however, with its large panel of chiseled foliage against a recessed, stippled, and gilt ground, can be associated with a group of swordsmiths, besides Acem Oğlu, that includes Isma'il al-Farghani, Ahmad Khurasani, Osman ibn Haji Muhammad, and Qara Sabar al-Erserumi, all of whom appear to have been active in the late eighteenth or early nineteenth century.[7] (Indeed, blades of this shape and decoration are numerous and typical of Ottoman swords of that period.) The earliest dated saber in this group seems to be one marked with the *tuğra* of Abdülhamid I;[8] other dated examples include several with dates in the early nineteenth century.[9]

PROVENANCE: S. Haim, Istanbul; George Cameron Stone, New York.

REFERENCE: Alexander 1984, no. 47.

NOTES

1. See also cat. 59 and Istanbul 1983, nos. E.204, E.265–E.267.

2. R. Skelton 1978.

3. For the former, see Copenhagen 1982, pp. 72–73, no. 25; Topkapı Sarayı Museum, Istanbul, nos. 1/2526, 1/2553, 1/491 (unpublished).

4. For example, Topkapı Sarayı Museum, Istanbul, no. 1/2553, has a scabbard decorated en suite with "butterfly-shaped" mounts and a cutaway upper chape; in addition, the silver-gilt and niello decoration on the scabbard fittings is in a style typical of sabers captured at Vienna in 1683. It should also be noted that the "butterfly-shaped" mounts on the Topkapı scabbard are of the same type as those on cat. 62—all of which support a dating of these edged weapons to the late seventeenth century.

5. See also Mayer 1962, p. 21, pl. II, and Yücel 1964–65, p. 69, which lists eleven blades by Acem Oğlu.

6. There are many other blades decorated in this style, with the same inscription along the length, preserved in numerous collections. Among these are Topkapı Sarayı Museum, Istanbul, nos. 1/5041, 1/1099, the latter also signed by Acem Oğlu. See also Paris 2007/Mohamed 2008, p. 75, no. 39, for another blade in this style signed by Acem Oğlu. Mayer 1962, p. 21, pl. II, no. 4, reproduces the signature on one of the museum's blades (acc. no. 36.25.1294).

7. The Metropolitan's collection includes a saber with a blade signed by Isma'il al-Farghani and dated A.H. 1217 (A.D. 1802/3), acc. no. 36.25.1616 (see Stone 1934, p. 357, fig. 449, no. 8); a blade signed Qara Sabar al-Erserumi, acc. no. 36.25.1299 (see ibid., p. 357, fig. 449, no. 4); and two signed by Ahmad Khurasani, acc. nos. 32.75.303, 36.25.1561 (the bladesmith's signature on the former illustrated in Mayer 1962, pl. II).

8. Topkapı Sarayı Museum, Istanbul, no. 1/2898; see Yücel 1964–65, p. 69.

9. For three other examples, dated 1804, 1809, and 1811, see, respectively, Lepke's Kunst-Auctions-Haus, Berlin 1925, lot 61; *Catalogue de la collection d'armes anciennes* 1933, no. 601; and Armeria Reale, Turin, no. G297 (Ghiron 1868, p. 71, no. 477).

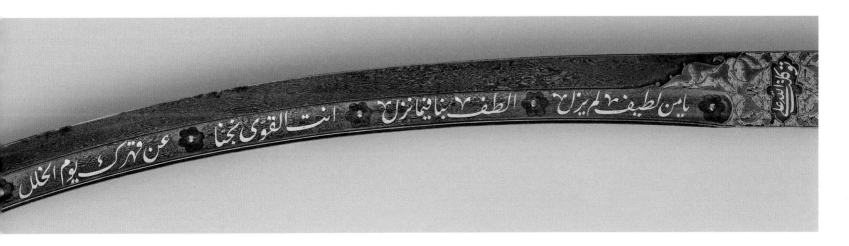

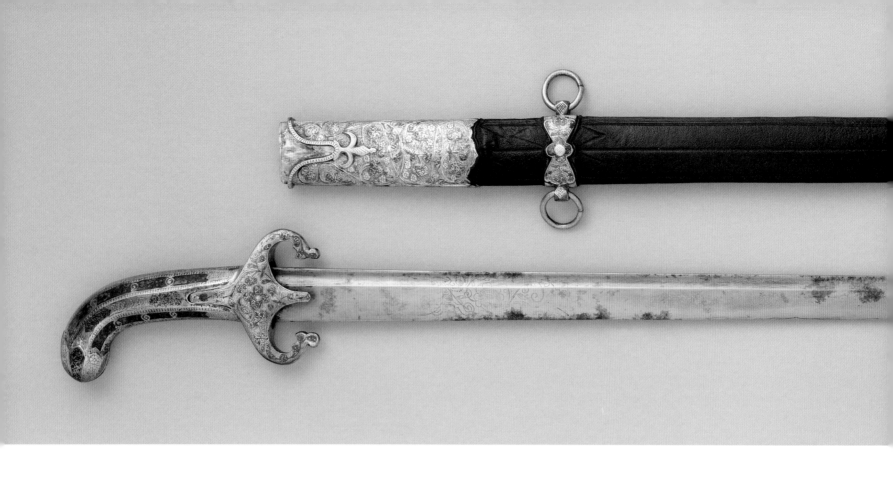

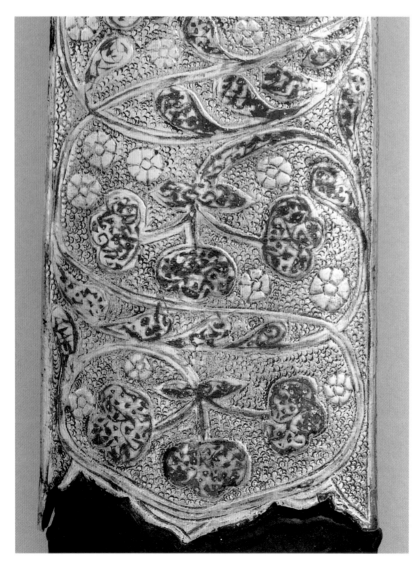

61 · Saber with Scabbard

Grip and guard, Turkey, Ottoman period, late 17th century; blade, Europe, 17th century

Steel, silver gilt, wood, leather, lapis lazuli, niello

Saber: length 39¾ in. (101 cm); blade 34¾ in. (88.3 cm); weight 1 lb. 13 oz. (827 g)

Scabbard: length 35⅜ in. (90 cm); weight 1 lb. (453 g)

Bequest of George C. Stone, 1935

36.25.1333a, b

DESCRIPTION: The hilt is of silver gilt. The rounded, caplike pommel is octagonal in section and is alternately engraved with flowers and inlaid with niello scrolls. The grip, also octagonal in section, is pierced with a series of openwork panels filled with lapis, the metal frame decorated in niello with a floral design against a punched ground. The cruciform guard is engraved and inlaid with niello en suite and has downward-curved quillons with half-palmette-shaped tips. The blade of European manufacture is straight, single edged, and has a wide, shallow groove along the back edge; it is etched below the hilt with an open floral design, now partly effaced. The wooden scabbard is covered with black leather embossed around the mounts, incised with geometric ornament, and mounted with a locket, ring mount, and chape of nielloed silver gilt en suite with the hilt. The locket has an applied raised rim ending with an inverted fleur-de-lis around the recessed mouth shaped to accommodate the lower langet of the guard. The narrow, butterfly-shaped mount is fitted with a ring at each side for a baldric.

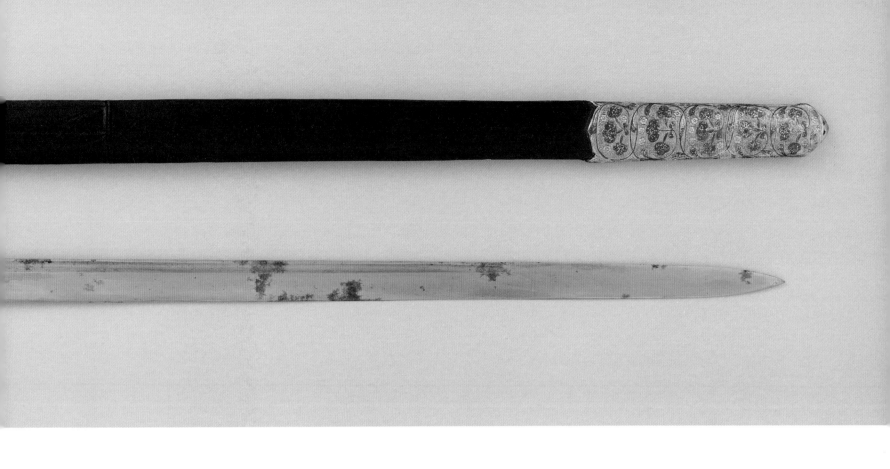

The shape of the mounts and their nielloed silver-gilt decoration are typical for Ottoman armor and weapons of the seventeenth century.[1] Many pieces of this type are stamped with the *tuğra* of Sultan Mehmed IV (r. 1648–87) and were among the booty taken from the Ottomans after the siege of Vienna in 1683. The scabbard mounts also indicate a dating to the seventeenth century, and their decoration and "butterfly" shape should be compared to those on cat. 62.[2] Significant too are the crescent-shaped arms on the guard and the distinctive half-palmette-shaped quillon tips, both of which are features that occur on a number of seventeenth-century swords and sabers.[3] Floral designs such as those ornamenting this example originated in Ottoman calligraphy of the mid-seventeenth century.[4] The straight single-edged blade is of a type used in Europe as a cavalry weapon. The etched decoration below the hilt is very worn but confirms a European origin, perhaps a center in Germany or the Austro-Hungarian Empire.

PROVENANCE: W. O. Oldman, London; George Cameron Stone, New York.

Unpublished.

NOTES

1. Other pieces decorated in this style and stamped with the *tuğra* of Mehmed IV include horse caparisons, armor, and a large number of daggers and sabers; see, for example, the dagger in the Militär Historisches Museum,

Dresden, no. Y 134, and the mail shirt and horse armor in the Badisches Landesmuseum Karlsruhe, nos. D.10, D. 117. For these three pieces, see Riyadh 1996, vol. 2, pp. 84–85, no. 73.

2. See also cat. 60.

3. Guards with downward-turned quillons terminating in half palmettes first appeared during the sixteenth century; see, for example, Washington, D.C., Chicago, and New York 1987–88, pp. 159, 314, no. 93, registered in the Ambras inventory of 1595; Alexander 2003, figs. 10, 11; and Aydın 2007, p. 200. The guard on the Museum's sword is more strongly arched than those on the sixteenth-century examples above and the half palmettes more schematic, clearly indicating that the Metropolitan's example is a later development of the sixteenth-century prototype. For other, later pieces similar to the Museum's weapon, see Kunsthistorisches Museum, Vienna, nos. C36, C181 (unpublished), and a number of sabers with enameled fittings now in the Topkapı Sarayı Museum, Istanbul, among them no. 1/2681 (unpublished). Another guard of this type—with crescent-shaped arms but with quillon tips terminating in dragon heads (Topkapı Sarayı Museum, no. 1/4934)—is in Zygulski 1978, p. 27, no. 38, ill.

4. For calligraphy and decoration by Hafiz Osman (1642–1698), see Derman 1976, pl. 10.

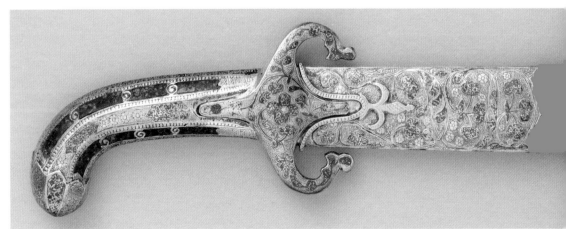

62 · Saber and Dart in a Scabbard

Mounts and scabbard, Turkey, Ottoman period, ca. 1700;
blade, Europe, 17th century
Steel, silver gilt, wood, leather, niello
Length overall (in scabbard) 33⅛ in. (84 cm); weight 2 lbs. 10 oz. (1,182 g)
Sword: length 32½ in. (82.4 cm); blade 28¼ in. (71.9 cm);
weight 1 lb. 3 oz. (548 g)
Dart: length 31½ in. (79.9 cm); weight 6 oz. (182 g)
Scabbard: length 29 in. (73.7 cm); weight 1 lb. (451 g)
Bequest of George C. Stone, 1935
36.25.1631a–c

DESCRIPTION: The sword and dart are contained in adjacent compartments within the same scabbard. The sword hilt, comprising a grip and cruciform guard, is of silver gilt, partially nielloed, and is decorated differently on each face. The outer face is chased and engraved with an overall diaper pattern composed of interconnected undulating leaves forming ogival compartments enclosing poppies and stylized tulips against a recessed, punched, and gilt ground. The inner face is decorated with large cartouches containing flowers against a recessed, stippled, and gilt ground, the interstices engraved with scrolling flowers, their heads and leaves similarly recessed and gilt. The grip of flattened oval section has lost its pommel, which has been replaced with a piece of dark horn fitted into the grip core, its sides finely crosshatched and its end rounded. The cruciform guard has two langets (the inner one defective) and a forward quillon shaped as a dragon head, with red glass set in its mouth; in place of the usual rear quillon is a hollow channel to accommodate the dart. The European blade is single edged and slightly curved, with a short, chamfered back edge; a wide, shallow groove extends down the center of each face and bears traces, now mostly polished away, of a stamped inscription and cogwheels. The dart has a wooden haft, round in section and expanding toward the top, which is covered with a nielloed, silver-gilt cap decorated to match the outer face of the sword hilt; the steel point is of hollow four-sided section with a baluster-shaped socket. The wooden scabbard is covered with black leather with raised edges shaped around the four silver-gilt and partially nielloed mounts. These comprise a locket, two narrow shaped bands with suspension rings, and a chape; the faces of the locket and chape are decorated to match the sword hilt. The mouth of the locket has separate compartments to accommodate the sword and dart, the recessed area accommodating the sword's langet having an applied raised rim and foliate finial.

T he silver-gilt and niello decoration on this set of throwing dart and saber, as well as the dragon-head quillon, date the ensemble to Ottoman Turkey during the late seventeenth century.[1] Dragon terminals were popular with Ottoman metalworkers through much of the sixteenth to eighteenth century, but there is considerable variation in the form of the dragons. The stylized, roundish heads of the Museum's saber are of a late seventeenth-century type; a comparable example can be seen on a jug sent as a gift to the empress of Russia in 1692.[2] A similar dating for the set is supported by the very similar silver-gilt decoration on a saber in the Wallace

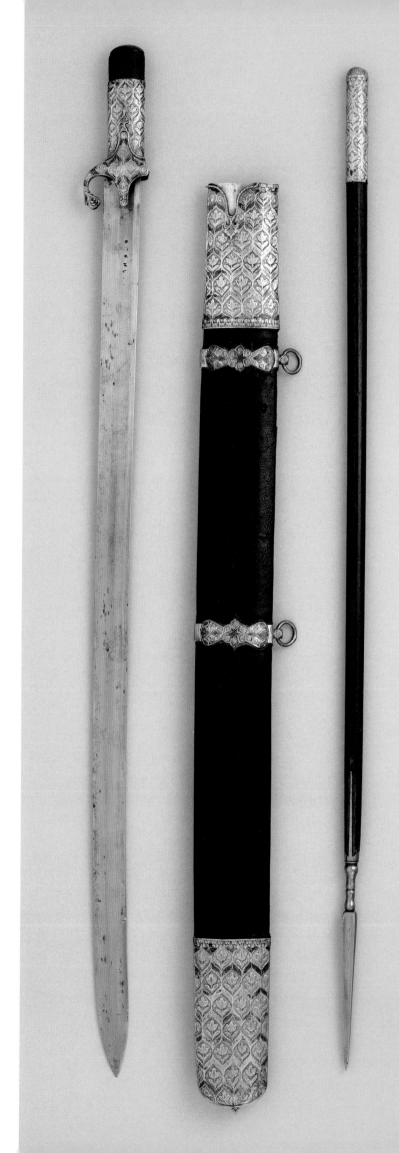

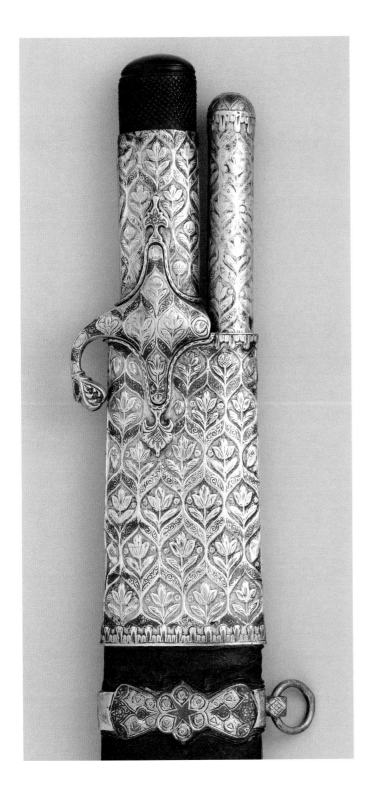

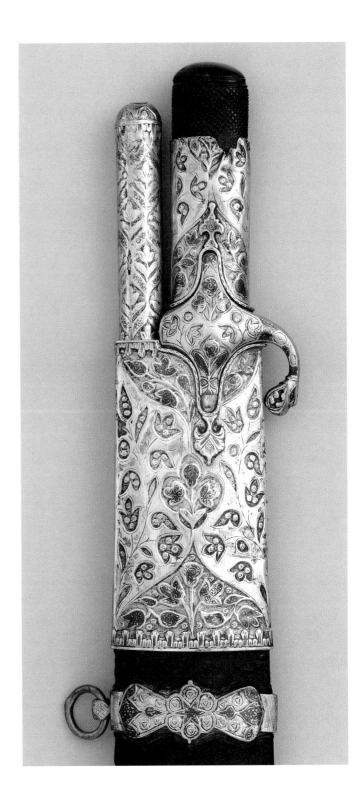

Collection, London, that bears an inscription stating that it was made in Constantinople in the year 1700.[3] The comparison with the Wallace Collection saber is important, as the inscription on the latter demonstrates that this kind of work was produced in the capital, then usually called Constantinya. Yet it should not be thought that this type of nielloed floral decoration was confined to this precise period, as examples exist dating from the time of Mehmed IV (r. 1648–87) to that of Mustafa III (r. 1757–74).[4] Both the dragon quillon and decoration on the Museum's set, however, are closer to work produced during the final years of the seventeenth century, and for that reason are dated here to approximately 1700.[5]

PROVENANCE: W. O. Oldman, London; George Cameron Stone, New York.

Unpublished.

NOTES

1. A similar example but with a half-palmette-shaped quillon tip is in the Kunsthistorisches Museum, Vienna, no. C181 (see Grosz and Thomas 1936, p. 105, no. 4).

2. Glück and Diez 1925, pl. 35.

3. Wallace Collection, London, no. OA 1750; see Laking 1964, p. 83. A large number of weapons decorated in this fashion were captured from the Turks at the siege of Vienna in 1683; see, for example, Petrasch et al. 1991, nos. 136, 142, 143, 145–52, 160, 161.

4. See, respectively, Furusiyya Art Foundation, Vaduz, nos. R-389, R-299 (Paris 2007/ Mohamed 2008, pp. 168–69, nos. 156, 157); see also cat. 61.

5. See also cat. 60, especially n. 3.

63 · Saber

Hilt, Turkey or North Africa, Ottoman period, 19th century;
blade, Iran, 18th–19th century
Steel, gold, rhinoceros horn
Length 36⅝ in. (93.1 cm); blade 30¾ in. (78.2 cm);
weight 1 lb. 11 oz. (776 g)
Bequest of George C. Stone, 1935
36.25.1632

DESCRIPTION: The pistol-shaped grip is formed of two plaques of rhinoceros horn fitted to each side of the tang and framed by a steel shim damascened in gold with foliate scrolls. The horn plaques are carved with raised panels having serrated edges and the pommel is pierced for a wrist strap, the hole framed by rosette-shaped grommets of gold-damascened steel. The cruciform guard of dark crucible steel has tapering quillons with applied acorn-shaped tips; the surface is damascened in gold with a floral design along the edge and on the tips. The curved and single-edged blade of dark gray crucible steel is forged in the "Muhammad's ladder" pattern. The outer face is inlaid in gold near the hilt with a series of four cartouches enclosing Arabic inscriptions (a–d; the first cartouche obscured by the guard) alternating with punched foliate motifs and with a gold-inlaid inscription further along its length punctuated by rosettes. The inner face is undecorated.

INSCRIPTIONS:
On the outer face of the blade
a. (First cartouche, obscured by the guard)

عمل عجم اوغلو

Made by Acem Oğlu.

b. (Second cartouche from the hilt)

و ما توفيقي الا بالله

My success is through God alone.

c, d. (Third and fourth cartouches from the hilt, continued along the blade)

مزجت دمعا جرى من مقلت بدم　　ا من تذكر جيران بذي سلم
و او مض البرق في الظلماء من اضم　　ام هبت الريح من تلقاء كاظمة

Is it from the recollection of friends at Dhu-Salam,
That thou hast mixed the tears flowing from thy eyes with blood?
Or is it because the wind has blown from the direction of Kazimah?
Or is it because lightning has flashed in the darkness of night from the mount of Idam?

The pommel carved with leaf forms is unusual; of the hundreds of hilts of horn with bulbous pommels, only a few are similarly embellished. This rare example was perhaps inspired by the floral forms carved on Mughal hardstone saber hilts of the eighteenth and nineteenth centuries.[1]

The watering on this blade is of the finest quality; it is signed by Acem Oğlu, a swordsmith active in the late eighteenth and early nineteenth centuries (see cat. 60).[2] The narrow, single-edged blade is typically Iranian in form and should probably be dated to the eighteenth century, making it earlier than the hilt. The inscription, however, is identical in its layout to those on several Ottoman examples in the Museum's collection (see, for example, cat. 60), indicating that the blade must have been imported and then decorated in an Ottoman atelier. The guard is Ottoman, perhaps even from North Africa; its decoration should be compared with that on the stirrups of a Tunisian saddle in the Museum's collection.[3]

The blade is also of interest because of its inscription, which gives the opening lines of the immensely popular poem *Qasida al-burda* (The Cloak), a mystical ode to the Prophet Muhammad and his cloak by Sharafuddin Muhammad al-Busiri (1212–ca. 1295). Robes and cloaks have always had an important symbolic and ceremonial function in the Near East.[4] From the early Islamic period onward the giving of a robe was a standard element in an investiture,[5] and the presentation of a robe of honor by a ruler was one of the primary forms by which a reward was bestowed. In the Islamic world the tradition is traced to the *sunna* (practice) of the Prophet, for the biographer Ibn Ishaq reports that the Prophet gave his cloak (*burda*) as a gift to the poet Ka'b ibn Zuhayr. Ka'b's satirical verses about Muhammad had earned him a death sentence; learning of this, Ka'b approached Muhammad, recited an adulatory poem, and was instantly forgiven. The cloak of striped Yemeni cloth that Muhammad laid on Ka'b's shoulders was both a gift and a public exoneration of the poet; the redeemed Ka'b was now under the Prophet's protection.[6]

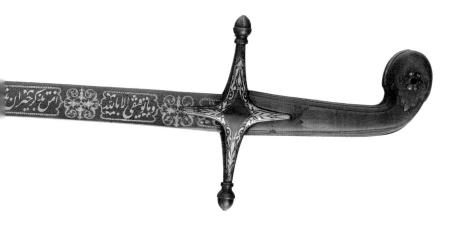

After the Prophet's death the *burda* became one of the objects known collectively as the "the Legacy of the Prophet" (*mirath rasul Allah*).[7] These objects, individually and collectively, were all associated with power and with political and spiritual legitimacy; the caliphs used them as insignia of their temporal and spiritual dominion. Although the Prophet's cloak and the other relics were probably destroyed during the conquest of Baghdad by the Mongols in 1258, in Ottoman times a claim was made that the *burda* was preserved in the sultan's palace in Istanbul.

Because of its symbolic importance, the significance and ownership of the cloak was disputed; according to the Shi'a, Muhammad used it to cover 'Ali and his family, thereby signifying their right to inherit the Prophet's political power. This incident is said to have occurred in A.H. 10 (A.D. 631/32), when a delegation from the Christian community of Najran arrived in Medina seeking a treaty. Naturally, Muhammad invited them to accept Islam. After consulting a book on the prophetic role, in which they found a reference to five primordial lights that God had told Adam were five of his descendants, the Christians challenged Muhammad to prove that he was indeed a prophet through an ordeal of mutual cursing, *mubahala*. The Prophet arrived with family members 'Ali, Fatima, Hasan, and Husayn, and all stood together under his cloak. When the Christian leader asked why Muhammad had come only with a youth, a woman, and two children rather than with the leaders of his sect, Muhammad replied that he was following God's command. The Christians immediately recalled the story of the five lights, canceled the contest, and agreed to pay tribute. Consequently, the five—Muhammad, 'Ali, Fatima, Hasan,

and Husayn—became known as the "people of the cloak," *ahl al-kisa*. The story of the *ahl al-kisa* represents the conceptual background for talismanic shirts bearing Shi'a inscriptions.[8] A rival tradition maintains that Muhammad covered his companion al-'Abbas and his family with his *burda*.[9]

The *burda* was widely regarded as having miraculous healing and prophylactic powers, and al-Busiri's poem was translated into every Near Eastern language. The poem itself eventually came to be regarded as a talisman, and verses from it were inscribed on numerous objects, especially Ottoman saber blades—perhaps because the Ottoman sultans claimed to possess Muhammad's cloak.

PROVENANCE: Istanbul bazaars; George Cameron Stone, New York.

REFERENCES: Grancsay 1958, p. 251, ill. (second from right); Wadsworth and Sherby 1979, fig. 3 (left); Washington, D.C., and other cities 1982–83, no. 245; Alexander 1985c, pp. 30, 33, fig. 4; Sherby and Wadsworth 1985, p. 113. Grancsay 1986, p. 454, fig. 109.14 (third from top).

NOTES

1. Other examples include Magyar Nemzeti Múzeum, Budapest, no. 56 4202; Topkapı Sarayı Museum, nos. 10891, 2912; and Metropolitan Museum, acc. no. 36.25.1295 (see Stone 1934, p. 356, fig. 448, no. 2).

2. Will Kwiatkowski (personal communication, May 2015) noted that here the name Acem Oğlu is spelled with a final *waw* rather than the final *ya* that appears on cat. 60. It is uncertain whether this is merely an alternate signature or whether it indicates two different swordsmiths.

3. Metropolitan Museum, acc. no. 36.25.579l, m.

4. Joseph's cloak of many colors, discussed in Genesis 37:3, is one such instance. In the Arab world before Islam a cloak was the characteristic garment of a seer, *kahin*, a kind of shaman, who covered himself with his cloaks and then contacted spirits who spoke through him; see Rodinson 1980, p. 57. Muhammad is referred to in the Qur'an as the "Mantled [or Cloaked] One." There are many references to cloaks in the *sira* (life of the Prophet) of Ibn Ishaq; when Muhammad was a youth, for example, he was called to adjudicate a quarrel over the black stone of the Ka'ba. He resolved the problem by allowing neither disputing party to handle the stone, but rather had it placed in a cloak that was carried to the location and the stone was deposited; Ibn Ishaq 1982, p. 86.

5. Stillman 1986.

6. Ibn Ishaq 1982, pp. 597–602.

7. For a discussion of the *mirath rasul Allah*, see Alexander 1999.

8. For talismanic shirts formed of mail, see cats. 3, 4.

9. Al-Majlisi 1982, pp. 322–24, and Momen 1985, pp. 13–14. Ibn Ishaq 1982, pp. 270ff., omits the story of the cloak; for the pro-'Abbasid version of the cloak story, see Kister 1983; for the five pre-existent lights, see Momen 1985, p. 14.

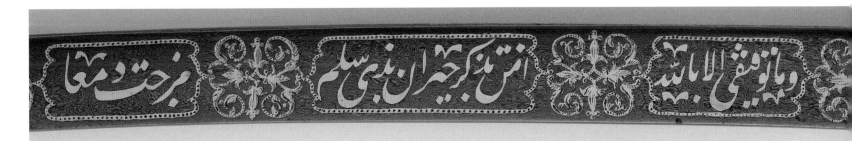

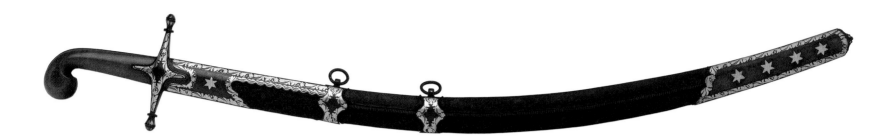

64 · Saber with Scabbard

Turkey, Ottoman period; hilt and scabbard, 19th century; blade, dated
A.H. 957 (A.D. 1550/51) but probably late 18th–early 19th century
Steel, gold, rhinoceros horn, wood, leather
Saber: length 36⅛ in. (91.7 cm); blade 30½ in. (77.5 cm);
weight 1 lb. 8 oz. (687 g)
Scabbard: length 31¾ in. (80.7 cm); weight 14 oz. (396 g)
Bequest of George C. Stone, 1935
36.25.1292a, b

DESCRIPTION: The pistol-shaped grip is formed of two plaques of rhinoceros horn
riveted to the tang and framed by a shim of blackened steel damascened in gold
with a leaf-and-petal scroll. The cruciform guard of blackened steel is decorated
en suite; it has tapering quillons of square section with applied vase-shaped finials.
The blade of brightly polished (crucible?) steel is curved and single edged, with a
wider double-edged section toward the point, and has a wide, shallow groove on
each face. On the outer face, proceeding from the hilt, are a palmette-shaped arch,
two cartouches, and a roundel between them, all chiseled in low relief and dama-
scened in gold with Arabic inscriptions (a–d). The outer face is also damascened in
the groove with an Arabic inscription in Kufic script (e). Inscriptions, including a
maker's name and a date, are inlaid flush in the areas above and below the roundel
(f) and along the back edge (g). The wood scabbard is covered with black leather
joined down the center on the outer side with woven copper wire. The four mounts
of blackened crucible steel are decorated en suite with the hilt with the addition of
six-pointed stars on the locket and chape. The locket is asymmetrical; its rear edge
opens to accommodate the passage of the curved blade and extends down to the
first of two ring-suspension mounts.

 The blade, perhaps of crucible steel, is now worn and polished bright. X-rays
show that the blade has been rehilted at least twice.

INSCRIPTIONS:
On the outer face of the blade, below the hilt
a. (In the raised arch)

لا اله الا الله (؟)

There is no God but God (?).

b. (In the first cartouche)
(Undeciphered)

c. (In the roundel)

[توكلت (؟)] على الله

[I put my trust (?)] in God.

d. (In the second cartouche)
(Undeciphered)

e. (In the groove along the blade)

لا اله الا هو الحي القيوم لا تأخذه سنة و لا نوم له ما في السموت و ما في الارض من ذا الذي يشفع
عنده الا باذنه يعلم

(In the Name of Allah, Most Gracious, Most Merciful.) There is no god but He, —the
Living, the Self-subsisting, Supporter of all / No slumber can seize Him nor sleep.
His are all things in the heavens and on earth. Who is thee can intercede in His
presence except as He permitteth? He knoweth. . . . (Qur'an 2:255)

f. (Inlaid above and below the roundel)

عمل الحاجى صنقر / تاريخ سلطان محمد سنة ٩٥٧

Made by al-Haji Sunqur, date, Sultan Mehmed, year 957 (A.D. 1550/51).

g. (Along the back edge of the blade)

بدوح / بدوح

Buduh, buduh (see commentary below).

While the hilt and mountings of this saber are
typical of the nineteenth century, the blade is of
interest for two reasons: its pious inscriptions
and the maker's signature. The religious inscriptions include
several of the names of God, collectively referred to in the Qur'an
as the Most Beautiful Names: "There is no god but He! To Him
belong the Most Beautiful Names" (Qur'an 20:8); "He is Allah, the
Creator, the Originator, the Fashioner / To Him belong the Most
Beautiful Names" (Qur'an 59:24). The word *buduh* in the inscrip-
tion along the back of the blade (g) refers to a magic square; such
squares were often placed on blades for talismanic purposes.[1]

 The name of the maker inscribed on the blade is Haji Sunqur,
one of the most renowned swordsmiths of the late fifteenth to
early sixteenth century.[2] He seems to have begun his career in
Egypt but then moved to Istanbul, where he had a workshop
between 1503 and 1511. The archives of the Topkapı Sarayı record
that he presented over a number of different occasions a total of
ten swords and four daggers to Sultan Bayezid II (r. 1481–1512).
One of these is probably the signed Dhu'l faqar dated A.H. 896
(A.D. 1490/91) and dedicated to Bayezid, perhaps indicating that
Haji Sunqur was in Istanbul before 1503.[3]

 Hundreds of saber blades are inscribed with this blade-
smith's name. Many of them are dated, but as the examples range
in date from 1490 to 1574, it is impossible that all are genuine. The

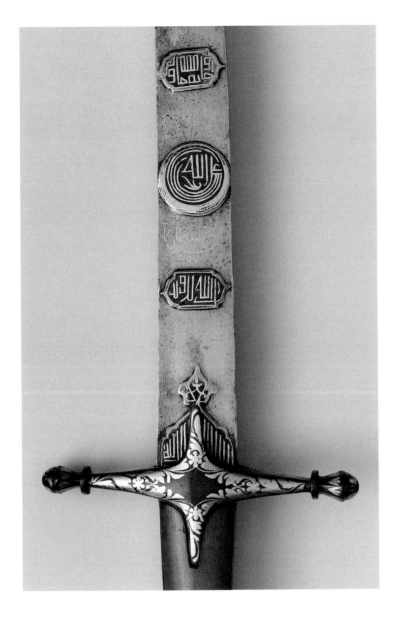

Generally, either the roundel or the lengthwise inscription bears the name of Süleyman ibn Selim. This entire group of forgeries, including the Museum's example, can be attributed to no earlier than the eighteenth century and possibly as late as the nineteenth. Another signed blade in the Topkapı (no. 1/479) is inscribed to Murad III (r. 1574–95).[5] Certainly, it is most unlikely that the Haji Sunqur who made a sword for Bayezid in 1490 could have still been active after 1574.

The Museum's blade represents the most common type that bears the signature "Haji Sunqur." In addition to the features already noted in this large, later group of signed swords, the inscriptions along the Museum's blade include two in a crude squared "Kufic" script frequently used on sword and saber blades during the eighteenth and nineteenth centuries.[6] Many of these blades, like the Museum's, are inscribed "In the time of Sultan Muhammad" and dated A.H. 957 (A.D. 1550/51), even though the ruling sultan in 1550 was Süleyman, not Muhammad. These late blades also usually have a shallow groove ending toward the hilt in a thumbprint-like indentation, a feature that first appeared on Ottoman sabers in the late seventeenth and early eighteenth centuries. There are scores of these surviving late Ottoman blades, and among them are even some made for non-Muslims, decorated with Christian iconography (two datable examples of the latter are a saber blade made for Constantin Brâncovreanu, prince of Wallachia from 1688 to 1714, and another recorded in the 1716 inventory of the Dresden Rüstkammer).[7] The Museum's blade is of this exact later type and should be dated no earlier than the very last years of the seventeenth century but is most likely of the late eighteenth to early nineteenth century.

PROVENANCE: Sami Bey, Istanbul; George Cameron Stone, New York.

REFERENCES: Stone 1934, p. 356, fig. 448, no. 1; Nickel 1974, p. 190, ill.; Katonah 1980, no. 29; Paris 2007/Mohamed 2008, p. 69, n. 1.

NOTES

1. For further discussion of magic squares as talismans, see Appendix A.

2. For Haji Sunqur, see Yücel 2001, pp. 161–62, with earlier literature cited.

3. Topkapı Sarayı Museum, Istanbul, no. 1/384; see ibid., pp. 137–38, pl. 96.

4. Among these variations in signatures are examples in the Topkapı Sarayı Museum, Istanbul, nos. 1/196, 1/185; Musée de l'Armée, Paris, no. J1006; and Livrustkammaren, Stockholm, no. 4364 (whose blade is further inscribed "in the time of Sultan Muhammad"; see Mayer 1962, p. 74, pl. XVIII).

5. See Yücel 1964–65, p. 92.

6. For other examples, see cat. 65, n. 2.

7. For the Brâncovreanu blade, see Mazzini 1982, pp. 404–5, no. 368. For the Dresden example, see Dresden 1995, no. 328 (Historisches Museum [Rüstkammer], Dresden, no. 431 [Y 26]). Another blade decorated in this style but without the typical groove is in the Kremlin Armory, Moscow, no. 5913. It was first recorded in the inventory of 1720 and was said to have belonged to Ivan Alekseyevich (r. 1682–89), elder brother of Peter the Great; see Opis' Moskovskoi Oruzheinaya palata 1884–93, vol. 2, pp. 172–73, and Madrid 1990, pp. 172–73, no. 96.

authentic blades must be those that can be securely dated to the late fifteenth and early sixteenth century, at approximately the time when he had a workshop in Istanbul. The other blades inscribed with his name may have been produced in his workshop long after he ceased to be active or perhaps are commemorative pieces or simply forgeries of later periods. The suspicion that not all the blades attributed to him are genuine is reinforced when the signatures are examined. Not only are they by different hands, but his name is spelled in six different ways.[4]

Although there are no blades signed by Haji Sunqur that can be securely attributed to the period of Selim I (r. 1512–20), Bayezid's successor, a large number bear dates during the reign of Selim's son, Süleyman I (r. 1520–66), and are often inscribed with that sultan's name. In both their decoration and type, the inscriptions on the latter differ completely from those that can be attributed to Bayezid's reign. Almost invariably these later "Süleyman" blades are worked with a sequence of raised inscribed panels, one of lobed palmette form, a roundel with a rectangular cartouche above and below, and an inscription along the blade.

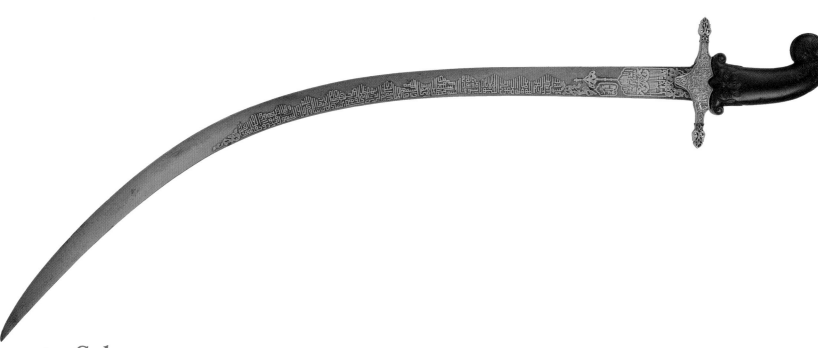

65 · Saber

Guard and decoration on blade, Turkey, Ottoman period, 19th century;
grip, India, Mughal period, 18th century; blade, possibly Iran,
18th–19th century
Steel, gold, nephrite
Length 36⅝ in. (93 cm); blade 30⅝ in. (77.7 cm); weight 2 lbs., 1 oz. (935.5 g)
Bequest of George C. Stone, 1935
36.25.1293

DESCRIPTION: The pistol-shaped grip is of dark green nephrite carved in relief at
the top and bottom with large leaves. The guard of cast and chased gold has short
straight quillons, square in section, with separately applied tips, pierced and chis-
eled, formed of symmetrical palmettes. The center of the guard is decorated in relief
with Arabic inscriptions (a, b) with interlocking leaf designs to each side and on the
upper and lower edges. The blade of pale gray crucible steel of Iranian type is curved
and single edged. It is inlaid below the hilt on the outer face with an arch-shaped
cartouche containing leaf forms and an Arabic inscription in square Kufic script (c);
forward of this is an inscribed cartouche (d), and running along the blade's length
is another Arabic inscription in Kufic script (e) arranged in a distinctive sawtooth
pattern. On the inner face are an inscribed hexagram (f) and three inscribed car-
touches (g, h, i). Most of the gold framing elements and foliate forms, but not the
calligraphy, are dot punched.

INSCRIPTIONS:
a. (On the outer face of the guard)

سلطان ابن السلطان |ا|السلطان سليمان خان

Sultan, son of the sultan, Sultan Süleyman Khan.

b. (On the inner face of the guard)

بسم الله الرحمن الرحيم

In the Name of Allah, Most Gracious, Most Merciful.

On the outer face of the blade
c. (Below the hilt in an arch-shaped cartouche)

بسم الله الرحمن الرحيم
لا اله الا الله محمد رسول الله

In the Name of Allah, Most Gracious, Most Merciful. There is no god but God, and
Muhammad is the messenger of God.

d. (In a lobed cartouche)

سليم ان ...

Selim / Süleyman (?) . . .

e. (Along the blade)

الله لا اله الا هو الحي القيوم لاتأخذه سنة و لا نوم له ما في السموات و ما في الارض من ذا الذي
يشفع عنده الا باذنه يعلم ما بين ايديهم و ما خلفهم و لا يحيطون بشيء من علمه الا بما شاء وسع
كرسيه السموات و الارض و لا يؤده حفظهما و هو العلي العظيم

Allah! There is no god but He, —the living, the Self-subsisting, Supporter of all /
No slumber can seize Him nor sleep. His are all things in the heavens and on earth.
Who is thee can intercede in His presence except as He permitteth? He knoweth
what (appeareth to His creatures as) Before or After or Behind them. Nor shall they
compass aught of His knowledge except as He willeth. His Throne doth extend over
the heavens and the earth, and He feeleth no fatigue in guarding and preserving
them for He is the Most High, the Supreme (in glory). (Qur'an 2:255)

On the inner face of the blade
f. (In a hexagram)
(Undeciphered)

g. (In a rectangular cartouche)
(Undeciphered)

h. (In an arch-shaped cartouche)
(Undeciphered)

i. (In an arch-shaped cartouche)

توكلت على الله

I put my trust in God.

The guard block is inscribed (a) with the titulature of Süleyman I (r. 1520–66), but it is highly unlikely that this is a genuine sixteenth-century piece. Made to fit an Indian grip of the eighteenth century, it is worked in a style characteristic of Ottoman craftsmanship of the late nineteenth century. A similar guard, probably from the same workshop, is found on another sword in the Museum's collection,[1] which is inscribed with the name of the Ottoman sultan Bayezid II (r. 1481–1512). That weapon is also a composite piece; both were perhaps assembled with parts from various sources in an Ottoman bazaar workshop during the late nineteenth century.

The crude squared Kufic-style inscription arranged in a sawtoothlike pattern along the blade is of a type found on a large number of Ottoman blades datable to the eighteenth to nineteenth century.[2] The Arabic inscription is the "Throne" sura, Qur'an 2:255; curiously, almost all of the blades inscribed in this debased style of writing are inscribed with the same verse. They are also almost always inlaid in gold with fleshy foliate forms, the details lightly engraved and dot punched. In addition, some of the blades inscribed in this style are signed with the names of such smiths as Haji Sunqur, Qara Sabar, and Ahmad.[3] A similar script, although not as tightly worked, is used on a blade signed by Haji Murad Khuskadam.[4]

The blades on which this style of inscription are found do not form a heterogeneous group and range in date from the eighteenth to the late nineteenth century. They were all probably decorated in the Istanbul bazaar during the late nineteenth and early years of the twentieth century.

PROVENANCE: S. Haim, Istanbul; George Cameron Stone, New York.

REFERENCES: Stone 1934, p. 356, fig. 448, no. 4; Grancsay 1937a, p. 55, fig. 1; Grancsay 1986, pp. 167–68, fig. 63.6 (second from left).

NOTES

1. Metropolitan Museum, acc. no. 36.25.1296; see Stone 1934, p. 356, fig. 448, no. 3; Grancsay 1937a, p. 55, fig. 1; Grancsay 1986, pp. 167–68, fig. 63.6 (second from left), in which the inscription on the guard is mistakenly read as referring to Sultan Babur (r. 1526–30) rather than Bayezid. Both swords were purchased by George Cameron Stone from the same dealer, Haim, in Istanbul. The blade of acc. no. 36.25.1296 is of Turkish type.

2. These include three examples in the Metropolitan Museum (cat. 64; acc. nos. 36.25.1295 [Stone 1934, p. 356, fig. 448, no. 2], 36.25.1296 [see note 1 above]) as well as three in the Furusiyya Art Foundation, Vaduz (nos. R-235, R-236, R-237; see Paris 2007/Mohamed 2008, pp. 69, 73, nos. 33 [R-235], 37 [R-236]).

3. A blade with the signatures of Qara Sabar and Ahmad and the spurious date A.H. 872 (A.D. 1467/68) is in the Metropolitan Museum (acc. no. 36.25.1295; see note 2 above).

4. Topkapı Sarayı Museum, Istanbul, no. 1/492.

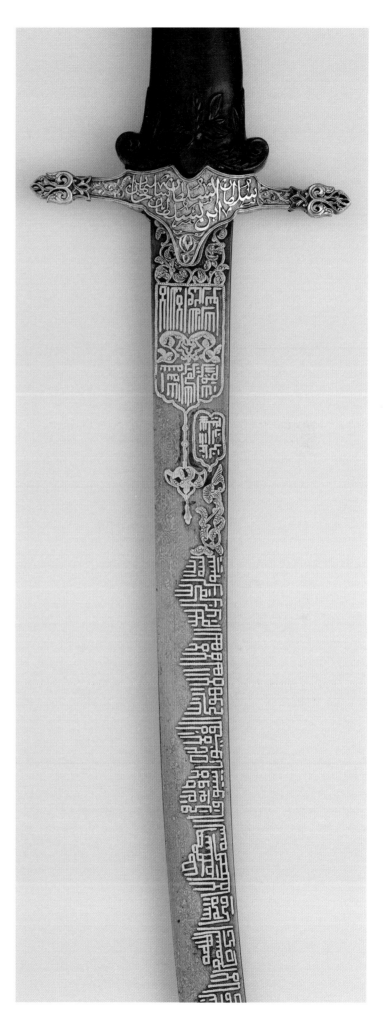

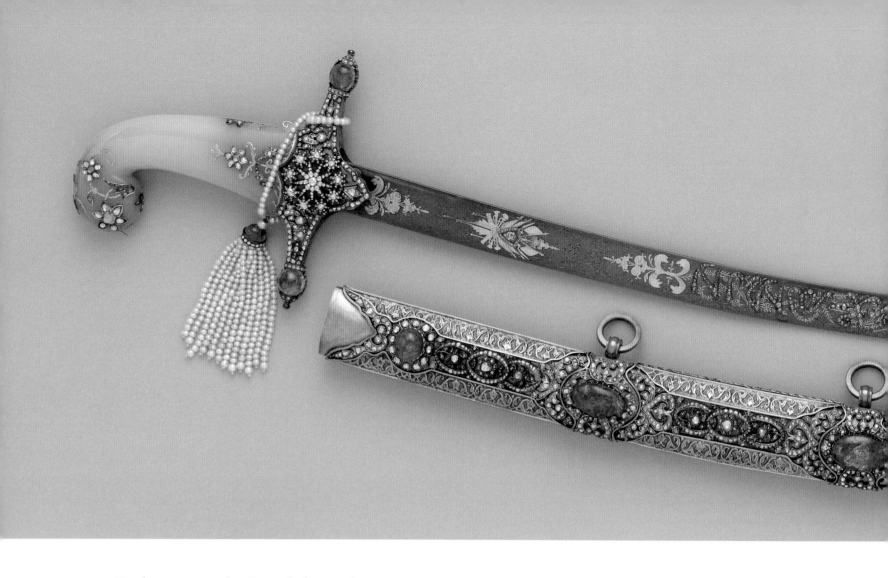

66 · Saber with Scabbard

Grip, India, Mughal period, 18th or 19th century; guard and scabbard,
Turkey, Ottoman period, 19th century; blade, Iran, dated A.H. 1099
(A.D. 1688); decoration on blade, Turkey, 19th century
Steel, gold, nephrite, diamonds, emeralds, pearls
Saber: length 39¼ in. (99.8 cm); blade 33 in. (83.7 cm);
weight 2 lbs. 8 oz. (1,129 g)
Scabbard: length 34⅝ in. (88 cm); weight 2 lbs. 4 oz. (1,023 g)
Gift of Giulia P. Morosini, in memory of her father, Giovanni P.
Morosini, 1923
23.232.2a, b

DESCRIPTION: The pistol-shaped grip is of pale green nephrite inlaid in floral pat-
terns with gold, diamonds, and emeralds. The guard is of gold alloy,[1] the outer face
overlaid with an applied silver-filigree mount set with faceted diamonds in a star
pattern at the center flanked by foliate scrolls; the quillon tips are also of silver
filigree set with diamonds, each enclosing a cabochon emerald. The inner face of
the guard is cast and chased with a trophy of arms flanked by crescents and stars;
the sides of the quillons are engraved with foliage; and the quillon tips are formed of
silver filigree set with diamonds. A string of small natural pearls encircles the grip
and ends in a tassel of pearls formed of thirteen strands; the silver top of the tassel is
set with diamonds and a cabochon emerald. The curved and single-edged blade of
crucible steel is forged with a ladder pattern. It is engraved and inlaid in gold on the
outer face, beginning near the hilt, with symmetrical floral designs, a trophy of arms
around a recessed shield-shaped cartouche set with diamonds and enclosing an
invocation to one of the names of God (a), and the *shahada* in cursive script along the

length of the blade at the center (b), the letters set with diamonds against a delicate
floral scroll, with symmetrical foliate ornament in gold at each end. The blade's inner
face is similarly decorated and has a stamped date in a gold cartouche near the hilt
(c), a trophy of arms enclosing an invocation to 'Ali (d) within a shield-shaped car-
touche framed with diamonds, and a longer Arabic inscription in praise of 'Ali and
Dhu'l faqar (e) in gold along the length separated by three diamond-studded rosettes.
The wood scabbard is overlaid with a gold alloy cast and chased along the edges of the
outer face with arabesques; down the center are applied silver-filigree mounts of
interlocking ovals set at intervals with faceted diamonds and with four large cabo-
chon or facet-cut emeralds in pronged settings of pink gold. The emerald at the top of

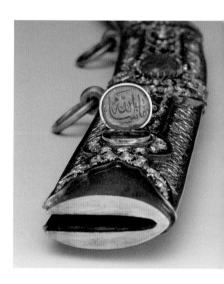

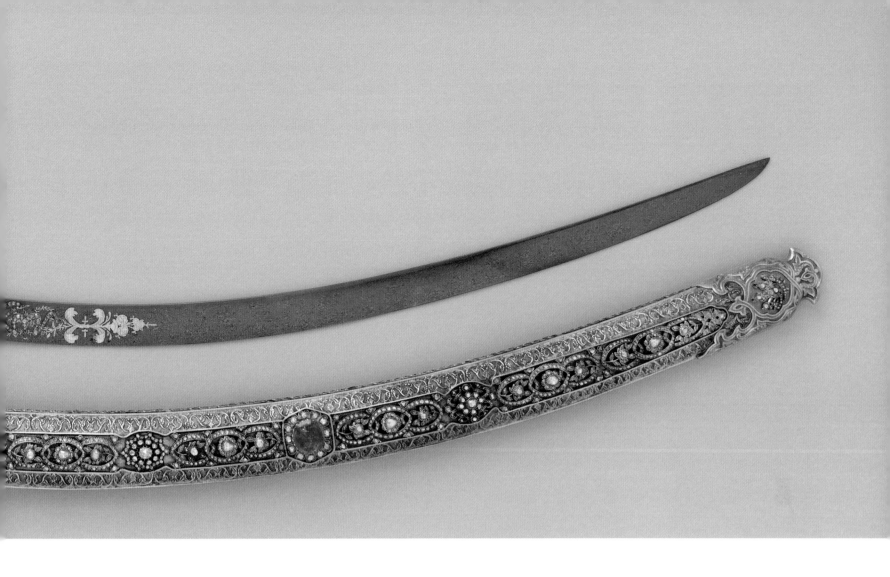

the scabbard is on a hinged setting that when lifted reveals the reverse side of a gold coin (Sultani) of the Ottoman sultan Süleyman the Magnificent (f); the underside of the emerald also bears a carved inscription (g).[2] The back of the scabbard is cast and chased in diagonal registers containing a prayer on the ninety-nine Beautiful Names of God (al-asma al-husna) (h) and, at the very bottom, the maker's name (i). The two ring mounts are cast on the back edge with trophies of arms that echo the design on the back of the guard; the chape with its ornamental finial is set on the front with trophies of arms outlined in diamonds and emeralds. The back edge of the scabbard is outlined with leaves in applied silver-filigree mounts set with diamonds.

INSCRIPTIONS:

On the outer face of the blade

a. (Within the trophy of arms)

يا فتاح

O Opener!

b. (Along the length of the blade, at center)

لا اله الا الله محمد رسول الله

There is no god but God, and Muhammad is the messenger of God.

On the inner face of the blade

c. (In a gold cartouche near the hilt)

سنة ١٠٩٩

Year 1099 (A.D. 1688/89).

d. (In the trophy of arms)

يا علي

O 'Ali!

e. (Along the blade, at center)

لافتى الا علي لا سيف الا ذو الفقار

There is no hero but 'Ali and no sword but Dhu'l faqar.

On the scabbard

f. (Under an emerald at the top of the scabbard, on the reverse side of a gold coin)

سلطان سليمان بن سليم خان عز نصره ضرب في مصر سنة ...

Sultan Süleyman Khan, the son of Selim Shah, may his victory be glorious, minted in Misr (Egypt), year . . . (date hidden by the mount).

g. (Underside of the emerald at the top of the scabbard)

ما شاء الله

According to God's will.

h. (On the back of the scabbard)

بسم الله الرحمن الرحيم الحمد لله رب العالمين الرحمن الرحيم مالك يوم الدين اياك نعبد و اياك نستعين
اهدنا الصراط المستقيم سراط الذين انعمت عليهم غير [المغضوب عليهم و لا الضالين] حق هو الله الذي
لا اله الا هو الرحيم الملك القدوس السلام المؤمن المهيمن العزيز الجبار المتكبر الخالق البارئ المصور
الغفار القهار الوهاب الرزاق الفتاح العليم القابض الباسط الخافض الرافع المعز المذل السميع البصير
الحكم العدل اللطيف العظيم الغفور الشكور العلي الكبير الحفيظ المقيت الحسيب الجليل الكريم الرقيب
المجيب الواسع الحكيم الودود المجيد الباعث الشهيد الحق الوكيل القوي المتين الولي الحميد المحصي
المبدئ المعيد المحيي المميت الحي القيوم الواجد الماجد الواحد الصمد المقتدر المقدم المؤخر الاول
الاخر الظاهر الباطن الوالي المتعالي البر التواب المنتقم العفو الروؤف مالك الملك ذو الجلال و الاكرام
المقسط اجامع الغني المغني المانع الضار النافع النور الهادي البديع الباقي الوارث الرشيد الصبور الذي
تقدست عن الاشباه ذاته و تنزهت عن مشابهة الامثال صفاته واحد لا من قلة و موجود لا من علة بالبر
معروف و بالاحسان موصوف معروف بلا غاية و موصوف بلا نهاية اول بلا ابتداء اخر بلا انتهاء لا
ينسب اليه البنون و لا يفنيه تداول الاوقات و لا توهنه السنون كل المخلوقات قهر عظمته و امره بالكاف
و النون

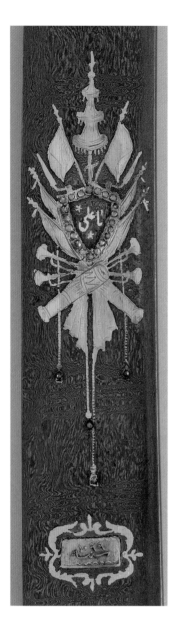
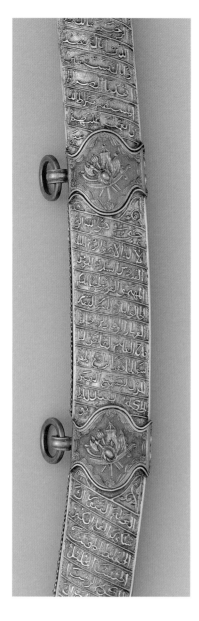

Ever-Enduring, the Inheritor, the Righteous Teacher, the Patient, whose nature is sanctified against and whose qualities are unblemished by likeness to anything comparable, who is one without lacking anything and existing without pretext, known for righteousness and characterized by charity, known without limit and described without end, the first without a beginning and the last without an end, He has no offspring and the passing of time does not annihilate Him, and the years do not weaken Him, all creatures are the object of the force of His might, His order is between *kaf* and *nun*.

i. (At the bottom of the scabbard)

عمل موسا [كذا] (موسى)

Made by Musa.[3]

Like many late Ottoman examples, this saber is a composite weapon. It has an eighteenth- or nineteenth-century Mughal grip (probably made for a dagger), a seventeenth-century Persian blade decorated during the nineteenth century in Istanbul, and a nineteenth-century Turkish guard and scabbard that date from the time when the sword was assembled in its present form. The saber is traditionally believed to have been made in 1876 for the investiture of Sultan Murad V, but no documentary evidence has been produced to confirm this. Murad V (r. May 30–August 31, 1876) was a liberal reformer. He suffered a nervous breakdown before the sword-girding ceremony that would have confirmed his installation as sultan and was deposed by his brother, Abdülhamid II (r. 1876–1909). Murad was kept prisoner until his death in 1904. The sword was acquired by the Italian-born American financier and collector Giovanni P. Morosini (1832–1908), although the time, place, and source of acquisition are not recorded. According to Bashford Dean (1867–1928), Morosini purchased it in Istanbul from the jeweler who had crafted it for Murad's investiture.[4]

The materials, decoration, inscriptions, and pattern on the blade are a potpourri of influences and symbolism. The nephrite grip is decorated with diamonds and emeralds and has a tassel of pearls. Many edged weapons from the Ottoman and Safavid periods have hilts and fittings, and even blades, set with precious stones: rubies, turquoises, diamonds, emeralds, and pearls. Their use is perhaps not always purely decorative, as gemstones and pearls were often regarded as having a religious, talismanic, magical, or medicinal significance. Islamic scientists provided detailed accounts of the properties of various stones. For example, the botanist and pharmacist Abu Muhammad Ibn al-Baytar (d. 1248) stated that pearls strengthen the heart, emeralds prevent epilepsy, and diamonds, although poisonous, give courage.[5]

The scholar Abu Rayhan al-Biruni (973–1050) called diamonds the "stone of the eagle," based on the legend that they were found by Alexander's troops in a valley where they had been dropped by eagles. This valley was filled with snakes, and in order to get the

In the Name of Allah, the Compassionate, the Merciful. Praise be to Allah the Cherisher and Sustainer of the Worlds: Most Gracious, Most Merciful; Master of the Day of Judgment. Thee do we worship, and Thine aid we seek. Show us the straight way, the way of those on whom Thou has bestowed Thy Grace, [those whose (portion) is not wrath and who go not astray] (Qur'an 1:1–7). Truth. Allah is He, than Whom there is no other god;— the Sovereign, the Holy One, the Source of Peace (and Perfection), the Guardian of Faith, the Preserver of Safety, the Exalted in Might, the Irresistible, the Supreme (Qur'an 59:23), the Creator, the Maker, the Shaper, the Forgiving, the Subduer, the Bestower, the Sustainer, the Opener, the All-Knowing, the Restrainer, the Extender, the Abaser, the Exalter, the Bestower of Honors, the Humiliator, the All-Hearing, the All-Seeing, the Judge, the Just, the Gentle, the Magnificent, the Forgiver of Faults, the Appreciative, the Sublime, the Great, the Preserver, the Nourisher, the Accounter, the Majestic, the Generous, the Watchful, the Responsive, the Boundless, the Wise, the Loving, the Majestic, the Resurrector, the Witness, the Truth, the Trustee, the Strong, the Forceful, the Governor, the Praiseworthy, the Appraiser, the Initiator, the Restorer, the Giver of Life, the Taker of Life, the Ever-Living, the Self-Subsisting, the Finder, the Glorious, the Indivisible, the Eternal, the All-Determiner, the Expediter, the Delayer, the First, the Last, the Manifest, the Hidden, the Patron, the Self-Exalted, the Most Kind, the Ever-Relenting, the Avenger, the Forgiver, the Clement, the Owner of All Sovereignty, the Lord of Majesty and Generosity, the Equitable, the Gatherer, the Rich, the Enricher, the Preventer, the Harmer, the Benefactor, the Light, the Guide, the Originator, the

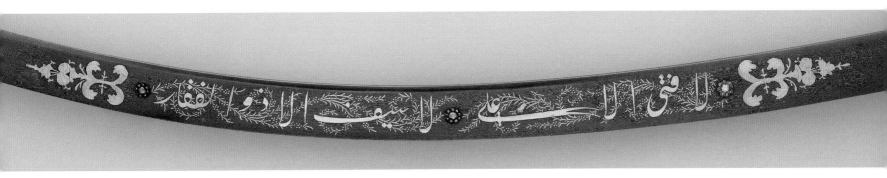

stones the treasure hunters had to walk ankle deep through the vipers.[6] Diamonds, therefore, may be described as stones befitting the courageous and as most appropriate for the decoration of a weapon.

Emeralds were widely held to have both protective and mystical qualities. According to the alchemist Jabir ibn Hayyan (721–776), they had a detrimental effect on the eyes of a snake.[7] More important, the emerald, being green, was generally associated with life itself; with the Prophet, whose favorite color was green; and with the green light reputedly perceived in the hearts of the spiritually elevated.[8] The emerald was also regarded as a revealer of mysteries. Jabir wrote that the emerald tablet of Hermes Trismegistos contained secret alchemical knowledge,[9] and the Shi'a theologian Muhammad Baqir al-Majlisi (d. 1698) related that God gave Moses emerald tablets containing secret knowledge that were subsequently passed on to the Prophet and then to 'Ali; the Shi'a imam Ja'far al-Sadiq (702–765) maintained that knowledge of "all science first and last" was written on them.[10]

Pearls were commonly used to embellish swords and daggers. In the Qur'an (sura 56:23) pearls are used as metaphors to indicate something treasured: "Like unto Pearls well-guarded." In sura 55:22 they are also referred to as a gift from God and a sign of his presence on the terrestrial level: "Out of them come Pearls and Coral."[11] This sura (55) is called *al-Rahman* ("Allah Most Gracious"), and it focuses on the gifts or favors that God showered upon mankind. Because not everyone sees these for what they are, they are in a sense hidden treasures—and perhaps such an idea led to the craftsman hiding a gold coin behind one of the emeralds on the scabbard. Although the obverse side of the coin is not visible here, the usual inscription would have been "(Süleyman) striker of the glittering (gold) and lord of the might and victory by land and sea," which is in harmony with the other symbolism of the saber.[12] In addition to their presence on this saber, pearls—or poetic verses mentioning them—appear on several weapons in the Metropolitan Museum's collection. Among these examples are a dagger inscribed with a verse comparing its curved blade to the crescent moon shimmering like a string of opalescent pearls and a gun that is almost completely covered in seed pearls, like myriad moon-shaped frozen raindrops.[13]

PROVENANCE: Giovanni P. Morosini, Riverdale, New York; his daughter, Giulia P. Morosini, Riverdale, New York.

REFERENCES: Dean 1923a; "Notes: An Inscribed Turkish Sabre" 1926, no. 25; Bullock 1947, p. 172; Grancsay 1958, p. 246, ill.; New York 1967, no. 32; Nickel 1969, p. 90, ill.; Wills 1972, pl. 140; New York 1973, p. 116, ill.; Nickel 1974, p. 1976, ill.; Grancsay 1986, p. 452, pl. 109.9; Nickel 1991a, p. 51; Pyhrr 2012a, pp. 25–26, fig. 37.

NOTES

1. The yellow metal used for the guard and scabbard is an unusual alloy of copper, silver, and gold—what might be called a low-gold alloy. Research scientist Mark Wypyski in the Metropolitan Museum's Department of Scientific Research tested a sample of the scabbard metal in April 2008 using energy-dispersive X-ray spectrometry in a scanning electron microscope (SEM-EDS). The composition of the metal was determined to be a copper-silver-gold alloy consisting mainly of copper, but the metal surface was found to have three times as much gold as on the interior. The surface thus appears to have been depleted of copper with subsequent enrichment of the gold content, rather than gilded by means of gold leaf or by mercury gilding.
2. The hinged mount for the topmost emerald is concealed and was accidentally discovered by Museum armorer and conservator Hermes Knauer while cleaning the sword in April 2008. The coin is of a relatively common type issued during the reign of Süleyman; of a standard weight, they are generally known as Sultani (although they are also sometimes called Ashrafi or Altin; see, for example, Jerusalem 1976, pp. 118–19).
3. The name "Musa" is spelled incorrectly, with a final upright *alif* rather than an *alif maqsura*.
4. Dean was the first curator of the Museum's Department of Arms and Armor and personally knew Morosini. Drawn to richly embellished art objects, Morosini possibly acquired it along with the seven jeweled daggers and one jeweled pistol that comprise the gift his daughter Giulia gave to the Museum in 1923 (acc. nos. 23.232.1–.9); see Dean 1923a.
5. Evans 1922, pp. 41, 46.
6. Kraus 1986, pp. 72, 75.
7. Ibid., p. 74.
8. Corbin 1983, pp. 87–88.
9. Kraus 1986, pp. 272–302.
10. Al-Majlisi 1982, p. 105.
11. In later traditions pearls were thought to be transformed raindrops; their journey from the clouds to the ocean and, through evaporation, back to the clouds, symbolized the journey of the soul and its relationship with God (Schimmel 1986, pp. 284–85). "Man, like a bird of the sea / emerged from the ocean of the soul / Earth is not the final rest / of a bird born of the sea / No, we are pearls of that ocean"; Jalal al-Din Rumi 1981, p. 37.
12. See, for example, Jerusalem 1976, p. 118, nos. 365, 366.
13. Metropolitan Museum, cat. 79, acc. no. 36.25.2219. For the latter, see Stone 1934, p. 264, fig. 327, no. 1.

67 · Saber with Scabbard

Hilt and scabbard, Algeria, late 17th or early 18th century;
blade, Europe, 16th or 17th century
Steel, copper, silver, tortoiseshell, horn, mother-of-pearl,
wood, leather, textile
Sword: length 26⅜ in. (67.1 cm); blade 21 in. (53.3 cm);
weight 1 lb. 6 oz. (632 g)
Scabbard: length 23 in. (58.5 cm); weight 9 oz. (263 g)
Bequest of George C. Stone, 1935
36.25.1550a, b

DESCRIPTION: The grip and wide right-angle pommel are made in one; the core
is of wood, the sides covered with brass sheet over which are placed thin, translu-
cent plaques of tortoiseshell. The angles of the grip are decorated with grooved
plaques alternately of dark horn and mother-of-pearl, the horn inlaid with circles
of tortoiseshell; the inner bend of the pommel is lined with horn. The pommel is
overlaid with silver chased and engraved with floral forms and geometric orna-
ment, with a flowering vase on the plate extending out from the top of the grip.
There is a similarly decorated silver collar at the base of the grip from which rise
arched panels on each of the grip's four sides. The one-piece guard of brass is
engraved with geometric ornament and consists of a knuckle guard with right-
angle bend, one forward and two rear quillons; the quillons curve downward and
end in bud-shaped tips, as does the knuckle guard. The curved blade of polished
steel is single edged, with a double-edged section toward the expanding point; it
has two parallel grooves along the back edge on each face and is stamped in the
grooves on the inner face with dentated, semicircular marks. The wooden scab-
bard is covered with black leather seamed along the lower edge. The throat is
covered with red velvet and has two arched flaps of leather faced with red velvet
that cover the lower part of the hilt. There are two narrow silver bands fitted with
suspension rings. The long chape of red leather is pierced and attached on the
outer face with an openwork design of interlacing strapwork, arabesques, and
foliage against green textile; the smooth inner face is incised with geometric
ornament.

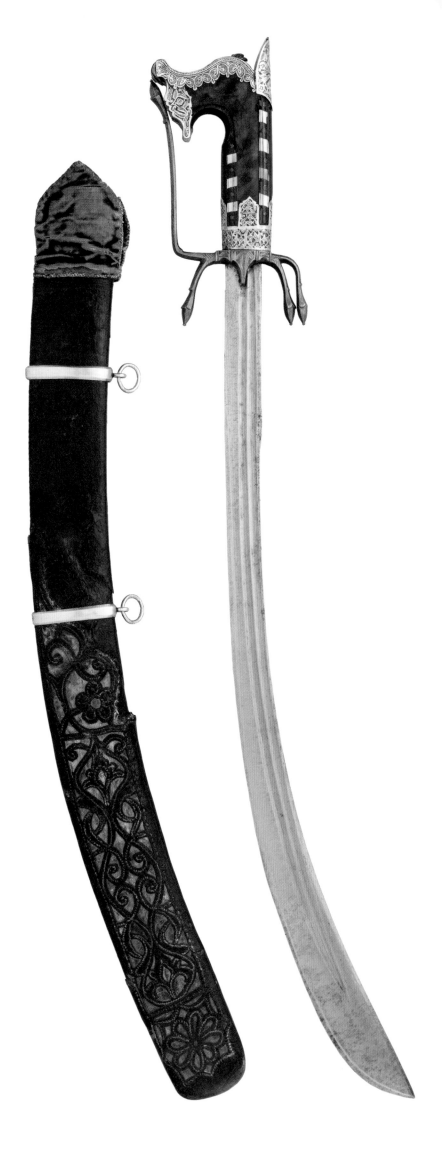

The evolution of this hilt type, usually referred to as a *nimcha*, has been traced to a late fifteenth-century Italian prototype. This influence probably arrived in North Africa through commercial and military contacts.[1] Very similar weapons are in the Kunsthistorisches Museum, Vienna; the Askeri Müzesi, Istanbul; the Kremlin Armory, Moscow; the Real Armería, Madrid; and the Topkapı Sarayı Museum, Istanbul.[2]

The decoration of the hilt and scabbard of the Museum's North African saber indicates an Ottoman influence,[3] which can be seen especially in the vase motif used on the pommel, the pierced leather applied to the scabbard, and the alternation of plaques of horn and mother-of-pearl on the hilt. The latter is especially relevant, as it is also found on a very similar saber in the Kunsthistorisches Museum, Vienna, that is stamped with the *tuğra* of Mustafa II (r. 1695–1703).[4] The Museum's saber is also of exactly the same type as five now in Madrid that were captured at the battle of Oran in western Algeria in 1732, when that port was reconquered by the Spanish.[5] At that time Oran was under the jurisdiction of the bey of Mascara, Bu Shalagham, who in turn was overseen by the dey of Algeria (who from 1708 to 1732 was subject to the Ottoman sultan). Because of its similarity to these pieces, the Metropolitan Museum's saber can also be attributed to the Algerian center and must date to the late seventeenth or early eighteenth century, certainly not later than 1732 and the battle of Oran.

PROVENANCE: Julius Scheurer, Vienna; George Cameron Stone, New York.

REFERENCES: Stone 1934, p. 469, fig. 594, no. 2; Paris 2007/Mohamed 2008, p. 77, n. 1, no. 41.

NOTES
1. See North 1985, pp. 28–30, for a discussion of several North African sabers in the Victoria and Albert Museum, London, including nos. 374-1880, 981-1884 (ibid., figs. 22a, b), whose hilts and blades are generally similar to those of the Museum's saber. Ibid., p. 28, fig. 20, illustrates a painting of about 1617 that shows an English captain wearing a saber of this Algerian type. See also North 1975 and Norman 1980, p. 70, hilt type 7 dated to ca. 1490, for a European prototype.
2. Kunsthistorisches Museum, Vienna, no. C.184; Askeri Müzesi, Istanbul, no. 2756; Kremlin Armory, Moscow, no. 6022, which comes from the armory of Peter the Great, transferred to the Oruzheynaya Palata in 1738 (see *Opis' Moskovskoi Oruzheinaya palata* 1884–93, vol. 2, pp. 230–31, vol. 3, pl. 392); Real Armería, Madrid, nos. M.42–M.46 (see Valencia de Don Juan 1898, p. 376, citing an inventory of 1778–90). There are several similar unpublished examples in the Topkapı Sarayı Museum, Istanbul, including nos. 1/5074, 1/2756, both of which have European blades (that of the latter stamped "GENOA"). The Furusiyya Art Foundation, Vaduz, also possesses a saber similar to the Museum's example, no. R-252; see Paris 2007/Mohamed 2008, p. 77, no. 41.

3. The decoration on the earliest datable example of the type (Kunsthistorisches Museum, Vienna, no. C.180; see Gamber and Beaufort 1990, p. 240 and fig. 135) can be attributed to the court workshop of the Ottoman sultan Murad III (r. 1574–95), and was probably the work of the head court jeweler, the Bosnian Mehmed ibn 'Imad. For Mehmed ibn 'Imad, see Alexander 2003, p. 225 and fig. 7 (illustrating Vienna C.180); for additional works attributed to him, see ibid., figs. 8, 9, and nos. 13, 16, 17, 20.
4. Kunsthistorisches Museum, Vienna, C.184 (see Grosz and Thomas 1936, p. 105, no. 3). For Ottoman pierced leatherwork, see saddle cat. 53; for a discussion of this decorative style, see Riyadh 1996, vol. 2, pp. 70–71, nos. 137, 138.
5. See note 2 above.

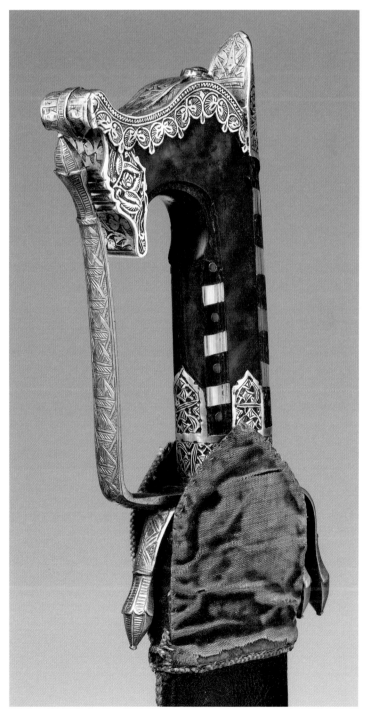

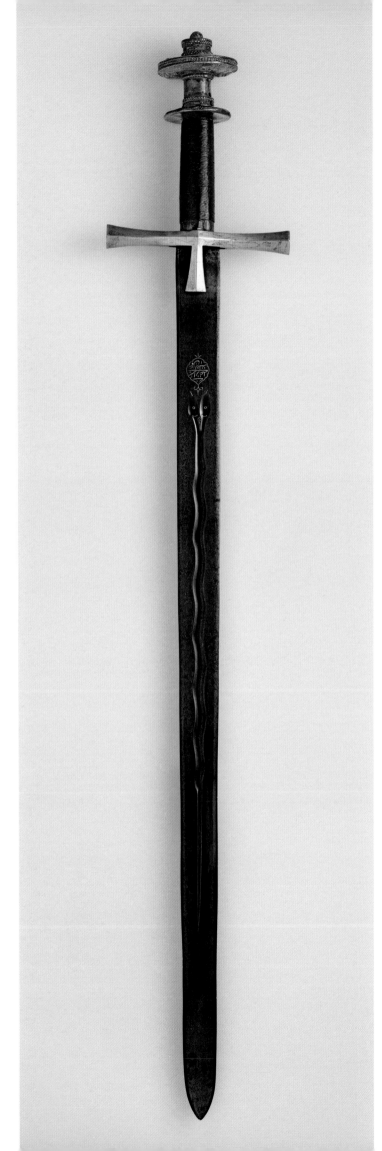

68 · Sword

Hilt, Sudan, late 19th century; blade, Iran, Qajar period, 1848–96
Steel, copper alloy, wood, leather, gold
Length 39⅝ in. (100.8 cm); blade 31¾ in. (80.5 cm); weight 2 lbs. 13 oz.
(1,288 g)
Rogers Fund, 1977
1977.162.1

DESCRIPTION: The large copper-alloy pommel is shaped like a spool, with two hollow disks connected by a spindle and surmounted by a short, spindle-shaped knob and a button. The upper disk is embossed and engraved on both faces with concentric bands of geometric ornament of alternating design separated by raised foliate bosses; the spindle is decorated with applied copper bands of raised beading. Similar beaded ornament is on the edge of the upper disk and on the knob above it. The grip is of wood wrapped with leather cord. The cruciform guard of polished steel has tapering quillons of hexagonal section expanding to blunt, diamond-section tips; the upper langet is hidden beneath the grip wrapping, whereas the lower one expands to a blunt tip. The straight blade of dark gray crucible steel is double edged and tapers to a shallow point. It is hollowed along its center on each face with a wriggling, double-headed snake, the heads facing the hilt and inlaid with gold eyes and tongues. On each face, between the hilt and snake's heads, is a gold-inlaid cartouche containing an inscription in cursive script in Persian and Arabic, respectively (a, b).

INSCRIPTIONS:
a. (On one side, in Persian)

عمل لطف علي شيرازي

Made by Lotf ʿAli Shirazi.

b. (On the other side, in Arabic)

السلطان ناصر الدين شاه قاجار

The Sultan Nasir al-Din Shah Qajar.

S traight-bladed swords of this type, with thick disk-shaped pommels and cruciform guards, are called *kaskara*s and are generic to the Sahara region, particularly Sudan. This example is said to have been taken as booty from the forces of the Sudanese Mahdi, Muhammad Ahmad ibn Abdullah (1844–1885), by the British officer (later general) James Grenfell Maxwell (1859–1929) at the battle of Omdurman in 1898.[1]

The second half of the nineteenth century was a period of turmoil in the Sudan. It had been annexed by the ruler of Egypt Muhammad ʿAli in 1821 and then suffered through a long period

of oppressive taxation, slavery, and other abuses. The rebellion this provoked against the Turko-Egyptian rulers and their British supporters (and eventual overlords) coalesced around the charismatic Sufi and mystic Muhammad Ahmad ibn Abdullah, who proclaimed himself Mahdi in 1881.[2] Drawing upon puritanical ideas of the early Islamic period, Muhammad Ahmad raised Sudanese expectations of freedom from unjust rule and an ensuing period of peace and justice; indeed, his rebellion has been called "the only successful third[-] world revolution of the nineteenth century."[3] Muhammad Ahmad died of typhus shortly after capturing Khartoum in 1885; his followers were then led by his *khalifa* (successor), Abdullah b. Muhammad al-Ta'aishi, who commanded the dervish army at Omdurman,[4] where the movement was finally crushed by the British. The Sudan remained under Egyptian control until 1956, when it finally achieved independence.

In the first inscription (a) the letters are badly formed and could not be reproduced here exactly as written; the second inscription (b), in the same style, is more accurately written. Inscription (a) purports to be the signature of a famous Iranian smith, Lotf 'Ali, who signed five saddle axes and one armor that bear dates between A.H. 1147 (A.D. 1734/35) and A.H. 1152 (A.D. 1739/40).[5] Although his signature is sometimes written "Lotf 'Ali Gholam," it is not "Lotf 'Ali Shirazi," as rendered here. The spurious signature may have been added in homage to this great armorer, about whom little is known; more likely, it was a blatant fake. The sultan cited in the second inscription (b), Nasir al-Din Shah Qajar, ruled in Iran from 1848 to 1896, which provides rather precise dating and provenance for the blade. The hilt, typical of Sudanese *kaskara*, presumably dates from the late nineteenth century.[6] Serpents and snakes, either chiseled in relief or formed as the groove, are often found on Iranian blades.[7] (A slightly different type, with the snake's head in profile, occurs on several swords from Zanzibar, but these have blades that may be from the Baluchistan region of Pakistan.)[8]

The motif of the serpent can perhaps be related to the use of dragons on Islamic sword blades and hilts. Ultimately, the image can be traced to the biblical story of the staff of Moses, which became a serpent when thrown onto the ground.[9] In addition, many of the representations of the Prophet's sword, Dhu'l faqar, are engraved with snakes. The serpent on the Museum's blade might also reflect the influence of the eighth-century scientist and alchemist Jabir ibn Hayyan (721–776), who wrote that "In order to kill serpents, make a design on paper with a specially prepared ink showing the figure of a serpent or of a man killing a serpent."[10] The serpents on Islamic blades may reflect this talismanic practice.

a, b

PROVENANCE: Estate of Brigadier General James Grenfell Maxwell; Soldier Shop, New York.

REFERENCES: Nickel 1979a; Washington, D.C., and other cities 1982–83, no. 43; Nickel 1993, p. 47, figs. 2, 3.

NOTES

1. General Maxwell commanded an Egyptian unit at the battle and afterward was responsible for the summary execution of dervish prisoners.
2. "I am the Mahdi," he declared, "the Successor of the Prophet of God. Cease to pay taxes to the infidel Turks and let everyone who finds a Turk kill him, for the Turks are infidels"; see Holt 1958, p. 51. In brief, the Mahdi is one who brings an era of peace and justice; for a general discussion of this, see Alexander 1999. The concept can be traced to the earliest days of Islam, and the modern puritanical example of Muhammad Ahmad in Sudan and Muhammad ibn Abd-al-Wahhab in Arabia owes much to the ideas of the thirteenth-century theologian Ibn Taymiyya.
3. Dekmejian 1987, p. 94.
4. For a garment worn by a dervish warrior at Omdurman and taken as booty by Maxwell, see Paris 1988, pp. 203–4, no. 255, ill. p. 150.
5. See Melikian-Chirvani 1979b and Richardson 1998.
6. A similar straight blade of dark crucible steel, also inscribed with the name of Nasir al-Din Shah Qajar, was published in Moshtagh Khorasani 2006, pp. 174, 555, no. 175.
7. In addition to the present blade, examples include a sword signed 'Abbasquli in the Historisches Museum, Bern (see Mayer 1962, pl. 1); a sword ascribed to Nasir al-Din (see American Art Association/Anderson Galleries, New York 1936, lot 283, ill.); a dagger with enameled fittings (see Sotheby's London 1976, lot 103, ill.); two blades in the Armeria Reale, Turin (nos. G.291, G.321); and a spearhead in the Metropolitan Museum's collection (acc. no. 22.75.290).
8. Collection of Helmut Nickel; see also Maindron 1890, p. 337.
9. Exodus 4:3.
10. Kraus 1986, p. 85.

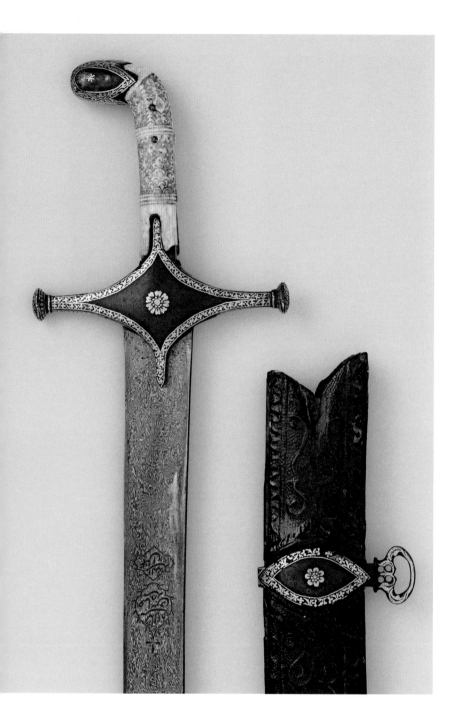

elaborately carved, the inner plaque broken and incomplete. The cruciform guard of blackened steel has tapered quillons with flattened globular tips; it is damascened in gold at the center with a rosette, along the edges with a stylized floral arabesque, and on the top with plant forms. The quillon tips are damascened with rosettelike flowers. The strongly curved, single-edged blade is of dark gray crucible steel forged in the "Muhammad's Ladder" pattern, with a finely grained pattern along the cutting edge. The outer face is inlaid in brass below the hilt with a lobed cartouche containing a Persian inscription in a cursive script (a) and with a pomegranate-shaped medallion above it similarly inscribed (b). The wood scabbard is covered with dark brown leather decorated with raised ornament on its outer face consisting of a medial panel containing a linear arabesque framed by a raised wriggling line, the raised motifs formed by pressing the leather over string glued to the wood core. The two oval suspension mounts of blackened steel are damascened en suite with the hilt, each with a rosette in the center, and have pierced rings for the belt; the long chape has a pierced foliate border along its upper edge and is also damascened in gold, including three palmette or rosette forms down the center.

INSCRIPTIONS:
On the outer face of the blade
a. (In a lobed cartouche)

عمل اسد الله ١٩١

Made by Asad Allah, 191 [A.H. 1191? (A.D. 1777/78?)].

b. (In a pomegranate-shaped medallion)

بنده شاه ولایت عباس

The servant of the King of Divine Trusteeship, 'Abbas.

69 · Saber with Scabbard

Iran, Zand or early Qajar period, blade dated A.H. 1191? (A.D. 1777/78?)
Steel, wood, leather, ivory, gold
Saber: length 37⅞ in. (96.1 cm); blade 32¾ in. (83.1 cm);
weight 1 lb. 12 oz. (784 g)
Scabbard: length 34¼ in. (87 cm); weight 15 oz. (420 g)
Bequest of Richard B. Seager, 1926
26.35.1a, b

DESCRIPTION: The elongated right-angled pommel of blackened steel has a dentate edge and is damascened in gold with floral scrolls. The grip consists of a walrus ivory plaque riveted to each face of the tang and framed by a steel shim damascened en suite with the pommel. The ivory plaques are carved with flowers and scales in alternating registers separated by horizontal bands, the outer plaque more

This saber is one of the more complete Iranian examples in the Museum's collection. Single-edged blades of this shape, generally without grooves and usually of crucible steel, are almost always Iranian or Indian in origin. The inscriptions on this example indicate an Iranian provenance, as does the use of a right-angled hilt of steel and ivory.

The maker's name as it appears in one inscription (a) is Asad Allah (Asadullah), while the other inscription (b) gives the formula used on the seal of Shah 'Abbas I (r. 1588–1629). Asadullah Isfahani (Asadullah of Isfahan) is traditionally regarded as the greatest Iranian swordsmith, but nothing about him is known.[1] His is the most commonly found signature on Iranian saber blades, and it is impossible that all the surviving blades bearing this name are by the same maker. Many of these blades are inscribed with dates that range from the fifteenth to the early nineteenth century.[2] Like the blades inscribed with the name of another famous smith, Haji Sunqur (see cat. 64), some may be genuine, others may be from his workshop, and others are probably forgeries. The English traveler James Fraser, who visited Iran in the early nineteenth century, reported a thriving industry in fake Asadullah blades.[3] Indeed, it is even possible that the entire corpus of Asadullah signatures results from a pious fiction.[4] This would have been based on conflating an appellation of 'Ali, "the lion of God" (Asadullah), with an actual person. In other words, the "signature"

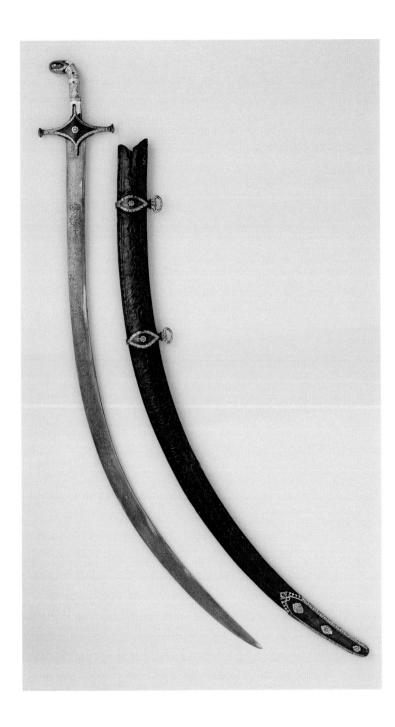

(r. 1694–1722) to the Austrian emperor during the early eighteenth century.[8] However, most blades of this type are securely dated to the Qajar period, especially to the reign of Fath 'Ali Shah (1797–1834), as contemporaneous paintings attest.[9]

PROVENANCE: Richard B. Seager, New York.

REFERENCE: Nickel 1974, p. 190, ill.

NOTES

1. Mayer 1962, pp. 26–29.
2. Ibid., p. 27, citing examples dating from A.H. 811 (A.D. 1408/9) to A.H. 1223 (A.D. 1808/9).
3. J. Fraser 1825.
4. Although the very existence of this swordsmith has been questioned, Allan and Gilmour 2000, pp. 102–4, quote several seventeenth-century accounts that suggest that Asadullah did work in Isfahan during the reign of Shah 'Abbas and that his grave existed and, as recently as 1937, was the object of an annual pilgrimage by members of the Isfahani swordsmiths guild.
5. Moshtagh Khorasani 2006, p. 163, however, speculated that Asadullah "was a title of mastery given to the best swordsmiths," who were then allowed to add the title to their blades.
6. One such example is the saber of Shah Tahmasp (r. 1524–76) in the Victoria and Albert Museum, London, no. IS.3378; see New York and Milan 2003–4, pp. 226–27, no. 8.21.
7. Nine saber blades in the Kremlin Armory can be attributed to the Persian swordsmith Rajab 'Ali of Isfahan. These were first described in the inventory of 1687 and are numbered 6084, 6086–93; 6084 was a gift to Czar Alexis from a merchant sent by the shah on February 11, 1664. Numbers 6086–93 were given to Czar Alexis by the shah's ambassador, Muhammad Hussain Beg, on February 3, 1675; all were made by Rajab 'Ali and stamped with his mark on the tang. See *Opis' Moskovskoi Oruzheinaya palata* 1884–93, vol. 2, pp. 252–55, vol. 3, pl. 348, nos. 6084, 6090, 6091, 6093, and Mayer 1962, pp. 69–70, nos. 6084, 6108, 6114.

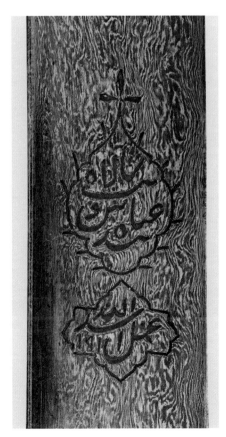

8. Cederström 1912–14, p. 222, refers to the sword now in the Kunsthistorisches Museum, Vienna, no. C.80; see Grosz and Thomas 1936, pp. 105–6.
9. For example, in a mural of 1812–13 in the Nigaristan Palace, Tehran, the shah and his courtiers are almost all depicted with sabers of this narrow, strongly curved type; see B. Robinson 1976, pl. 1281.

may have been a kind of talisman, transforming the blade on which it appeared into a sword of 'Ali.[5]

Despite the inscribed reference to Shah 'Abbas on this saber (b), none of the slender, highly curved blades of this type can be securely dated to the period of his reign. Miniature paintings of that time invariably depict blades of a different type, slightly curved and single edged with a sharpened back edge before the tip.[6] When Shah 'Abbas II (r. 1642–66) sent a gift to the Russian czar Alexis in 1664, the sabers were still of that type. If the blades of Asadullah were as popular at this moment as has been suggested, they probably would have been included in the state gift; those blades, however, were made and signed by Rajab 'Ali.[7] The earliest documented blade of the same narrow, strongly curved shape as the Museum's saber is one sent by Shah Husain

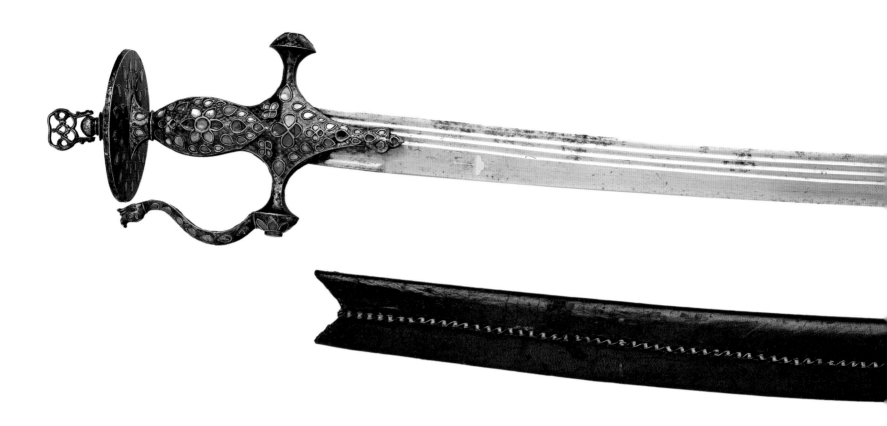

70 · Saber with Scabbard

Hilt and scabbard, India, Mughal period, probably 19th
century; blade, Europe, late 16th–17th century,
but dated 1673/74
Steel, silver, enamel, crystal (?), copper alloy, gold, leather
Sword: length 36⅝ in. (93 cm); blade 31⅝ in. (80.3 cm);
weight 2 lbs. 11 oz. (1,220 g)
Scabbard: length 32½ in. (82.5 cm); weight 12 oz. (348 g)
Bequest of George C. Stone, 1935
36.25.1591a, b

DESCRIPTION: The hilt is of silver engraved overall with a diaper pattern champlevé-
enameled in translucent emerald green and set with table-cut clear stones, perhaps
crystals, in copper-alloy settings. The large disk-shaped pommel is surmounted by a
domed, rosette-shaped boss of gilt copper engraved with foliage and geometric
ornament and is fitted with a hinged loop, pierced and enameled green, for a wrist
strap. The flattened hexagonal grip expands at the center and is made in one with
the guard, which consists of long, straight quillons with flaring, domed tips, long
langets with palmette-shaped tips, and an S-shaped knuckle guard that ends in a
makara head (the knuckle guard is made separately and screws into the end of the
forward quillon). The blade of European type is curved and single edged, with a

double-edged section toward the point. It has three grooves parallel to the back edge
on each side; on the inner face are stamped marks, partly effaced, which consist of
sickle-shaped and interlace forms with dentated edges. Inlaid in gold on the back
edge near the hilt is an inscription in Persian and Arabic, and on the outer face near
the hilt a parasol. The wooden scabbard is formed of thick, dyed green leather
stitched down the center of the front with copper-alloy wire and has an enameled-
and-jeweled chape to match the hilt.

INSCRIPTION:
(In the cartouches along the back of the blade)

نصر من الله وفتح قريب

Help from Allah and a speedy victory. (Qur'an 61:13)

بى مهر

Merciless (*bi-mehr*).

(In the third and fifth cartouches)

هست این شمشیر اورنگزیب دین پناه کو بضرب تیغ عالم گیر خود شد بادشاه

This is the sword of Shah Aurangzeb, the Refuge of Religion,
Who through striking his world-seizing (*'alamgir*) saber became emperor (*padshah*).

(In the fourth cartouche)

ل ١٦ ص ل ٦١

lam 16 sad lam 61

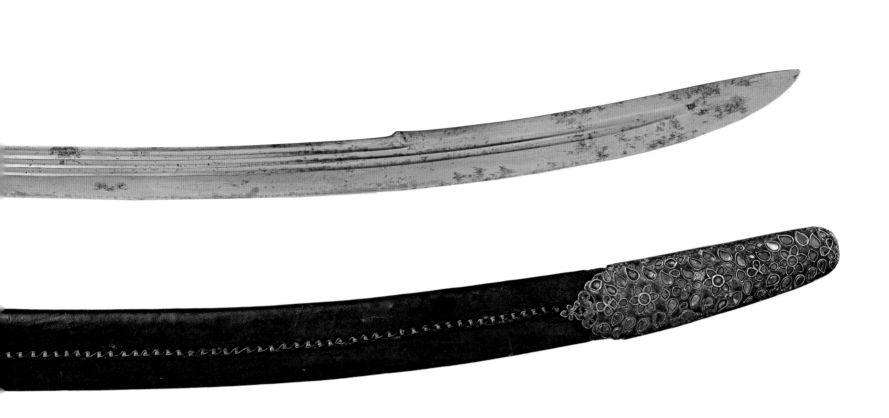

Hilts with disk- or saucer-shaped pommels such as this, usually referred to as *talwars* (or tulwars), are a uniquely Indian form often adopted by the Mughals.

The inscription on the blade includes the name of the Mughal emperor Aurangzeb (r. 1658–1707)[1] and gives the sword a name, *bi-mehr*, or "Merciless." Several other blades from Aurangzeb's armory are similarly named, one of which is inscribed *khun-asham*, or "Bloodthirsty."[2] Naming a sword was not unusual, and numerous examples can be cited from a variety of cultures.[3] For Aurangzeb, the naming suggests that among the many swords at his disposal these had a special significance for him. Also included among the inscriptions is what might be the regnal year, in this example "16," which would correspond to 1673/74. Unfortunately, the significance of these numbers and of the Arabic characters between them (*sad lam*) is not certain. Comparable sequences of letters and numbers occur on blades from the arsenal of the Mughal shahs Jahangir (r. 1605–27) and Jahan (r. 1627–58).[4]

Several surviving sabers are inscribed with Aurangzeb's name; on this blade there is also a reference to his title, *'alamgir*, which means "world-seizing."[5] As with the other examples, the Museum's blade is inlaid with a parasol mark indicating along with the inscription that the saber is from Aurangzeb's personal armory.[6]

The parasol is an ancient symbol of the dome of heaven and was long used in the Middle East and in India as a symbol of royal authority—the monarch protected by it was a divinely appointed ruler sheltered by the power of heaven. Parasols as royal symbols are found in Assyrian art and, immediately before the coming of Islam, in Sasanian art. A Sasanian ruler beneath a parasol is depicted on a relief at Taq-i-Bustan, Iran.[7] This symbolism

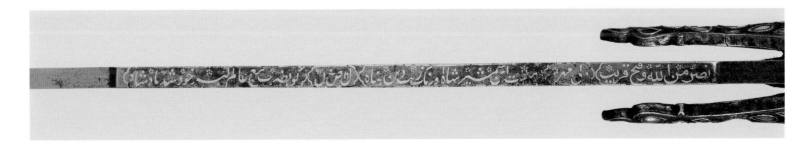

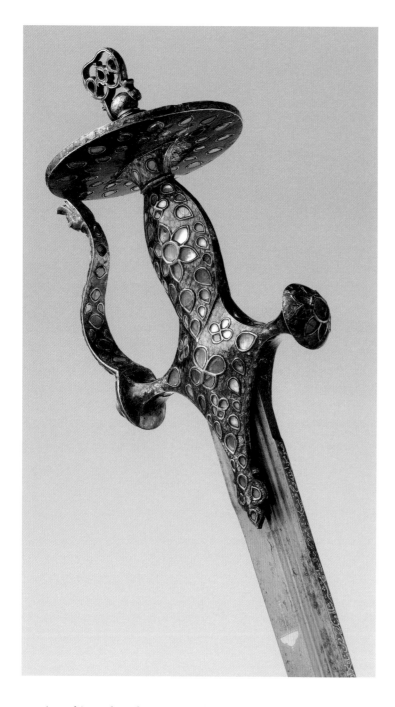

Copenhagen, that was owned by "a eunuch of the King of Oude."[10] A *kard*, a type of dagger, now in the Freer Gallery of Art, Washington, D.C., and said to have been made for Jahangir in 1620/21 from meteoric iron, is damascened on the left side with the imperial parasol mark;[11] another *kard* thought to have been made for Shah Jahan, now in the collection of Sheikh Hamad Al-Thani, also bears this mark.[12]

PROVENANCE: W. O. Oldman, London; George Cameron Stone, New York.

REFERENCES: Stone 1934, p. 602, fig. 770, no. 2; Paris 2007/Mohamed 2008, p. 100, no. 64, n. 2.

NOTES

1. Aurangzeb was crowned twice: the first time after the defeat of his brother Dara at Samugarh in A.H. 1068 (A.D. 1658) and the second time the following year.

2. Christie's London 2015, lot 120. The Italian traveler Niccolao Manucci (1639–1717), who chronicled events at the Mughal court, recounted the names of some of Aurangzeb's personal sabers, including "Killer of Enemies, Fine tempered, Infidel-slayer, Waist Adorner, Tyrant-slayer, Venomous, and World Conqueror," this last "the one Aurangzeb usually carries in his hand"; see Manucci 1906–8, vol. 2, pp. 358–59.

3. In Islam, the most obvious examples are the named swords of the Prophet, of which Ibn Sa'd alone records seven; see Alexander 1999, p. 169.

4. Khalili Collection, London; see Alexander 1992, pp. 192, 194–95, nos. 127, 128.

5. An example in the Furusiyya Art Foundation, Vaduz, no. R-250, dated A.H. 1072 (A.D. 1661/62), is also inscribed *'alamgir* (Aurangzeb); see Paris 2007/Mohamed 2008, p. 100, no. 64. For another of Aurangzeb's swords mounted with a European blade and bearing a similar inscription to that on the Museum's example, see Ciuk 2001. See also Paris 2007/Mohamed 2008, pp. 98–99, nos. 62, 63, for related Indian swords mounted with European blades and bearing similar inscriptions.

6. If the hilt is contemporary, it is a rare dated example of Mughal enameling; Manuel Keene, however, has suggested that it is of the nineteenth century (Department of Arms and Armor Files, The Metropolitan Museum of Art, New York).

7. Fukai and Horiuchi 1969–72, vol. 2, pl. 88.

8. See Bosworth 1973, p. 280, n. 21.

9. See Washington, D.C. 1981–82, p. 187, no. 18d, recto.

10. See Copenhagen 1982, pp. 200–202, no. 165.

11. Freer Gallery of Art, Washington, D.C., no. 55.27; see Washington, D.C. 1985–86, no. 36.

12. See New York 1985–86b, no. 131; Jaffer 2013, pp. 91–92, no. 4; and New York 2014–15, pp. 26–27. A Hindu blade in the Museum's collection adorned with a parasol mark (acc. no. 36.25.1325) shows that this custom was not confined to the Mughal court.

continued into the Islamic period; under many dynasties there was even a special office for the bearer of the imperial parasol (*chatr-dar*), who, in the case of the Ghaznavid dynasty, was in charge of the black imperial parasol topped by a falcon.[8] A parasol can be seen in a Mughal painting of about 1650 showing Shah Jahan as ruler of the world, presiding over the Peaceable Kingdom.[9] The emperor is depicted standing atop a globe on which are painted scales, a lion lying down with a lamb, a group of Sufis, and an inscription describing the shah as the conveyor of harmony and peace to the world. Above the emperor are three angels, one carrying his sword (Dhu'l faqar), another his crown, and the third a parasol raised over Shah Jahan's head.

The use of the parasol as an imperial mark on sword and saber blades is clearly demonstrated on a number of other Mughal weapons, including a saber in the David Collection,

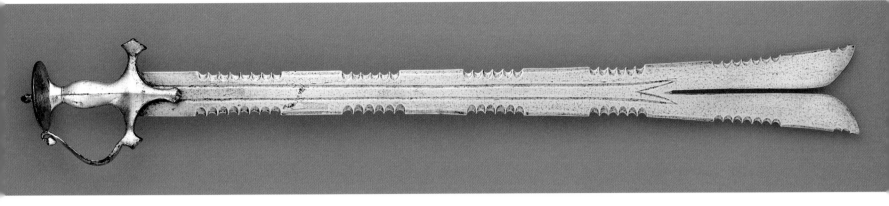

71 · Sword

India, probably Deccan, possibly late 17th–18th century
Steel, iron, silver
Length 34 in. (86.5 cm); blade 29⅜ in. (74.5 cm); weight 2 lbs. (916 g)
Bequest of George C. Stone, 1935
36.25.1508

DESCRIPTION: The hilt is of iron silvered overall. The flattened saucer-shaped pommel is fitted with a domed cap sitting on a petaled rosette washer and surmounted by a button pierced for a wrist strap. The swelling grip is made in one with the guard, which consists of short, straight quillons ending in palmette-shaped tips, with lobed scabbard prongs (langets), and with an S-shaped knuckle guard terminating in an outward-turned knob that connects the forward quillon to the pommel. The straight, double-edged blade of polished steel flares toward a bifurcated point. There is a short ricasso, and the edges are alternately smooth and serrated, now filed very sharp. Each face is engraved along its length with two shallow parallel grooves ending in a notched point in emulation of the blade's shape.

T his sword represents an Indian version of the Dhu'l faqar, or sword of the Prophet. Its split tip and serrated edges reflect two different interpretations of the shape of Muhammad's sword, as a sword with a bifurcated blade or as a sword with either grooves or scalloped sides.[1] Although blades worked according to the latter conception are relatively rare,

there are at least two additional Indian examples as well as several Ottoman blades worked with scalloped edges.[2]

Hilts with disk- or saucer-shaped pommels are a common Indian type, called *talwars*, but an S-shaped knuckle guard found in tandem with very large palmette-shaped quillon tips seems to be a Deccani characteristic. Several dated examples of the hilt type have been preserved, including one inscribed with the name of 'Ali 'Adil Shah, almost certainly 'Ali b. Muhammad of Bijapur (r. 1656–72).[3] The hilt of the Museum's example is heavier and somewhat cruder, less finely worked, and probably later in date. It is perhaps also from Bijapur, which was ruled by the 'Adil Shah dynasty from 1489 to 1686, when they were conquered by the Mughals under Aurangzeb (r. 1658–1707).

PROVENANCE: W. O. Oldman, London; George Cameron Stone, New York.

REFERENCE: Alexander 1984, no. 10.

NOTES

1. For other Indian swords with flaring tips, see Rawson 1967, pls. 10, 17. For further discussion of the various representations of Dhu'l faqar, see Alexander 1999, pp. 172–82. The idea that the sword had a bifurcated blade can be traced to the account by Ibn Ishaq (d. 767) in which the Prophet is reported to have said, "on the tip of my sword I saw a notch"; ibid., p. 172. The belief that it was grooved or had scalloped sides is traceable to the ninth-century historian al-Tabari, who reported an instance in which the sword was unsheathed, and he "saw eighteen vertebrae (*faqar*) carved on it"; al-Tabari 1988–89, vol. 1, "The Year 145 (1 April 662–20 March 763)," p. 125, verse 247. Following this, the anthologist al-Tha'alibi (961–1038) maintained that the Dhu'l faqar had "small beautiful hollows" along its edge; see Alexander 1999, p. 174.

2. The Indian sabers with wide, sharply curved blades having split tips and scalloped edges are illustrated by Pant, who attributes them to Almora in Uttar Pradesh; see Pant 1978–83, vol. 2, pls. LXXX, LXXXI. For the Ottoman sabers, late fifteenth- or early sixteenth-century examples with unusual serpentine blades, see Alexander 1999, p. 174, fig. 5., and Yücel 2001, pp. 139–41, nos. 97–99.

3. Furusiyya Art Foundation, Vaduz, no. R-708; see Paris 2007/Mohamed 2008, p. 89, no. 53. For related Deccan-style hilts in the same collection, see ibid., pp. 91–93, 95, nos. 55–57, 59.

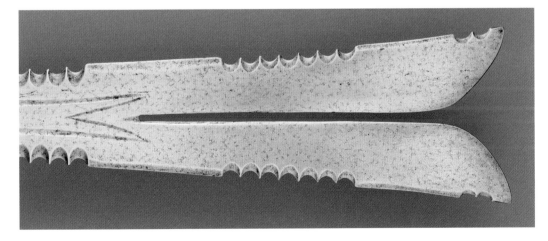

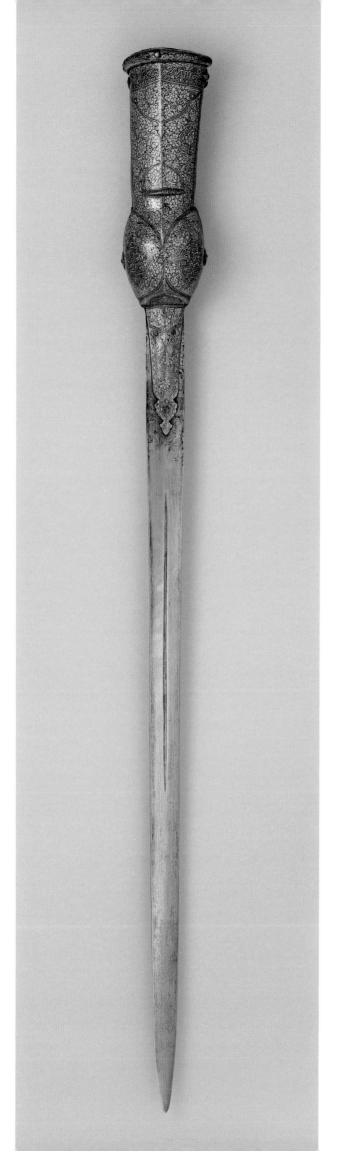

72 · Gauntlet Sword

Hilt, Central India, dated A.H. 1126 (A.D. 1714/15); blade,
Europe, probably 16th century
Steel, gold, textile
Length 52½ in. (133.3 cm); blade, 40⅜ in. (102.6 cm);
weight 3 lbs. 2 oz. (1,425 g)
Bequest of George C. Stone, 1935
36.25.1538

DESCRIPTION: The sword comprises a gauntlet-shaped hilt and straight blade. The
one-piece hilt, which covers the outside of the hand and forearm, consists of a long
narrow cuff tapering to the bulbous hand. The cuff has a medial ridge, an embossed
transverse ridge at the base, and a prominent half-round border riveted at the top.
The hilt is of blued steel damascened in gold with a dense overall foliate design, the
foliage at the top and base of the cuff contained within palmette-shaped fields. The
borders along the sides and across the top and two medallions on the hand are
damascened with Arabic inscriptions in cursive script (a–c). Elongated brackets
extend downward from the base of the hand to sandwich the blade, which is held
rigid by three transverse rivets. The brackets end in palmette shapes and are dama-
scened to match the gauntlet. Riveted inside the hand is a transverse iron grip
wrapped with strips of red cotton textile printed overall with tiny yellow stars and
blue dots, the rivets secured on the outside by gold-damascened rosette washers.
Inside the cuff at the top is a swiveling metal loop with recurved ends that are held
to the top of the cuff by gold-damascened brackets. The straight, double-edged blade
of polished steel tapers to a point and has a shallow central groove on each face;
although unmarked, it is probably a European import. The base of the blade around
the brackets is damascened in gold with a feathery aureole of leaves as well as with
an Arabic inscription, now badly rubbed and illegible.

INSCRIPTIONS:
a. (Repeated along the bottom of the cuff)

<div dir="rtl">نصر من الله و فتح قريب</div>

Help from Allah and a speedy victory. (Qur'an 61:13)

b. (Repeated in the two medallions on the hand)

<div dir="rtl">في النوايب سينجلي كل هم و غم بنبوتك يا محمد ١١٢٦</div>

In crisis, every sorrow and care will pass through your Prophethood, O Muhammad,
1126 (A.D. 1714/15).

c. (Repeated along each side of the hilt, an undeciphered inscription containing a
repetition of one word)

<div dir="rtl">... ذا الفقار ...</div>

Dhu'l faqar.

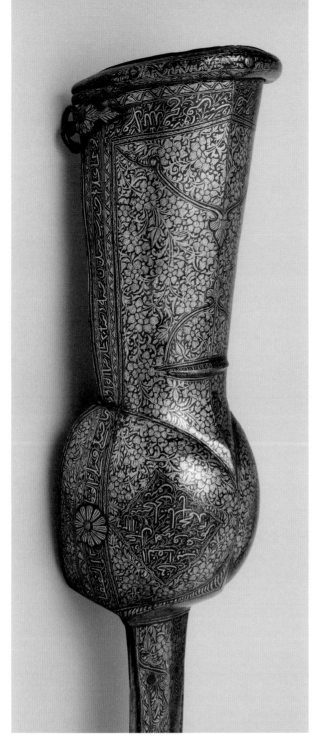

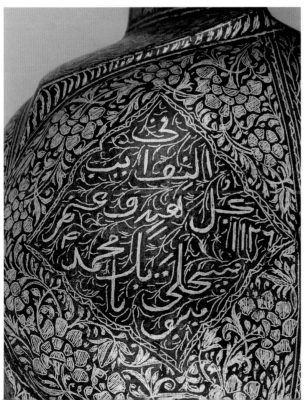

This type of straight-bladed cut-and-thrust sword, called a *pata* in Hindi, is designed for use by a mounted warrior and has a built-in gauntlet for the protection of the lower arm. Such weapons seem to have originated in central India during the late sixteenth century and were particularly favored by Mahratta warriors.[1] Many of the surviving examples are Hindu, but others, including the Museum's sword, are clearly Islamic. They were often used in the Deccan during the seventeenth and eighteenth centuries and were usually fitted with European blades.

The inscription includes part of the *nadi 'Ali*, or prayer to 'Ali. The prayer has in Shi'a histories been ascribed to the battle of Uhud (A.D. 625) and connected with the Prophet's sword, Dhu'l faqar. In these accounts the angel Gabriel appeared at the critical moment during the battle and told Muhammad to recite the following verse: "Call upon 'Ali the revealer of miracles, you will find him a comfort to you in crisis. Every care and every sorrow will pass through your trusteeship. Trust in God, O 'Ali, O 'Ali, O 'Ali."[2] Immediately thereafter, 'Ali appeared brandishing Dhu'l faqar and routed the enemy. The prayer is inscribed as a talisman on many objects, especially swords.[3] However, in the form of the prayer given here only Muhammad, and not 'Ali, is mentioned, perhaps indicating that the sword may have been made for a Sunni rather than a Shi'a patron.

PROVENANCE: Fenton and Sons, London; George Cameron Stone, New York.

REFERENCES: Stone 1934, p. 486, fig. 619, no. 4; Pant 1978–83, vol. 2, p. 63; New York 1996, pp. 34–35, 47, no. 62, pl. 23.

NOTES

1. For these and related Deccani swords, see Rawson 1967, pp. 43–48. Rawson notes that in about 1600 they began to appear in miniature painting from Bijapur and Ahmadnagar. See also Elgood 2004a, p. 97, fig. 8.58, in which a South Indian *pata* from around 1570 in the Metropolitan Museum, acc. no. 36.25.1534, is considered one of the earliest of the type.

2. Birge 1937, pp. 138–39. Linda Komaroff 1979–80 has argued that the use of this prayer on metalwork does not seem to predate the Timurid period.

3. As, for example, an Iranian sword in the Metropolitan Museum, acc. no. 36.25.1306a–c.

73 · Saber with Scabbard

Hilt and scabbard, India, probably Lucknow, early 19th century,
but dated 1819; blade, probably India, 18th century
Steel, silver, enamel, ivory, gold, glass
Saber: length 36¼ in. (92.2 cm); blade 31⅛ in. (79 cm);
weight 3 lbs. 6 oz. (1,521 g)
Scabbard: length 33½ in. (85 cm); weight 3 lbs. 3 oz. (1,435 g)
Bequest of George C. Stone, 1935
36.25.1302a, b

DESCRIPTION: The hilt and scabbard mounts are of silver, the surfaces finely
engraved and champlevé enameled, the predominant colors translucent dark blue
and emerald green and opaque orange and yellow. The pommel, formed as a ram's
head, is enameled in blue, the ears orange, and the foliate collar green; the eyes are
inset with clear stones or glass (the left one missing). The mouth is pierced and
formerly retained fragments of gold-wrapped thread that may originally have
attached a wrist strap. The grip is formed of two plaques of walrus ivory secured to
either side of the tang by rivets with leaf-shaped washers of green-enameled silver
and is framed by silver shims enameled in blue and green with a leafy scroll. The
ivory plaques are beveled along the edges and near the bottom to accommodate the
wrapping of twisted gold wire encircling the base of the grip; attached to the wire on
the outer face of the grip is an inscribed gold medallion (a). The cruciform guard of
silver has tapered quillons with ram's-head tips enameled to match the pommel; it is
engraved with birds and floral forms enameled in blue, green, and orange. The
strongly curved blade of dark gray crucible steel is single edged; on the outer face it
is engraved with a cartouche containing an Arabic inscription in cursive script (b),
now partly effaced. The wood scabbard is completely encased in engraved and
enameled silver. The decoration on each face of the scabbard consists of a central
band containing a series of roundels with green borders, inside of which are ani-
mals and birds, some in combat, against a blue ground; between the roundels are
stylized flowers enameled in translucent red and green as well as orange and yellow.
Framing this band are narrow borders of scrolling green leaves and squared crosses
on a dark blue ground. The oval sling mounts, decorated en suite with animals, fish,
birds, and plants, have flattened suspension loops with split-leaf terminals. The
chape is decorated on the outer face with horizontal registers containing animals,
fish, birds, and flowers and on the inner face with an allover foliate design. The back
edge of the scabbard is engraved with squared crosses against a green ground.

Much of the enamel is missing, and the blade is heavily rubbed, obscuring
areas of the watered pattern and engraved inscription.

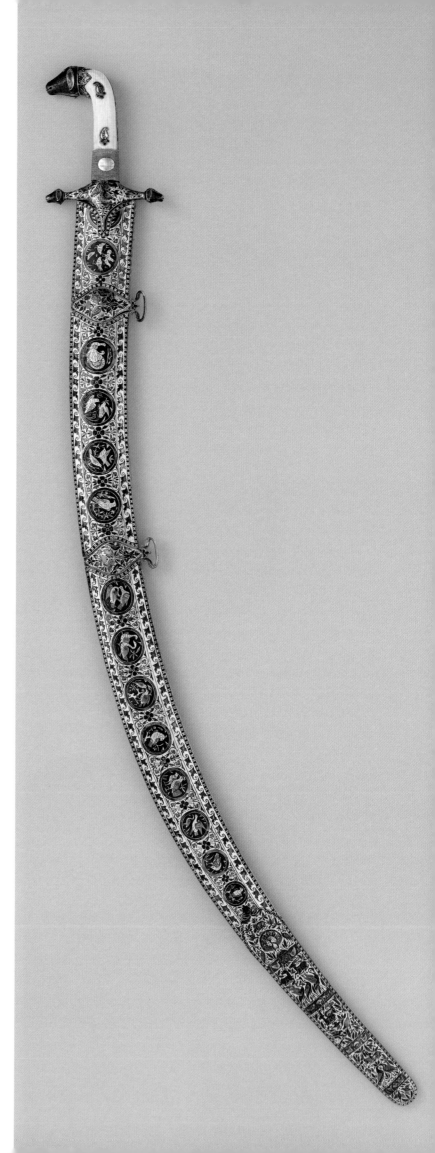

INSCRIPTIONS:
a. (Medallion on the grip)
From the Marquis of Hastings to Captn. H. Caldwell 1819.

b. (On the blade)

توكلت على الله

I put my trust in God.

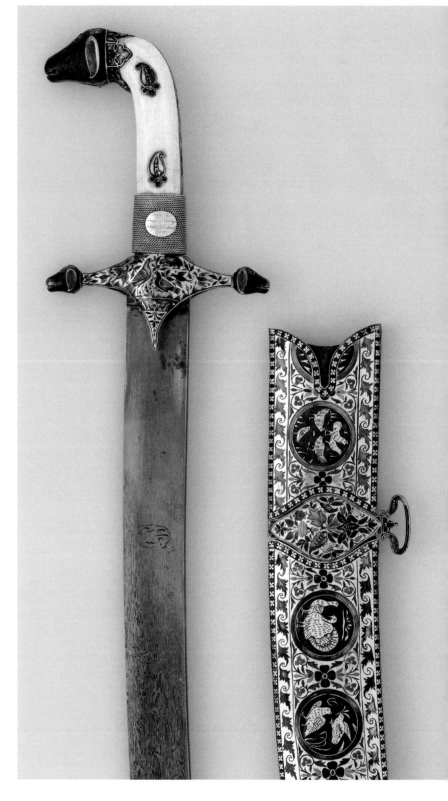

This saber was presented to an English officer, Captain Hugh Caldwell (1785–1882) of the Bengal Army, by his commander Francis Rawdon-Hastings (1754–1826), governor-general of Bengal from 1813 to 1823. The presenter, a well-known historical figure, fought in the American Revolutionary War; in 1793 he became the second Earl of Moira and in 1817 the first Marquess of Hastings. He was recalled from India in 1823 as the result of financial skulduggery. The recipient, Hugh Caldwell, was a professional soldier stationed in India from 1806 until his retirement with the rank of lieutenant colonel in 1835 or 1836. He was aide-de-camp to the governor-general from 1815 to 1819 and was appointed paymaster in Calcutta in 1819. As this date is inscribed on the sword, its gift from Lord Hastings may have had something to do with Caldwell's appointment, or perhaps was a token of esteem on a more personal level.[1]

A number of Indian centers producing enameled metalwork and jewelry between the seventeenth and nineteenth centuries have been identified, although many other workshops remain to be enumerated.[2] The enameled silver fittings on the Museum's saber may have been produced in either Lucknow or Jaipur, as similar work is known from both centers. Contemporary accounts, however, place this style in Lucknow, capital of the Mughal province of Oudh (Awadh, in the modern state of Uttar Pradesh) from 1775, where extensive use was made of the squared cross (on the Museum's saber that pattern decorates the outer borders on the scabbard) and where the motifs were generally looser and more finely drawn than those on work from Jaipur.[3] The hilt is very similar to, and probably from the same workshop as, two other Lucknow-style enameled sword hilts with zoomorphic pommels and quillon tips now in the Wallace Collection, London.[4] The blade of one of these is inscribed with the name of the nawab (governor) of Oudh, Shuja 'al-Duala (1731–1775).

PROVENANCE: W. O. Oldman, London; George Cameron Stone, New York.

REFERENCES: Stone 1934, p. 551, fig. 709, no. 3; New York 1985–86a, p. 17.

NOTES
1. Information about Captain Caldwell, derived from various printed and Internet sources, was provided by Stephen Wood (personal communication, March 5, 2008). Caldwell is identified as captain on the plaque, although he was only promoted to that regimental rank on May 1, 1824, suggesting that the plaque, recording an earlier presentation, was added between that year and 1830, when he was promoted to major. There is, however, an earlier reference to him as brevet captain, indicating that his appointment as paymaster may have required that he have an army rank of captain.
2. Stronge 1988–89.
3. For swords from Lucknow, see Simla 1881. For Lucknow enamels, see Markel 1993, pp. 114–16; Zebrowski 1997, pp. 86, 92, figs. 70–74; and, more generally, Los Angeles and Paris 2010–11, pp. 199–225. For enamels from Jaipur, see Bradford and London 1988–89, especially no. 43.
4. Wallace Collection, London, nos. OA 1540, OA 1408, the latter illustrated in Copenhagen 1982, p. 11.

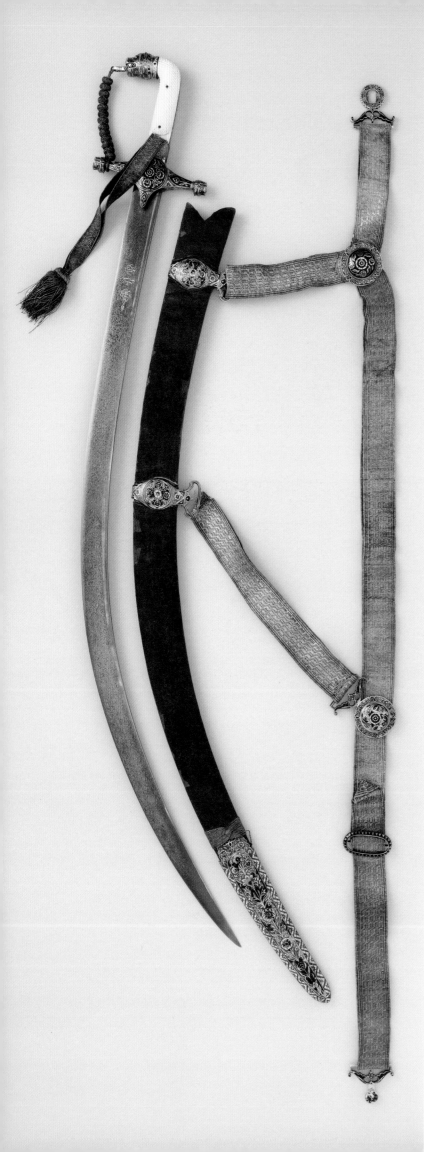

74 · Saber, Scabbard, and Belt

Hilt, scabbard, and belt, India, Lucknow or Jaipur, early 19th century;
blade, northern India, dated A.H. 1162 (A.D. 1748/49)
Steel, silver, enamel, ivory, wood, textile, gold
Sword: length 36¼ in. (92.2 cm); blade 30¾ in. (78.1 cm);
weight 2 lbs. 4 oz. (1,011 g)
Scabbard: length 32¾ in. (83.3 cm); weight (with belt) 1 lb. 6 oz. (630 g)
Bequest of George C. Stone, 1935
36.25.1304a, b

DESCRIPTION: The metal mounts of the hilt, scabbard, and belt are of silver
engraved and champlevé enameled in translucent dark blue and emerald green.
The pommel is shaped as a tiger's head; a pierced ring attachment for the beaded
knuckle guard of enriched silk is fastened by a swivel pin in the tiger's mouth. The
lower end of the knuckle guard is attached to the forward quillon by a loop. The
checkered ivory grip plaques are framed by shims enameled in blue and green
with a chevron design. A wrist strap of metallic thread, with a tassel at its end, is
wrapped around the base of the grip. The cruciform guard has tapered quillons
with tiger-head tips matching the pommel. Its center is engraved with a roundel
containing a floral rosette encircled by an alternating leaf-and-petal motif on a
blue ground. Arched panels on the sides of the quillons contain single flowers in
blue and green. The blade of dark gray crucible steel is curved and single edged. It
is inscribed in Arabic and Persian in gold in three cartouches on the outer face
(a–c), with traces of a magic square (buduh) nearby. The wood scabbard is covered
with torn and faded green silk and has two suspension mounts and a chape of
enameled silver decorated en suite with the hilt. The belt and suspension straps
are of silk enriched with metallic thread and are fitted with a buckle and slides
enameled in translucent blue and green matching the hilt and scabbard. The
scabbard has a wrapping of metallic thread just above the chape.

INSCRIPTIONS:
On the outer face, in three
cartouches near the hilt

a.

نصر من الله وفتح قريب

Help from Allah and a speedy
victory. (Qur'an 61:13)

b.

صفدر جنگ بهادر ١١٦٢

Safdar Jang Bahadur, 1162 (A.D.
1748/49).

c.

عمل باقر مشهدى

Made by Baqir Mashhadi.

This saber has survived with its original wrist strap, knuckle guard, and belt, which is a rare occurrence.[1] Like those of cat. 73, the enameled mounts of this saber are in the style attributed to Lucknow and probably datable to the period of British rule, beginning in 1801, when the nawab (governor) of Oudh was forced to give up half of his territory to permanent British control. Lucknow enamel is often distinguished by the use of the colors blue and green; the enameled decoration on this saber, however, differs from that of cat. 73 in that the motifs here consist of bold floral forms in contrast to that example's birds, fish, and animals. Yet another characteristic of the plant forms here is the jagged or serrated edges of the leaves, a feature often found on enamels attributed to Jaipur[2]—all of which leaves open the question as to where these fittings were crafted.

The blade is earlier than the hilt[3] and is one of fourteen recorded works signed by Muhammad Baqir Mashhadi (Muhammad Baqir from Mashhad), an Iranian bladesmith active in northern India in the mid-eighteenth century.[4] Among them are one in the Furusiyya Art Foundation, Vaduz, dated A.H. 1163 (A.D. 1750), and another in the Khalili Collection, London, dated A.H. 1163 (A.D. 1749/50).[5] These blades are also inscribed with the name of the Iranian-born Mughal vizier Safdar (or Asaf) Jang Bahadur (ca. 1708–1754), who distinguished himself in the wars against the Mahrattas and was nawab of Oudh from 1739 to 1754 (fig. 30).

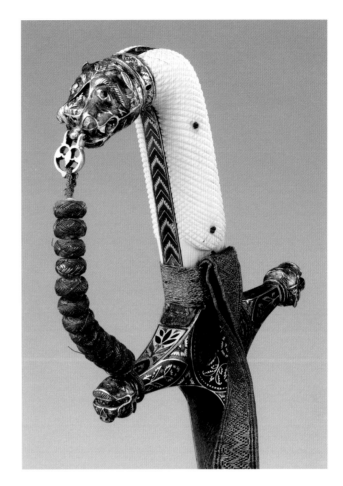

PROVENANCE: Bachereau, Paris; George Cameron Stone, New York.

REFERENCES: Stone 1934, p. 550, fig. 708, no. 4; Mayer 1962, p. 31; Alexander 1992, p. 139; Paris 2007/Mohamed 2008, p. 85, no. 49, n. 1; Augustin 2009, p. 101.

NOTES

1. Another such example is a saber with an enameled bird-head pommel now in the Royal Collection, Windsor Castle, no. 1742; the blade is inscribed with the names of the Qajar ruler Fath 'Ali Shah (r. 1797–1834) and Mir Murad 'Ali Khan Talpur of Sind (r. 1783–1801). See also Paris 1988, p. 198, no. 227, ill. p. 135.

2. See, for example, a turban ornament from the Jaipur Treasury now in the Victoria and Albert Museum, London, no. IM 241-1923; see Bradford and London 1988–89, no. 43, ill.; see also Bala Krishnan and Shushil Kumar 1999, especially pl. 438.

3. Blades associated with enameled fittings of this general type are almost invariably much earlier than the fittings, as seen on the saber with an enameled ram's-head pommel now in the Wallace Collection, London, no. 1540; it is signed Asad Allah of Isfahan and bears the seal of the Safavid shah Sulaiman (r. 1666–94). See Laking 1914, pp. 38–39.

4. Because he signs himself "from Mashhad," it can be assumed that he was working in another center. For a detailed examination of Baqir's work, see Augustin 2009, pp. 99–121.

5. For the blade in the Furusiyya Art Foundation, Vaduz, no. R 199, see Mayer 1962, p. 31, and Paris 2007/Mohamed 2008, p. 85, no. 49; for the example in the Khalili Collection, London, see Alexander 1992, pp. 139–40, no. 82.

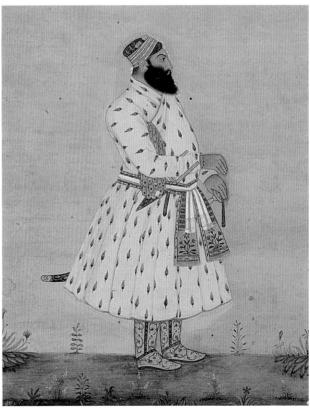

Fig. 30. *Safdar Jang*. Iran, early 18th century. Color and gold on paper. Freer Gallery of Art and Arthur M. Sackler Gallery, Smithsonian Institution, Washington, D.C. (F1907.233)

75 · Dagger Blade

Afghanistan, probably Ghaznavid or Ghurid period, 10th–13th century
Steel, gold
Length (including tang) 5⅜ in. (13.6 cm); blade 4¼ in. (10.7 cm);
weight .45 oz. (13 g)
Purchase, Arthur Ochs Sulzberger Gift, 2005
2005.382

DESCRIPTION: The blade of crucible steel is straight and single edged and has a short tang filed to a sharp point. The flat back edge is gilt; the slightly concave sides taper to a chamfered edge that curves downward as a spur at the base of the blade and tapers upward toward the point. Each side is damascened in gold with delicate linear designs of different patterns. On one side the ornament reads vertically and, from the base upward, consists of a wide, compartmented band enclosing leaf designs, surmounted by a guilloche band and a triangular panel of leaf ornament from which springs on a stem a grotesque birdlike head that confronts a bird; above this is a transverse band, like that at the base, supporting a symmetrical design of two outward-facing birds, a medallion enclosing interlace designs, and a pair of confronted birds amid foliage supporting a third bird above. On the other side the ornament is arranged horizontally and consists of a narrow braided, or guilloche, band parallel to the base, adjacent to which is a triangular panel of entwined-leaf design; parallel to the back edge are three running animals, a hare flanked by two dogs. The first side, unlike the second, has an incised groove along the back edge. The tang has been filed down to a needlelike stem and retains traces of gilding near the blade.

The Museum's dagger blade is related to a recently identified group that can be attributed to Afghanistan and dated broadly to the tenth to thirteenth century A.D. Those daggers are reputed to have come from undocumented excavations in Afghanistan and then sold on the international market; consequently, it is not possible to know exactly where they were found or in what context. The Metropolitan's blade, on the other hand, is said to have been found in Tibet or Nepal, which would indicate the wide diffusion of these objects over the centuries. The blade's well-preserved surfaces show no sign of having been in the ground, confirming the likelihood that it comes from a different source than that of the excavated group.

Key to identifying the Afghan group is a hilt of silver gilt and niello, now in the Furusiyya Art Foundation, Vaduz, that is worked with the representation of a cupbearer;[1] the figure has long braided hair with side curls and wears a costume decorated

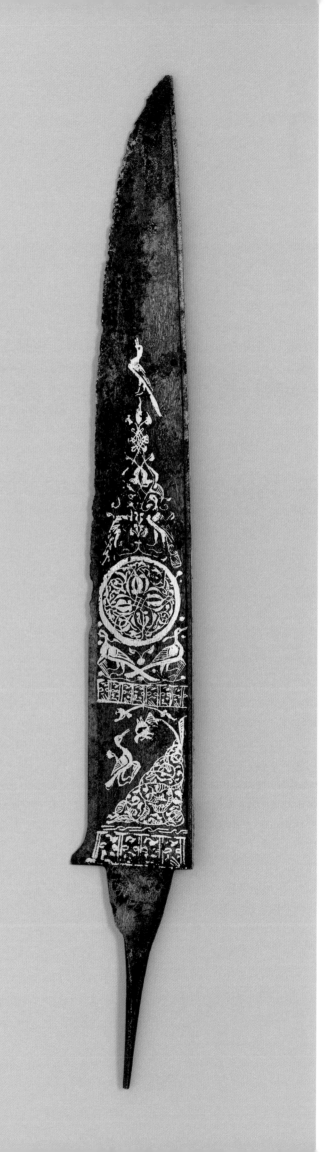

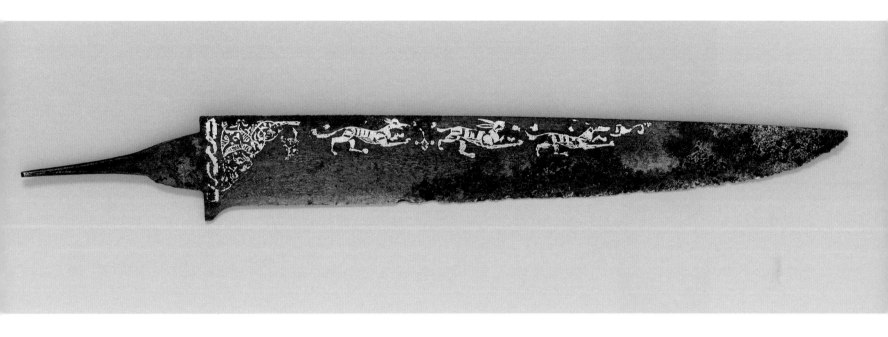

with large bold designs. While these features occur in sixth- to eighth-century paintings from cities along the ancient Silk Road, they also appear in Ghaznavid wall paintings of royal bodyguards from Lashkari Bazar in present-day Afghanistan.[2] The Furusiyya hilt should probably be dated to the Ghaznavid (977–1186) or the Ghurid (ca. 1010–1215) dynasties, which dominated Afghanistan from the tenth to the early thirteenth century.

Three blades from the Afghan group are in the Furusiyya Art Foundation, Vaduz;[3] two of these (nos. R-424 and R-426) are exquisitely and intricately damascened with gold and silver wire ornament of a delicacy that would generally be associated with manuscript illustration from a royal atelier. They are most likely the earliest in the series and should probably be dated to the tenth to eleventh century. The decoration on the third blade (no. R-393), like the Museum's example, is slightly less sophisticated; these two blades perhaps represent the work of less competent craftsmen copying an earlier royal style. The three Furusiyya pieces, whose decoration includes Arabic inscriptions, would seem to belong to the same cultural milieu as the hilt with the cupbearer, described above.[4]

The three Furusiyya blades are each fitted with an iron collar or ferrule at the base of the blade, an element not now present on the Museum's example. The Metropolitan's blade is unusually well preserved by comparison, its "watered" surface still largely intact. Only the forward cutting edge is chipped and corroded. The filed-down tang, which retains traces of gilding, suggests that the blade has been cut down in length.

PROVENANCE: Dhoundrup Khangsar Asian Art, Kathmandu, Nepal.

Unpublished.

NOTES
1. Furusiyya Art Foundation, Vaduz, no. R-418; see Paris 2007/Mohamed 2008, p. 151, no. 144.
2. For Lashkari Bazar, see Schlumberger 1952, pl. 31. For comparisons from such cities as Dandan-Uiliqk, Dunhuang, Kizil, and Panjikent, see, for example, Rice 1965, pp. 211, 216; Azarpay 1981; and Vienna 1996, especially pl. 198.
3. Furusiyya Art Foundation, Vaduz, nos. R-393, R-424, R-426; see Paris 2007/Mohamed 2008, pp. 148, 150, 146, nos. 140, 143, 138, respectively.
4. Interestingly, the schematic decoration immediately below the tang on the Museum's blade is very similar not only to that on Furusiyya, no. R-393 (see note 3 above), but also to one on an eastern European sword of this period, which is now in the Magyar Nemzeti Múzeum, Budapest, no. B67 8521 (unpublished).

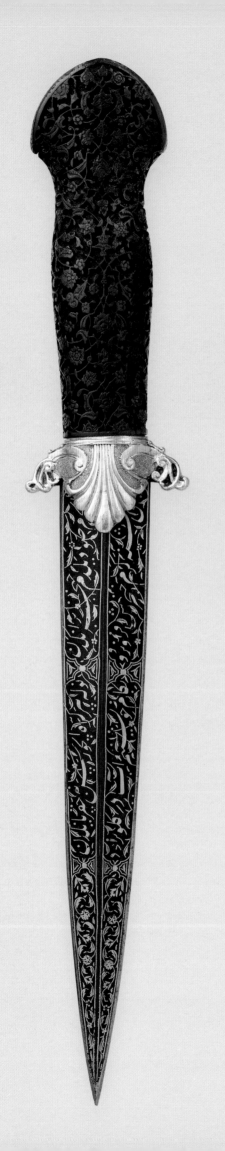

76 · Dagger

Grip and blade, Turkey, Ottoman period, mid-16th century; guard,
Turkey, Ottoman period, 1774–89
Steel, ivory, silver, gold
Length 12⅛ in. (30.7 cm); blade 7⅜ in. (18.7 cm); weight 6 oz. (175 g)
Bequest of George C. Stone, 1935
36.25.670

DESCRIPTION: The grip and pommel are formed from a single piece of green-
stained ivory that is oval in section, swells slightly at the center, and widens near the
top in a bluntly pointed arch-shaped pommel. The ivory is deeply carved with an
exceptionally delicate overall floral scroll composed of lotuses, peonies, and split
leaves. A beaded band outlines the flattened top edge of the pommel. The guard of
silver gilt is cast and chased with scrolls that form the short quillons, with a shell-
like motif between, the background matted with a circle punch. One side of the
guard is stamped with the *tuğra* of the Ottoman sultan Abdülhamid I (r. 1774–89).
The blade of dark gray (crucible?) steel is of flattened diamond section with a raised
medial rib chiseled on each face; it is straight and double edged and tapers to an
acute point, the extreme tip of which is broken off. One side is damascened in gold
with four cartouches enclosing Ottoman Turkish (a) and Persian (b) inscriptions
and with two panels of foliate scrolls at the point; the other side with undulating
foliate designs above and below the medial rib, each register formed of two overlap-
ping tendrils with either split-leaf or trefoil elements.

INSCRIPTIONS:
a. (On the blade, in Ottoman Turkish)

بر ایچوم صو دیلدم خنجر برانکدن نوله برکره ایچورسن نه چقر یانکدن

I asked for a sip of water from your sharp dagger,
What would happen if you were once to make [me] drink [it]? What would leave
your side (i.e., what would you lose)?

b. (On the blade, in Persian)

بحلق تشنه گرم خنجرش فرو نرود بکام خویشتم آب در گلو نرود

Though I am thirsty, his dagger does not go through [my] neck,
Water does not go down [my] throat in the way I wish.

This dagger belongs to a small but distinctive group
of sixteenth-century daggers having straight, double-
edged blades inlaid in gold with Persian and occasion-
ally Arabic or Turkish inscriptions. Anatol Ivanov, who studied
this group, has attributed the majority of the blades to Iranian
workshops because of their inscriptions and *nasta'liq* script,
though he acknowledges that Turkish versions were also known.[1]
For reasons discussed below, this example is considered more
likely to be Turkish.

Our dagger is a composite. The grip and blade are of the six-
teenth century, whereas the guard, struck with the *tuğra* of the
Ottoman sultan Abdülhamid I (r. 1774–89), is in the European-
inspired rococo taste that became very popular at the Ottoman
court in the late eighteenth century. However, the shape of the
guard, with its tightly scrolled quillons and V-shaped quillon
block, recalls the compact form of guards frequently found on

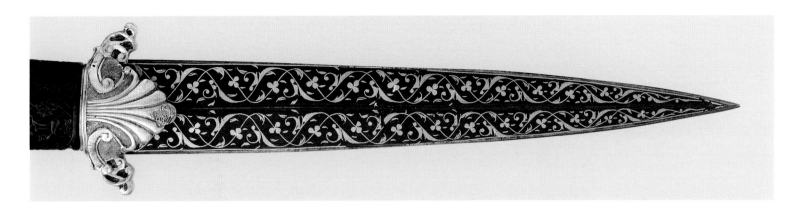

this notable group of daggers, suggesting that the dagger's original such guard may have been damaged and a replacement of generally similar type, but interpreted in an eighteenth-century framework, substituted.[2] The proportion of the grip to the blade is harmonious and suggests that these two elements may originally have been part of the same dagger. Indeed, despite the later guard, the overall appearance of the dagger is probably very close to what it must have been initially.

Deeply carved, the sophisticated composition of the floral scrollwork on the grip of the Museum's dagger recalls similar ivory objects made for the Ottoman court during the reign of Süleyman I (r. 1520–66). Two ivory fans in the Topkapı Sarayı Museum, Istanbul, one of them dated 1543–44, provide direct comparisons.[3]

The unusual green staining of the ivory grip underscores the importance of that color in Islamic thought, where it is generally associated with life itself. In the Qur'an, the color green is one of the signs of God and elicits the idea of tranquility and refuge.[4] In addition, mystics speak about a green light reputedly perceived in the hearts of the spiritually elevated;[5] the Sufi philosopher Ibn al-'Arabi (1165–1240) compares the divine essence to a green ocean in which various misty, short-lived forms appear and vanish.[6] Furthermore, green is said to have been the Prophet's favorite color.[7]

The use of both Ottoman and Persian inscriptions on the blade is characteristic of works produced for the Ottoman court. The verses here are from a poem by the sixteenth-century Turkish poet Necati (d. 1509); another dagger inscribed with the same text is in the National Museum of Scotland, Edinburgh.[8] In light of this, the Museum's blade is likely to be an Ottoman creation, though perhaps directly inspired by similar Persian examples. It should be kept in mind that the Ottoman court was deeply impressed with and influenced by Persian art, and following the conquest of Persia numerous craftsmen were conscripted to work in the imperial ateliers in Istanbul. Strong Persian influence can also be seen in the decoration of an early sixteenth-century yatagan in the Museum's collection (cat. 57).

Of particular iconographic interest, the verses on the blade make a subtle play on the word "water," alluding not only to the "watered," or crucible, steel of sword and dagger blades but also to the martyrdom in 680 of Husayn, grandson of the Prophet, who fruitlessly begged his killers, led by the Umayyad Yazid, for water. The meanings evoked here also include the waters of divine mercy, in particular the waters of paradise that believers and holy martyrs were thought to drink in the hereafter.[9] Numerous Islamic weapons bear inscriptions that refer to the divine water, which the Torah describes as the heavenly dew. Emphasis on the heavenly waters is equally pronounced in the Qur'an and the Torah; the concept reached special prominence for both Muslims and Jews as early as the ninth century, from which period there survive Muslim and Jewish prayers—and objects inscribed with prayers—calling for the heavenly rain.[10] Thus a whole range of Islamic objects embellished with references to and calls for rain or water contains this deeper symbolism. So-called talismans for rain, for instance, are in fact inscribed not with magical calls for rain but with mystical prayers for divine nourishment.[11]

PROVENANCE: S. Haim, Istanbul; George Cameron Stone, New York.

REFERENCE: Alexander 1983, pp. 106–7, fig. 1.

NOTES

1. Ivanov 1979.

2. Ibid., figs. 60, 61, 64–67.

3. See Washington, D.C., Chicago, and New York 1987–88, pp. 138–40, nos. 73, 74.

4. This is echoed in hadith, or traditions, reported by the historian Ibn Ishaq: "The martyrs are at Bariq, a river at the gate of the Garden, in a green tent." See Ibn Ishaq 1955, p. 400, pt. 2, verse 605.

5. Corbin 1983, pp. 87–88.

6. Schimmel 1986, pp. 284ff.

7. It was regarded as the color of the Prophet and of the family of 'Ali; consequently, the Shi'a distinguished themselves from the 'Abbasids by adopting green, and sometimes white, as their color.

8. National Museum of Scotland, Edinburgh, no. 1890.280; see London 1976, pp. 198–99, no. 232.

9. For a detailed discussion of the "water of life," "watered steel," and the rivers of paradise, see Alexander 1983.

10. It is difficult to know in which way the influences ran, but perhaps they were mutually interactive; for the Jewish prayers, see, for example, Goodenough 1989, pp. 151–52.

11. For the rain talismans, see Kalus 1981, pp. 91–100; and Alexander 1983.

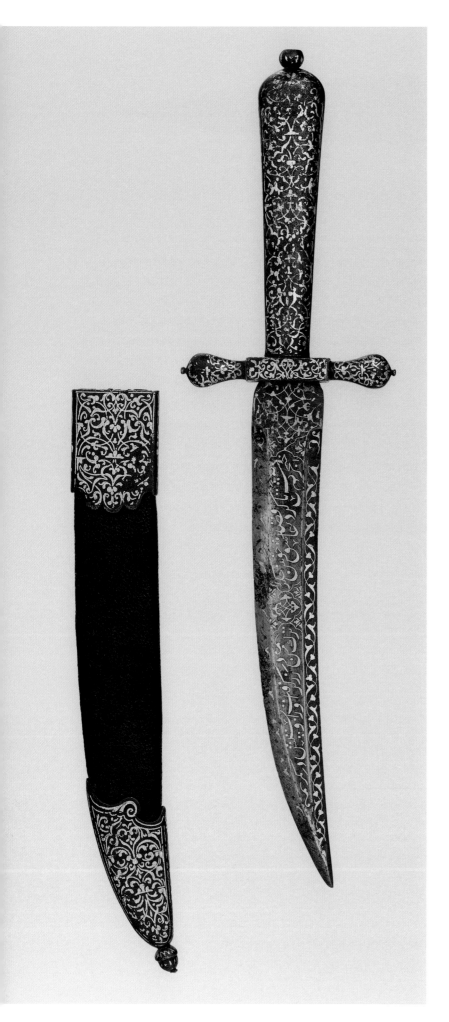

77 · Dagger with Scabbard

Blade, Turkey, Ottoman period, mid-16th century; hilt and scabbard,
Europe, Italy (?), probably mid-16th century
Steel, iron, wood, leather, gold
Dagger: length 10⅜ in. (26.4 cm); blade 6¼ in. (16 cm); weight 7 oz. (191 g)
Scabbard: length 7¼ in. (18.5 cm); weight 2 oz. (55 g)
Gift of Jean Jacques Reubell, in memory of his mother, Julia C. Coster,
and of his wife, Adeline E. Post, both of New York City, 1926
26.145.159a, b

DESCRIPTION: The hilt is entirely of iron, blackened and damascened overall in
gold with arabesques. The grip is of oval section, flattened along the front and back
edges, and expands toward the top, where it is rounded and surmounted by a globu-
lar button. The quillons spring from a rectangular quillon block and are of flattened
oval section, expanding to rounded ends with tiny buttons. The blade of flattened
hexagonal section with a short ricasso is curved, double edged, and tapers to an
acute point. It is inlaid in gold on both sides of the ricasso with a centrally organized
arabesque and along the chamfered edges with two intertwined leafy scrolls (the
decoration along the cutting edge is now almost effaced). The center flat on each
side is decorated with Persian inscriptions (a, b) in cursive script contained within
two lobed cartouches, which are separated by a quatrefoil containing a foliate inter-
lace; the interstices between the cartouches and quatrefoil are filled with flowers.
The wooden scabbard is covered with black leather and mounted with an iron locket
and chape decorated to match the hilt. The locket is of rectangular section with a
lobed lower edge and has a vertically aligned rectangular iron belt loop at the back.
The curved, asymmetrical chape has a scrolled upper edge and terminates in an
acorn-shaped button.

INSCRIPTIONS:

a. (Outer face of the blade)

خنجرش تا كرد قصد عاشق خونين جگر ترك من در زر گرفت او را و بستش در کمر

Once his dagger had aimed for the bloody-livered lover,
My Turk wrapped it in gold (i.e., its sheath) and tied it to his waist.

b. (Inner face of the blade)

بکش خنجر که جان بهر تو ای نا مهربان دارم تو خنجر در ميان داری و من جان در ميان دارم

Draw your dagger, because I keep my soul for you, O unkind one!
At your waist you have a dagger while I have my soul at mine.

The hilt and the scabbard mounts are typically European in form and of the mid-sixteenth century. The Ottoman blade is inscribed in a style found on a number of sixteenth-century blades.

The verses here are comparable to those on a group of blades inscribed with poetry that explores the relationship between love and death.[1] Some of these must certainly be interpreted mystically, following the teachings of the Sufi mystic and poet al-Hallaj (ca. 858–922), to mean that the individual sacrifices himself through his love of God.[2] Indeed, in this view the ultimate way to reach God is by means of sacrifice. The influence of al-Hallaj was profound, particularly on some of the dervish groups; the Bektashi even featured a gibbet, one element of al-Hallaj's public execution for heresy, in their initiation ceremonies.

Not all such verses should be interpreted in a mystical sense, however. Many should be regarded as secular in intent, merely following the established canons of mystical prose. It is difficult to decide whether this example is of a mystical nature. Although the sentiments expressed certainly seem secular, the word employed here for "lover" is عاشق (*ashiq*), a generic term used by lay members of the Bektashi dervishes; consequently, "lover" in this instance might be interpreted as "lover of God," and the verse would therefore perhaps refer to the mystical annihilation or loss of self of the lover in God (the beloved). Bernard Lewis has pointed out that during the fifteenth and sixteenth centuries the word *ashiq* was applied to "wandering poet-minstrels" whose repertories included heroic, erotic, and mystical songs.[3] Perhaps the verse on the Museum's dagger derives from such a tradition. Whatever the case, most of the verses found on daggers such as this one remain unidentified, and their precise meaning elusive.

PROVENANCE: Jean Jacques Reubell, Paris.

REFERENCES: Dean 1929, p. 77, no. 27, pl. 96; Alexander 1983, pp. 107–9, fig. 2.

NOTES
1. See also dagger cat. 76 and Ivanov 1979. Will Kwiatkowski has noted (personal communication, March 2015) that these verses are typical of courtly love poetry, in which the beloved is portrayed as bloodthirsty and violent. In Persian poetry the beautiful and bellicose lover was sometimes depicted as a Turk, as in the famous *ghazal* (a poetic form akin to the English sonnet) of the poet Hafiz. Such verses could also be interpreted metaphorically, with human love standing for the divine.
2. For al-Hallaj, see Massignon 1982, especially the accounts in which al-Hallaj begs for martyrdom (p. 289).
3. See Lewis 1960.

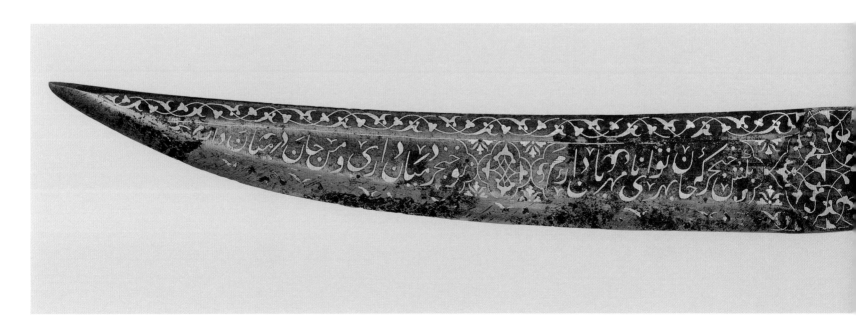

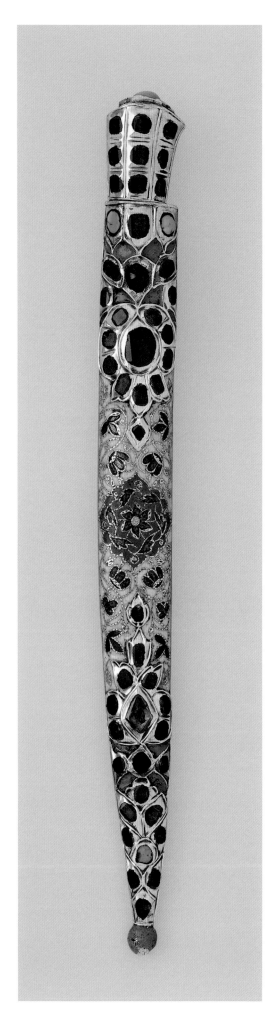
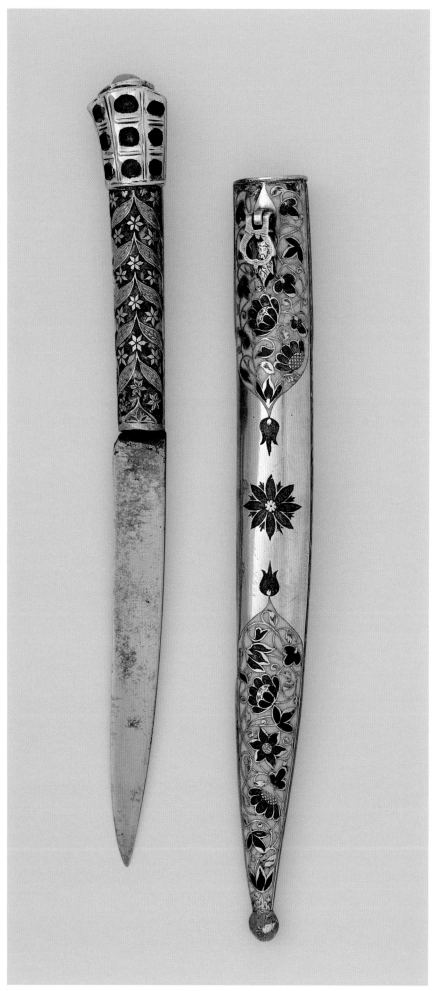

78 · Knife with Scabbard

Turkey, Ottoman period, ca. 1660–1700

Steel, gold, enamel, ruby, turquoise

Knife: length 6½ in. (16.4 cm); blade 3½ in. (9 cm); weight 1 oz. (32 g)

Scabbard: length 6¼ in. (15.8 cm); weight 2 oz. (47 g)

Gift of J. Pierpont Morgan, 1917

17.190.821a, b

DESCRIPTION: The guardless hilt is of enameled gold. The columnar grip tapers slightly toward the blade and is flattened along the front and back edges. Each side is engraved with vertically aligned pairs of leaves arranged chevronlike, with six-pointed stars or flowers between; the leaves are enameled opaque pale blue, the interstices translucent green. The edges are engraved with geometric ornament against an opaque blue ground. The pommel is slightly larger than the grip and is asymmetrical, with one edge projecting slightly as a "beak." The sides are faceted to form nine slightly concave compartments divided by ridges, each compartment set with table-cut rubies; the flattened edges are engraved with geometric ornament and foliate scrolls against an opaque blue ground. The top is set with a cabochon turquoise within a raised tulip-shaped mount, the surrounding area with six circles of opaque white enamel against a translucent green ground. The plain, single-edged blade of brightly polished steel curves slightly downward and tapers to an acute point. The scabbard, also of gold, is of pointed oval section and ends in a pointed globular terminal enameled opaque green. The outer face at the top and bottom has raised leaf-shaped settings enclosing table-cut rubies and several cabochon turquoises, with opaque green enamel filling the interstices. The center section is engraved with scrolling tendrils and leaves, the latter enameled translucent green, on an opaque bluish-white ground. In the center is a lobed medallion engraved with a central flower and surrounding leaves, these in translucent green on an opaque blue ground. The back of the scabbard is enameled at the top and bottom with a pointed panel filled with foliate scrolls incorporating sunflower-like blossoms with rounded petals, these in translucent green, with touches of red, and opaque blue on a bluish-white ground; each panel terminates with a leaf enameled translucent green. The central section is engraved with a symmetrical flower in translucent green against the gold ground. The flattened back edge is engraved with scrolling tendrils on an opaque blue ground, as on the hilt. A hinged suspension loop with foliate mounts is attached near the top of the scabbard on the back.

Fig. 31. Detail of "Interior Reception," folio from a *Bustan* of Sa'di. Painted by Shaikh Zada. Present-day Uzbekistan (probably Bukhara), ca. 1525–35. Ink, opaque watercolor, and gold on paper. The Metropolitan Museum of Art, New York, Purchase, Louis V. Bell Fund and The Vincent Astor Foundation Gift, 1974 (1974.294.3)

Small knives such as this one, with straight or very slightly curved single-edged blades and straight guardless hilts tapering toward faceted ferrules that abut the blades, are stylistically rather like common utility knives. Examples are preserved from as early as the eleventh to twelfth century (see cat. 75).[1] They are also frequently depicted in miniature paintings of the Timurid period (1370–1500), as seen in a scene from a *Bustan* of the Persian poet Sa'di painted in Bukhara in 1514, in which they are suspended from cords attached to a belt (fig. 31).

The dagger is designed to fit deeply into the scabbard so that only the tip of the pommel is visible.

Daggers of this guardless type are referred to in Persian as *kards* (see cat. 89). However, Ottoman daggers of this type generally differ from those used in Iran: the Ottoman pommels are larger and asymmetrical, a stylistic feature not confined to small daggers such as this but also seen on much larger examples. These include sets of three daggers with pommels of the same shape as the Museum's weapon, contained together in elaborately

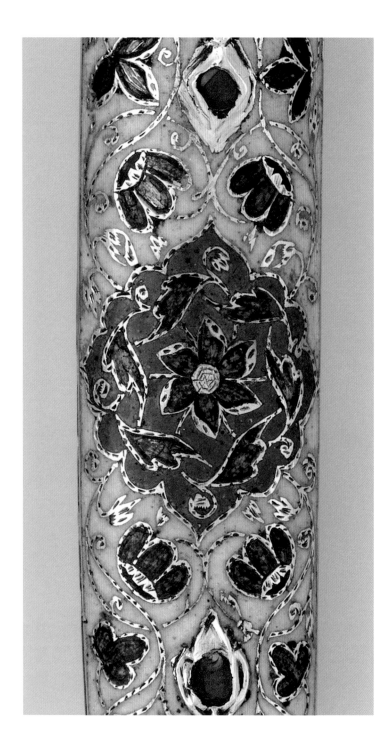

worked scabbards of silver gilt and enamel; one example was formerly in the Hanover Collection and is dated A.H. 1068 (A.D. 1657/58), while another is in the Rüstkammer of the Staatliche Kunstsammlungen Dresden and first appeared in an inventory of 1697.[2]

Not only is the pommel of the Metropolitan's dagger similar to these seventeenth-century examples, but its enameled decoration as well as its step-cut gems and their raised settings suggest a similar dating. Comparable enamelwork is found on a dagger scabbard in the Livrustkammaren, Stockholm; on another in the Topkapı Sarayı Museum, Istanbul; and on a third in the Badisches Landesmuseum, Karlsruhe.[3] These examples are worked with the same configuration on jeweled sections at either end framing an enameled center. The Topkapı dagger was given in 1663 to the Ottoman sultan Mehmed IV (r. 1648–87) by his mother, Hadice Turhan Sultan; the Karlsruhe example was recorded in 1691. Our dagger should also be dated to the second half of the seventeenth century.[4]

PROVENANCE: J. Pierpont Morgan, New York.

Unpublished.

NOTES

1. Two additional examples are in the Furusiyya Art Foundation, Vaduz, nos. R-271, R-419; see Paris 2007/Mohamed 2008, p. 149, nos. 141, 142.
2. For the Hanover dagger, see Sotheby's Hanover 2005, vol. 2, lot 142; and *Fine Antique Arms and Armour* 2008, no. 19. For the Dresden example, see Schuckelt 2010, pp. 262–63, no. 238.
3. For the Livrustkammaren dagger, no. 1004, see Nordström [1984], pp. 250–51, no. 6; and Stockholm 1985, pp. 16–17, no. 12. For the Topkapı dagger, no. 2/152, see Washington, D.C., and other cities 1966–68, p. 113, no. 239. For the Karlsruhe example, see Petrasch et al. 1991, pp. 197–98, no. 143.
4. See also Rogers 1987a, pp. 194–95, no. 44, all nn. Another example on which areas of gemstones frame enameled work is an Ottoman saber given to Czar Ivan V Alekseyevich (r. 1682–96), Kremlin Armory, Moscow, no. OR-4567/1-2; see Madrid 1990, no. 96.

79 · Dagger with Scabbard

Hilt, probably India, 18th century; blade and scabbard,
Turkey, Ottoman period, second half of the 19th century
Steel, gilt copper, nephrite, agate, colored stones, gold,
silver
Dagger: length 16⅝ in. (42.3 cm); blade 11⅝ in. (29.5 cm);
weight 1 lb. 2 oz. (505 g)
Scabbard: length 13¼ in. (33.7 cm); weight 8 oz. (229 g)
Bequest of George C. Stone, 1935
36.25.994a, b

DESCRIPTION: The hilt of pistol-grip shape is formed of grayish-white
nephrite inlaid with variegated agate, colored stones, and foiled crystals
in gold and silver settings arranged in an overall pattern of flowers and
leaves. The flowers in the center of the pommel and guard are of carved
crystal on yellow foil, with red centers; the flower at the guard has green
leaves and red stones, and red stones are set into the faces and sides of
the scrolled quillons. A flower on the curled underside of the pommel is
set in gold with red petals with a faceted crystal in the center. The leaves
are of agate, several with red-foiled crystals at their bases. The blade of
crucible steel is curved and double edged. It is chiseled in relief near the
hilt on each face with stylized floral forms and, in front of this, with two
narrow fullers converging at the point. Each face is damascened in gold
in a panel below the hilt with Arabic inscriptions (a) and along the edges
of the blade with Persian inscriptions (b). Each face also has a tiny
teardrop-shaped cartouche at the base of the fullers containing a call to
God and a name of God in Arabic, respectively (c). The wood-lined scab-
bard is of gilt copper embossed with strapwork and leafy arabesques
against a tooled matte ground. The mouth of the scabbard is fitted with a
framing band of green stones. Applied to the upper half of the scabbard
on the outer face is an openwork mount of gold (?) set with rubies and
emeralds, mostly facet cut, that includes a turban and panoply of arms; a
circular arrangement of green stones below the turban centers on a large
cabochon emerald. An applied garland of gilt copper frames the upper
half of the mount. A smaller openwork jeweled mount is applied at the tip
and terminates in a large pointed emerald. Two small gilt-copper suspen-
sion loops are fixed at the sides near the top.

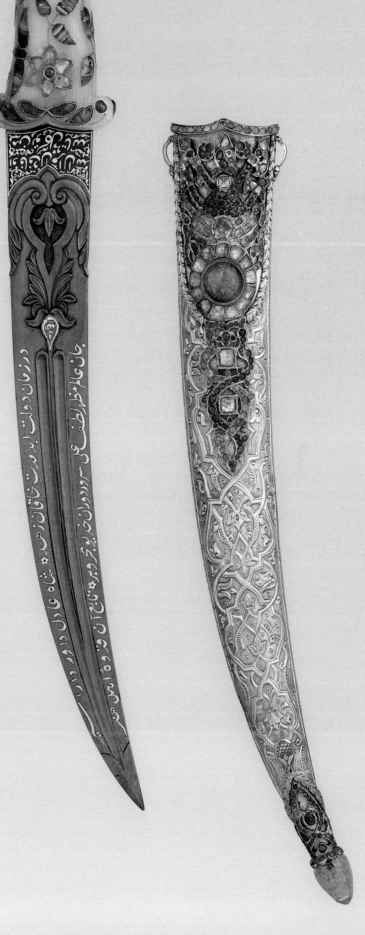

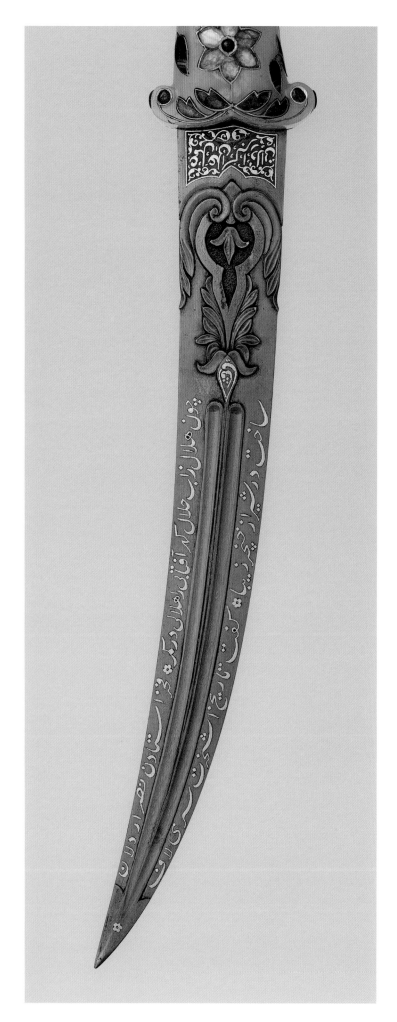

INSCRIPTIONS:

On the outer face

a. (Below the hilt)

اوفاف ذل امر ال الله [كذا] (أفوض امري لله)
من توكل تالله [كذا] (من يتوكل على الله)

My (own) affair I commit to Allah. (Qur'an 40:44)
(And if any one puts) his trust in Allah, sufficient is (Allah) for him. (Qur'an 65:3)

b. (Along the edges of the blade)

در زمان دولت ابد مدت خاقان زهر [كذا] (زاهر؟) / شاه عادل داور دارا سير
جان [كذا] عالم مظهر لطف على سرور دوران خديو بحر و بر / تابع آن قدوه اهل هنر

In the time of the eternally lasting rule of the radiant (?) ruler (*khaqan*), the just shah, the monarch with the nature of Dara,
The Khan of the World, the locus of 'Ali's kindness, the leader of the era, the lord (*khediv*) of land and sea. [Made by] the follower of the chief of artisans.

c. (In a teardrop-shaped cartouche)

يا الله

O Allah!

On the inner face

a. (Below the hilt)

عمل على اكبر اردلانى

Made by 'Ali Akbar Ardalani.

b. (Along the edges of the blade)

چون هلال زآب حلال گهر آفتابى را هلالى در كمر / فخر استادان نصر [كذا] اردلان
ساخت در شيراز خنجر زيبا / گفت تاريخ اشخرت سرى لاف

Like a crescent moon, from water . . . gems, for a sun has a crescent in its belt.
The pride of masters, Nasir of Ardalan, made the beautiful dagger in Shiraz . . . said the date.

c. (In a teardrop-shaped cartouche)

يا فتا[ح]

O Opener!

The dagger is a composite piece, with an Indian hilt fitted with an Ottoman blade and scabbard. These three elements must have been united in the Istanbul bazaar during the second half of the nineteenth century. The nephrite hilt is of a typical Indian pistol-grip form, although the agate inlay is somewhat unusual, suggesting that it may have been a plain eighteenth- or nineteenth-century Indian example that was subsequently decorated in Turkey; the scabbard is embossed and set with jewels in a commonplace Ottoman style of the nineteenth century. The boldly chiseled floral decoration on the blade is in a style found on a large number of dagger blades, many of which are inscribed with spurious dates of the sixteenth, seventeenth, and eighteenth centuries[1] and which are invariably embellished with elaborately decorated and heavily jeweled mounts of

nineteenth-century Turkish type. It is difficult to attribute these blades to a specific center of production, though most likely they were made in Istanbul, where the completed weapons were sold.

The inscriptions on the Museum's blade mimic very similar inscriptions found on two other daggers. One of these is in the British Museum, London, and is dated A.H. 1184 (A.D. 1770/71); the other is in the Freer Gallery, Washington, D.C., and is dated A.H. 1191 (A.D. 1777/78).[2] On both daggers, however, the inscriptions are chiseled on the all-steel I-shaped hilts and scabbards of

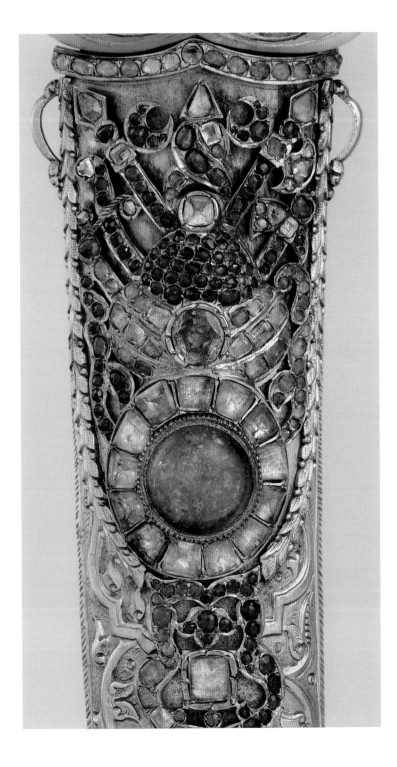

distinctly Iranian type rather than damascened on the blade, as in the Museum's example. The original inscriptions—including two Qur'anic quotations; praise of a Zand ruler; a couplet likening the owner to the sun, the dagger to a crescent moon in his belt, and the watered blade to gems; a chronogram giving the date of production; and the name of the maker (Nasir of Ardalan)—have here been copied out of order and in garbled form. As the part of the inscription containing the name of the maker was not understood, the name of another maker ('Ali Akbar Ardalani) has been added. The mistakes and misspellings are ample proof that the Museum's inscription has been copied from the Freer dagger, or another very similar one, at some later date.

This dagger is but one of a group of flamboyant, gem-studded edged weapons that were probably made in Istanbul during the second half of the nineteenth century. Common features of this group include the use of repoussé silver-gilt or gilt-copper sheet worked with dense designs of strapwork and split-leaf arabesques for sheathing scabbards; a lavish display of faceted gems or colored glass set into applied filigreed strapwork settings; the frequent use of Indian hardstone hilts; and blades of crucible steel, chiseled in bold relief with simple scroll or palmette designs or perhaps pierced, and often damascened in gold with inscriptions and spurious dates. Most of these jeweled weapons were made largely for the benefit of wealthy European and American tourists.[3]

PROVENANCE: S. Haim, Istanbul; George Cameron Stone, New York.

REFERENCES: Grancsay 1937a, p. 57, fig. 4; [Nickel] 1968, p. 220, no. 40, ill.; Alexander 1983, p. 108, fig. 4; New York 1985–86a, p. 18; Grancsay 1986, p. 167, fig. 63.7.

NOTES

1. See, for example, Hasson 1987, pp. 149–50, nos. 216, 218.

2. British Museum, London, no. 78 12–30 902; Freer Gallery of Art, Washington, D.C., no. 39.44. Both examples are published in Washington, D.C. 1985–86, p. 217, fig. 71, and pp. 214–19, no. 35, respectively.

3. Nine further examples in the Metropolitan Museum came from the collection of Giovanni P. Morosini (1832–1908), who acquired them in Istanbul about 1900 (acc. nos. 23.232.1–.9; see Dean 1923a). One of these, the saber of Murad V (see cat. 66), is of much finer materials and workmanship and must be considered apart from the rest. Another six examples (unpublished) are now in the George F. Harding Collection at the Art Institute of Chicago (nos. 1982.2162–.2167), having originally been acquired by an American collector visiting Istanbul in 1904. Four of the blades are dated: A.H. 985 (A.D. 1577/78), A.H. 1099 (A.D. 1687/88), A.H. 1118 (A.D. 1706/7), and A.H. 1128 (A.D. 1715/16). Several more weapons of this type were also acquired by Henry Walters (1848–1931) and are now in the Walters Art Museum, Baltimore (among them nos. 51.6, 51.84, unpublished).

80 · Dagger with Scabbard

India, Mughal period, 1605–27
Steel, iron, gold, rubies, emeralds, glass, wood, textile
Dagger: length 13⅜ in. (33.9 cm); blade 9⅛ in. (23.2 cm);
weight 13 oz. (357 g)
Scabbard: length 10¼ in. (26 cm); weight 4 oz. (113 g)
Purchase, Harris Brisbane Dick Fund and The Vincent
Astor Foundation Gift, 1984
1984.332a, b

DESCRIPTION: The hilt of gold over an iron core is profusely inlaid with table-cut
rubies (or spinels) and emeralds arranged in an overall leaf-and-petal design, the
framing gold areas engraved with minute foliate ornament, scrolls, and figures of
birds and animals. The cylindrical grip expands toward the top, where it is bifur-
cated. The faces of the grip are decorated with vertically organized large lotus and
peony (?) flowers with ruby petals and large emerald leaves, the surrounding areas
filled with leaf-and-petal scrolls in the same stones. Each face of the grip is outlined
by a narrow band of rubies at the sides and by pavé emeralds across the top. The
bifurcated faces of the grip are beveled away from one another; the beveled areas
are inlaid with a flower-and-leaf motif in rubies. The shim separating the two faces
is covered with pavé emeralds. A transverse band of cabochon emeralds divides
the grip from the guard. The guard consists of two short, straight quillons and
short, pointed langets; the tip of one langet is broken off, revealing the iron core.
In the center of the quillon block is a peony in rubies with emerald leaves within a
diamond-shaped frame of rubies. The rounded quillon faces are covered with a scale
design in rubies and expand toward the tips, each set at the end with a large cabo-
chon emerald; the quillon tips show signs of damage and repair, with the likelihood
that the emeralds and their crude gold settings are modern replacements. The flat
upper sides of the quillons are decorated with a leaf-and-petal scroll in rubies and
emeralds. Several small leaves on the grips and on the guard are inlaid with what
appears to be blue glass. The blade of crucible steel is of thick diamond section and
is straight and double edged; at the forte it has a long, arch-shaped recess, with a
prominent medial ridge, where the fine "watered" pattern is evident. The edges of
the blade are polished bright and are now stained by corrosion. The wood scabbard
is covered with worn red velvet (a modern replacement) and has a jeweled gold
locket and chape decorated to match the hilt. The locket is shaped at the top to
receive the langets and has a lobed and pointed lower edge; at the back is a swiveling
suspension ring. The chape has a lobed upper edge and a raised horizontal band of
emeralds below it. The edges of both mounts are outlined with pavé emeralds.

This exquisite dagger belongs to a small group of sump-
tuously jeweled gold objects probably made in the court
workshops of the Mughal emperor Jahangir (r. 1605–27);
these works include a dagger in the Dar al-Athar al-Islamiyya,
al-Sabah Collection, Kuwait City, and a ceremonial spoon and an
archer's thumb ring in the Victoria and Albert Museum, London.[1]
Cylindrical hilts of this type were originally constructed from
either one or two pieces of nephrite or ivory that were fastened to

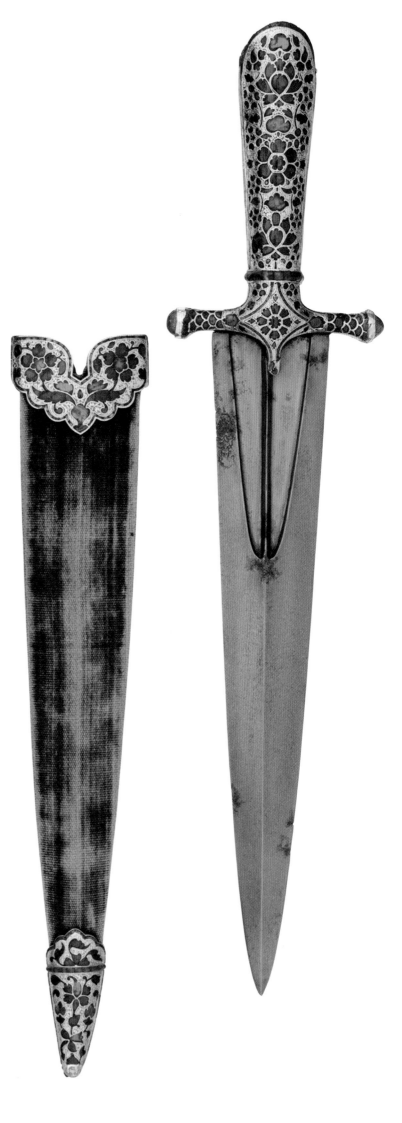

each side of the tang and sometimes framed by a metal shim. In Mughal examples of the sixteenth and seventeenth centuries, the grip plaques of nephrite or metal protruded to create a split pommel. Daggers with such pommels first appear in imperial Mughal painting of the early seventeenth century,[2] and although some paintings show similar daggers worn by Iranians, it seems most probable that they were a Mughal invention.[3] By the late seventeenth century they were also seen in Deccani painting; one can assume that by this date such daggers were popular throughout Muslim India.[4] The technique used for the settings on the hilt and scabbard is known as *kundan*: gold is purified until it becomes malleable at room temperature, at which point the gemstones can be pushed into place relatively easily.[5]

Another related dagger, in the Furusiyya Art Foundation, Vaduz, is perhaps slightly later in date,[6] as it is characterized by the use of heavier settings for the stones and lacks the finely worked subsidiary design used to decorate the other objects in the group. Stylistically, the settings on the Furusiyya dagger are very similar to those on a dagger in the State Hermitage Museum, Saint Petersburg, that was first recorded in 1730 as being in the Kunst-kammer of Peter I.[7] These two daggers should probably be dated to the late seventeenth or early eighteenth century, indicating the longevity of this style.

PROVENANCE: Sotheby's, New York (purchased by private treaty).

REFERENCES: Alexander 1985a; New York 1985–86b, no. 133; *Islamic World* 1987, pp. 142–43, no. 110; Nickel 1991a, p. 51; Bala Krishnan and Shushil Kumar 1999, p. 114, fig. 161; Melikian-Chirvani 2004, p. 24, figs. 18, 19; Paris 2007/Mohamed 2008, p. 184, s.v. no. 172; David G. Alexander and Stuart W. Pyhrr in Ekhtiar et al. 2011, pp. 365–66, no. 255.

NOTES

1. For the dagger in the Dar al-Athar al-Islamiyya, al-Sabah Collection, Kuwait City, no. LNS 25 J, see New York 1985–86b, pp. 126–28, fig. 127, and London and other cities 2001–2, pp. 56–57, fig. 5.2. For the spoon and thumb ring in the Victoria and Albert Museum, London, nos. IM. 173.1910, IM. 207-1920, see

New York 1985–86b, pp. 200–201, nos. 128, 129, and Bradford and London 1988–89, no. 93. Manuel Keene attributed the group to the early seventeenth century by comparison with an archer's ring made for Shah Jahan (r. 1627–58); see London and other cities 2001–2, pp. 56–57.

2. Daggers with hilts like the Museum's example appear frequently in miniature paintings from the period of Jahangir, and in many instances, but not invariably, are worn by the emperor himself. See, for example, the *Padshahnama* of Shah Jahangir in New Delhi and other cities 1997–98, pls. 12, 24, 37, 39.

3. See Williamstown and other cities 1978–79, p. 109, pl. 36, in which a dagger possibly of this type is carried by Shah ʻAbbas I of Iran (r. 1588–1629).

4. See, for example, daggers of this type in a miniature painting of about 1680 from Bijapur in the Deccan in the Metropolitan Museum, acc. no. 1982.213, published in New York 1985–86b, no. 208, ill.

5. Described by Keene in London and other cities 2001–2, p. 18; see also Keene 2004.

6. Furusiyya Art Foundation, Vaduz, no. R-59; see Paris 2007/Mohamed 2008, p. 184, no. 172.

7. State Hermitage Museum, Saint Petersburg, no. OR-452; see Kuwait 1990, pp. 132–33, no. 112.

81 · Dagger

Hilt, India, possibly Deccan, 17th century; blade, Turkey or
Iran, probably 17th century
Steel, nephrite, rubies, gold
Length 15½ in. (39.4 cm); blade 10⅝ in. (27 cm); weight 9 oz. (248 g)
Bequest of George C. Stone, 1935
36.25.666a

DESCRIPTION: The hilt of white nephrite is constructed of three pieces, the pommel,
grip, and guard; the join between the pommel and the grip is covered by crumpled
gold foil, the join between the grip and the guard by a gilt-copper washer. The pom-
mel, of inverted-T section, is shaped like a chevron, concave toward the grip, with
lobed upper edges and a bud-shaped finial; its base is carved with a raised band at
the join. The baluster grip of octagonal section tapers toward the pommel and has a
raised band at the upper join. The flat guard echoes the chevron shape of the pom-
mel. The surfaces of all three sections are inlaid almost flush with leaf-shaped
rubies, the points upward, in *kundan* settings with short "stems"; the edges of the
pommel and guard are outlined with bands formed of square-cut rubies in gold
settings. The blade of crucible steel is curved and double edged, though unsharp-
ened; the tang has been welded on. It is chiseled at the forte with a palmette-topped
panel damascened in gold with foliate scrolls, with a pierced central groove in which
roll six tiny ruby and emerald balls, three of each. The central section of the blade is
slightly recessed, the end near the point irregularly shaped and terminating in a
fleuron, and pierced down the center with two parallel slots chiseled with tracery
and outlined by engraved lines. Crosshatching along the edges, at the point, and on
the piercings of the blade indicate that much more of the surface was originally
damascened. The dagger was acquired with a later gilt-copper scabbard (36.25.666b),
not illustrated, which is undecorated; it has a flaring throat piece shaped to fit the
guard, a small suspension loop, and a bud-shaped finial.

 The hilt has lost some rubies, notably one on the button, several set pavé-style
along the edge of the pommel, as well as those on the transverse bands at either end
of the grip. The same crumbly gold foil as seen on the upper band is also found
beneath the missing stones on the edge of the pommel. The gilt-copper washer at
the base of the grip has punched dots along its inner edges that presumably once
helped secure a band of foiled rubies.

F rom the sixteenth century on, pierced blades were
popular in Turkey, Arabia, Iran, and India, and there are
a number of examples in the Museum's collection.[1] In
several respects the blade of this dagger is similar to that of
cat. 92, dated to the eighteenth–nineteenth century, notably in
the pierced leaf forms below the lobed section that contains a slot
for the "rolling balls"—which here are tiny polished rubies and
emeralds that were strung on a wire dropped through a hole at
the top of the blade before the tang was welded on. The same
feature also occurs on a late sixteenth- or early seventeenth-
century Ottoman dagger in the Landesmuseum Württemberg,
Stuttgart, and on another almost identical example in the

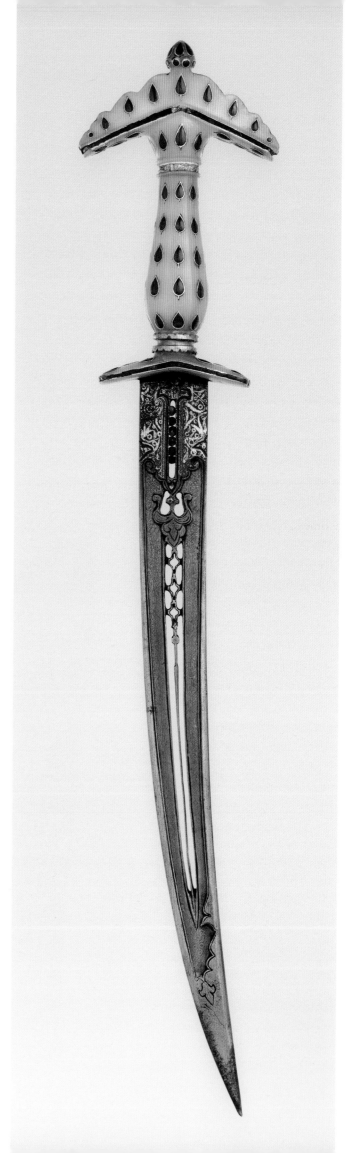

Rüstkammer of the Staatliche Kunstsammlungen Dresden, all of which indicates that dagger blades in this style were probably produced over a long period of time.[2] It is uncertain where these pierced blades—as opposed to their fittings—were crafted, whether they originated from one center of production in Iran or Turkey or whether the style was widely imitated. The blade of this dagger is embellished with a coherently executed arabesque design, which in later examples of the eighteenth to nineteenth century degenerates into disconnected floral motifs, suggesting that this more finely worked blade is probably of the seventeenth century.

Indigenous to India, daggers fitted with hilts of this type are known as *chilanum* and are characterized by an elongated splayed pommel and guard, sometimes chevronlike or curved to create a double crescent, usually with baluster-shaped grips; in some examples the forward quillon is curved upward to form a knuckle guard. The hilt type probably originated in the Deccan.[3] Among the earliest representations of the type appears in a Deccani miniature dated about 1555, which portrays Sultan Husain Nizam Shah I of Ahmadnagar (r. 1553–65) wearing a *chilanum* in his belt (fig. 32). Numerous examples also appear in Mughal miniatures from the time of Akbar I (r. 1556–1605), where most of the hilts appear to be of gilt metal and have globular elements in the center of the grips, but are otherwise unembellished.[4] In the seventeenth century the daggers were often worked in nephrite and were more elaborately decorated, usually with colored gems.[5]

The hilt of this dagger, like the blade, seems to be relatively early in date, presumably also of the seventeenth century. It is decorated with restraint and clarity, in contrast to the overabundance of ill-cut gems found on later hilts.[6] As with much Indian

jewelry and jeweled daggers, the hilt of the Museum's example is difficult to attribute to a particular center because there are no precisely dated parallels. It is, however, similar in construction and form (but not decoration) to a dagger in the Furusiyya Art Foundation, Vaduz, that is also constructed in several parts and has a baluster-shaped grip that is octagonal in section.[7] The Furusiyya dagger can be dated to before 1730 by comparison with a similar piece in Saint Petersburg.[8] In addition, there are a number of nephrite sword and dagger hilts decorated with rows of stones in *kundan* settings all very similar in conception to the decoration of the Museum's dagger. These have recently been dated by Manuel Keene to the mid- to late seventeenth century.[9] Consequently, the Museum's dagger is tentatively attributed here to approximately this period.

PROVENANCE: Devine; George Cameron Stone, New York.

REFERENCE: Stone 1934, p. 366, fig. 460, no. 1.

NOTES

1. Examples in the Metropolitan Museum's collection include what may be an Indian blade of seventeenth-century type with two slots near the hilt filled with rolling steel balls, acc. no. 36.25.1037; four nineteenth-century Turkish examples, acc. nos. 23.232.7, 23.232.8, 36.25.993, 36.25.1003; and a blade associated with Arab mountings, cat. 92. For a discussion of pierced blades, see Ivanov 1979.

2. The Stuttgart dagger, no. E.7260, which has two slots for rolling balls, is recorded in the Kunstkammer of Herzog Johann Friedrich in 1616; see Fleischhauer 1976, p. 16, fig. 35. For the Dresden dagger, no. Y139, a gift from Emperor Matthias to Prince-Elector Johann Georg I of Saxony in 1617, see Schuckelt 2010, p. 140, no. 123, ill. p. 108 (detail). The "balls" of the Dresden dagger are seed pearls.

3. The type appears in Buddhist cave paintings at Ajanta of the fifth to seventh century A.D.; see Rowland 1971, pl. 186. It also occurs in Jain painting of about 1400; see Barrett and Gray 1978, p. 57.

4. See an image in the *Anvar-i Suhayli* (1570) in S. Welch 1978, pl. 4. For Mughal examples, such as the miniatures painted for the *Hamzanama* (ca. 1562–77) and the *Akbarnama* (1590s), see Stronge 2002, pls. 9, 21, 25, 27, 30, 31.

5. Later examples in miniature paintings can be seen in the *Padshahnama* of Shah Jahan (Royal Library, Windsor Castle), in which several jeweled *chilanum* are illustrated; see New Delhi and other cities 1997–98, no. 9 (painted ca. 1640).

6. A similar allover pattern of ruby leaves with short gold stems that adorns a nephrite fly whisk and belt ornament in the Dar al-Athar al-Islamiyya, al-Sabah Collection, Kuwait City, is attributed to a mid-seventeenth-century or slightly later Mughal or Deccan workshop; see London and other cities 2001–2, pp. 38, 41, nos. 2.18, 2.26.

7. Furusiyya Art Foundation, Vaduz, no. R-59; see Elgood 2004b, p. 166, fig. 16.8 (right).

8. A dagger with very similar *kundan* settings is in the State Hermitage Museum, Saint Petersburg, no. OR-452, and is recorded as being in the Kunstkammer of Peter I in 1730; see Kuwait 1990, no. 112.

9. London and other cities 2001–2, pp. 38, 42–43, 78–79, nos. 2.18, 2.31, 6.39.

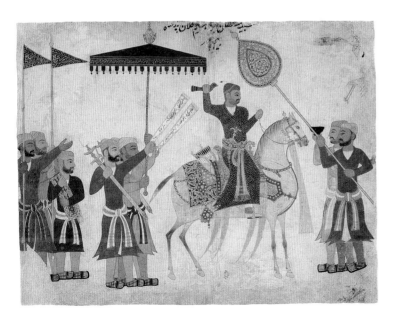

Fig. 32. *Sultan Husain Nizam Shah I on Horseback*. Ahmadnagar, ca. 1555. Ink, opaque watercolor, gold, and silver on paper. The sultan wears a *chilanum*. Cincinnati Art Museum, John J. Emery Endowment (1983.3110)

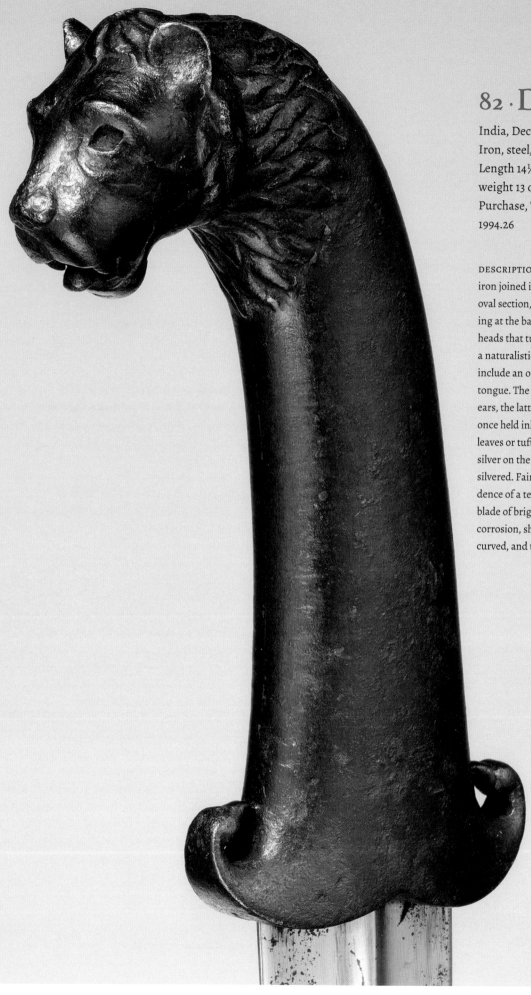

82 · Dagger

India, Deccan, second half of the 17th century
Iron, steel, silver, copper
Length 14⅛ in. (36 cm); blade 9⅝ in. (24.4 cm);
weight 13 oz. (363 g)
Purchase, The Sulzberger Foundation Inc. Gift, 1994
1994.26

DESCRIPTION: The hilt of pistol-grip shape is constructed of dark
iron joined in several sections by copper brazing; it is of flattened
oval section, tapering toward the curved pommel and expand-
ing at the base with two small quillons shaped as stylized birds'
heads that turn back to touch the grip. The pommel is formed as
a naturalistic lion head, with carefully delineated features that
include an open mouth with individual teeth and a projecting
tongue. The hollow eye sockets and a circular recess between the
ears, the latter framed by radiating tufts of hair, undoubtedly
once held inlays, probably jewels in *kundan* settings. Stylized
leaves or tufts of hair are chiseled beneath the eyes. Traces of
silver on the mane suggest that at least part of the hilt was once
silvered. Faint horizontal striations across the grip provide evi-
dence of a textile or cord wrapping, now missing. The associated
blade of brightly polished steel, now deeply pockmarked with
corrosion, shows no signs of watering; it is double edged, double
curved, and thickened at the point.

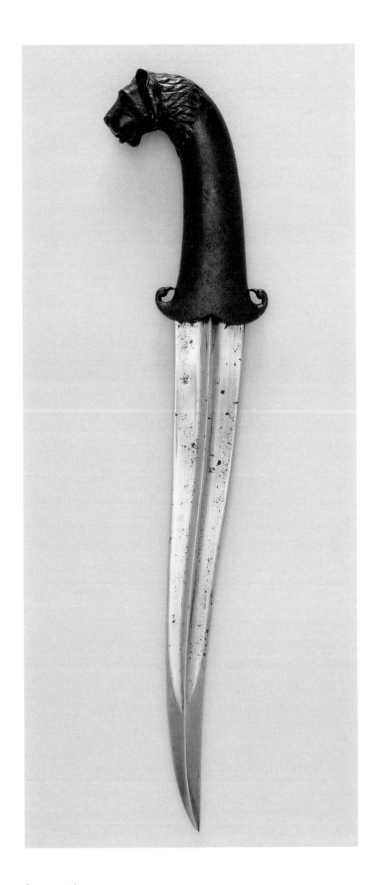

an iron saber hilt in the Khalili Collection, London.[3] The latter is the most relevant comparison with the Museum's dagger, as its one-piece hilt has a very similar tiger-head pommel with a projecting tongue and is certainly from the same milieu and perhaps even from the same workshop as the Museum's hilt.

Particularly important for the attribution of these pieces are the large palmette-shaped quillon tips of the Khalili sword hilt, which are typically Deccani. A number of all-metal hilts with similar quillons are recorded,[4] one of them mounted with a blade bearing the name of one of the 'Adil Shahi dynasty that ruled Bijapur from 1489 to 1686, until that Deccani state was conquered by the Mughals under Aurangzeb.[5] The inscription on the blade, only partially legible, is thought to refer to 'Ali 'Adil Shah (r. 1656–72). Many of these hilts date approximately to this period, as does the Museum's dagger.

The bird-head quillon tips on the Museum's dagger are noteworthy for the subtlety of their modeling, and they appear to be unique. Nonetheless, they belong within the tradition of delicately carved bud-shaped quillons found on many Indian sword and dagger hilts of the seventeenth century.

Finally, the elaborate construction of the hilt deserves mention. The grip is formed in two halves joined along the edges, with the quillons added on, each of one piece. The lion head appears to be joined to the grip along the edge of the mane and is formed of several sections, of which the lower jaw and tongue are one. Presumably the copper brazing now visible at the joins would have been masked, possibly with silver. The Museum's dagger, like many of the nephrite and ivory examples, was formerly inlaid, very sparingly, with gems, now missing. The traces of silvering and evidence of a former textile wrapping the grip suggest that the original appearance of the dagger was once much more colorful. The blade, now overcleaned, has been associated with the hilt in recent times.

PROVENANCE: Terence McInerney Fine Arts Ltd., New York.

REFERENCE: New York 2002–3, p. 40, no. 36.

NOTES
1. A number of lion-headed dagger hilts in various media are recorded; see, for example, Pant 1978–83, vol. 2, pls. 77, 80; Alexander 1992, pp. 200–201, no. 135; Paris 2007/ Mohamed 2008, p. 195, no. 183.
2. Furusiyya Art Foundation, Vaduz, no. R-22, with a horse-head pommel; see Elgood 2004a, p. 175, fig. 16.28 (right).
3. Alexander 1992, pp. 139, 141, no. 82.
4. See Paris 2007/Mohamed 2008, pp. 91–93, 95, nos. 55–57, 59.
5. Furusiyya Art Foundation, Vaduz, no. R-708; see Paris 2007/Mohamed 2008, p. 89, no. 53.

This is an unusually fine animal-head dagger, a much rarer example in chiseled iron than the more numerous and familiar Mughal examples in nephrite or ivory that came into fashion by the second quarter of the seventeenth century (see cat. 83).[1] It fits firmly within the tradition of all-metal Deccani sword and dagger hilts, examples of which include a bronze dagger hilt in the Furusiyya Art Foundation, Vaduz,[2] and

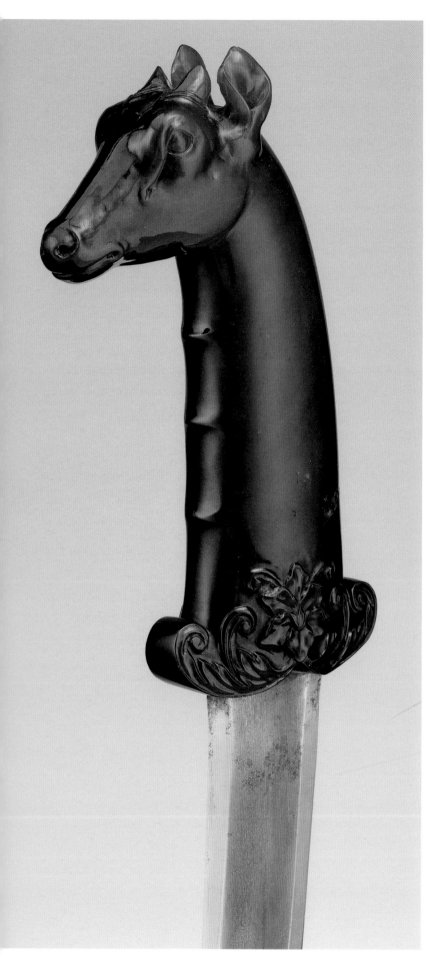

83 · Dagger

India, Mughal period, 17th century
Steel, nephrite
Length 14⅞ in. (37.9 cm); blade 9¾ in. (24.9 cm);
weight 14 oz. (407 g)
The Alice and Nasli Heeramaneck Collection,
Gift of Alice Heeramaneck, in memory of Nasli Heeramaneck, 1985
1985.58a

DESCRIPTION: The hilt of dark green nephrite is carved at its pommel with the head of a nilgai, a large Indian antelope, with two short horns and large, upstanding ears (the right one slightly chipped). The inside curve of the grip is carved with three ridges for the fingers. At the base of the hilt are two upward-scrolled quillons, carved with leaves and scrolling tendrils along the base and with a large lotuslike flower in the center. The blade of crucible steel is slightly double curved and double edged, with a low medial ridge and strongly chamfered, brightly polished edges. The tang is riveted on (the tang stem is visible at the base of the hilt), indicating that the blade has been adapted to fit its current hilt. When acquired, the dagger was accompanied by an associated, probably modern scabbard (1985.58b), not illustrated, formed of a leather-covered wood body with a plain locket and chape of dark green nephrite.

One of the most beautiful animals found in India is the nilgai, or "blue bull." A large bluish-gray antelope, it is the subject of a fine painting in the Museum's collection (fig. 33) by Mansur, a court painter to the emperor Jahangir (r. 1605–27) known especially for his depictions of animals, birds, and flowers. Scenes depicting an emperor hunting this rare creature appear occasionally in Mughal painting. A miniature of about 1660 now in the Chester Beatty Library, Dublin, portrays the emperor Aurangzeb (r. 1658–1707) stalking these animals.[1] A captured nilgai buck and doe to the lower right of the emperor are being used to lure their unsuspecting wild relatives to within shooting distance. No doubt the painting reflects an actual situation—the captive animals were perhaps nilgai from the imperial zoo.

Nilgai are also represented on Mughal dagger hilts, like the present one, although they are less frequently encountered than the more ubiquitous horse, antelope, and camel. They are always represented with short, stumpy, or pointed horns, and most of the surviving examples are carved from greenish nephrite.[2] Mughal artists of the seventeenth century were noted for their careful study of nature and their astounding realism, and daggers with zoomorphic, and occasionally even anthropomorphic, hilts of carved nephrite were a specialty of the Mughal lapidaries.[3] Later, during the eighteenth and nineteenth centuries, this naturalism often degenerated into mere copying, the animal heads weakly

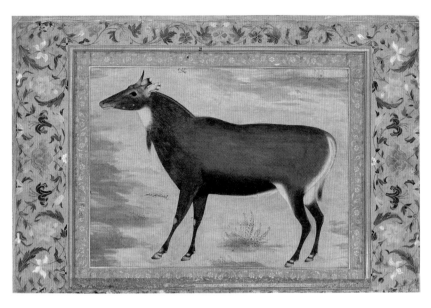

Fig. 33. *Nilgai* (blue bull), leaf from the Shah Jahan Album. By Mansur. India, Mughal period, ca. 1620. Ink, opaque watercolor, and gold on paper. The Metropolitan Museum of Art, New York. Purchase, Rogers Fund and The Kevorkian Foundation Gift, 1955 (55.121.10.13)

carved and stylized, reflecting a lack of understanding of the subject on the part of the carver.[4] The Metropolitan's dagger hilt, on the other hand, is a particularly finely carved piece, and even though it is a small object it has a monumental quality that sets it apart from all other examples.

PROVENANCE: The Alice and Nasli Heeramaneck Collection, New York.

REFERENCES: New York 1985–86a, pp. 8–9; New York 1985–86b, pp. 257–59, no. 168, ill.; *Islamic World* 1987, pp. 150–51, no. 116; Los Angeles and other cities 1989–91, p. 155, no. 174, ill.; London 2002, no. 32.

NOTES
1. Chester Beatty Library, Dublin, MS 11, no. 27; New York 1985–86b, pp. 266–71, no. 176.
2. Nilgai should not be confused with the more common brown antelope; the difference between a buck antelope and a nilgai can be seen in a seventeenth-century wine cup now in the Victoria and Albert Museum, London, that is carved from white nephrite and depicts an animal with long, curved horns (see fig. 34). For other very similar nilgai dagger hilts, see London 2002, pp. 32–33; Sotheby's London 2011b, lot 106. For more generally comparable examples of the type, see Paris 1988, no. 160; Pant and Agrawal 1995, no. 55; London and other cities 2001–2, no. 8.26. For a later example, see Paris 2007/Mohamed 2008, p. 197, no. 185.
3. For a history of zoomorphic hilts, see Michael Spink and Robert Skelton in Jaffer 2013, pp. 101–2, s.v. no. 32. For a human-headed hilt, the so-called Shah Jahan dagger, see ibid., pp. 91–92, s.v. no. 4.
4. Furusiyya Art Foundation, Vaduz, no. R-260; see Paris 2007/Mohamed 2008, p. 196, no. 184. That nilgai is stiffly carved and probably of the eighteenth or nineteenth century.

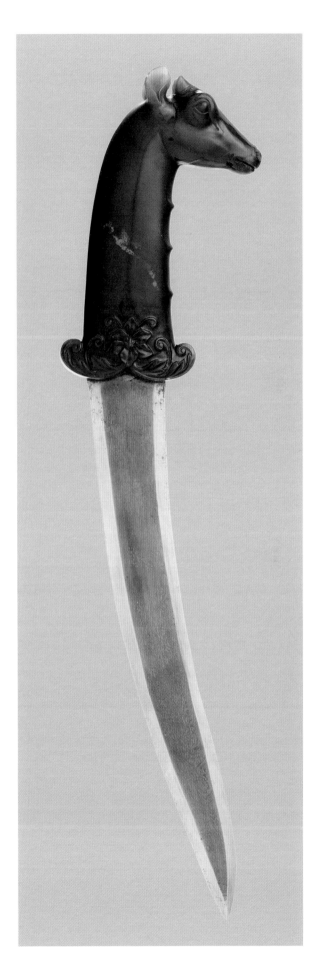

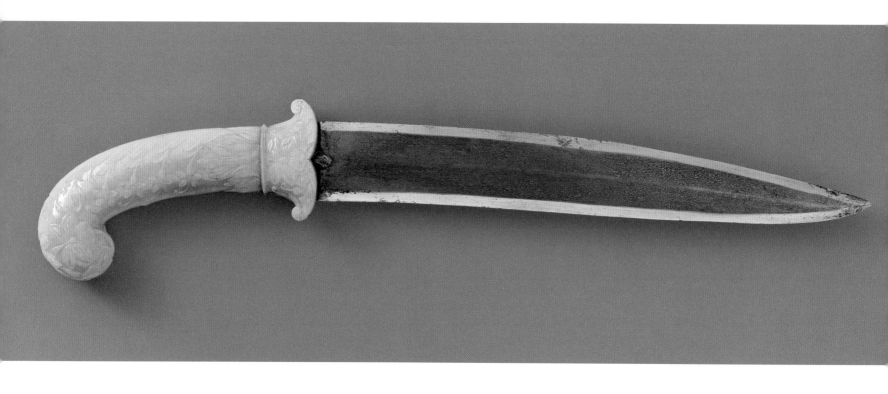

84 · Dagger

India, Mughal period, mid-17th century
Steel, nephrite
Length 14⅜ in. (36.5 cm); blade 9⅝ in. (24.4 cm); weight 11 oz. (312 g)
Purchase, Mr. and Mrs. Nathaniel Spear Jr. Gift, 1982
1982.321

DESCRIPTION: The hilt of pistol-grip shape is constructed of two pieces of intricately carved white nephrite joined horizontally between the grip and the guard. The base of the grip is carved with upright acanthus leaves; along the back of the grip is a symmetrical branch issuing feathery leaves from which emerge four flower-bearing tendrils and three stems with buds that spread over each face of the grip. Each flower has five grooved petals and a long curved stamen emerging from the center. The central branch terminates with two large flowers that spread over each side of the curled pommel. The inside curve of the hilt is carved with two low ridges for finger grips. The guard is carved at the top with a shaped molding and has two upward-scrolled quillons. The lower edge and sides of the guard are carved with acanthus foliage. From the scrolls at each quillon emerge a cornucopia that issues two curving tendrils, one with a bud; a large five-petaled flower, like that on the pommel, is carved in the center of the guard on each face. The blade of crucible steel is slightly double curved and double edged and has a low medial ridge and a riveted tang; the edges are strongly chamfered and are polished bright. The tang is new, the end visible below the hilt, indicating that the blade and hilt are associated.

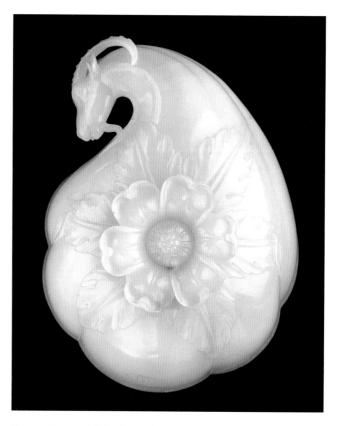

Fig. 34. Wine cup of Shah Jahan. India (Agra or Delhi), 1657. White nephrite (jade). Victoria and Albert Museum, London. Purchased with the assistance of The Art Fund, the Wolfson Foundation, Messrs Spink and Son, and an anonymous benefactor (IS.12-1962)

The hilt of this dagger is notable for its slender, elegant profile; for the graceful, well-proportioned design of the foliate ornament; and for the subtlety of its carving. It can be compared to a number of pieces from the imperial Mughal workshops, including a wine cup of Shah Jahan (r. 1627–58) carved with identical acanthus leaves, now in the Victoria and Albert Museum, London (fig. 34). The Metropolitan's dagger may also have been made for Shah Jahan, perhaps about 1640.

Dagger hilts, usually of nephrite, carved with rounded curling pommels appeared in India during the second half of the seventeenth century. The development of the curved pommel, sometimes called a pistol grip, coincides with the evolution of the saber, which, being an asymmetrical weapon, required a hilt from which the hand would not slip when delivering a slicing cut. Sabers with angled hilts are known from at least the sixth century A.D., but it was not until the late sixteenth and seventeenth centuries that the angled grip gave way to one with a virtually right-angled bend at the pommel. In India, under Persian or even Ottoman influence, this feature most likely evolved into the curled pommel or "pistol grip."[1]

One of the earliest representations of this type of dagger in Mughal art occurs in a painting depicting the emperor Aurangzeb (r. 1658–1707) early in his reign, about 1660, with his third son, Sultan A'zam, and courtiers.[2] The dagger's quillons are hidden by Aurangzeb's arm, but the rest of the hilt looks to be of whitish jade set along its grip and at the pommel with jewels arranged in petal formation. In another early representation, Aurangzeb is hunting nilgai; he wears a similar, but apparently not jeweled, version of the same dagger. A painting from the former Indian state of Bundi dated A.H. 1072 (A.D. 1661/62) shows that they were also known and used in Rajasthan.[3] Stuart Cary Welch suggested that such hilts may have originated in the Deccan, whence it was introduced into northern India.[4] Unfortunately, it is difficult to confirm this with the evidence currently available. Whatever the source, dagger hilts of this type can be securely dated from the mid-seventeenth century, and by the eighteenth century they seem to have become the most popular Mughal variety.

PROVENANCE: Greater India Company, Cambridge, Massachusetts.

REFERENCES: S. Welch and Swietochowski 1983, ill.; New York 1985–86b, pp. 270–71, no. 177; *Islamic World* 1987, p. 150, no. 115; Los Angeles and other cities 1989–91, pp. 155, 158, no. 169; Paris 2007/Mohamed 2008, p. 201, no. 191, n. 3.

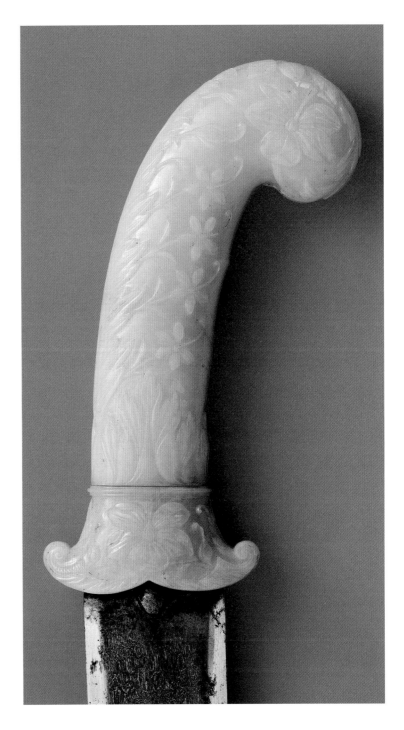

NOTES

1. For a recent review of the typology and development of the pistol grip, see Michael Spink and Robert Skelton in Jaffer 2013, p. 187, s.v. no. 53. Pistol grips, a uniquely Indian type, were also fashioned from other hardstones, rock crystal, ivory, and various metals.
2. See S. Welch 1978, pl. 37, *Durbar of 'Alamgir* (private collection).
3. See Barrett and Gray 1978, p. 140, pl. 146.
4. S. Welch and Swietochowski 1983, where it was suggested that "the curving end of the hilt was originally in the form of a bird's head, which became, with the loss of the beak, an abstract form," a proposal rejected in Michael Spink and Robert Skelton in Jaffer 2013, p. 187.

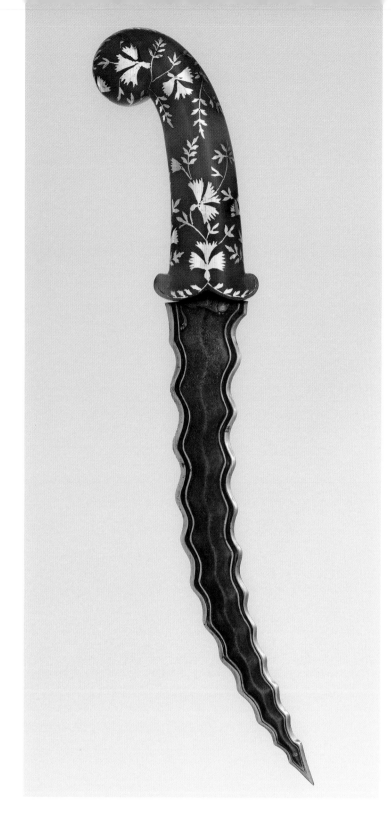

tiger, of which only the upper half remains since the lower half of each has been cut off by the shortening of the blade; the eyes and tails and the nose of one animal are inlaid with gold.

The sparsely drawn floral design seen here —characterized by an alternation of large flower heads and wispy serrated leaves—belongs to a distinctive group of Indian dagger hilts.[1] These all show a strong Ottoman influence; the floral forms on the Museum's hilt are probably carnations, and the leaves resemble the serrated leaf forms known as *saz* that were popular in Ottoman art from the sixteenth century onward. An Ottoman influence is not surprising; there were strong contacts between the Ottoman Empire and various Indian states especially during the seventeenth and eighteenth centuries, to which period the hilt should probably be dated.

The technique, particularly the inlay of largish flat areas of silver against a darkened ground, specifically recalls the metal objects inlaid in silver and brass with large plant forms known as *bidri* ware. *Bidri* ware is said to have originated in India in the city of Bidar in the Deccan, although objects decorated in this style were also produced in other Deccani centers such as Bijapur, Ahmednagar, and Hyderabad and in northern cities such as Lucknow. The pivotal piece connecting *bidri* ware and these dagger hilts is a nephrite pot now in the National Palace Museum, Taipei.[2] This vessel is inlaid in silver with carnations and long wispy leaf (cypress) forms that are exactly of the same style as those on the dagger hilts. Publishing a group of these hilts and the large pot, Stephen Markel has argued that the hilts were probably produced in Hyderabad,[3] but until an inscribed object confirming this specific attribution appears, this must remain hypothetical.

The scallop-edged blade is also Indian, indicated especially by the remnant of the carved lion below the hilt. However, as mentioned in the description, the blade was cut down when associated with the present hilt, so that it does not fit snugly with the curve of the quillons and portions of the animals carved at its base have been lost.

PROVENANCE: W. O. Oldman, London; George Cameron Stone, New York.

REFERENCES: Grancsay 1958, p. 246; Grancsay 1986, p. 452.

NOTES

1. These include one example (present location unknown) published in Copenhagen 1982, pp. 140–41, no. 97, and subsequently in Paris 1988, pp. 113, 190, no. 189. Two similarly decorated examples are in the Furusiyya Art Foundation, Vaduz, nos. R-30, R-32; see Paris 2007/Mohamed 2008, pp. 201, 195, nos. 190, 183, respectively. Among the many other examples in public and private collections, one in the British Royal Collection at Windsor Castle is notable for its inlay of gold and further embellishment with thirteen rubies; see London 1991–92, p. 230, no. 205, ill. p. 204.

2. Markel 2004, p. 70, fig. 3.

3. Ibid., pp. 71–72, figs. 5–7.

85 · Dagger

India, Deccan, possibly Hyderabad, 17–18th century
Steel, nephrite, silver, gold
Length 14 in. (35.5 cm); blade 9 in. (23 cm); weight 13 oz. (371 g)
Bequest of George C. Stone, 1935
36.25.667

DESCRIPTION: The hilt of pistol-grip shape is of gray green nephrite inlaid flush in silver with stylized flowers, each having three petals with serrated edges, and scrolling tendrils. The associated blade of dark crucible steel is curved and double edged, the edges filed in a wave pattern and polished bright, with chiseled grooves parallel to the edges. Below the hilt on each face the blade is chiseled in low relief with a

86 · Punch Dagger with Scabbard

India, Mughal period, 17th century
Steel, iron, gold, wood, leather
Dagger: length 18¼ in. (46.2 cm); blade 9⅝ in. (24.5 cm);
weight 1 lb. 4 oz. (554 g)
Scabbard: length 10½ in. (26.7 cm); weight 2 oz. (43 g)
Bequest of George C. Stone, 1935
36.25.973a, b

DESCRIPTION: The hilt is of iron damascened overall in gold. The narrow uprights are solid and parallel sided, with palmettes pierced at the ends; the faces are damascened in slight relief with a dense split-leaf arabesque, the sides with a conventional scroll. The grip consists of two large, horizontally fluted beads, with tapered ends, vertically connected to one another by a bead and connected to the uprights by openwork arabesques. The base is lobed, with a pointed center. The wide triangular blade of crucible steel is of diamond section, straight and double edged, and ends in a thickly reinforced point. A central recessed panel shows a fine watered pattern in contrast to the brightly polished edges and is chiseled in low relief around the edges with split-leaf scrolls and with a palmette-topped medallion just below the hilt. The wood scabbard is covered with tooled gilt leather having a central recessed panel corresponding to that on the blade, the recess decorated with two raised floral groups in brown. A transverse band of foliate scrolls, brown on a gilt ground, is applied below the scabbard mouth, which was formerly lobed to correspond to the hilt's lower profile but is now incomplete. The chape is of dark iron cut and pierced with foliate forms along its top edge, the surface damascened with arabesques matching those on the hilt.

This is one of the few known punch daggers to retain its original leather scabbard. The plant decoration on the scabbard is drawn with a vitality characteristic of the height of Mughal art, indicating it should probably be dated to the seventeenth century.[1]

Daggers with an H-shaped hilt composed of two arms extending upward from the blade and connected by a cross bar are uniquely Indian. They were designed for use in close combat, and their thickened points indicate that they were specifically intended for punching through mail or armor. Also used in the hunt, they reputedly could kill an elephant.[2] They are variously known as *katars* (piercing daggers) or *jamadhar* (death tooth). It has been argued that the correct term for these daggers is *jamadhar*, which is the word used to designate them in the *Akbarnama* of the Mughal vizier and historian Abu'l Fazl (1551–1602).[3] The identification of this type of dagger with the word *jamadhar* is alluded to in a Sanskrit inscription on another punch dagger in the

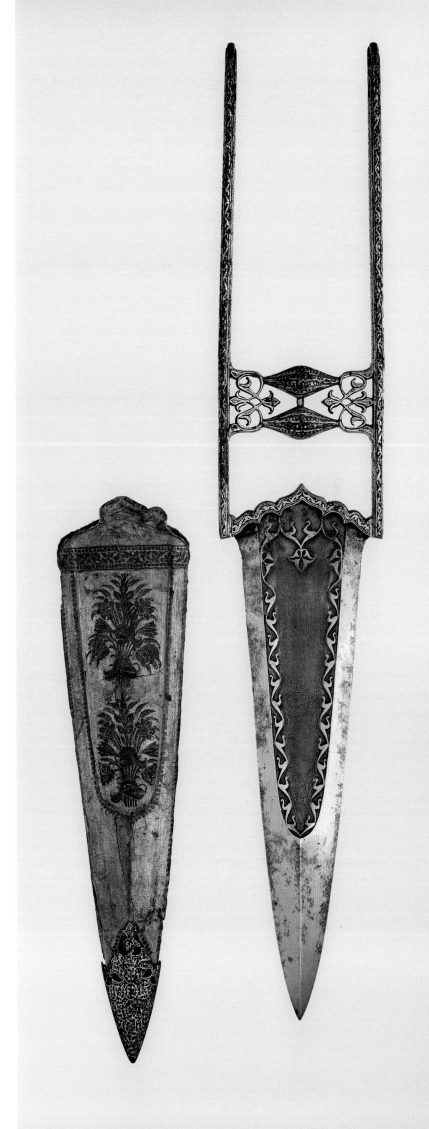

Fig. 35. "Raja Suraj Singh Rathor," folio from the Shah Jahan Album. India, late 16th century. By Bishan Das. Ink, opaque watercolor, and gold on paper. The Metropolitan Museum of Art, New York. Purchase, Rogers Fund and The Kevorkian Foundation Gift, 1955 (55.121.10.7r)

Metropolitan Museum: "This *Kadarika karalaisha* (dagger) . . . is capable of piercing the temples of elephants and hence is called the tooth of the god of Death."[4] The "tooth of the god of Death" could be taken as a reference to the Hindu god Yama, who is represented as having fanglike teeth. Such teeth are also one of the most important attributes of the Hindu goddess Kali: when she kills, she does so with her teeth, with her noose, and with her sword. Consequently, it seems certain that punch daggers had a religious association in Hindu thought.[5]

Punch daggers are certainly Hindu in origin, and their earliest representations in Hindu art date back to the tenth century;[6] it has been suggested that they can be traced in Islamic literature to as early as the thirteenth century.[7] Regardless of its date or place of origin, the punch dagger was the most common sidearm worn throughout India, in both Hindu and Muslim cultures,

from the sixteenth century on.[8] Several miniature paintings in the Museum's collections depict Mughal courtiers wearing punch daggers, among them the portrait of Raja Suraj Singh Rathor (d. 1619) from the Shah Jahan Album (fig. 35).

PROVENANCE: W. O. Oldman, London; George Cameron Stone, New York.

REFERENCE: Stone 1934, p. 347, fig. 434, no. 3.

NOTES

1. Very similar plant forms are chiseled on a blade now in the Furusiyya Art Foundation, Vaduz, no. R-272; see Paris 2007/Mohamed 2008, p. 203, no. 193.
2. Nordlunde 2013, p. 72.
3. Pant 1978–83, vol. 2, pp. 162–73.
4. Metropolitan Museum, acc. no. 36.25.912; see Stone 1934, p. 347, fig. 434, no. 30.
5. For Kali, see, for example, Kinsley 1977, pt. 2, chap. 3.
6. Nordlunde 2013 explores the origins of the *katar*, finding evidence of it in a temple structure in Orissa dating to the tenth century.
7. Robert Elgood 2004a, pp. 249–50, cites a note and conversations with Simon Digby in which the latter proposed that in an Islamic context such daggers are referred to in the early thirteenth-century manuscript *'Adab al-Harb*.
8. *Katar*s are frequently depicted in the *Hamzanama* painted for Akbar about 1562–77 and in the *Akbarnama* painted about 1590–95; see Stronge 2002, pls. 3, 4, 6, 25, 26. The same can be said for the narrative paintings and portraits from the time of Jahangir, Shah Jahan, Aurangzeb, and their successors.

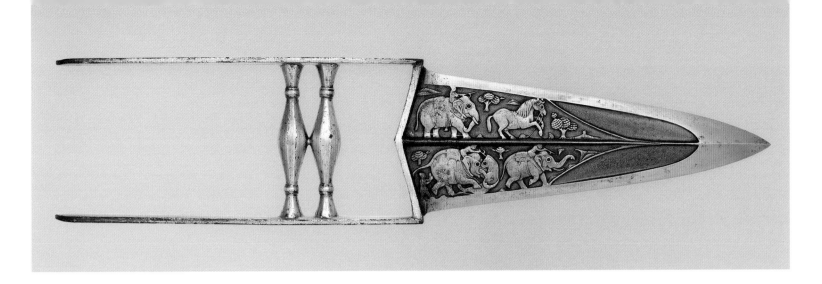

87 · Punch Dagger

India, late 17th–18th century
Steel, iron, silver, gold, rubies
Length 14 in. (35.4 cm); blade 7¼ in. (18.4 cm); weight 15 oz. (430 g)
Bequest of George C. Stone, 1935
36.25.913

DESCRIPTION: The hilt is of iron covered with silver-gilt foil. The straight side bars are concave on the outer faces, convex on the inner, and expand slightly toward the rounded ends. The double-baluster grip is longitudinally faceted, with small knobs on each side of the center spindles. The blade of crucible steel is straight, double edged, and ends in a thickly reinforced point. The center is recessed, with a high median ridge to each side of which are chiseled in relief animals and human figures in landscapes. On one face of the blade the upper scene shows an elephant, with its driver (mahout) holding an elephant goad (ankus), preceded by a prancing horse; the lower scene shows two elephants with drivers, the rear elephant fighting a tiger while the driver attacks it with his ankus. On the other face the upper scene shows two elephants, each with a driver, tethered by the feet to nearby trees, the latter filled with birds; the lower scene includes a tethered elephant behind a mounted hunter who holds a falcon in his right hand, with a barking dog nearby. The eyes of the elephants, tiger, and horse are inlaid with rubies in gold settings (one missing). The chamfered edges of the blade are polished bright.

Daggers of this type are variously known as *katars* (piercing daggers) or *jamadhar* (death tooth); for further discussion of the type, see cat. 86.
Hunting scenes are frequently chiseled on the blades of Indian swords and daggers of both Mughal and Hindu origin; a subgroup depicts elephants involved in the hunt and, sometimes, simply elephant heads. The present dagger is the Museum's finest and most elaborate example of this type of relief-chiseled decoration, which more often tends to be limited to one or two figures. Establishing its origin and date, however, remains problematic.

Two comparable chiseled blades are in the Victoria and Albert Museum, London; one belongs to a punch dagger, the other to a curved dagger with a grip of twisted steel.[1] The curved dagger, which is chiseled on one side with a combat between a horseman and elephant and on the other side with a tiger hunt, has variously been called Mughal or attributed to Rajasthan, possibly Kotah.[2]

The punch dagger is a tiny sculptural masterpiece, with a single elephant head chiseled on each face. The elephant's cut tusks and head covering are features that can also be seen in both Mughal and Rajasthan painting.[3] While these blades may have originated from the same center of production, they differ in quality and must have been made by different craftsmen or at varying times.[4]

Parallels could also be drawn with the figural scenes chiseled on a punch dagger in the Historisches Museum, Bern, and those carved on certain seventeenth-century ivory priming flasks.[5] The hilt on a final example from Rajasthan, although not a dagger blade,[6] further illustrates the fascination with elephants and hunting and demonstrates that these themes continued to attract artists and patrons into the nineteenth century. With the difficulty in assigning these daggers to a specific center, perhaps the most that can be said at present is that the carving on their blades reflects the naturalism seen in Indian art of the seventeenth and early eighteenth century.

PROVENANCE: W. O. Oldman, London; George Cameron Stone, New York.

REFERENCES: Oldman 1910, no. 25, ill.; Stone 1934, p. 347, fig. 434, no. 8.

NOTES
1. Victoria and Albert Museum, London, nos. IS.56-1985, IS.86-1981, respectively; for the latter, see Susan Stronge in London 1982, p. 131, no. 421; New York 1985–86b, p. 353, no. 236; and Elgood 2004a, p. 94.
2. For the Mughal attribution, see London 1982, p. 131, no. 421; for Rajasthan, see New York 1985–86b, p. 353, no. 236.
3. See, for example, the elephants in a Mughal painting of ca. 1620, "Emperor Jahangir in Darbar," from *Tuzuk-i Jahangiri* (The Memoirs of Jahangir), and a painting of the early eighteenth century from Rajasthan, *Emperor Bahadur Shah I in Battle*, in New York 1985–86b, nos. 115, 244, respectively.
4. They are also not necessarily Islamic, as one of those in the Victoria and Albert Museum, no. IS.86-1981, is inscribed in Sanskrit using Devanagari script, and is perhaps part of the booty captured by the Mughal commander Anup Singh at the battle of Adoni in 1689; see Susan Stronge in London 1982, p. 131, no. 421.
5. Historisches Museum, Bern, no. M.W. 463 (see Balsiger and Kläy 1992, p. 86), shows an elephant killing a man with its tusks, and the men on the elephant wear turbans of exactly the same type as those on an ivory priming flask in the Historisches Museum, Dresden, no. Y381 (see London 1982, no. 439). An ivory priming flask in the Metropolitan Museum, cat. 117, provides an example of a related animal motif.
6. Victoria and Albert Museum, London, no. IS.87-1981; see London 1982, p. 134, no. 435.

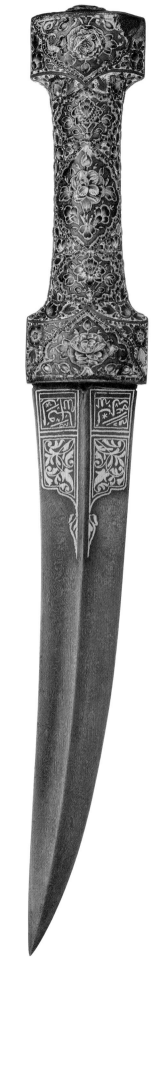

88 · Dagger with Scabbard

Iran, Qajar period, late 18th–early 19th century
Steel, copper alloy, enamel, gold, glass
Dagger: length 15⅛ in. (38.3 cm); blade 9⅛ in. (23.2 cm);
weight 15 oz. (413 g)
Scabbard: length 11 in. (28.1 cm); weight 9 oz. (251 g)
Bequest of George C. Stone, 1935
36.25.684a, b

DESCRIPTION: The I-shaped hilt of elliptical section is of gilt copper alloy enameled *en plein* with flowers in opaque pink, blue, lavender, yellow, and orange. The flowers along the central axis on each face of the hilt are contained within lobed medallions having a background of translucent green enamel on a tooled gold-foil ground; the flowers in the interstices are on an opaque white ground. Applied to the top of the pommel is a gold mount, now incomplete, set with a red-colored stone or glass. The blade of crucible steel is slightly curved and double edged and has a medial rib. The forte is damascened in gold on each face with shaped panels containing floral designs and four Arabic inscriptions in cursive script (a, b). The scabbard is of gilt copper with a wooden core and is enameled to match the hilt; it ends in a separately applied bud-shaped terminal. On the back, near the top, is a suspension loop on which there is an inscription (c).

INSCRIPTIONS:
Front
a. (On the forte of the blade)

اقبال (؟) لله / لله ...

Prosperity (?) is God's. God's is . . .

Back
b. (On the forte of the blade)

... لله / لله ...

. . . is God's. God's is . . .

c. (On the enamel of the scabbard)

يا محمود

O Mahmud!

that are almost identical to those on the dagger in Stockholm, yet it is enameled overall with bouquets of flowers in a style that shows a strong Iranian, rather than Mughal, influence.[2] The same is true for the famous diamond-and-emerald-studded "Topkapı dagger" made at the order of Mahmud I (r. 1730–54), probably about 1746, as part of an undelivered gift to Nadir Shah of Iran, which has in the center of its gold scabbard a large enameled panel in the Iranian style.[3] While some of the enameled daggers can be attributed to Ottoman workshops in the capital, Istanbul, others—such as one in the Metropolitan's collection (acc. no. 32.75.263)—should probably be attributed to a workshop in Syria during the Ottoman period.

The present dagger has more in common with provincial work, especially that from Syria or Iran, than with pieces created in Istanbul. Stylistically, the decoration is very similar to that seen on Qajar lacquerwork of the late eighteenth and nineteenth centuries. The outstanding features of this style are the use of large and voluptuous flower forms, often depicted from above, and the alternation of rectangular and ovular cartouches filled with and surrounded by a multitude of floral forms. Typical of this decorative style is the embellishment on a pen box in the Khalili Collection, London, dated 1747–48.[4]

PROVENANCE: Samuel H. Austin, Philadelphia; George Cameron Stone, New York.

REFERENCE: American Art Association, New York 1917, lot 678.

NOTES

1. Livrustkammaren, Stockholm, no. 1004; see Nordström [1984], pp. 250–51, no. 6, and Stockholm 1985, pp. 16–17, no. 12.

2. Topkapı Sarayı Museum, Istanbul, no. 2/152; see Washington, D.C., and other cities 1966–68, no. 239.

3. Topkapı Sarayı Museum, Istanbul, no. 160; see Rogers 1987a, pp. 194–95, no. 44. A saber with fittings by the same maker as the Mahmud dagger and with a blade signed by Oghlu Mu izzi 'Ali is also in the Topkapı, no. 1/2543; see Mayer 1962, p. 64. These examples indicate that Iranian and Mughal decorative elements mingled in the Ottoman arts of the seventeenth and eighteenth centuries. See also cat. 78 for further discussion of this group and other related Ottoman daggers.

4. For the Khalili Collection pen box, no. LAQ1160, see Khalili, B. Robinson, and Stanley 1996–97, vol. 1, no. 43.

From the sixteenth until the nineteenth century artists in different geographic centers of the Islamic world produced finely crafted enameled fittings for edged weapons; unfortunately, it is often difficult to distinguish between the enamelwork of certain regions, notably Turkey, Iran, and India. A seventeenth-century dagger now in the Livrustkammaren, Stockholm, illustrates the problem: it has jewelry settings that are certainly Ottoman, yet the enameled center of the scabbard is decorated with a floral design that includes a large and typically Mughal lily.[1] As another example, a dagger in the Topkapı Sarayı Museum, Istanbul, which was presented to Mehmed IV (r. 1648–87) by his mother in 1663, has settings for the jewels

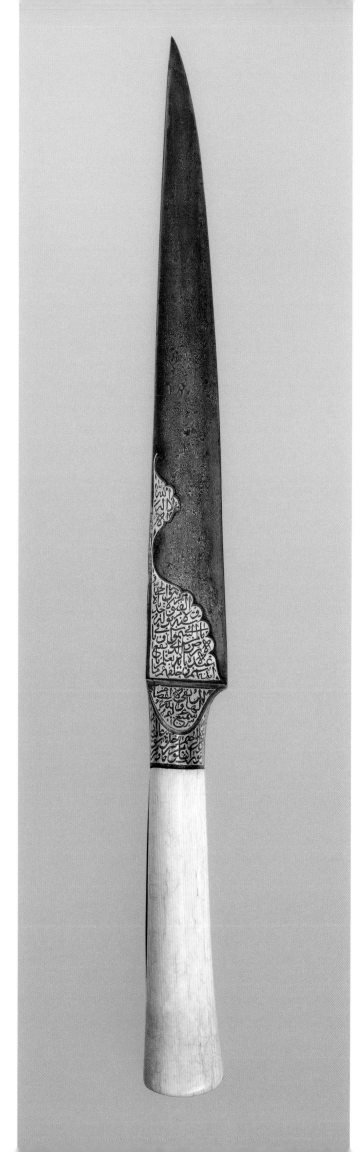

89 · Dagger

Iran, Qajar period, early 19th century
Steel, ivory, gold
Length 14⅛ in. (35.8 cm); blade 8⅝ in. (22 cm); weight 12 oz. (339 g)
Edward C. Moore Collection, Bequest of Edward C. Moore, 1891
91.1.902

DESCRIPTION: The grip is formed of two plaques of walrus ivory riveted to either side of the tang and framed by an iron shim chiseled with Arabic inscriptions (a) against a reserved gold-inlaid ground. At the base of the grip are two chamfered ferrules decorated like the shim. The blade of crucible steel is straight, single edged, and tapers to an acute point; it is chiseled in relief on each face near the hilt with a half-lobed medallion topped by a half palmette, the surfaces also chiseled with Arabic inscriptions (b) against a reserved gold ground. The thick back edge of the blade is chiseled with longitudinal ribs and medallions with flowers on a reserved gold ground.

INSCRIPTIONS:

a. (On the hilt, beginning on the back of the shim)

بسم الله الرحمن الرحيم قل يا ايها الكافرون لا اعبد ما تعبدون و لا انتم عابدون ما اعبد و لا انا عابد
ما عبدتم و لا انتم عابدون ما اعبد لكم دينكم و لي دين

In the Name of Allah, Most Gracious, Most Merciful. Say: O ye that reject Faith! I worship not that which ye worship, nor will ye worship that which I worship. And I will not worship that which ye have been wont to worship / Nor will ye worship that which I worship. To you be your Way, and to me mine. (Qur'an 109)

(On the right side of the rounded section of the ferrule)

بسم الله الرحمن الرحيم قل هو الله احد الله الصمد لم يلد و لم يولد و لم يكن له كفوا احد

In the Name of Allah, Most Gracious, Most Merciful. Say: He is Allah, the One; Allah, the Eternal, Absolute; He begetteth not, nor is He begotten; and there is none like unto Him. (Qur'an 112)

(On the left side of the rounded section of the ferrule and continuing up the front of the shim)

بسم الله الرحمن الرحيم قل اعوذ برب الفلق من من شر ما خلق و من شر غاسق اذا وقب و من شر
النفاثات في العقد و من شر حاسد اذا حسد بسم الله الرحمن الرحيم قل اعوذ برب الناس ملك الناس اله
[الناس]

In the Name of Allah, Most Gracious, Most Merciful. Say: I seek refuge with the Lord of the Dawn, from the mischief of created things; from the mischief of Darkness as it overspreads; from the mischief of those who blow on knots; and from the mischief of the envious one as he practices envy. (Qur'an 113)

In the Name of Allah, Most Gracious, Most Merciful. Say, I seek refuge with the Lord and Cherisher of Mankind, the King (or Ruler) of Mankind, The God (or Judge) [of Mankind]. (Qur'an 114:1–3)

b. (On each side of the blade and continuing on the chamfered sections of the ferrule)

الله لا اله الا هو الحي القيوم لا تأخذه سنة و لا نوم له ما في السموات و ما في الارض من ذا الذي
يشفع عنده الا باذنه يعلم ما بين ايديهم و ما خلفهم و لا يحيطون بشيء من علمه الا بما شاء وسع
كرسيه السموات و الارض و لا يؤده حفظهما و هو العلي العظيم لا اكراه في الدين قد تبين الرشد من
الغي فمن يكفر بالطاغوت و يؤمن بالله فقد استمسك بالعروة الوثقى لا انفصام لها و الله سميع عليم

Allah! There is no god but He, —the Living, the Self-subsisting, Supporter of all / No slumber can seize Him nor sleep. His are all things in the heavens and on earth.

Who is thee can intercede in His presence except as He permitteth? He knoweth what (appeareth to His creatures as) Before or After or Behind them. Nor shall they compass aught of His knowledge except as He willeth. His Throne doth extend over the heavens and the earth, and He feeleth no fatigue in guarding and preserving them for He is the Most High, the Supreme (in glory).

Let there be no compulsion in religion: Truth stands out clear from Error: whoever rejects [evil] and believes in Allah hath grasped the most trustworthy hand-hold, that never breaks. And Allah heareth and knoweth all things. (Qur'an 2:255–56)

In Persian the term *kard* means "knife"; in Afghani, *kard* becomes *karud*. These guardless daggers, which typically have straight, acutely tapered, single-edged blades and straight hilts, are similar in form to common utility knives. The tang of the blade is usually flat and of I-shaped section, to which grip plaques, often of walrus ivory, are riveted; the grip tapers toward shaped metal ferrules that abut the base of the blade.[1]

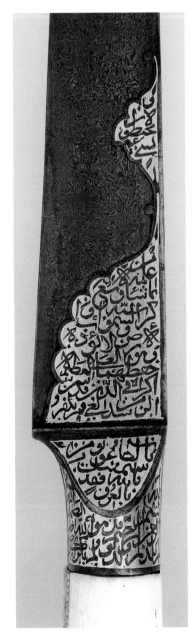 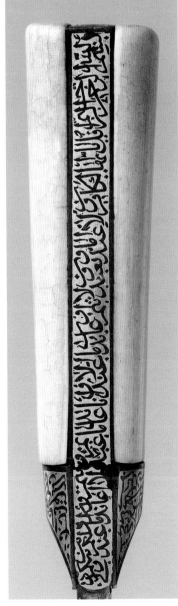

Recently, a number of Ghaznavid and Golden Horde daggers of this type, some with exquisitely carved bone hilts, excavated at unknown sites in Afghanistan, have appeared on the art market. Dating perhaps from the tenth to the thirteenth century, they represent the earliest known examples of the type.[2] *Kards* are frequently depicted in miniature paintings of the late Timurid period (1370–1500), and it is possible that this precise form may have originated in one of the Timurid centers in Central Asia.[3]

Many *kards* are carved with zoomorphic pommels, and it seems reasonable to assume that Timurid craftsmen were also the first to produce dagger pommels of this type, an assumption perhaps confirmed by the existence of a sixteenth-century painting showing a captured Uzbek warrior wearing such a dagger.[4] Although *kards* tend not to be depicted in Mughal painting until late in the reign of Akbar I (r. 1556–1605),[5] they were probably introduced into the Indian subcontinent by Babur (1483–1530), the founder of the Mughal dynasty.[6]

Several daggers similar to the Museum's have been recorded, one in the Historisches Museum, Bern, signed by 'Ali Akbar; another by the same maker that was previously in a Danish private collection; and a third, unsigned, that was on the art market in 2011.[7] All bear virtually the same sequence of inscriptions, also reserved against a gold ground, as on the Metropolitan's example, suggesting that perhaps all four are from the same center. The calligraphy on the Museum's dagger is not as fine, however, making it unlikely that all of them are from the same workshop. As the Danish dagger is dated A.H. 1218 (A.D. 1803/4) and the example sold in 2011 is dated A.H. 1229 (A.D. 1813/14), the Museum's weapon should also be dated to the early nineteenth century.

PROVENANCE: Edward C. Moore, New York.

REFERENCE: Sotheby's London 2011a, lot 373, ill.

NOTES

1. For a detailed study of *kard* typology, see Zeller and Rohrer 1955, pp. 173–76; Allan and Gilmour 2000, pp. 146–52; and Moshtagh Khorasani 2006, pp. 230–36.

2. See Paris 2007/Mohamed 2008, pp. 148–49, nos. 140–42. For further discussion of this group, see cat. 75.

3. One such example can be seen in an illustration from *Bustan* (Orchard) by the Persian poet Sa'di (ca. 1213–1292), probably painted in Bukhara about 1525–35, in which courtiers are shown wearing *kards* (see cat. 78, fig. 31).

4. See New York and Los Angeles 1973, no. 15.

5. Several *kards* are illustrated in the paintings of the *Akbarnama* of ca. 1590–95; see Stronge 2002, pls. 39, 51 (the latter apparently with a zoomorphic pommel).

6. Babur was a prince of Fergana (Turkistan) and, in trying to establish a state of his own, captured the Central Asian city of Samarqand on three occasions. He was therefore well acquainted with contemporary Timurid artistic styles.

7. For the Bern example, see Zeller and Rohrer 1955, p. 191, no. 190, pl. 45. For the Danish dagger, see Copenhagen 1982, p. 116, no. 76 (now in a collection in the Middle East). For the example sold on the art market in 2011, see Sotheby's London 2011a, lot 372.

90 · Dagger

Iran, Qajar period, ca. 1825–50
Steel, ivory
Length 15⅛ in. (38.4 cm); blade 10¼ in. (25.9 cm); weight 14 oz. (404 g)
John Stoneacre Ellis Collection, gift of Mrs. Ellis and Augustus Van
Horne Ellis, 1896
96.5.138

DESCRIPTION: The hilt is formed of a single piece of I-shaped walrus ivory of ellipti-
cal section. It is carved in relief with panels with beaded borders containing genre
scenes and a Persian verse in cursive script (a). Figural scenes fill the vertical sec-
tions of the grip: on the outer face a woman in a dancelike pose holds the hand of a
naked male child, and on the inner face a young, long-haired man, a Sufi, stands
amid foliage holding a scepter topped by a hoopoe in his left hand and a leafy
branch, with a boat-shaped beggar's bowl (kashkul) over his arm, in the right.
Inscribed panels form the horizontal sections on both faces of the pommel and
guard. The blade of crucible steel is sharply curved and double edged; each face has
two wide fullers to either side of a medial rib, and the point is slightly reinforced.
The forte is chiseled and engraved on each face with a lion attacking an antelope on
a slightly recessed, blackened ground.

INSCRIPTION:

a. (On both faces, in the horizontal sections of the pommel and guard)

قبضه خنجرت جهان گیر است گرچه یکمشت استخوان باشد

نرسد کار عالمی به بنظام [کذا] گر نه پای تو در میان باشد

The handle of your dagger is world-seizing
Although it is a fistful of bone,
The affairs of the world would not be well-ordered
Were your feet not in the center.

The same inscription occurs on a comparable ivory-
hilted Qajar dagger in the Museum's collection and on
an Indian dagger of very different type in the Freer
Gallery of Art, Washington, D.C., where it is dated to the second
quarter of the seventeenth century.[1] Another dagger with an ivory
hilt carved in a very similar style, and perhaps from the same
workshop, is in the Fogg Museum / Harvard Art Museums,
Cambridge, Massachusetts. That weapon, made for Hasan ʿAli
Shah (1804–1881), the first Aga Khan of the Ismaʿilis (the title was
bestowed on him by the shah of Persia), can be dated to between
1834 and 1848, which also serves as an approximate date for our
example.[2]

Many Iranian daggers of the Qajar period (1797–1925) were
fitted with one-piece ivory hilts carved with figural scenes and
inscriptions.[3] Much of the figural imagery reflects the dynasty's
revival of ancient Iranian, pre-Islamic themes, including Sasanian-
inspired scenes of enthronement or battle, or representations of
heroes from the *Shahnama* by Firdausi, while a few bear the like-
nesses of Qajar rulers. Other daggers are carved with scenes
based upon Western prototypes, often derived from prints,

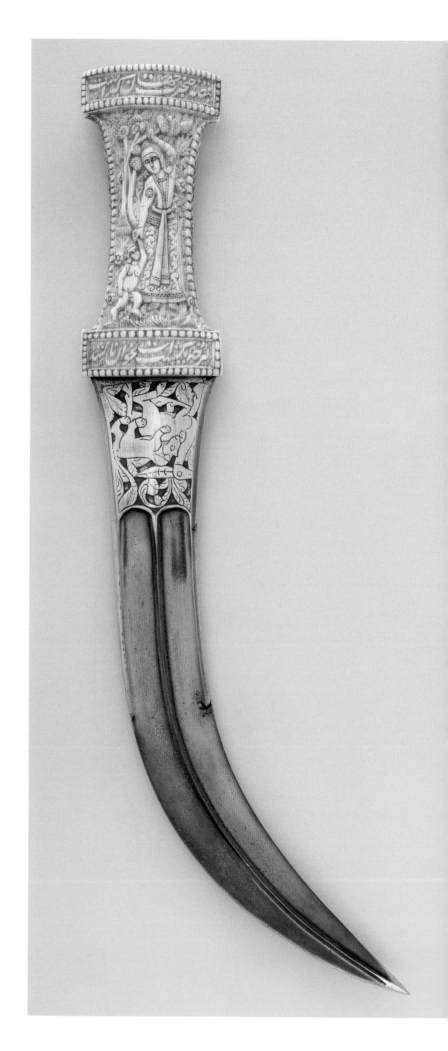

including individuals wearing European costumes or even Christian iconography; these may have been intended for the European market. A large group of these hilts, including one dated A.H. 1225 (A.D. 1810/11) and another dated A.H. 1257 (A.D. 1841/42), both decorated with Iranian themes, are in the Historisches Museum, Bern.[4] Another datable example in the Wallace Collection, London, has a superbly carved hilt that includes a portrait of Muhammad Shah Qajar (r. 1834–48) and bears the signature of the maker Ahmad al-Husayni, who also signed daggers now in the Moser Collection of the Historisches Museum, Bern, as well as in the Victoria and Albert Museum, London, the latter dated A.H. 1254 (A.D. 1838/39).[5]

The figure on one side of the Museum's grip is identifiable as a Sufi by his attributes—a conical hat (stitched of twelve sections for the twelve Shi'ite imams), a staff topped with a hoopoe (an exotic bird mentioned in the Qur'an and considered a symbol of virtue in Iran), and a beggar's bowl. It may be intended to portray Nur 'Ali Shah (d. 1797), an eighteenth-century leader of the Ni'matullahi dervish order. During the reign of Muhammad Shah, the period to which this dagger should be dated, there was a strong alliance between the court and members of the Ni'matullahi order.[6]

Most surviving daggers with I-shaped hilts come from Iran and date to the late Safavid, Zand, and Qajar periods. The form, however, is recorded in earlier examples: one is of the Timurid period and is dated 1496/97;[7] other relatively early daggers of this type include a sixteenth-century Safavid example in Vienna and a seventeenth-century Ottoman dagger in the "plain style."[8]

PROVENANCE: John Stoneacre Ellis, Westchester, New York.

REFERENCE: New York 1883, p. 84, no. 1040.

NOTES

1. For the Metropolitan Museum dagger, acc. no. 36.25.1056, see Stone 1934, p. 313, fig. 396, no. 37. For the dagger in the Freer Gallery of Art, Washington, D.C., no. 58.15, see Washington, D.C. 1985–86, pp. 207–13, no. 34, ill. (p. 213, n. 5, includes a reference to the Museum's dagger). Esin Atıl, in ibid., noted that the Freer dagger was of a type seen in a portrait of Shah Jahangir and that the inscription on the dagger included the word *jahangir* (a title meaning "world conqueror" or "world conquering"), but he also pointed out that none of this meant that "the dagger was necessarily made for the Mughal ruler." Two other Qajar daggers with similar inscriptions are recorded in Moshtagh Khorasani 2006, pp. 586–87, nos. 219, 220.

2. See New York 1979, pp. 158–59.

3. For Iranian daggers with I-shaped hilts and curved blades, usually referred to by the Persian word *khanjar*, see Moshtagh Khorasani 2007.

4. See Zeller and Rohrer 1955, pp. 133–44, nos. 95–112, with dated examples nos. 96, 112, respectively. The Metropolitan Museum's collection includes four other Qajar daggers of this type with carved ivory grips, acc. nos. 36.25.781, 36.25.1054, 36.25.1056, 36.25.1058; see Stone 1934, p. 313, fig. 396, nos. 34, 35, 37, 36, respectively.

5. For the dagger in the Wallace Collection, London, no. OA1713, see Copenhagen 1982, pp. 9, 12, fig. 10. For the signed dagger in the Moser Collection, Historisches Museum,

Bern, see Zeller and Rohrer 1955, p. 133, no. 95. For the example in the Victoria and Albert Museum, London, see North 1985, p. 38, fig. 35b.

6. For Nur 'Ali Shah, see Brooklyn 1998–99, pp. 259–60, no. 85. We are grateful to Maryam Ekhtiar, Associate Curator in the Metropolitan Museum's Department of Islamic Art, for identifying this figure and providing related images and references.

7. See Melikian-Chirvani 1976.

8. For the Safavid dagger in the Kunsthistorisches Museum, Vienna, no. C88, see Munich 1910, no. 239, pl. 241; and Ivanov 1979, pp. 68–70, no. 69. For the Ottoman "plain-style" example, see Allan and Raby 1982, p. 27, fig. 8b.

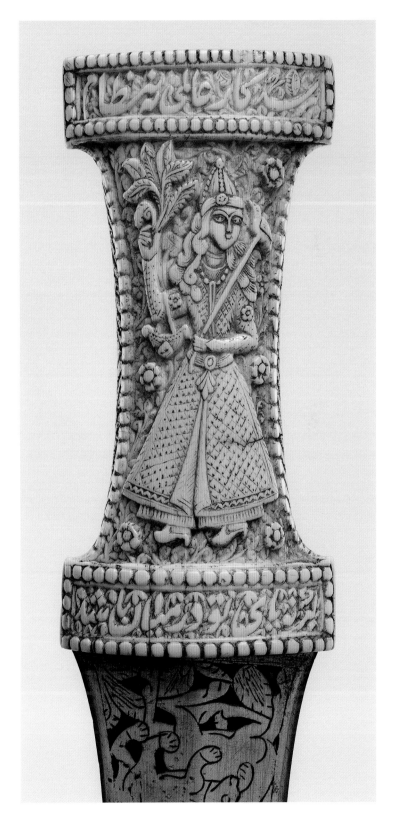

91 · Dagger with Scabbard and Fitted Storage Case

Arabia, Medina, 1876–1909

Steel, silver gilt, wood, textile, gold

Dagger: length 11⅛ in. (28.2 cm); blade 6¾ in. (17.2 cm); weight 9 oz. (258 g)

Scabbard: length 8⅞ in. (22.5 cm); weight 14 oz. (386 g)

Case: length 13¾ in. (35 cm); weight 11 oz. (310 g)

Rogers Fund, 1931

31.35.1a–c

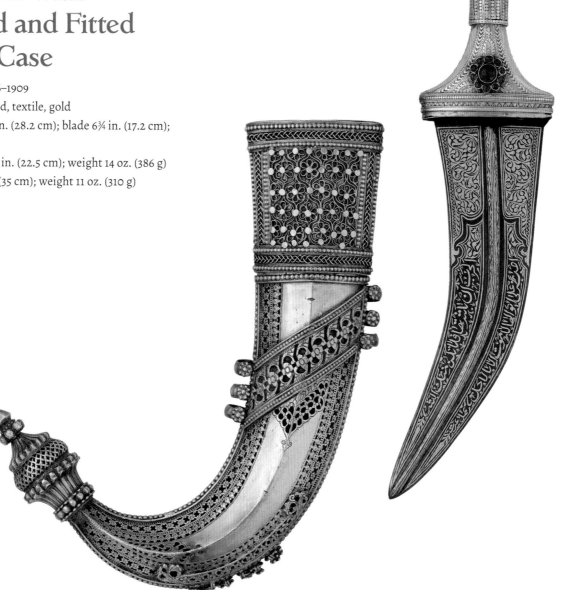

DESCRIPTION: The I-shaped hilt of oval section is of silver gilt over a wooden core. The outer face is engraved and punched with foliate scrolls and leaves on a hatched ground within chevron borders, the inner face with a scale pattern, and the sides with geometric ornament. The band encircling the center of the grip is made up of vertical rows of beaded ornament separated by twisted wire. Applied across the top of the pommel are nineteen turquoises arranged in a geometric pattern; domed bosses with raised buttons at their centers are applied to the tips of the pommel. Rosettes composed of ten small red stones (foiled crystals?) around a large central one are applied to the outer face of the pommel and guard. The blade of blued steel is curved, double edged, and has a thick medial rib on each face. It is damascened overall in gold on both sides with zigzag borders, dense floral scrolls, and two Arabic couplets in cursive script (a, c). At the end of the second couplet is the maker's signature (b). The scabbard is of silver gilt over a wooden core. The outer face of the locket has beaded borders with applied braided wire and guilloche filigree enclosing a pattern of filigree rosettes within an ogival grid; the locket's inner face is chased with an Ottoman Turkish inscription in cursive script (d) within a chevron border. The outer face of the scabbard below the locket has a beaded border and is pierced along the edges with bands of leaf-and-petal designs; across this there is an applied cast diagonal band, pierced and engraved with flowers and leaves, with three suspension rings at each side. Along the outer edge of the scabbard at the base of the curve are six applied rings from which hang six filigreed hexafoils. The bulbous terminal has a beaded base from which emerges an elaborately shaped calyx and pierced globular finial. The scabbard's inner face below the locket is covered with orange velvet. The dagger is contained within a fitted wood storage case covered with gold-tooled brown leather stamped along the edges with foliate scrolls, stars and crescents, and the *tuğra* of Abdülhamid II (r. 1876–1909). The case interior is lined on the bottom with green velvet, on the cover with green satin.

Although the dagger and its scabbard fit together well and were undoubtedly made for one another, there are small differences in workmanship and ornament that suggest they were made by different craftsmen.

INSCRIPTIONS:

On the outer face of the blade

a. (On each side of the medial rib, verses in Arabic, attributed to Imam 'Ali)

الحرب ان باشرتها فلا تكن منك البشر [كذا] (الفشل)

اصبر على اهوالها لا موت الا بالاجل

If you practice war
Do not give in,
Endure its horrors
For there is no death before the appointed hour.

b. (At the end of the couplet on the outer face of the blade)

عمل عزت

Work of Izzet.

On the inner face of the blade

c. (On each side of the medial rib, a couplet from an Arabic *qasida* by the poet al-Mutanabbi [d. 965])

جراحات السنان لها التيام لا يلتام ما جرح السنان

Wounds inflicted by the spear have a cure,
But what the tongue wounds cannot be cured.

On the inner face of the scabbard

d. (On the locket, in Ottoman Turkish)

مدينة منورّةده الحاج شيخ علي افندي يه عائد

In Medina al-Munawarra, belonging to al-Hajj Shaykh Ali Effendi.

The title "effendi" in the inscription on the inner face of the scabbard locket indicates that the owner of this weapon was a Turk and suggests that the dagger must have been made in Medina ("Munawarra" is the epithet for Medina and means the bright, brilliant, or illuminated city) for a Turkish pilgrim, who, after the fulfillment of his religious duty of making the pilgrimage to Mecca, added the title Hajj to his name.[1] The *tuğra* of the Ottoman sultan Abdülhamid II (r. 1876–1909) on

the case suggests that it may have been made in Istanbul after the owner's return. The stylized floral forms contrasting with plain areas as on the hilt are typical of the Arabian daggers of this period.[2] Two other datable examples with the same form and very similar decoration belonged to the British archaeological scholar, adventurer, military strategist, and writer T. E. Lawrence (1888–1935); one of these, in gold, was made for him in Mecca in 1917, and the other, of silver gilt and also made in Mecca, was presented to him by the Hashimite sharif Nasir b. 'Ali in the same year.[3]

Although the blade, which is signed by its maker, or perhaps its decorator, Izzet, is typically Arab in form, the epigraphy and surrounding decoration have much in common with work produced in Turkey during the nineteenth century.[4] This, however, does not necessarily indicate that the decoration and inscription were added in Turkey after the owner's return, as both Mecca and Medina were home to Muslims from throughout the Islamic world and to numerous Turks during the Ottoman period. Until more is known about the crafts produced in Medina during the second half of the nineteenth century, the question as to its place of manufacture must remain open.

PROVENANCE: Daniel Z. Noorian, New York.

REFERENCE: American Art Association/Anderson Galleries, New York 1931, lot 600, ill.

NOTES

1. The pilgrimage to Mecca is a religious duty, whereas visiting Medina is a nonobligatory pious act. Shaykh Ali must have visited Medina to pray at the Prophet's tomb after making the pilgrimage to Mecca.

2. See, for example, Elgood 1994, p. 75, pl. 9.11.

3. Ibid., p. 73, pls. 9.7, 9.9.

4. See, for example, cat. 79 and Geneva 1995, pp. 237, 262–63, nos. 164, 186.

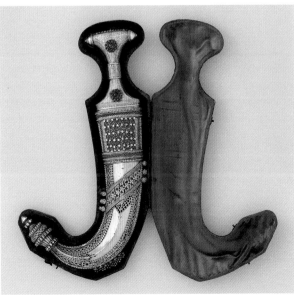
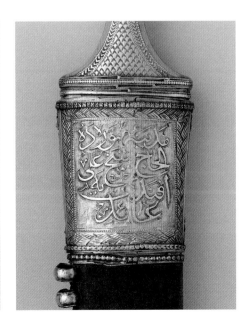

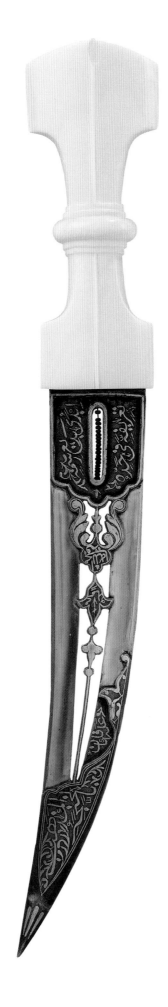

92 · Dagger (Jambiya) with Scabbard

Arabia, Jedda, late 19th century; blade, Iran or Turkey, 18th–19th century
Steel, ivory, wood, silver gilt, gold, rubies, emeralds
Dagger: length 12⅛ in. (30.8 cm); blade 7½ in. (19 cm);
weight 8 oz. (238 g)
Scabbard: length 8⅛ in. (20.5 cm); weight 6 oz. (159 g)
Gift of Mrs. Anna L. Fisher, 1922
22.107a, b

DESCRIPTION: The I-shaped hilt is formed of one piece of elephant ivory, the cross-pieces (serving as the pommel and guard) of elliptical section, the narrow grip of faceted section. It is carved with a rib down the center of each face and across the top of the pommel; the grip is carved at the center with a ring, with two stepped moldings above and below. The blade, probably of crucible steel but now polished bright, is curved and double edged, with a reinforced point. On both faces of the blade the forte is chiseled with a raised and gold-damascened molding framing a gold-damascened panel in the form of a lobed arch, in the center of which is a slot, also framed by a gold molding, containing tiny ruby and emerald beads strung on a central wire; the areas within the frame are damascened with Arabic inscriptions in cursive script (a). The center of the blade is pierced and chiseled in relief with palmette forms along the central axis and damascened in gold on both faces with Arabic inscriptions (b, c). The tip is chiseled on both faces with a raised panel of half-palmette form and also damascened in gold with floral forms and Arabic inscriptions (d, e). The scabbard is of silver gilt over a wood core, the faces engraved with broad floral forms against a zigzag ground. The outer face is additionally outlined by two applied bands of beaded ornament, and applied down the center is a band of stylized leaves and palmette forms. An applied band around the throat consists of beaded borders, twisted wire, and ribbon filigree. The bud-shaped terminal has flattened, grooved faces and beaded collars at the stem. A silver-gilt belt loop is applied at the back.

INSCRIPTIONS:
All the inscriptions run from one side of the blade to the other (inner face, then outer face).
a. (Closest to the hilt, half on one side, half on the other)

ذا خنجر مجوهر و هو وضيع حده
ابدى بديع رسمه تعريفه في حده

That jeweled dagger
That has an inferior blade,
Though its design may appear ingenious,
It (i.e., its true worth) is known from the blade.

b. (In the trefoils at the bottom of the large leaf designs, an Arabic saying, starting on one side and finishing on the other)

رأس الحكمة / مخافة الله

The beginning of wisdom is the fear of God.

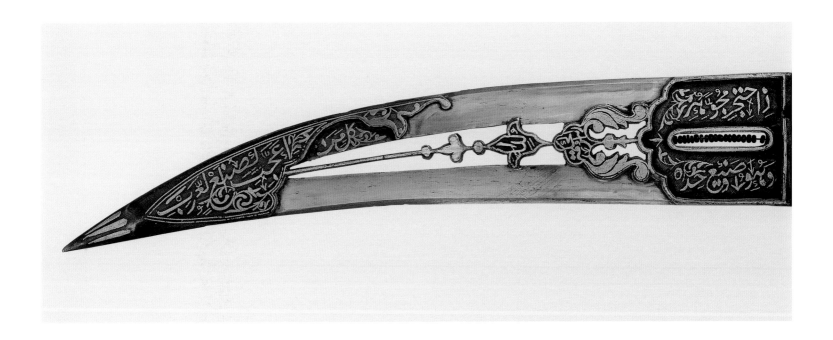

c. (In the palmettes below them, one on each side)

الله / محمد

Allah. Muhammad.

d. (In the two small indentations near the end of the blade)

كل من / عليها فان

All that is on earth will perish. (Qur'an 55:26)

e. (At the point, half on one side, half on the other)

اعجب كصنع العرب / بالخنجر المذهب

I admire, as the (great) art of the Arabs, the gilded dagger.

This dagger is of interest not only as a late, finely crafted example of Arab workmanship from the Arabian Peninsula, but also because of its unusual history. A letter from the donor, Anna L. Fisher, dated April 13, 1922, states that this dagger was made in Jedda for a Hashimite sharif of Mecca. It was allegedly worn by Sharif Husayn ibn ʻAli (ca. 1854–1931), amir of Mecca (r. 1908–16) and king of the Hejaz (r. 1916–24), then given by him to his son Faisal (1885–1933), briefly king of Syria (r. March–July 1920) and subsequently king of Iraq (r. 1921–33), placed in power by the British. The dagger was apparently presented by Faisal to the donor's husband in Damascus in 1920.[1]

Blades chiseled and pierced in this fashion are known from the sixteenth century on. The earliest recorded example is a dagger made for the Ottoman sultan Selim I (r. 1512–20) in about 1514, now in the Topkapı Sarayı Museum, Istanbul.[2] Another documented example of the late sixteenth or early seventeenth century, also with Ottoman mounts, a gift from the Holy Roman Emperor Matthias (r. 1612–19) to Prince-Elector Johann Georg I (r. 1611–56) of Saxony in 1617, is in the Rüstkammer of the Staatliche Kunstsammlungen Dresden.[3] (For a possibly seventeenth-century example, mounted with a Mughal or Deccani hilt, see cat. 81.) The Museum's dagger has a thickened tip sculpted with a palmette form that runs along the lower edge of the blade. This style of smithing was also used on a dagger belonging to a group that can be dated to the eighteenth century, and our blade is very probably of this period, perhaps rehilted during the nineteenth century.[4]

PROVENANCE: Anna. L. Fisher, New York.

Unpublished.

NOTES

1. Anna L. Fisher, personal communication, Department of Arms and Armor Files, The Metropolitan Museum of Art, New York.
2. Topkapı Sarayı Museum, Istanbul, no. 2/254; see Washington, D.C., Chicago, and New York 1987–88, p. 158, fig. 91.
3. For the Dresden dagger, no. Y139, see Schuckelt 2010, p. 140, no. 123, ill., detail p. 108. Other blades of this type, reputedly of sixteenth-century date, are illustrated in Ivanov 1979, nos. 62, 63, 70, 71.
4. One such dagger, formerly in the George F. Harding Collection (now Art Institute of Chicago, acc. no. 1982.2165, unpublished), is from the same workshop as cat. 79.

93 · Lance Head

Syria or Egypt, Mamluk period, ca. 1500
Steel, gold
Length 26⅜ in. (67 cm); weight 1 lb. 10 oz. (741 g)
Gift of William H. Riggs, 1913
14.25.474

DESCRIPTION: The long, slender lance head of steel is of deeply hollowed diamond section, the edges beveled, and is made in one with its socket. The latter is faceted at the top and bottom, the facets changing into fluting, which is organized in three registers, each turning in the direction opposite that of the adjacent one; shaped rings are chiseled on the socket below the head and at the base. The lance was originally gilt overall, of which only traces remain.

Engraved at the base of the socket is the *tamğa* of the Ottoman arsenal.

The fluted socket of this lance head is typically Mamluk and can be compared to fluted Mamluk sword hilts, ax and mace hafts, and a series of similar lances preserved in the Topkapı Sarayı Museum, Istanbul.[1] These surviving lances are all extremely long and have carefully fluted metal heads and metal hafts; their simple beauty is an indication of the high regard in which the Mamluks held this weapon. Like the lances in the Topkapı Sarayı Museum, the Metropolitan's example was presumably taken to Istanbul as booty following the Ottoman defeat of the Mamluks in 1517.

Lances were used by the Arabs during the pre-Islamic period, and the weapon frequently appeared in depictions of Arab warriors in sculpture from Palmyra and other major centers in the Middle East; they were also employed by the Central Asian Turks, as illustrated in paintings and recorded in historical accounts.[2] The poet Abu'al-Najm Manuchihri (d. ca. 1040/41) wrote of the lance used by the sultan Mas'ud of Ghazna (r. 1030–41), "The lance (*niza*) of 20 *arashs* length which you wield will pierce the livers of twenty champions on the day of battle."[3] The use of such long lances by the Mamluks, who were recruited from the Turks of Central Asia, continued this tradition.

The popularity of these lances is reflected in fourteenth- and fifteenth-century military training manuals of the Mamluk period. These books on chivalry, such as the *Nihayat as-Su'l wa'l-Umniyya fi-ta'allum al-furusiyya* (Ultimate search to acquire the methods of knighthood) of A.H. 773 (A.D. 1371), frequently illustrated exercises for the lance that were designed to improve a rider's agility as well as his ability with the weapon. Games incorporating the lance were very popular with the Mamluks.[4] Writing about a *furusiyya*

manuscript (involving horsemanship, chivalry, and knighthood) in the British Library, London, G. Rex Smith pointed out that the lance had "pride of place" and noted that many of the exercises relating to the weapon's use were developed by a fourteenth-century Mamluk master named Najm al-Din al-Ahdab.[5]

PROVENANCE: Ottoman arsenal, Istanbul; C. Beshiktash, Paris; William H. Riggs, Paris.

Unpublished.

NOTES
1. One of these long Mamluk lances is illustrated in Riyadh 1996, vol. 2, pp. 95–96, no. 82, another in Paris 2007/Mohamed 2008, p. 277, no. 268.
2. For the paintings, see Azarpay 1981, pl. 4.
3. Bosworth 1973, p. 120.
4. For examples of these games from the Mamluk period, see Haldane 1978, p. 21; Riyadh 1996, vol. 2, pp. 78–79, nos. 67, 68; and al-Sarraf 1996.
5. G. Smith 1979, p. 21.

94 · Ax

Egypt or Syria, Mamluk period, 15th century
Steel, gold, wood
Length overall 28½ in. (72.3 cm); axhead length 9⅞ in. (25.1 cm),
width 9¼ in. (23.5 cm); weight 2 lbs. 15 oz (1,341 g)
Purchase, Bashford Dean Memorial Fund, 1969
69.156

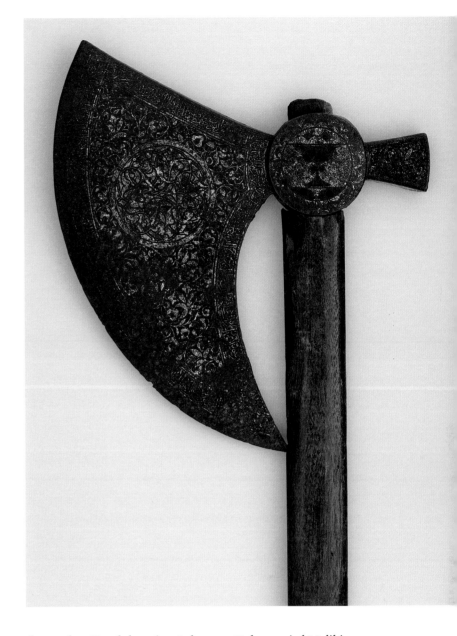

DESCRIPTION: The axhead, apparently forged from one piece of steel, has an asymmetrical crescent-shaped blade that curves downward, the lower tip nearly reaching the haft; a disk-shaped socket of thick rectangular section; and, opposite the blade, a faceted hammerhead that expands in width and thickness toward the flattened end. The surfaces are damascened overall in gold. On each side of the ax blade is a central medallion containing a floral arabesque in the contour-reserve style; the medallion is surrounded by a meandering leaf-and-petal arabesque and framed by a narrow border of badly worn, partially legible Arabic inscriptions (a–c) that follow the blade contours. The socket is damascened in gold with a blazon that consists of a roundel containing a field divided into three uneven registers: the upper one containing two squares (napkins, black on a gold ground), the wide middle band containing a large cup (black on a gold ground), and the lower containing a smaller cup (gold on a black ground). The socket is pierced near the bottom on each side with two holes through which the head was originally nailed to the haft. The steel surfaces are now aged to a dark brown color and are very worn and deeply pitted, particularly on the right side of the blade (not shown). The present wooden haft of oval section is modern.

INSCRIPTIONS:

Side 1

a. (Along the top of the blade)

الله لا اله الا هو ... ما في السموات و ...

Allah! There is no god but He . . . all things in the heavens and [on earth.] . . . (Qur'an 2:255)

b. (Down the blade, from the floral device at top right)

الله لا اله الا هو ... ما في السموات ... ذا الذي ...

Allah! There is no god but He . . . all things in the heavens [and on earth.] Who is thee [can intercede in His presence.] . . . (Qur'an 2:255)

Side 2

c. (From the bottom point of the ax up the inside of the blade and along the top)

تأخذه سنة و لا نوم له ما في السموات ... يشفع ... يحيطون بشيء من علمه الا بما شاء وسع ...
و لا يؤده حفظهما و هو العلي ...

[No] slumber can seize Him nor sleep. His are all things in the heavens and [on earth. Who is there] can intercede [in His presence except as He permitteth?] . . . [Nor] shall they compass aught of His knowledge except as He willeth. [His Throne] doth extend [over the heavens and the earth,] and He feeleth no fatigue in guarding and preserving them for He is the Most High, [the Supreme (in glory)]. (Qur'an 2:255)

The decoration of the ax includes a blazon of a type that is distinctively Mamluk.[1] It was tentatively identified by Helmut Nickel as most probably that of the Mamluk amir Nauruz al-Hafizi, viceroy of Syria from 1399 to 1414.[2] The same blazon, however, is known to have been used by at least three other Mamluk amirs: Aqbuga at-Tulutumri al Maliki an-Nasiri (ca. 1400), Badr al-Din b. al-Kuwaiz (before 1481), and Muhammad al-Malati (dates unknown).[3] It is also engraved on an unpublished saber blade in the Topkapı Sarayı Museum, Istanbul.[4] Consequently, the ax may date anywhere in the fifteenth century. Dating is further complicated by the unusual shape of the axhead, which is without an exact parallel and differs from the well-known series of late Mamluk axes dating to the reign of Sultan Qa'itbay (r. 1468–96) and his successors.[5] Earlier forms of Mamluk axes are not documented, and therefore typology does not help in dating this example.

Axes do not seem to have been used by the Arabs at the time of the Prophet; they are mentioned neither in early Arab poetry nor in the eighth-century life of the Prophet by Ibn Ishaq. Their use by Muslim warriors is therefore likely to have resulted from contacts with other Middle Eastern societies, especially those of Byzantium, during the first centuries of Islam. The influence of Byzantine ceremonial practices on the developing Muslim states

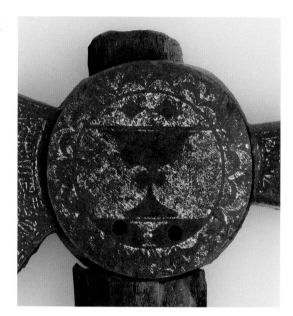

in the Middle East has been well documented, and the employment of a special corps of ax bearers as royal bodyguards in the princely protocol in the Islamic world reflects one such specifically Byzantine practice.[6] These Muslim warriors were modeled after the Varangians—the Russian, Scandinavian, and Norman mercenaries who pledged *var*, loyalty, to the Byzantine emperor. From at least 988, sizable numbers of these soldiers served as imperial bodyguards,[7] and their characteristic weapon was the large crescent-bladed ax.[8] Both the shape and function of these axes are reflected in two examples in the Museum's collection, the present ax and cat. 95, which were quite possibly carried by Mamluk bodyguards known as *Tabardariyya* (from the Arabic word *tabar*, ax). Many fifteenth-century examples bearing the names of Mamluk rulers and amirs have been preserved, including those bearing the name of Sultan Qa'itbay.[9]

The use of ceremonial ax bearers was not confined to the Mamluks; indeed, Islamic chronicles, miniature painting, and metalwork indicate that rulers throughout much of the Muslim world employed warriors as ceremonial ax bearers (fig. 36).[10] Muslim warriors were frequently mentioned as being armed with "Frankish" or "Danish" axes. The French chronicler Jean de Joinville (ca. 1224–1317), for example, noted in his eyewitness account of the Seventh Crusade that "Whenever the Old Man of the Mountain [the Grand Master of the Assassins] went out riding, a crier would go before him bearing a Danish ax with a long haft encased in silver, to which many knives were affixed. As he went the man would continually cry out: 'Turn out of the way of him who bears in his hands the death of kings!'"[11] In this instance, the ax bearer served in a ceremonial context to emphasize his leader's power over life and death.

PROVENANCE: Alan Zasky, New Jersey.

REFERENCES: "Outstanding Recent Accessions" 1970, p. 395, ill.; "Recent Acquisitions of American and Canadian Museums" 1970, pp. 445, 457, ill.; Nickel 1972; Nickel 1975; *Islamic World* 1987, p. 60, fig. 43; Nickel 1991a, p. 50.

NOTES

1. The blazon of a cup within a circle decorating the socket of the ax indicates that the amir may originally have been a cupbearer to the sultan; see *Islamic World* 1987, p. 60, fig. 43.

2. Nickel 1972, p. 219.

3. See Meinecke 1972, especially p. 261, fig. KW 13.

4. Topkapı Sarayı Museum, Istanbul, no. 1/5028 (unpublished).

5. These are entirely of steel, including the haft; the crescentic blades symmetrical; the sockets of square or diamond section; and the peen or hammer diminutive. For most of the better-known examples, see Nickel 1972; for three examples in the Museo Nazionale del Bargello, Florence, nos. M1226, M1227, M1772, see Florence 2002, pp. 58–59, nos. 17–19. Another ax in the Museum's collection, cat. 95, belongs to this group.

6. See, for example, Canard 1951, Grabar 1955, and Ettinghausen 1972.

7. Ostrogorsky 1969, p. 304, n. 1.

8. Heath 1979, pp. 14–17, fig. p. 27.

9. See note 4 above.

10. Ax bearers were often depicted on metalwork and in miniature painting; see, for example, Gabrieli and Scerrato 1979, fig. 567. Ottoman artists also frequently depicted imperial ax bearers, as in a painting of about 1588 showing Süleyman I (r. 1520–66) leading his army (see Nickel 1972, fig. 21; Atıl 1986, no. 62, ill.). Although axes with asymmetrical crescent-shaped blades can be seen in miniature paintings of the fourteenth century (see Grube 1981, fig. 49), it is not known when such axes were first crafted.

11. Jean sire de Joinville in Joinville and Villehardouin 1963, pp. 279–80.

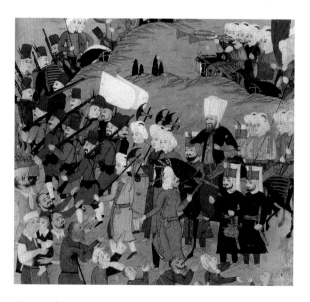

Fig. 36. Ax bearers marching in front of a general, detail of a painting from the *Pashanama*. Turkey, ca. 1630. Opaque watercolor on paper. British Museum, London (Sloane 3584, fol. 20a)

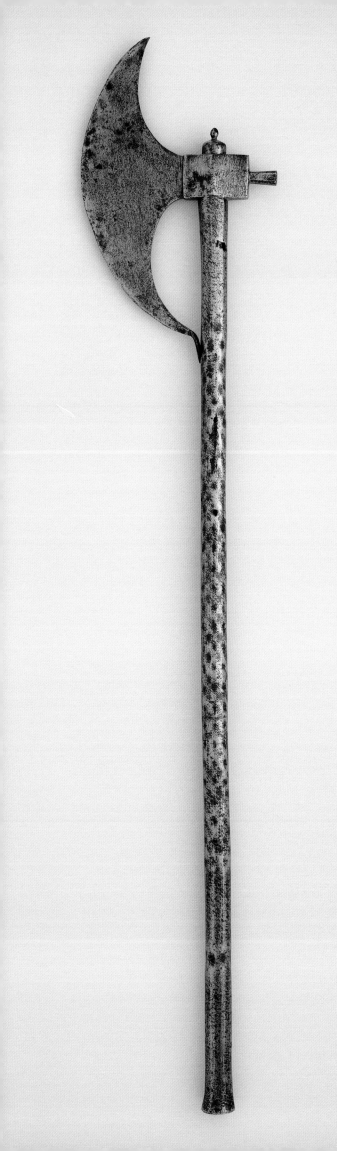

95 · Ax

Syria or Egypt, Mamluk period, ca. 1500
Steel
Length 36¼ in. (92 cm); width 6¾ in. (17 cm);
weight 3 lbs. 1 oz. (1,378 g)
Bequest of George C. Stone, 1935
36.25.1829

DESCRIPTION: The ax is made entirely of steel. The axhead has a crescent-shaped blade, a thick socket of chamfered diamond section, and a narrow, faceted hammerhead that tapers toward the socket. The lower end of the blade is flattened and turned out to rest against the haft. A domed cap with a small knob is set atop the socket. The shaft is hollow and expands slightly at the flat end; the areas at the top and at the grip are faceted; the middle section has hammered "dimples" overall. The surfaces are deeply scratched and lightly pitted overall, with numerous small corrosion holes along the length of the shaft and a drilled hole in the flat bottom edge.

Mamluk armorers of the fourteenth to the early sixteenth century excelled in twisting, faceting, fluting, and piercing metal. Many of their finely crafted surviving weapons are works of beauty, even when otherwise undecorated. A variety of weapons bear witness to this facility, among them swords, axes, maces, lances, and standard heads.[1] Most Mamluk axes, of which large numbers are preserved in the Topkapı Sarayı and Askeri Müzesi in Istanbul, have iron hafts that are integral with the head and are faceted, hammered, or spirally chiseled.[2] The Metropolitan's ax clearly belongs to this group.

The form of the Museum's axhead, as well as its shaped socket, domed cap, and hammerhead, are also features characteristic of this Mamluk group. Although our example is undecorated, it may be compared to several gold- or silver-damascened axheads inscribed with the names and titles of various Mamluk sultans and amirs, including Sultan Qa'itbay (r. 1468–96) and his son Muhammad (r. 1496–98),[3] and at least one with the name of the Syrian amir Dawlat Bay, governor of Gaza under Sultan Qansawh al-Ghauri (r. 1501–16).[4] These documented pieces suggest that the Museum's ax most likely dates to the late fifteenth or early sixteenth century.

PROVENANCE: Constantinople bazaar; George Cameron Stone, New York.

REFERENCES: Stone 1934, p. 110, fig. 142, no. 5; Nickel 1972, fig. 13.

NOTES

1. For the swords, see Yücel 1988, nos. 56, 59, 60, 67, 72. For the axes, see Nickel 1972, figs. 9–15; Nickel 1979b, figs. 164–70; Riyadh 1996, vol. 2, no. 81i; and Florence 2002, pp. 58–59, nos. 17–19. For the standards, see T. Tezcan 1983, p. 13, ill. (at right); and Istanbul 1987, nos. A.159, A.161, A.163. For Mamluk lances, see cat. 93.

2. Nickel 1972, figs. 9–10; and Nickel 1979b, figs. 164, 165.

3. Among these are examples in the Museo Nazionale del Bargello, Florence, such as no. M1227 (see Florence 2002, no. 17); in the Hofjagd- und Rüstkammer, Kunsthistorisches Museum, Vienna, no. C113 (see Nickel 1972, fig. 11; Nickel 1979b, fig. 166); in the Askeri Müzesi, Istanbul, no. 8434 (see Istanbul 1987, no. A.149); and in the Topkapı Sarayı Museum, Istanbul, nos. 13/20, 13/23 (see T. Tezcan 1983, p. 27).

4. Rüstkammer, Dresden, no. Y252; see Nickel 1972, fig. 14; Nickel 1979b, fig. 169; and Schuckelt 2010, no. 252.

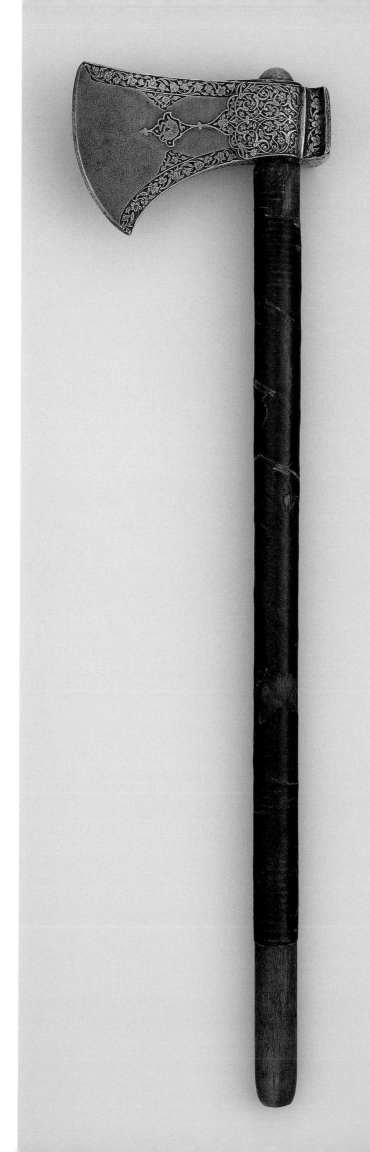

96 · Saddle Ax

Iran, ca. 1725–50
Steel, wood, leather, gold
Length 21 in. (53.3 cm); weight 1 lb. 11 oz. (751 g)
Bequest of George C. Stone, 1935
36.25.1794

DESCRIPTION: The axhead of crucible steel has a curved and chamfered cutting edge, the upper edge slightly concave in profile, the lower edge more sharply curved, with a short, flaring hammerhead of square section opposite. With the exception of the cutting edge and the center of each face, the axhead is covered with chiseled and engraved ornament consisting of delicate leafy arabesques and floral designs. The decoration on the faces is reserved in borders following the contours of the upper and lower edges and in a large medallion at the center of the head that issues a smaller medallion chiseled with an antelope; on the hammerhead a lion attacks a gazelle, the design now obscured by damage. At the top the pin securing the head to the haft is covered by a circular boss, formerly gilt, with a flanged base that ends in a trefoil-shaped terminal pointing to the front. The wooden haft of round section is wrapped with string and covered with brown leather (defective), the leather surface reflecting the underlying texture of the string. The lower end of the haft lacks a leather covering, suggesting that the original grip, perhaps of silver or brass, has been lost.

There are two basic types of saddle ax. One arches slightly at the top, has a moderately downturned blade, and was frequently used by the Ottomans; with origins in Russian axes of the eleventh to thirteenth century, the Ottoman examples must have resulted from contact with the Slavs in southeastern Europe.[1] The second type of saddle ax has a symmetrical head and was used for almost all Iranian and Indian axes; the present example approximates this type.

Saddle axes, *tabarzin* in Persian, were carried under the saddle and used in hand-to-hand combat; numerous examples from Ottoman Turkey, Iran, and India have survived. They are frequently mentioned in Iranian literature, with multiple references in the *Shahnama* of Firdausi (ca. A.D. 1000): "Saddle-axes rattled and bows twanged. The earth became more agitated than the heavens."[2] In addition, lines of verse about *tabarzins* were often inscribed on axes of various types, further illustrating that these weapons were commonly considered synonymous with bloody combat. Such a verse, by the Persian poet Hatifi (d. 1521), appears on two axes in Danish collections; the inscription refers to the "bloodthirsty *tabarzin* . . . bloodstained from the blood of heroes like the purple comb of a fighting cock."[3]

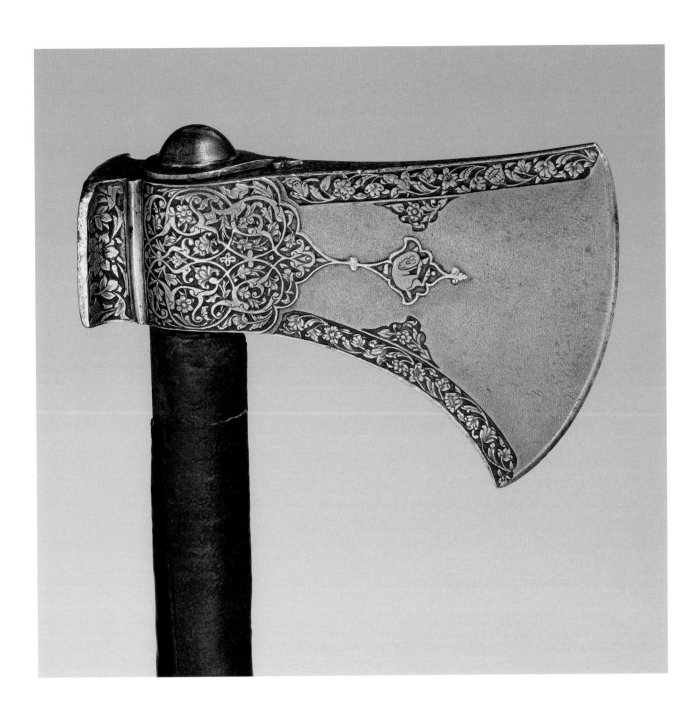

One of the finely decorated and inscribed Iranian saddle axes now in Copenhagen is dated A.H. 1138 (A.D. 1726); another saddle ax, very similar in style, is in the Royal Collection at Windsor Castle.[4] Two saddle axes signed by Lotf 'Ali and dated A.H. 1148 (A.D. 1735/36) and A.H. 1152 (A.D. 1739/40), now in the Museo Poldi Pezzoli, Milan, and the Wallace Collection, London, respectively, help to establish a chronology for a number of pieces, including the present ax.[5] The area below the hammerhead on the Lotf 'Ali ax in Milan is deeply chiseled and engraved with a floral scroll of alternating petal and leaf forms. A very similar design occurs on the Metropolitan's ax, indicating that it probably dates to about the same period.

PROVENANCE: Fenton and Sons, London; George Cameron Stone, New York.

REFERENCE: Stone 1934, p. 81, fig. 101, no. 8.

NOTES

1. Kirpicnikov 1968, fig. 10.

2. For this verse, see Melikian-Chirvani 1979b, p. 117. For additional verses, as well as a discussion of saddle axes in general, see ibid., pp. 117–35.

3. Copenhagen 1982, pp. 122–25, nos. 80, 81 (the latter, dated 1726, ill.) .

4. Ibid., pp. 122–23, no. 80; and Royal Collection, Windsor Castle, no. 634.

5. Melikian-Chirvani 1979b, pp. 121–24, 126–29. A dagger (kard) in the Metropolitan Museum, acc. no. 64.303.1, is similarly chiseled.

97 · Dervish Ax

Turkey, Ottoman period, dated A.H. 1241 (A.D. 1825/26)
Steel, silver, copper, wood
Length overall 52 in. (132 cm); axhead 15⅜ × 8¾ in. (39 × 22.1 cm);
weight 3 lbs. 2 oz. (1,420 g)
Rogers Fund, 1904
04.3.467

DESCRIPTION: The axhead of blackened steel has a large crescent-shaped blade, the
lower tip of which is flattened and nailed to the haft; the stem of the blade merges
into a round hollow socket from which projects a small flat hammerhead. The blade
is inlaid in silver on each side with lobed cartouches and roundels containing Arabic
inscriptions, some of which are worn and unclear; the concave back edges are inlaid
in copper along the contours. The wooden haft of octagonal section is scored with
crisscross lines on the lower half; the butt is slightly stepped, indicating that it
probably once had a metal fitting. The axhead has apparently been in a fire, the
black firescale on the surface is now partially delaminated, and some of the silver
inlay is lost. The haft is a later association.

INSCRIPTIONS:
Side 1 (Handle is on the right, shown vertically)
a. (At center right of blade, with the word "Muhammad" repeated and addorsed)

<div dir="rtl">الله محمد محمد علي</div>

Allah, Muhammad, Muhammad, 'Ali.

b. (To the left of this in the large oblong cartouche)

<div dir="rtl">بسم الله الرحمن الرحيم

في بيوه [كذا] اذن الله ان ترفع و يذكر فيها

اسمه و يسبح له فيها بالغدو و الاصال رجال

لا تلهم [يـ] هم تجارة و لا بيع عن ذكر الله و اقام

الصلوة و ايتاء الزكوة يخافون يوما

تتقلب فيه القلوب و الابصار</div>

In the Name of Allah, Most Gracious, Most Merciful. In houses, which Allah hath
permitted to be raised to honour; for the celebration, in them, of His name: In them
is He glorified in the mornings and in the evenings, (again and again),—By men
whom neither trade nor sale can divert from the Remembrance of Allah, nor from
regular Prayer, nor from paying zakat [the practice of regular charity]. Their (only)
fear is for the Day when hearts and eyes will be turned about. (Qur'an 24:36–37)

c. (In the four roundels on either side of the central inscriptions, from bottom
to top)

<div dir="rtl">و من يتوكل

على الله فهو

حسبه ان الله

بالغ امره و

١٢٤١</div>

And whoever relies upon Allah—then He is sufficient for him. Indeed, Allah will
accomplish His purpose. (Qur'an 65:3) waw. 1241.

<div dir="rtl">الله

محمد ابو بكر

عمر

عثمان علي</div>

Allah, Muhammad, Abu Bakr, 'Umar, 'Uthman, 'Ali.

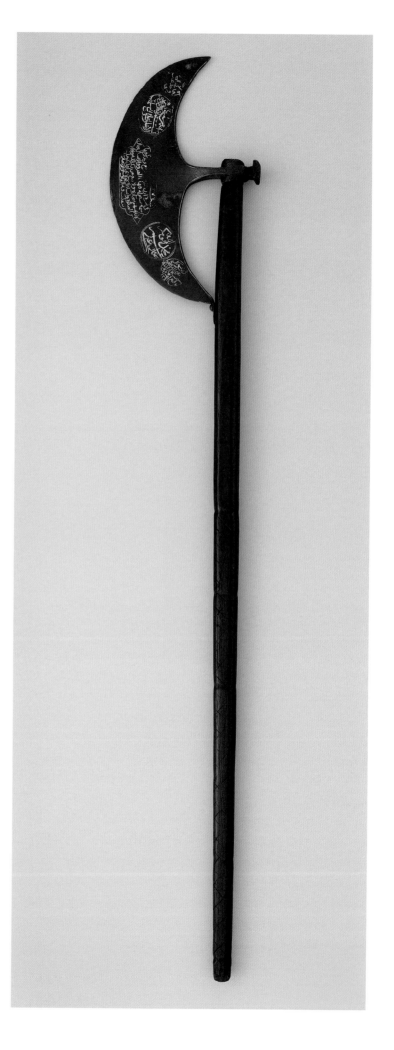

انه من سليمان و انه

بسم الله الرحمن الرحيم

الا تعالوا علي و اتوني مسلمين

It is from Solomon, and is (as follows): In the Name of Allah, Most Gracious, Most Merciful: Be ye not arrogant against me, but come to me in submission. (Qur'an 27:30–31)

كلما دخل على

ها زكريا المحراب

وجد عند

ها رزقا ۱۱

Every time that Zakariya entered (her) chamber to see her, He found her supplied with sustenance. (Qur'an 3:37) 11.

Side 2 (Handle is on the left, shown vertically)
d. (At center, very worn, with 'Ali repeated and addorsed)

علي علي

حسن حسين

'Ali, 'Ali, Hasan, Husayn.

(Immediately to the left of this, the letter *waw* repeated and addorsed)

وو

waw waw.

e. (To the right of this in the long oblong cartouche)

بسم الله الرحمن الرحيم و لنبلونكم

بشيء من الخوف و الجوع و نقص من الاموال

و الانفس و الثمرات و بشر الصابرين و الذين

اذا اصابتهم مصيبة قالوا انا لله و انا

اليه راجعون

In the Name of Allah, Most Gracious, Most Merciful. Be sure we shall test you with something of fear and hunger, some loss in goods or lives or the fruits (of your toil), but give glad tidings to those who patiently persevere, who say, when afflicted with calamity: "To Allah we belong, and to Him is our return." (Qur'an 2:155–56)

f. (In the four roundels on either side of the central inscriptions, from top to bottom) (The square in the roundel at top is filled with magic numbers; in the sides around it are magic letters.)

(In the next two roundels, a couplet from a poem by Hatayi)

لا فتى الا علي اولدر ارنلر سروري لا سيف الا ذو الفقار بلنده تيغ حيدري

There is no hero but 'Ali, he is the champion of saints (*erenler*),
There is no sword but Dhu'l faqar (Zülfikar), around his waist is the blade of Haydar.
(In the bottom roundel, the square in the middle and the sides around it are filled with magic letters.)

Large axes with crescent-shaped blades have a long history and were first depicted in Egyptian paintings of Dynasty 12 (ca. 1981–1802 B.C.).[1] In an Islamic context, axes with crescent-shaped blades were first depicted on a Mamluk basin of about 1290–1310.[2] Such blades were commonly used by the Ottomans and appear in miniatures from the sixteenth and seventeenth centuries.[3] A number of these axes were taken as booty by the Austrians during their seventeenth- and eighteenth-century campaigns against the Turks.[4]

Crescent-shaped blades such as this one are often described as "dervish axes," although this does not preclude a military use. According to John Kingsley Birge, for example, the Bektashi Order of Dervishes carried such axes in memory of warriors like Sayyid 'Ali Sultan, one of the forty legendary heroes who fought for the Ottoman sultan Orhan Ghazi (r. 1326–60).[5] Whether this is the precise historical reason for their adoption by the dervishes remains unclear; nonetheless, crescent-bladed axes certainly became for them a major symbol of jihad. The association of these axes with the dervishes, and especially with the Bektashi, is confirmed by two axes of this type inscribed in honor of Haji Bektash. One of these is in the State Hermitage Museum, Saint Petersburg, and the other is in the Furusiyya Art Foundation, Vaduz; the former is dated 1757, the latter 1750.[6] Both are by the same maker, Ayyubi. Although they are slightly earlier than the Museum's ax, they help document the type and its dervish connotations.

The use of crescent-bladed axes by dervishes is further documented in Iranian and Ottoman miniature painting

Fig. 37. Jean-Léon Gérôme, *The Whirling Dervish*, 1899. Oil on canvas. Private collection

and in paintings and photographs by Europeans in the Near East. A fifteenth-century Iranian miniature shows a princess preceded by a bearded figure, probably a dervish, shouldering a broad-bladed, asymmetrical, crescent-shaped ax.[7] A late nineteenth-century photograph, possibly by the Armenian photographer Antoine Sevruguin (died 1933), shows a young dervish with a similar broad-bladed decorated ax.[8] A painting of 1899 by Jean-Léon Gérôme (1824–1904), *The Whirling Dervish*, depicts a Mevlevi *sama'* (mystical dance) and the ambiance in which such axes could be found (fig. 37). In the painting a lone Sufi spins among his companions; on the wall of the large arched niche to his right are several crescent-bladed axes.[9] Similar axes are preserved in the Khalili Collection, London, the Askeri Müzesi, Istanbul, and the Furusiyya Art Foundation, Vaduz.[10]

The inscriptions on the Museum's ax, especially Qur'an 24:36–37, also support the theory that this is a dervish ax, belonging to someone who could not be diverted "from the Remembrance of Allah." These verses are from the *Sura al-Nur* (sura 24), the "Light" sura, which is often used on mosque lamps and on lamps in Sufi shrines.[11] The presence among the inscriptions on the Museum's ax of an Ottoman Turkish couplet by Hatayi, a Bektashi poet, confirms that it was made in a Sufi milieu. The same can be said for the repeated and adorsed letter *waw*, which is found on a banner once belonging to the Janissaries, who had a Bektashi affiliation.[12]

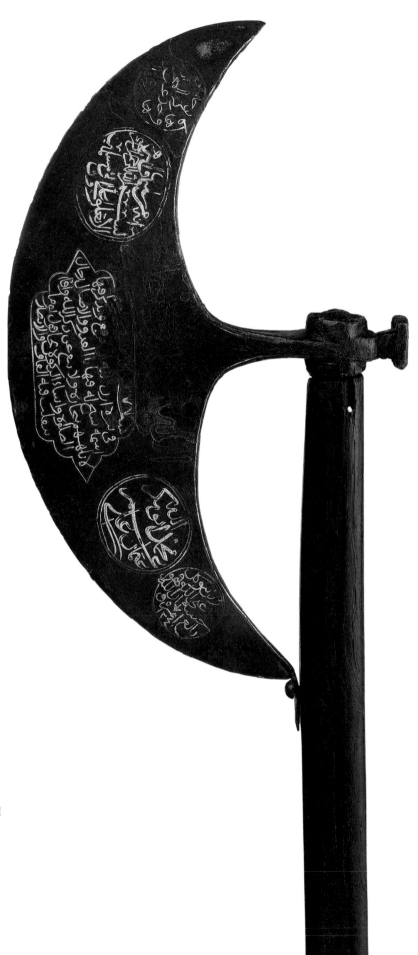

PROVENANCE: Maurice de Talleyrand-Périgord, duc de Dino, Paris.

REFERENCES: Cosson 1901, pp. 84–85, no. H.15; Macoir 1910, pp. 22–23, no. 2, pl. III; Nickel 1972, fig. 19; Nickel 1979b, fig. 172.

NOTES

1. Gamber 1978, fig. 88. Other early examples are known from Mesopotamia, Syria, and Anatolia; see Muscarella 1988, nos. 508, 509, 532, 533.

2. Musée du Louvre, Paris, no. LP 16; see, for example, Riyadh 1996, vol. 2, no. 59.

3. For their depictions in miniature painting of this period, see, for example, Jaeckel 1970, p. 17.

4. Oberschleissheim 1976, nos. 125, 126.

5. Birge 1937, p. 233.

6. For the Hermitage ax, see Miller 1958; for the example in the Furusiyya Art Foundation, Vaduz, no. R-135, see Paris 2007/Mohamed 2008, p. 266, no. 256.

7. Topkapı Sarayı Museum, Istanbul, H.2153, fols. 3v, 4v.

8. Active in Tehran; see Stein 1989, p. 122, fig. 18. For a rare example of an inscribed dervish ax, see Melikian-Chirvani 1979a, pp. 113–15.

9. G. Ackerman 2000, no. 459.

10. Khalili Collection, London, no. 1160, which is also inscribed; see Alexander 1992, pp. 110–11, no. 58. Askeri Müzesi, Istanbul, no. 2876, is signed by its maker and dated A.H. 1109 (A.D. 1697/98). The Furusiyya ax (Furusiyya Art Foundation, Vaduz, no. R-136) is dated 1648 and is typical of those captured at the siege of Vienna in 1683; see Paris 2007/ Mohamed 2008, p. 265, no. 255.

11. See, especially, Melikian-Chirvani 1987.

12. Will Kwiatkowski, personal communication, January 2015. For the banner, see Istanbul 2008, p. 112.

98 · Mace Head

Iran, 10th–11th century
Rock crystal
Height 3¼ in. (8.3 cm); diameter 3⅜ in. (8.7 cm);
weight 2 lbs. (918 g)
Rogers Fund, 1981
1981.86

DESCRIPTION: The mace head of heavy rock crystal is circular in section, with straight sides, a curved top, and a slightly more angular bottom. A cylindrical hole, slightly wider at the top, is drilled through the center (the shaft was probably wedged in with a circular cap). Traces of cuprite in the hole indicate that the shaft was metal, probably copper. The horizontal center section is carved in relief with a continuous inscription (a) in Kufic script, with a narrow raised band above and below. The top and bottom are each carved with sixteen radiating grooves, pointed near the hole, with engraved outlines; the molding around the hole is recessed at the top and raised on the bottom. The entire surface is irregularly pitted, scratched, and worn, and the rock crystal shows numerous occlusions.

INSCRIPTION:
a. (Around the center section)

نوذر بن اسفنديار

Nowzar son of Esfandiyar (Naudhar ibn Isfandiyar).

Maces were often used in the Islamic world as symbols of power and authority. As ceremonial objects rather than utilitarian arms, they were frequently made of precious metal or fragile nephrite or rock crystal, sometimes decorated with precious stones.[1] Rock-crystal maces are relatively rare; fewer than a dozen dating prior to the seventeenth century have survived, and they are mostly from the Fatimid period (909–1171). One of these, a possibly Fatimid mace whose head is carved with lions, is part of the Hungarian royal regalia.[2] A later rock-crystal mace, presumably Mughal, is also in the Museum's collection (cat. 102).

A passage from the Qur'an illuminates the symbolic importance of the mace and helps to explain its repeated appearance in Islamic chronicles and artistic representations as an object of strength and authority: "Those who deny (their Lord)—for them will be cut out a garment of Fire: over their heads will be poured out boiling water. With it will be melted what is within their bodies, as well as (their) skins. In addition there will be maces of iron (to punish) them" (Qur'an 22:19–21). Malik, the guardian of hell, is often represented in miniature paintings with an ox-headed mace, as seen in a fifteenth-century *Miraj-nama* (describing the

night journey of the Prophet); other miniatures in the same man-uscript portray demons with flanged or round-headed maces tormenting sinners.[3]

The Qur'anic association of the mace with the punishment of sinners and unbelievers imbues the weapon with the power and severe justice of God. Capitalizing on this symbolism, Islamic rulers were almost ubiquitously accompanied by mace bearers, an important office under many dynasties; the Seljuq vizier Nizam al-Mulk (1018–92) mentions officials who carried what seems to have been a long slender staff, probably a type of mace depicted in later miniature painting.[4] As a symbol of military rank, accord-ing to Nizam al-Mulk, a mace (with a ring for attaching it to the saddle) was presented to a young slave-warrior only after he had trained for five years, at which time the warrior was well on his way to becoming a commander, a position accorded in his sev-enth year.[5] Probably the best-known ceremonial mace bearers were the guards of the Turkic Ghaznavid and Samanid sultans in Iran and Afghanistan (tenth–twelfth century).[6] In addition, mace bearers were prominent in Ottoman and Mughal ceremonials, as illustrated in numerous miniature paintings.[7] The Sufis also used the mace as a symbolic weapon.[8]

The inscription on the Museum's mace head is in a Kufic script. The Persian name suggests that the mace head is Iranian in origin, an attribution confirmed by the style of the inscription, especially the head of the *waw*, which overlaps its tail in the name "Naudhar." One of the earliest examples of this style of inscrip-tion occurs on the early twelfth-century palace of Mas'ud in Ghazni, and although it also appears much later in inscriptions on the fifteenth-century Friday mosque in Herat, the Museum's mace head should be attributed to the earlier period.[9] It has been suggested that the use of the names "Naudhar" and "Isfandiyar" indicate that the mace head probably originated somewhere to the south of the Caspian Sea.[10] When it was examined at acquisi-tion, the Museum's Conservation Department judged that the copper corrosion in the crevices was of "considerable age" and that there was no evidence of recent working on the quartz sur-face.[11] While not providing a specific dating for the mace head, this assessment, in conjunction with the epigraphic evidence, gives added support for a tenth- to eleventh-century date.

PROVENANCE: Sotheby Parke Bernet sale, London, April 12, 1976, lot 96A, ill.

REFERENCES: Sotheby Parke Bernet, London 1976, pp. 42–43, lot 96A, ill.; Alexander 1981, ill.

NOTES

1. Examples of such luxurious weapons, probably made solely for ceremonial purposes, include an early sixteenth-century mace delicately inlaid with mosaic work and now in the Kunsthistorisches Museum, Vienna, and several maces decorated with gold, neph-rite, and precious stones. Kunsthistorisches Museum, Vienna, no. C61 (see Riyadh 1996, vol. 2, p. 97, no. 84v); Topkapı Sarayı Museum, Istanbul, nos. 693, 696, 711, 713, 724 (see Rogers 1987a, nos. 43a, b); and Livrustkammaren, Stockholm, no. 57.30.2 (see Stockholm 1985, no. 8).

2. Magyar Nemzeti Múzeum, Budapest; see Kovács and Lovag 1988, pp. 83–88, 94–95.

3. Séguy 1977, pls. 47–52, 54.

4. Burton-Page 1965; B. Robinson 1979, pl. LXVIII.

5. As quoted in Lewis 1976, vol. 2, p. 237.

6. Bosworth 1973.

7. New Delhi and other cities 1997–98, pls. 10, 11. For a painting of about 1620 depicting a group of mounted mace bearers of the Ottoman sultan Murad III, see Washington, D.C., and other cities 1981–82, no. 31, ill.; for mace bearers at the court of the Mughal emperor Shah Jahan depicted in the *Padshahnama* (Royal Library, Windsor Castle, fols. 46b–47a, 70b–71a), see New Delhi and other cities 1997–98, pls. 6–7, 12–13.

8. In his work on the Mevlevi dervishes, *Menaqibu'l Arifin* (The acts of the adepts), the fourteenth-century Ottoman historian Ahmed Eflaki, for example, describes the initi-ation of a *ghazi* warrior by the sheikh of the Mevlevi dervishes in Konya; he records that the warrior took the mace offered him by the sheikh and said, "I shall beat down my passions with this club, and with it I shall strike dead the enemies of the faith"; see Mélikoff 1965, p. 1044.

9. Will Kwiatkowski, personal communication, January 2015. This view is shared by Manijeh Bayani, who maintains that the mace head could not be Timurid and should be dated to no later than the early twelfth century.

10. Manijeh Bayani, personal communication, January 2015.

11. Report by Pieter Meyers, Senior Research Chemist, The Metropolitan Museum of Art, New York, 1980.

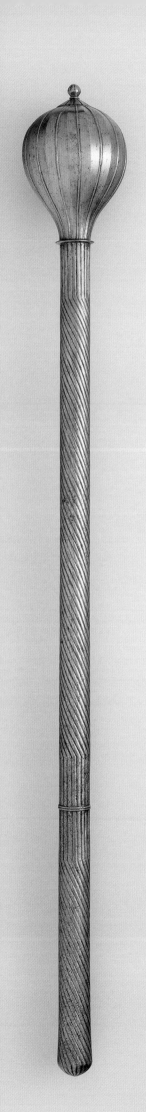

99 · Mace

Probably Turkey, Ottoman period,
mid-16th century
Steel
Length 28 in. (71.1 cm); diameter
of head 3 in. (7.6 cm);
weight 2 lbs. 12 oz. (1,256 g)
Gift of William H. Riggs, 1913
14.25.1330

DESCRIPTION: The mace, formed entirely of steel, is
hollow. The faceted, globular head, which tapers
toward a flange at the base, is chiseled with fourteen
slightly raised longitudinal ribs and is surmounted
by a flattened conical cap and spherical button, both
engraved with radiating lines. The shaft is divided
into two spirally grooved sections of unequal length,
separated by a transverse molding, the spiral design
emanating from vertical grooves at each end.

Weapons with spirally
fluted steel shafts seem
to have been developed
by Mamluk craftsmen during the
fourteenth and fifteenth centuries.[1]
By the sixteenth century this feature
appears to have become widespread, as
very similar fluting occurs on a mace
that has been called Iranian and dated to
the sixteenth century and is now in the
Magyar Nemzeti Múzeum, Budapest.[2]
Another sixteenth-century mace, now in
the Kunsthistorisches Museum, Vienna,
is decorated in a style typical of Turkey
or Syria from the Ottoman period[3] and
is of nearly identical form, with the
exception that it is decorated with
mosaic inlay and has a plain, unfluted
haft.[4] In contrast to these two, the
Museum's mace is distinguished by its
relative simplicity and restrained
embellishment; it typifies, decoratively,
what has been called the "plain tradition"
current in Ottoman Turkey during the
sixteenth century.[5] An attribution to a
center within the Ottoman Empire

seems certain for the Vienna mace, but the origin of the mace in
Budapest needs further examination. Because it is so similar in
certain of its structural details to the Museum's example, the
resolution of this issue is crucial. The original attribution to Iran
must have been based on the arabesque decoration, but compa-
rable work also occurs on numerous Ottoman pieces of the
sixteenth century, and for this reason an Ottoman attribution is
likely for all three maces.[6]

PROVENANCE: Ambrogio Uboldo, Milan; William H. Riggs, Paris.

REFERENCES: Los Angeles and Hagerstown 1953–55, no. 114; Nickel 1974, p. 195, ill.

NOTES
1. See cats. 93, 95.
2. See Munich 1910, no. 349 (previously in the Kunsthistorisches Museum, Vienna,
no. C. 66, but transferred to the Magyar Nemzeti Múzeum, Budapest, in 1918); for an
Ottoman example of similar shape, see Washington, D.C., Chicago, and New York
1987–88, no. 85.
3. For this style, see, for example, Istanbul 1983, no. E 75, which is dated to the mid-
sixteenth century.
4. Kunsthistorisches Museum, Vienna, no. C. 61; see Riyadh 1996, vol. 2, p. 97, no. 84v.
5. See Allan and Raby 1982, pp. 27–29.
6. See, for example, the arabesques on an Ottoman bookbinding dated 1519, in the
Topkapı Sarayı Museum, Istanbul, no. A 21; see London 2005b, no. 285. In the entry
for the binding, Zeren Tanındı notes that its style originated in Herat and was later
brought to Istanbul by craftsmen taken there by Sultan Selim I (r. 1512–20). Other
examples of the same style occur on sword fittings from the Ottoman palace work-
shops of the mid-sixteenth century, including one bearing the imperial fish symbol
and now in the Topkapı Sarayı Museum, Istanbul, no. 1/294; see ibid., no. 295. For the
fish emblem, see Alexander 2003. Finally, the decorated sections on the Budapest
mace alternate with plain areas, exactly the same format as that of several gilt-copper
helmets that are certainly Ottoman, such as one in the Askeri Müzesi, Istanbul,
no. 1092; see Riyadh 1996, vol. 2, p. 110, no. 89i.

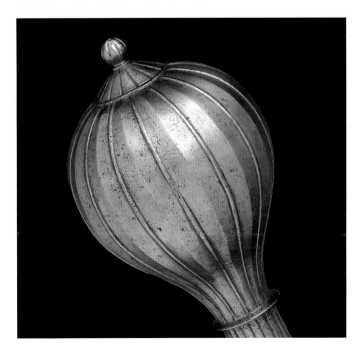

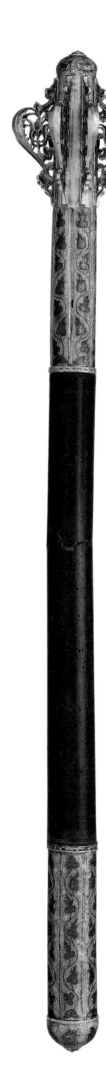

100 · Mace

Turkey, Ottoman period, 1648–87
Silver gilt, niello, wood
Length 24½ in. (62.3 cm); diameter
of head 3⅛ in. (8 cm);
weight 1 lb. 3 oz. (535 g)
Bequest of George C. Stone, 1935
36.25.2958

DESCRIPTION: The head of silver gilt consists of
eight radial flanges shaped as half medallions, each
pierced with a tulip design, fitted into a tubular
socket surmounted by a domed cap engraved with
nielloed vine leaves on a ring-punched ground, with
a rosette-shaped rivet head at the apex. Below the
flanges the socket is shaped with six longitudinal
sections, each slightly convex and engraved and
nielloed with a scrolling tendril issuing tulips
against a ring-punched ground, with a collar at the
base having beaded and scalloped rings. Stamped
near the base of the socket is a fragmentary *tuğra*.
The wooden haft of round section is engraved with
two pairs of concentric rings at each end and is
fitted at the base with a silver-gilt and nielloed grip
that matches the socket. Stamped near the top of
the grip is a fragmentary *tuğra* that appears to be the
same as that on the socket. The silver shows minor
wear, the gilding now pale; the haft is wormholed
and cracked through the center.

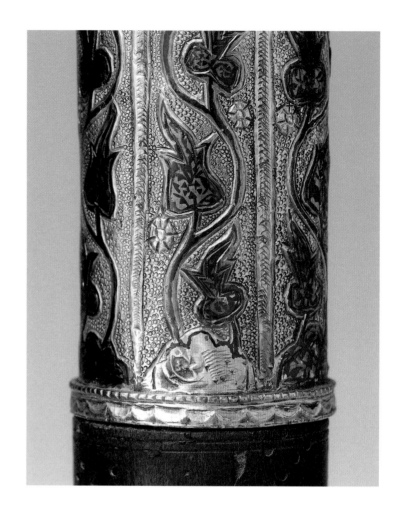

Maces of this lightweight, decorative type were used
as ceremonial pieces, insignia of command in the
Ottoman army. The *tuğra* struck on both mounts is
that of the Ottoman sultan Mehmed IV (r. 1648–87), and based on
comparisons to similarly decorated weapons captured from the
Turks following the siege of Vienna in 1683 this mace should
probably be dated to the later years of his reign.[1] Among the
related maces are one in Karlsruhe that is recorded in a will of
1691,[2] and another in the Khalili Collection, London.[3] Both have
pierced flanges and silver-gilt mounts with raised foliate decora-
tion, including tulips, partly nielloed, on a ring-punched ground.
Nielloed silverwork of this type is often encountered on other
Ottoman weapons of the period, including several sabers in the
Metropolitan's collection (cats. 61, 62).

PROVENANCE: Morgan S. Williams, Saint Donat's Castle, Glamorganshire, Wales;
W. O. Oldman, London; George Cameron Stone, New York.

REFERENCE: Christie, Manson and Woods, London 1921a, lot 316.

NOTES

1. Complete, legible *tuğras* of Mehmed IV are struck on the nielloed silver mounts of
an Ottoman mail shirt dated 1682, now in the Badisches Landesmuseum, Karlsruhe,
no. D242; see Petrasch et al. 1991, pp. 210–11, no. 156.
2. Ibid., pp. 85–87, no. 19.
3. Alexander 1992, pp. 118–19, no. 63.

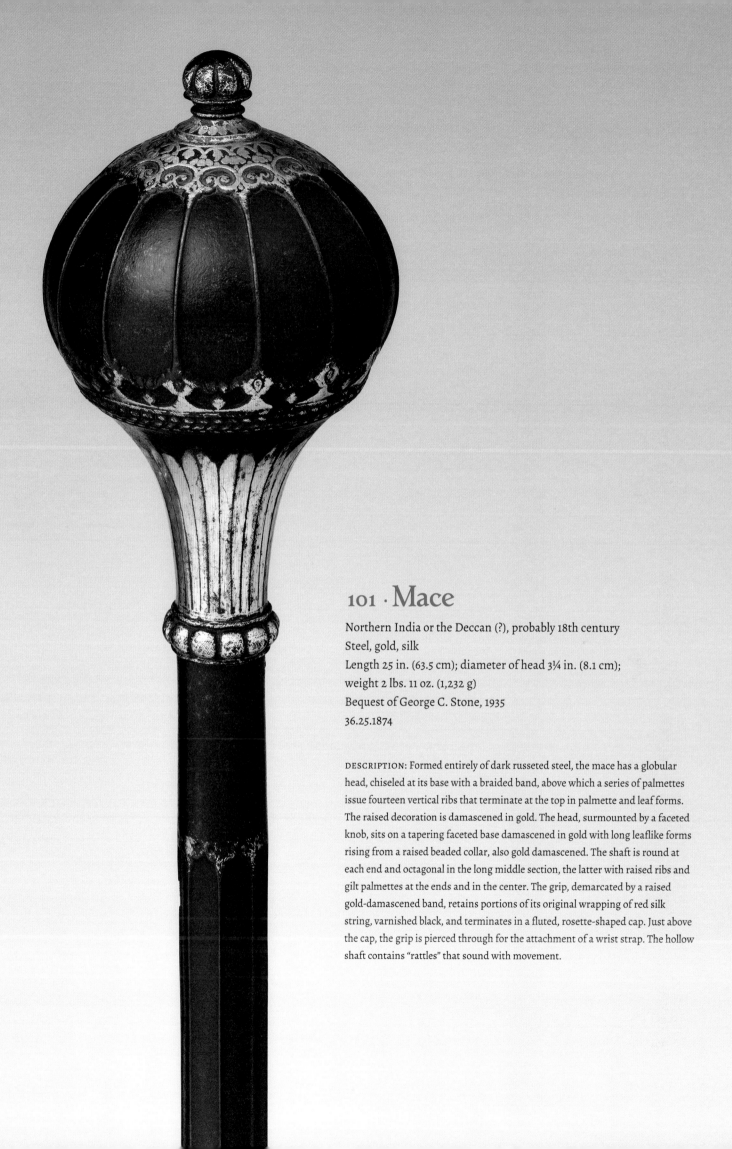

101 · Mace

Northern India or the Deccan (?), probably 18th century
Steel, gold, silk
Length 25 in. (63.5 cm); diameter of head 3¼ in. (8.1 cm);
weight 2 lbs. 11 oz. (1,232 g)
Bequest of George C. Stone, 1935
36.25.1874

DESCRIPTION: Formed entirely of dark russeted steel, the mace has a globular
head, chiseled at its base with a braided band, above which a series of palmettes
issue fourteen vertical ribs that terminate at the top in palmette and leaf forms.
The raised decoration is damascened in gold. The head, surmounted by a faceted
knob, sits on a tapering faceted base damascened in gold with long leaflike forms
rising from a raised beaded collar, also gold damascened. The shaft is round at
each end and octagonal in the long middle section, the latter with raised ribs and
gilt palmettes at the ends and in the center. The grip, demarcated by a raised
gold-damascened band, retains portions of its original wrapping of red silk
string, varnished black, and terminates in a fluted, rosette-shaped cap. Just above
the cap, the grip is pierced through for the attachment of a wrist strap. The hollow
shaft contains "rattles" that sound with movement.

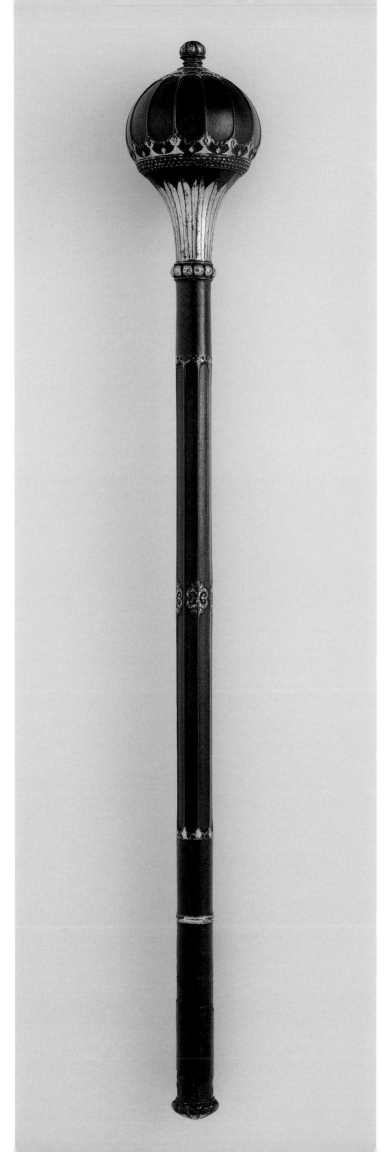

Although maces with decorated heads such as this are related to the all-steel examples discussed in mace cat. 99, they are decoratively more complex and as a group almost certainly later in date. Numerous examples can be found in public and private collections, where they are generally described as Iranian or Indian and dated from as early as the sixteenth century to as late as the nineteenth.[1] The decoration of these maces, however, has more in common with that found on Indian metalwork of the eighteenth to nineteenth century; this is especially true of the pointed palmette forms around the head of the Metropolitan's example and the elongated, shieldlike palmette forms on the haft.[2] A similar but more finely decorated mace in a private collection has been attributed to the Deccan and dated to the seventeenth century,[3] while another mace, with a flanged head but very similar haft and comparable treatment of the floral bands at either end of the haft's flutings, has been called Mughal and dated to the first half of the eighteenth century.[4] No reason is provided for these attributions or for their dating; thus for the present the precise origin and dating of these maces remain hypothetical.

PROVENANCE: Sir Guy Francis Laking, London; W. O. Oldman, London; George Cameron Stone, New York.

REFERENCES: Christie, Manson and Woods, London 1920, lot 356; Stone 1934, p. 422, fig. 533, no. 20; Grancsay 1937b, pp. 169, 170, fig. 2; Grancsay 1986, pp. 182–83, fig. 63.23 (incorrectly identified with acc. no. 36.25.1883); Paris 2007/Mohamed 2008, p. 256, no. 246.

NOTES

1. See Grancsay 1937b and Grancsay 1986, in which the present example was called Persian, sixteenth century (Grancsay 1986 misidentified the object's accession number). Another similar mace is in the Metropolitan Museum, acc. no. 36.149.3.
2. The same hard-edged floral forms and palmettes appear on an Indian shield of 1708–9; see London 1982, no. 459, ill.
3. Furusiyya Art Foundation, Vaduz; see Paris 2007/Mohamed 2008, p. 256, no. 246, where it is compared to the present mace and Grancsay's attribution and dating are erroneously accepted (see note 1 above).
4. Victoria and Albert Museum, London, no. IS-3526; see Guy and Swallow 1990, fig. 81. Another mace with a ribbed haft and chiseled palmettes in the Victoria and Albert Museum, no. 742-1889, is described as Persian and dated to the first quarter of the eighteenth century; see North 1985, fig 39a.

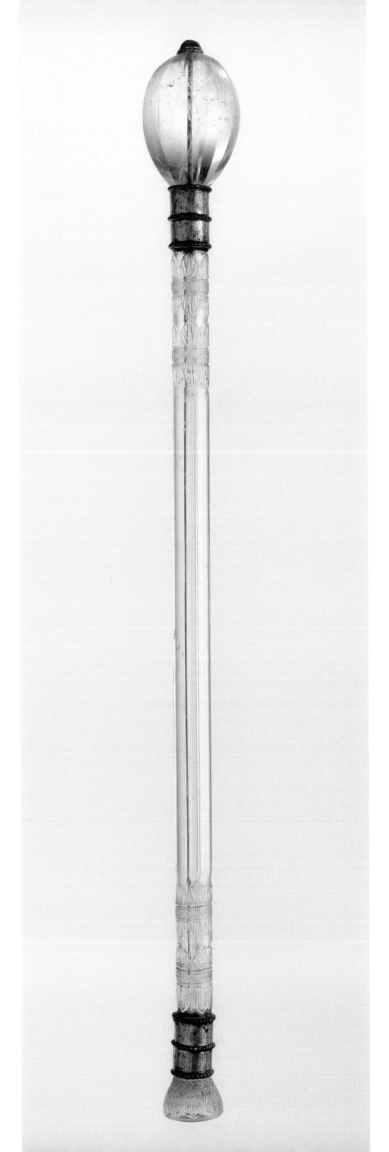

102 · Mace

India, Mughal period, 18th century
Rock crystal, gilt-copper alloy, ruby
Length 21 in. (53.5 cm); diameter of head 2 in. (5 cm);
weight 1 lb. 6 oz. (636 g)
Bequest of George C. Stone, 1935
36.25.1884

DESCRIPTION: The mace of rock crystal is constructed in three sections: head, shaft, and base, joined by gilt-copper collars with beaded edges and a middle band. The longitudinally faceted oval head is secured to the haft by a metal rod inserted through a hole in its center and is capped by a cabochon ruby in a gilt-copper setting with beaded edge. The slender haft of round section is hollow and is carved at each end with two registers of zigzag bands framed by stylized leaves. The base of flattened conical form is also engraved with geometric ornament and leaves and has a hemispherical recess on the end.

This ceremonial mace is a rare example fashioned entirely from rock crystal. Rock crystal was often carved to produce luxurious objects, including an Islamic, perhaps Fatimid, mace that became part of the Hungarian royal regalia.[1] Several detached rock-crystal mace heads are known, among them a probably tenth- to eleventh-century Iranian example in the Museum's collection (cat. 98).

Most likely from Mughal India, the Museum's mace has a haft that is decorated in a style found on several Indian maces and axes now in the Wallace Collection, London.[2] A very similar ovoid head is on an all-steel Indian mace dated 1880 and now in the Khalili Collection, London.[3] The ovoid shape, however, is not confined to India; similar mace heads are known from Bukhara as well.[4] Much earlier examples of ovoid mace heads exist, probably from the eleventh or twelfth century, among them a Seljuq mace in the Furusiyya Art Foundation, Vaduz.[5] It is likely that this is a Central Asian type imported into India by the Mughals, who originally came from Bukhara.

The debased acanthus leaves with which the rock-crystal shaft of the present mace is decorated preclude a dating to the grand period of Mughal art during the seventeenth century. Consequently a later dating, provisionally to the eighteenth century, is suggested.

PROVENANCE: S. Haim, Istanbul; George Cameron Stone, New York.

REFERENCES: Grancsay 1937a, p. 57, fig. 4; [Nickel] 1968, p. 220, no. 40, ill.; Grancsay 1986, p. 169, fig. 63.7; Paris 2007/Mohamed 2008, p. 249, s.v. no. 238.

NOTES

1. Kovács and Lovag 1988, pp. 82–89.
2. Wallace Collection, London, nos. 1563, 1595; see Laking 1914, pp. 43, 47.
3. Khalili Collection, London, no. MTW 1130; see Alexander 1992, pp. 178–79, no. 112.
4. Flindt 1979, pp. 27–28, figs. 31, 32.
5. Furusiyya Art Foundation, Vaduz, no. R-101 (unpublished).

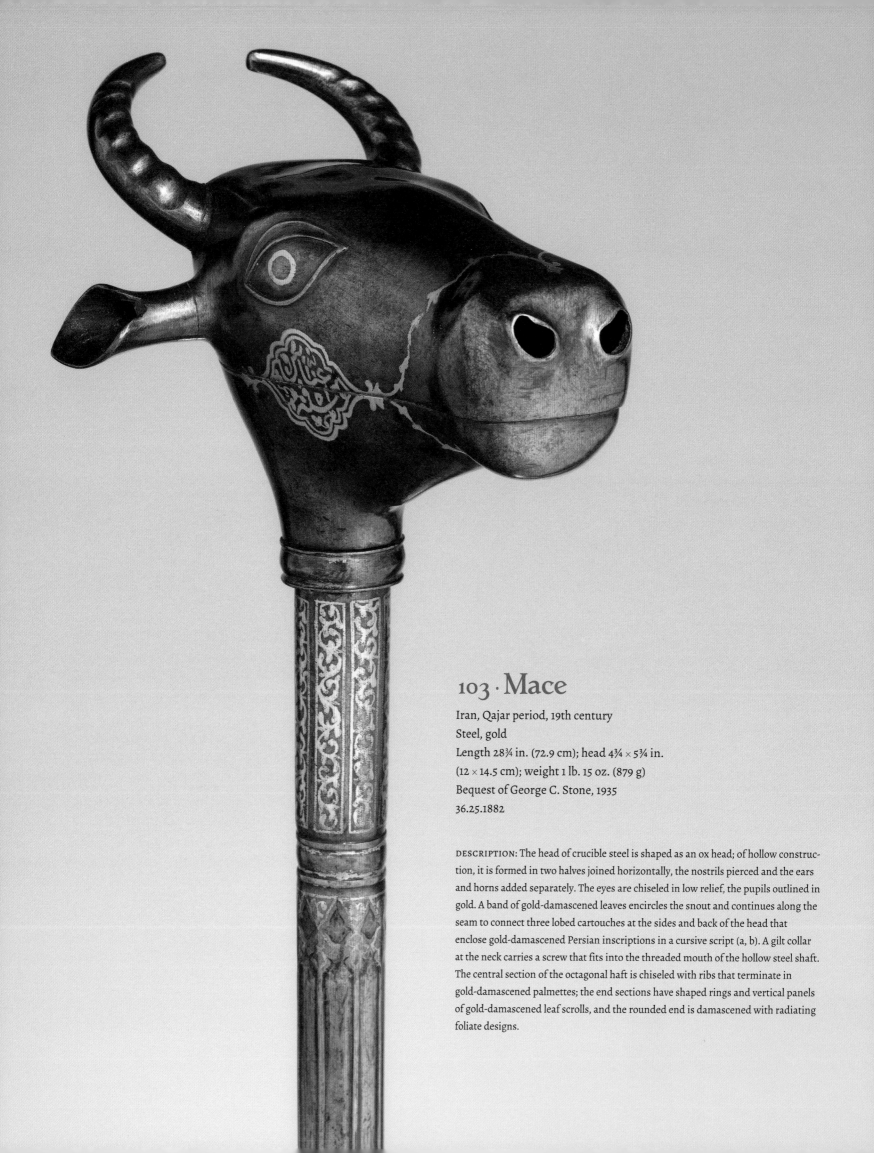

103 · Mace

Iran, Qajar period, 19th century
Steel, gold
Length 28¾ in. (72.9 cm); head 4¾ × 5¾ in.
(12 × 14.5 cm); weight 1 lb. 15 oz. (879 g)
Bequest of George C. Stone, 1935
36.25.1882

DESCRIPTION: The head of crucible steel is shaped as an ox head; of hollow construc-
tion, it is formed in two halves joined horizontally, the nostrils pierced and the ears
and horns added separately. The eyes are chiseled in low relief, the pupils outlined in
gold. A band of gold-damascened leaves encircles the snout and continues along the
seam to connect three lobed cartouches at the sides and back of the head that
enclose gold-damascened Persian inscriptions in a cursive script (a, b). A gilt collar
at the neck carries a screw that fits into the threaded mouth of the hollow steel shaft.
The central section of the octagonal haft is chiseled with ribs that terminate in
gold-damascened palmettes; the end sections have shaped rings and vertical panels
of gold-damascened leaf scrolls, and the rounded end is damascened with radiating
foliate designs.

INSCRIPTIONS:

a. (In the two medallions on the ox's cheeks)

عمل حاجی / عباس سنة ۹٥۱

Made by Haji 'Abbas [in the] year 951 (A.D. 1544/45).

b. (On the back of the ox's head)

السلطان شاه عباس

The sultan, Shah 'Abbas.

Most zoomorphic mace heads of the Islamic period were fashioned in the form of horned animals, primarily oxen, bulls, cows, and rams, whose iconographic significance can be traced to pre-Islamic sources. Horned maces (bulls, rams), for instance, were used in Iran in pre-Islamic times; among these are a bronze example from Luristan, now in the Museum's collection, that has been dated to between the late second and early first millennium B.C.[1] In the poet Firdausi's epic *Shahnama* (completed ca. A.D. 1000), which tells of the ancient heroes and kings of pre-Islamic Iran, Ahriman (the god of darkness) killed the cow that nursed the hero Bahram Gur. As a memorial, Bahram, aided by the blacksmith Kavad, fashioned a cow-headed mace that became an emblem of good, or light. This mace was subsequently inherited by a succession of heroes, most notably Feridun and Rustam. It was prophesied in the *Shahnama* that during the final battle between good and evil this horned mace would be used to vanquish the forces of darkness, just as in Islamic eschatology the two-pointed sword Dhu'l faqar would be used to destroy the forces of evil.

Due to its association with the heroes of the *Shahnama*, the ox-head mace appears frequently in miniature painting. A number of examples can be seen in the famous sixteenth-century Safavid *Shahnama* of Shah Tahmasp (r. 1524–76), among them one miniature showing the hero Feridun striking down the tyrant Zahhak with his mace (fig. 38) and another depicting Rustam wearing his distinctive leopard-skin helmet and carrying an ox-head mace.[2] Persian chronicles record that Sultan Mas'ud of Ghazna (r. 1030–41) also had a horned mace;[3] because the *Shahnama* of Firdausi was composed for his father, Mahmud, it could be assumed that Mas'ud had the mace crafted on the basis of that literary tradition.

Contrary to the inscriptions on the Museum's mace, neither the style of this object nor its date coincide with the reign of the Safavid ruler Shah 'Abbas (r. 1588–1629); it is, instead, a Qajar forgery of the nineteenth century. Haji 'Abbas was a legendary Iranian smith who supposedly worked for Shah 'Abbas. There are a great many objects that bear his signature, with attributed dates ranging from the mid-sixteenth to the late nineteenth century. These include a beggar's bowl previously in the Nuhad Es-Said

collection, Oxford, dated A.H. 1015 (A.D. 1606/7), which identifies its maker as the son of the late armorer Aqa Rahim; an ox-head mace in the Museum für Islamische Kunst, Berlin;[4] two steel birds in the British Museum, London; and two bowls in the Victoria and Albert Museum, London.[5] James W. Allan divided this corpus of material into an earlier and a later group; unfortunately, it seems unlikely that any of the surviving examples can be securely dated to the seventeenth century.

Indeed, the majority of surviving ox-head maces and related zoomorphic and anthropomorphic examples are of Qajar manufacture, and many were presumably made for the tourist trade.[6] The machine-made screw thread joining the Museum's mace head to its haft leaves no doubt as to its relatively modern manufacture. The Metropolitan possesses two additional nineteenth-century Qajar ox-head maces.[7] As with many other arms, the spurious inscriptions and dates were presumably intended to suggest the antiquity and historic associations of these modern pieces, thereby increasing their value.

Fig. 38. Detail of "Feridun Strikes Down Zahhak," folio 36v from the *Shahnama* (Book of Kings) of Shah Tahmasp. Attributed to Sultan Muhammad assisted by 'Abd al-'Aziz. Opaque watercolor, ink, and gold on paper. Freer Gallery of Art and Arthur M. Sackler Gallery, Smithsonian Institution, Washington, D.C. (F1996.2)

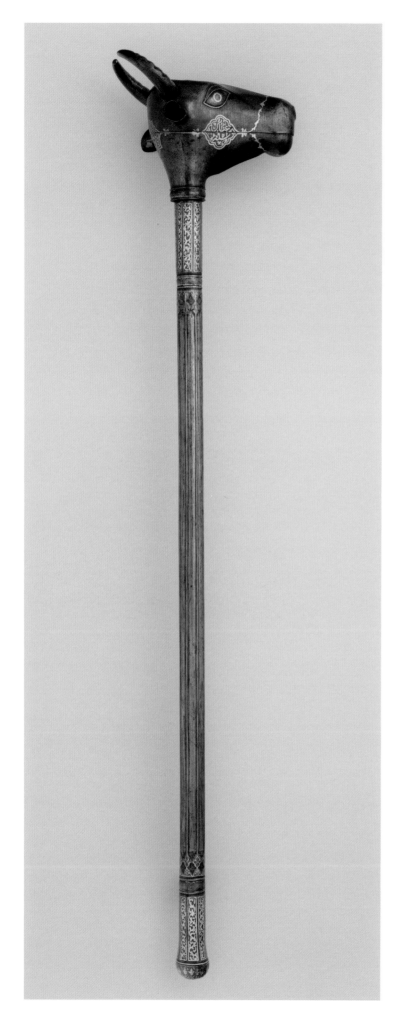

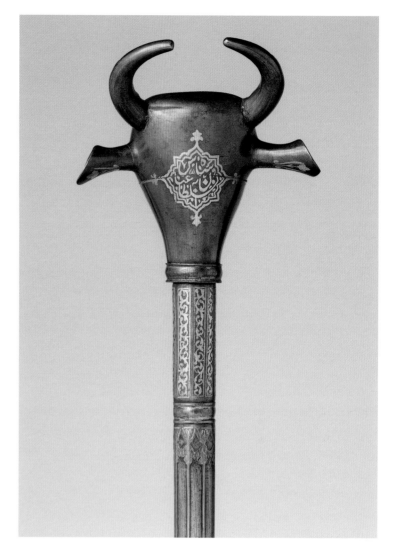

PROVENANCE: Fenton and Sons, London; George Cameron Stone, New York.

REFERENCES: Stone 1934, p. 422, fig. 533, no. 10; Nickel 1969, p. 92, ill.

NOTES

1. Muscarella 1988, pp. 288–89, no. 394. For a detailed study of the subject, see Harper 1985. For a recent review of zoomorphic and anthropomorphic maces, see Moshtagh Khorasani 2006, pp. 258–61.

2. See S. Welch 1976, pp. 112–15, 128–31; and Canby 2014, fols. 36v, 121v, respectively. See also ibid., p. 51, especially n. 60, where other miniatures showing ox-headed maces are listed.

3. Bosworth 1973, p. 120.

4. For the Berlin mace, see Phillip 2011, p. 63, fig. 4. In addition to the Metropolitan Museum's example and that in Berlin, there are two more ox-head maces of identical form signed by Haji 'Abbas, one in the Museo Stibbert, Florence (no. 5695, see Florence 1997–98, p. 108, no. 69), and the other in the State Hermitage Museum, Saint Petersburg (see Kaemmerer 1869, pl. 17, no. 4). The Hermitage mace is recorded as a gift to Czar Alexander II in 1868, thus establishing a date by which this group was made. They cannot be the work of the Haji 'Abbas of Isfahan who is identified in Allan 1994 as living from 1865/66 to 1964.

5. For this group, see Allan 1982a, pp. 114–17, no. 26; and Allan and Gilmour 2000, pp. 319–20.

6. Moshtagh Khorasani 2006, p. 261, discusses these late Qajar examples.

7. The two additional Metropolitan maces are acc. nos. 36.25.1881, inscribed "Sultan Feridun" and dated A.H. 445 (A.D. 1063/64), and 36.25.1891; see Stone 1934, p. 422, fig. 533, nos. 6, 2, respectively.

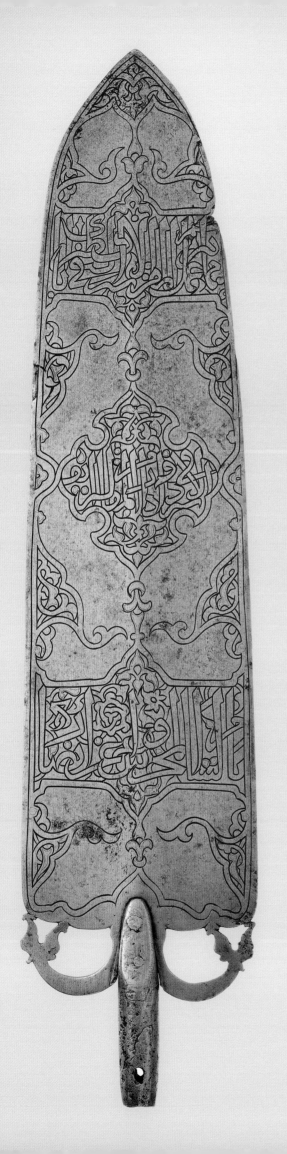

104 · Standard Head

Egypt or Syria, Mamluk period, ca. 1500–1511
Steel, iron
Length 20⅛ in. (51.2 cm); width 4⅝ in. (11.7 cm);
weight 1 lb. 12 oz. (802 g)
Bequest of George C. Stone, 1935
36.25.1961

DESCRIPTION: The spatulate, spear-shaped head of steel has a slight medial ridge
on each side and tapers to a broad point; it has an openwork design of two stylized
dragon heads at the base. It is attached to a solid iron socket (a later replacement)
with two transverse rivets. Each side of the head is engraved with floral designs
around the edges and with three cartouches, a symmetrical cartouche in the center
and one each of horizontal form above and below, containing Arabic inscriptions in
cursive script (a, b); some of the foliate ornament and calligraphy has punched
ornament within.

INSCRIPTIONS:
a. (Side 1)

<div dir="rtl">

الله لا اله الا هو الحي

القيوم لا تأخذه لا سنة و لا نوم

له ما في السموات و ما في الارض من الذي يشفع عنده الا باذنه

</div>

Allah! There is no god but He, —the living, the Self-subsisting, Supporter of all /
No slumber can seize Him nor sleep. His are all things in the heavens and on earth.
Who is thee can intercede in His presence except as He permitteth? (Qur'an 2:255)

b. (Side 2)

<div dir="rtl">

مما عمل برسم المقر الاشرف السيفي طراباي

الاشرفي دوادار المقام الشريف

بالشام المحروس عز انصاره

</div>

Made at the order of the noble excellency al-Sayfi Tarabay, officer of al-Ashraf, secre-
tary (*dawadar*) of His Noble Dignity (*al-maqam al-sharif*) in Syria, the protected, may
[God] glorify his victories.

Side 2

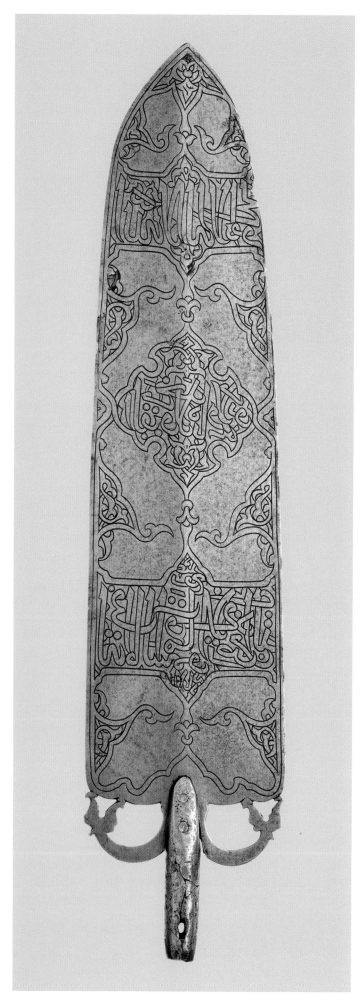

ayf al-Din Tarabay (d. 1511), for whom this standard was made, was a Mamluk Amir of Ten (a rank indicating the number of mamluks under his command) during the early sixteenth century; in 1503/4 he commissioned a mausoleum in Cairo. At the time this standard was made he was serving under a sultan whose titles included *al-ashraf* and *al-maqam al-sharif* (a reference to the sultan as guardian of the two Holy places, Mecca and Medina), probably either Sultan Janbalat (r. 1500–1501) or the last Mamluk sultan, Qansawh al-Ghauri (r. 1501–16). Although Tarabay is mentioned several times in the contemporary chronicle of Ibn Iyas, little is known of him;[1] it is possible that he was a member of the Tarabay clan of northern Palestine who served first the Mamluks and later the Ottomans.[2]

Mamluk standards are almost always of this flattened spearlike shape and in many instances include the names of rulers and amirs as well as Qur'anic inscriptions.[3] This particular example is probably one of the many standards taken as booty by the Ottomans when they defeated the Mamluks in 1517, the majority of which are preserved in the Topkapı Sarayı and Askeri museums in Istanbul.

In general, several distinct types of objects qualify as standards, or field ensigns, among them emblems placed atop flagpoles, certain nasals on helmets, and objects, generally rather heavy, that were carried by more than one man.[4] Virtually all surviving Islamic standards were originally fixed atop poles, sometimes in conjunction with flags or small streamers. One of the earliest depictions of such standard heads appears in an 'Abbasid miniature painting of A.H. 634 (A.D. 1237).[5]

PROVENANCE: S. Haim, Istanbul; George Cameron Stone, New York.

REFERENCES: Mayer 1943, p. 10, n. 90, fig. 12; Mayer 1952, p. 46, n. 9; Washington, D.C., and other cities 1981–82, p. 116, no. 43; *Islamic World* 1987, p. 61, no. 44.

NOTES
1. See Ibn Iyas 1985, pp. 34, 42, 58, 120.
2. See Leeuwen 2000.
3. See, especially, H. Tezcan and T. Tezcan 1992 for a number of these now in the Topkapı Sarayı Museum, Istanbul. Several Mamluk standard heads are also illustrated in Istanbul 1987, pp. 162, 164, nos. A159, A161.
4. A contemporary poem about the battle of Uhud (A.H. 3 [A.D. 625]) by Hasan b. Thabit (d. 665), as quoted in Ibn Ishaq 1982, pp. 416–17, pt. 3, verse 626, relates that "Nine carried the standard. . . . They stood firm together in their place till all were slain. . . . Only the best men can carry the standard." If this refers to nine men collectively carrying one standard, such a large object may be related to the portable domed tents of red leather, *qubbah*, which were carried into battle by the Arabs of the *jahiliyya* (pre-Islamic period). These tents, which housed idols and sacred stones and provided areas of asylum, came to signify power and authority and seem to have been the origin of the *mahmal*, camel-borne litter, which from the Mamluk period onward was sent to Mecca by the sultan; see Ettinghausen 1954, especially pp. 136–45.
5. This painting, now in the Bibliothèque Nationale de France, Paris (Ms. Arabe 5847, fol. 191r), has been reproduced on numerous occasions; see, for example, Riyadh 1996, vol. 1, p. 88.

105 · Standard Head

Turkey (?), 15th–16th century (?)
Steel
Length 15⅞ in. (40.3 cm); width 6⅛ in. (15.6 cm)
Gift of William H. Riggs, 1913
14.25.466

DESCRIPTION: The three-pronged, tridentlike head is cut from a steel sheet; the two outer prongs curve slightly away from the center, expanding toward the top with a notched tab on the outer edges; the straight center prong is shaped at the top with a palmette and a lozenge. The socket is octagonally faceted and has a collar at the base. Both sides of the head and each facet of the socket are engraved with squares and rectangles filled with magical numbers and knotted designs that may be inscriptions, though these have not been deciphered. The finial of the center prong is engraved on one side with a sun and on the other side with a crescent moon. At the base of the head is a rectangular panel with a border filled with Arabic inscriptions that start in the top right corner, run down the right side, and return up the left (a–d). (The head is currently mounted for display on a modern wood shaft.)

INSCRIPTIONS:

Side 1

a. (At the top right corner of the panel at the base of the trident)

بسم الله الرحمن الرحيم نصر من الله و فتح قريب

In the Name of Allah, Most Gracious, Most Merciful. Help from Allah and a speedy victory. (Qur'an 61:13)

b. (Along the right and up the left sides of the panel is a magical text, not all of which has been deciphered; at the top left corner)

علا فتعالى نوره تدكدكت الجبال بعظمة . . .

. . . exaltation, may His light be exalted, the great mountains were destroyed by [His] might.

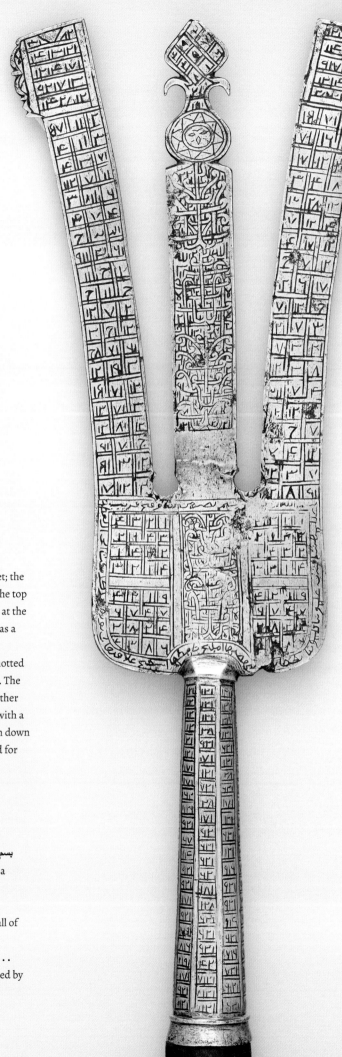

Side 2 (shown)

c. (At the top right corner of the panel at the base of the trident)

بسم الله الرحمن الرحيم نصر من الله و فتح قريب

In the Name of Allah, Most Gracious, Most Merciful. Help from Allah and a speedy victory. (Qur'an 61:13)

d. (Along the right and up the left sides is an incompletely deciphered magical text, including quotations from the Qur'an.)

سيزحم الجمع و يولون الدبر ... و قيل من راق ...

[Their] multitude will be put to flight, and they will show their backs [in retreat]. (Qur'an 54:45) . . . And it is said, "Who will cure [him]?" (Qur'an 75:27) . . .

Among the numerous inscriptions on this standard head are several Qur'anic verses and numbers. With the exception of the passages given above, most of the inscription around the base of the standard has not been translated; it is repetitive, perhaps a talismanic incantation. The numbers and letters in the squares and rectangles are interchangeable (because each letter in Arabic has a numerical equivalent) and are probably based on the magic squares of the numerologist al-Buni (d. 1225).

The shape of the Museum's standard head is related to a Mongol type known as the *k'i-mori*.[1] Symbols of good luck, these objects were associated with the wind, which may support the view that this standard was a talismanic object used by a dervish group, perhaps by one of the orders closely connected with the military, such as the Naqshbandi, the Bektashi, or the Khalwati. Curiously, the standard head was acquired by the donor, William Riggs, in Paris from a (Turkish?) dealer named Beshiktash, but whether this indicates he was a member of this sect or was named after that area in Istanbul is unknown.

Although it lacks the characteristic *tamğa* mark, this distinctive standard head undoubtedly comes from the Ottoman arsenal in Istanbul. It—or an identical standard head—is illustrated in a series of photographs of the arsenal holdings made by the firm of Abdullah Frères in 1889 (fig. 39);[2] the donor acquired it in 1892 or 1893.[3] Although it bears certain resemblances to two ceremonial sword blades and a late-Mamluk standard, all in the Topkapı Sarayı Museum, Istanbul,[4] the Museum's piece does not have any exact parallels—in either its specific form or in its decoration—to any known Ottoman or Mamluk standard. At present it should be attributed to an unknown workshop and geographical area. Decoratively and conceptually, the Metropolitan's standard and the Topkapı blades and standard are closely related to a group of so-called talismanic shirts that date to the fifteenth to seventeenth century.[5]

PROVENANCE: Ottoman arsenal, Istanbul; C. Beshiktash, Paris; William H. Riggs, Paris.

REFERENCE: Pyhrr 2007a, pp. 39, 46, n. 12.

NOTES

1. Kler 1957.
2. Pyhrr 2007a, p. 39, fig. 14.
3. The standard head was acquired with a lance head, which is struck with a *tamğa* (cat. 93), for 100 francs. Beshiktash's invoice is undated, but the other purchases Riggs made from the same dealer, which include a shirt of European mail, also bearing a *tamğa* (now in the Metropolitan Museum, acc. no. 14.25.1564), date from those years.
4. The two sword blades with unsharpened edges—suggesting that they were intended for some kind of ceremonial use rather than for battle—are decorated in exactly the same style and, consequently, must come from the same workshop; Topkapı Sarayı Museum, Istanbul, nos. 1/5067, 1/5069 (unpublished). The related standard from the late Mamluk period, Topkapı Sarayı Museum, no. 1/460 (unpublished), is of a typical fifteenth-century type, with a flattened, spearlike shape.
5. For talismanic shirts, see, for example, Alexander 1992, pp. 21–22, nos. 33, 34 (probably Iranian); London 2005b, no. 322 (Ottoman); and Paris 2007/Mohamed 2008, p. 335, no. 322 (Indian, Delhi Sultanate), as well as fig. 15 in this publication.

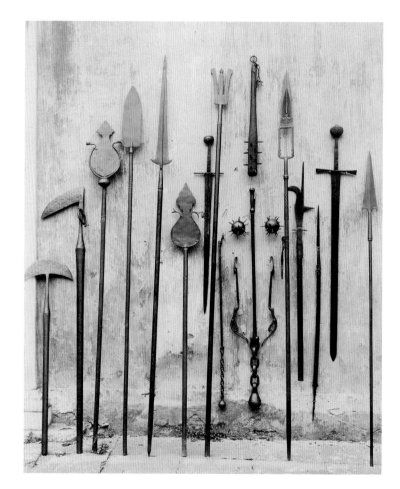

Fig. 39. Miscellaneous weapons and standards from the Askeri Müzesi, Istanbul. Photographed by Abdullah Frères, 1889

106 · Standard Head

Turkey, Ottoman period, ca. 1675–1700
Gilt copper, iron, wood
Length 21½ in. (54.6 cm); width 7 in. (17.8 cm);
weight 3 lbs. 4 oz. (1,483 g)
Bequest of George C. Stone, 1935
36.25.2861

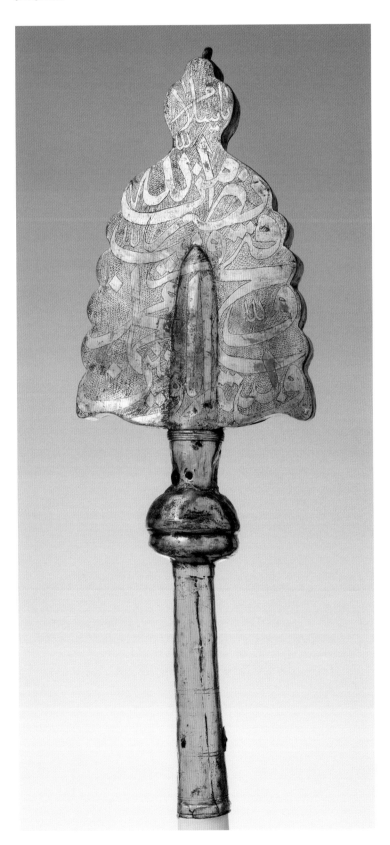

DESCRIPTION: The palmette-shaped head is hollow, formed of four sheets of gilt copper brazed along the edges, and has lobed edges and a pear-shaped finial surmounted by a ring. The faces, which are embossed in the center to accommodate the haft, are incised with Arabic inscriptions (a, b), the interstices matted with zigzag tooling. The head has a ring molding at the neck and sits on a long tubular socket with a large stepped knob below the head; below the knob the socket is incised at irregular intervals with four pairs of concentric rings. The socket is pierced near the top and bottom with a number of nail holes, several filled with iron nails, where it is secured to the haft. Portions of the original haft are preserved within the socket. The gilt surfaces are worn, with numerous dents; the socket is split above the knob and repaired with solder, and the seams of the socket are split.

INSCRIPTIONS:

a. (Side 1, shown)

<div dir="rtl">

يا الله

لا اله الا الله محمد رسول الله

</div>

O God! There is no god but God, and Muhammad is the messenger of God.

b. (Side 2)

<div dir="rtl">

يا سلام

نصر من الله و فتح قريب و بشر المؤمنين محمد

</div>

O Peace! Help from Allah and a speedy victory. So give the Glad Tidings to the Believers. (Qur'an 61:13). Muhammad.

This standard head of gilt copper (*tombak*) is typically Ottoman and probably dates to the late seventeenth or eighteenth century. Among the surviving *tombak* standard heads of this period are examples in the Victoria and Albert Museum, London, and the Topkapı Sarayı Museum, Istanbul.[1] Standards of this palmette form were used by the Ottomans from at least the early sixteenth century; the datable early examples have clearly defined lobed borders composed of split palmette leaves, and their inscriptions are often embossed.[2] Later examples, such as the Museum's standard head, are more stylized in form, and the inscriptions are engraved. An almost identical standard head in Istanbul that is probably from the same workshop as the Metropolitan's has been ascribed to the seventeenth to eighteenth century,[3] based on a comparison to another similar standard in the Topkapı Sarayı that is dated 1709.[4]

PROVENANCE: S. Haim, Istanbul; George Cameron Stone, New York.

REFERENCE: New York 1996, p. 47, no. 63.

NOTES

1. Victoria and Albert Museum, London, no. 933.1884; see Allan and Raby 1982, p. 41, North 1976, p. 276, fig. 4, and North 1985, p. 45. Topkapı Sarayı Museum, Istanbul, no. 1/1972, dated 1709 (see also note 4 below).

2. Topkapı Sarayı Museum, Istanbul, no. 1/824, with the name of Selim I (r. 1512–20); see H. Tezcan and T. Tezcan 1992, p. 88, no. 55, fig. 35.

3. Topkapı Sarayı Museum, Istanbul, no. 1/8351; see ibid., p. 86, no. 51.

4. Topkapı Sarayı Museum, Istanbul, no. 1/1972; see ibid., p. 108, no. 79, fig. 53.

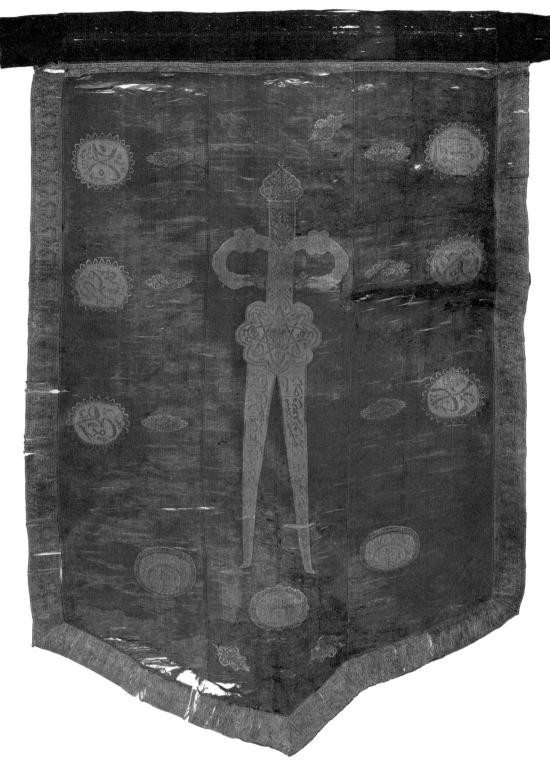

107 · Banner

Turkey, Ottoman period, ca. 1683
Silk, metallic thread
Length approximately 78⅝ × 66¾ in.
(199.8 × 169.5 cm)
Rogers Fund, 1911
11.181.1

DESCRIPTION: The banner is rectangular with a pointed lower edge. The main field is constructed of three longitudinal panels of red and yellow-green silk enriched with metallic thread and has a separately applied border of yellow-green silk and metallic thread. The field and border are executed in the same plain-weave technique with two supplementary wefts and are contemporary in date. The center of the field is occupied by the twin-bladed sword Dhu'l faqar with dragon-headed quillons and a lobed rose between the hilt and the blades. Around the sword are nine oval medallions, three on each side and three across the bottom; those at the sides have lobed borders, each lobe filled with a trefoil, and those across the bottom are formed as crescent moons. Between the sword and medallions are stylized cloud bands. The sword (a) and eight of the medallions (b–c) bear Arabic inscriptions in cursive script. (Although banners of this shape are usually displayed vertically, the inscriptions read horizontally, with the point to the viewer's left.) The border, which measures about 5 in. (13 cm) wide, is decorated with a repeating design of stylized tulips alternating with a symmetrical flower motif. The banner is now in deteriorated condition.

INSCRIPTIONS:

a. (Running down the two blades of the sword)

و فضل الله المجاهدين على القاعدين على القاعدين اجرا عظيما / درجات منه و مغفرة و رحمة و كان الله غفورا رحيما

But those who strive and fight hath He distinguished above those who sit (at home) by a great reward.— Ranks specially bestowed by Him and Forgiveness and Mercy. For Allah is oft-forgiving. Most Merciful. (Qur'an 4:95–96)

(In the rosette just below the hilt of the sword, repetitions in mirror image of two invocations to names of God)

يا ديان يا برهان

O All-Requiting! O Proof!

b. (In the three roundels down the right)

الله / ابو بكر / عثمان

Allah, Abu Bakr, 'Uthman

(In the three roundels down the left)

محمد / عمر / علي

Muhammad, 'Umar, 'Ali

c. (In each of the two roundels at the bottom on either side of the sword)
(At the center of the crescent)

الله الحافظ و الله الناصر

Allah is the Protector and Allah is the Victor.

(In the crescent around the center)

نصر من الله ش فتح قريب و بشر المؤمنين

Help from Allah and a speedy victory. So give the Glad Tidings to the Believers. (Qur'an 61:13)

B anners such as this were made for display during battle, and a number of them were taken as war booty from the Ottomans. Among these are the many similar banners captured from the Turks at the battle of Vienna in 1683, including one taken by Atanazy Miączyński (1639–1723), the voivode of Wołyń in Poland.[1] Another example, said to have been captured in 1684, is now in the Heeresgeschichtliches Museum, Vienna.[2] Although the Museum's banner is undated, it can be ascribed to the seventeenth century by comparison to examples such as the almost identical banner, now in the Fogg Art Museum, Cambridge, Massachusetts, that bears the date 1683.[3] The Museum's banner therefore probably belongs to the group taken from the Ottomans at the siege of Vienna or during the many subsequent battles in southeastern Europe. The production of banners of this design continued throughout the eighteenth century and into the early years of the nineteenth, as demonstrated by a banner dated 1810–11 and inscribed with the same parts of the Qur'anic verse as the present work.[4]

In addition to the inscriptions, which include a call to the warrior to fight for victory in the Holy War (Qur'an 4:95–96), the iconography of the Museum's banner includes a number of images. The sword of victory, the Dhu'l faqar, originally one of the swords of the Prophet, was also regarded as a symbol of the ultimate triumph of good over evil.[5] Furthermore, it was prophesied that in the battle preceding the Last Judgment, the Mahdi would wield the Dhu'l faqar.[6] The presence of a rose on the sword is perhaps an allusion to the mystic rose of the Bektashi dervishes, who exerted a major spiritual influence on the Ottoman military and in particular on the Janissaries. In legends, tradition, and poetry the rose was said to have been formed from a drop of the Prophet's sweat.[7] Its many petals, one hiding the other, and its combination of beauty and thorn also contributed to its use as a mystical symbol. A painting of the "Muhammadan Rose," each petal of which bears one of the names of God, demonstrates the deep meaning that it could convey.[8]

The crescent moon (*hilal*) that appears on one of the banner's nine medallions is an ancient device that was first used in the Islamic world during the seventh century; it eventually became a recurrent symbol throughout the Islamic world, in both secular and religious contexts, and is an important device on the flags of a number of modern states.[9] Its widespread use in Islam perhaps results from the stress given in the Qur'an to God as the lord of the sun and moon and from the importance of the new moon in a religion that uses a lunar calendar and determines its major observances by the sighting of the new moon.

PROVENANCE: Bacri Frères, Paris.

REFERENCES: Alexander 1992, p. 112, no. 59, n. 2; Alexander 1999, pp. 175–76, fig. 7; Geneva 1995, p. 137, no. 81, n. 1.

NOTES

1. Zygulski 1968, pp. 411–16; Zygulski 1972, pp. 26–66; and Zygulski 1992, especially chap. 1. See also Vienna 1983, nos. 11/8, 11/20, 13/4, 19/2.
2. Heeresgeschichtliches Museum, Vienna, no. 128.090; see Vienna 1983, no. 11/18.
3. Fogg Art Museum, Cambridge, Massachusetts, no. 1958.20; see Denny 1974, fig. 2. The design of these banners can be traced to the sixteenth century: a triangular banner with an identical Dhu'l faqar was captured at the battle of Lepanto in 1571 (now in the Museo Correr, Venice). Florica Zaharia, Conservator in Charge, and Janina Poskrobko, Conservator, of the Metropolitan Museum's Department of Textile Conservation examined the present banner and provided technical notes for its description.
4. Geneva 1995, p. 133, no. 78. Another banner of this type, dated A.H. 1235 (A.D. 1819/20), is in the Metropolitan Museum, acc. no. 1976.312; see Ekhtiar et al. 2011, pp. 326–27, no. 232.
5. See also Appendix A.
6. Alexander 1999, especially pp. 163–69, fig. 7.
7. Schimmel 1985, pp. 34–35, 270, n. 43.
8. Ibid., p. 111, cover pl.
9. Ettinghausen 1971, pp. 381–85.

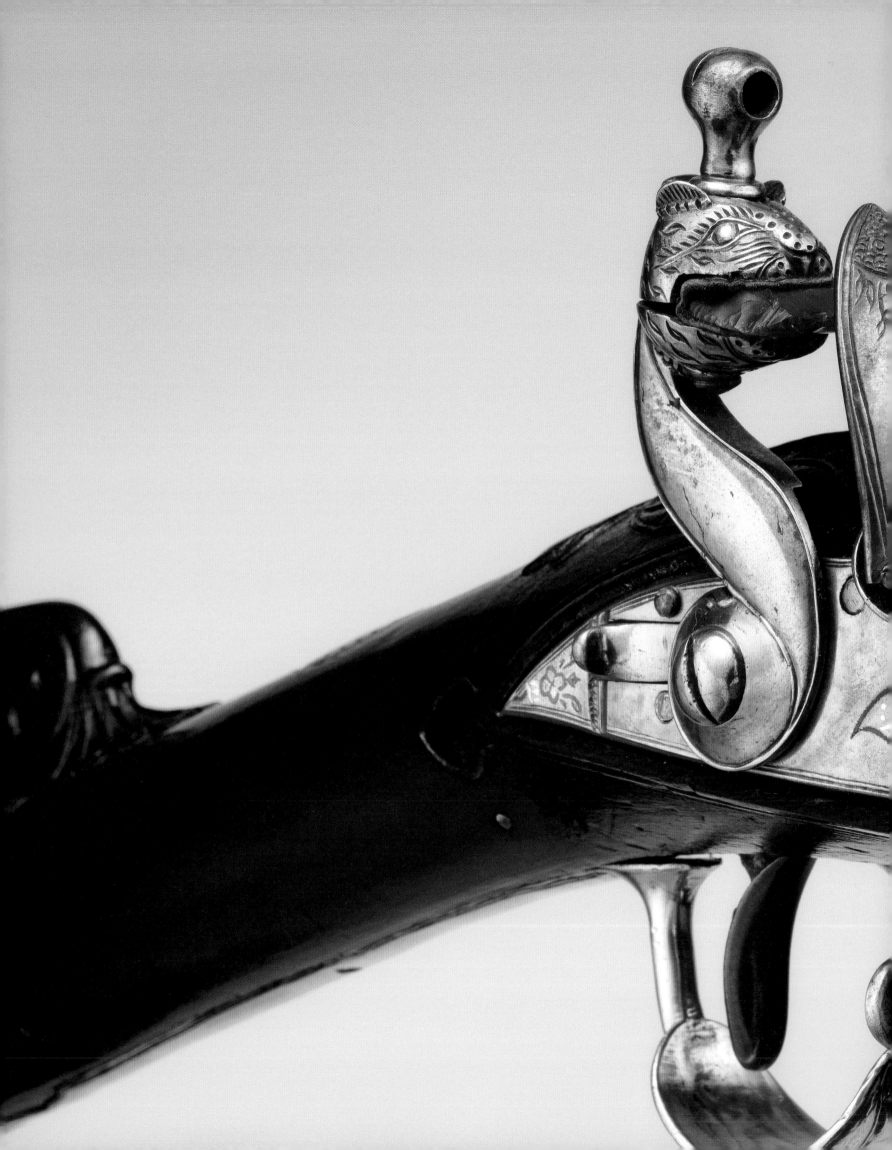

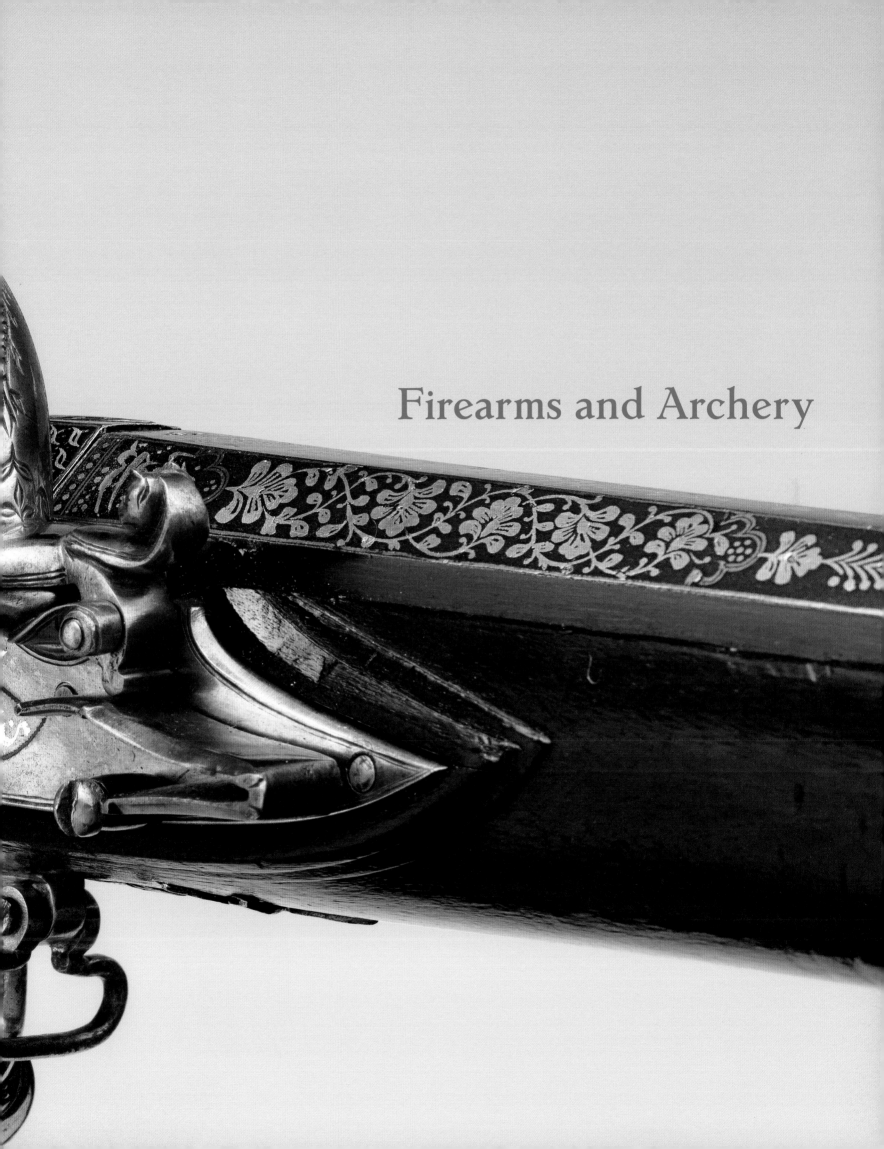

Firearms and Archery

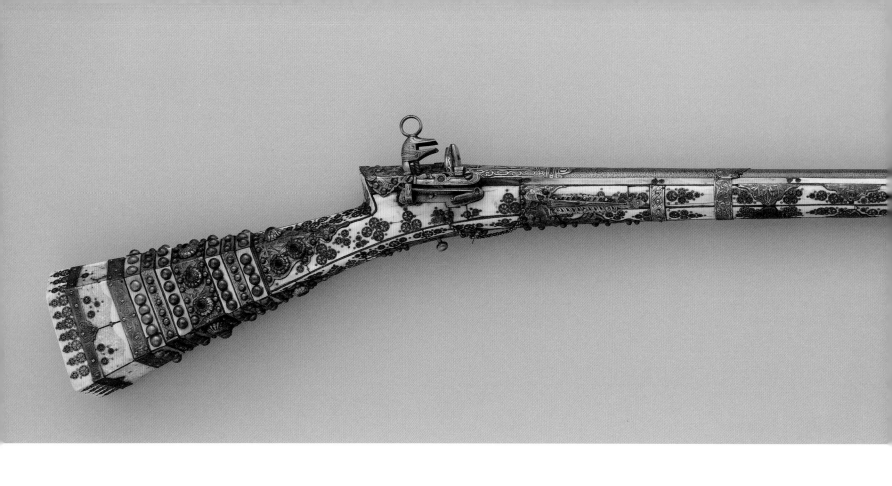

108 · Miquelet Rifle

Turkey, Ottoman period, late 18th century

Steel, wood, ivory, mother-of-pearl, copper alloys, gold, silver, glass paste

Length 60⅞ in. (154.7 cm); barrel 47 in. (119.4 cm); caliber .48 in. (12 mm); weight 10 lbs. 12 oz. (4,862 g)

The Collection of Giovanni P. Morosini, presented by his daughter Giulia, 1932

32.75.270

DESCRIPTION: The round barrel of pattern-welded steel, rifled with seven grooves, is divided into three stages by transverse moldings. At the breech end is an arched, single-aperture rear sight, the edges inlaid in gold with scrolls; in front of this is a panel inlaid in gold with a vase and stylized flowers framed by a border of scrolls and stamped with a gold-covered, teardrop-shaped proofmark in Ottoman Turkish (a). The long middle stage is chiseled with raised medallions and leaves at each end and has a sighting rib extending down the center; the medallions are inlaid in gold with leaves and scrolls, and near the breech end there is a second stamped, teardrop-shaped maker's mark, formerly gold covered, in Ottoman Turkish (b). The muzzle end is chiseled in a spiral pattern outlined by close-set silver dots and has a muzzle ring chiseled and gilt with a series of ovals and inset with a copper blade front sight. The miquelet lock is inlaid in gold with long leaves; the bridle (the plate connecting the cock pivot to that of the steel) is deeply stamped with a gold-covered circular maker's mark in Ottoman Turkish (c).

 The stock of wood is veneered with thin plaques of ivory (minor losses and repairs), some stained green, the plaques outlined with braided brass wire and inlaid with numerous brass nailheads and with circlets of brass-trimmed mosaic filled with stained green ivory; set at intervals along the stock are large plaques of gilt copper engraved with foliate scrolls against a circle-punched ground, some of the plaques studded with copper-alloy bosses or with raised mounts set with colored

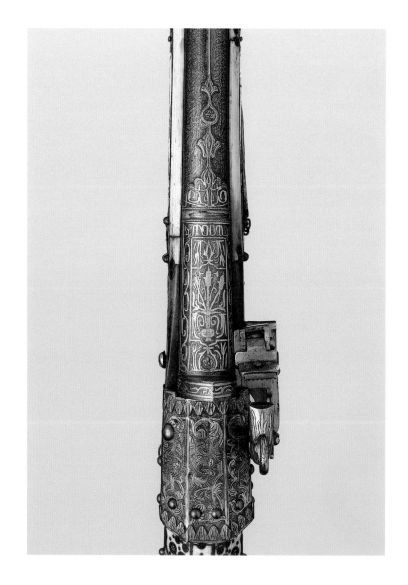

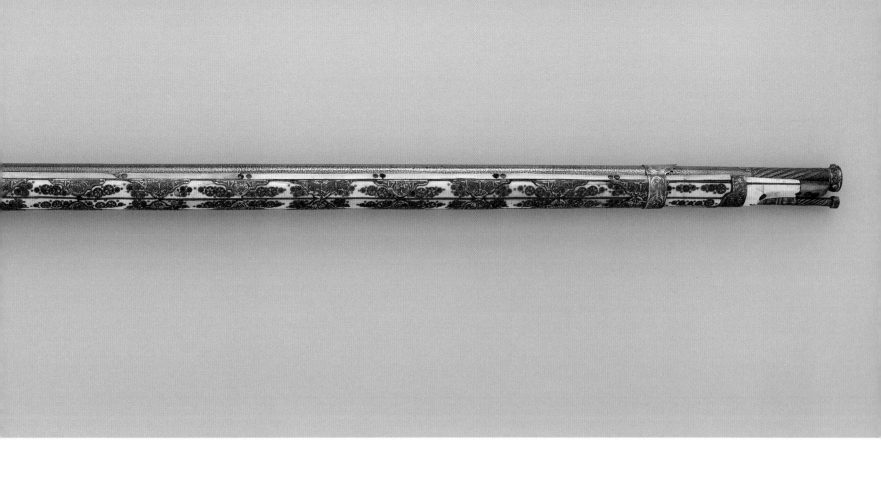

glass gems (one missing). The thick butt of hexagonal section is decorated with a series of transverse bands of mother-of-pearl alternating with gilt copper, the bands studded with domed nailheads, the wide center band of engraved gilt copper studded with jeweled mounts. The end of the butt has punched and engraved silvered-copper bands framing one panel each of walrus and elephant ivory, these too inlaid with brass nailheads and mosaic circles. Below the lock is nailed a gilt-brass chain to which is affixed a pricker, the latter sheathed in a narrow, funnel-shaped receptacle of gilt copper attached horizontally to the forestock. The ball trigger is of steel. The barrel is attached to the stock by two barrel bands of engraved and punched gilt copper. The ramrod of wood, now broken, has a long shaped head of steel.

INSCRIPTIONS:
a. (At the breech)

امتحان

Tested.

b. (Forward of the breech)

... محمد

...Mehmed.

c. (On the lock)

محمد ايوبي

Mehmed Eyyubi.

The barrel of this handsome rifle is stamped with an Ottoman proofmark and a maker's mark. The former, inscribed *imtihan*, or "tested," is frequently found on Ottoman barrels; its use as a proofmark has been dated to the late eighteenth to early nineteenth century.[1] A number of barrels in the Museum's collection bear this mark.[2] A comparable weapon, now in the Khalili Collection, London, has a lock signed by Ahmed Eyyubi,[3] although it is uncertain whether this was the maker's full name or whether it refers to his working in the region of Istanbul known as Eyyub (that is, Ahmed of Eyyub, or, in this case, Mehmed of Eyyub).

Guns of this ivory-stocked type are sometimes identified as having been carried by the Ottoman imperial guard.[4] This theory is based both on the high quality of these weapons and on the large number of them still preserved in the Topkapı Sarayı Museum in Istanbul. Although the suggestion is plausible, it cannot be corroborated at this time.

Firearms such as this have been dated as early as 1680–1720, but again without any evidence.[5] The absence of any examples among the documented holdings of Turkish booty collected at the siege of Vienna (1683) suggests that they do not date from that period. In decorative terms it is equally unlikely that the engraved metal plates found on these guns are that early in date, as they are usually ornamented in a loose, rococo-like style. The mosaic inlays, on the other hand, defy a precise assignment because they were popular throughout the Middle East from at least the

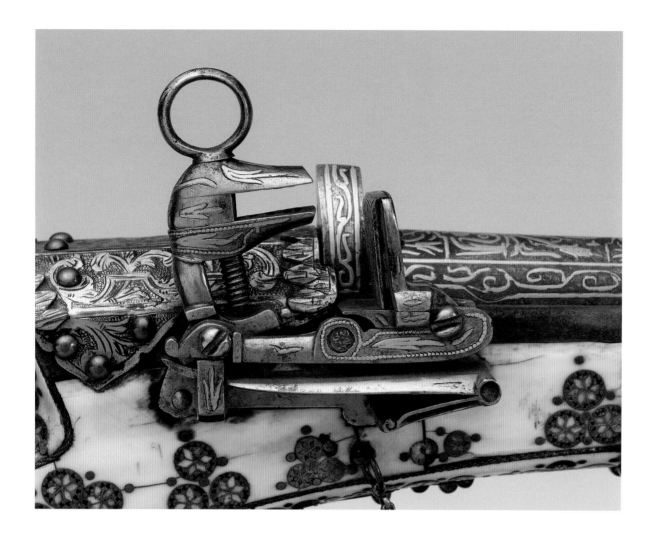

sixteenth century until the nineteenth century.[6] Fortunately, one example of this type has a barrel dated A.H. 1191 (A.D. 1777/78), with the consequence that the entire group should probably be attributed to the late eighteenth century.[7] Consistent with this date are four very similar guns reputed to have been presented to Charles III of Spain by the dey of Algiers in 1787.[8]

PROVENANCE: Giovanni P. Morosini, Riverdale, New York, by descent to his daughter Giulia Morosini.

REFERENCES: Grancsay 1939, p. 18, fig. 3; Blackmore 1965, fig. 273; Norwich, Cincinnati, and Toronto 1982–83, p. 84, s.v. nos. 40, 41; Grancsay 1986, p. 226, fig. 74.5; Paris 1988, p. 126, s.v. no. 43; Alexander 1992, p. 126, s.v. no. 72.

NOTES

1. Lenz 1912–14, pp. 301–2; Elgood 1995, p. 48.
2. These include acc. nos. 32.75.272, 43.82.10.
3. Alexander 1992, p. 126, no. 72.
4. See, for example, Paris 1988, nos. 42, 43; Dresden 1995, no. 341.
5. Paris 1988, nos. 42, 43.
6. For a sixteenth-century example with mosaic inlays, see Istanbul 1983, no. E.76; a nineteenth-century example is in the Metropolitan's collection, dated 1829–30 (acc. no. 36.25.2160).
7. Khalili Collection, London; see Alexander 1992, pp. 128–29, no. 73. Two additional examples are in the Metropolitan Museum (acc. nos. 36.25.2155, 36.25.2226).
8. Real Armería, Madrid, nos. K.189–K.192; Valencia de Don Juan 1898, p. 331.

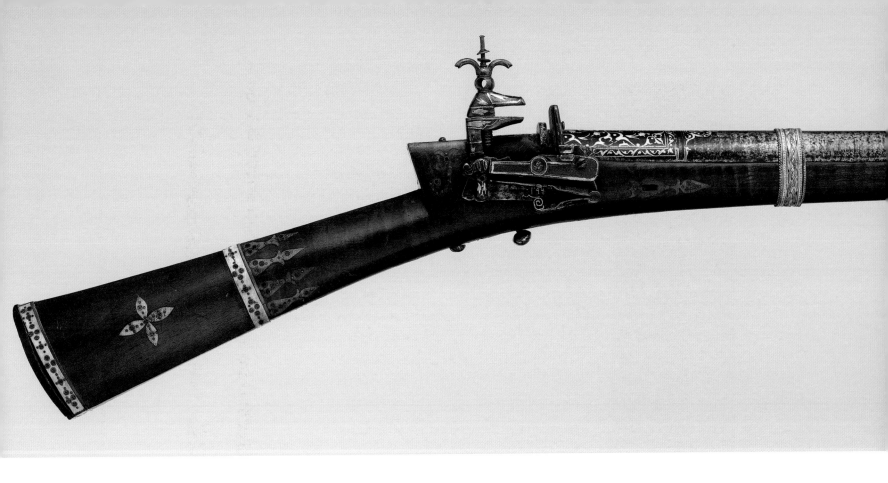

109 · Miquelet Gun

Turkey, Ottoman period, 18th century, lock dated A.H. 1199 (A.D. 1784/85)
Steel, wood, bone, copper alloy, gold
Length 46½ in. (118 cm); barrel 33½ in. (85.2 cm); caliber .80 in. (20 mm);
weight 7 lbs. 11 oz. (3,496 g)
Bequest of George C. Stone, 1935
36.25.2164

DESCRIPTION: The round, smoothbore barrel of pattern-welded steel has slightly
raised transverse moldings at the breech and muzzle, a slender raised sighting rib
extending down the center, and a muzzle ring. The rear sight is in the form of a low
slotted arch, and the front sight is a brass bead on the muzzle ring. The breech and
muzzle ends are inlaid in gold with rectangular panels of leaf scrolls within a border
of scrollwork, with adjacent half medallions along the plane of the barrel; the deco-
ration at the breech includes inscriptions in Ottoman Turkish (a). The muzzle open-
ing is inlaid with gold dots. The long barrel tang is fitted with a later hinged,
spring-operated peep sight pierced with three apertures, the sight popping up when
a small lever at the side is pressed. The vent is brass lined. The lock of miquelet type
is of dark steel inlaid in gold with long, lanceolate leaves and with gold lines outlin-
ing the parts. The terminal of the jaw screw was once decorated with a knob of some
sort, perhaps a coral, now lost, which was held between two brass washers, still
present. The face of the steel is covered by a vertically grooved plate held by a screw.
The bridle is deeply stamped with a circular maker's mark, once probably gold
covered and now much obliterated (b); inlaid in gold on the lock plate is the date 1199
(c). The stock of wood extends almost to the end of the barrel and has a narrow butt
that is flat on the top and bottom and rounded on the sides. The forestock is pierced
with two lateral holes, one near the lock and one in the middle, for the attachment of
a shoulder strap. The stock is sparingly inlaid with plaques of white and green-dyed
bone, the plaques themselves inlaid with brass nailheads and filigree circles filled
with wood and nailheads; the white plaques form bands across the butt, the green
ones lanceolate panels or stylized flowers on the butt, at the top of the stock around

the barrel tang, and around the trigger, lock screws, and slots for the shoulder strap.
The butt end is faced with dark horn. The trigger of iron has a ball-shaped head. The
barrel is attached to the stock by four bands of gilt copper alloy cast with braided
and beaded borders framing a large openwork braid. The associated ramrod has a
modern wood shaft fitted with a steel fore-end having a large, flattened conical head
that is longitudinally split to facilitate the attachment of a cleaning rag.

INSCRIPTIONS:
a. (At the breech end of the barrel)

حـ |ا|لا قپودان دريا
غازي حسن پاشا

Currently the admiral of the navy, Gazi Hasan Pasha.

b. (In a small cartouche)

قره محمود (؟)

Kara Mahmud (?).

c. (On the lock plate)

سنة ١١٩٩

Year 1199 (A.D. 1784/85).

This gun has several unusual features worth noting. The
barrel is unlike any other Turkish example in the
Museum's collection, being round in section rather
than octagonal, thick walled with an unusually large bore, and
comparatively short. It shows signs of being associated with the
stock, as its vent has been plugged with brass and redrilled, and
beneath the barrel there are the remains of three pierced lugs for
a European-style attachment to the stock by means of transverse
pins. The present stock, however, has never been pierced for

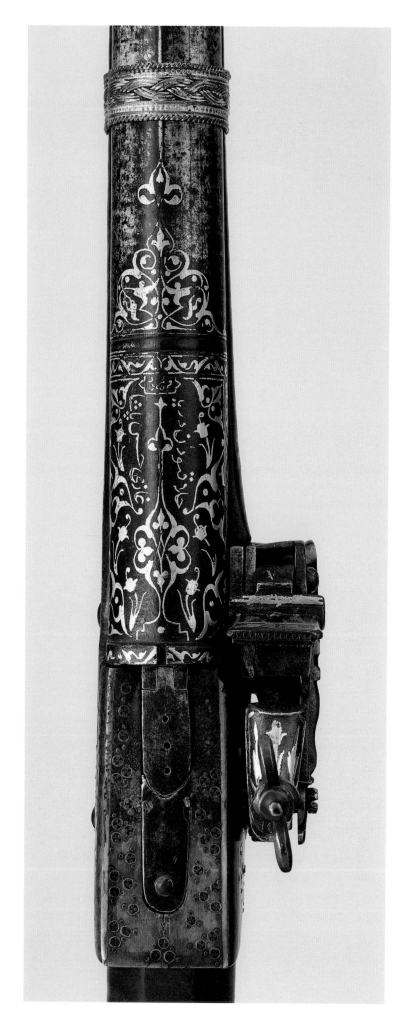

barrel pins, and the barrel is attached with bands, in the Ottoman style. The barrel tang has been modified during its working life to provide a spring-activated peep sight, a distinctive feature that is also found on another example in the Museum.[1] The lock is drilled with a small circular hole through the rear vertical bar of the bridle fitted on the outside of the lock, with a corresponding hole in the lock plate; when the weapon is fully cocked and a pin is passed horizontally through these two holes, the tension of the mainspring on the cock is held by the pin, freeing the cock and thus allowing the lock to be disassembled without use of a special tool to compress the mainspring.

The slender shape of the butt, with its rounded sides, was common in Iran and the Caucasus and differs from the usual polygonal butt of Turkish guns (for example, cat. 108). However, Turkish butts of this slender type are known, another example of which is in the Museum's collection.[2] The inscription on the barrel of this gun indicates that this weapon belonged to Cezayirli Hasan Pasha, grand admiral of the Ottoman navy from 1770 to 1790, and confirms its Turkish provenance.

PROVENANCE: George Cameron Stone, New York.

Unpublished.

NOTES
1. Cat. 110, dated A.H. 1240 (A.D. 1824/25).
2. Also in the Metropolitan, acc. no. 32.75.272, is an Ottoman example with a butt inlaid in brass with the Turkish motif of a crescent and star and a barrel struck with Ottoman proofmarks.

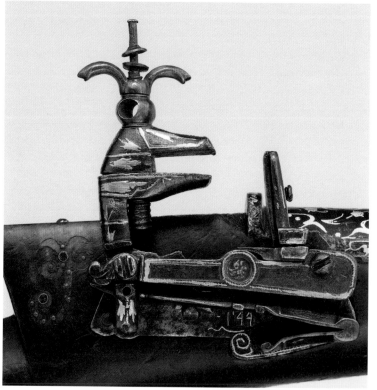

110 · Miquelet Rifle

Barrel, probably Iran, dated A.H. 1151 (A.D. 1738/39); lock and stock,
Turkey, the lock dated A.H. 1240 (A.D. 1824/25)
Steel, wood, silver, gold, copper alloy, textile
Length 61⅜ in. (156.6 cm); barrel 47⅜ in. (120.4 cm); caliber .60 in.
(15 mm); weight 11 lbs. 3 oz. (5,076 g)
Gift of Mrs. William E. S. Griswold, Mrs. William Sloane, Mr. John
Sloane, 1943
43.82.7

DESCRIPTION: The barrel of finely figured pattern-welded steel is octagonal in
section and flares slightly at the muzzle; it is rifled with eight grooves. The slotted,
arch-shaped rear sight is inlaid in gold with a pattern of S-shaped leaves alternating
with flowers formed of seven dots. On the breech the upper three flats are inlaid in
gold with symmetrical arabesques, with two medallions extending up the center
flat, the forward one containing the maker's name (a) inscribed in Persian in
reserve. Farther along the barrel are six long cartouches, arranged in pairs, contain-
ing Persian inscriptions (b) inlaid in gold. The muzzle is decorated to match the
breech and has a brass blade front sight. The vent is gold lined. The barrel tang is
fitted with a four-aperture hinged peep sight, like that on cat. 109. The miquelet lock
of blued steel is inlaid with gold scrolls, leaves, rosettes, and, on the lower jaw of the
cock, the date in Arabic numerals (c). The faceted finials of the jaw-head screw and
the rear terminal of the lock are of copper alloy. The stock of dark wood is hexagonal
in section at the butt and is inlaid with sheet silver pierced and engraved with strap-
work and leafy scrolls; the butt end is of paler wood than the rest. The ball-shaped
trigger is of steel. The barrel is attached to the stock by seven silver barrel bands
engraved with leaves. Two silver sling swivels are attached to the offside and secure
the remaining portions of a shoulder strap of black woven textile. The associated
wood ramrod has a steel fore-end with a truncated conical head.

INSCRIPTIONS:
a. (On the barrel)

عمل كاملى (؟)

Made by Kamili (?).

b. (In six cartouches along the barrel)

بنصر عزيز و فتح قريب اصابت كند اين اصابت ناى

شراريكه تابد از قصر دلش بسوزد دل دشمن ناسزاى

هميشه اصابت شود حال او بتوفيق حق دست اسلام گراى

سنة ١١٥١

Through the help of The Mighty and a "speedy victory" (Qur'an 61:13),
This Esabat aims the reed (i.e., the barrel).
The spark that shines from the castle of its heart,
Burns the heart of an unworthy enemy.
By God's favor, precision in hitting the target,
Is always the state of the hand that promotes Islam.

Year 1151 (A.D. 1738/39).

c. (On the lock)

١٢٤٠

1240 (A.D. 1824/25).

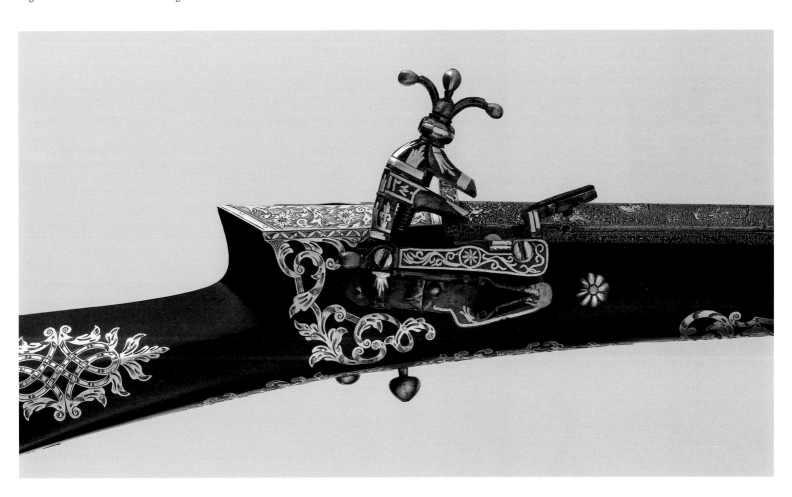

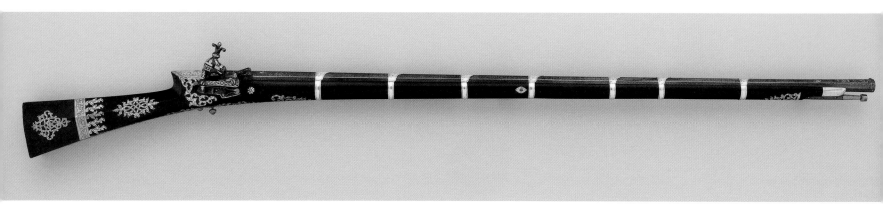

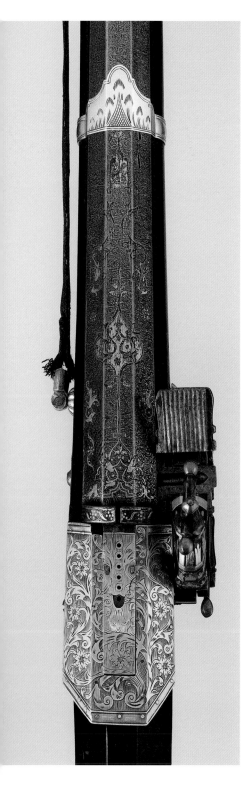

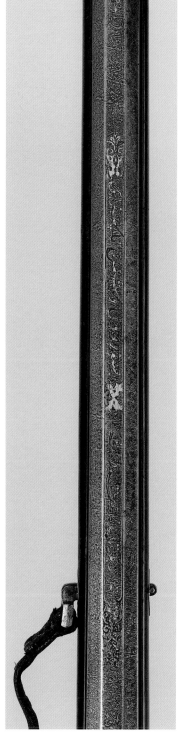

T his gun is significant for its very fine dated barrel, which is one of the earliest Islamic examples in the Museum's collection. The barrel is probably Iranian and may have belonged to someone who had Esabat as part of his name (for example, Esabat Khan); the poem on the barrel contains puns on the name Esabat, which means "to hit a mark." While the barrel is much earlier than the lock, which is dated 1824/25, we can most likely assume that the stock and its decorative mounts are of roughly the same period as the lock.[1]

According to the donors, this gun, one of a group of ten, came from the collection of ʻAli Pasha Tepedelenli (ca. 1744–1822).[2] The Ottoman sultan appointed him wali of Rumelia and then, in 1803, governor of Ioannina. His independent ways angered the sultan, however, and in 1822, after a long period of bitterness and frequent quarrels, ʻAli Pasha rebelled, launching an uprising against the sultan that was quickly defeated. He was friendly with the French, who supplied him with arms. A romantic figure, ʻAli Pasha was not only a fierce warrior but also deeply interested in mysticism and astrology. Because he sided with the Greeks against the Ottomans, he was admired by many Europeans, including Lord Byron.[3] Although this rifle is traditionally said to have belonged to ʻAli Pasha, the date on the lock places it after his death.

PROVENANCE: Acquired from the grandson of ʻAli Pasha Tepedelenli by J. W. Wittal, Istanbul; John Sloane, New York; by descent to his children Mrs. William E. S. Griswold, Mrs. William Sloane, and John Sloane, through William Griswold, New York.

Unpublished.

NOTES
1. Similarly constructed and decorated locks among the Metropolitan's Turkish firearms include miquelet mechanisms dated A.H. 1218 (A.D. 1803/4), A.H. 1221 (A.D. 1806/7), A.H. 1245 (A.D. 1829/30), and A.H. 1272 (A.D. 1855/56, acc. nos. 43.82.10, 32.75.271, 36.25.2160, and 1982.96 (a detached lock), respectively.
2. These comprise acc. nos. 43.82.1–.10.
3. For ʻAli Pasha Tepedelenli, see Bowen 1960.

111 · Miquelet Gun

Lock and stock, Algeria, dated A.H. 1172 (A.D. 1758/59); barrel, Europe, 18th century

Steel, wood, silver, copper alloy, gold, coral

Length 76½ in. (194.4 cm); barrel 60¼ in. (153 cm); caliber .64 in. (16 mm); weight 10 lbs. 9 oz. (4,799 g)

The Collection of Giovanni P. Morosini, presented by his daughter Giulia, 1932

32.75.274

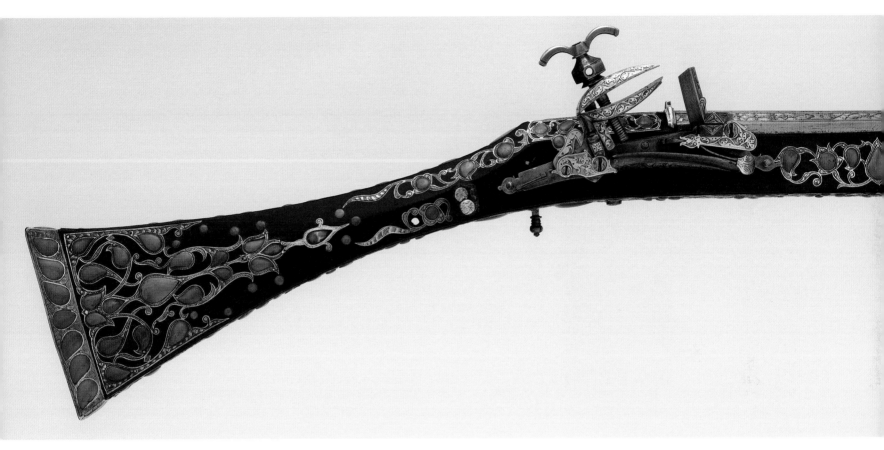

DESCRIPTION: The octagonal smoothbore European barrel of steel tapers toward the muzzle and is chiseled with a series of longitudinal ridges along its entire length; there is a slotted silver rear sight at the breech and a silver bead front sight. The upper flats of the breech section are chiseled with panels of strapwork and foliage against a stippled-and-gilt ground, with a long, narrow panel bearing a maker's signature in stamped Roman letters (a). The barrel tang is covered with silver sheet chiseled and punched with stylized leaves. The miquelet of steel is of the "Kabyle" type, with a large external mainspring bearing down on the toe of the cock and with a hook behind the cock that provides a safety or half-cock position. The thick steel lock plate is sandwiched between plates of brass, the edges deeply engraved with stylized foliage. The jaws of the cock, the face of the steel, and the plates at the base of both are covered with sheet silver engraved with foliage. The toe catch is inset with coral. The brass wing nut on top of the jaw screw is probably a replacement. The lower edge of the cock is engraved in Arabic with the maker's name, with the date engraved beneath it on the lower edge of the lock plate (b). The three-quarter-length stock of dark wood reaches to within 16 in. (40.5 cm) of the muzzle and has an evenly flaring butt of flattened hexagonal section. The stock is inlaid with circular and teardrop-shaped pieces of coral (several replaced) within

openwork settings of engraved silver sheet arranged in stylized foliate designs. The brass butt cap is engraved with foliage and inlaid along the sides with coral; it is attached to the stock by two screws. Behind the lock, two nails with engraved silver heads secure a remnant of the thick leather flap that protected the shooter's hand. The iron trigger ends with a brass baluster knop. The four barrel bands (originally five) of sheet silver are embossed with foliage and rosettes against a stippled ground. Large holes pierced through the neck of the stock and in the forestock formerly held sling swivels for a shoulder strap. The wood ramrod is a replacement.

INSCRIPTIONS:

a. (At the breech)
LAZARINO COMINASSO.

b. (On the cock and lock plate)

عمل مصطفى
عـ |٤| م (؟) ١١٧٢

Made by Mustafa. Year (?) 1172 (A.D. 1758/59).

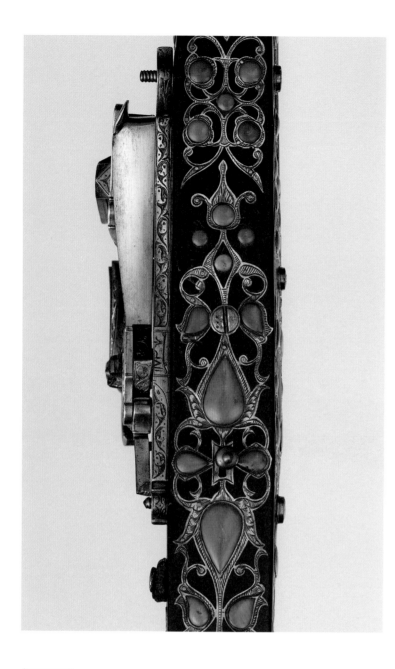

presented to the Prince Regent, the future George IV of Great Britain, by the Algerian ambassador on behalf of the dey of Algiers on February 25, 1811, and May 20, 1819.[6]

Another gun quite like the present example, the lock signed "Muhammad" and dated A.H. 1213 (A.D. 1798/99), is in the Metropolitan's collection.[7] The patterns of decoration on the Museum's two guns, which differ in date by forty years, are very close indeed and suggest that the style remained in use for many decades.

The barrel of this weapon, like those on most North African guns, is a European export piece. It bears the misspelled name of the famous Italian gunsmith Lazarino Cominazzo of Gardone Val Trompia and Brescia, which was copied on to barrels from other workshops to increase their value.[8] Cominazzo's name is said to have been added frequently to guns made in Spain and Liège for export to South America, where they were known as "lazarinos."[9] The chiseled European-style ornament against a gilt ground is not Italian in style and therefore is more likely the work of a Liège or Saint-Étienne barrelsmith.

PROVENANCE: Giovanni P. Morosini, Riverdale, New York; his daughter, Giulia Morosini, Riverdale, New York.

REFERENCES: Grancsay 1949, p. 33, fig. 22; Blackmore 1965, fig. 272; Nickel 1991a, p. 52.

NOTES
1. See especially Andersen 2014; see also cat. 112.
2. Schuckelt 2010, pp. 258–60, no. 231; Andersen 2014, pp. 78–82.
3. See Zygulski 1983, p. 444.
4. Real Armería, Madrid, nos. K.187, K.188, with Spanish (Ripoll) barrels; see Andersen 2014, pp. 175–78, 243.
5. Real Armería, Madrid, nos. K.194, K.197, K.198; see ibid., pp. 167–72, 244.
6. See ibid., pp. 83–166, 237–42. These range in date from A.H. 1152 to 1210 (A.D. 1739/40 to 1795/96).
7. Metropolitan Museum, acc. no. 43.82.1. A third coral-inlaid gun of lesser quality, undated, is also in the Metropolitan Museum, acc. no. 36.25.2207.
8. A similar long gun with a coral-inlaid and silver-decorated stock, its barrel signed "Lazzarino Comminazzo" and its lock signed "Ahmed" and dated A.H. 1186 (A.D. 1772/73), was exhibited in Paris 1988, no. 70.
9. Blackmore 1965, p. 38.

This gun is one of a large series of coral-inlaid, North African–type firearms that were apparently made in Algeria from the second half of the seventeenth century; some of these were presented as diplomatic presents to the courts of Europe and are therefore documented as to their date and origin.[1] The earliest recorded surviving example appears to be a gun in Dresden that was presented by Czar Peter the Great to Elector August the Strong of Saxony on the occasion of his coronation as king of Poland in 1697.[2] Another early example is a pistol signed "Ben Kassem" and dated A.H. 1127 (A.D. 1715/16).[3] The majority, however, date from the second half of the eighteenth century. These include a pair of guns with locks signed "Hamud" and dated A.H. 1188 (A.D. 1774/75), which were presented to Charles III of Spain (r. 1759–88) by the Ottoman sultan;[4] three guns dating between A.H. 1171 and 1188 (A.D. 1757/58 and 1774/75) presented to the same monarch by the dey of Algiers in 1787;[5] and a series of long guns, pairs of pistols, and matching accessories

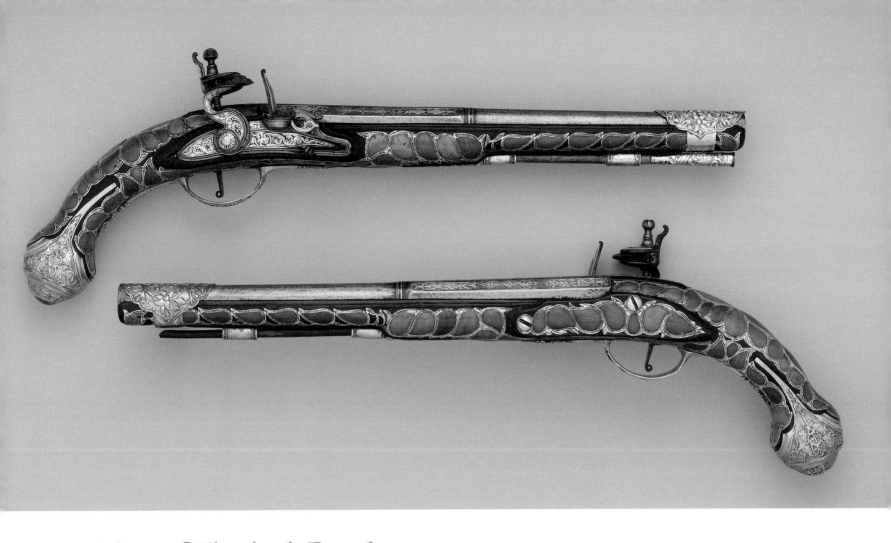

112 · Pair of Flintlock Pistols

Algeria, late 18th or early 19th century
Steel, wood, silver, coral, gold
Length (a) 19 in. (48.2 cm); barrel 12¾ in. (32.5 cm); caliber ⅝ in. (17 mm);
weight 3 lbs. 1 oz. (1,386 g)
Length (b) 19 in. (48.2 cm); barrel 12¾ in. (32.5 cm); caliber ⅝ in. (17 mm);
weight 3 lbs. (1,374 g)
Bequest of George C. Stone, 1935
36.25.2246a, b

DESCRIPTION: The smoothbore barrels of bright steel are octagonal at the breech
and round at the muzzle, the sections separated by transverse moldings. The three
upper flats of the breech, as well as the barrel tangs, are inset with shaped panels of
silver chiseled in low relief with stylized foliage on a stippled ground. The locks are
of conventional flintlock construction; the flat-faced lock plates and cocks, as well as
the steels and pans, formerly blued, are inlaid with silver sheet chiseled in low relief
with foliate scrolls; the pans are overlaid with brass, and there is a band of brass
inlaid into the face of the steel. Inside each lock the tumbler and sear are blued, and
the face of the bridle is covered with brass. The jaw screws are mismatched: that of
(b) differs from that of (a) in that the head was formerly covered with a red paste in
imitation of coral, whereas the screw of (a), a replacement, is of conventional type.
The stocks are of wood inlaid with petal-shaped pieces of coral framed by bands of
engraved silver. The mounts are of silver gilt (the gilding now worn very thin) and
include bulbous pommels with octagonal ends, the surfaces embossed with foliage
and bearing a coral set into the center of each; trigger guards with foliate terminals
and panels of raised foliate scrolls; and barrel bands at the muzzles embossed with
foliate scrolls. Two wood ramrods are present, both replacements, that of (b) retain-
ing its embossed silver tip.

Firearms and edged weapons decorated with coral were
popular throughout the Ottoman Empire, especially
during the eighteenth and nineteenth centuries. Many of
these examples may have been made by Greek craftsmen working
in Greek enclaves in Anatolia, such as Saframopolis.[1] The corals
used on arms and jewelry that can be assigned to Greek work-
shops, however, are often carved with vertical lines, very different
from the rounded corals here.

The red coral (*Corallium rubrum*) used to decorate these two
pistols, as well as cats. 111 and 113, is from the Mediterranean.
Highly prized, it has been exploited since antiquity.[2] Following
European penetration into India, red coral became a valuable
export during the seventeenth and eighteenth centuries, and it
was often traded for diamonds. The centers for this trade were
Marseille in France, and Genoa, Naples, and Livorno in Italy.

During the early medieval period, the reefs near Genoa pro-
vided the richest source of red coral, and by the late fifteenth cen-
tury a thriving industry for processing coral was centered there.
Another area rich in *Corallium rubrum* was located off the North
African coast. Between the sixteenth and nineteenth centuries
the rights to harvesting North African coral were hotly contested
among Spain, France, and England (although in many cases the
fishermen were Italian). By the eighteenth century the French,
operating from Marseille but working from La Calle (El Kala) in
Algeria, controlled the Algerian harvest. The turmoil of the French

Revolution undermined this situation, and in 1807 the dey of Algiers gave exclusive rights to the British for a ten-year period, after which the French regained control in 1817. Understanding not only where the coral was harvested but especially where it was processed and polished helps to establish that the coral used on the Algerian firearms may have come from one center in particular and that some examples may be assigned to a single workshop.

Coral was usually cut and polished in a major trading center rather than where it was harvested, and there are at least three possibilities for where the coral used on these firearms was processed: Marseille, Livorno, or Algiers. Marseille seems the least probable, since production of these firearms continued during the period when Marsaille lost its importance in the trade. Livorno is a strong possibility, as a number of contemporary accounts attest.[3] Certainly Livorno was a major center for the coral trade, and its merchants had worldwide connections to facilitate its production, distribution, and exchange, notably in India (Goa), for other goods such as diamonds.[4] The third possibility—that these corals were polished in Algeria—might also explain the fact that although the majority of the inlays were petal shaped, some (often on the same piece) were cut in the form of tulip heads,[5] indicating an Ottoman influence and pointing to a single local workshop for this group of firearms in nominally Ottoman Algiers.[6]

Four pairs of coral-inlaid pistols were included among the presents given to the Prince Regent (the future King George IV of Great Britain) by the dey of Algiers in 1811 and 1819, of which only two pairs are preserved.[7] A number of similar examples are found in public and private collections,[8] including a pair of the same type, dated A.H. 1198 (A.D. 1783/84), now in the Tareq Rajab Museum, Kuwait.[9] Dating the group is complicated. These firearms were all assembled using parts from different workshops, with the barrels and locks sometimes of European manufacture while the coral decoration was probably from Algerian or Italian workshops. Certainly, the corals were cut and polished in different styles, suggesting not only different workshops but also different dates of production. The finest work is found on the pistols presented by the dey to the Prince Regent in 1811 and 1819, as well as on those in the Tareq Rajab Museum.[10] These are all from the same workshop and are distinguished by the central rib on the coral petals and by the inclusion of tulip-shaped coral. A lock on one of the Tareq Rajab examples is dated to 1784; assuming the pistols were assembled at this time, the entire group should be dated to that period. The Museum's examples are not as finely worked, the corals are relatively flat, and they do not include tulip shapes.[11] They are most likely from a different workshop and are probably also slightly later in date.

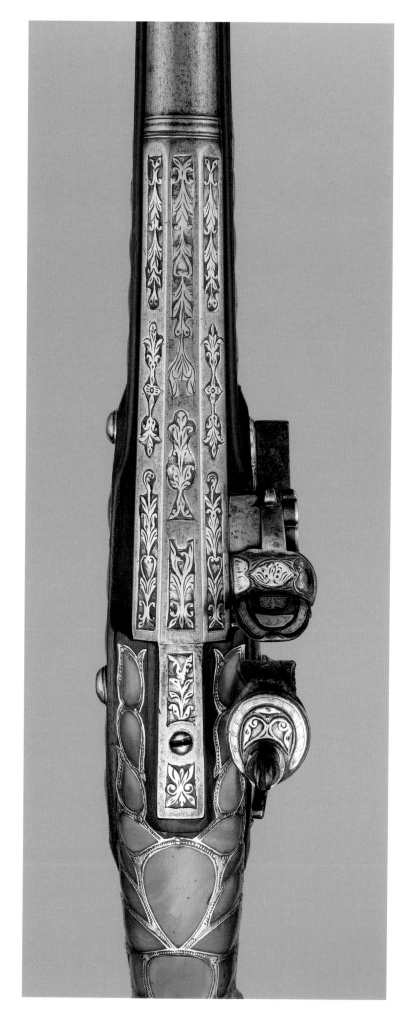

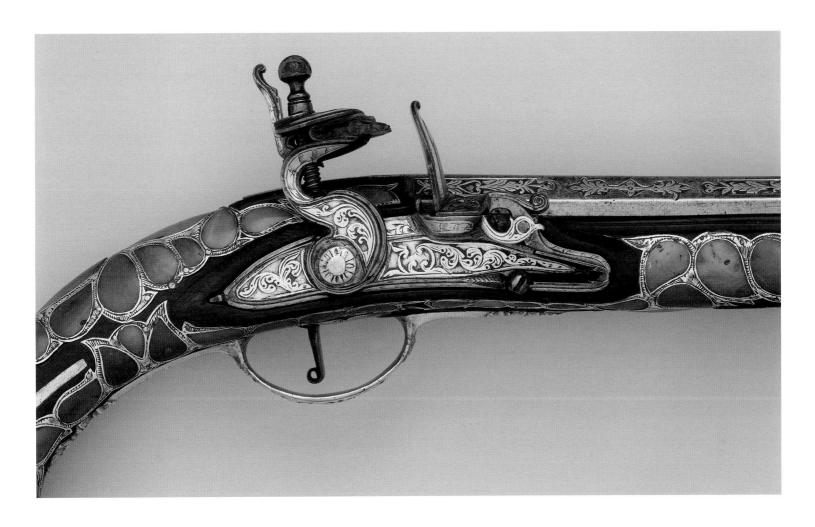

PROVENANCE: Hal Furmage, London; George Cameron Stone, New York.

REFERENCE: Stone 1934, p. 506, fig. 646, no. 5 (a only).

NOTES

1. Athens 1980, especially nos. 88, 89.

2. See Pliny the Elder 1938–62, vol. 3, bk. 1, who also reports that red coral was used by the Gauls to decorate their shields and helmets and that it was exported to India, where it was especially esteemed.

3. In 1822 the economist David Ricardo wrote from Pisa, about fifteen miles from Livorno, that "we saw a manufactory of coral beads, in which a number of people were employed in cutting, rounding and polishing pieces of coral"; Ricardo 1973, p. 322 (October 24, 1822). Ricardo's brothers were "coral makers." The large number of individuals involved in Livorno is underlined by Trivellato 2009, especially chap. 9.

4. For this trade network, see Trivellato 2009 and Yogev 1978.

5. Corals cut in the form of tulip heads were used on guns presented to the future George IV, now in the Royal Collection (see note 7 below), pistols in the Tareq Rajab Museum (see note 9 below), as well as examples in Paris 1988, no. 71, and in auctions such as that of Thomas Del Mar Ltd, London 2011, lot 153.

6. For this group of firearms, see also cat. 111. Also among the gifts sent by the dey in 1811 and 1819 were several flasks decorated with coral beads; see Andersen 2014, pp. 108–9, 136–37, and cat. 113. These are faceted with great precision and are reminiscent of accounts from Livorno that record the shaping of coral into beads; see Trivellato 2009, p. 363, n. 21.

The artisans of these centers, like so many others who followed this trade, were probably Jewish: "The circumstance of the trade in wrought coral being almost wholly in the hands of the Jews, who . . . are a very numerous and powerful class at Leghorn [Livorno]. . . . The city of Algiers is one of the connecting points of that Israelite net. . . .

It employs already every year about 200,000 francs worth of little bits, the carving and polishing of which occupy several Jewish families." See *Sporting Review* 1845, p. 252.

7. Andersen 2014, pp. 104–7, 133–35, 237, 239. One pair in the Royal Collection, Windsor Castle, no. RCIN 64422, is dated A.H. 1152 and 1153 (A.D. 1739/40 and 1740/41).

8. Among them is another pair in the British Royal Collection (apparently unrelated to the gifts of 1811 and 1819; see London 1991–92, no. 208); a pair in the Wallace Collection, London (nos. O.2041, O.2042; see Blair 1968, figs. 819, 820); and several examples in private collections (Paris 1988, nos. 69, 71).

9. Elgood 1995, nos. 40, 41.

10. See notes 7 and 9 above.

11. Some of the pistols presented in 1819 are set with flat-cut coral, in the same style as the Museum's examples here. These cannot be from the same workshop as those with ribs and tulip-shaped petals.

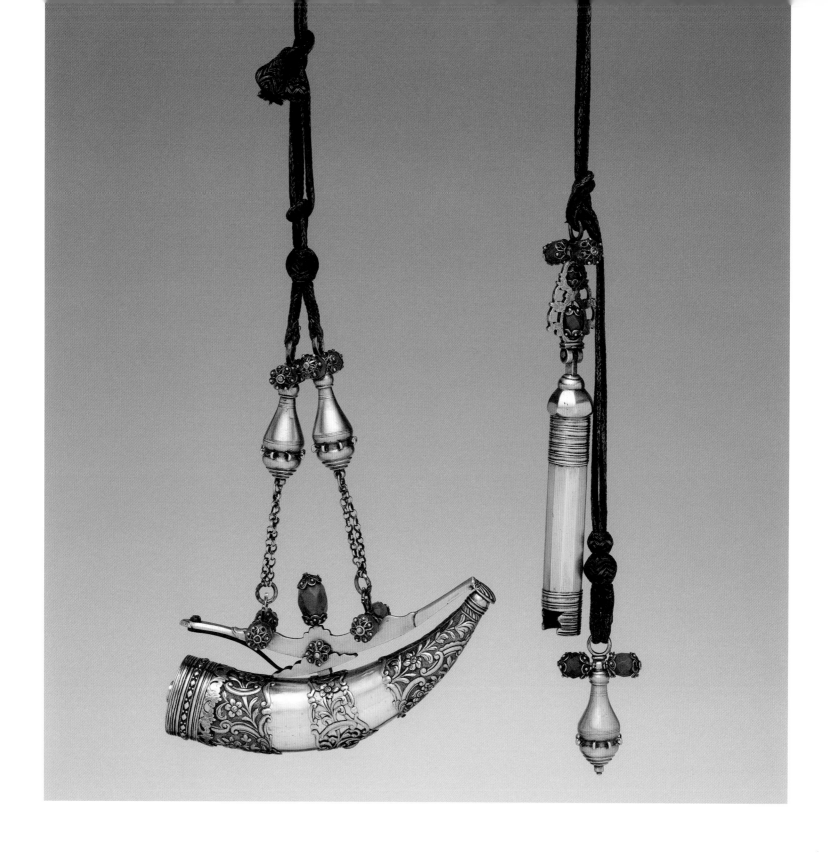

113 · Priming Flask, Powder Measure, and Suspension Cords

Algeria, late 18th century or early 19th century
Silver, gold, steel, coral, textile
Length of flask 7⅝ in. (19.5 cm); weight (including cord) 1 lb. 3 oz. (547 g)
Length of measure (including finial) 8½ in. (21.5 cm); weight (including cord) 11 oz. (304 g)
Bequest of George C. Stone, 1935
36.25.2444

DESCRIPTION: The powder flask and powder measure are suspended at the ends of separate looped cords (now tied together) of red silk thread woven with bands of metal-covered thread, with globular slides and terminals near the ends.

The horn-shaped flask of silver is fitted with silver-gilt mounts, those at the ends embossed in low relief with rococo designs of foliate motifs and C-shaped scrolls on a circle-punched ground, the middle one pierced with foliate scrolls and flowers. The wide end is covered by a deep cap with pierced foliate border, the sides ridged with a central band of repeating diamond shapes, and a pierced end engraved as a rosette; the latter has a central hole to which an ornamental fitting, now missing, was originally attached. The sprung lever is of silver gilt, the pivot covered on each side by a filigree rosette of the same metal, the spring of dark steel. The top of the lever is mounted in the center with a large faceted coral bead

with filigree caps and at each side by a pivoting ring mounted horizontally by faceted corals with filigree caps. The flask is suspended from its loops by a double silver chain attached to large silver-gilt balusters mounted at the sides with loops, from which corals on silver chains were formerly suspended, and at the tops with horizontally aligned corals; rings at the top of the balusters provide attachment for the cord.

The tubular powder measure of silver gilt is transversely ridged at each end, the ten-sided central section alternately gold and silver in color, the base cut away on one side, the top with an octagonal mushroom cap. Attached to the cap is a pierced, engraved, and coral-set swivel mount which when pulled reveals the notched powder gauge of silvered steel. A suspension ring and two horizontally mounted faceted corals with filigree caps are attached to the top of the finial. The end of the suspension cord is fitted with a silver-gilt and coral-mounted baluster.

The silver is struck three times with the same circular control mark consisting of a beaded border enclosing an Arabic inscription (a). The marks appear on the inside of the powder measure, near the bottom opening, on the measure's swivel mount, and on the ring attaching the swivel mount to the cord.

INSCRIPTION:

a. (Inside the powder measure, near the bottom opening, on the measure's swivel mount, and on the ring attaching the swivel mount to the cord)

فجرة

Fajara / fedjera
Silver.[1]

T hese firearm accessories are of importance not only because of their finely and subtly worked mountings and decoration but also because they are stamped with the Algerian *fedjera* silver mark that is identical to one that appears on several guns in the Museum's collection attributed to Algeria.[2] The same mark is also stamped on the hilts and fittings of a group of sabers with silver and enamel mounts that are preserved in the Topkapı Sarayı Museum in Istanbul.[3] The center in which these pieces were crafted is uncertain, as silversmithing and enameling is recorded in Bejaïa, Algiers, Oran, and Tlemcen. However, comparable chased decoration and granulated clasps can be seen on jewelry from the Great Kabylia, a region of the Atlas Mountains around the city of Algiers.[4]

An attribution to Algeria is further supported by the existence of several similar powder flasks and powder measures included in gifts from the dey of Algiers to the Prince Regent (later George IV of England) in 1811 and 1819, which are now in the Royal Collection at Windsor Castle.[5] The buoy-shaped balusters on the Windsor flasks are fitted with numerous loops from which are suspended small faceted corals on silver chains; these pendants are now missing from the Museum's example.

PROVENANCE: W. O. Oldman, London; George Cameron Stone, New York.

Unpublished.

NOTES

1. The *fedjera* silver mark is found on numerous Algerian nineteenth-century weapons, and the word *fajara* appears to be a word for silver in North Africa (Will Kwiatkowski, personal communication, 2014).

2. These include acc. nos. 36.25.2156 (dated 1815–16), 43.82.1 (dated 1798–99), 43.82.2 (dated 1805–6), 43.82.4 (dated 1814–15), and cat. 114 (dated 1809–10). For a discussion of the silver marks, see the commentary for cat. 114. The same mark is also found on an Algerian yatagan in the Museum's collection, acc. no. 36.25.1618. For further discussion of these control marks, see Eudel 1902, pp. 121, 401.

3. This large group in the arms collection of the Topkapı Sarayı Museum, Istanbul, includes nos. 2557, 2563, 4942, 492, 2762 (unpublished). The latter is signed and stamped with the date A.H. 1170 (A.D. 1756/57).

4. For centers of production of enameling and silversmithing, see Gonzalez 1994, especially pt. 3. For jewelry attributed to the Great Kabylia, see ibid., figs. 167 (silver), 139 (silver and enamel).

5. Andersen 2014, pp. 108–11, 136–37, 238–39. Unlike many of the firearms included in these gifts, the flasks and related accessories are not dated. A similar coral-mounted flask and powder measure, called Turkish, eighteenth century, are in the Victoria and Albert Museum, London; see North 1985, p. 23, figs. 15c, d. Another flask is in the David Collection, Copenhagen (see Copenhagen 1996, p. 197, no. 167); and a similar powder measure is in the Khalili Collection, London (see Alexander 1992, p. 124, no. 70).

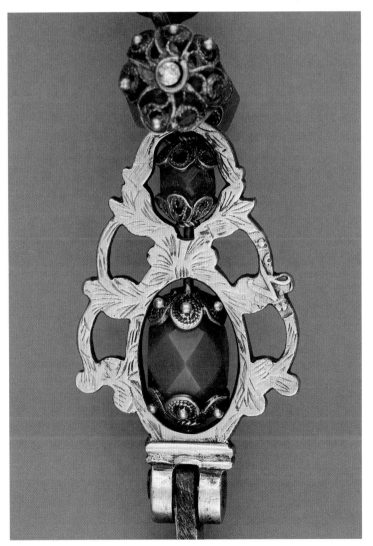

Detail of swivel mount

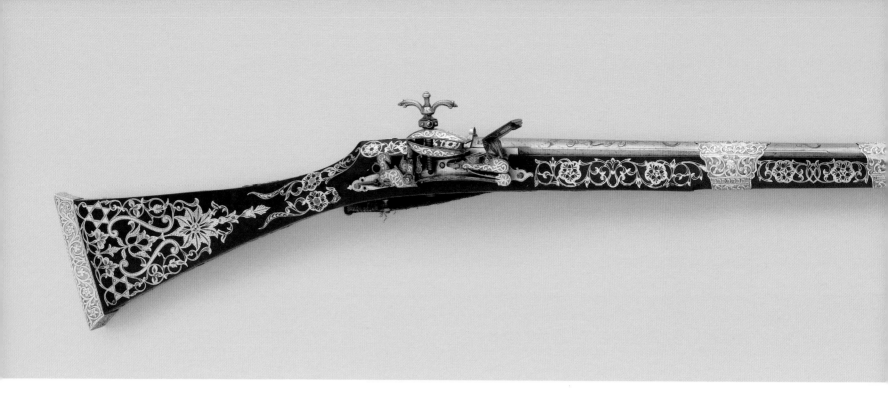

114 · Miquelet Rifle

Algeria, dated A.H. 1224 (A.D. 1809/10); barrel, Europe, 18th century
Steel, wood, silver, copper alloy, textile
Length 67 in. (170.3 cm); barrel 50⅞ in. (129.2 cm); caliber .70 in.
(18 mm); weight 10 lbs. 9 oz. (4,800 g)
Gift of Mrs. E. S. Griswold, Mrs. William Sloane, and Mr. John
Sloane, 1943
43.82.3

DESCRIPTION: The European smoothbore barrel has a short octagonal breech section and then is round the remainder of its length, with a flat sighting rib extending down the center. The three upper breech flats are stamped with three rectangular marks, each consisting of the letters *FC* separated by a pellet and surmounted by a crown, the marks originally covered in thin copper alloy, much of it now missing; beneath the breech are stamped additional marks, *TC* within a rectangle and *O*, with an oak-leaf-shaped mark on the left flat. Forward of the breech the surface is engraved with symmetrical foliate scrollwork inlaid in places with copper alloy. There is a low, slotted, arch-shaped rear sight and hogback front sight, both of silver. The barrel tang is covered by silver sheet engraved with scrolls on a recessed stippled ground. The vent is gold lined. The miquelet lock of Kabyle type is covered with plaques of silver chiseled with raised scrollwork against a recessed stippled ground. The lower edge of the cock and adjacent edge of the lock plate bear the maker's name and date (a). The three-quarter-length wood stock is inlaid in sheet silver pierced and engraved with flowers, leafy scrollwork, and hexagrams. The butt plate of silver is chiseled around the sides with foliate scrollwork on a stippled ground; the top edge bears an Arabic inscription and date (b). A silver plaque at the top of the stock behind the barrel tang is also inscribed and dated (c). Another inscription (d) is found on the offside of the silver fore-end cap. The baluster-shaped trigger is covered with silver. The five silver barrel bands are embossed with scrollwork, shells, and rosettes, and each is stamped with a control mark (e); traces of the same mark, struck twice, are on the end of the butt plate. The ramrod is of wood, its fore-end covered with silver engraved in a spiral pattern with a vine, the silver struck with a control mark, its rear end of iron. Iron sling swivels are attached on the offside of the stock at the neck and between the third and fourth barrel bands (counting from the muzzle) and retain the shoulder strap of woven textile covered with silver-gilt thread and backed with a dyed green fabric. The pad of leather formerly nailed to the stock behind the lock, which protected the web of the thumb, is missing.

INSCRIPTIONS:
a. (On the lock)

<div dir="rtl">

عمل احمد
١٢٢٤

</div>

Made by Ahmad. (Year) 1224 (A.D. 1809/10).

b. (On the butt plate)

<div dir="rtl">

نصر من الله
و فتح قريب
ما شاء الله
سنة ١٢٢٤

</div>

Help from Allah and a speedy Victory (Qur'an 61:13). As God wills. Year 1224 (A.D. 1809/10).

c. (On the stock behind the barrel tang)

<div dir="rtl">

و مالكه
سيد
عمار اغـ[ـا] ١٣٨
١٢٢٤

</div>

Its owner and possessor, Sayyid 'Ammar Agh[a] 138. (Year) 1224 (A.D. 1809/10)

d. (On the silver fore-end cap of the stock)

<div dir="rtl">

ما شاء الله عمل مصطفى

</div>

As God wills. Made by Mustafa.

e. (On the barrel bands and butt plate)

<div dir="rtl">

فجرة

</div>

Fajara / fedjera[1]
Silver.

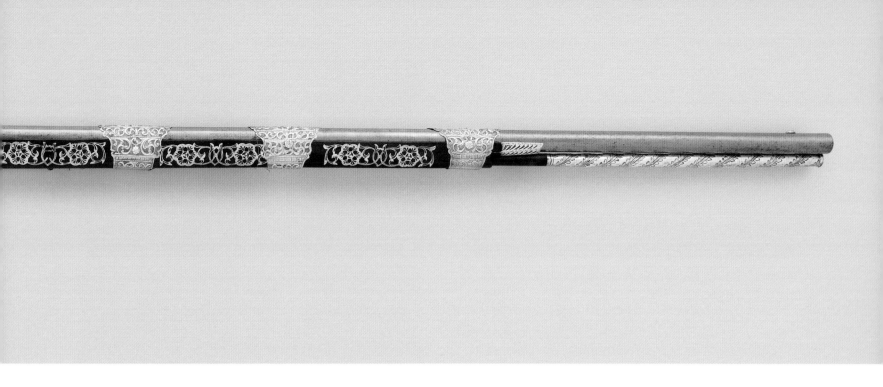

This gun is one of a group of ten (acc. nos. 43.82.1–.10) said to have come from the collection of 'Ali Pasha Tepedelenli (ca. 1744–1822), a provenance discussed more fully in cat. 110. 'Ali Pasha was friendly with the French, who supplied him with arms; if this gun did in fact belong to him, it was perhaps transported by the French from Algeria. The present rifle is notable for bearing the names of the gunsmith Ahmad, the decorator Mustafa, and the owner Sayyid 'Ammar, as well as the date of manufacture.

The Museum's gun is almost identical in its decoration to one reputed to have been among the holdings of the French general Joseph Vantini, also known as General Youssouf, who led the French armies in Algeria during the mid-nineteenth century.[2] As with the Museum's example, the sides of the stock of the Vantini rifle are decorated with a large central floral form framed by smaller scrolls of flowers. Exactly the same arrangement is used on an exceptional gold-mounted Algerian rifle dated A.H. 1214 (A.D. 1799/1800) below the lock plate.[3] The pierced-and-engraved floral decoration on these three guns ultimately derives from an Ottoman style of the seventeenth century;[4] it can be traced from the bold floral designs seen in Iznik ceramics to the pierced-and-engraved designs that embellish Ottoman ceremonial shaffrons of the eighteenth century and, in Algeria, through such pieces as a set of daggers formerly in the collection of the princes of Hanover, several sabers datable to the 1732 battle of Oran, and a gun of this type with a lock dated 1758/59.[5]

In terms of decoration, the finest of these Algerian rifles is the example given above dated 1799/1800; although it is of the same decorative style as the other two, it is more delicately worked, and the appliqués are of gold rather than silver. The titles in the inscriptions on some of these guns (as on the Museum's firearm, which was owned by an aga) indicate that they were probably made for important officials of the dey of Algiers. At the turn of the nineteenth century the dey supported the so-called Barbary pirates, making him an important and powerful figure in

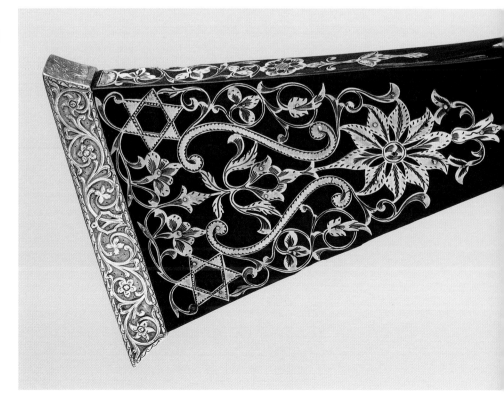

the Mediterranean world and beyond.[6] Judging from its quality, the gun dated 1799/1800 may very well have been a personal weapon of the dey. It is also very likely that all these guns were from the same or, at least, related workshops that employed very skilled craftsmen.

As is often the case with North African guns, the barrels were imported from Europe, though made to suit local tastes. The marks on this gun, a brass-filled square struck with the letters *FC* beneath a crown, repeated three times, are also found on a similar Algerian gun in the Museum's collection (acc. no. 43.82.2). While none of these marks have been identified, they are presumed to be Italian.

PROVENANCE: Acquired from the grandson of 'Ali Pasha Tepedelenli by J. W. Wittal, Istanbul; John Sloane, New York; by descent to his children Mrs. William E. S. Griswold, Mrs. William Sloane, and John Sloane, through William Griswold, New York.

Unpublished.

NOTES

1. For the *fedjera* silver mark, see cat. 113, n. 1.

2. See Paris 1988, no. 79.

3. See Bailly-Pommery & Voutier Associés, Paris 2010, lot 23.

4. Algiers became part of the Ottoman Empire in 1517/18 and remained nominally so until the French conquest in 1831.

5. For the shaffrons, see Alexander 1992, pp. 120–21, no. 65; for the dagger from the Hanover Collection, see Sotheby's Hanover 2005, vol. 3, lot 3603. The sabers captured

at the battle of Oran include examples in the Real Armería, Madrid, such as no. M.42-46 (Valencia de San Juan 1898, p. 376), and a related example in the Metropolitan Museum, cat. 67. For the gun, see cat. 111.

6. In 1800, for example, the United States sent Commodore William Bainbridge (1774–1833) to pay tribute to Dey Mustafa IV, but having to do so irked the Americans and eventually led to war. For the relationship between the United States and the Barbary states in the early nineteenth century, see Andersen 2014, pp. 200–213.

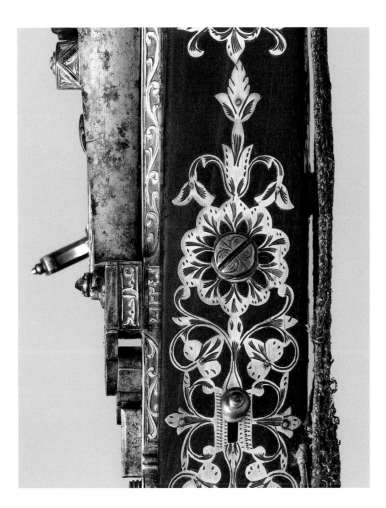

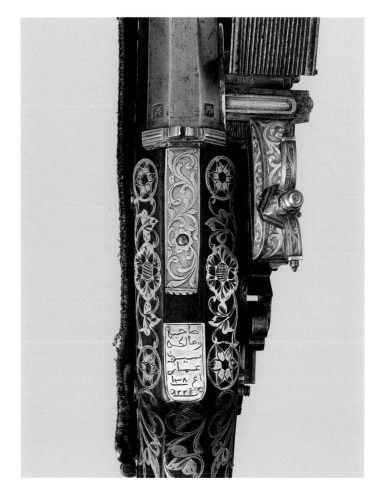

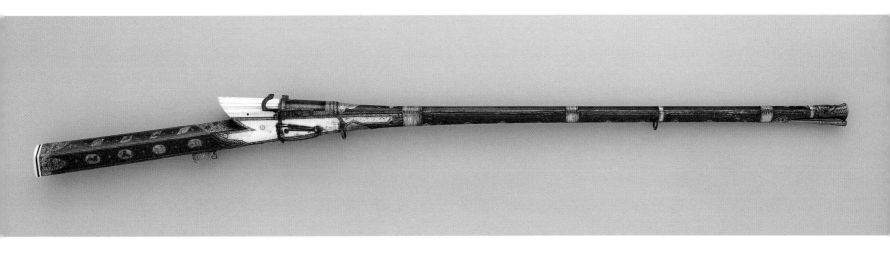

115 · Matchlock Gun

India, possibly Gwalior, late 18th–19th century
Steel, iron, wood, ivory, gold, silver, copper alloy, polychromy
Length 59⅝ in. (151.3 cm); barrel 41¾ in. (106 cm); caliber .68 in. (17 mm);
weight 9 lbs. 11 oz. (4,405 g)
Rogers Fund, 1933
33.28.2

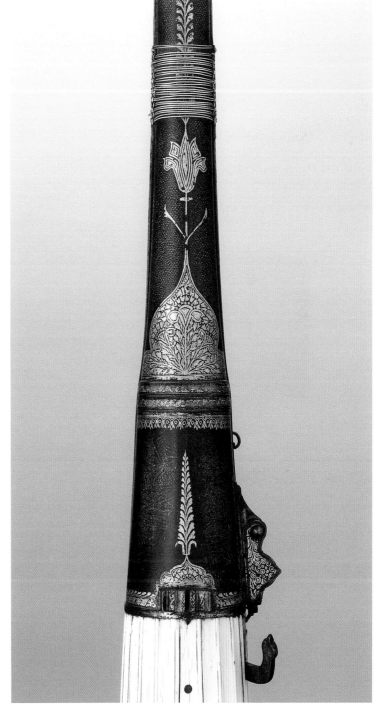

DESCRIPTION: The round, smoothbore barrel of dark pattern-welded steel (pattern clearly visible at the breech end) is divided into three zones of decoration. The breech, which expands dramatically in diameter, is framed by transverse moldings and is damascened in gold with a border of stylized flowers and a cypresslike tree extending down the middle from the slotted rear sight; brazed at the right side of the breech is a shaped pan with powder recess and drilled vent, the pan having a pivoted iron cover that envelops the pan top and bottom and to which is affixed an iron ring and portions of a silver chain to facilitate its opening. The rear sight, pan, and pan cover are also damascened in gold with foliage and geometric ornament. The long middle section is punched overall with a minute lozengelike pattern, each lozenge containing a dot, and is damascened in gold along the edges with a repeating flower design. At each end are large half medallions damascened in gold with dense floral patterns, with stylized flowers projecting toward the center from each medallion, and with a leafy branch extending down the middle of the barrel to connect the two medallions. The barrel end is shaped as a dragon or makara head emitting from its mouth a flared muzzle. The head is damascened in gold in imitation of hair and whiskers and has vermilion paste inset into the eyes; the muzzle is fluted, the recesses silvered, the raised panels damascened in gold with leaves, and the rim damascened in silver with geometric ornament.

The matchlock of traditional Indian type comprises a trigger that is linked within the stock to a pivoting serpentine (match holder) that emerges behind the breech of the barrel. The flat iron trigger is shaped in outline as a crouching feline and is damascened in silver with a crisscross pattern on the sides and leaves along the edge; the serpentine, which is also of silver-damascened iron, has a shaped head that is split to hold a match.

The stock of wood is painted and varnished a dark green color, over which is painted a dense pattern of feathery scrollwork and flowers in a paler olive green, with some leaves and flower centers in red and white. At regular intervals this decoration is interrupted by oval or leaf-shaped medallions enclosing animals, birds, and flowers painted in naturalistic colors on a gold ground. The straight, narrow butt, which is of pentagonal section, has large panels of flowers on the top behind the

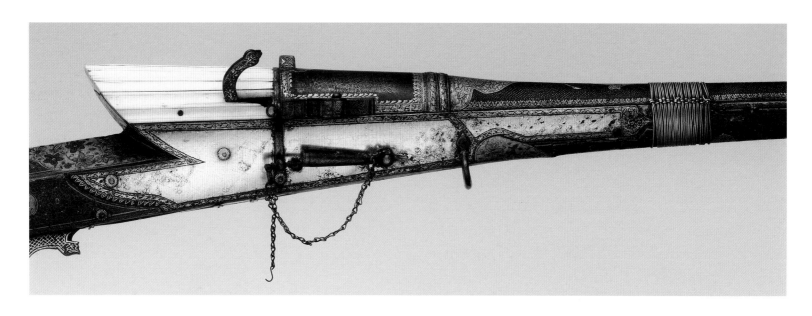

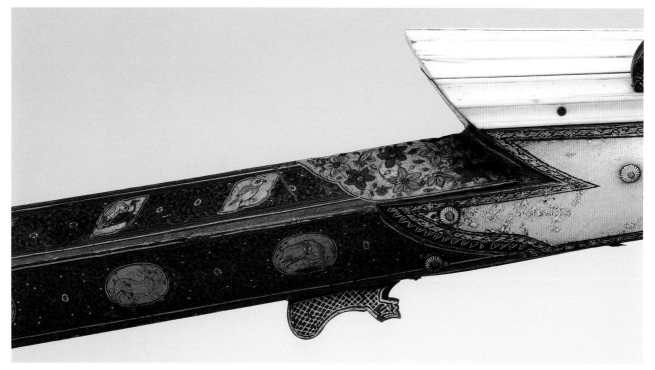

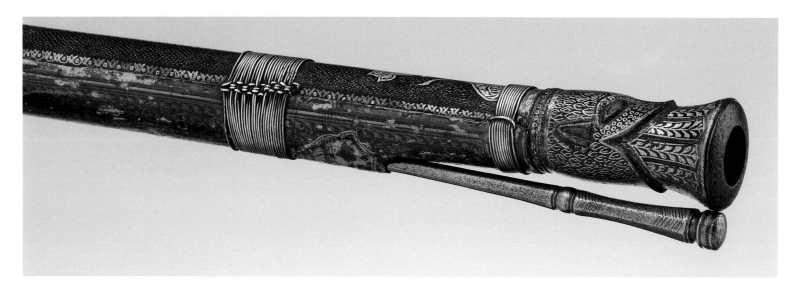

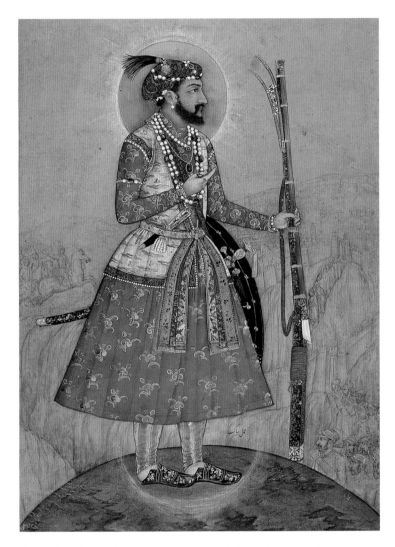

Fig. 40. *Shah Jahan Standing on a Globe*. Miniature painting by Payag, 1635. Chester Beatty Library, Dublin (07B.28a)

Lightweight matchlocks with straight stocks such as this were used throughout northern and central India from the sixteenth to the nineteenth century, and their slender stocks probably indicate an Iranian influence.[1] The decoration on the stock is also very similar to that found on Iranian art of the Qajar period, especially in the use of roundels containing genre scenes or portrayals of animals set within feathery-leaved floral designs.[2] However, despite the Iranian influences this gun is typically Indian in both its form and decoration. A comparable example now in the Royal Collection at Sandringham, Norfolk, also painted green and embellished with vignettes of animals and flowers, is said to date to the eighteenth century and to come from Gwalior in Rajasthan.[3] Another rifle of the same form, with a black painted stock, also said to be from Gwalior, was published by Egerton.[4] A third example, seemingly the pair to the Museum's gun, recently passed through the art market.[5]

The fluted ivory plaque behind the lock is a feature that first seems to have appeared on Mughal guns during the seventeenth century. One of this type, also with a green-painted stock, is shown in a miniature painting of 1635 (fig. 40) depicting the emperor Shah Jahan (r. 1628–58). Similar animal designs with ovular cartouches were frequently used on Indian playing cards of the eighteenth century.[6]

Cannon, rifles, and pistols with dragon-mouthed barrels, which the Ottomans called *ezhder-dihan* (dragon-mouthed), were produced throughout the Islamic world.[7] For discussion of the pattern-welded barrel and its use in India, see cat. 116.

PROVENANCE: Arthur E. Oxley, Cambridge; his collection sold at Ritter-Hopson Galleries, New York, February 2, 1933.

REFERENCES: Grancsay 1933a, pp. 196–97, ill.; Grancsay 1933b, ill.; Ritter-Hopson Galleries, New York 1933, lot 191; Grancsay 1958, p. 250; Grancsay 1986, pp. 119–21, 452–53, figs. 46.1, 109.12.

NOTES
1. See Norwich, Cincinnati, and Toronto 1982–83, p. 116, no. 107.
2. See, for comparison, B. Robinson 1985, nos. 166, 169, both of the late nineteenth century, and Zeller and Rohrer 1955, no. 383, fig. 195.
3. C. Clarke 1910, p. 24, no. 324, pl. 13.
4. Egerton 1880, no. 424, pl. IV.
5. Sotheby's London 2004, lot 154.
6. See, especially, Mayer 1971, figs. 48–55, and Von Leyden 1982.
7. See Parry 1960, p. 1062.

barrel and at the butt end, the latter also having a band of polychrome flowers encircling the end; other flower panels are found under the forestock and behind the ramrod. The edges of the stock, panels, and medallions are outlined in red and white. The raised section on top of the stock, immediately behind the barrel, is covered by a curved, fluted plaque of ivory; the angled section of stock behind that plaque is painted red. Two plaques of ivory, sandwiching a darker plaque of wood, form the butt plate, and a narrow, pointed strip of ivory, held by three narrow silver plates nailed to the stock, is inset beneath the stock in front of the trigger. Each side of the stock between the trigger and forestock is reinforced with a plate of silvered iron attached by nails with rosette-shaped heads of silvered iron; the plates have narrow borders damascened in gold with leaf scrolls. An iron loop encircles the breech of the barrel, the ends nailed through the iron plates. On the outer plate is nailed a tube for the vent pricker, both of gilt iron, the latter attached to the base of the tube by swivel mounts and a silver chain. Two brass swivel loops for a shoulder strap are attached to the forestock in front of the breech and farther up the forestock. The barrel is attached to the stock by the iron loop at the breech, mentioned above, and by five groups of silver wire banding. The iron ramrod has a long, faceted head.

116 · Matchlock Gun

India, possibly Lahore, probably late 18th century or early 19th century
Steel, wood, gold, silver, polychromy
Length 61⅜ in. (156.4 cm); barrel 42⅞ in. (108.8 cm); caliber .44 in.
(11 mm); weight 8 lbs. (3,631 g)
Bequest of George C. Stone, 1935
36.25.2153

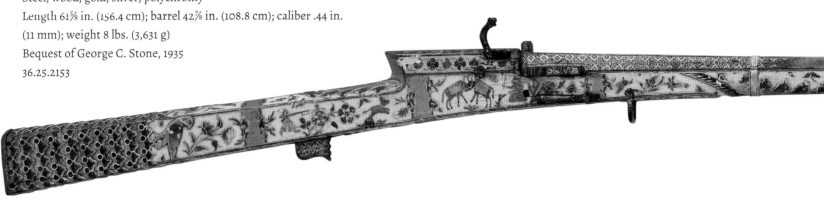

DESCRIPTION: The barrel of pattern-welded steel is of square section that widens slightly at each end and has a square bore. At the breech end is a slotted rear sight of steel; on the outer side of the barrel is a shaped pan with vent (the pivoting pan cover is missing). The breech is damascened in gold with a textilelike repeat pattern of quatrefoils enclosing a three-petaled flower, in gold on a darkened ground, with four-petaled rosettes in reverse colors in the interstices. A transverse band of gold scrolls divides this panel into two, the forward section with a cartouche inscribed in Persian with the maker's name (a). A similar section of damascened decoration, but lacking an inscription, is at the muzzle end. The front sight is missing. The conventional matchlock mechanism consists of a flat, spring-held trigger and a serpentine with split head, shaped and pierced as a leaf and slotted to hold the match, both damascened in gold with leaf scrolls. The stock extends almost to the muzzle and has a straight, narrow butt of pentagonal section. The stock is painted and varnished with a white ground on which the polychrome decoration in opaque and translucent colors consists of flowers, birds, rabbits, monkeys, deer, lions, two oxen butting heads, and several human figures including a male hunter armed with a gun. The butt end is carved in low relief with a repeat design of overlapping trefoils in red and gold, perhaps suggesting peacock feathers; in front of this are raised designs of parrots at the sides and palmettes on the top and bottom planes. Panels of raised leaves are also found at the neck and on the underside of the forestock and muzzle. The raised area of the stock just behind the breech is longitudinally grooved as a rear sight and is painted with red and green floral scrolls on a gold ground. The stock is fitted with two iron sling swivels and a narrow tube for holding the vent prick (missing), these damascened in gold. The barrel is attached to the stock by nine sections of silver wire binding. The iron ramrod has a long, octagonally faceted head damascened in gold.

INSCRIPTION:
a. (At the breech end of the barrel)

عمل حاجى شعبان صف شكان|ن|

Made by Haji Sha'ban Saff-Shekan.

On a matchlock gun the powder in the barrel is ignited through a touchhole with a slow-burning rope, or "match," thereby propelling the bullet toward its target. The type was used for handguns in northern Europe from the late fourteenth century.[1] Based on a number of passages in the *Tuzak-i Baburi* (*Baburnama*)—the chronicle of Babur (r. 1526–30), the first Mughal emperor—that report various battles during the early sixteenth century, it is clear that at this time the Mughals used matchlocks.[2] It has been suggested that Babur brought firearms with him from Central Asia;[3] even if true, it is unlikely that they were made there—it is more probable that they were imported from or via Ottoman Turkey or were supplied by the Portuguese. What is certain, however, is that Babur had two master gunners: Ustad Ali Quli and Mustafa Rumi. The latter was certainly a European, and it was perhaps he who was responsible for first organizing Babur's matchlock-bearing infantry.

The pair to the Museum's gun, or at least a very similar example from the same workshop, is in the Khalili Collection, London.[4] The stocks of both are carved and painted by the same hand and have virtually identical coloring, although the decorative motifs vary slightly. The barrel of the Khalili gun is also of square section and is signed by the same maker as our firearm; it differs from the Museum's weapon in that it has a round bore and the gold-damascened decoration on the barrel consists of tightly interwoven arabesques. A third gun apparently from the same workshop is in the Museo Stibbert, Florence.[5] Like the other two, the Stibbert example has a square-sectioned barrel (in this case with round bore) of pattern-welded steel damascened in gold at the breech and muzzle ends and a carved-and-painted stock of nearly identical design on a white background. The

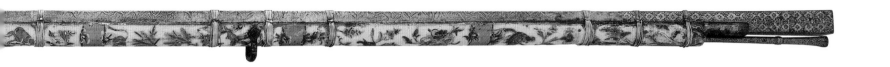

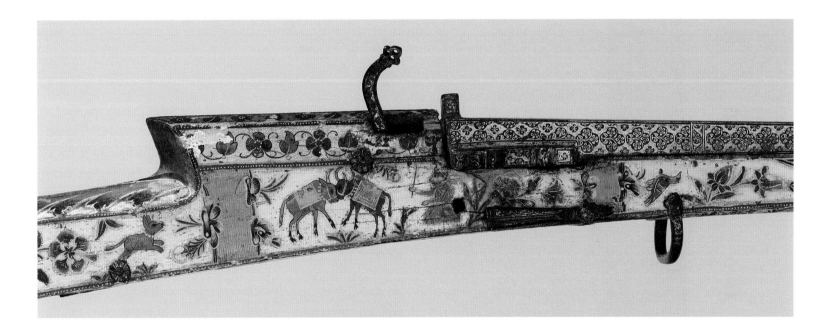

decoration on the Stibbert gun includes hunting scenes, one of which depicts a Mughal dignitary hunting with a European companion.

All three of these firearms have been variously dated to the seventeenth and eighteenth centuries. The Museum's gun was ascribed by Stephen Grancsay to about 1700.[6] Henry Russell Robinson catalogued the Stibbert weapon as Rajput and of the eighteenth century, whereas Philippe Missillier and Howard Ricketts classified the Khalili gun as a Mughal work of the second half of the seventeenth century.[7] Given the dense, exceedingly elaborate ornament that covers the surface of the gun and the similarity of the high-relief flowers to those on a shield dated to about 1774, a date for the Museum's gun in the late eighteenth or early nineteenth century seems more likely.[8]

The barrel of the Museum's rifle is forged with a twist pattern; according to the emperor Akbar's vizier and chronicler Abu'l Fazl (1551–1602), this was a technique introduced into India by Akbar

(r. 1556–1605). The twisting added strength, and these improved barrels were much less likely to explode when fired. They were constructed by taking the iron, flattening it, and, as Abu'l Fazl explained, "twist[ing] it round obliquely in the form of a roll, so that the folds get longer at every twist; then they join the folds, not edge to edge, but so as to allow them to lie one over the other, and heat them gradually in the fire [pattern welding]. They also take cylindrical pieces of iron, and pierce them when hot with an iron pin. Three or four such pieces make one gun. . . . There are now many masters to be found among gunmakers; e.g., Ustád Kabír, and Husain."[9]

PROVENANCE: W. O. Oldman, London; George Cameron Stone, New York.

REFERENCES: Grancsay 1937b, p. 171; Grancsay 1958, p. 250, ill.; Grancsay 1986, pp. 183, 452–53, fig. 109.11; Paris 1988, no. 178; Alexander 1992, pp. 182–83, no. 116; Florence 2014, p. 139, no. 78.

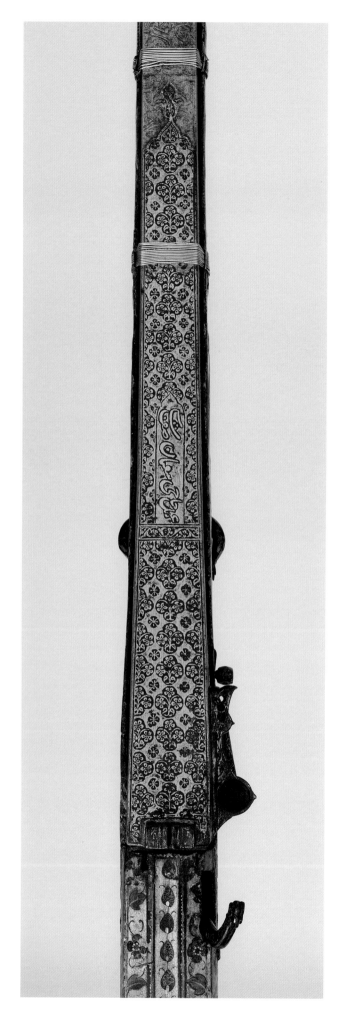

NOTES

1. See, for example, Tarassuk and Blair 1979, p. 219.

2. Various words—*firingi*, *tufeng*, and *araba*—were used by Babur to describe the guns under the control of his master gunners. Although the precise meanings of these words in this period is sometimes uncertain, it is clear that handguns, specifically matchlocks, were used, since Babur describes infantrymen armed with guns; see Elliot 1872, pp. 270, 279, and Thackston 1995, p. 378 (verse 315b): "Master Ali-Quli and all his matchlockmen were ordered to march on foot in array." For an introduction to Indian firearms, see Elgood 1995, pp. 129–85, and Bottomley 2002.

3. Bottomley 2002, p. 78.

4. See Alexander 1992, p. 182, no. 116. The inscription on the Khalili gun was originally read as Haji Shungharban, but should now be read as Haji Sha'ban Saff-Shekan (as reviewed by Will Kwiatkowski and Manijeh Bayani); "Saff-Shekan" means "hero," or, literally, "one who breaks the rank (of the enemy)." Hewitt 1859, p. 110, class 15, nos. 383–85, recorded three other similar examples, now in the British Museum, London, no. OA+7371, the barrel signed Haji Sha'ban, and Royal Armouries at Leeds, nos. XXVIF.99, XXVIF.119; the latter is illustrated in Richardson 2007, p. 30 (bottom). They are said to have come from Lahore; even if correct, this does not prove that they were made there.

5. Museo Stibbert, Florence, no. 5618; see H. Robinson 1973, p. 195, no. 22, pl. 42a; Florence 1997–98, no. 70; and Florence 2014, no. 78.

6. Grancsay 1958, p. 250, ill.; Grancsay 1986, p. 453, fig. 109.11 (caption).

7. For Henry Russell Robinson, see note 5 above; for Missillier and Ricketts, see Paris 1988, no. 178.

8. For the distinctive qualities of Indian lacquerwork, see Zebrowski 1983; for the shield, see London 1982, no. 461.

9. "On Matchlocks, &c," in Abu'l Fazl 1873, p. 113, bk. 1, pt. 37. For Akbar's interest in firearms, see Elgood 1995, pp. 135–37.

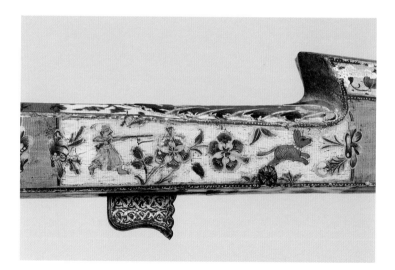

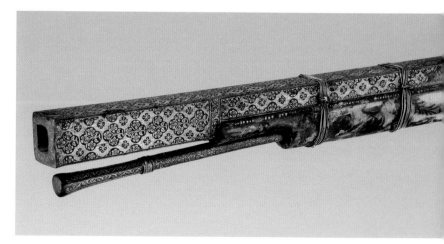

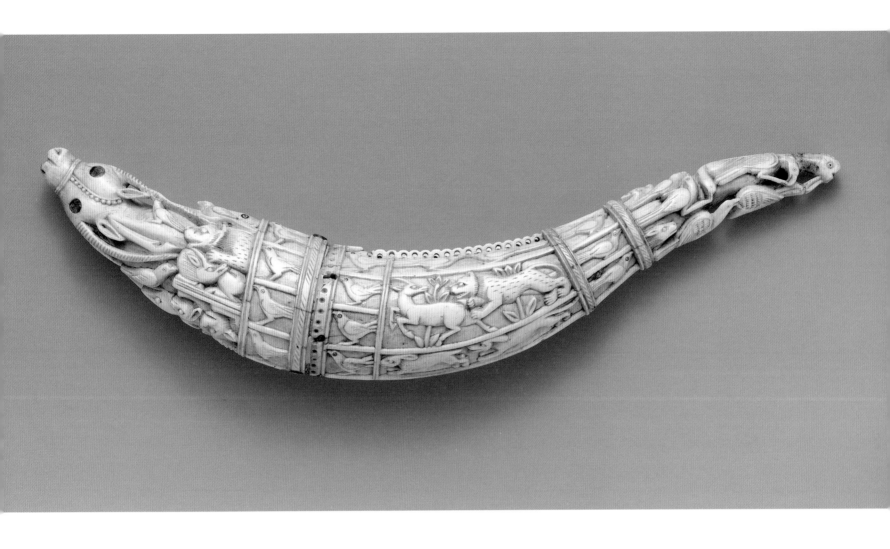

117 · Priming Flask

India, probably Deccan, mid-17th century
Ivory, wood, polychromy, resin
Length 9 in. (23 cm); weight 4 oz. (107 g)
Rogers Fund, 1907
07.71

DESCRIPTION: The flask of ivory, of oval section tapering toward each end, is formed in two parts joined by transverse wood (originally ivory) pins. The wider nozzle section, beginning at the join, is carved in low relief with a vertical band containing registers of birds, next to which is a compressed group of animals (including felines and antelopes) and birds; the section terminates in a double-sided antelope head, wearing a headstall, carved in the round so as to be read in four directions. The antelope's open mouth served as the pouring spout; its drilled eyes are set with translucent colored resin or amber (one socket void); its horns and ears are undercut and pierced (one horn is broken off). The rear section is carved with horizontal and vertical registers on each side that are filled with birds and with hunting scenes of a lion attacking a gazelle and a dog pursuing a rabbit; the section terminates in a composite of animals and birds carved in the round. Along the top of the flask are two parallel raised ridges drilled through with a series of circular holes. There are traces of red polychromy in some of the low areas of the carving, and the eyes of some of the birds and animals, formed as a circle with a dot in the center, are filled with a black color. The spring-operated stopper (see cat. 118) is now missing. A later silver suspension chain formerly attached to the flask has been removed.

Priming flasks, or primers, were containers for the more finely ground gunpowder needed to set off the charged gun. A small quantity of powder was carefully poured through the nozzle into the pan adjacent to the barrel's touchhole and then ignited by a spark from the flint or—as was more common in India—from the lighted taper of a matchlock.

Primers carved with hunting scenes or with composite animals were created by Indian craftsmen from the seventeenth century onward. Large numbers of these survive and represent a distinctive group of ivory carvings (none, unfortunately, are documented as to their specific place and date of origin). They have

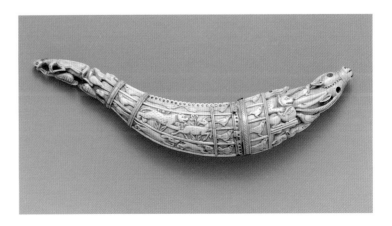

documented examples are found on two primers in Dresden that were recorded in the collection of the elector Johann Georg II of Saxony in 1658—although they may have been made several decades earlier.[3] Other examples include several listed in the Royal Danish Kunstkammer inventories of 1674 and 1690[4] and a flask in Kraków said to have been taken from the Turks at Vienna in 1683.[5] The Museum's collection includes six such primers.[6] The present example is possibly the earliest. In certain details, such as its pierced-and-scalloped border, it closely resembles one of the Dresden primers and thus should also be attributed to the mid-seventeenth century.

PROVENANCE: E. Stolzenberg, New York.

REFERENCE: Born 1942, p. 109, fig. 9.

NOTES
1. Born 1942.
2. For Iranian painting, see, for example, the rock forms in the miniature by Khwaju Kirmani of 1396 (British Museum, London, no. Add.18 113, fol. 31r) and "Kai Khusrau Rides Bihzad for the First Time," from the *Shahnama* (Book of Kings) of Shah Tahmasp (Metropolitan Museum, acc. no. 1970.301.33, fol. 212r; Canby 2014, p. 192). For Deccani painting, see, for example, Zebrowski 1983, pl. XVIII (attributed to Golconda, Deccan, early seventeenth century), and New York 1987–88, no. 92. On composites in general, both Muslim and Hindu, see Del Bonta 1999.
3. Born 1942, figs. 2, 3. See also Schöbel 1975, no. 169, and London 1982, no. 439 (citing the 1658 inventory).
4. See Dam-Mikkelsen and Lundbaek 1980, p. 112, ill. p. 111; London 1982, no. 440; and Gundestrup 1991, vol. 1, p. 281, vol. 2, p. 20 (no. EDb64, recorded in 1690; no. ED663, recorded in 1738, bears a silver ring inscribed, in translation: "This is made by the Blacks in East India").
5. The flask in the Muzeum Narodowe w Krakowie, Kraków, no. XIV-341, retains its original tassels; see Oberschleissheim 1976, no. 173, and Zygulski 1979, fig. 226.
6. Born 1942, figs. 4, 6–9, 12 (Metropolitan Museum acc. nos. 36.25.2422–.2424, cats. 118 and 117, and acc. no. 36.25.2419, respectively).

Fig. 41. *Magic Camel.* India, early 17th century. Ink, watercolor, and gold on paper. Museum für Islamische Kunst, Staatliche Museen zu Berlin

been studied in detail by Wolfgang Born, who observed that they seemed to combine elements ultimately derived from the art of the Steppes with Mughal naturalism and that the inspiration for the motifs is found in miniature paintings of the hunt as well as scenes of fantastic animals that were a popular theme in imperial Mughal ateliers (fig. 41).[1] The creation of larger forms from an amalgam of smaller figures occurs in Iranian art of the fourteenth century; however, the combination of naturalism and composite animal forms is generally associated with the Deccan.[2] The naturalism of the carving was usually heightened by the use of color, which today tends to be preserved only in some of the carved recesses of the primers, the paint having been rubbed off during handling. Often the animals' eyes are inlaid with a translucent resin or with amber.

A number of these ivory flasks were exported to Europe and are recorded in seventeenth-century inventories. The earliest

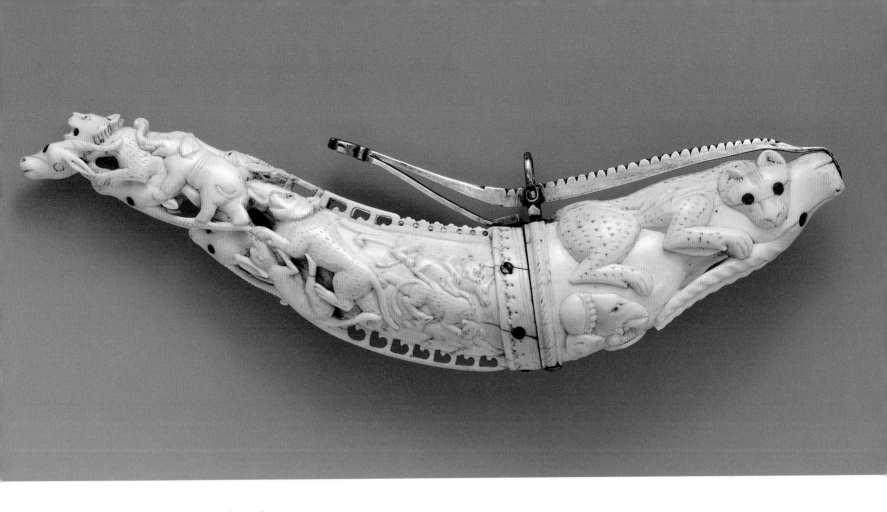

118 · Priming Flask

India, Mughal period, second half of the 17th century

Ivory, silver, polychromy, resin

Length 10¼ in. (26 cm); weight 9 oz. (251 g)

Bequest of George C. Stone, 1935

36.25.2420

DESCRIPTION: The ivory flask, oval in section tapering toward each end, is formed in two parts joined by transverse brass screws (later replacements for the original ivory pins), with raised roped and trefoil moldings at the join. The nozzle section is carved in the round with the head and shoulders of an antelope, its mouth pierced for pouring, on top of which is a cheetah with its jaws around the antelope's neck. At the base on each side is an elephant head. The rear segment beginning at the join is carved in low relief on each side with vignettes of animal hunts, in higher relief toward the end with felines (lions or cheetahs), monkeys, elephants, and a long-snouted Indian crocodile, and on the underside at the tip with heads of gazelles, a cheetah, and a water buffalo. The figures nearest the end are carved in the round with piercings between them. The upper and lower edges of the rear section are carved and pierced with trefoil and curled designs. The animals in both sections have inset amber-colored resin eyes and retain traces of red polychromy in their ears. The spring-operated stopper is of silver alloy and has a suspension loop.

This flask is almost identical to a primer in the Khalili Collection, London, and to at least half a dozen more in public and private collections,[1] indicating that the design was a popular one. A very well-preserved example in the Badisches Landesmuseum, Karlsruhe, retains traces of both red and green coloring.[2] The pierced edges along the midsections of

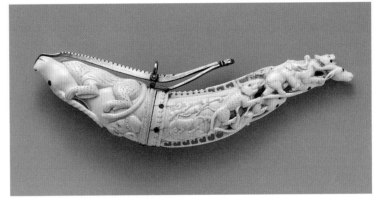

these flasks may once have served to secure decorative tassels like those still attached to the Kraków example, noted in cat. 117, reputedly captured from the Turks at Vienna in 1683.[3]

For a further discussion of this type of priming flask, see cat. 117.

PROVENANCE: C. O. von Kienbusch, New York; George Cameron Stone, New York.

REFERENCES: Stone 1934, p. 516, fig. 660, no. 4; Born 1942, p. 108, fig. 8.

NOTES

1. For the Khalili flask, see Alexander 1992, p. 182, no. 115; for an incomplete list of comparable examples in public collections, see Petrasch et al. 1991, p. 393. A very similar primer in the Museo degli Argenti, Florence, no. Bg. M1202, can be documented in Medici inventories to the second half of the seventeenth century; see Florence 2002, pp. 24, 91, no. 70.

2. Badisches Landesmuseum, Karlsruhe, no. G 729; see Petrasch et al. 1991, no. 324.

3. The flask is in the Muzeum Narodowe w Krakowie, Kraków, no. XIV-341; see Oberschleissheim 1976, no. 173, and Zygulski 1979, fig. 226.

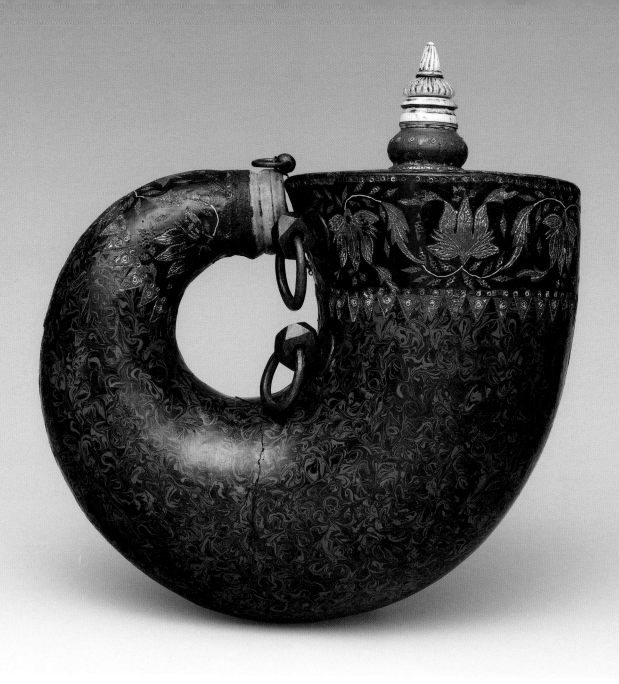

119 · Powder Flask

India, possibly Deccan, 17th century
Horn, lacquer, ivory, bone, gold, silvered copper, iron, paint
Length 7¾ in. (19.7 cm); weight 1 lb. 4 oz. (576 g)
Purchase, Arthur Ochs Sulzberger Gift, 2009
2009.469

DESCRIPTION: The deeply curved body of horn is lacquered overall, the principal surfaces marbled in blue and black. Wide bands around the ends are incised and punched with gilt foliate designs on a black lacquered ground, the ornament consisting of an undulating leafy tendril issuing lotuslike flowers facing in opposite directions. The bands are framed by a narrow filet punched with gold circles on a red ground, the lower edge of each band bordered by a row of gilt triangles, each punched with a circle. A narrow band extends around the bottom edge of the flask and is incised and gilt with alternating rosettes and leaves, some of the rosettes with red centers, framed by gold filets. The outer face is further decorated with incised-and-gilt lotus flowers and tendrils issuing from either end and converging toward the center. The narrow end is capped with a turned plug of yellowed horn or bone. The wide end has a flat cap incised with a checkerboard pattern in gold and black overlaid with four gilt lotus flowers and leaves; in the center is a turned

baluster-shaped nozzle of ivory, the base stamped with gold circles on a blue-painted ground, the upper section left white and highlighted with red bands. The pointed ivory cap for the nozzle is fluted and highlighted in red and black; the interior of the cap and nozzle are painted red. The flask is fitted with two large iron carrying rings on faceted mounts attached to the inner face near the wide end; there is also a smaller iron ring at the flask's narrow end that anchors a chain connected to the nozzle cap to prevent the cap's loss; the chain, consisting of links and bars of silvered copper alloy, is a later addition.

The earliest datable Indian example of a powder flask of this type can be seen in a miniature painting from the *Akbarnama* attributed to about 1590–95.[1] The painting represents the Mughal emperor Akbar shooting the Rajput leader Jaimal. In the center of the lower section of the painting, a warrior holding a long orange matchlock rifle has attached to his belt a powder flask with a wide top and a strongly upcurved tip. Dozens of powder flasks of this type, with varying degrees of curvature, are represented in the

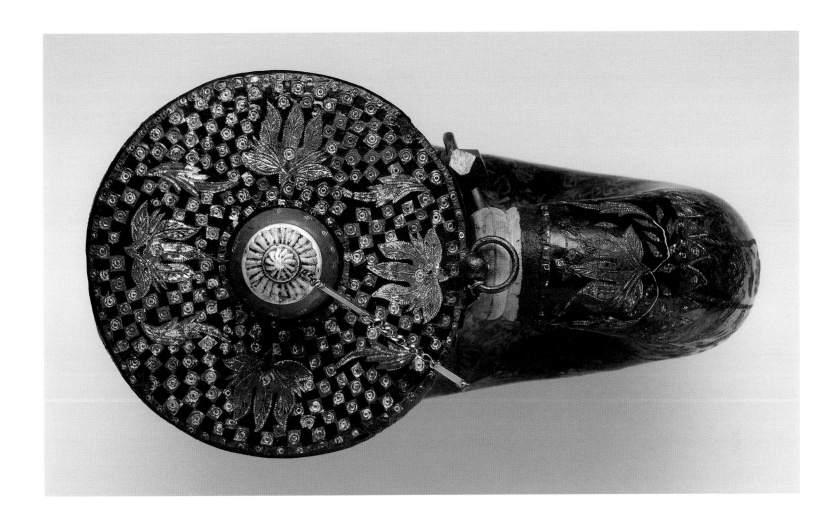

miniature paintings of the *Padshahnama* in the Royal Library at Windsor Castle.[2]

Most of these flasks were fashioned from water buffalo horn that was soaked—probably in water—to render it flexible and then bent to form the required shape. While it is possible that the idea of bending the horn in this way was to imitate the shape of a nautilus shell, none of the actual nautilus-shell powder flasks are as early in date as those formed from buffalo horn, leaving this prototype possibility purely hypothetical.

The Museum's flask is of rare beauty and remarkably well preserved.[3] It was certainly made in India, but exactly where and when is not known. Although lotus leaves such as those that adorn the flask appear in Mughal art, the decoration here is not typical—especially such features as the featherlike flower resembling the tail of a peacock on the front. Throughout, the flower forms are studded with small circles with tiny globules at their centers. While there seem to be no exact parallels to this, the closest comparison is with studding on Deccani or Gujarati caskets of the sixteenth and seventeenth centuries.[4] Circles also decorate the top of the powder horn, but these are arranged in square blocks and again can be compared to similar arrangements on Gujarati caskets.[5] The allover blue-and black marbling, however, is without precedent, and it should be noted that this technique was widely practiced in India and especially in the Deccan. The location of the workshop responsible for the Museum's flask remains uncertain, but a Deccani origin is perhaps the most probable.

PROVENANCE: Hermann Historica, Munich, October 8, 2009.

REFERENCE: Hermann Historica, Munich 2009, lot 433.

NOTES

1. Victoria and Albert Museum, London, no. IS.2-1896 68/117; see Stronge 2002, p. 74, pl. 48.
2. The Windsor examples include fol. 51A, datable to ca. 1640 (New Delhi and other cities 1997–98, p. 40, no. 11); fol. 72B (ibid., p. 47, no. 14); fol. 174A, ca. 1637 (ibid., p. 89, no. 35); fol. 204B, ca. 1650 (ibid., p. 99, no. 40); fol. 92B, ca. 1633 (ibid., p. 49, no. 15, fig. 52 [detail]).
3. An almost identical flask in the Bharat Kala Bhavan, Varanasi (Uttar Pradesh), was probably decorated by the same artist who embellished the Museum's example; see Pant and Agrawal 1995, p. 100, no. 103.
4. See, for example, a Gujarati casket of the sixteenth century now in the Monasterio de las Descalzas Reales, Madrid; see Madrid 2003, p. 137, pl. VII.4.
5. See London 2009, no. 11.

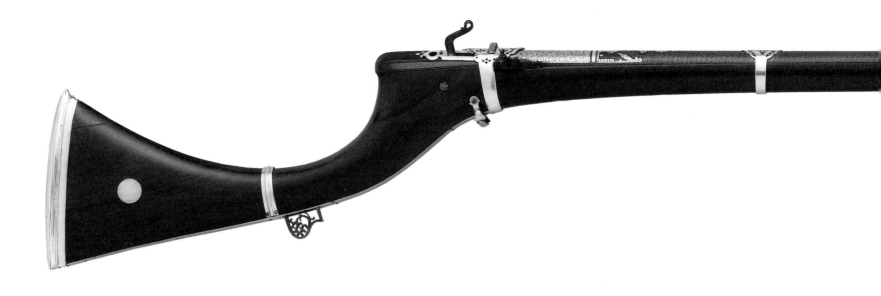

120 · Matchlock Rifle

India, Sind, second quarter of the 19th century
Steel, wood, silver, gold, copper alloy
Length 60 in. (152.4 cm); barrel 44⅜ in. (112.6 cm); caliber .53 in.
(13 mm); weight 7 lbs. 4 oz. (3,291 g)
Bequest of George C. Stone, 1935
36.25.2141

DESCRIPTION: The round barrel of pattern-welded steel, rifled with eight grooves,
is divided into three stages by transverse gold-damascened moldings. The short
breech section is damascened overall in gold, with a dense floral pattern cut through
the gold, and framed by a border with a leaf-and-petal scroll; forged on to the outer
side is a shaped iron pan having a pivoted, domed pan cover with baluster finial.
The barrel tang is damascened in gold with flowers and an Arabic inscription (a).
The long middle section has a raised sighting rib down the center and is chiseled in
low relief at each end with gold-damascened panels of flowers and leaves and with a
square medallion containing an Arabic inscription (b). The muzzle end, decorated
like the breech with flowers reserved against a gold ground, has a slightly belled
muzzle chiseled in relief with leaves and a copper bead front sight; the edge of the
muzzle is also damascened in gold with eight sprays of leaves. The matchlock mech-
anism consists of a plate trigger of steel, of recurved shape pierced with foliate

scrolls, and a match holder, the jaws of which are formed as an openwork, turned-
back tendril. The stock of reddish brown wood has a deeply bowed neck ending in a
wide, flaring, triangular butt. The top of the stock behind the barrel is incised with a
series of parallel grooves converging at the rear. The mounts are of silver and consist
of a butt plate with simple raised moldings; a flat circular medallion set into the
center of the butt on each side; a narrow molded band around the neck; a flat band
along the underside of the butt end, through which the trigger projects; the shaped
surround for the match holder, which is also pierced with a circular hole (into which
the burning taper was stubbed out); a fitting at the end of the forestock; five barrel
bands pierced with foliate scrolls, the rearmost band fitting over the rear sight, the
second from the muzzle having a sling swivel for a shoulder strap attached below;
and a rear sling swivel attached through the stock in front of the trigger. There is an
iron ramrod with a shaped and flattened tip, the fore-end damascened with gold
stripes.

INSCRIPTIONS:

a. (On the barrel tang)

سركار مير محمد نصير خان تالپر

Sarkar Mir Muhammad Nasir Khan Talpur.

b. (On the barrel midsection)

يا علي مدد

O 'Ali, help!

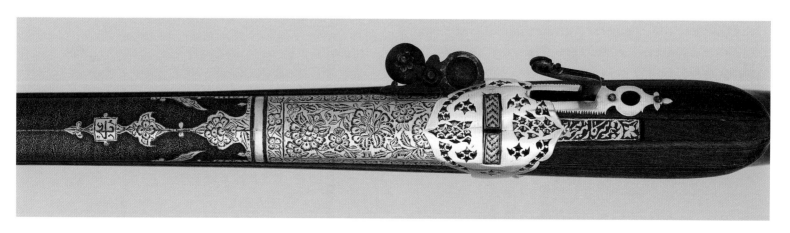

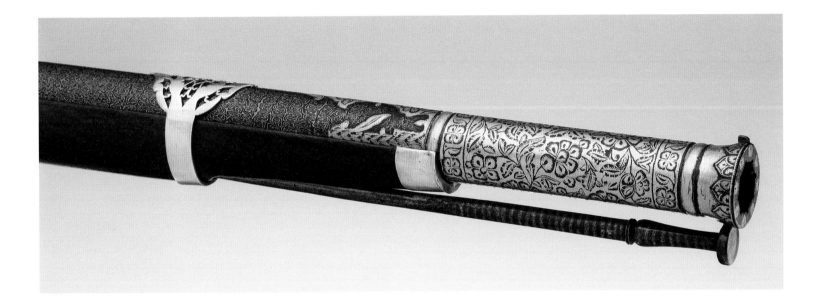

Guns of this distinctive shape, with the neck of the stock curving deeply downward then turning up to a wide, flaring triangular butt of flattened oval section, are characteristic of firearms made in Afghanistan and the adjacent Sind region in northwest India (now Pakistan).

The inscription on the barrel identifies the gun as having belonged to a member of the ruling Talpur dynasty of Sind. The Talpurs were a Baluchi tribe that came to power in Sind in 1783 and ruled until 1843, when Murad 'Ali Khan Talpur was deposed by the British, who were eager to open up a new path for their armies to enter Afghanistan. After the defeat of the Talpurs at the battle of Dubbo in 1843, Sind was annexed to British India. It is probable that at this time their armory was dispersed and weapons and armor found their way into European collections.[1] The gun's owner, Sarkar Mir Muhammad Nasir Khan Talpur, was a member of the ruling Talpur dynasty and died in 1845 in British custody.[2]

Three very similar Sind rifles are in the Khalili Collection, London.[3] Like the Museum's example, all of these have barrels with floral decoration reserved against a gold ground. The most elaborately decorated of the Khalili guns was also made for Sarkar Mir Muhammad Nasir Khan Talpur.[4] Another rifle with the inscription "Sarkar Mir Muhammad" on the barrel was formerly in the Figiel collection.[5] A rifle, perhaps from the same workshop, is in the Historisches Museum, Bern.[6]

PROVENANCE: George Cameron Stone, New York.

REFERENCE: Stone 1934, p. 264, fig. 327, no. 5.

NOTES
1. See also cat. 16.
2. The Talpurs were important patrons of architecture and of the decorative arts; see, especially, Karachi 1999.
3. Alexander 1992, pp. 202–5, nos. 136–38.
4. Ibid., p. 202, no. 137.
5. Figiel 1991, pp. 120–21, no. GI, ill.; its present whereabouts are unknown.
6. See Zeller and Rohrer 1955, pp. 403–4, no. 490, pls. CVI, CVII. The decoration on the barrel, however, includes a rectangle containing the words "ya 'Ali," which is almost exactly the same as that on the Museum's example.

121 · Flintlock Rifle

India, Sind, second quarter of the 19th century
Steel, wood, copper alloy, enamel, gold, textile
Length 58⅞ in. (149.5 cm); barrel 42¾ in. (108.7 cm); caliber .56 in.
(14 mm); weight 9 lbs. 11 oz. (4,393 g)
Bequest of George C. Stone, 1935
36.25.2152

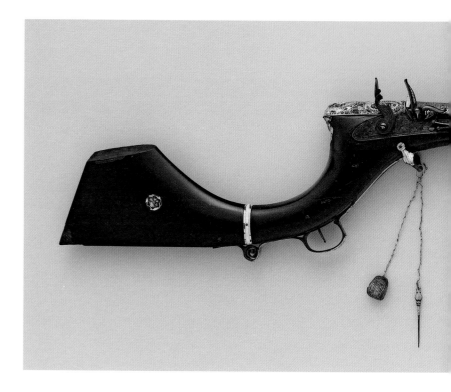

DESCRIPTION: The round barrel of pattern-welded steel (the surface deeply etched to bring out the spiral-twist design), rifled with eight grooves, is divided into three stages by gold-damascened transverse moldings. The breech segment has a slight median ridge and is damascened in gold with a band of repeating floral motifs along the edges; the edges of the slotted rear sight, breech tang, and the forward molding are gilt. The long middle section has a flat sighting rib extending down the center and is damascened in gold at each end with shaped medallions enclosing flowers and, toward the breech, an Arabic inscription (a). The muzzle is shaped as a stylized tiger head, engraved with fur and S-shaped strips, and is gilt overall; the eyes are set with red glass, the ears with green glass. Inset at the forehead is a copper blade front sight (a later replacement). The English flintlock has a friction-reducing roller between the steel and its spring, the surfaces blued and engraved with foliate scrolls within a notched border. The upper part of the cock, including the jaws, has broken off. The outer face of the steel is inlaid with gold leaves, the pan retains traces of its former gilding, and the screw head for the cock pivot is also gilt with leaves. Inside the lock plate are the stamped (and slightly misstruck) initials *H. M.* (b). The stock of dark wood curves sharply downward before the flared fishtail butt, which has lost its separately applied butt end, the entire top section, and its mounts. The remaining mounts are of enameled gold with floral designs in various shades of opaque red, pink, blue, white, and yellow, as well as translucent green, and constitute a large U-shaped mount surrounding the barrel tang at the top of the stock; a narrow band around the neck; a circular rosette set into the center of the butt, one on each side; and four barrel bands. The second barrel band from the rear has a pierced faceted stud that formerly secured a sling swivel for the shoulder strap; a corresponding sling swivel is attached to the underside of the stock beneath the lock. The small, elliptical side plate, the trigger and trigger guard, and the sling swivel are all of gilt iron; the iron ramrod has a gilt fore-end. Attached to the rear sling swivel by a gold chain is a gilt-iron prick to clean the vent and a small pad covered with woven fabric; the prick was formerly sheathed in a tubular mount, now missing, that was attached to the neck of the stock behind the lock and for which two nail holes remain.

INSCRIPTIONS:
a. (On the barrel midsection)

<div dir="rtl">یا علی مدد</div>

O 'Ali, help!

b. (Inside the lock plate)
H. M.
H. M(ortimer?).

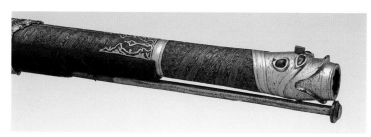

This Sind rifle differs from the previous matchlock example, cat. 120, in its incorporation of an English flintlock mechanism and its richly enameled gold mounts.

According to a nineteenth-century witness, Sind guns were of superior quality, "particularly the matchlock-barrels, which are twisted in the Damascus style. The nobles and chiefs procure many from Persia and Constantinople, and these are highly prized, but nearly as good can be made in the country. They are inlaid with gold, and very highly finished. . . . The European lock is attached to the Eastern barrel: the best of Joe Manton's and Purdy's guns and rifles, of which sufficient to stock a shop have at various times been presented to the Sindhian [*sic*] chiefs by the British government, share this mutilating fate. The Sindh [*sic*] matchlock is a heavy, unwieldy arm; the stock much too light for the great weight of the barrel."[1] As this observation attests, the Mirs of Sind had little use for English firearms apart from the locks, which were stripped from the guns and applied to locally made weapons. The lock on the Museum's rifle is one such example, having been made by an unidentified smith, H. M.

Sindi enameling on gold is found on a number of deluxe sporting guns made for the Talpur court.[2] There are also a number of edged weapons with enameled hilts and scabbards that are attributed to these workshops.[3] Taken as a group, these enamels draw on both Mughal and Iranian prototypes:[4] characteristic of Mughal motifs are the thin willowy green leaves that are included in the decoration of one of the guns in the Khalili Collection, London,[5] while Iranian enamelwork is distinguished by designs incorporating large flower heads, often closely packed together in

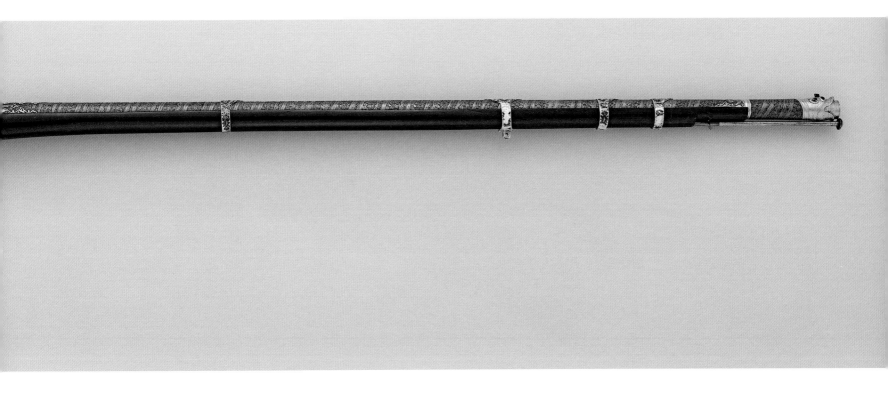

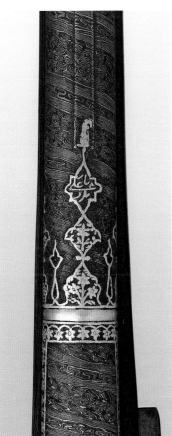
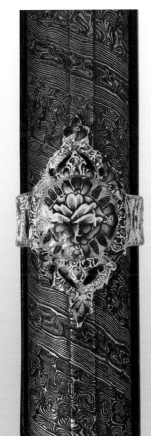

a lush brocade.[6] According to a contemporary report, two Persian goldsmiths were employed as enamelers at the Talpur court, and perhaps they or their students were responsible for many of these enameled gun mounts as well as the enameling on the sword and dagger scabbards and hilts.[7]

The enamelwork on the Museum's gun is very similar to that on one of the rifles in the Khalili Collection.[8] Although the name of the decorator is unknown, both sets of enamel are perhaps by the same master, and if not, are certainly from the same workshop.

PROVENANCE: W. O. Oldman, London; George Cameron Stone, New York.

REFERENCE: Alexander 1992, p. 202, s.v. no. 136.

NOTES

1. Postans 1843, p. 103, as quoted in Egerton 1880, p. 136. Postans was referring to two preeminent London gunmakers, Joseph Manton (1766–1835) and James Purdey (1784–1863).

2. In addition to the Museum's rifle, examples include two in the Khalili Collection, London (Alexander 1992, p. 202, nos. 136, 137), two in a European private collection (Geneva 1985, no. 332), and two illustrated in Egerton 1880, pl. IV, nos. 733, 736.

3. See, for example, an enameled and gem-set dagger and matching scabbard dedicated to Shir Muhammad Talpur, the "Lion of Sindh" (d. 1874), and a sword with enameled scabbard mounts dedicated to Murad 'Ali Khan, which were sold in 2013; see Sotheby's London 2013, lots 212, 213. See also Stronge 1988–89, p. 37, n. 26, in which Susan Stronge comments on the difference between Mughal and Sind enamelwork, and notes that the latter is closer to the Iranian style. For two enameled dagger scabbards (albeit of inferior work to that on the rifles) now in Kuwait, see London and other cities 2001–2, nos. 6.40, 6.41.

4. See Stronge 1988–89, p. 37.

5. See Alexander 1992, p. 202, no. 136.

6. Related enameling on Iranian daggers of this period can be seen on cat. 88. See also the floral designs in nineteenth-century Iranian lacquerwork, such as those on several pen boxes in the Khalili Collection, London, nos. LAQ 344, LAQ 237, LAQ 28; illustrated in Khalili, B. Robinson, and Stanley 1996–97, vol. 2, nos. 340, 341, 361, respectively.

7. Burnes 1831, p. 86.

8. The Khalili gun is signed in gold on the barrel by Hajji Mir Khan; see Alexander 1992, p. 202, no. 137. The signature must refer to the maker of the barrel and not to the decorator, as a rifle without enameled mounts but signed by the same maker was sold in 2007; see Sotheby's London 2007b, lot 255.

122 · Flintlock Blunderbuss

India, Mysore, Seringapatam, dated Mauludi-era 1222 (A.D. 1793/94)
Steel, wood, silver, gold
Length 37½ in. (95.3 cm); barrel 21⅛ in. (53.8 cm); caliber 1¾ in.
(44 mm); weight 6 lbs. 4 oz. (2,831 g)
Bequest of George C. Stone, 1935
36.25.2227

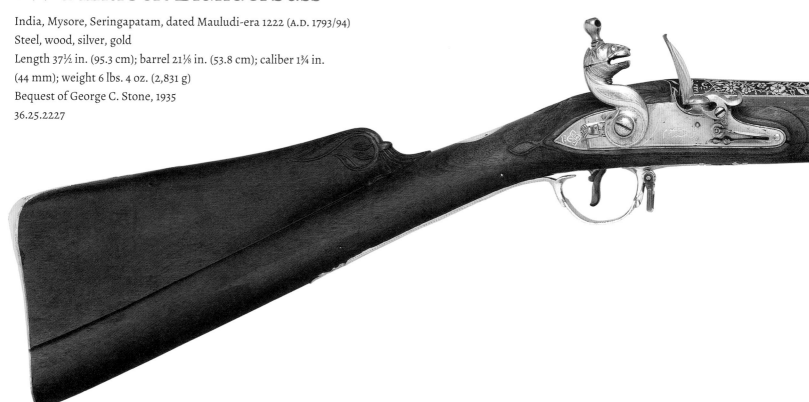

DESCRIPTION: The barrel of blued steel is octagonal at the breech then round the remainder of its length, the two stages separated by gilt transverse moldings; it ends in a flaring muzzle characteristic of blunderbusses. The surface of the barrel is inlaid with gold over its entire length. The decoration includes, on the top flat at the breech, a talismanic square containing the letters *HYDR* of the name Haidar (a) and two Persian couplets in praise of the gun (b); the right flat is inscribed with the Mauludi-era date and place of production (c), foliate scrolls, and a tiger stalking a gazelle; the left flat is similarly decorated and is inscribed with the name of the maker (d) and stamped with a gold-overlaid *bubri*-shaped control mark (e). A Persian inscription is contained in two S-shaped *bubri* above the heads of the gazelles on the right and left flats (f). The round muzzle section is inlaid overall with *bubri* and with a calligraphic tiger head consisting of a repeated and addorsed Arabic phrase in praise of 'Ali (g), and foliage near the transverse moldings. A band of gold leaves encircles the muzzle, whose edge is damascened in gold with interconnected S-shaped leaves. The vent is gold lined. The barrel is held to the stock by three transverse screws passing through lugs brazed to the barrel underside, the forward screw also serving to affix the sling swivel. The barrel tang (false breech) is blued and inlaid with gold *bubri* and has a recessed sighting groove. The flintlock, now of bright steel, retains faint traces of its former bluing. The flat-faced lock plate has beveled edges outlined in gold and is inscribed in gold with the place of production and the maker's name below the pan (h), and with a talismanic square and the date on the recessed tail (i). The cock, which has a sliding safety, is shaped as a *bubri*, its jaws as a tiger head, and is gold inlaid. The frizzen is inlaid with gold *bubri* and works on a roller fitted to the exterior spring; the pan is gold lined and has a flash guard. The stock of walnut is carved with stylized *bubri*-shaped tendrils at the heel of the butt, with a plantain leaf behind the barrel tang, and with *bubri*-shaped leaves along the sides of the tang. The moldings around the lock and side plate also terminate in *bubri*. The mounts of cast, chiseled, and engraved silver constitute a *bubri*-shaped side plate held by two steel screws with flat leads engraved as rosettes; an oval escutcheon with engraved border; a butt plate with engraved frames around the two securing screws, the top with a slightly raised relief of a tiger with a gazelle in its jaws; a trigger guard engraved with flowers and terminating at each end with *bubri*-shaped leaves; and three ramrod pipes. Each of the mounts is struck with a *bubri*-shaped control mark (struck twice on the trigger guard). The trigger assembly, two sling swivels, and ramrod are of blued steel; the ramrod is pierced with a hole below the head and is threaded at the end for the attachment of cleaning tools.

INSCRIPTIONS:
a. (On the top barrel flat)

ح ى د ر

HYDR.

b. (On the top barrel flat)

تفنگ بی نظیر خسرو هند که باشد برق سوزان ثانی او
تواند سر نوشت خصم بر داشت هدف گردد اگر پیشانی او

The matchless gun of the Emperor of India,
To whom the flashing lightning is second,
Can uproot the destiny of the enemy,
If his forehead becomes its target.

c. (On the right barrel flat)

پتن
سنة ۲۲۲۱

Patan (Seringapatam). Year 1222 (A.D. 1793/94).

d. (On the left barrel flat)

سید معصوم

(Made by) Sayyid Ma'sum

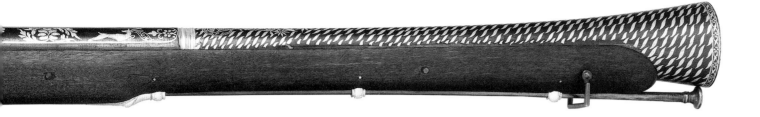

e. (On the left barrel flat)

Haidar.

حيدر

f. (On the right and left barrel flats)

The royal factory.

كارخانه / حضور

g. (On the round muzzle section, in the calligraphic tiger head)

The conquering lion of God.

اسد الله الغالب

h. (On the lock plate below the priming pan)

Patan (Seringapatam). (Made by) Sayyid Ma'sum.

پتن سيد معصوم

i. (At the tail of the lock plate, behind the cock)

HYDR. Year 1222 (A.D. 1793/94).

ح ی د ر
سنة ١٢٢٢

The gun and the example that follows, cat. 123, were made in Seringapatam, the capital of Tipu Sultan of Mysore (1750–1799; r. from 1782). Tipu (fig. 43) was the son of the Haidar 'Ali (1722–1782), a soldier who had served the maharaja of Mysore and whom he eventually deposed to create a Muslim state within largely Hindu southern India. Haidar and Tipu sought to limit British influence in India and fought four wars, between 1767 and 1799, against them and their Indian allies. Finally, the British besieged Seringapatam in 1799, killed Tipu in battle, took the city, and carried off his armory as booty. It is undoubtedly from this source that these two guns come.[1]

Tipu created for himself a personal iconography associated with the tiger. His father's name, Haidar, means (in Arabic) "lion."[2] In India the same word (*sher*) is used for both lion and tiger; consequently, for Tipu there was no contradiction in this conflation of the two animals. Tipu seems to have adopted the lion/tiger as his symbol not only in deference to his father and to 'Ali (the lion of God) but also because of the animal's strength, speed, and ferocity. He called himself the "Tiger of Mysore," and the animal features prominently on arms and armor made for him. Many pieces are decorated with stylized tiger stripes, known

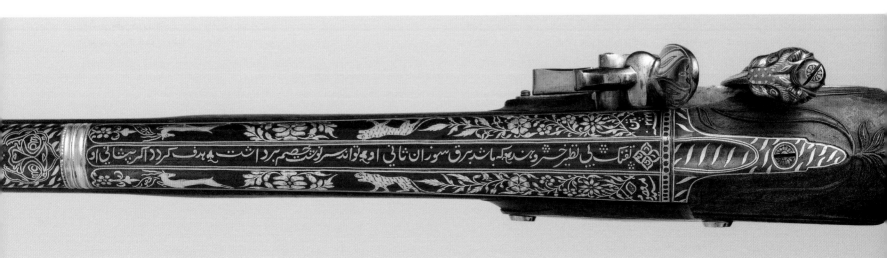

Fig. 42. Tipu's Tiger. India, Mysore, ca. 1793. Carved and painted wood with internal mechanism of brass and iron. Victoria and Albert Museum, London (IS 2545)

Fig. 43. *Tipu Sultan*, India, Mysore, ca. 1790. Opaque watercolor on paper. Victoria and Albert Museum, London (IS 266-1952)

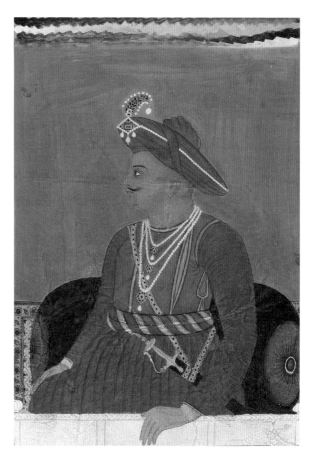

as *bubri*, and it became a motif used on virtually everything associated with him; he even outfitted his palace guard with uniforms and weapons decorated with *bubri*. He seems to have regarded this motif as a potent symbol of victory; in 1790 he had a large organ constructed in the shape of a mechanical tiger that when played devoured a prostrate European (fig. 42).[3]

In the fifth year of his reign (1786/87) Tipu abandoned the lunar calendar used in the Islamic world, which is based on the hijra of the Prophet. In its place he substituted a solar calendar that began with the Prophet's birth date. (Tipu regarded the sun as one of his symbols.) Thus, unlike the dates found on most Islamic weapons, those on Tipu's arms must be converted from this new Mauludi-era calendar into the equivalent Christian-era dates. In addition, the Mauludi-era dates on these weapons were written in reverse order (in the present case, 2221 for 1222).

The Museum's two blunderbusses correspond exactly to the characteristics of Tipu's firearms as distinguished by Robin Wigington.[4] Especially typical is the repetition of the *bubri*, not only in the applied decoration but also in the shape of the lock elements, mounts, and control marks. The barrels are noteworthy for the very fine quality of gold ornament, invariably inlaid flush on a blued-steel surface, and for the presence of the maker's name, the date, and the place of manufacture. Other barrel markings usually include the Arabic numeral *313* in Urdu and the Hindi *tin terah*, a curse meaning "destroyed"; the talismanic square with four compartments containing the Arabic letters *HYDR* (for Haidar), which combines the *buduh* symbol and the badge of the East India Company;[5] control marks like European ordnance markings, containing the name Haidar in Arabic in a *bubri*-shaped stamp, or the letter *H* in Arabic within a stamp of varying shapes; and a calligraphic tiger head formed in mirror image and reading "assad

allah al-ghalib" (the conquering lion of God). The control marks are found not only on the barrel but also on the locks, the silver mounts, and occasionally even on the wood stocks.

Tipu's guns demonstrate both his love for fine arms and his knowledge of the most advanced European design and technology. He established at Seringapatam eleven armories for the making and finishing of arms and, like his father, employed a number of Europeans among his craftsmen. The flintlock ignition system he adopted for his firearms was copied after British or French models and was a decisive departure from the traditional Indian matchlock. The use of friction-reducing rollers between the frizzen and its spring, as well as sliding safeties to prevent accidental discharge, reflects the most up-to-date features found on London-made firearms of the period. The blunderbuss, a shotgun distinguished by its short barrel with flaring muzzle (which facilitated loading and, as was then believed, provided a wider dispersal of shot), seems to have been a favorite weapon, and one gold-mounted example, now at Windsor Castle, was taken from Tipu's bedchamber at the fall of Seringapatam.[6]

The Museum's gun was made by Sayyid Ma'sum, who signed at least eleven of the forty known Tipu firearms.[7] The barrel decoration, with a tiger stalking a gazelle, recurs on four other barrels, and the Persian verses praising the gun, found on the top flat, are among the most common of several found on Tipu's guns (see also cat. 123).[8] The excellent condition of the gun, in particular the deep bluing of the barrel, is noteworthy.

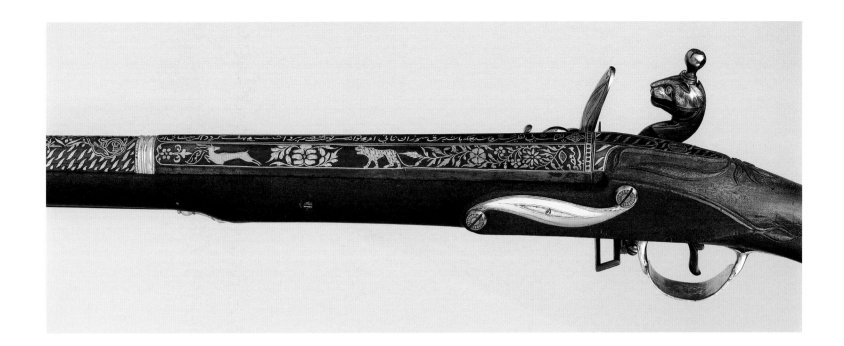

PROVENANCE: Sir Alexander Allan; by descent to Alexander Allan Webbe; his posthumous sale, Christie, Manson and Woods, London, April 23, 1914, lot 51; W. O. Oldman, London; George Cameron Stone, New York.

REFERENCES: Christie, Manson and Woods, London 1914, lot 51; Stone 1934, p. 154, fig. 196; Grancsay 1937b, p. 171; Grancsay 1986, p. 183; London 1990, p. 57, ill.; Wigington 1992, no. 16.

NOTES

1. According to the donor's records, this gun was formerly the property of Alexander Allan (ca. 1764–1820), a member of the British East India Company from 1780 and from 1814 one of its directors. He served as deputy quartermaster general during the Fourth Mysore War of 1799. He was appointed to carry the flag of truce into the palace following the fall of Seringapatam to the British and to negotiate with Tipu. He was with his commander, General Sir David Baird, when Tipu's body was found afterward.

2. The term became an epithet for 'Ali, the son-in-law of the Prophet, who was sometimes referred to as Haidar Allah (the lion of God).

3. Victoria and Albert Museum, London, no. 2545(IS); see London 1990, especially p. 6. For further discussion and related objects from Tipu's armory, see Miller 1956; Miller 1957; Archer, Powell, and R. Skelton 1987, p. 47, no. 34; and Alexander 1992, pp. 184, 190, nos. 117, 123.

4. See Wigington 1992, pp. 13–35. Wigington formed an important collection of Tipu's weapons; see Sotheby's London 2005.

5. Wigington 1992, p. 14.

6. Ibid., pp. 85–86, no. 13.

7. Ibid., nos. 1, 4–8, 13, 14, 16 (the present example), 22, 24.

8. For those guns bearing the same tiger-and-gazelle motif, see ibid., nos. 8, 9, 22, 39; for those bearing the same Persian verse as that on the Museum's weapon, see ibid., nos. 4–6, 9, 10, 13, 14, 18, 19 (cat. 123), 22, 23, 38.

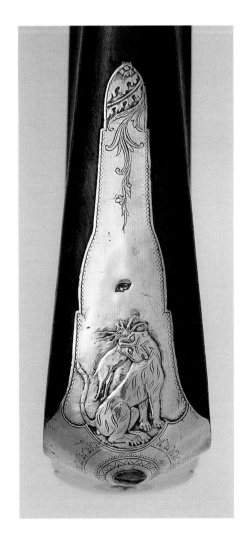

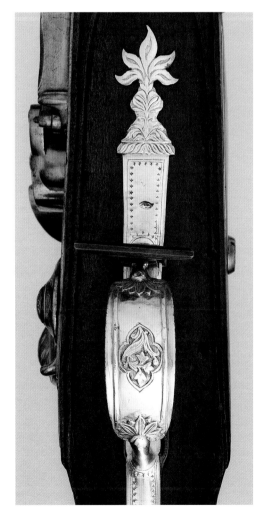

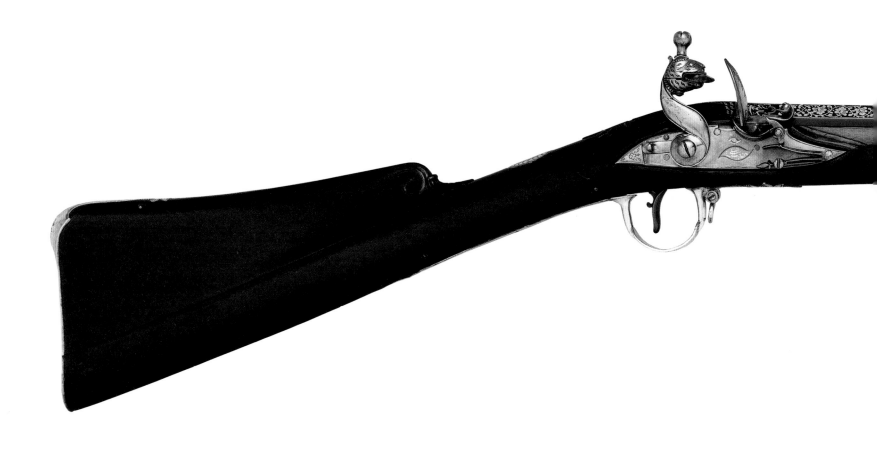

123 · Flintlock Blunderbuss

India, Mysore, Seringapatam, dated Mauludi-era 1225
(A.D. 1796/97)
Steel, wood, silver, gold, copper alloy
Length 40⅜ in. (102.5 cm); barrel 23¾ in. (60.2 cm); caliber 1¾ in.
(44 mm); weight 6 lbs. (2,741 g)
Gift of Christian A. Zabriskie, 1936
36.149.2

DESCRIPTION: The barrel of blued steel (reblued) is octagonal at the breech then round the remainder of its length, the two sections separated by a gilt transverse molding, and ends in a wide, flaring muzzle. The breech is profusely inlaid in gold and silver, the silver outlining the flats and forming cartouches containing gold floral scrolls, stylized cypress trees, S-shaped *bubri*, and Arabic and Persian inscriptions. The top flat is struck at the base with a gold-overlaid, *bubri*-shaped control mark (a) and is inlaid in front of it with the Haidar talismanic square (b); two Persian couplets praising the gun are divided among four cartouches along the remainder of its length (c). The side flats are inscribed at the breech with the place of manufacture (d) and with the maker's name and the year of manufacture according to the cyclical calendar (e). On the round barrel section in front of the molding are gold inlays of a roselike flower rising from a base containing the Mauludi-era date 1225 (f) in reverse, four leaves containing the names of the Four Rightly Guided Caliphs (g), and a blossom in the form of a calligraphic tiger head made of an addorsed inscription (h). Above the flower is a lobed medallion containing an inscription (i) and a cypress tree. A narrow band of gold foliate scrolls within a silver border encircles the muzzle. The vent is gold lined. On the false breech the *bubri*-shaped barrel tang is inlaid in gold with *bubri*, the Arabic number *313*, and an inscription (j). The underside of the barrel is struck with a feather-shaped mark at the breech.

The flintlock, now of bright steel, retains faint traces of its former bluing. The flat-faced lock plate, cock, steel, and pan are *bubri* shaped, the cock's jaws formed as a tiger head. The steel is engraved on its face with a fish, and its curved spur forms a tiger head; the steel's pan cover, also *bubri* shaped, is recessed and forms a waterproof seal with the pan. The face of the lock plate is stamped with a gold-covered, *bubri*-shaped control mark (k), below which is a gold-inlaid, *bubri*-shaped cartouche containing the name of the maker and the place of manufacture (l); the recessed tail of the lock plate is inlaid in gold and silver with a Haidar talismanic square (m) and an incomplete date (122) in reverse (n). There is a sliding safety behind the cock. The inside of the lock plate is incised with an inscription (see commentary).

The full-length stock of walnut is carved with stylized *bubri*-shaped tendrils at the heel of the butt and with a plantain at the base of the barrel tang, with two *bubri* flanking the tang. The mounts of cast, chiseled, and engraved silver constitute a *bubri*-shaped side plate; an oval escutcheon with engraved border; a butt plate with plantain-shaped finial at the comb, a calligraphic tiger head engraved at the heel (o), and circular frames with radiating *bubri* around the two screw heads; a trigger guard with a plantain-shaped forward finial and a *bubri*-shaped rear finial, the bow engraved with panels and a central rosette, with a sling swivel of silvered brass in front of the bow; and three round ramrod pipes, the rear one with a pointed extension. All of the mounts, except for the two forward pipes, are stamped with a *bubri*-shaped control mark (p; struck three times on the trigger guard); the interiors of all the mounts are incised with an inscription (see commentary). The forestock is fitted with a silvered brass sling swivel that is secured by a transverse screw that also secures the front end of the barrel. The trigger assembly and two transverse barrel slides, by which the barrel is attached to the stock, are of blued steel. The steel ramrod is threaded at the end for the attachment of cleaning tools and terminates with a pierced baluster and a flat head incised with an inscription (see commentary).

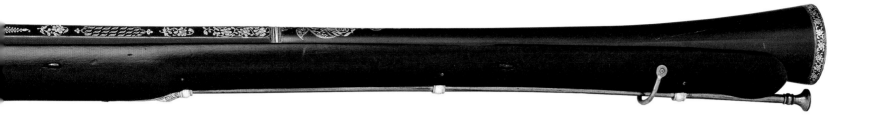

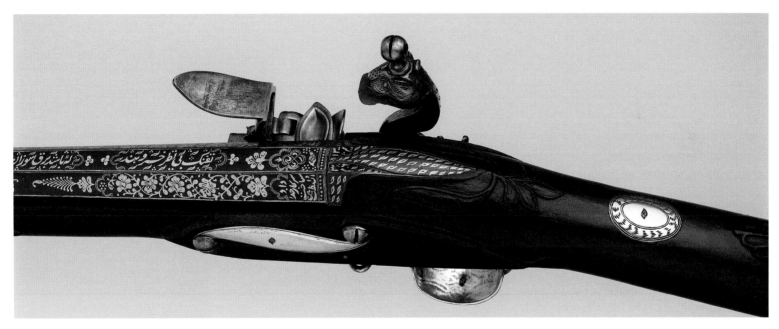

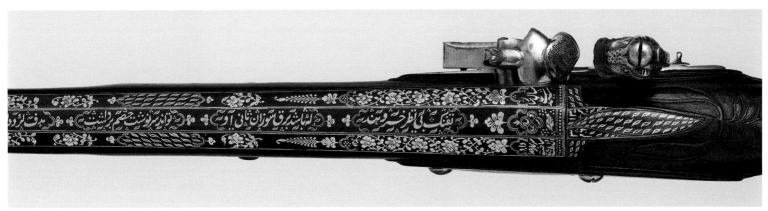

INSCRIPTIONS:

a. (On the top barrel flat)

حیدر

Haidar.

b. (On the top barrel flat)

ح ی د ر

HYDR.

c. (On the top barrel flat)

که باشد برق سوزان ثانی او تفنگ بی نظیر خسرو هند

هدف گردد اگر پیشانی او تواند سر نوشت خصم بر داشت

The matchless gun of the Emperor of India,
To whom the flashing lightning is second,
Can uproot the destiny of the enemy,
If his forehead becomes its target.

d. (On the left barrel flat)

سرکار خداداد ساخت دا[ر] السلطنت پتن

The God-given government, seat of the sultanate, Patan (Seringapatam).

e. (On the right barrel flat)

سال ساز سید علی

The year saz (cycle year 51). (Made by) Sayyid 'Ali.

f. (On the round barrel section, in the base of the flower)

سنة ۵۲۲۱

Year 1225 (A.D. 1796/97).

g. (On the round barrel section, in the four leaves of the flower)

ابو بکر عمر / عثمان علی

کارخانہ / حضور

Abu Bakr, 'Umar, 'Uthman, 'Ali.
The royal factory.

h. (On the round barrel section, in the calligraphic tiger head/flower)

اسد الله الغالب

The conquering lion of God.

i. (On the round barrel section, above the flower)

الله اکبر محمد

God is the Greatest. Muhammad.

j. (On the false breech)

۳۱۳ تیر ٦ م

313 shot 6 m.

k. (Mark on the face of the lock plate)

حیدر

Haidar.

l. (On the face of the lock plate)

پتن سید علی

Patan (Seringapatam). (Made by) Sayyid 'Ali.

m. (On the recessed tail of the lock plate)

ح ی د ر

HYDR.

n. (On the recessed tail of the lock plate)

سنة ۲۲۱

Year 122.

o. (On the butt plate, in the calligraphic tiger head)

اسد الله الغالب

The conquering lion of God.

p. (Mark on the silver mounts)

حیدر

Haidar.

This gun, generally similar to the previous blunderbuss, cat. 122, appears to be exceptional among the forty published Tipu firearms to the extent that every part is marked. The incised inscriptions found inside the lock plate, the silver mounts, and even on the tip of the ramrod, which have not been transcribed, are possibly inventory numbers, weights, or even valuations, the amounts given either in *siyaq* or Perso-Arabic numerals. Many of these contain the word *imami*. Tipu formulated all his own currency and system of weights and measures; *imami* was the name for his silver rupee.[1] The maker, Sayyid 'Ali, whose name is found on the barrel and lock, also signed two pistols and a flintlock blunderbuss previously in the Robin Wigington collection in Stratford-upon-Avon.[2] The mark beneath the barrel represents a feather known as a *jhair*, the ornament worn on the turban as a symbol of royalty.

PROVENANCE: Frank Gair Macomber, Boston.

REFERENCES: Probably Boston 1899, no. 138; American Art Association/Anderson Galleries, New York 1936, lot 223, ill.; Wigington 1992, p. 101, no. 19.

NOTES
1. The inscription inside the lock plate, for example, appears to read "20 *imami* . . .," while that on the ramrod reads "75 *imami*."
2. Wigington 1992, nos. 18, 28, 40, and Sotheby's London 2005, lots 12, 14, 47.

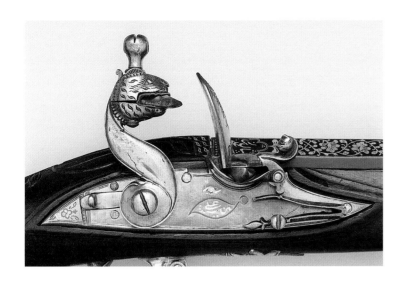

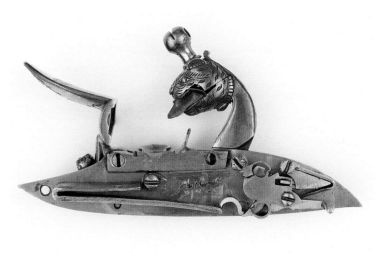

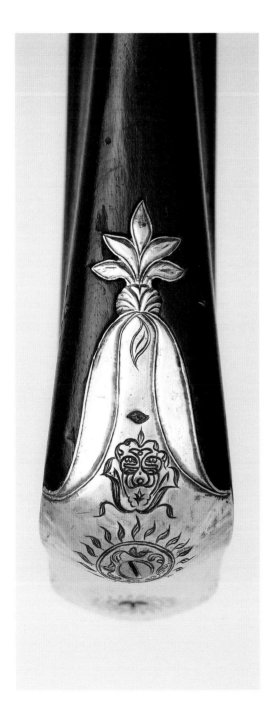

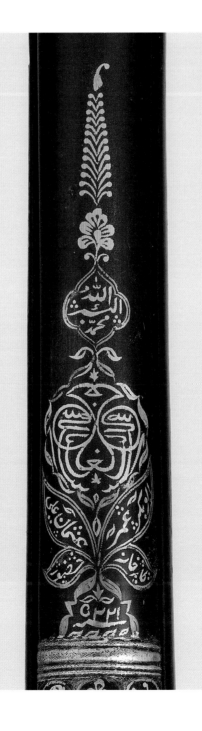

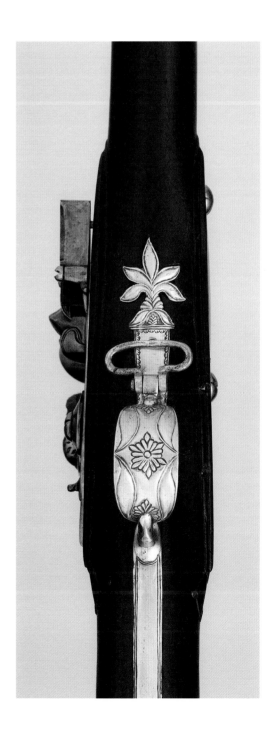

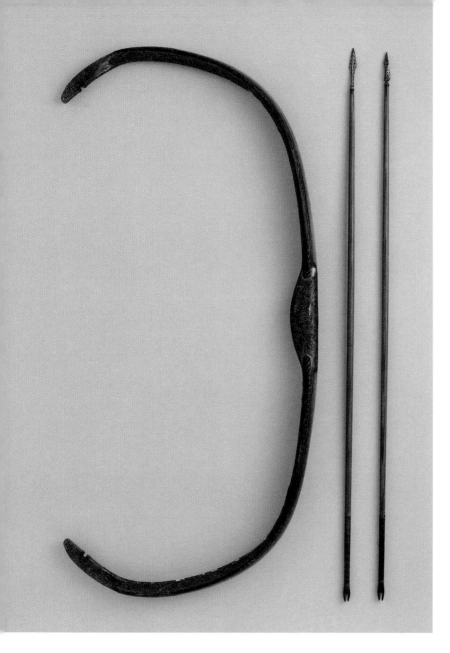

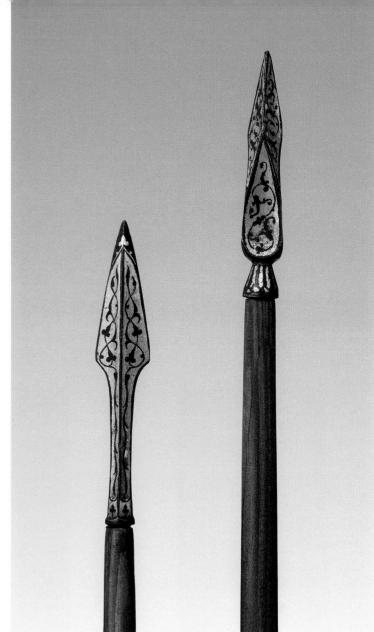

124 · Composite Bow

Turkey, Ottoman period, dated A.H. 1132 (A.D. 1719/20)
Wood, horn, sinew, paper (?), lacquer
Length 25½ in. (64.8 cm); weight 13 oz. (365 g)
Rogers Fund, 1935
35.113.1a

DESCRIPTION: The composite bow of wood, horn, and sinew is lacquered on the grip and back (outer face) of the arms with gold and red floral designs on a dark green (now almost black) ground; the slotted tips of the arms, the nocks, are lacquered red with gold foliate scrolls. The belly (inner face) is covered with translucent horn. A small cartouche incorporated into the decoration on the inner face, just below each tip, includes an Arabic inscription giving the maker's name and date. The bowstring is missing.

INSCRIPTIONS:

عمل ... ابراهيم
سنة ١١٣٢

Made by . . . Ibrahim.
Year 1132 (A.D. 1719/20).

125 · Two Arrows

Turkey or Iran, probably 16th century
Wood, textile, lacquer, steel, gold, copper alloy
Length (a) 25¾ in. (65.4 cm); (b) 26 in. (65.9 cm)
Bequest of George C. Stone, 1935
36.25.2591a, b

DESCRIPTION: The thin shafts of wood taper at each end. The nock ends are wrapped in silk thread, lacquered purple, and wound in a spiral with fine copper wire; wrappings of green silk are found at the bases of this area and just below the swelling ends of the nocks. The tips of dark steel, damascened in gold as a background to fine arabesque scrolls, are of two different shapes: one (a) has a concavely faceted head formed of two pyramidal forms one atop the other and a short conical socket; and the other (b) has a double-edged triangular-shaped head with a raised medial ridge on each side and a long faceted socket. The fletchings are missing.

There are two basic types of bows, hand bows and foot bows (crossbows). Hand bows can be classified as either simple or composite:[1] simple bows were made of a single stave, a single stave split lengthwise, or two staves split lengthwise; the construction of a composite bow is described below.[2] Foot bows, or crossbows, were frowned upon because the Prophet was said to have declared them accursed.[3] The only surviving Islamic crossbows are from Nasrid Spain.[4]

As the name implies, a composite bow (such as cat. 124) is composed of several materials, usually wood, horn, sinew, and glue. The stave has a wood core that consists of a swelling hand grip, two tapering arms that take the bend, and curved portions at the end of the arm, the nocks, that are slotted to take the loops of the bowstring. The core is veneered on each face; on the outer side (or back) there is a layer of animal sinew and glue, and on the inner side (or belly) there is a layer of horn. Bows of this type, when unstrung, have a strong reflex curve (the tips of the arms curve outward, away from the archer), and when strung the curve is reversed (fig. 44); they are thus referred to as reflex bows. The entire surface is covered and sealed with skin or leather, glued in place, and then lacquered or painted.[5] The floral design on the Museum's bow is characterized by flowers with rounded petals and leaves with serrated edges that curl at the ends. Very similar forms are found on numerous Ottoman textiles of the eighteenth century, representative of the style of the *Lala Devri*, or Tulip Period.[6] The decoration on the Museum's bow shows a strong European influence and was most probably produced in Istanbul.

This bow was acquired with an associated group of forty arrows (not illustrated), their shafts of wood fitted with small conical heads of iron or ivory and some with feathers dyed in various colors. A number of the arrows are painted with what are probably the names of the owners (Kamil Aga, Selim, al-Haji Rida, Khair al-Din Aga, Mehmet Selim, Haidar, Sadik) and numbers (119 or 92), perhaps the numbers of a Janissary *orta*, or regiment. The Janissaries, elite members of the Ottoman military, were essentially an infantry corps, and their chief weapons during the fifteenth and sixteenth centuries were the bow and arrow (they were later also noted for their use of firearms). They were organized into 196 *ortas*, and they seem to have taken great pride in the units to which they belonged. Each *orta* had its own flag, and the number of the unit was tattooed on each soldier's arm.

The Museum's collection includes more than a dozen painted composite bows of Turkish or Iranian origin. A second Turkish bow of similar type (acc. no. 35.113.2a) is signed and dated "Made by Ibrahim, 1115 (A.D. 1703/4)," and another (acc. no. 36.25.2528) is inscribed "Made by Wali, 1193 (A.D. 1779/80),"

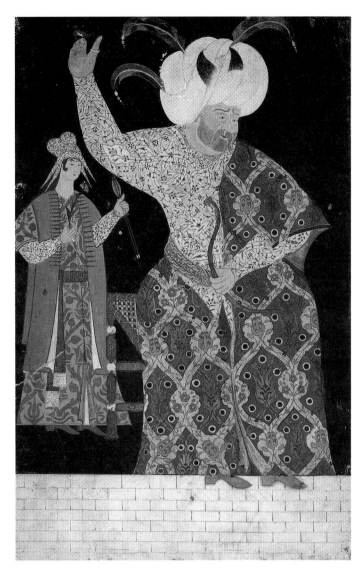

Fig. 44. *Prince Selim Practicing the Royal Sport of Archery*. By Haydar Reis (Nigari), ca. 1561–62. The painting shows a strung bow, an archer's ring on the right thumb, and a page holding two arrows. Topkapi Sarayi Museum, Istanbul (H.2134, fol. 3)

but unfortunately their finely painted staves are now badly damaged. A large group of similar bows dated between 1633/34 and 1793/94 is in the Museo Nazionale del Bargello, Florence.[7]

The damascened tips of the two arrows are decorated in a style typical of the sixteenth century; it is difficult, however, to know whether they are Ottoman or Safavid. Their finely executed decoration against a gold ground distinguishes them from all other known examples and suggests that they were made for a wealthy or important patron. They bring to mind the creations of a craftsman named Mawdud, whose arrows contained enough gold to cover the funeral costs of anyone killed by them.[8]

PROVENANCE (124): Robert W. Ehrich, New York.

Unpublished.

PROVENANCE (125): S. Haim, Constantinople; George Cameron Stone, New York.

REFERENCE: Canby 2014, p. 52, fig. 86.

NOTES

1. The Mamluks seem to have also differentiated between Arab, Persian, and Turkish types. Turkish and Persian bows were said to be similar to those of the Arabs but with longer ends before the nock, shorter arms, and were perhaps also heavier. In addition, Turkish bows were asymmetrical, with the grip below the center. Fifteenth-century accounts also record that some of the finest bows were made in Syria, including a type called "the superb" (*fahlah*). A drawing of 1438 by the Veronese artist Pisanello (Antonio Pisano, 1395–1455) probably illustrates a bow of this type; see Vickers 1978, p. 420, fig. 8. That such Mamluk objects were much sought after and prized in Europe is further evidenced by the report of Bertrandon de la Brocquière, who visited Damascus in about 1432. He purchased "a white tarquais (a sort of quiver) complete, to which hung a sword and knives; but as to the tarquais and sword, I could only buy them privately; for if those who have the administration of justice had known of it, the seller and myself would have run great risks"; see Wright 1848, p. 304.

2. It is likely that the Arabs at first used only long simple bows, such as the "bow of the Prophet" now in the Topkapı Sarayı Museum, Istanbul, and that the composite bow was introduced as a result of Persian influence. At a very early date Herodotus noticed the difference and wrote that the Arabs "carried at their right side long bows, which when unstrung bent backwards"; Herodotus 1942, 7:69.

3. Faris and Elmer 1945, pp. 10–12.

4. See Granada and New York 1992, p. 299, no. 69, for an example of the fourteenth or fifteenth century.

5. In the Middle Ages this was done with liquid sandarac; see Latham and Paterson 1970, pp. 11–16. The earliest surviving bows from the Islamic period, apparently dating from the late twelfth to thirteenth century, were illegally excavated in the citadel of Damascus during the 1980s. These are probably the earliest examples of Islamic lacquerwork. This cache, which includes medieval armor, horse equipment, and weapons, is now in the Museum of Islamic Art, Doha, Qatar; see Nicolle 2008.

6. At the time this bow was made, the Ottoman Empire was in a state of simultaneous development and decline. Under the rule of Ahmed III (r. 1703–30) strenuous efforts were being made, with French help, to modernize the empire, and the era beginning approximately in 1718, when Ahmed moved the court from Edirne to Istanbul, is known as the Tulip Period. It was characterized by a delight in flower festivals and parades, the creation of magnificent libraries, the building of French-style palaces, and even the rebuilding of the crumbling Byzantine city walls. Yet at exactly the same time, in 1718, the Ottomans signed a humiliating peace treaty at Passarowitz after a series of defeats inflicted by Austrian Prince Eugene of Savoy. Inflation was causing economic distress, and Istanbul was overcrowded with destitute Anatolian peasants and disgruntled Janissaries.

7. Florence 2002, pp. 60–65, nos. 21–36.

8. Allan 1979, p. 92, quoting the thirteenth-century sultanate scholar Fakhr-i Mudabbir.

126 · Archer's Thumb Ring

Turkey, Ottoman period, 16th–17th century
Nephrite, gold, emeralds, ruby
Height 1 in. (2.5 cm); width 1½ in. (3.7 cm)
Bequest of George C. Stone, 1935
36.25.2793

DESCRIPTION: Of typical asymmetrical form, the ring of pale greenish gray nephrite is inlaid flush in gold on the projection with split-leaf scrolls and is set on the back with three raised gold rosettes containing two emeralds (one replaced) and a ruby, the rosettes connected by raised leaf scrolls.

Rosette-shaped settings of this type are commonly found on Ottoman jeweled objects, and for this reason Ernst Grube first suggested that this ring was Turkish.[1] The fact that the object was purchased in Delhi does not necessarily contradict this attribution, as trade between Ottoman Turkey and Mughal India was extensive.

Archers' rings, which have been used since antiquity, facilitate drawing the bow and prevent injuries caused by the string.[2] Far Eastern rings are usually cylindrical, whereas those used in the Islamic world are asymmetrical, generally thickened and pointed at one end. An anonymous Mamluk author of the fifteenth century claimed that rings caused inaccuracy, but, if used, he maintained that the best material was leather, especially the skin of horses and goats.[3] The majority of surviving thumb rings are made of harder, more durable materials with smooth surfaces, among them bone, horn, ivory, hardstone such as nephrite, and various metals such as copper alloy, silver, and gold.[4]

Although most of the surviving rings are decorated examples from Mughal India and Ottoman Turkey, a few rare and beautiful examples from other periods and dynasties have been preserved.[5]

The survival of many of the Mughal and Ottoman gem-set rings may be due to the custom of wearing an archer's ring as an item of male jewelry. Its appearance on a man's hand or hanging from his belt proclaimed in a subtle yet beautiful way that the wearer was a military man proficient in fighting and hunting. This is precisely the symbolism behind the frequent depiction of rulers and warriors wearing archers' rings in Ottoman, Mughal, and Iranian miniature painting.[6]

PROVENANCE: Delhi art market; George Cameron Stone, New York.

REFERENCE: Stone 1934, p. 15, fig. 22, no. 26.

NOTES

1. Ernst Grube (Department of Arms and Armor Files, The Metropolitan Museum of Art, New York, 1967). For similar Ottoman settings, see, for example, Rogers 1987a, nos. 58, 60, 62; and Washington, D.C., Chicago, and New York 1987–88, no. 96. This last item, a nephrite archer's ring dated to the second half of the sixteenth century, is also inlaid with split-leaf scrolls like those on the Museum's example.

2. In most Asian and Middle Eastern countries, archers armed with a composite bow used the so-called Mongolian release, in which they drew the bow by hooking their thumb around the string below the arrow. This method called for some form of protection for the thumb against friction and blistering.

3. Faris and Elmer 1945, pp. 123–24. For a drawing showing how such rings are used, see *Jewellery through 7,000 Years* 1976, p. 251. The evidence of miniature painting, however, indicates that an aversion to the use of archers' rings was a minority view, as rulers and heroes are frequently shown sporting this accoutrement of military prowess; see note 6 below.

4. For an introduction to this subject, see Reid 2001. For a selection of the Museum's large collection of Islamic thumb rings, see Stone 1934, p. 15, fig. 22.

5. See also Alexander 2007 for an Ottoman ring in the National Gallery of Victoria, Australia.

6. An Ottoman miniature of about A.H. 968 (A.D. 1560) shows Süleyman I accompanied by two pages, one of whom carries his saber, while the sultan wears an archer's ring on his right thumb; see Washington, D.C., Chicago, and New York 1987–88, p. 34, fig. 10. A Mughal painting of about A.H. 1048 (A.D. 1639) presents Shah Jahan enthroned beneath a domelike parasol, with an archer's ring on his right thumb; see Williamstown and other cities 1978–79, nos. 3, 4.

Appendix A
Comments on Iconography and Decoration on Islamic Arms and Armor

David G. Alexander

Arms and armor from the Islamic world are sometimes decorated with figural imagery, such as the birds and other animals on the Museum's dagger from Afghanistan (cat. 75), the Mughal hilt carved with an animal head (cat. 83), the Indian punch dagger chiseled with hunting scenes (cat. 87), and the dragon-and-phoenix imagery on the Museum's yatagan (cat. 57). However, stylized floral designs and inscriptions are by far the most common types of decoration. The inscriptions are composed of Qur'anic passages, pious phrases, religious and mystical verses, the names of God, poetry, and talismans. The latter include *wafk*, magic squares, and *buduh*, a derivation of the magic square. In addition, many pieces, especially sword and saber blades, are inscribed with the names of their owners and makers. The following discussions give a brief introduction to a number of the most commonly used inscriptions.

RELIGIOUS INSCRIPTIONS

Among the most frequently occurring Qur'anic verses are Sura 2:255–56 (*ayat al-Kursi*, "The Throne Verse") and the first lines from Sura 48 (*al-Fath*, "The Victory"); also appearing regularly are Sura 112 (*al-Ikhlas*, "Purity"); and Sura 61:13, which proclaims an imminent victory for the faithful. Foremost among the pious phrases found on the blades is the *shahada*, or testimony of the faith: "There is no god but God, and Muhammad is the messenger of God."

Such expressions as *bismallah al rahman al rahim*, "In the name of Allah, Most Gracious, Most Merciful"; *tawakkaltu*, "I trust in God"; and *mashalla*, "Whatever God wills," can be found repeatedly. Other

religious verses commonly found include the *nadi 'Ali*, the intercessory prayer to 'Ali, "Call upon 'Ali the revealer of miracles, you will find him a comfort to you in crisis," as well as verses evoking the Last Judgment and the duty to participate in the jihad.

Sura 2:255–56 (*ayat al-Kursi*, "The Throne Verse")

Allah! There is no god But He, —the Living, the Self-subsisting, Supporter of all / No slumber can seize Him, nor sleep. His are all things in the heavens and on earth. Who is thee can intercede in His presence except as He permitteth? He knoweth what (appeareth to His creatures as) Before or After or Behind them. Nor shall they compass aught of His knowledge except as He willeth. His Throne doth extend over the heavens and the earth, and He feeleth no fatigue in guarding and preserving them, for He is the Most High, the Supreme (in glory).

The throne of God was a paramount symbol for the divinity in ancient Greece and was used in pre-Islamic times by the Hebrews to represent God's omnipotence and omnipresence. Qur'an 69:17 states that on the Day of Judgment the throne will be carried aloft by eight angels, and a vision of it was thought to be reserved for the spiritually elect.

According to a hadith recorded by the scholar and mystic al-Tirmidhi (d. ca. 892), the Prophet called this verse the lord of all the verses in the Qur'an. The theologian Ibn 'Ata' Allah (d. 1309) claimed it has a special mystical power, that it provides a unique reference to God's infinite essence, and that every other Qur'anic verse is a tributary of it.[1] He regarded it as analogous to the relationship between the Prophet and other men, saying that the Prophet, like the *ayat al-kursi*, was lord of all Adam's children, symbolized by the other Qur'anic verses.[2] The use of this verse therefore makes a definitive statement about the nature of God, creation, and divine order. When a warrior went into battle carrying arms or wearing armor inscribed with it, he could perhaps see himself as an enforcer and fighter for the divine order.

Sura 48 (*al-Fath*, "The Victory")

Verily We have granted thee a manifest Victory: That Allah may forgive thee thy faults of the past and those to follow; fulfil His favour to thee; and guide thee on the Straight Way; and that Allah may help thee with powerful help. (48:1–3)

These opening lines to Sura 48 often appear on Islamic armor and weapons. According to a hadith recorded by historian and biographer of Muhammad, Ibn Ishaq (d. 767), it was revealed to Muhammad under the following circumstances. In 628, six years after the

emigration of the Muslims to Medina and after many bloody battles, Muhammad announced that he intended to make the 'umra, pilgrimage, to Mecca. He further proclaimed that the pilgrimage was to be peaceful and set off with a large number of men and four women. The pilgrims eventually reached a place called Hudaybiya, where their advance was blocked by the Meccan cavalry. The Meccans, however, were divided about whether to attack and eventually sent out a party of negotiators. The discussion was laborious, but ultimately there was no violence and a peace treaty was agreed upon, written, and signed.

Under its terms the two sides agreed to a ten-year truce, and although the Muslims were denied immediate entry into Mecca, it was agreed that in the following year they could enter the city and pray at the Ka'ba; the sole conditions were that they stay for no more than three nights, the traditional period of hospitality, and that they carry only a rider's weapons—swords in their sheaths. At the conclusion of this treaty the Prophet shaved and cut his long hair,[3] as reflected in the final verses of the sura: "Ye shall enter the Sacred Mosque, if God wills, with minds secure, heads shaved, hair cut short, and without fear" (48:27).

The sura, as revealed at the time of Hudaybiya, is not as it might at first sound, an invocation to battle. It is rather an elegy to a victory achieved, for at this time Muhammad knew that Meccan resistance would ultimately crumble. The terrible battles of the earlier years for the very survival of the community seemed to be at an end. Ibn Ishaq summed up the situation when he wrote, "No previous victory in Islam was greater than this. There was nothing but battle when men met; but when there was an armistice and war was abolished and men met in safety and consulted together none talked about Islam intelligently without entering it. In those two years double as many or more than double as many entered Islam as ever before."[4]

"I Trust in God" (Tawakkultu)
The phrase tawakkaltu, "I trust in God," appears with great frequency, especially on sword blades. Occurring fifty-eight times in the Qur'an, it was commented on in religious texts starting at a very early period. Its meaning was clearly expressed by theologian al-Ghazali (1058–1111), who maintained that trust in God was the only rational stance for living in a world of often unfathomable perfections, and that this statement was a way of expressing in one's life the central concept of Islam, submission and obedience to the will of God.[5]

The Names of God and Muhammad's Ladder
The Beautiful Names of God (al-asma al-husna), of which there are generally considered to be ninety-nine,[6] were also inscribed repeatedly on Islamic arms and armor, particularly on sword blades.[7] The significance of one of the most highly regarded patterns of watered steel used for sword and saber blades, "Muhammad's Ladder," should also be understood as an allusion to the names of God. Their importance is stressed in Qur'an 20:8: "Allah! there is no god but He! To

Him belong the Most Beautiful Names" and is often elaborated in Islamic theology. These names occur throughout the Qur'an, and, indeed, the entire revelation may be regarded as one great, virtually endless name. Theologians and mystics speculated that God created the universe through the power of His names. According to a hadith of the Prophet recorded by the scholar al-Bukhari (810–870), "Allah has ninety-nine Names; one hundred less one; and he who memorized them all by heart will enter paradise."[8] The great power with which the names were invested made them ideal talismans for use on arms and armor to protect the warrior from harm in this world as well as renew his focus on the eternal (cats. 12, 14).

The names were often considered as steps on which the devout ascend to contemplate the divine majesty. This clarifies the meaning behind blades forged with the pattern called "Muhammad's Ladder." Many saber blades are forged with this pattern (cat. 69; see also the discussion of crucible steel, below), and they were highly prized, both for their technical virtuosity, and because of the symbolic associations of the ladder pattern.

The word ma'arij, ladder, conveys the notion of a progressive, steplike ascent, in this case a progression toward heaven and the divine. Such an ascent is regarded as the highest of mystical experiences, granted only rarely to chosen individuals, such as Jacob, Enoch, and Muhammad.[9] Tradition differs as to when Muhammad's ascent, mi'raj, occurred, but it is sometimes said to have been on the twenty-seventh night of the seventh month in the year A.D. 620. The sleeping Prophet was visited by Gabriel, purified with water from Zamzam, the river of paradise, and mounted upon a winged animal called Buraq. They then flew to Jerusalem, which became the gateway to an ascent through the seven heavens, where Muhammad met all the previous prophets and, finally, experienced the divine essence.

The mystic Sufi philosopher Ibn al-'Arabi (1165–1240) developed this theme and linked it with the names of God. He described the steps leading up to a minbar (pulpit in a mosque, placed on a wall facing Mecca) as "the ladder of the Most Beautiful Names, to climb this ladder—is to be invested with the qualities of the Names."[10]

That certain swordsmiths, or the patrons who commissioned their work, were conscious of the connection between this type of pattern and the Qur'anic verses associated with the Beautiful Names, is demonstrated by an Iranian saber blade (cat. 66) that has both a ladder pattern and an inscription from the Qur'an (59:23). Both pattern and verse relate to the names of God and to the mystical ascent to the divine.

The association of such blades with the Prophet is doubly emphasized in an example from a private collection in which the spaces between the steps are each forged with a flowering-rose form.[11] In Islamic lore it is said that during the Prophet's mi'raj a drop of sweat fell from his brow and that from this drop grew the rose. Thus to smell a rose is to inhale the sweet scent of Muhammad.[12] Almost certainly the rose form added in the center of the Dhu'l faqar on Ottoman banners is a subtle reference to the Prophet (cat. 107).

Other Religious Inscriptions

Another type of religious inscription consists of calling on God to bless the owner of an object. This takes the form of a series of good wishes, such as perpetual glory, increasing prosperity, penetrating authority, ascending good fortune, helping destiny, complete grace, perfect blessing, and so on. Inscriptions of this nature began to appear as early as the tenth century and are found on a variety of objects ranging from ceramics to metal vessels to arms and armor.[13] Other inscriptions with religious overtones include the commonly used quotation, "May the world comply with your wishes and Heaven be your friend. May the Creator of the World (be your guardian)" from the preface to the *Bustan* of the Persian poet Sa'di (ca. 1213–1292; cat. 47).

Inscriptions such as these were not specific to arms and armor, but others were expressly formulated for such a use. The most commonly used refer to, are addressed to, or praise the object on which they have been placed.[14] Typical of such verses in praise of a particular object are those on the Museum's blunderbuss, cat. 123: "The matchless gun of the emperor of India, to whom the flashing lightning is second"; and on three helmets in the Askeri Müzesi, Istanbul, made for Turkman rulers: "This helmet of grace and good fortune, a crown of power and majesty is on the head of the courageous knight."[15]

Other examples of object-specific inscriptions in the Museum's collection include an Indian shield of the eighteenth or nineteenth century, cat. 46, where the shield is equated with the "flower of victory." A dagger, cat. 90, has a hilt inscribed with a verse that plays with the idea of the dagger as a "world-seizing" weapon ("The handle of your dagger is world-seizing").

Some inscriptions (such as that on cat. 76) contain multiple allusions; in the case of this dagger, the inscriptions allude to the watering pattern on the blade, to the death of Husayn (grandson of the Prophet), to an unfaithful lover, and so on. Another dagger in the collection with a mystical or erotic verse of this type is cat. 77: "Once his dagger had aimed for the bloody-livered lover, my Turk wrapped it in gold and tied it to his waist."

Talismans: Magic Squares

Talismans in the form of numbered and lettered squares were often used on sword and saber blades. These are essentially of two types. One is called *wafk*, a square divided into nine (three-by-three) chessboard-like compartments, each of which contains a number or a letter (every Arabic letter has a numerical equivalent and vice versa); the total of the numbers read in any direction must be the same. The second is called *buduh*, a square divided into four compartments, each containing a letter that when combined with the others spells out the word *buduh*. The word was thought to have such power that it was even written alone, without the square, and was said to be a name of God (cat. 64).[16]

The significance of these squares is best understood as speculation on the nature of the universe and the importance of letters and their numerical equivalents in its creation and basic construction.

From the rich sources of Hebrew, Pythagorean, and Gnostic ideas on letters and numbers as well as indigenous Arab and Qur'anic traditions, Muslim mystics developed a unique form of numerology. As in the other systems, the letters/numbers were thought to emanate from the Godhead to form the structure of the universe; the letters of the Arabic alphabet were read both individually and in combination as being part of this divine structure. Various combinations of letters were therefore interpreted as some of the names of God. Magic squares were constructed according to these principles, and the numbers in the square usually added up to one of the names of God, making them efficacious talismans.

In Arabic the number five is the alphabetical equivalent of the letter *ha*, which is the last letter in the name Allah and which was interpreted by the numerologist al-Buni (d. 1225), among others, to be the highest name of God.[17] Al-Buni related the three-by-three square to the ninety-nine names of God by computing two basic forms of the square, one masculine, the other feminine, which when added formed a new square whose numbers totaled ninety-nine.[18]

Perhaps the craftsmen who placed such seals on sword blades and the owners who commissioned them were aware of these multiple meanings. The magic square, a reminder of God and of the order of the universe, would at the same time protect the warrior and bring destruction to his enemies.

For the Warriors in the Jihad

Some armors and helmets are inscribed with a verse that invokes the warriors who fight in the jihad. These pieces are mostly Ottoman and were perhaps made for warriors who took part in the various Ottoman campaigns in Europe during the sixteenth century.

The word *jihad* means "to struggle" and "to strive" and can refer to both a spiritual struggle within oneself toward becoming a better individual, or it can designate "Holy War." It should also be remembered that during the early years of Muhammad's mission the new movement had been peaceful, often in the face of insult, ridicule, and violence. During this "Meccan" period, Islam can be regarded as an almost pacifist movement, and new adherents were convinced by the Prophet's theological and moral teachings. This message was simple and straightforward. Man must submit to the will of God and follow His laws; indeed, the word *Islam* means submission to the will of God, and the word *Muslim*, which derives from it, means one who submits. The code of conduct required by Islam involves five major points: belief in one God and the Last Day; regular prayer; practice of charity; fasting during the month of Ramadan; and making the *Hajj*, or pilgrimage. These were all requisite obligations for the believer, and such duties are stressed throughout the Qur'an.[19]

However, as his following grew Muhammad aroused the anger of the Meccan establishment, and in the year A.H. 1 (A.D. 622) to escape persecution he and his followers left Mecca for Medina. New revelations now commanded that the fledgling community fight for its survival. This fight in the cause of religion is known as the jihad.[20]

The concept of the jihad is also connected with the hadith stating that with the advent of Islam the world was divided into the *dar al-harb*, the Land of War, and the *dar al-islam*, the Land of Peace. The former term designates the part of the world that has not accepted Islam and is submerged in discord, misery, and strife; the latter term designates the part of the world that lives according to Islamic law.[21] According to this viewpoint the goal of the jihad was to defend and constantly expand the Muslim community until the entire world lived in peace and security under Islam. Like the other duties mentioned above, participation in jihad was obligatory for every able-bodied adult male in the community (sometimes conditional upon parental permission).[22]

The example set by the communities of young warriors, *ghazi*, living solely for worship and jihad in *ribat*, fortress outposts on the frontiers, was also adapted by religious leaders, especially Sufis, as an educational tool in the proper training of the young. Such ideals were adopted by the 'Abbasid caliph al-Nasir (r. 1180–1225), who helped the Sufi Abu Hafs 'Umar organize an order, *futuwwa*, that traced its spiritual lineage to the Prophet's cousin and son-in-law, 'Ali. This Islamic order has been compared to European knightly orders, and there are many common points, especially those involving the investiture ceremony, which for the *futuwwa* entailed girding with a belt, the bestowal of trousers (the garb of a mounted warrior), and a drink from a cup. These precepts were eventually absorbed by certain dervish sects, such as the Bektashi, who heavily influenced the Janissary troops of the Ottoman Empire.[23] Indeed, it was as *ghazi* frontier warriors that the Ottomans began their rise to supremacy and gradually carved out a new state in Anatolia and the Balkans.[24] A *ghazi* was described by the Ottoman poet Taj al-Din Ahmadi (ca. 1334–1413) as "the instrument of the religion of God, a servant of God who cleans the earth from the defilement of polytheism; a *ghazi* is the sword of God, he is the protector and the refuge of the Believers, if he becomes martyr while following the paths of God, do not think him dead, he lives with God as one of the blessed, he has Eternal Life."[25]

The use of titles garnered from the vocabulary of the jihad and the portrayal of the owner as a warrior in the holy cause are often found on arms and armor. A saber blade preserved in the Museum of Islamic Art in Cairo, made for one of the last Mamluk sultans, Tumanbay (r. 1505), bears the titulature, "sultan of Islam and all Muslims, father of the poor and the miserable, killer of the unbelievers and the polytheists, reviver of justice among all, may God prolong his kingdom and may his victory be glorious."[26] Similar titles were also used by the Ottomans. On a saber now in the Topkapı Sarayı Museum, Istanbul, Mehmed II is called the "sultan of warriors for the faith," and the blade itself is described as "the sword of God unsheathed in the jihad, Sultan Mehmed ibn Sultan Murad Khan, let God make the necks of all those who are against Islam into scabbards for his swords."[27]

Numerous pieces are inscribed with verses referring to the Prophet's sword (cat. 66) or with representations of it, all of which thus relate to the jihad. Early Islamic chronicles indicate that the Prophet owned several swords. Ibn Sa'd (784–845) records seven, with an eighth and ninth mentioned by others.[28] Dhu'l faqar, the most important sword owned by the Prophet, became one of Islam's most enduring symbols. Representations of it were made throughout the Islamic world, and it is referred to in numerous inscriptions, many examples of which are represented in the Museum's collection (cats. 71, 107); it came to be regarded as part of the legacy of the Prophet, whose possession was often seen as underscoring political and spiritual legitimacy in the community. It was also regarded as one of the insignia of the caliphate, a sign of the Mahdi, and a symbol of the Last Days.[29]

Additional inscriptions relating to the jihad include two phrases on a sixteenth-century Ottoman helmet now in Paris that occur on a number of other weapons and armor (fig. 24).[30] The first of these, "glory is in obedience and wealth is in contentment," is found on a number of so-called turban helmets and is also stamped on the individual links of a mail shirt in the Museum's collection (cats. 22, 2, respectively). The other inscription on the Paris helmet, "for the *ghazi* and the jihad in the cause of Allah," appears on a number of Ottoman helmets, shaffrons, and weapons of the sixteenth century. All of the Ottoman pieces inscribed in this way are of relatively high quality. In the case of the helmets, the slogan is engraved on the tops of the nasals (and in the case of the shaffrons, prominently on the brow), thus it can be surmised that it functioned as an insignia of honor bestowed on distinguished warriors.

CRUCIBLE STEEL

The swords most praised in early Islamic poetry and geographies were either from India or were made from a type of steel associated with India but in fact produced throughout much of the Middle East and Iran: crucible steel. Sometimes called Damascus steel, watered steel, or *wootz*, crucible steel was produced by combining different types of iron, especially some high in carbon, in a clay crucible (thus the name). This was then cast in an ingot, slowly cooled, and finally hammered out to create an object. The complex structure created by the combination of materials in the crucible resulted in natural patterns in the forged metal. Often described as "damascened," these patterned steels have commonly and mistakenly been thought to originate in the city of Damascus; although blades of high quality were produced in Syria and Damascus during the Middle Ages, there is no evidence that crucible steel was invented there. In fact, steel of this type predates the Islamic period; the earliest written account of its production was by the philosopher and alchemist Zosimos of Alexandria in the third century A.D.[31] Fifteenth-century Persian poets used the word *ab*, or "watered," to distinguish such steels. This terminology is useful for two reasons: first, it aptly describes the shimmering, wavelike patterns found on a majority of the blades, and, second, it avoids the confusion evoked by the word "damascened." The term was used by Ottoman and Persian poets to connect the ideas of a

"watered blade," the "waters of paradise," and the water denied to Husayn, grandson of the Prophet, as he lay dying at the hands of the Umayyads. Such poetic connotations firmly relate watered blades to the jihad, a resonance fundamental in any consideration of Islamic arms and armor.[32]

Because crucible steel is produced by premixing different types of iron, it has a natural pattern when forged, but patterns can also be created mechanically during the forging process, when the crafts-man hammers, folds, cuts, and then re-hammers the metal to produce rhythmic designs in the finished product.[33] In practice, most blades of patterned steel were made by using a combination of these techniques.

NOTES

1. See Ibn 'Ata' Allah 1981, pp. 149–50.

2. Ibid., pp. 149–52; see also Huart and Sadan 1986.

3. For this hadith, see Ibn Ishaq 1955, pp. 499–507, pt. 3, verses 740–51.

4. Ibid., p. 507, pt. 3, verse 751.

5. See Ormsby 1984, pp. 38–41. This attitude has also been described as producing an outlook that sees into the very nature of reality and likened to "the sword of God on earth [because] it cuts everything that it touches"; see Dhu'l-Nun al-Misri quoted in M. Smith 1944, p. 167, n. 2.

6. Gardet 1960; al-Bukhari 1987, vol. 9, p. 363; and Gimaret 1988, p. 51.

7. In some instances just one or two of the names are given (cat. 47), although one cuirass (cat. 14) and a shirt of mail and plate (cat. 12) include most of them.

8. Al-Bukhari 1987, vol. 9, p. 363.

9. Al-Tabari 1980–88, vol. 1, pp. 92–95, for the ascent of Enoch/Idris. Muhammad is also said to have visited hell and witnessed the tortures inflicted on sinners and unbelievers; for a miniature painting depicting this, see Séguy 1977.

10. Ibn al-'Arabi 1978, p. 89.

11. Figiel 1991, p. 86, fig. 31a.

12. Schimmel 1985, p. 35.

13. See, for example, Melikian-Chirvani 1982b, especially chap. 1.

14. See Melikian-Chirvani 1969; Ivanov 1979; Kalus 1980; Melikian-Chirvani 1982b; and Kalus 1992.

15. One of these is attributed to the Shirvanshah Farrukhyasar (r. 1462–1501) and the others to Yasr (or Syar) Shah ibn Sultan Khalil. Askeri Müzesi, Istanbul, nos. 163, 5911, 9488; see Kalus 1992, especially pp. 162–63.

16. See Ruska 1934 and Graefe, Macdonald, and Plessner 1965.

17. Here his views parallel those of Ibn 'Ata' Allah 1981, especially chap. 8; see also Winkler 1930, p. 135.

18. Gérardin 1986, p. 120.

19. See, for example, Sura 2:177: "It is righteousness—to believe in Allah and the Last Day, and the Angels, and the Book, and the Messengers; to spend of your substance, out of love for Him, for your kin, for orphans, for the needy for the wayfarer, for those who ask, and for the ransom of slaves; to be steadfast in prayer, and give Zakat [practice regular charity], to fulfill the contracts which ye have made; and to be firm and patient, in pain (or suffering) and adversity, and throughout all periods of panic. Such are the people of truth, the God-fearing."

20. There are some differences of legal opinion in the interpretation of jihad, mainly due to the fact that the Qur'an was not revealed at a single moment in time but rather over a period of about twenty-five years. For the theory in its early stages, see Firestone 1999. Tyan 1965, p. 538, posits four major Qur'anic stages: peaceful persuasion, defensive war, aggressive war (but not during the sacred months), and aggressive war at any time or place.

21. See Abel 1965.

22. See Ibn Rushd's chapter on the jihad from the *Bidayat al-Mudjtahid* in R. Peters 1977, pp. 15–17.

23. See, especially, Taeschner 1965.

24. See also Tyan 1965.

25. Taj al-Din Ahmadi, as quoted in Mélikoff 1965, p. 1044.

26. Washington, D.C., and other cities 1981–82, no. 42.

27. Topkapı Sarayı Museum, Istanbul, no. 1/90; see Yücel 1988, no. 87.

28. Ibn Sa'd 1967, pp. 576–78. The Arabs habitually named their swords, among them the famous sword, "the stone-cutter," of the Qurayshi Al-Walid b. al-Walid b. al-Mughira. See 'Abd al-Malik Ibn Hisham in Ibn Ishaq 1955, p. 729, n. 263; Baladhuri 1959, p. 521; and al-Tabari 1988–89, vol. 2, pp. 194–97.

29. See Alexander 1999.

30. Musée de l'Armée, Paris, no. H.452; see Paris 1990, no. 76 (the inscriptions were translated by Ludvik Kalus for the Paris exhibition). See also Alexander 2003, no. 10.

31. Craddock and Lang 2004, p. 40. No original text by Zosimos survives; the most important of his works are preserved in later Syriac and Arabic copies. The manufacture of crucible steel in the pre-Islamic and early Islamic period has been discussed in a number of specialist works; see Allan and Gilmour 2000 and Craddock and Lang 2004.

32. For further discussion, see Alexander 1983.

33. The technique was probably invented by the Celts; by the fifth century it was a characteristic of European sword blades. Numerous examples of these so-called Viking swords survive; see, for example, Maryon 1960a, Maryon 1960b, and Davidson 1962.

Appendix B
Turkman-Style Armor

David G. Alexander

Many of the armors and helmets discussed in this catalogue are described as being in the "Turkman" style. This designation has been used both to cover a decorative style and to group together pieces of similar form originating in a variety of Turkic states, such as those of the Ak-Koyunlu, Kara-Koyunlu, Shirvanshahs, Karamans, and Ottomans.

At the beginning of the fourteenth century, Anatolia was divided between a number of Turkic states known as beyliks; these included a small area centered on Bursa that was under Ottoman control. By the late fifteenth century most of these tiny states—such as Germiyan, Karaman, and Kastamonu—had been absorbed by the Ottomans, with only Dhu'l-Kadr maintaining a quasi-independence. The powerful Ak-Koyunlu controlled large areas of eastern Anatolia as well as substantial parts of what are now Syria, Iraq, Iran, and the Caucasus (fig. 45).

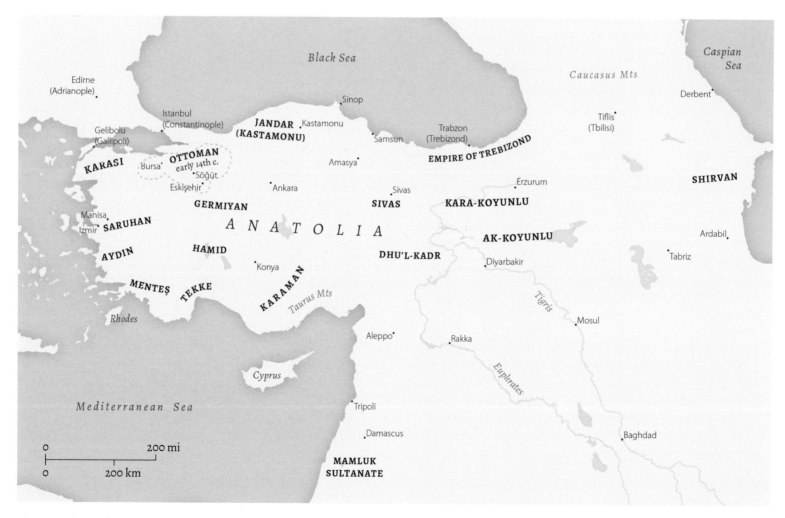

Fig. 45. Map showing the Turkman principalities of the 14th and 15th centuries in Anatolia and western Iran, including those of the Ak-Koyunlu, Dhu'l-Kadr, Hamids, Kara-Koyunlu, Karamans, Kastamonu, and Ottomans

Fig. 46. "Zal Slays Khazarvan," folio 104r from the *Shahnama* (Book of Kings) of Shah Tahmasp. Iran, Tabriz, 1525–30. Opaque watercolor, ink, silver, and gold on paper. The Metropolitan Museum of Art, New York, Gift of Arthur A. Houghton Jr., 1970 (1970.301.15)

A large corpus of Near-Eastern armor for man and horse datable to the fourteenth to sixteenth century has been preserved in various collections throughout the world. These armors are best understood in a broad Turko-Iranian context. All were made for mounted warriors—not surprisingly, as all Near-Eastern Islamic dynasties of the period were controlled by horse-riding elites. All are remarkably similar in form, and when they can be attributed to a specific dynasty it is occasionally because of their decoration but more often due to the content of their inscriptions. Unfortunately, no complete garniture has been assembled, and numerous pieces have defied attempts to assign specific geographical or chronological attributions. The starting point for the attribution of many of these pieces is the work of James Allan and Sylvia Auld on Turkman metalwork. Allan has argued that an especially robust decorative style of the fifteenth century should be regarded as Turkman, and Auld has suggested that the work of several masters associated with the craftsman Mahmud al-Kurdi should also be attributed to Turkman metalworkers.[1]

An idea of how complete garnitures looked during this period can be obtained by recourse to miniature painting. In one example from Iran datable to 1525–30 (fig. 46), a defeated Turkic warrior wears an armor of mail, a knee defense of mail and plate, arm guards, and a partially fluted helmet with an elongated finial. His horse has a shaffron and a colorful caparison, probably of metal plates covered with fabric. The victor, the Iranian hero Zal, has a similar helmet, but his armor is not visible (most likely it is a *kasha-gand*, an armor of mail or mail and plate covered with fabric).[2] Most of the warriors on either side also wear *kashagand* armor, although some have shoulder defenses, and the warrior at the lower left wears an armor of mail and plate. In a Turkman painting of 1493–94 (fig. 47), three of the warriors wear helmets with cusps around the eyes, armors of mail set with large sculpted shoulder plates, and some have arm defenses. Armor of this type is also known from Mamluk Egypt and Syria and, in the east, from India (the major Islamic dynasties in India, such as those of the Sultanate and Mughal periods, were of Turko-Mongol stock). Few elements of Indian Islamic armor datable to the fifteenth and sixteenth century have survived, although miniature paintings from the period of Shah Jahan (r. 1627–58) indicate that armor in this style probably remained in use well into the seventeenth century. The Museum's Mughal armor of 1632–33 is a rare surviving example (cat. 12)

Some of the surviving armors of the type represented in these paintings are inscribed with names and titles that provide attributions to Mamluk, Ottoman, Ak-Koyunlu, Shirvanshah, Karaman, and perhaps Timurid workshops, while others are clearly decorated in styles associated with one or another of these major dynasties.

Fig. 47. *Battle Scene*. Dedicated to 'Ali Mirza. Turkman, dated A.H. 899 (A.D. 1493/94). Freer Gallery of Art and Arthur M. Sackler Gallery, Smithsonian Institution, Washington, D.C. (S86.0175)

Yet the precise origin of large numbers of armors and helmets remains mysterious. Decoratively these differ among themselves and cannot be the product of any single workshop or center. They do not belong exclusively to any of the above dynastic styles, and yet they contain decorative elements found in all of them. For example, features that seem to be Timurid occur together with motifs usually associated with the Mamluks, while in other examples Ottoman styles merge with those that are probably Ak-Koyunlu. These helmets and armors for man and horse have what the philosopher Ludwig Wittgenstein called a "family resemblance."[3] There are a series of similar features running through an apparent diversity of decorative forms, and although no single definition can describe them, they somehow belong together. They have a "family resemblance" sharing in a series of interconnected definitions, so that at the same time there is both diversity and similarity.

Certain common features can be regarded as representative of a "Turkman" style prevalent throughout Anatolia, northern Syria, Iran, and Azerbaijan. "Turkman" or "Turkic" is used here in the broad sense to cover the descendants of the twenty-four tribes who were once members of the Oghuz Confederation, and in particular the tribal dynasties that succeeded the Il-Khanids and ruled throughout Anatolia, Iran, and Azerbaijan. The Seljuqs were one such tribal group, as were the Ottomans, Karamanids, Ak-Koyunlu, Kara-Koyunlu, Shirvanshahs, Germiyan, Hamids, Cayindir, and so on.[4] In addition, the Mamluk elite in Egypt and Syria were of Turkic and Circassian origin, and the northernmost reaches of the Mamluk Empire included the cities of Sis and Adana in present-day Turkey and incorporated numerous minor Turkman tribes.

There are further complications. James Woods, in a pioneering study of the Ak-Koyunlu, pointed out that many of these tribal groups have not been adequately studied and that from the mid-fourteenth to early sixteenth century, "the history of the Irano-Turkish cultural area . . . remains obscure in many of its fundamental aspects."[5] Woods did much to remedy this as regards the Ak-Koyunlu, but at the same time showed how complicated, perhaps impossible, it would be to identify artistic centers. Just as the Ak-Koyunlu were originally one of twenty-four tribes within the Oghuz Confederation, forty-two tribes, according to Woods, made up the Ak-Koyunlu Confederation. Some of these, such as the Ahmadlu, lived in Iran and Azerbaijan; others, such as the Afshar, had their power base in northern Syria; yet others, such as the Bulduqani-Mardasi, were Kurds and their fief was in Egil in the region of Diyarbakır.[6] Each of these forty-two tribes furnished cavalry to their Ak-Koyunlu overlords, and each must have employed armorers with their own particular artistic styles. Furthermore, in addition to the Turks, the peoples of Anatolia, western Iran, and Azerbaijan included a variety of ethnic and linguistic groups and subgroups, such as Kurds, Iranians, Armenians, and Jews. Craftsmen from all these groups probably worked as armorers and must also have merged their artistic repertoires with that of the Turkmen.[7] Finally, during the course of the fifteenth and early sixteenth centuries the Ottomans incorporated all of Anatolia into their empire, thereby inheriting a variety of regional styles.

The inscriptions embellishing these armors and helmets are usually either in Persian or Arabic. Several helmets are inscribed with a Persian poem in praise of the owner and end in the name "Siyar" or "Yasr Shah." The Arabic inscriptions often consist of a series of titles or parts of titles referring to an unspecified ruler: "Glory to our lord, the greatest sultan, the mighty Khaqan, master of the necks of nations, the lord of the kings of the Arabs and non-Arabs" (cats. 23, 25). They can also express good wishes to the owner or present a poem generally associated with Mamluk and Turkman metalwork: "to its owner happiness and peace and long life as long as a dove coos."[8] In many cases the inscription is a political or religious maxim: "Glory is in obedience and wealth in contentment." The last occurs on several of the Museum's helmets (for example, cat. 22) in addition to mail shirts (cat. 2), as well as on a sixteenth-century conical helmet that is certainly Ottoman (fig. 24).[9] Its presence on a helmet that appears to include the name of the Ak-Koyunlu sultan Ya'qub (cat. 23) indicates that it could be a formula common to both the Ottomans and the Ak-Koyunlu. However, in some cases the inscriptions are quite specific and include names, as on the earliest surviving datable armor of this type, which is inscribed "made for the treasury of Ibrahim Sultan."[10] This inscription refers to the grandson of Timur, Ibrahim Sultan b. Shahrukh b. Timur, who was governor of Shiraz between 1414 and 1434.

Other inscriptions also provide datable attributions, including armors made for the Mamluk sultans Inal (r. 1453–61) and Qa'itbay (r. 1468–96); others probably made for the Ak-Koyunlu Hasan ibn 'Ali and Ya'qub (r. 1478–90); and an armor made for Khalilullah (perhaps the Shirvanshah Khalilullah I (r. 1418–63).[11] A shaffron in the Khalili Collection, London, is inscribed with the name of the Ak-Koyunlu prince Husayn b. Alikhan Jahangir (d. 1497).[12] Another armor, probably of the fifteenth century, is inscribed with the name Kaykubad—although it is unlikely that this refers to a Seljuq sultan of that name, and it should probably be attributed to a prince from one of the Turkman states in Anatolia.[13]

Mail and plate armors were worn with arm and leg defenses and with helmets that were sometimes large and bulbous with flutings imitating the folds of a turban—hence the designation "turban" helmets. One of the earliest datable helmets of this type is inscribed with the name of the Ottoman ruler Orhan Ghazi (r. 1326–60).[14] When the Ottomans captured Bursa in 1326, Orhan made it his capital, and it is very possible that this helmet was made there (for the type, see cat. 22).

A large group of similar, but certainly not identical, helmets can be attributed to a non-Ottoman milieu. To modern eyes the differences between them are subtle: one smooth sided, another slightly bulbous; one with wide and bold flutings, another with thin spiral flutes. Yet when originally worn they must have been easily recognizable as belonging to specific tribal or military groups (as well as reflecting the evolution of forms over time). These examples include helmets inscribed with such names or titles as Bilalzade, Khalilullah, Abu Sa'id, Muhammad Bahadur, Bahadur Khan, al-Malik al-Ashraf,

and Inal. Although we can say that Abu Saʿid is probably the Timurid sultan who ruled from 1452 to 1469, most of the other names cannot with certainty be ascribed to specific individuals. All but the helmets inscribed "al-malik al-ashraf" and "sultan al-ashraf" seem to be from one or the other of the multitude of Turkman principalities in Anatolia, Iran, Azerbaijan, and the Caucasus. The "al-ashraf" and especially the "Inal" helmets provoke a number of questions. While the titulature is Mamluk, it is unlike any Mamluk titulature attributed to Syria and Egypt, and in shape and decoration they are unlike any other Mamluk helmets, having more in common with the "Turkman" or "Turko-Iranian" examples.[15] It seems likely that the "al-ashraf" helmets were made in the northern regions of the Mamluk Empire in a center such as Sis in Anatolia.

Four decorative conventions stand out within this interconnected family of "Turkman" or "Turko-Iranian" styles. The first of these is the use of boldly drawn, exuberant, almost fleshy leaf and floral forms that are well organized yet overflow with wildness and confidence (cat. 5). The leaf forms on the Museum's armor have the same pneumatic quality as the cloud bands on a late fifteenth-century metalwork dish in the Victoria and Albert Museum, London, which Allan regards as typically Turkman.[16] A second hallmark of the style is the use of lobed knots to join cartouches, a decorative device also used on Iznik ceramics of the early sixteenth century and in the work of Mahmud al-Kurdi. A third is the incorporation of trilobate floral forms as a key element in border decoration (Metropolitan Museum, acc. no. 04.3.209). And a fourth convention is the use of interlocking knots and loops around the rims of such seemingly diverse helmets as an elongated conical example made for the Mamluk sultan Barsbay (r. 1422–38) and others of fluted and bulbous form (cat. 24).

Such elements as these do not occur on every piece, and in themselves do not define the entire production, underscoring that these are a "family" of objects produced in different workshops, over a long period of time, representing the work of hundreds of different craftsmen and decorators who provided armors for tens of thousands of warriors.[17] At the same time, this production is linked by a common cultural and artistic ethos. How these connections ran is as yet unknown. They might have resulted from craftsmen moving voluntarily from one center to another, from craftsmen in one center copying elements from the work of those in other regions or workshops, or from craftsmen captured as the result of warfare who then transferred their decorative repertoires to the workshops of their captors. For these reasons, it is for the most part not possible to isolate specific centers of production.

NOTES

1. Allan 1991; Allan and Gilmour 2000, especially pp. 468–70; and Auld 2004.

2. See Melikian-Chirvani 1983. Only a few early examples have survived, including one in the Topkapı Sarayı Museum, Istanbul (see Stöcklein 1934, fig. 5), one in the Askeri Müzesi, Istanbul, no. 249 (unpublished), and a third in the Museo Nazionale del Bargello, Florence (no. M 1244, made for the Mamluk sultan Jaqmaq [r. 1438–53]; see Florence 2002, p. 18, fig. 1).

3. Wittgenstein 2001, pp. 65–71.

4. For the history of the term "Turkman" and a discussion of the various tribal groupings, see Kellner-Heinkele 2000; for the tribal marks of the Oghuz tribes, see Nickel 1973b. For a tamğa probably from a member of the Çavuldur tribe (a branch of the Cepni) from eastern Turkey, see cats. 10, 22.

5. Woods 1999, p. 1.

6. Ibid., appendix B. See also Minorsky 1939, p. 939, in which he suggests that the mother of the founder of the Bulduqani dynasty was probably Turkish.

7. Many of these armors bear inscriptions, or truncated inscriptions, in Arabic, Persian, and Turkish that are grammatically incorrect; see, for example, cats. 23–25.

8. Allan 1991, pp. 155–56.

9. The inscription is used on two helmets that are certainly Ottoman, one now in the Musée de l'Armée, Paris, no. H.452 (see fig. 24 and Paris 1990, no. 76), and the other in the Museo Stibbert, Florence, no. 6209 (see Venice 1993, no. 251).

10. Furusiyya Art Foundation, Vaduz, no. R-945; see Riyadh 1996, vol. 2, p. 114, no. 90, and Paris 2007/Mohamed 2008, pp. 300–301, no. 289. See also cat. 33.

11. For Inal, Askeri Müzesi, Istanbul, no. 22518, and a second armor made for him, now in the Furusiyya Art Foundation, Vaduz, no. R-749, see Paris 2007/Mohamed 2008, pp. 298–99, no. 288; for Qaʾitbay, Topkapı Sarayı Museum, Istanbul, no. 821, see Stöcklein 1934, fig. 10; for Hasan ibn ʿAli, Askeri Müzesi, Istanbul, no. 4331/2, see London 2005b, pp. 201–11, no. 156; for Yaʿqub, Askeri Müzesi, Istanbul, no. 16462, see Istanbul 1987, p. 155, no. A.151; and for Khalilullah, Askeri Müzesi, Istanbul, no. 16376 (unpublished). A number of these inscribed armors and helmets in the Askeri Müzesi are discussed and illustrated in Kalus 1992.

12. Khalili Collection, London, no. MTW 928; see Alexander 1992, pp. 86–89, no. 40. This shaffron, signed by Kamal b. Amir al-Janahi, was probably made in Tabriz, where Husayn died.

13. Askeri Müzesi, Istanbul, no. 21300.

14. Askeri Müzesi, Istanbul, no. 15723; see Alexander 1983, pp. 97–98, fig. 1.

15. One of them (Askeri Müzesi, Istanbul, no. 14628) is inscribed "made for the treasury of al-mansur al-muyad al-malik al-ashraf"; Ludvik Kalus has suggested this might refer to a member of the Badasbandid dynasty from the Caspian region (personal communication, 2000).

16. Victoria and Albert Museum, London, no. 374-1897; see Allan 1999, fig. XXIVB. Closely related craftsmanship, perhaps from the same workshop, can be seen on a shaffron in the Museo Poldi Pezzoli, Milan; see Boccia and Godoy 1985–86, vol. 2, no. 995.

17. Some idea of the numbers of cavalry involved in battles of the late fifteenth century is provided in accounts of the conflict between the Ottomans and Ak-Koyunlu at Erzincan in 1473. According to a European account, the Ak-Koyunlu fielded 300,000 horsemen (although another tally gives it as 40,000); see Woods 1999, p. 117.

Bibliography

ABBREVIATIONS

MMA—The Metropolitan Museum of Art
MMAB—The Metropolitan Museum of Art Bulletin
MMJ—Metropolitan Museum Journal

Abel 1965
Abel, A. "Dar al-Harb." In *Encyclopaedia of Islam, New Edition*, edited by B[ernard]. Lewis, Ch. Pellat, and J. Schacht, vol. 2, p. 126. 2nd ed. Leiden: Brill; London: Luzac and Co., 1965.

Abu'l Fazl 1873
Abu'l Fazl. *A'in-i Akbari*. Vol. 1. Translated by H. Blochmann. Calcutta: Printed by Baptist Mission Press for Asiatic Society of Bengal, 1873.

G. Ackerman 1986
Ackerman, Gerald M. *The Life and Work of Jean-Léon Gérôme: With a Catalogue Raisonné*. London: P. Wilson for Sotheby Publications; New York: Harper and Row, 1986.

G. Ackerman 2000
Ackerman, Gerald M. *Jean-Léon Gérôme: Monographie révisée; Catalogue raisonné mis à jour*. Orientalistes 4. Courbevoie: ACR, 2000.

Akurgal 1980
Akurgal, Ekrem. *The Art and Architecture of Turkey*. New York: Rizzoli, 1980.

Alexander 1980
Alexander, David G[eoffrey]. "Matrices for Sword Mounts." *The Metropolitan Museum of Art: Notable Acquisitions, 1979–1980*, 1980, p. 27.

Alexander 1981
Alexander, David G[eoffrey]. "Mace Head." *The Metropolitan Museum of Art: Notable Acquisitions, 1980–1981*, 1981, p. 18.

Alexander 1983
Alexander, David G[eoffrey]. "Two Aspects of Islamic Arms and Armor." *MMJ* 18 (1983), pp. 97–109.

Alexander 1984
Alexander, David Geoffrey. "Dhu l-fakar." 2 vols. PhD diss., New York University, 1984.

Alexander 1985a
Alexander, David G[eoffrey]. "Arms and Armor: Dagger with Scabbard." *The Metropolitan Museum of Art: Notable Acquisitions, 1984–1985*, 1985, pp. 15–16.

Alexander 1985b
Alexander, D[avid]. G[eoffrey]. "Decorated and Inscribed Mail Shirts in the Metropolitan Museum." *Waffen- und Kostumkünde*, 3rd ser., 27, no. 1 (1985), pp. 29–36.

Alexander 1985c
Alexander, D[avid]. G[eoffrey]. "European Swords in the Collections of Istanbul; Part 1: Swords from the Arsenal of Alexandria." *Waffen- und Kostumkünde*, 3rd ser., 27, no. 2 (1985), pp. 81–118.

Alexander 1987
Alexander, David G[eoffrey]. "European Swords in the Collections of Istanbul: Part 2." *Waffen- und Kostumkünde*, 3rd ser., 29, no. 1 (1987), pp. 21–24.

Alexander 1989
Alexander, David G[eoffrey]. "The Guarded Tablet." *MMJ* 24 (1989), pp. 199–207.

Alexander 1992
Alexander, David G[eoffrey]. *The Arts of War: Arms and Armour of the 7th to 19th Centuries*. Nasser D. Khalili Collection of Islamic Art 21. London: Nour Foundation; Azimuth Editions; Oxford University Press, 1992.

Alexander 1999
Alexander, David G[eoffrey]. "*Dhu'l faqar* and the Legacy of the Prophet, Mirath Rasul Allah." *Gladius* 19 (1999), pp. 157–87.

Alexander 2001
Alexander, David G[eoffrey]. "Swords and Sabers during the Early Islamic Period." *Gladius* 21 (2001), pp. 193–219.

Alexander 2003
Alexander, David G[eoffrey]. "The Silver Dragon and the Golden Fish: An Imperial Ottoman Symbol." *Gladius* 23 (2003), pp. 211–68.

Alexander 2004
Alexander, David G[eoffrey]. "Pisanello's Hat: The Costume and Weapons Depicted in Pisanello's Medal for John VIII Palaeologus; A Discussion of the Saber and Related Weapons." *Gladius* 24 (2004), pp. 135–85.

Alexander 2007
Alexander, David [Geoffrey]. "An Ottoman Turkish Archer's Ring." In "Arts of Islam." Special issue, *TAASA Review: The Journal of the Asian Arts Society of Australia* 16, no. 1 (March 2007), pp. 16–17.

Alexander and Ricketts 1985
Alexander, David [Geoffrey.], and Howard Ricketts. "Arms and Armour." In Geneva 1985, pp. 294–317.

Allan 1979
Allan, James W. *Persian Metal Technology, 700–1300 A.D.* With appendix by Alex Kaczmarczyk and Robert E. M. Hedges. Oxford Oriental Monographs 2. London: Ithaca Press for Faculty of Oriental Studies and Ashmolean Museum, University of Oxford, 1979.

Allan 1982a
Allan, James W. *Islamic Metalwork: The Nuhad Es-Said Collection*. London: Sotheby Publications, 1982.

Allan 1982b
Allan, James W. *Nishapur: Metalwork of the Early Islamic Period*. New York: MMA, 1982.

Allan 1988
Allan, James W. "The Nishapur Metalwork: Cultural Interaction in Early Islamic Iran." In *Content and Context of Visual Arts in the Islamic World: Papers from a Colloquium in Memory of Richard Ettinghausen, Institute of Fine Arts, New York University, 2–4 April 1980*, edited by Priscilla P. Soucek, pp. 1–11. University Park and London: Pennsylvania State University Press, 1988.

Allan 1991
Allan, James W. "Metalwork of the Turcoman Dynasties of Eastern Anatolia and Iran." *Iran* 29 (1991), pp. 153–59.

Allan 1994
Allan, J[ames]. W. "Shorter Notices: Hajji 'Abbas." *Iran* 32 (1994), pp. 145–47.

Allan 1999
Allan, James. W. *Islamic Metalwork: The Nuhad Es-Said Collection*. London: Philip Wilson Publishers, 1999.

Allan and Gilmour 2000
Allan, James [W.], and Brian Gilmour. *Persian Steel: The Tanavoli Collection*. Oxford Studies in Islamic Art 15. Oxford: Oxford University Press, 2000.

Allan and Raby 1982
Allan, James, and Julian Raby. "Metalwork." In Petsopoulos 1982, pp. 17–71.

American Art Association, New York 1917
Ancient Arms and Weapons, Egyptian Antiquities and Oriental and European Curios [Samuel H. Austin Collection]. Sale cat., American Art Association, New York, April 24–28, 1917.

American Art Association/Anderson Galleries, New York 1928
European Arms and Armour, Mainly XV–XVI and XVII Centuries. Sale cat., American Art Association/Anderson Galleries, New York, November 23–24, 1928.

American Art Association/Anderson Galleries, New York 1931
Egyptian and Near Eastern Antiquities; From the Collection of the Late Daniel Z. Noorian. Sale cat., American Art Association/Anderson Galleries, New York, March 12–14, 1931.

American Art Association/Anderson Galleries, New York 1936
Arms and Armour, Oriental and European Examples of the V to XVIII Centuries Valuable Gothic and Renaissance Tapestries, Paintings by Old Masters, Majolica, Stone Sculptures and Wood Carvings, Furniture, Wrought Iron, Books on Art: Collection of Frank Gair Macomber, Boston, Mass. Sale cat., American Art Association/Anderson Galleries, New York, December 10–12, 1936.

Andersen 2014
Andersen, Niels Arthur. *Gold and Coral: Presentation Arms from Algiers and Tunis.* Edited by Ole Skøtt. Translated by Erik Troldhuus. Naestved: Devantier; [Denmark]: Niels Arthur Andersen, 2014. Also pub. as *Vaabenhistoriske Aarbøger* 59.

Archer, Powell, and R. Skelton 1987
Archer, Mildred, Christopher Powell, and Robert Skelton. *Treasures from India: The Clive Collection at Powis Castle.* New York: Meredith Press, 1987.

Arendt 1935
Arendt, V[sevolod Viktorovich]. "Türkische Säbel aus den VIII.–IX. Jahrhunderten." In *Studia levedica: Archaeologischer Beitrag zur Geschichte der Altungarn im IX. Jh. / Studia levedica: Régészeti adatok a magyarság IX. századi történetéhez,* pp. 48–86. Archaeologica Hungarica 16. Budapest: Magyar Történeti Múzeum, 1935.

Armoury Chamber of the Russian Tsars 2002
Armoury Chamber of the Russian Tsars: One Hundred Items from the Collection of the Russian Emperors/ Gosudareva Oruzheinaiapalata: Sto predmetov iz sobranii rossiiskikh imperatorov. Saint Petersburg: Atlant, 2002.

Atasoy and Raby 1989
Atasoy, Nurhan, and Julian Raby. *Iznik: The Pottery of Ottoman Turkey.* Edited by Yanni Petsopoulos. London: Alexandria Press in association with Thames and Hudson, 1989.

Athens 1980
Greek Traditional Jewelry. Exh. cat., Benaki Museum, Athens. Athens: Melissa, 1980. Catalogue by Angelos Delevorrias.

Atıl 1986
Atıl, Esin. *Süleymanname: The Illustrated History of Süleyman the Magnificent.* Washington D.C.: National Gallery of Art; New York: H. N. Abrams, 1986.

Augustin 1993
Augustin, Bernd. "Arms." In Hamburg 1993, pp. 182–225.

Augustin 2009
Augustin, Bernd. "Persische Blumen erblühen in Indien: Das Werk des Muhammad Baqir Maschhadi; Klingen- und Goldschmiedekunst in Delhi unter Safdar Jang Bahadur." *Indo-asiatische Zeitschrift: Mitteilungen der Gesellschaft für Indo-Asiatische Kunst* 13 (2009), pp. 99–121.

Auld 2004
Auld, Sylvia. *Renaissance Venice, Islam and Mahmud the Kurd: A Metalworking Enigma.* London: Altajir World of Islam Trust, 2004.

Aydın 2007
Aydın, Hilmi. *Sultanların silahları: Topkapı Sarayı Silah Kolleksiyonu.* T. C. Kültür ve Turizm Bakanlığı, Kütüphaneler ve Yayımlar Genel Müdürlüğü 3099, Sanat Eserleri Dizisi 464. Ankara: T. C. Kültür ve Turizm Bakanlığı, Kütüphaneler ve Yayımlar Genel Müdürlüğü, 2007.

Azarpay 1981
Azarpay, Guitty. *Sogdian Painting: The Pictorial Epic in Oriental Art.* With contributions by A. M. Belenitskii, Mark J. Dresden, and B. I. Marshak. Berkeley: University of California Press, 1981.

Babinger 1978
Babinger, Franz. *Mehmed the Conqueror and His Time.* Edited by William C. Hickman. Translated by Ralph Manheim. Bollingen Series 96. Princeton: Princeton University Press, 1978.

Babinger and Bosworth 1995
Babinger, Franz, and C[lifford]. E[dmund]. Bosworth. "Padishah." In *Encyclopaedia of Islam, New Edition,* edited by C[lifford]. E[dmund]. Bosworth., E. van Donzel, W. P. Heinrichs, and G. Lecomte, vol. 8, p. 237. 2nd ed. Leiden: Brill, 1995.

Bailly-Pommery & Voutier Associés, Paris 2010
Militaria souvenirs historiques, ordres de chevalerie, armes blanches et armes à feu du XVIIe au XIXe siècle, médailles. Sale cat., Bailly-Pommery & Voutier Associés, Paris, November 8, 2010.

Baladhuri 1959
Baladhuri, Ahmad ibn Yahya. *Ansab al-ashraf.* Dhakha'ir al-'Arab 27. Cairo: Dar al-Ma'arif, 1959.

Bala Krishnan and Shushil Kumar 1999
Bala Krishnan, Usha R[amamrutham]., and Meera Shushil Kumar. *Dance of the Peacock: Jewellery Traditions of India.* Mumbai: India Book House, 1999.

Bálint 1989
Bálint, Csanád. *Die Archäologie der Steppe: Steppenvölker zwischen Volga und Donau vom 6. bis zum 10. Jahrhundert.* Edited by Falko Daim. Vienna and Cologne: Böhlau, 1989.

Balsiger and Kläy 1992
Balsiger, Roger N., and Ernst J. Kläy. *Bei Schah, Emir und Khan: Henri Moser Charlottenfels, 1844–1923.* Schaffhausen: Meier, 1992.

Baltimore and other cities 1990–92
Islamic Art and Patronage: Treasures from Kuwait. Exh. cat., Walters Art Gallery, Baltimore, and other venues, 1990–92. New York: Rizzoli, 1990. Catalogue edited by Esin Atıl.

Barrett 1949
Barrett, Douglas [E]. *Islamic Metalwork in the British Museum.* London: Trustees of the British Museum, 1949.

Barrett and Gray 1978
Barrett, Douglas E., and Basil Gray. *Indian Painting.* Geneva: Skira; London: Macmillan, 1978.

Bartol'd 1958
Bartol'd, V[asilii]. [Vladimirovich]. *Turkestan down to the Mongol Invasion.* 2nd ed. Translated and revised by the author with H. A. R. Gibb. E. J. W. Gibb Memorial Series 5. London: Luzac and Co., 1958.

Bartol'd and Golden 1978
Bartol'd, V[asilii]. [Vladimirovich], and P. B. Golden. "Khazar." In *Encyclopaedia of Islam, New Edition,* edited by C[lifford]. E[dmund]. Bosworth, E. van Donzel, B[ernard]. Lewis, and Ch. Pellat, vol. 4, pp. 1172–81. 2nd ed. Leiden: Brill, 1978.

Batur 1984
Batur, Sabahattin. "Tombak üstüne bir araştırma." *Sanat dünyamız* [Our art world] 10, no. 31 (1984), pp. 19–29.

Beardmore 1845
Beardmore, John. *A Catalogue with Illustrations of the Collection of Ancient Arms and Armour, at Uplands, near Fareham, Hampshire.* London: T. and W. Boone, 1845.

Behrens-Abouseif 2014
Behrens-Abouseif, Doris. *Practising Diplomacy in the Mamluk Sultanate: Gifts and Material Culture in the Medieval Islamic World.* Library of Middle East History 44. London: I. B. Tauris, 2014.

Birge 1937
Birge, John Kingsley. *The Bektashi Order of Dervishes.* Luzac's Oriental Religions 7. London: Luzac and Co.; Hartford, Conn.: Hartford Seminary Press, 1937.

Bishop Collection [1902]
The Heber R. Bishop Collection of Jade and Other Hard Stones. Hand-Book 10. New York: MMA, [1902].

Bishop Collection 1906
The Bishop Collection: Investigations and Studies in Jade. 2 vols. New York: Privately printed [De Vinne Press], 1906.

Blackmore 1965
Blackmore, Howard L. *Guns and Rifles of the World.* London: B. T. Batsford, 1965.

Blair 1968
Blair, Claude. *Pistols of the World.* London: B. T. Batsford, 1968.

Bloomington 1970
Islamic Art across the World: An Exhibition. Exh. cat. Bloomington: Indiana University Art Museum, 1970. Catalogue by Theodore [Robert] Bowie.

Bobrovnitskaia et al. 1988
Bobrovnitskaia, I[rina]. [Akimovna], et al. *Gosudarstvennaia Oruzheinaia palata* [The armoury in the Moscow Kremlin]. Moscow: Sov. Khudozhnik, 1988.

Boccia 1991
Boccia, Lionello Giorgio. *L'armeria del Museo civico medievale di Bologna.* Busto Arsizio: Bramante, 1991.

Boccia and Godoy 1985–86
Boccia, Lionello G., and José A. Godoy. *Museo Poldi Pezzoli: Armeria.* 2 vols. Museo Poldi Pezzoli 5–6. Milan: Electa Editrice, 1985–86.

Bocheński 1971
Bocheński, Zbigniew. "The 'Bekhter,' a Body Armour of Plates and Mail, Poznań 1580, and Its Typology." *Studia i materiały do dziejów dawnego uzbrojenia i ubioru wojskowego* 5 (1971), pp. 5–56 (includes English summary, pp. 53–56).

Born 1942
Born, Wolfgang. "Ivory Powder Flasks from the Mughal Period." *Ars Islamica* 9 (1942), pp. 93–111.

Boston 1899
Exhibition of Arms and Armor. Exh. cat. Boston: Museum of Fine Arts; Alfred Mudge and Son, 1899.

Bosworth 1973
Bosworth, Clifford Edmund. *Ghaznavids: Their Empire in Afghanistan and Eastern Iran 994:1040.* Beirut: Librairie du Liban, 1973.

Bosworth 2004
Bosworth, Clifford Edmund. *The New Islamic Dynasties: A Chronological and Genealogical Manual.* Edinburgh: Edinburgh University Press, 2004.

Bottomley 2002
Bottomley, Ian. "A Tentative Classification of Indian Matchlock Guns." *Royal Armouries Yearbook* 7 (2002), pp. 77–83.

Bottomley and Stallybrass 2000
Bottomley, Ian, and Helen Bowstead Stallybrass. "Galvanized Indian Mail." *Royal Armouries Yearbook* 5 (2000), pp. 133–38.

Bowen 1960
Bowen, H[arold]. "'Ali Pasha Tepedelenli." In *Encyclopaedia of Islam, New Edition,* edited by B[ernard]. Lewis, Ch. Pellat, and J. Schacht, vol. 1, pp. 398–99. 2nd ed. Leiden: Brill; London: Luzac and Co., 1960.

Bradford and London 1988–89
A Golden Treasury: Jewellery from the Indian Subcontinent. Exh. cat., Bradford Art Galleries and Museums and Zamana Gallery, London, 1988–89. New York: Rizzoli in association with the Victoria and Albert Museum, London, and Grantha Corp., 1988. Catalogue by Susan Stronge, Nima Smith, and J. C. Harle.

Brooklyn 1998–99
Royal Persian Paintings: The Qajar Epoch, 1785–1925. Exh. cat., 1998–99. Brooklyn: Brooklyn Museum of Art in association with I. B. Tauris, 1998. Catalogue edited by Layla S. Diba with Maryam Ekhtiar.

Bruhn de Hoffmeyer 1981
Bruhn de Hoffmeyer, Ada. *Arms and Armour in Spain: A Short Survey.* Vol. 2, *From the End of the 12th Century to the Beginnings of the 15th Century.* Gladius 1981. Madrid: Instituto de Estudios sobre Armas Antiguas, Consejo Superior de Investigaciones Científicas, Patronato Menendez y Pelayo, 1981 (pub. 1982).

al-Bukhari 1987
al-Bukhari, Muhammad bin Isma il. *Sahih al-Bukhar.* Edited by Muhammad Muhsin Khan. 9 vols. New Delhi: Kitab Bhavan, 1987.

Bukowskis, Stockholm 1920
Förteckning över Greve Kellers samling av orientaliska och europeiska vapen. Sale cat., Aktiebolaget H. Bukowskis Konsthandel, Stockholm, March 5, 1920.

Bukowskis, Stockholm 1937
Oljemålingar, möbler, keramik, europeisk och orientalisk, glas, silver, guld och bijouterier, textilier, tenn, akvareller, etsningar, gravyrer, vapen. Sale cat., H. Bukowskis Konsthandel, Stockholm, December 15, 1937.

Bullock 1947
Bullock, Randolph. "Oriental Arms and Armor." *MMAB,* n.s., 5, no. 6 (February 1947), pp. 169–72.

Burnes 1831
Burnes, James. *A Narrative of a Visit to the Court of Sinde: A Sketch of the History of Cutch, from Its First Connexion with the British Government in India till the Conclusion of the Treaty of 1819; and Some Remarks on the Medical Topography of Bhooj.* Edinburgh: R. Cadell, 1831.

Burton-Page 1965
Burton-Page, J[ohn]. "Durbash." In *Encyclopedia of Islam, New Edition,* edited by B[ernard]. Lewis, Ch. Pellat, and J. Schacht, vol. 2, pp. 627–28. 2nd ed. Leiden: Brill; London: Luzac and Co., 1965.

Canard 1951
Canard, M[arius]. "Le Cérémonial fatimite et le cérémonial byzantin: Essai de comparaison." *Byzantion* 21, no. 2 (1951), pp. 355–420.

Canby 2014
Canby, Sheila R. *Shahnama of Shah Tahmasp: The Persian Book of Kings.* New York: MMA, 2014.

Carswell 1982
Carswell, John. "Ceramics." In Petsopoulos 1982, pp. 73–119.

Catalogue de la collection d'armes anciennes 1933
Catalogue de la collection d'armes anciennes européennes et orientales de Charles Buttin. Rumilly: [Bellegarde, Imp. Sadag], 1933.

Cederström 1912–14
Cederström, Rudolf. "Literatur; Sammlung Henri Moser-Charlottenfels: Orientalische Rüstungen und Waffen (Liepzig, 1912)." *Zeitschrift für historisch Waffenkunde* 6, no. 6 (1912–14), pp. 221–22.

Chirkov 1971
Chirkov, D. *Dekorativnoe iskusstvo Dagestana/L'Art décoratif du Daguestan/Daghestan Decorative Art.* With introduction by Rasula Gamzatova. Moscow: Sov. Khudozhnik, 1971.

Christie, Manson and Woods, London 1888
Valuable and Extensive Collection of Armour and Arms, Carvings in Ivory, Celtic and Saxon Antiquities, &c., of the Right Hon. Earl of Londesborough. Sale cat., Christie, Manson and Woods, London, July 4–6, 9–11, 1888.

Christie, Manson and Woods, London 1914
Decorative Furniture and Porcelain. Sale cat., Christie, Manson and Woods, London, April 23, 1914.

Christie, Manson and Woods, London 1919
Arms and Armour [Wetherly Collection]. Sale cat., Christie, Manson and Woods, London, July 29–30, 1919.

Christie, Manson and Woods, London 1920
Collection of Arms and Armour and Objects of Art Formed by Sir Guy Francis Laking. Sale cat., Christie, Manson and Woods, London, April 19–22, 1920.

Christie, Manson and Woods, London 1921a
Collection of Arms and Armour, Early English Oak, and Tapestry Formed by Morgan. S[tuart]. Williams, Esq. Sale cat., Christie, Manson and Woods, London, April 26–28, 1921.

Christie, Manson and Woods, London 1921b
Catalogue of the Collection of Arms and Armour Formed Early in the 19th Century by the Late John Beardmore, Esq. of Uplands, near Fareham, Hants and Now Sold by Order of Colonel H. Carey Batten, O. B. E. of Abbott's Leigh, Bristol. Sale cat., Christie, Manson and Woods, London, July 5, 1921.

Christie, Manson and Woods, London 1975
Fine Antique Arms: The Properties of the Hon. Mrs. A. Bromley-Martin, the Lord Montagu of Beaulieu, and from Various Sources. Sale cat., Christie, Manson and Woods, London, October 13, 1975.

Christie's London 1986
Antique Arms and Armour. Sale cat., Christie's London, October 29, 1986.

Christie's London 1994
Important 19th Century Orientalist Pictures and Watercolours. Sale cat., Christie's London, November 17, 1994.

Christie's London 2000
Islamic Art and Manuscripts. Sale cat., Christie's London, April 11, 2000.

Christie's London 2008
Art of the Islamic and Indian Worlds. Sale cat., Christie's London, April 8, 2008.

Christie's London 2013
Art of the Islamic and Indian Worlds. Sale cat., Christie's London, April 25, 2013.

Christie's London 2015
Art of the Islamic and Indian Worlds. Sale cat., Christie's London, April 23, 2015.

Ciuk 2001
Ciuk, Christopher E. "Sword of the Emperor, Emperor of Swords." *Man at Arms* 23, no. 1 (January–February 2001), pp. 42–45.

C. Clarke 1910
Clarke, Casper Purdon. *Arms and Armour at Sandringham: The Indian Collection Presented to King Edward VII When Prince of Wales, on the Occasion of His Visit to India in 1875–1876; Also Some Asiatic, African and European Weapons.* London: Griggs, 1910.

Copenhagen 1982
Islamiske våben i dansk privateje/Islamic Arms and Armour from Private Danish Collections. Exh. cat., David Collection, Copenhagen. Copenhagen: Udstilling på Davids Samling, 1982. Catalogue by André Leth.

Copenhagen 1996
Sultan, Shah, and Great Mughal: The History and Culture of the Islamic World. Exh. cat. Copenhagen: Nationalmuseet, 1996.

Corbin 1983
Corbin, Henry. *Cyclical Time and Ismaili Gnosis.* London and Boston: Kegan Paul International in association with Islamic Publications Ltd., 1983.

Cosson 1901
Cosson, Charles Alexander, baron de. *Le Cabinet d'armes de Maurice de Talleyrand-Périgord, duc de Dino.* Paris: E. Rouveyre, 1901.

Craddock and Lang 2004
Craddock, P. T., and J. Lang. "Crucible Steel–Bright Steel." *Historical Metallurgy* 38, no. 1 (2004), pp. 35–46.

Dam-Mikkelsen and Lundbaek 1980
Dam-Mikkelsen, Bente, and Torben Lundbaek, eds. *Etnografiske genstande i Det kongelige danske Kunstkammer, 1650–1800/Ethnographic Objects in The Royal Danish Kunstkammer, 1650–1800.* Nationalmuseets Skrifter, Etnografisk Række 17. Copenhagen: Nationalmuseet, 1980.

Davidson 1962
Davidson, H[ilda]. R[oderick]. Ellis. *The Sword in Anglo-Saxon England: Its Archaeology and Literature.* Oxford: Clarendon Press, 1962.

Dean 1905
Dean, Bashford. *Catalogue of European Arms and Armor.* Hand-Book 15. New York: MMA, 1905.

Dean 1915
Dean, Bashford. *Handbook of Arms and Armor: European and Oriental, Including the William H. Riggs Collection.* New York: MMA, 1915.

Dean 1923a
Dean, Bashford. "Notes: Gem-Encrusted Arms." *MMAB* 18, no. 10, pt. 1 (October 1923), pp. 237–38.

[Dean] 1923b
[Dean, Bashford.] "Recent Accessions: Gem-Encrusted Arms." *MMAB* 18, no. 12 (December 1923), p. 287.

Dean 1929
Dean, Bashford. *Catalogue of European Daggers: Including the Ellis, de Dino, Riggs, and Reubell Collections.* New York: MMA, 1929.

Dekmejian 1987
Dekmejian, R. Hrair. "Charismatic Leadership in Messianic and Revolutionary Movements: The Mahdi (Muhammad Ahmad) and the Messiah (Shabbatai Sevi)." In *Religious Resurgence: Contemporary Cases in Islam, Christianity, and Judaism,* edited by Richard T. Antoun and Mary Elaine Hegland, pp. 78–107. Syracuse, N.Y.: Syracuse University Press, 1987.

Del Bonta 1999
Del Bonta, Robert J. "Reinventing Nature: Mughal Composite Animal Painting." In *Flora and Fauna in Mughal Art,* edited by Som Prakesh Verma, pp. 69–82. Mumbai: J. J. Bhabha for Marg Publications on behalf of National Centre for the Performing Arts, 1999.

Denny 1974
Denny, Walter, B. "A Group of Silk Islamic Banners." *Textile Museum Journal* 4, no. 1 (December 1974), pp. 67–81.

Deny 1995
Deny, J. "Pasha." In *Encyclopaedia of Islam, New Edition,* edited by C[lifford]. E[dmund]. Bosworth, E. van Donzel, W. P. Heinrichs, and G. Lecomte, vol. 8, p. 237. 2nd ed. Leiden: Brill, 1995.

Derman 1976
Derman, M. Uğur. "Hat sanatında Türklerin yeri" [The Turks and the art of calligraphy]. In *Islâm sanatında Türkler* 1976, pp. 52–56.

Diessl 1981
Diessl, Wilhelm G. "Die orientalischen Helme des OÖ. Landesmuseum in Linz." *Jahrbuch des Oberösterreichischer Musealvereines, Gesellschaft für Landeskunde* 126, no. 1 (1981), pp. 111–47.

Dimand 1930
Dimand, M[aurice]. S[ven]. *A Handbook of Mohammedan Decorative Arts.* 1st ed. New York: MMA, 1930.

Dimand 1944
Dimand, M[aurice]. S[ven]. *A Handbook of Muhammadan Art.* 2nd ed. New York: MMA, 1944.

Dimand 1958
Dimand, M[aurice]. S[ven]. *A Handbook of Muhammadan Art.* 3rd ed. New York: MMA, 1958.

Dimand and Mailey 1973
Dimand, M[aurice]. S[ven]., and Jean Mailey. *Oriental Rugs in The Metropolitan Museum of Art.* New York: MMA, 1973.

Ditler 1961
Ditler, P. A. "Mogil'nik v rajone poselka Kolosovka na reke Fars." *Sbornik materialov po archeologii Adygei* 2 (1961), pp. 127–87.

Doha 2002
Metalwork Treasures from the Islamic Courts. Exh. cat., Marriott Gulf Hotel, Doha, Qatar. Doha: Museum of Islamic Art; London: Islamic Art Society, 2002. Catalogue by James W. Allan with contribution by Francis Maddison.

Dresden 1995
Im Lichte des Halbmonds: Das Abendland und der türkische Orient. Exh. cat., Staatliche Kunstsammlung, Dresden. Dresden: Staatliche Kunstsammlung; Bonn: Kunst- und Ausstellungshalle der Bundesrepublik Deutschland; Leipzig: Edition Leipzig, 1995. Catalogue essays by Holger Schuckelt et al.

Dubois, Paris 1825
Catalogue des antiquités, armures, armes, drapeaux et guidons; Sculptures en bronze, en ivoire, en marbre, et en albatre; Tableaux, émaux, et vitraux peints, etc., etc., qui composaient la collection de feu M. le baron Percy. Sale cat., L. J. J. Dubois [and Boucher], Paris, June 15, 1825.

"Edward C. Moore Collection" 1892
"The Edward C. Moore Collection." *Collector* 3, no. 13 (May 1, 1892), pp. 199–201.

Egerton 1880
Egerton, Wilbraham. *An Illustrated Handbook of Indian Arms: Being a Classified and Descriptive Catalogue of the Arms Exhibited at the India Museum; With an Introductory Sketch of the Military History of India.* London: W. H. Allen, 1880.

Egerton 1896
Egerton, Wilbraham. *A Description of Indian and Oriental Armour: Illustrated from the Collection Formerly in the India Office, Now Exhibited at South Kensington, and the Author's Private Collection; With an Introductory Sketch of the Military History of India.* London: W. H. Allen, 1896.

Ekhtiar et al. 2011
Ekhtiar, Maryam D., Pricilla P. Soucek, Sheila R. Canby, and Navina Najat Haidar, eds. *Masterpieces from the Department of Islamic Art in The Metropolitan Museum of Art.* New York: MMA, 2011.

Elgood 1979
Elgood, Robert, ed. *Islamic Arms and Armour.* London: Scolar Press, 1979.

Elgood 1994
Elgood, Robert. *The Arms and Armour of Arabia in the 18th–19th and 20th centuries.* Aldershot, U.K.:

Scolar Press; Brookfield, Vt.: Ashgate Publishing Company, 1994.

Elgood 1995
Elgood, Robert. *Firearms of the Islamic World in the Tareq Rajab Museum, Kuwait.* London: I. B. Tauris, 1995.

Elgood 2004a
Elgood, Robert. *Hindu Arms and Ritual: Arms and Armour from India, 1400–1865.* Delft: Eburon, 2004.

Elgood 2004b
Elgood, Robert. "Mughal Arms and the Indian Court Tradition." In *Jewelled Arts of Mughal India: Papers of the Conference Held Jointly by the British Museum and the Society of Jewellery Historians at The British Museum, London in 2001,* edited by Beatriz Chadour-Sampson and Nigel Israel, pp. 76–98. Jewellery Studies 10. London: Society of Jewellery Historians, 2004.

Elgood 2015
Elgood, Robert. *Arms and Armour at the Jaipur Court: The Royal Collection.* New Delhi: Niyogi Books, 2015.

Elliot 1872
Elliot, Henry Miers. *The History of India, As Told by Its Own Historians.* Vol. 4, *The Muhammedan Period.* Edited by John Dowson. London: Trübner, 1872.

"Elmhurst" 1902
"'Elmhurst,' a Hudson River Home: Mr. Giovanni P. Morosini's Residence at Riverdale is a Museum of War and Art Trophies." *Town and Country,* August 9, 1902, pp. 10–13.

Elwell-Sutton 1979
Elwell-Sutton, L. P. "Persian Armour Inscriptions." In Elgood 1979, pp. 5–19.

Esin 1968
Esin, Emel. "The Hunter Prince in Turkish Iconography." In *Die Jagd bei den altaischen Völkern; Vorträge der VIII. Permanent International Altaistic Conference vom 30. 8. bis 4. 9. 1965 in Schloss Auel,* pp. 18–76. Asiatische Forschungen 26. Wiesbaden: O. Harrassowitz, 1968.

Esin 1970
Esin, Emel. "'Ay-Bitiği': The Court Attendants in Turkish Iconography." *Central Asiatic Journal* 14, nos. 1–3 (1970), pp. 78–117.

Esin 1974
Esin, Emel. "L'Arme zoomorphe du guerrier turc (Etude iconographique)." In *Sprache, Geschichte und Kultur der altaischen Völker: Protokollband der XII. Tagung der Permanent International Altaistic Conference 1969 in Berlin,* edited by Georg Hazai and Peter Zieme, pp. 193–217. Schriften zur Geschichte und Kultur des Alten Orients 5. Berlin: Akademie-Verlag, 1974.

Ettinghausen 1952
Ettinghausen, Richard. "The 'Beveled Style' in the Post-Samarra Period." In *Archaeologica Orientalia*

in memoriam Ernst Herzfeld, edited by George C[arpenter]. Miles, pp. 72–83. Locust Valley, N.Y.: J. J. Augustin, 1952.

Ettinghausen 1954
Ettinghausen, Richard. "Notes on the Lusterware of Spain." *Ars Orientalis* 1 (1954), pp. 133–56.

Ettinghausen 1961
Ettinghausen, Richard. "Turkish Elements on Silver Objects of the Seljuk Period of Iran." In *First International Congress of Turkish Arts, Ankara, 19–24 Oct. 1959: Communications Presented to the Congress,* pp. 128–33. Ankara: s.n., 1961.

Ettinghausen 1963
Ettinghausen, Richard. "Chinese Representations of Central Asian Turks." In Oktay Aslanapa, *Beiträge zur Kunstgeschichte Asiens: In Memoriam Ernst Diez,* pp. 208–22. İstanbul Üniversitesi, Sanat Tarihi Enstitüsü, Yagin 1. Istanbul: [İstanbul Üniversitesi Edebiyat Fakültesi], 1963.

Ettinghausen 1971
Ettinghausen, R[ichard]. "Hilal." In *Encyclopaedia of Islam, New Edition,* edited by B[ernard]. Lewis, V. L. Mènage, Ch. Pellat, and J. Schacht, vol. 3, pp. 379–85. 2nd ed. Leiden: Brill; London: Luzac and Co., 1971.

Ettinghausen 1972
Ettinghausen, Richard. *From Byzantium to Sasanian Iran and the Islamic World: Three Modes of Artistic Influence.* L. A. Mayer Memorial Studies in Islamic Art and Archaeology 3. Leiden: Brill, 1972.

Eudel 1902
Eudel, Paul. *L'Orfévrerie algérienne et tunisienne.* Algiers: A. Jourdan, 1902.

Evans 1922
Evans, Joan. *Magical Jewels of the Middle Ages and the Renaissance, Particularly in England.* Oxford: Clarendon Press, 1922.

Faris and Elmer 1945
Faris, Nabih Amin, and Robert Potter Elmer, trans., eds. *Arab Archery: An Arabic Manuscript of about A.D. 1500, "A Book on the Excellence of the Bow and Arrow" and the Description Thereof.* Princeton: Princeton University Press, 1945.

Fehér 1975
Fehér, Géza. *Craftsmanship in Turkish-Ruled Hungary.* Translated by Lili Halápy. Budapest: Corvina, 1975.

Fekete 1977
Fekete, Lajos. *Einführung in die Persische Paläographie: 101 persische Dokumente.* Translated by Lajos Fekete and M. Lorenz. Budapest: Akadémiai Kiadó, 1977.

Ferrandis Torres 1943
Ferrandis Torres, J[osé]. "Espadas granadinas de la jineta." *Archivo español de arte* 16 (1943), pp. 142–66.

Figiel 1991
Figiel, Leo S. *On Damascus Steel.* Atlantis, Fla.: Atlantis Arts Press, 1991.

Fillitz 1971
Fillitz, Hermann. *Katalog der Weltlichen und der Geistlichen Schatzkammer.* Kunsthistorisches Museum Wien, Führer durch das Kunsthistorische Museum 2. Vienna: Kunsthistorisches Museum, 1971.

***Fine Antique Arms and Armour* 2008**
Fine Antique Arms and Armour and Related Objects. London: Peter Finer, 2008.

Firestone 1999
Firestone, Reuven. *Jihad: The Origin of Holy War in Islam.* New York: Oxford University Press, 1999.

Fleischhauer 1976
Fleischhauer, Werner. *Die Geschichte der Kunstkammer der Herzöge von Württemberg in Stuttgart.* Veröffentlichungen der Kommission für Geschichtliche Landeskunde in Baden-Württemberg; Reihe B, Forschungen 87. Stuttgart: Kohlhammer, 1976.

Flindt 1979
Flindt, Torben W. "Some Nineteenth Century Arms from Bukhara." In Elgood 1979, pp. 20–29.

Florence 1997–98
Tra Oriente e Occidente: Cento armi dal Museo Stibbert. Exh. cat., Sala d'Arme di Palazzo Vecchio, Florence, 1997–98. Livorno: Sillabe; Florence: Opera Museo Stibbert, 1997.

Florence 2002
Islam: Specchio d'Oriente; Rarità e preziosi nelle collezioni statali fiorentine. Exh. cat., Palazzo Pitti, Florence. Livorno: Sillabe, 2002. Catalogue edited by Giovanna Damiani and Mario Scalini.

Florence 2014
Islam: Armi e armature dalla collezione di Frederick Stibbert. Exh. cat., Museo Stibbert, Florence. Florence: Centro Di, 2014. Catalogue edited by Francesco Civita.

Fraehn 1826
Fraehn, Christian Martin. *Numi Muhammedani: Qui in Academiae Imperialis Scientiarum Petropolitanae museo Asiatico asservantur.* Vol. 1, *Recensionem omnium musei Asiat. numor. Muhammedanorum seu titulos eorum interpretatione auctos continens.* Saint Petersburg: Litteris Academicis, 1826.

I. Fraser 1986
Fraser, Ian H. C. *The Heir of Parham: Robert Curzon, 14th Baron Zouche.* Alburgh, U.K.: Paradigm Press, 1986.

J. Fraser 1825
Fraser, James B[aillie]. *Narrative of a Journey into Khorasan: In the Years 1821 and 1822, Including Some Account of the Countries to the North-East of Persia;*

With Remarks upon the National Character, Government, and Resources of That Kingdom. London: Longman, Hurst, Rees, Orme, Brown, and Green, 1825.

Fukai and Horiuchi 1969–72
Fukai, Shinji, and Kiyoharu Horiuchi. *Taq-i-Bustan.* Vols. 1, 2. The Tokyo University, Iran-Iraq Archaeological Expedition Reports 10, 13. Tokyo: Institute of Oriental Culture, University of Tokyo, 1969–72.

Gabrieli and Scerrato 1979
Gabrieli, Francesco, and Umberto Scerrato. *Gli Arabi in Italia: Cultura, contatti e tradizioni.* Milan: Libri Scheiwiller, 1979.

Gamber 1978
Gamber, Ortwin. *Waffe und Rüstung Eurasiens: Frühzeit und Antike; Ein waffenhistorisches Handbuch.* Bibliothek für Kunst-und Antiquitätenfreunde 51. Brunswick: Klinkhardt & Biermann, 1978.

Gamber and Beaufort 1990
Gamber, Ortwin, and Christian Beaufort with Matthias Pfaffenbichler. *Katalog Der Leibrüstkammer.* Vol. 2, *Der Zeitraum von 1530–1560.* Kunsthistorisches Museum Wien, Führer Durch das Kunsthistorische Museum 39. Vienna: Kunsthistorisches Museum; Busto Arsizio: Bramante, 1990.

Gardet 1960
Gardet, L. "Al-Asma' al-Husna." In *Encyclopaedia of Islam, New Edition,* edited by B[ernard]. Lewis, Ch. Pellat, and J. Schacht, vol. 1, pp. 714–17. 2nd ed. Leiden: Brill; London: Luzac and Co., 1960.

Geneva 1985
Treasures of Islam. Exh. cat., Musée Rath, Geneva. London: Sotheby's; Philip Wilson Publishers; Geneva: Musée d'Art et d'Histoire, 1985. Catalogue edited by Toby Falk.

Geneva 1995
Empire of the Sultans: Ottoman Art from the Collection of Nasser D. Khalili. Exh. cat., Musée Rath, Geneva. Geneva: Musée d'Art et d'Histoire; London: Nour Foundation in association with Azimuth Editions, 1995. Reprinted 1997 by Nour Foundation in association with Azimuth Editions, London. Catalogue by J. M[ichael]. Rogers.

Gérardin 1986
Gérardin, Lucien. *Les Carrés magiques.* Horizons Esotériques. Saint-Jean-de-Braye, France: Dangles, 1986.

al-Ghazali 1983
al-Ghazali, Abu Hamid. *The Jewels of the Qur'an: Al-Ghazali's Theory; A Translation, with Introduction and Annotation of al-Ghazali's "Kitab Jawahir al-Qur'an."* Translated by Muhammad Abul Quasem. London: Kegan Paul International, 1983.

Ghiron 1868
Ghiron, Isaia. *Le iscrizioni arabe della Reale Armeria di Torino.* Florence: Tip. dei Succesoir Le Monnier, 1868.

Gimaret 1988
Gimaret, Daniel. *Les Noms divins en Islam: Exégèse lexicographique et théologique.* Paris: Editions du Cerf, 1988.

Glück and Diez 1925
Glück, Heinrich, and Ernst Diez. *Die Kunst des Islam.* Propyläen-Kunstgeschichte 5. Berlin: Propyläen-Verlag, 1925.

Goncharenko and Narozhnaia 1976
Goncharenko, V., and V[alentina]. [Ivanova] Narozhnaia. *The Armoury Chamber: A Guidebook for the Tourist.* Translated by Natalie Ward. Moscow: Progress, 1976.

Gonzalez 1990
Gonzalez, Valérie. "Les Collections d'oeuvres d'art du métal émaillé hispano-musulman dans les musées mondiaux hors d'Espagne." *Sharq al-Andalus* 7 (1990), pp. 195–202.

Gonzalez 1994
Gonzalez, Valérie. *Emaux d'al-Andalus et du Maghreb.* Aix-en-Provence: Edisud, 1994.

Goodenough 1989
Goodenough, Erwin Ramsdell. *Jewish Symbols in the Greco-Roman Period.* Abridged by Jacob Neusner. Bollingen Series. Princeton: Princeton University Press, 1989. Unabridged ed. 1953–68, 13 vols. by Pantheon Books, New York.

Gorelik 1979
Gorelik, Michael. "Oriental Armour of the Near and Middle East from the Eighth to the Fifteenth Centuries as Shown in Works of Art." In Elgood 1979, pp. 30–63.

Grabar 1955
Grabar, Oleg. "Ceremonial and Art in the Umayyad Court." PhD diss., Princeton University, 1955.

Graefe, Macdonald, and Plessner 1965
Graefe, E., D. B. Macdonald, and M. Plessner. "Djadwal." In *Encyclopaedia of Islam, New Edition,* edited by B[ernard]. Lewis, Ch. Pellat, and J. Schacht, vol. 2, p. 370. 2nd ed. Leiden: Brill; London: Luzac and Co., 1965.

Granada and New York 1992
Al-Andalus: The Art of Islamic Spain. Exh. cat., Alhambra, Granada, Spain; and MMA, New York. New York: MMA, 1992. Catalogue edited by Jerrilynn D. Dodds.

Grancsay 1928
Grancsay, Stephen V[incent]. "A Loan Collection of Oriental Armor." *MMAB* 23, no. 5 (May 1928), pp. 127–29. Reprinted in Grancsay 1986, pp. 26–28.

Grancsay 1930
Grancsay, Stephen V[incent]. "Two Chinese Swords, Dating about A.D. 600." *MMAB* 25, no. 9 (September 1930), pp. 194–96. Reprinted in Grancsay 1986, pp. 69–71.

Grancsay 1933a
Grancsay, Stephen V[incent]. *The Bashford Dean Collection of Arms and Armor in The Metropolitan Museum of Art.* With introduction and bibliographical outline by Carl Otto von Kienbusch. Portland, Maine: Southworth Press for Armor and Arms Club of New York City, 1933.

Grancsay 1933b
Grancsay, Stephen V[incent]. "An East Indian Gun." *MMAB* 28, no. 11 (November 1933), pp. 196–97. Reprinted in Grancsay 1986, pp. 119–21.

Grancsay 1937a
Grancsay, Stephen V[incent]. "The George C. Stone Bequest: Turkish, Balkan, Caucasian and North African Arms and Armor." *MMAB* 32, no. 2 (March 1937), pp. 54–58. Reprinted in Grancsay 1986, pp. 166–70.

Grancsay 1937b
Grancsay, Stephen V[incent]. "The George C. Stone Bequest: Indian and Persian Arms and Armor." *MMAB* 32, no. 7 (July 1937), pp. 162–72. Reprinted in Grancsay 1986, pp. 177–85.

Grancsay 1939
Grancsay, Stephen V[incent]. "The Bequest of Giulia P. Morosini: Arms and Armor." *MMAB* 34, no. 1 (January 1939), pp. 15–19. Reprinted in Grancsay 1986, pp. 222–26.

Grancsay 1949
Grancsay, Stephen V[incent]. "Firearms of the Mediterranean, Conclusion." *American Rifleman* 97, no. 3 (March 1949), pp. 30–33.

Grancsay 1958
Grancsay, Stephen V[incent]. "The New Galleries of Oriental Arms and Armor." *MMAB,* n.s., 16, no. 9 (May 1958), pp. 241–56. Reprinted in Grancsay 1986, pp. 443–63.

Grancsay 1986
Grancsay, Stephen V[incent]. *Arms and Armor: Essays by Stephen V. Grancsay from The Metropolitan Museum of Art Bulletin, 1920–1964.* With biography and complete bibliography by Stuart W. Pyhrr. New York: MMA, 1986.

Gray 1977
Gray, Basil. *Persian Painting.* New York: Rizzoli; Geneva: Skira, 1977.

Gray 1978
Gray, Basil. *The World History of Rashid al-Din: A Study of the Royal Asiatic Society Manuscript.* London: Faber and Faber, 1978.

Grosz and Thomas 1936
Grosz, August, and Bruno Thomas. *Katalog der Waffensammlung in der Neuen Burg: Schausammlung.* Führer durch die Kunsthistorischen Sammlungen in Wien 28. Vienna: Kunsthistorisches Museum, 1936.

Grube 1974
Grube, E[rnst]. J[oseph]. "Notes on the Decorative Arts of the Timurid Period." In *Gururajamañjarika: Studi in onore di Giuseppe Tucci*, vol. 1, pp. 233–79. Naples: Istituto Universitario Orientale, 1974.

Grube 1981
Grube, Ernst Joseph, ed. *Islamic Art I: An Annual Dedicated to the Art and Culture of the Muslim World; Proceedings of the Tenth Colloquy on Art and Archaeology in Asia, Held in London, June 1980*. New York: Islamic Art Foundation, 1981.

Güçkıran 2009
Güçkıran, Tünay. *Askeri müze at zırhları koleksiyonu* [Military Museum collection of horse armor]. Istanbul: Askeri Müze ve Kültür Sitesi Komutanlığı, 2009.

Gundestrup 1991
Gundestrup, Bente. *Det Kongelige danske Kunstkammer, 1737/The Royal Danish Kunstkammer, 1737*. 3 vols. Copenhagen: Nationalmuseet; A. Busck, 1991.

Gutowski 1997
Gutowski, Jacek. *Broń i uzbrojenie Tatarów*. Katalog Zatków Tatarskich Tom 1. Warsaw: Fundacja Res Publica Multiethnica, 1997.

Guy and Swallow 1990
Guy, John, and Deborah Swallow, eds. *Arts of India: 1550–1900*. With contributions by Rosemary Crill, John Guy, Veronica Murphy, Susan Stronge, and Deborah Swallow. London: Victoria and Albert Museum, 1990.

Haldane 1978
Haldane, Duncan. *Mamluk Painting*. Warminster, U.K.: Aris and Phillips, 1978.

Hales 2013
Hales, Robert. *Islamic and Oriental Arms and Armour: A Lifetime's Passion*. Guernsey, U.K.: Robert Hales C. I. Ltd., 2013.

Hamburg 1993
Oriental Splendour: Islamic Art from German Private Collections. Exh. cat. Hamburg: Museum für Kunst und Gewerbe, 1993. Catalogue edited by Claus-Peter Haase, Jens Kröger, and Ursula Lienert.

Hampel 1897–99
Hampel, Josef. "Der sogenannte Säbel Karls des Grossen." *Zeitschrift für Historische Waffenkunde* 1, no. 2 (1897–99), pp. 45–49.

Harper 1985
Harper, Prudence Oliver. "The Ox-Headed Mace in Pre-Islamic Iran." In *Papers in Honour of Professor Mary Boyce*, pp. 247–59. Acta Iranica 24; Deuxième Série, Hommages et Opera Minora 10. Leiden: Brill, 1985.

Hasson 1987
Hasson, Rachel. *Early Islamic Jewellery*. Jerusalem: L. A. Mayer Memorial Institute for Islamic Art, 1987.

Hauser and Wilkinson 1942
Hauser, Walter, and Charles K. Wilkinson. "The Museum's Excavations at Nishapur." In "The Iranian Expedition, 1938–1940." Special issue, *MMAB* 37, no. 4, (April 1942), pp. 81, 83–119.

Heath 1979
Heath, Ian. *Byzantine Armies, 881–1118*. Men-at-Arms 89. London: Osprey, 1979.

Herberstein 1567
Herberstein, Sigmund, Freiherr von. *Moscouiter wunderbare Historien: In welcher deß treffenlichen Grossen land Reüssen, sampt der hauptstatt Moscauw, und anderer nammhaftigen vmliegenden Fürstenthumb vnd stetten gelegenheit, Religion, vnd seltzame gebreüch. Auch deß erschrocklichen Großfürsten zu Moscauw härkomen, mannliche tathen, gewalt, vnd lands ordnung, auff das fleyßigest ordentlichen begriffen; So alles biß här bey uns in Teütscher nation vnbekandt gewesen*. Basel: Brillinger, 1567.

Hermann Historica, Munich 2008
Ausgesuchte Sammlungsstücke/Selected Historical Objects. Sale cat., Hermann Historica, Munich, October 9, 2008.

Hermann Historica, Munich 2009
Ausgesuchte Sammlungsstücke/Selected Historical Objects. Sale cat., Hermann Historica, Munich, October 8, 2009.

Hermann Historica, Munich 2013
Antiken, Alte Waffen, Jagdliches und Kunsthandwerk/Antiquities, Antique Arms and Armour, Hunting Antiques and Works of Art. Sale cat., Hermann Historica, Munich, November 6–8, 2013.

Hermann Historica, Munich 2014
Alte Waffen, Jagdliches und Kunsthandwerk, Antiken/Antique Arms and Armour, Hunting Antiques and Works of Art, Antiquities. Sale cat., Hermann Historica, Munich, November 5–6, 2014.

Hermann Historica, Munich 2015
Alte Waffen, Jagdliches und Kunsthandwerk, Antiken/Antique Arms and Armour, Hunting Antiques and Works of Art, Antiquities. Sale cat., Hermann Historica, Munich, May 4–5, 2015.

Herodotus 1942
Herodotus. *The Persian Wars*. Translated by George Rawlinson. With introduction by Francis R. B. Gololphin. New York: Modern Library, 1942.

Herz 1910
Herz, Max. "Armes et armures arabes." *Bulletin de l'Institut français d'archéologie orientale* (Cairo) 7 (1910), pp. 1–14.

Herzfeld 1927
Herzfeld, Ernst. *Die malereien von Samarra*. Ausgrabungen von Samarra 3. Berlin: D. Reimer, 1927.

Hewitt 1859
Hewitt, John. *Official Catalogue of the Tower Armories*. London: Eyre, 1859.

Hildburg 1941
Hildburg, W. L. "A Hispano-Arabic Silver-Gilt and Crystal Casket." *Antiquaries Journal* 21, no. 3 (July 1941), pp. 211–31.

Holt 1958
Holt, P[eter]. M[alcolm]. *The Mahdist State in the Sudan, 1881–1898*. Oxford: Clarendon Press, 1958.

Hôtel Drouot, Paris 1888
Catalogue des objets d'art de l'orient et de l'occident, tableaux, dessins composant la collection de feu M. Albert Goupil. Sale cat., Hôtel Drouot, Paris, April 23–28, 1888.

Huart and Sadan 1986
Huart, Cl., and J. Sadan. "Kursi." In *Encyclopaedia of Islam, New Edition*, edited by C[lifford]. E[dmund]. Bosworth, and E. van Donzel, vol. 5, p. 509. 2nd ed. Leiden: Brill, 1986.

Iakubovskii and Diakonov 1954
Iakubovskii, A[leksandr]. Iu[r'evich]., and M[ikhail]. M[ikhailovich]. Diakonov. *Zhivopis' drevnego Piandzhikenta* [Painting of ancient Panjakent]. Moscow: Izd-vo Akademii nauk SSSR, 1954.

Ibn al-ʿArabi 1975
Ibn al-ʿArabi. *The Wisdom of the Prophets/Fusus al-Hikam*. Translated from Arabic to French with notes by Titus Burckhardt. Translated from French to English by Angela Culme-Seymour. Aldsworth, U.K.: Beshara, 1975.

Ibn al-ʿArabi 1978
Ibn al-ʿArabi. *The Tarjumán al-Ashwáq: A Collection of Mystical Odes*. Edited by Reynold A. Nicholson. With new preface by Martin Lings. London and Wheaton, Ill.: Theosophical Publishing House, 1978.

Ibn ʿAtaʾ Allah 1981
Ibn ʿAtaʾ Allah, Ahmad ibn Muhammad. *Traité sur le nom Allah* [Qasd al-mujarrad fi maʿrifat al-ism al-mufrad]. Translated and with notes and introduction by Maurice Gloton. Paris: Deux Océans, 1981.

Ibn Ishaq 1955
Ibn Ishaq, Muhammad. *The Life of Muhammad: A Translation of Ishaq's* Sirat rasul Allah. With introduction and notes by A[lfred]. Guillaume. London, New York, and Toronto: Oxford University Press, 1955.

Ibn Ishaq 1982
Ibn Ishaq, Muhammad. *Sirat rasul Allah/The Life Of Muhammad*. Edited by ʿAbd al-Malik Ibn Hisham. Translated and annotated by A[lfred]. Guillaume. Oxford: Oxford University Press, 1982.

Ibn Iyas 1985
Ibn Iyas. *Alltagsnotizen eines ägyptischen Bürgers*. Translated and edited by Annemarie Schimmel. Bibliothek Arabischer Klassiker 13. Stuttgart: Edition Erdmann, 1985.

Ibn Saʿd 1967
Ibn Saʿd, Muhammad. *Kitab al-tabaqat al-kabir* [The great book of strata]. Vol. 1. Translated by S[yed]. Moinul Haq with H. K. Ghazanfar. Pakistan Historical Society Publication 46. Karachi: Pakistan Historical Society, 1967.

Inalcık 1970
Inalcık, Halil. "The Rise of the Ottoman Empire." In *The Cambridge History of Islam*, edited by P. M. Holt, Ann K. S. Lambton, and Bernard Lewis, vol. 1, pp. 295–323. Cambridge, U.K.: Cambridge University Press, 1970.

Indianapolis 1970–71
Treasures from the Metropolitan: Catalogue of the Inaugural Exhibition of the Indianapolis Museum of Art. Exh. cat., 1970–71. Indianapolis: Indianapolis Museum of Art, 1970. Catalogue by Carl J. Weinhardt.

Islamic World 1987
The Islamic World. With introduction by Stuart Cary Welch. The Metropolitan Museum of Art 11. New York: MMA, 1987.

Islâm sanatında Türkler 1976
Islâm sanatında Türkler/The Turkish Contribution to Islamic Arts. Translated by Adair Mill, Maggi Quigley, and Graham Clarke. Istanbul: Binbirdirek Matbaacılık Sanayii A. Ş., 1976.

Istanbul 1983
The Anatolian Civilisations. Vol. 3, *Seljuk/Ottoman.* Exh. cat., Topkapı Sarayı Museum, Istanbul. Istanbul: Turkish Ministry of Culture and Tourism, 1983. Catalogue by Serap Aykoç, Filiz Çağman, and Nazan Tapan. Translated by Esin Atıl.

Istanbul 1987
Türk Maden Sanatı/The Art of Turkish Metalworking. Exh. cat., Hagia Irene, Istanbul. Istanbul: Türk Kültürüne Hizmet Vakfı, 1987. Catalogue by Fulya Bodur.

Istanbul 2008
Askeri Müze bayraklar ve sancaklar koleksiyonu. Exh. cat. Istanbul: Askeri Müze ve Kültür Sitesi Komutanlığı, 2008. Catalogue by İlkay Karatepe.

Istanbul 2010
Topkapi Palace Museum: Arms Collection. Exh. cat. Istanbul: Turkish Republic, Ministry of Culture and Tourism, General Directorate for Cultural Heritage and Museums; Topkapı Palace Museum, 2010. Catalogue by Ahmet Ayhan.

Ivanov 1979
Ivanov, A[natol]. "A Group of Iranian Daggers of the Period from the Fifteenth Century to the Beginning of the Seventeenth, with Persian Inscriptions." In Elgood 1979, pp. 64–77.

Jaeckel 1970
Jaeckel, Peter. "Türkische Kopfbedeckungen in mitteleuropäischen Museen." *Waffen- und Kostümkunde* 12, no. 1 (1970), pp. 1–18.

Jaffer 2013
Jaffer, Amin, ed. *Beyond Extravagance: A Royal Collection of Gems and Jewels.* With essays by Vivienne Becker, Jack Ogden, Katherine Prior, Judy Rudoe, Robert Skelton, Michael Spink, and Stephen Vernoit. New York: Assouline, 2013.

Jalal al-Din Rumi 1981
Jalal al-Din Rumi, Maulana. *The Ruins of the Heart: Selected Lyric Poetry of Jelaluddin Rumi.* Translated by Edmund Helminski. 3rd ed. Putney, Vt.: Threshold Books, 1981.

Jenkins-Madina 2000
Jenkins-Madina, Marilyn. "Collecting the 'Orient' at the Met: Early Tastemakers in America." In "Exhibiting the Middle East: Collections and Perceptions of Islamic Art." Special issue, *Ars Orientalis* 30 (2000), pp. 69–89.

Jerusalem 1976
Islamic Coins/Matbeʿot Islamiyim. Exh. cat. Jerusalem: L. A. Mayer Memorial Institute for Islamic Art, 1976. Catalogue by Ariel Berman.

Jewellery through 7,000 Years 1976
Jewellery through 7,000 Years. With introduction by Hugh Tait. London: British Museum Publications, 1976.

Jodidio 2008
Jodidio, Philip. *Museum of Islamic Art: Doha, Qatar.* Munich and New York: Prestel, 2008.

Joinville and Villehardouin 1963
Joinville, Jean, sire de, and Geoffroi de Villehardouin. *Chronicles of the Crusades.* Translated and with introduction by Margaret R[enée]. B[yers]. Shaw. Penguin Classics L124. Baltimore: Penguin Books, 1963.

Kaemmerer 1869
Kaemmerer, Georges de. *Tsarskoselʹskii arsenal, ili, Sobranie oruzhiia/Arsenal de Tsarskoé-Selo, ou, Collection d'armes de sa majesté l'Empereur de toutes les Russies.* Saint Petersberg: s.n., 1869.

Kalmár 1971
Kalmár, János. *Régi magyar fegyverek.* Budapest: Natura, 1971.

Kalus 1980
Kalus, Ludvik. "Inscriptions arabes et persanes sur les armes musulmanes de la Tour de Londres." *Gladius* 15 (1980), pp. 19–78.

Kalus 1981
Kalus, Ludvik. *Catalogue des cachets, bulles et talismans islamiques.* Paris: Bibliothèque Nationale, Département des Monnaies, Médailles et Antiques, 1981.

Kalus 1992
Kalus, Ludvik. "Les Armures des Timourides, des Aqqoyunlus, et des Shirvanshahs." In *Timurid Art and Culture: Iran and Central Asia in the Fifteenth Century*, edited by Lisa Golombek and Maria Subtelny, pp. 158–67. Studies in Islamic Art and Architecture 6. Leiden and New York: Brill, 1992.

Karachi 1999
Treasures of the Talpurs: Collections from the Courts of Sindh. Exh. cat. Karachi: Mohatta Palace Museum, 1999. Catalogue by Nasreen Askari.

Katonah 1980
Islamic Insights: An Introduction to Islamic Art. Exh. cat. Katonah, N.Y.: Katonah Gallery, 1980.

Keene 2004
Keene, Manuel. "The *Kundan* Technique: The Indian Jeweller's Unique Artistic Treasure." In *Arts of Mughal India: Studies in Honour of Robert Skelton*, edited by Rosemary Crill, Susan Stronge, and Andrew Topsfield, pp. 190–202. London: Victoria and Albert Museum; Ahmedabad: Mapin Publishing, 2004.

Kellner-Heinkele 2000
Kellner-Heinkele, Barbara. "Türkmen." In *Encyclopaedia of Islam, New Edition*, edited by P[eri]. J. Bearman, Th. Bianquis, C[lifford]. E[dmund]. Bosworth, E. van Donzel, and W. P. Heinrichs, vol. 10, pp. 682–85. 2nd ed. Leiden: Brill, 2000.

Kerr Fish 1999
Kerr Fish, Elizabeth L. "Edward C. Moore and Tiffany Islamic-Style Silver, c. 1867–1889." *Studies in the Decorative Arts* 6, no. 2 (Spring–Summer 1999), pp. 42–63.

Khalili, B. Robinson, and Stanley 1996–97
Khalili, Nasser D., B[asil]. W[illiam]. Robinson, and Tim Stanley. *Lacquer of the Islamic Lands.* 2 vols. Nasser D. Khalili Collection of Islamic Art 22. London and New York: Nour Foundation in association with Azimuth Editions and Oxford University Press, 1996–97.

al-Kindi 1952
al-Kindi. *As-suyuf wa ajnasuha: A risala/Swords and Their Types: Essay.* Edited by ʿAbd al-Rahman Zaki. Cairo: Fouad I Press, 1952.

Kinsley 1977
Kinsley, David R. *The Sword and the Flute: Kali and Krsna; Dark Visions of the Terrible and the Sublime in Hindu Mythology.* Berkeley: University of California Press, 1977.

Kirpicnikov 1968
Kirpicnikov, Anatolij N. "Die russischen Waffen des 9.–13. Jahrhunderts und orientalistische und westeurpäische Einflüsse auf ihre Entwicklung." *Gladius* 7 (1968), pp. 45–74.

Kirpicnikov 1972
Kirpicnikov, A[natolij]. [N]. "Der sogenannte Säbel Karls des Grossen." *Gladius* 10 (1972), pp. 69–80.

Kirpicnikov 1973
Kirpicnikov, Anatolij N. "Russische Helme aus dem frühen Mittelalter." *Waffen- und Kostümkunde*, 3rd ser., 15, no. 2 (1973), pp. 89–98.

Kister 1983
Kister, M. J. "The Sirah Literature." In *Arabic Literature to the End of the Umayyad Period*, edited by A[lfred]. F[elix]. L[andon]. Beeston, T. M. Johnstone, R. B. Serjeant, and G. R. Smith, pp. 352–67. Cambridge History of Arabic Literature. Cambridge and New York: Cambridge University Press, 1983.

Kler 1957
Kler, P. Josef. "Die Windpferdfahne oder das k'i-mori bei den Ordos-Mongolen." *Oriens* 10, no. 1 (July 31, 1957), pp. 90–106.

Koch 1988
Koch, Ebba. *Shah Jahan and Orpheus: The Pietre Dure Decoration and the Programme of the Throne in the Hall of Public Audiences at the Red Fort of Delhi*. Graz: Akademische Druck- u. Verlagsanstalt, 1988.

Komaroff 1979–80
Komaroff, Linda. "Timurid to Safavid Iran: Continuity and Change." *Marsyas* 20 (1979–80), pp. 11–16.

Kovács and Lovag 1988
Kovács, Eva, and Zsuzsa Lovag. *Die ungarischen Krönungsinsignien*. Translated by Tamás Szántó. 2nd and rev. ed. Budapest: Corvina Kiadó, 1988.

Kramarovsky 1996
Kramarovsky, Mark. "Mongol Horse Trappings in the Thirteenth and Fourteenth Centuries." In Riyadh 1996, vol. 1, pp. 48–53.

Kraus 1986
Kraus, Paul. *Jabir Ibn Hayyan: Contribution à l'histoire des idées scientifiques dans l'Islam; Jabir et la science grecque*. Paris: Les Belles Lettres, 1986.

Kuwait 1990
Bada'i' al-fann al-islami fi-Mathaf al-Harmitaj bi-al-Ittihad al-Sufiyati/Shedevry islamskogo iskusstva v Ermitazhe SSSR/Masterpieces of Islamic Art in the Hermitage Museum. Exh. cat. Kuwait: Dar al-Athar al-Islamiyyah, 1990.

Laking 1914
Laking, Guy Francis. *Wallace Collection Catalogue: Oriental Arms and Armour*. London: Printed for Her Majesty's Stationery Office, 1914. Reprinted 1964 by Wallace Collection, London.

Laking 1920–22
Laking, Guy Francis. *A Record of European Armour and Arms through Seven Centuries*. With introduction by Baron de Cosson. Vols. 2–5, edited by Francis Henry Cripps-Day. 5 vols. London: G. Bell and Sons, 1920–22. Reprinted 2000, 5 vols. by Ken Trotman Ltd., Cambridge, U.K.

Laking 1964
Laking, Guy Francis. *Oriental Arms And Armour*. London: Printed by W. Clowes for the Trustees [of the Wallace Collection], 1964.

Lane 1971
Lane, Arthur. *Later Islamic Pottery: Persia, Syria, Egypt, Turkey*. Revised by Ralph Pinder-Wilson. 2nd ed. London: Faber and Faber, 1971.

La Rocca 2008
La Rocca, Donald J. "Recent Acquisitions of Tibetan and Mongolian Arms and Armor in The Metropolitan Museum of Art." *Waffen- und Kostumkünde*, 3rd ser., 50, no. 2 (2008), pp. 19–32.

Latham and Paterson 1970
Latham, J[ohn]. D[erek]., and W. F. Paterson. *Saracen Archery: An English Version and Exposition of a Mameluke Work on Archery (ca. A.D. 1368)*. London: Holland Press, 1970.

Lavoix 1885
Lavoix, Henri. "La Collection Albert Goupil: L'Art oriental." *Gazette des beaux-arts* 32, per. 2, no. 4 (October 1, 1885), pp. 287–307.

Leavitt, New York 1873
Catalogue of a Private Cabinet of Antiques. Sale cat., Messrs. Leavitt, New York, May 15–17, 1873.

Leavitt, New York 1876
Executor's Sale of the Gates Collection. Sale cat., Messrs. Leavitt, New York, December 21–22, 1876.

Leavitt, New York 1877
Collection of Arms, Armor and Other Objects of Art. Sale cat., Messrs. Leavitt, New York, November 19–21, 1877.

Lebedynsky 2008
Lebedynsky, Iaroslav. *De l'épée scythe au sabre mongol: Les Armes blanches des nomes de la steppe, IXe siècle av. J.-C.–XIXe siècle apr. J.-C.* Paris: Errance, 2008.

Lebrun, Paris 1830
Catalogue des armures et armes diverses: Composant la collection formée originairement par feu M. le baron Percy et complétée par M. Durand. Sale cat., Salle Lebrun, Paris, January 18, 1830.

Leeuwen 2000
Leeuwen, R. van. "Tarabay." In *Encyclopaedia of Islam, New Edition*, edited by P[eri]. J. Bearman, Th. Bianquis, C[lifford]. E[dmund]. Bosworth, E. van Donzel, and W. P. Heinrichs, vol. 10, p. 211. 2nd ed. Leiden: Brill, 2000.

Lenz 1908
Lenz, Eduard von. *Al'bom izobrazenij vydajuscichsja predmetov iz sobranija oruzija/Collection d'armes de l'Ermitage Impérial*. Saint Petersburg: Hermitage, 1908.

Lenz 1912–14
Lenz, Eduard von. "Arsenalzeichen oder Beschau?" *Zeitschrift für Historische Waffenkunde* 6 (1912–14), pp. 299–303.

Lepke's Kunst-Auctions-Haus, Berlin 1925
Griffwaffen aus der Sammlung Max Dreger, Berlin; Europa: Deutsche Degen, Schwerter, Dolche, zwei Hifthörner aus Elfenbein, Jagdbestecke; Orient: Polen, Rumänien, Türkei, Arabien, Kaukasus, Marokko, Indien, Persien, Hinterindien, Mongolei, China, Tibet und Japan; Versteigerung. Sale cat., Rudolf Lepke's Kunst-Auctions-Haus, Berlin, December 8, 1925.

Lewis 1960
Lewis, B[ernard]. " 'Ashik." In *Encyclopaedia of Islam, New Edition*, edited by B[ernard]. Lewis, Ch. Pellat, and J. Schacht, vol. 1, p. 697. 2nd ed. Leiden: Brill; London: Luzac and Co., 1960.

Lewis 1976
Lewis, Bernard. *Islam: From the Prophet Muhammad to the Capture of Constantinople*. 2 vols. London: Macmillan, 1976.

Lexington 2010
A Gift from the Desert: The Art, History and Culture of the Arabian Horse. Exh. cat. Lexington, Ky.: International Museum of the Horse, Kentucky Horse Park, 2010. Catalogue by Sandra L. Olsen and Cynthia Culbertson.

Lings 1978
Lings, Martin. *The Quranic Art of Calligraphy and Illumination*. Boulder, Colo.: Shambhala, 1978.

London 1869
Armour and Miscellaneous Objects of Art, Known as the Meyrick Collection, Lent by Colonel Meyrick of Goodrich Court, Herefordshire and Exhibited at the South Kensington Museum. With introduction by J. R. Planché. Exh. cat., South Kensington Museum [now Victoria and Albert Museum], London. London: George E. Eyre and William Spottiswoode for Her Majesty's Stationery Office, 1869.

London 1875
Londesborough Collection of Arms and Armour: With a Descriptive Account of the Antiquities and Works of Art, the Property of Lord Londesborough. Exh. cat., Alexandra Palace, London. London: Harrison and Sons, 1875. Catalogue by William Chaffers.

London 1931
International Exhibition of Persian Art; Patrons: His Majesty the King, His Majesty Riza Shah Pahlavi. 3rd ed. Exh. cat., Royal Academy of Arts, London. London: Office of the Exhibition, 1931.

London 1976
The Arts of Islam. Exh. cat., Hayward Gallery, London. London: Arts Council of Great Britain, 1976. Catalogue edited by Dalu Jones and George Michell.

London 1982
The Indian Heritage: Court Life and Arts under Mughal Rule. Exh. cat. London: Victoria and Albert Museum, 1982.

London 1988
Süleyman the Magnificent. Exh. cat., British Museum, London. London: British Museum Publications for the Trustees of the British Museum, 1988. Catalogue by J. M[ichael]. Rogers and R[achel]. M. Ward.

London 1990
Tigers round the Throne: The Court of Tipu Sultan (1750–1799). Exh. cat. London: Zamana Gallery, 1990.

London 1991–92
Carlton House: The Past Glories of George IV's Palace. Exh. cat., 1991–92. London: Queen's Gallery, Buckingham Palace, 1991.

London 2002
Indian and Islamic Works of Art. Exh. cat. London: Simon Ray, 2002.

London 2005a
Indian and Islamic Works of Art. Exh. cat. London: Simon Ray, 2005.

London 2005b
Turks: A Journey of a Thousand Years, 600–1600. Exh. cat. London: Royal Academy of Arts, 2005. Catalogue edited by David J. Roxburgh.

London 2009
Global India: Court, Trade and Influence, 1300–1900. London: Francesca Galloway Gallery, 2009.

London and other cities 2001–2
Treasury of the World: Jewelled Arts of India in the Age of the Mughals. Exh. cat., British Museum, London; MMA, New York; Cleveland Museum of Art; Museum of Fine Arts, Houston; and Los Angeles County Museum of Art, 2001–2. New York: Thames and Hudson in association with The al-Sabah Collection, Dar al-Athar al-Islamiyyah, Kuwait National Museum, 2001. Catalogue by Manuel Keene with Salam Kaoukji.

Los Angeles and Hagerstown 1953–55
Mediaeval and Renaissance Arms and Armor from The Metropolitan Museum of Art. Exh. cat. Los Angeles: Los Angeles County Museum, 1953; Hagerstown, Md.: Washington County Museum of Fine Arts, 1955. Catalogue by Stephen V[incent]. Grancsay.

Los Angeles and Houston 2011–12
Gifts of the Sultan: The Arts of Giving at the Islamic Courts. Exh. cat., Los Angeles County Museum of Art; and Museum of Fine Arts, Houston, 2011–12. Los Angeles: Los Angeles County Museum of Art; New Haven: Yale University Press, 2011. Catalogue edited by Linda Komaroff.

Los Angeles and Paris 2010–11
India's Fabled City: The Art of Courtly Lucknow. Exh. cat., Los Angeles County Museum of Art; and Museé Guimet, Paris, 2010–11. Los Angeles: Los Angeles County Museum of Art; Munich and New York: DelMonico Books/Prestel, 2010. Catalogue by Stephen Markel with Tushara Bindu Gude.

Los Angeles and other cities 1989–91
Romance of the Taj Mahal. Exh. cat., Los Angeles County Museum of Art; Toledo Museum of Art, Ohio; Virginia Museum of Fine Arts, Richmond; and Asia Society, New York, 1989–91. London: Thames and Hudson; Los Angeles: Los Angeles County Museum of Art, 1989. Catalogue by Pratapaditya Pal, Janice Leoshko, Joseph M. Dye III, and Stephen Markel.

Louisville 1955
Equestrian Equipment from The Metropolitan Museum of Art. Catalogue 131. Exh. cat. Louisville, Ky.: J. B. Speed Art Museum, 1955. Catalogue by Stephen V[incent]. Grancsay.

H. Lowry 2011
Lowry, Heath W. *Hersekzâde Ahmed Paşa: An Ottoman Statesman's Career and Pious Endowments/Hersekzâde Ahmed Paşa: Bir Osmanlı devlet adamının meslek hayatı ve kurduğu vakıflar.* Translated by M. Alper Öztürk. Occasional Papers in History 4. Istanbul: Bahçeşehir University Press, 2011.

Macoir 1910
Macoir, Georges. *La Bardiche: Note sur un fer de hache d'armes du musée de la Porte de Hal.* Brussels: Vromant et Cie., 1910.

Madrid 1990
Tesoros del Kremlin: Ceremonial de gala en la Rusia del siglo XVII; Desfile de gala y caza real. Exh. cat., Real Armería, Madrid. Munich: Hirmer, 1990.

Madrid 2003
Oriente en Palacio: Tesoros asiáticos en las colecciones Reales españolas. Exh. cat., Palacio Real de Madrid. Madrid: Patrimonio Nacional, 2003.

Maindron 1890
Maindron, Maurice. *Les Armes.* Bibliothèque de l'Enseignement des Beaux Arts. Paris: Ancienne Maison Quantin, 1890.

al-Majlisi 1982
al-Majlisi, Muhammad Baqir. *The Life and Religion of Muhammad.* Vol. 2, *Hiyat al-Qulub.* Translated by James L[yman]. Merrick. San Antonio, Tex.: Zahra Trust, 1982. First pub. 1850 by Phillips, Sampson and Company, Boston.

Malinovskaya 1974
Malinovskaya, N. V. "Kolchany XIII–XIV vv. s kostyanymi ornamentirovannymi obkladkami na territorii Evrazskikh stepei." In *Goroda Povolzh'ia v srednie veka*, edited by A[leksei]. P[etrovich]. Smirnov and German Alekseevich Fedorov-Davydov, pp. 132–74. Moscow: Nauka, 1974.

Mann 1933
Mann, James G[ow]. "Notes on the Armour Worn in Spain from the Tenth to the Fifteenth Century." *Archaeologia, or, Miscellaneous Tracts Relating to Antiquity* 83 (1933), pp. 285–305.

Manucci 1906–8
Manucci, Niccolao. *Storia do Mogor, or, Mogul India, 1653–1708.* Translated and with introduction and notes by William Irvine. 4 vols. London: John Murray for Government of India, 1906–8.

Markel 1993
Markel, Stephen. "Luxury Arts of Lucknow." In "Asian Art in the Cincinnati Art Museum." Special issue, *Arts of Asia* 23, no. 2 (March–April 1993), pp. 108–20.

Markel 2004
Markel, Stephen. "Non-Imperial Mughal Sources for Jades and Jade Simulants in South Asia." In *Jewelled Arts of Mughal India: Papers of the Conference Held Jointly by the British Museum and the Society of Jewellery Historians at The British Museum, London in 2001*, edited by Beatriz Chadour-Sampson and Nigel Israel, pp. 68–75. Jewellery Studies 10. London: Society of Jewellery Historians, 2004.

Maryon 1960a
Maryon, Herbert. "Pattern-Welding and Damscening of Sword-Blades—Part 1: Pattern-Welding." *Studies in Conservation* 5, no. 1 (February 1960), pp. 25–37.

Maryon 1960b
Maryon, Herbert. "Pattern-Welding and Damscening of Sword-Blades—Part 2: The Damascene Process." *Studies in Conservation* 5, no. 2 (May 1960), pp. 52–60.

Massignon 1982
Massignon, Louis. *The Passion of al-Hallaj: Mystic and Martyr of Islam.* Translated by Herbert Mason. Bollingen Series 98. Princeton: Princeton University Press, 1982.

Mayer 1943
Mayer, L[eo]. A[ry]. "Saracenic Arms and Armor." *Ars Islamica* 10 (1943), pp. 1–12.

Mayer 1952
Mayer, L[eo]. A[ry]. *Mamluk Costume: A Survey.* Geneva: A. Kundig, 1952.

Mayer 1962
Mayer, L[eo]. A[ry]. *Islamic Armourers and Their Works.* Catalogue compiled by Gaston Wiet. Geneva: Kundig, 1962.

Mayer 1971
Mayer, L[eo]. A[ry]. *Mamluk Playing Cards.* Edited by Richard Ettinghausen and Otto Kurz. L. A. Mayer Memorial Studies in Islamic Art and Archaeology 1. Leiden: Brill, 1971.

Mazzini 1982
Mazzini, Franco, ed. *L'Armeria Reale di Torino.* With texts by Claudio Bertolotto, Marisa Sobrito Cartesegna, Giorgio Dondi, Michela di Macco, Franco Mazzini, Giovanni Romano, Raffaele Natta Soleri, and Carlenrica Spantigati. Busto Arsizio: Bramante Editrice, 1982.

Meinecke 1972
Meinecke, Michael. "Zur mamlukischen Heraldik." *Mitteilungen des Deutschen Archäologischen Instituts, Abteilung Kairo* 28, no. 2 (1972), pp. 213–87.

Meinecke 1996
Meinecke, Michael. "Heraldry and *Furusiyya*." In Riyadh 1996, vol. 1, pp. 152–57.

Melikian-Chirvani 1969
Melikian-Chirvani, Assadullah Souren. "Bronzes et cuivres iraniens du Louvre: I, L'Ecole du Fârs au XIVe siècle." *Journal asiatique* 257, nos. 1–2 (1969), pp. 19–36.

Melikian-Chirvani 1976
Melikian-Chirvani, Assadullah Souren. "Four Pieces of Islamic Metalwork: Some Notes on a Previously Unknown School." *AARP: Art and Archaeological Research Papers* 10 (December 1976), pp. 24–30.

Melikian-Chirvani 1978
Melikian-Chirvani, [Assadullah] Souren. "The Art Market: The Confusion at Islamic Auctions." *International Herald Tribune*, April 8–9, 1978, p. 7.

Melikian-Chirvani 1979a
Melikian-Chirvani, A[ssadullah]. S[ouren]. "The Tabar of a Turkish Dervis." In Elgood 1979, pp. 112–15.

Melikian-Chirvani 1979b
Melikian-Chirvani, A[ssadullah]. S[ouren]. "The Tabarzins of Lotf'ali." In Elgood 1979, pp. 116–35.

Melikian-Chirvani 1982a
Melikian-Chirvani, Assadullah Souren. "An English Sword with an Ottoman Blade in the Swiss National Museum—The Blade." In *Blankwaffen/Armes blanches/Armi bianche/Edged Weapons: Festschrift Hugo Schneider zu seinem 65. Geburtstag*, edited by Karl Stüber and Hans Wetter, pp. 69–78. Zurich: T. Gut, 1982.

Melikian-Chirvani 1982b
Melikian-Chirvani, Assadullah Souren. *Victoria and Albert Museum: Islamic Metalwork from the Iranian World, 8–18th Centuries*. London: Her Majesty's Stationery Office, 1982.

Melikian-Chirvani 1983
Melikian-Chirvani, A[ssadullah]. S[ouren]. "The Westward Journey of the Kazhagand." *Journal of the Arms and Armour Society* 11, no. 1 (June 1983), pp. 8–35.

Melikian-Chirvani 1987
Melikian-Chirvani, Assadullah Souren. "The Lights of Sufi Shrines." In *Islamic Art 2: An Annual Dedicated to the Art and Culture of the Muslim World*, edited by Ernst J. Grube and Eleanor G. Sims, pp. 117–47. Genoa: Bruschettini Foundation for Islamic and Asian Art; New York: Islamic Art Foundation, 1987.

Melikian-Chirvani 1992
Melikian-Chirvani, Assadullah Souren. "The Iranian Sun Shield." *Bulletin of the Asia Institute*, n.s., 6 (1992), pp. 1–42.

Melikian-Chirvani 1997
Melikian-Chirvani, A[ssadullah]. S[ouren]. "Precious and Semi-precious Stones in Iranian Culture; Chapter I: Early Iranian Jade." *Bulletin of the Asia Institute*, n.s., 11 (1997 [pub. 2000]), pp. 123–73.

Melikian-Chirvani 2004
Melikian-Chirvani, Assadullah Souren. "The Jewelled Objects of Hindustan." In *Jewelled Arts of Mughal India: Papers of the Conference Held Jointly by the British Museum and the Society of Jewellery Historians at The British Museum, London in 2001*, edited by Beatriz Chadour-Sampson and Nigel Israel, pp. 9–32. Jewellery Studies 10. London: Society of Jewellery Historians, 2004.

Mélikoff 1965
Mélikoff, I[rene]. "Ghazi." In *Encyclopaedia of Islam, New Edition*, edited by B[ernard]. Lewis, Ch. Pellat, and J. Schacht, vol. 2, pp. 1043–45. 2nd ed. Leiden: Brill; London: Luzac and Co., 1965.

Mexico City 1994–95
Arte islámico del Museo Metropolitano de Arte de Nueva York. Exh. cat., Colegio de San Ildefonso, Mexico City, 1994–95. Mexico City: Consejo Nacional para la Cultura y las Artes, 1994.

Migeon 1907
Migeon, Gaston. *Manuel d'art musulman*. Vol. 2, *Les Arts plastiques et industriels*. Paris: A. Picard, 1907.

Migeon 1926
Migeon, Gaston. *Les Arts musulmans*. Bibliothèque d'Histoire de l'Art. Paris and Brussels: G. van Oest, 1926.

Miller 1956
Miller, Y[uri]. K. "La Selle et le sabre de Tippoo-Sultan." *Soobshchenya Gosudarstvennogo Ermitazha* [Reports of the State Hermitage Museum] 10 (1956), pp. 45–47.

Miller 1957
Miller, Y[uri]. K. "Sur l'attribution des armes de Tipoo Sahib." *Soobshchenya Gosudarstvennogo Ermitazha* [Reports of the State Hermitage Museum] 11 (1957), pp. 59–60.

Miller 1958
Miller, Y[uri]. K. "An XVIII Century Turkish Axe in the Arsenal of the Hermitage Museum." *Epigrafika vostoka* 12 (1958), pp. 98–106.

Miller 1972
Miller, Yuri [K]. "Jade in Turkish Applied Art of the Seventeenth Century." *Soobshchenya Gosudarstvennogo Ermitazha* [Reports of the State Hermitage Museum] 35 (1972), pp. 66–68, 91.

Miller 1976
Miller, Yuri [K]. "Mamlyukskiy shlem." *Soobshchenya Gosudarstvennogo Ermitazha* [Reports of the State Hermitage Museum] 41 (1976), pp. 46–48.

Miller 1982
Miller, Yuri [K.], ed. *Russian Arms and Armour*. Leningrad: Aurora Art Publishers, 1982.

Miller 2000
Miller, Yuri [K]. "Kaukasiske våben fra Eremitagemuseet, Skt. Petersborg: Våbenkunst i Kaukasus og Transkaukasien i dit 18.–19. århundrede/Caucasian Arms from the State Hermitage Museum, St. Petersburg: The Art of Weaponry in Caucasus and Transcaucasia in the 18th and 19th Centuries." Edited by Ole Skøtt. Special issue, *Vaabenhistoriske Aarbøger* 45 (2000).

Miller 2006
Miller, Yuri [K]. "Nogle typer af orientalske hjelme fra det 16. og 17. århundrede og deres europæske efterligninger/Various Categories of Oriental Helmets from the 16th and 17th Centuries and Their European Derivatives." Translated by Erik Troldhuus. *Vaabenhistoriske Aarbøger* 51 (2006), pp. 5–78.

Minorsky 1939
Minorsky, V[ladimir]. "A Soyurghal of Qasim b. Jahangir Aq-qoyunlu (903/1498)." *Bulletin of the School of Oriental and African Studies* 9, no. 4 (February 1939), pp. 927–60.

Minorsky 1942
Minorsky, V[ladimir]. "The Poetry of Shah Isma'il I." *Bulletin of the School of Oriental and African Studies* 10, no. 4 (1942), pp. 1006a–53a.

Minorsky 1978
Minorsky, Vladimir. *The Turks, Iran and the Caucasus in the Middle Ages*. With preface by J. A. Boyle. London: Variorum Reprints, 1978.

Momen 1985
Momen, Moojan. *An Introduction to Shi'i Islam: The History and Doctrines of Twelver Shi'ism*. New Haven: Yale University Press, 1985.

Moshtagh Khorasani 2006
Moshtagh Khorasani, Manouchehr. *Arms and Armor from Iran: The Bronze Age to the End of the Qajar Period*. Tübingen: Legat, 2006.

Moshtagh Khorasani 2007
Moshtagh Khorasani, Manouchehr. "The Khanjar: Dagger of the Ayyaran." *Classic Arms and Militaria* 14, no. 6 (2007), pp. 25–29.

Munich 1910
Meisterwerken muhammedanischer Kunst, Musikfeste Muster-Ausstellung von Musik-Instrumenten. Exh. cat., Die Ausstellung, Munich. Munich: Rudolf Mosse, 1910.

Muscarella 1988
Muscarella, Oscar White. *Bronze and Iron: Ancient Near Eastern Artifacts in The Metropolitan Museum of Art*. New York: MMA, 1988.

Musée de Tzarskoe-Selo 1835–53
Musée de Tzarskoe-Selo, ou collection d'armes de Sa Majesté l'Empereur de toutes les Russies. With lithographs by Asselineau, after drawings by A. Rockstuhl, and historical introduction by Florent Gille. 3 vols. Saint Petersburg and Karlsruhe: Velten, 1835–53. Reprinted 1981 by Klenau, Darmstadt.

Nagel Auktionen, Stuttgart 2007
Auction of Rugs, Carpets, and Ethnologica. Sale cat., Nagel Auktionen, Stuttgart, November 5, 2007.

New Delhi and other cities 1997–98
King of the World; The Padshahnama: An Imperial Mughal Manuscript from the Royal Library, Windsor Castle. Exh. cat., National Museum of India, New Delhi, and other venues, 1997–98. London: Azimuth; Washington, D.C.: Sackler Gallery, 1997. Catalogue by Milo Cleveland Beach and Ebba Koch with new translations by Wheeler Thackston.

New York 1883
Pedestal Fund Art Loan Exhibition. Exh. cat. New York: National Academy of Design, 1883.

New York 1967
In the Presence of Kings: Royal Treasures from the Collections of The Metropolitan Museum of Art. Exh. cat. New York: MMA, 1967.

New York 1973
"Gold." Special issue, *MMAB*, n.s., 31, no. 2 (Winter 1972–73). Exh. cat., MMA, New York, 1973. Catalogue by Thomas Hoving and Carmen Gómez-Moreno.

New York 1978
The Royal Hunter: Art of the Sasanian Empire. Exh. cat. New York: Asia Society in association with John Weatherhill, 1978. Catalogue by Prudence Oliver Harper with contributions by Carol Manson Bier, Martha L. Carter, and Jens Kröger.

New York 1979
Calligraphy in the Arts of the Muslim World. Exh. cat., Asia House Gallery (Asia Society), New York. Austin: University of Texas Press, 1979. Catalogue by Anthony Welch.

New York 1983
Islamic Jewelry in The Metropolitan Museum of Art. Exh. cat. New York: MMA, 1983. Catalogue by Marilyn Jenkins and Manuel Keene.

New York 1985–86a
The Costumes of Royal India. Exh. checklist, 1985–86. New York: MMA, 1986.

New York 1985–86b
India: Art and Culture, 1300–1900. Exh. cat., 1985–86. New York: MMA; Holt, Rinehart, and Winston, 1985. Catalogue by Stuart Cary Welch.

New York 1987–88
The Emperor's Album: Images of Mughal India. Exh. cat., 1987–88. New York: MMA, 1987. Catalogue by Stuart Cary Welch, Annemarie Schimmel, Marie L. Swietochowski, and Wheeler M. Thackston.

New York 1996
The Gods of War: Sacred Imagery and the Decoration of Arms and Armor. Exh. cat. New York: MMA, 1996. Catalogue by Donald J. La Rocca.

New York 1998–99
Heroic Armor of the Italian Renaissance: Filippo Negroli and His Contemporaries. Exh. cat., 1998–99. New York: MMA, 1998. Catalogue by Stuart W. Pyhrr and José A. Godoy with essays and compilation of documents by Silvio Leydi.

New York 2002–3
Arms and Armor: Notable Acquisitions, 1991–2002. Exh. cat., 2002–3. New York: MMA; New Haven: Yale University Press, 2002. Catalogue by Stuart W. Pyhrr, Donald J. La Rocca, and Morihiro Ogawa.

New York 2006
Warriors of the Himalayas: Rediscovering the Arms and Armor of Tibet. Exh. cat. New York: MMA; New Haven: Yale University Press, 2006. Catalogue by Donald J. La Rocca with essays by John Clarke, Amy Heller, and Lozang Jamspal.

New York 2014–15
Treasures from India: Jewels from the Al-Thani Collection. Exh. cat., 2014–15. New York: MMA, 2014. Catalogue by Navina Najat Haidar and Courtney Ann Stewart.

New York 2015
Sultans of Deccan India, 1500–1700: Opulence and Fantasy. Exh. cat. New York: MMA, 2015. Catalogue by Navina Najat Haidar and Marika Sardar with contributions by John Robert Alderman, Jake Benson, William Dalrymple, Richard M. Eaton, Maryam Ekhtiar, Abdullah Ghouchani, Salam Kaoukji, Terence McInerney, Jack Ogden, Keelan Overton, Anamika Pathak, Howard Ricketts, Courtney A. Stewart, Sanjay Subrahmanyam, and Laura Weinstein.

New York and Los Angeles 1973
Turkish Miniature Paintings and Manuscripts: From the Collection of Edwin Binney, 3rd. Exh. cat. New York: MMA; Los Angeles: Los Angeles County Museum of Art, 1973. Catalogue by Edwin Binney.

New York and Milan 2003–4
Hunt for Paradise: Court Arts of Safavid Iran, 1501–1576. Exh. cat., Asia Society Museum, New York; and Museo Poldi Pezzoli and Palazzo Reale, Milan, 2003–4. Milan: Skira, 2003. Catalogue edited by Jon Thompson and Sheila R. Canby.

[Nickel] 1968
[Nickel, Helmut.] "The Ottoman Empire" [Entries 39–43]. *MMAB*, n.s., 26, no. 5 (January 1968), pp. 219–21.

Nickel 1969
Nickel, Helmut. *Warriors and Worthies: Arms and Armor through the Ages.* New York: Atheneum, 1969. Revised ed. 1971, *Arms and Armor through the Ages*, pub. by Collins, London.

Nickel 1972
Nickel, Helmut. "A Mamluk Axe." In *Islamic Art in The Metropolitan Museum of Art*, edited by Richard Ettinghausen, pp. 213–25. New York: MMA, 1972. Reprinted in Elgood 1979, pp. 149–61.

Nickel 1973a
Nickel, Helmut. "About the Sword of the Huns and the 'Urepos' of the Steppes." *MMJ* 7 (1973), pp. 131–42.

Nickel 1973b
Nickel, Helmut. "Tamgas and Runes, Magic Numbers and Magic Symbols." *MMJ* 8 (1973), pp. 165–73.

Nickel 1974
Nickel, Helmut. *Ullstein-Waffenbuch: Eine kulturhistorische Waffenkunde mit Markenverzeichnis.* Berlin: Ullstein, 1974.

Nickel 1975
Nickel, Helmut. "Battle-Ax." *The Metropolitan Museum of Art: Notable Acquisitions, 1965–1975*, 1975, p. 42.

Nickel 1979a
Nickel, Helmut. "Group of Sudanese Swords." *The Metropolitan Museum of Art: Notable Acquisitions, 1975–1979*, 1979, pp. 28–29.

Nickel 1979b
Nickel, Helmut. "A Mamluk Axe." In Elgood 1979, pp. 149–61. Reprint of Nickel 1972.

Nickel 1991a
Nickel, Helmut. "Arms and Armor: From the Permanent Collection." Special issue, *MMAB*, n.s., 49, no. 1 (Summer 1991).

Nickel 1991b
Nickel, Helmut. "A Crusader's Sword: Concerning the Effigy of Jean d'Alluye." *MMJ* 26 (1991), pp. 123–28.

Nickel 1993
Nickel, Helmut. "Neun Schwerter aus dem Lande des Mahdi." *Waffen- und Kostümkunde* 35, nos. 1–2 (1993), pp. 45–56.

Nicolle 1988
Nicolle, David. *Arms and Armour of the Crusading Era, 1050–1350.* 2 vols. White Plains, N.Y.: Kraus International Publications, 1988. Rev. ed. 1999, 2 vols. by Greenhill Books, London, and Stackpole Books, Mechanicsburg, Pa.

Nicolle 1989
Nicolle, David. *El Cid and the Reconquista: Warfare in Medieval Spain, 1050–1492.* Men-at-Arms 120. London: Osprey, 1989.

Nicolle 2008
Nicolle, David. "A Medieval Islamic Arms Cache from Syria." *Journal of the Arms and Armour Society* 19, no. 4 (September 2008), pp. 153–63.

Nordlunde 2013
Nordlunde, Jens. "How Old is the Katar?" *Arms and Armour* 10, no. 1 (Spring 2013), pp. 71–80.

Nordström [1984]
Nordström, Lena. *White Arms of the Royal Armoury*.
Stockholm: Royal Armoury, [1984].

Norman 1980
Norman, A. V[esey]. B. *The Rapier and Small-Sword, 1460–1820*, London: Arms and Armour; New York: Arno, 1980.

Norman 1982
Norman, A. V[esey]. B. "Some Princely Arms from India and Persia in the Wallace Collection." In Copenhagen 1982, pp. 7–20.

North 1975
North, A[nthony]. R. E. "A Late 15th Century Italian Sword." *Connoisseur* 190, no. 766 (December 1975), pp. 238–41.

North 1976
North, A[nthony]. R. E. "Islamic Arms and Armour." *Connoisseur* 191, no. 770 (April 1976), pp. 274–79.

North 1985
North, Anthony [R. E]. *An Introduction to Islamic Arms*. London: Her Majesty's Stationery Office, 1985.

Norwich, Cincinnati, and Toronto 1982–83
Treasures from the Tower of London: An Exhibition of Arms and Armour. Exh. cat., Sainsbury Centre for Visual Arts, University of East Anglia, Norwich; Cincinnati Art Museum, Ohio; and Royal Ontario Museum, Toronto, 1982–83. London: Lund Humphries for Sainsbury Centre for Visual Arts, University of East Anglia, Norwich, 1982. Catalogue by A. V[esey]. B. Norman and G. M. Wilson.

"Notes: An Inscribed Turkish Sabre" 1926
"Notes: An Inscribed Turkish Sabre." *Rupam: An Illustrated Quarterly Journal of Oriental Art* 25, no. 1 (January 1926), p. 36.

Oberhummer 1917
Oberhummer, Eugen. *Die Türken und das Osmanische Reich*. Leipzig and Berlin: Teubner, 1917.

Oberschleissheim 1976
Kurfürst Max Emanuel: Bayern und Europa um 1700. Exh. cat., Altes Schloss Schleissheim (Bayerisches Nationalmuseum), Alten und Neuen Schloss Schleissheim, Oberschleissheim, Germany. Munich: Hirmer, 1976. Catalogue edited by Hubert Glaser.

Oldman 1910
Oldman, W[illiam]. O. *Illustrated Catalogue of Ethnographical Specimens* 7, no. 82 (1910).

Opis' Moskovskoi Oruzheinaya palata 1884–93
Opis' Moskovskoi Oruzheinaya palata [Catalogue of the Moscow Arms and Armory Museum]. 10 pts. in 5 vols. Moscow: Tip. Ob-va Rasprostraneniia Poleznykh Knig, 1884–93.

Ormsby 1984
Ormsby, Eric L. *Theodicy in Islamic Thought: The Dispute over al-Ghazali's "Best of All Possible Worlds."* Princeton: Princeton University Press, 1984.

Ostrogorsky 1969
Ostrogorsky, Georgije. *History of the Byzantine State*. Translated by Joan Hussey. With foreword by Peter Charanis. New Brunswick, N.J.: Rutgers University Press, 1969.

"Outstanding Recent Accessions" 1970
"Outstanding Recent Accessions." *MMAB*, n.s., 28, no. 9 (May 1970), pp. 394–99.

Oxenham and Son, London 1842
A Matchless Collection of Ancient Armour and Arms, Recently Imported from Constantinople. Sale cat., Oxenham and Son, London, July 21–22, 1842.

Pant 1978–83
Pant, G[ayatri]. N[ath]. *Indian Arms and Armour*. With foreword by M. N. Deshpande. 3 vols. New Delhi: Army Educational Stores, 1978–83.

Pant 1997
Pant, G[ayatri]. N[ath]. *Horse and Elephant Armour*. New Delhi: Agam Kala Prakashan, 1997.

Pant and Agrawal 1995
Pant, G[ayatri]. N[ath]., and Yashodhara Agrawal. *A Catalogue of Arms and Armours in Bharat Kala Bhavan*. Delhi: Parimal Publications, 1995.

Paris 1988
Splendeur des armes orientales. Exh. cat., Galerie Art 4, Paris. Paris: Acte-Expo, 1988. Catalogue by Howard Ricketts and Philippe Missillier.

Paris 1990
Soliman le Magnifique. Exh. cat., Galeries Nationales du Grand Palais, Paris. Paris: Ministère des Affaires Etrangères, Secrétariat d'Etat aux Relations Culturelles Internationales, Association Française d'Action Artistique, 1990.

Paris 2002–3
Chevaux et cavaliers arabes dans les arts d'Orient et d'Occident. Exh. cat., Institut du Monde Arabe, Paris, 2002–3. Paris: Institut du Monde Arabe; Gallimard, 2002.

Paris 2007/Mohamed 2008
L'Art des chevaliers en pays d'Islam: Collection de la Furusiyya Art Foundation. Exh. cat., Institut du Monde Arabe, Paris. Milan: Skira, 2007. Catalogue edited by Bashir Mohamed. (English ed., *The Arts of the Muslim Knight: The Furusiyya Art Foundation Collection*, 2008.)

Parry 1960
Parry, V. J. "Barud: iv.—The Ottoman Empire." In *Encyclopaedia of Islam, New Edition*, edited by B[ernard]. Lewis, Ch. Pellat, and J. Schacht, vol. 1, pp. 1061–66. 2nd ed. Leiden: Brill; London: Luzac and Co., 1960.

F. Peters 1994
Peters, F. E. *The Hajj: The Muslim Pilgrimage to Mecca and the Holy Places*. Princeton: Princeton University Press, 1994.

R. Peters 1977
Peters, Rudolph. *Jihad in Medieval and Modern Islam: The Chapter on Jihad from Averroes' Legal Handbook: "Bidayat al-Mudjtahid" and the Treatise "Koran and Fighting" by the Late Shaykh Al-Azhar, Mahmud Shaltut*. Nisaba 5. Leiden: Brill, 1977.

Petrasch et al. 1991
Petrasch, Ernst, Reinhard Sänger, Eva Zimmerman, and Hans Georg Majer, eds. *Die Karlsruher Türkenbeute: Die "Türckische Kammer" des Markgrafen Ludwig Wilhelm von Baden-Baden; Die "Türckischen Curiositaeten" der Markgrafen von Baden-Durlach*. Munich: Hirmer, 1991.

Petsopoulos 1982
Petsopoulos, Yanni, ed. *Tulips, Arabesques and Turbans: Decorative Arts from the Ottoman Empire*. London: Alexandria Press; New York: Abbeville Press, 1982.

Philadelphia 1986–87
African Sculpture from The University Museum, University of Pennsylvania. Exh. cat., 1986–87. Philadelphia: Philadelphia Museum of Art, 1986. Catalogue by Allen Wardwell.

Phillip 2011
Phillip, Filiz Çakır. "The Shahnama: On the Forging of Heroes and Weapons." In *Heroic Times: A Thousand Years of the Persian Book of Kings*, edited by Julia Gonnella and Christoph Rauch, pp. 58–63. Exh. cat., Museum für Islamische Kunst, Staatliche Museen zu Berlin, 2011. Munich: Edition Minerva, 2012. (German ed., *Heroische Zeiten: Tausend Jahre Persisches Buch der Könige*, Munich: Edition Minerva; Berlin: Museum für Islamische Kunst, Staatliche Museen zu Berlin, 2011.)

Pliny the Elder 1938–62
Pliny the Elder. *Natural History*. Vols. 1–5, translated by H. Rackham. Vols. 6–8, translated by W. H. Jones. Vol. 10, translated by D. E. Eichholz. 10 vols. Cambridge, Mass.: Harvard University Press, 1938–62.

Pope 1938–58
Pope, Arthur Upham, ed., with Phyllis Ackerman. *A Survey of Persian Art: From Prehistoric Times to the Present*. 7 vols. London and New York: Oxford University Press, 1938–58.

Postans 1843
Postans, Thomas. *Personal Observations on Sindh: The Manners and Customs of Its Inhabitants, and Its Productive Capabilities with a Sketch of Its History, a Narrative of Recent Events, and an Account of the Connection of the British Government with That Country to the Present Period*. London: Longman, Brown, Green, and Longmans, 1843.

Pyhrr 1979
Pyhrr, Stuart W. "Scimitar." *The Metropolitan Museum of Art: Notable Acquisitions, 1975–1979,* 1979, pp. 27–28.

Pyhrr 1989
Pyhrr, Stuart W. "European Armor from the Imperial Ottoman Arsenal." *MMJ* 24 (1989), pp. 85–116.

Pyhrr 1991
Pyhrr, Stuart W. "Leg Defense." In "Recent Acquisitions: A Selection 1990–1991." Special issue, *MMAB,* n.s., 49, no. 2 (Autumn 1991), p. 22.

Pyhrr 1993
Pyhrr, Stuart W. "Workshop of Ahmed Tekelü (Iranian [?], active in Istanbul, ca. 1520–30), Yatagan." In "Recent Acquisitions: A Selection, 1992–1993." Special issue, *MMAB* 51, no. 2 (Autumn 1993), p. 21.

Pyhrr 2001
Pyhrr, Stuart W. "De la Révolution au romantisme: Les Origines des collections modernes d'armes et d'armures." Translated by Lydie Echasseriaud. In *Vies de Dominique-Vivant Denon 2, Conférences et Colloques,* pp. 617–50. Paris: Musée du Louvre, 2001.

Pyhrr 2007a
Pyhrr, Stuart W. "The Ottoman Arsenal in Hagia Eirene: Some Early Photographs and Visitors' Accounts." *London Park Lane Arms Fair* [Catalogue], Spring 2007, pp. 29–46.

Pyhrr 2007b
Pyhrr, Stuart W. "From Revolution to Romanticism: France and the Collecting of Arms and Armour in the Early 19th Century." *ICOMAM 50: Papers on Arms and Military History, 1957–2007,* edited by Robert Douglas Smith, pp. 106–35. Leeds: Basiliscoe Press in association with ICOMAM, 2007.

Pyhrr 2010
Pyhrr, Stuart W. "Shirt of Mail and Plate." In "Recent Acquisitions; A Selection: 2008–2010." Special issue, *MMAB* 68, no. 2 (Fall 2010), p. 30.

Pyhrr 2012a
Pyhrr, Stuart W. "Of Arms and Men: Arms and Armor at the Metropolitan, 1912–1993." Special issue, *MMAB* 70, no. 1 (Summer 2012).

Pyhrr 2012b
Pyhrr, Stuart W. "Armor for America: The Duc de Dino Collection." *MMJ* 47 (2012), pp. 183–230.

Pyhrr and Alexander 1984
Pyhrr, Stuart W., and David G[eoffrey]. Alexander. "Arms and Armor: Parade Helmet." *The Metropolitan Museum of Art: Notable Acquisitions, 1983–1984,* 1984, pp. 21–22.

Rabino 1945
Rabino, Hyacinth Louis. *Coins, Medals, and Seals of the Shahs of Iran, 1500–1941.* Hertford, U.K.: S. Austin and Sons, Ltd., Oriental and General Printers, 1945.

Raby and Tanındı 1993
Raby, Julian, and Zeren Tanındı. *Turkish Bookbinding in the 15th Century: The Foundation of an Ottoman Court Style.* Edited by Tim Stanley. London: Azimuth Editions on behalf of l'Association Internationale de Bibliophile, 1993.

Rawson 1967
Rawson, P[hilip]. S. *The Indian Sword.* Copenhagen: Danish Arms and Armour Society, 1967.

"Recent Acquisitions of American and Canadian Museums" 1970
"Recent Acquisitions of American and Canadian Museums, April–June 1970." *Art Quarterly* (Detroit) 33, no. 4 (1970), pp. 445–65.

Reid 2001
Reid, William. "The Bowman's Thumb-Ring." *Royal Armouries Yearbook* 6 (2001), pp. 150–61.

Ricardo 1973
Ricardo, David. *The Works and Correspondence of David Ricardo.* Vol. 10, *Biographical Miscellany.* Edited by Piero Sraffa with M. H. Dobb. London: Cambridge University Press, 1973. First pub. 1955 by Cambridge University Press, U.K.

Rice 1965
Rice, Tamara Talbot. *Ancient Arts of Central Asia.* New York: Praeger, 1965.

Richardson 1998
Richardson, Thom. "Another Saddle Axe by Loft'ali." *Royal Armouries Yearbook* 3 (1998), pp. 194–95.

Richardson 2007
Richardson, Thom. *An Introduction to Indian Arms and Armor.* Leeds: Trustees of the Royal Armouries, 2007.

Richardson and Bennett 2015
Richardson, Thom, and Natasha Bennett. *Indian Arms and Armour.* Royal Armouries Arms and Armour. Leeds: Trustees of the Armouries, Royal Armouries Museum, 2015.

Richmond 2013
Richmond, Walter. *The Circassian Genocide.* New Brunswick, N.J., and London: Rutgers University Press, 2013.

Ricketts 1982
Ricketts, Howard. "Some Early Collectors and Scholars of Oriental Arms." In Copenhagen 1982, pp. 21–27.

Ritter-Hopson Galleries, New York 1933
Oriental Arms Together with Pewter, Glass, Porcelain, Prints, Furniture and Decorative Objects [Dr. Arthur E. Oxley Collection]. Sale cat., Ritter-Hopson Galleries, New York, February 2, 1933.

Riyadh 1996
Furusiyya. 2 vols. Exh. cat. Riyadh: King Abdulaziz Public Library, 1996. Catalogue edited by David G[eoffrey]. Alexander.

B. Robinson 1976
Robinson, B[asil]. W[illiam]. *Persian Paintings in the India Office Library: A Descriptive Catalogue.* London: Sotheby Parke Bernet, 1976.

B. Robinson 1979
Robinson, Basil William. "The Turkman School to 1503." In *The Arts of the Book in Central Asia, 14th–16th Centuries,* edited by Basil Gray, pp. 215–47. Boulder, Colo.: Shambhala; Paris: UNESCO, 1979.

B. Robinson 1985
Robinson, B[asil]. W[illiam]. "Lacquer, Oil-Paintings and Later Arts of the Book." In Geneva 1985, pp. 176–205.

H. Robinson 1967
Robinson, H[enry]. Russell. *Oriental Armour.* Arms and Armour Series. London: Jenkins, 1967.

H. Robinson 1973
Robinson, Henry Russell, ed. *Il Museo Stibbert a Firenze.* Vol. 1, *Armi e armature orientali.* Milan: Electa Editrice, 1973.

Rodinson 1980
Rodinson, Maxime. *Muhammad.* New York: Pantheon Books, 1980.

Rogers 1986
Rogers, J. M[ichael]. *The Topkapı Saray Museum: The Albums and Illustrated Manuscripts.* Original Turkish version by Filiz Çağman and Zeren Tanındı. Boston: Little, Brown and Company, 1986.

Rogers 1987a
Rogers, J. M[ichael]. *The Topkapı Saray Museum: The Treasury.* Original Turkish version by Cengiz Köseoğlu. London: Thames and Hudson, 1987.

Rogers 1987b
Rogers, J. M[ichael]. *The Topkapı Saray Museum: Carpets.* Original Turkish version by Hülya Tezcan. London: Thames and Hudson, 1987.

Rogers 1988
Rogers, J. M[ichael]. "Two Masterpieces from 'Süleyman the Magnificent': A Loan Exhibition from Turkey at the British Museum." *Orientations* 19, no. 8 (August 1988), pp. 12–17.

Rogers 1993
Rogers, J. M[ichael]. *Mughal Miniatures.* London: British Museum Publications for the Trustees of the British Museum, 1993.

Rose 1902–5
Rose, Walther. "Die Verzierung alt-orientalischer Panzerringe." *Zeitschrift für historische Waffenkunde* 3, no. 1 (1902–5), pp. 8–15.

Rowland 1971
Rowland, Benjamin. *The Art and Architecture of India: Buddist, Hindu, Jain.* The Pelican History of Art Z2. Baltimore: Penguin Books, 1971.

Roxburgh 2005
Roxburgh, David J. *The Persian Album, 1400–1600: From Dispersal to Collection*. New Haven: Yale University Press, 2005.

Ruska 1934
Ruska, J. "Wafk." In *Encyclopaedia of Islam*, edited by M. Th. Houtsma, A. J. Wensinck, H. A. R. Gibb, W. Heffening, and E. Lévi-Provençal, vol. 4, pp. 1081–83. 1st ed. Leiden: Brill; London: Luzac and Co., 1934.

Ruysbroeck 1990
Ruysbroeck, Willem van. *The Mission of Friar William of Rubruck: His Journey to the Court of the Great Khan Möngke, 1253–1255*. Translated by Peter Jackson. With introduction, notes, and appendices by Peter Jackson with David Morgan. Works Issued by the Hakluyt Society, 2nd ser., 173. London: Hakluyt Society, 1990.

Sadeque 1956
Sadeque, Syedah Fatima. *Baybars I of Egypt*. Dhaka, Bangladesh: Oxford University Press, 1956.

Sa'di 1964
Sa'di. *Bustan-i Sa'di: Ba istifadah az nuskhah-'i tashih shudah-'i Muhammad 'Ali Furughi "Zaka' al-Mulk."* Edited by Muhammed 'Ali Furughi. Tehran: Iqbal, 1964.

San Francisco 1937
Exhibition of Islamic Art. Exh. cat. San Francisco: M. H. de Young Memorial Museum, 1937. Catalogue introduction by Mehmet Aga-Oglu.

al-Sarraf 1996
al-Sarraf, Shihab. "*Furusiyya* Literature of the Mamluk Period." In Riyadh 1996, vol. 1, pp. 118–35.

al-Sarraf 2002
al-Sarraf, Shihab. "Close Combat Weapons in the Early 'Abbasid Period: Maces, Axes and Swords." In *A Companion to Medieval Arms and Armour*, edited by David Nicolle, pp. 149–78. Woodbridge, U.K., and Rochester, N.Y.: Boydell Press, 2002.

Sárvár 1971
Muvészi fegyverek. Exh. cat. Sárvár: Városi Tanács VB, Muvelodésügyi Osztálya; Nádasdy Ferenc Múzeum, 1971. Catalogue by Ferenc Temesvári.

Schimmel 1985
Schimmel, Annemarie. *And Muhammad Is His Messenger: The Veneration of the Prophet in Islamic Piety*. Studies in Religion. Chapel Hill: University of North Carolina Press, 1985.

Schimmel 1986
Schimmel, Annemarie. *Mystical Dimensions of Islam*. Chapel Hill: University of North Carolina Press, 1986.

Schimmel 1992
Schimmel, Annemarie, with Barbara Rivolta. "Islamic Calligraphy." Special issue, *MMAB*, n.s., 50, no. 1 (Summer 1992).

Schlosser 1892
Schlosser, Julius Ritter von. *Schriftquellen zur Geschichte der karolingischen Kunst*. Quellenschriften für Kunstgeschichte und Kunsttechnik des Mittelalters und der Neuzeit, Neue Folge 4. Vienna: C. Graeser, 1892.

Schlumberger 1952
Schlumberger, Daniel. "Le Palais ghaznévide de Lashkari Bazar." *Syria* 29, nos. 3–4 (1952), pp. 251–70.

Schöbel 1975
Schöbel, Johannes. *Fine Arms and Armour: Treasures in the Dresden Collection*. Translated by M. O. A. Stanton. New York: Putnam, 1975.

Schuckelt 2010
Schuckelt, Holger. *Die Türckische Cammer: Sammlung orientalischer Kunst in der kurfürstlich-sächsischen Rüstkammer Dresden*. Dresden: Sandstein, 2010.

Schwarzer 2004
Schwarzer, Joseph K. "The Weapons." In George F. Bass et al., *Serçe Limanı: An Eleventh-Century Shipwreck*, vol. 1, *The Ship and Its Anchorage, Crew, and Passengers*, pp. 363–97. College Station: Texas A&M University Press with the cooperation of the Institute of Nautical Archaeology, 2004.

Schwarzer and Deal 1986
Schwarzer, J[oseph]. [K.], and E. C. Deal. "A Sword Hilt from the Serçe Liman Shipwreck." *MASCA Journal* 4, no. 2 (1986), pp. 50–59.

Séguy 1977
Séguy, Marie-Rose. *The Miraculous Journey of Mahomet: Miraj nameh; Bibliothèque Nationale, Paris (Manuscrit supplément Turn 190)*. Translated by Richard Pevear. New York: G. Braziller, 1977.

Seville 1992
Arte y cultura en torno a 1492/Art and Culture around 1492: 1992 Seville Universal Exposition. Exh. cat., Cartuja de Santa María de las Cuevas, Seville. Seville: Centro Publicaciones, Expo '92, 1992

Shahnavaz Khan Awrangabadi 1979
Shahnavaz Khan Awrangabadi. *The Maathir-ul-umara: Being Biographies of the Muhammadan and Hindu Officers of the Timurid Sovereigns of India from 1500 to about 1780 A.D.* Translated by H. Beveridge. Revised, annotated, and completed by Baini Prashad. 2 vols. 2nd ed. Patna, India: Janaki Prakashan, 1979.

Sherby and Wadsworth 1985
Sherby, Oleg D., and Jeffery Wadsworth. "Damascus Steels." *Scientific American* 252, no. 2 (February 1985), pp. 112–20.

Sherwani 1965
Sherwani, H. K. "Golkonda." In *Encyclopaedia of Islam, New Edition*, edited by B[ernard]. Lewis, Ch. Pellat, and J. Schacht, vol. 2, pp. 1118–19. 2nd ed. Leiden: Brill; London: Luzac and Co., 1965.

Simla 1881
Third Exhibition of Native Fine and Industrial Art. Exh. cat., Simla, India, 1881. London: Woodbury Permanent Photographic Print Co., 1883.

Simpson 2000
Simpson, Marianna Shreve. "'A Gallant Era': Henry Walters, Islamic Art, and the Kelekian Connection." In "Exhibiting the Middle East: Collections and Perceptions of Islamic Art." Special issue, *Ars Orientalis* 30 (2000), pp. 91–112.

Sinor 1981
Sinor, Denis. "The Inner Asian Warriors." *Journal of the American Oriental Society* 101, no. 2 (April–June 1981), pp. 133–44.

J. Skelton 1830
Skelton, Joseph. *Engraved Illustrations of Antient [sic] Armour: From the Collection of Llewelyn Meyrick at Goodrich Court, Herefordshire; After the Drawings and with the Descriptions of Dr. Meyrick*. 2 vols., notes for projected vol. 3. London: Printed by G. Schulze for J. Skelton, 1830.

R. Skelton 1978
Skelton, Robert. "Characteristics of Later Turkish Jade Carving." In *Fifth International Congress of Turkish Art* [1975], edited by G[éza]. Fehér, pp. 795–807. Budapest: Akadémiai Kiadó, 1978.

C. Smith 1959
Smith, Cyril Stanley. "Methods of Making Chain Mail (14th to 18th Centuries): A Metallographic Note." *Technology and Culture* 1, no. 1 (Winter 1959), pp. 60–67.

G. Smith 1979
Smith, G[erald]. Rex. *Medieval Muslim Horsemanship: A Fourteenth-Century Arabic Cavalry Manual*. London: British Library, 1979.

M. Smith 1944
Smith, Margaret. *Al-Ghazali, the Mystic: A Study of the Life and Personality of Abu Hamid Muhammad al-Tusi al-Ghazali, Together with an Account of His Mystical Teaching and an Estimate of His Place in the History of Islamic Mysticism*. London: Luzac and Co., 1944.

Sotheby Parke Bernet, London 1976
Islamic Ceramics, Metalwork, Arms and Armour, Glass, Qajar Enamels and Other Islamic Works of Art from Iran, Egypt, Turkey, Syria, Mesopotamia and India. Sale cat., Sotheby Parke Bernet, London, April 12, 1976.

Sotheby Parke Bernet, London 1978
Islamic Arms and Armour, Glass, Textiles, Ceramics, Woodwork and Metalwork, Qajar Enamels, Moghul Jades, Indian, Tibetan, Nepalese and South-East Asian Art. Sale cat., Sotheby Parke Bernet, London, April 3, 1978.

Sotheby Parke Bernet, London 1983
The Hever Castle Collection. Vol. 1, *Arms and Armour*. Sale cat., Sotheby Parke Bernet, London, May 5, 1983.

Sotheby Parke Bernet, New York 1980
Important Egyptian, Classical, and Western Asiatic Antiquities. Sale cat., Sotheby Parke Bernet, New York, May 16, 1980.

Sotheby, Wilkinson and Hodge, London 1920
A Selected Portion of the Renowned Collection of Armour and Weapons, Formed by Robert Curzon (1810–1873), Fourteenth Baron Zouche of Haryngworth. Sale cat., Sotheby, Wilkinson and Hodge, London, November 10–11, 1920.

Sotheby's Hanover 2005
Works of Art from the Royal House of Hanover/Kunstwerke des Königlichen Hauses Hannover. 3 vols. Sale cat., Sotheby's Hanover, October 5–15, 2005.

Sotheby's London 1976
Islamic Works of Art; Part 1: Arms and Armour. Sale cat., Sotheby's London, November 22, 1976.

Sotheby's London 1989
Islamic Works of Art, Carpets and Textiles. Sale cat., Sotheby's London, October 11, 1989.

Sotheby's London 1993
Islamic Works of Art; Indian, Himalayan and South-East Asian Art. Sale cat., Sotheby's London, April 29, 1993.

Sotheby's London 2003
Arts of the Islamic World. Sale cat., Sotheby's London, October 15, 2003.

Sotheby's London 2004
Arts of the Islamic World. Sale cat., Sotheby's London, April 28, 2004.

Sotheby's London 2005
The Tipu Sultan Collection. Sale cat., Sotheby's London, May 25, 2005.

Sotheby's London 2007a
Arts of the Islamic World. Sale cat., Sotheby's London, April 18, 2007.

Sotheby's London 2007b
Arts of the Islamic World: Including Fine Carpets and Textiles. Sale cat., Sotheby's London, October 24, 2007.

Sotheby's London 2011a
Arts of the Islamic World: Including Fine Carpets and Textiles. Sale cat., Sotheby's London, April 1–5, 2011.

Sotheby's London 2011b
The Stuart Cary Welch Collection: Part One, Arts of the Islamic World. Sale cat., Sotheby's London, April 6, 2011.

Sotheby's London 2013
Arts of the Islamic World: Including Fine Carpets and Textiles, Art of the Middle East and Turkey. Sale cat., Sotheby's London, April 24, 2013.

Sotheby's New York 1994
19th Century European Paintings, Drawings and Sculpture. Sale cat., Sotheby's New York, February 16, 1994.

Soudavar 1992
Soudavar, Abolala. *Art of the Persian Courts: Selections from the Art and History Trust Collection.* New York: Rizzoli, 1992.

Sourdel 1978
Sourdel, D. "The 'Abbasid Caliphate." In *The Cambridge History of Islam,* edited by P. M. Holt, Ann K. S. Lambton, and Bernard Lewis, vol. 1A, pp. 104–40. Cambridge, U.K., and New York: Cambridge University Press, 1978.

Sporting Review 1845
Saron. "Coral Fisheries." *Sporting Review* 14, no. 4 (October 1845), pp. 247–52.

Stchoukine 1966–71
Stchoukine, Ivan. *La Peinture turque d'après les manuscrits illustrés.* 2 vols. Bibliothèque Archéologique et Historique 83, 84. Paris: P. Geuthner, 1966–71.

Stein 1989
Stein, Donna. "Three Photographic Traditions in Nineteenth-Century Iran." *Muqarnas* 6 (1989), pp. 112–30.

Stillman 1986
Stillman, N. A. "Khil'a." In *Encyclopaedia of Islam, New Edition,* edited by C[lifford]. E[dmund]. Bosworth, E. van Donzel, B[ernard]. Lewis, and Ch. Pellat, vol. 5, pp. 6–7. 2nd ed. Leiden: Brill, 1986.

Stockholm 1985
Islamiskt i de Kungliga Samlingarna: Konsthantverk från 1500- och 1600-talen/Islamic Treasures in the Royal Collections: Applied Art from the 16th and 17th Centuries. Exh. cat., Royal Palace, Stockholm. Stockholm: Kungl. Husgerådskammaren, 1985. Catalogue edited by Gudrun Ekstrand.

Stockholm 2007
Krigsbyte/War-Booty. Livrustkammaren: The Journal of the Royal Armoury 2007–8. Exh. cat. Stockholm: Livrustkammaren, 2007. Catalogue by Barbro Bursell et al.

Stöcklein 1934
Stöcklein, Hans. "Die Waffenschätze im Topkapu Sarayi müzesi zu Istanbul: Ein Vorläufiger Bericht." *Ars Islamica* 1, no. 2 (1934), pp. 200–218.

Stöcklein 1939
Stöcklein, Hans. "Arms and Armor." In Pope 1938–58, vol. 3, *Text: The Art of the Book, Textiles, Carpets, Metalwork, Minor Arts,* pp. 2555–85. London and New York: Oxford University Press, 1939.

Stone 1934
Stone, George Cameron. *A Glossary of the Construction, Decoration and Use of Arms and Armor in All Countries and in All Times, Together with Some Closely Related Subjects.* Portland, Maine: Southworth Press, 1934. Reprinted 1961 by Jack Brussel, New York, and 1999 by Dover Publications, Mineola, N.Y.

Stronge 1988–89
Stronge, Susan. "Jewellery of the Mughal Period." In Bradford and London 1988–89, pp. 27–50.

Stronge 2002
Stronge, Susan. *Painting for the Mughal Emperor: The Art of the Book, 1560–1660.* London: Victoria and Albert Museum, 2002.

Sydney and Melbourne 1990
The Age of Sultan Süleyman the Magnificent. Exh. cat., Art Gallery of New South Wales, Sydney; and National Gallery of Victoria, Melbourne. Sydney: Beagle Press for the International Cultural Corporation of Australia Ltd., 1990.

Szendrei 1896
Szendrei, Johann. *Ungarische kriegsgeschichtliche Denkmäler in der Millenniums-Landes-Ausstellung.* Translated by Julius Reymond-Schiller. Budapest: Kgl. Ung. Handelsminister, als Präses der Landes-Commission für die Millenniums-Ausstellung, 1896.

al-Tabari 1980–88
al-Tabari. *Chronique* [Ta'rikh al-rusul w'al-muluk]. Translated by Hermann Zotenberg from original Persian manuscript by Abu 'Ali Muhammad ibn Muhammad Bal'ami. 4 vols. Paris: Sindbad, 1980–88.

al-Tabari 1988–89
al-Tabari. *The Early 'Abbasi Empire.* Translated by John Alden Williams. 2 vols. Cambridge, U.K.: Cambridge University Press, 1988–89.

Taeschner 1965
Taeschner, Fr. "Futuwwa." In *Encyclopaedia of Islam, New Edition,* edited by B[ernard]. Lewis, Ch. Pellat, and J. Schacht, vol. 2, pp. 961–69. 2nd ed. Leiden: Brill; London: Luzac and Co., 1965.

Tarassuk and Blair 1979
Tarrasuk, Leonid, and Claude Blair, eds. *The Complete Encyclopedia of Arms and Weapons.* New York: Simon and Schuster, 1979. Reprinted 1982.

H. Tezcan and T. Tezcan 1992
Tezcan, Hülya, and Turgay Tezcan. *Türk sancak alemleri.* Atatürk Kültür, Dil ve Tarih Yuksek Kurumu Atatürk Kültür Merkezi Yayını 55. Ankara: Türk Tarih Kurumu Basımevı, 1992.

T. Tezcan 1983
Tezcan, Turgay. *Silahlar.* Topkapı Sarayı Müzesi 9. Istanbul: Yapı ve Kredi Bankası Kültür ve Sanat Hizmetleri, 1983.

Thackston 1995
Thackston, Wheeler M., trans., ed. *The Baburnama: Memoirs of Babur, Prince and Emperor.* Washington, D.C.: Freer Gallery of Art, Arthur M. Sackler Gallery, Smithsonian Institution; New York: Oxford University Press, 1995.

Thackston 1999
Thackston, Wheeler M., trans., ed. *The Jahangirnama: Memoirs of Jahangir, Emperor of India.* Washington, D.C.: Freer Gallery of Art, Arthur M. Sackler Gallery; New York: Oxford University Press, 1999.

Thomas and Gamber 1976
Thomas, Bruno, and Ortwin Gamber. *Katalog der Leibrüstkammer.* Vol. 1, *Der Zeitraum von 500 bis 1530.* Führer Durch das Kunsthistorische Museum 13. Vienna: Kunsthistorisches Museum; Verlag Anton Schroll & Co., 1976.

Thomas Del Mar Ltd, London 2011
Antique Arms, Armour and Militaria. Sale cat., Thomas Del Mar Ltd, London, June 29, 2011.

Trivellato 2009
Trivellato, Francesca. *The Familiarity of Strangers: The Sephardic Diaspora, Livorno, and Cross-Cultural Trade in the Early Modern Period.* New Haven: Yale University Press, 2009.

Tumanovskii 2002
Tumanovskii, V[ladimir]. E., ed. *Gosudareva Oruzhein-aia palata: Sto predmetov iz sobraniirossiskikh imperatorov* [Armoury Chamber of the Russian tsars: One hundred items from the Collection of the Russian Emperors]. Saint Petersburg: Atlant, 2002.

Turcherie 2001
Turcherie. Museo Stibbert Firenze 4. Florence: Polistampa, 2001.

Tyan 1965
Tyan, E. "Djihad." In *Encyclopaedia of Islam, New Edition,* edited by B[ernard]. Lewis, Ch. Pellat, and J. Schacht, vol. 2, pp. 538–40. 2nd ed. Leiden: Brill; London: Luzac and Co., 1965.

Uray-Köhalmi 1989
Uray-Köhalmi, Käthe. *Über mongolische Elemente in Tungusischen Erzählungen.* Wiesbaden: Harrassowitz, 1989.

Uzunçarşılı 1960
Uzunçarşılı, I[smail]. H[akkı]. "Bostandji." In *Encyclopaedia of Islam, New Edition,* edited by B[ernard]. Lewis, Ch. Pellat, and J. Schacht, vol. 1, pp. 1277–78. 2nd ed. Leiden: Brill; London: Luzac and Co., 1960.

Valencia 2008
Three Empires of Islam: Istanbul, Isfahan, Delhi; Master Pieces of the Louvre Collection. Exh. cat., Centro Cultural Bancaja, Valencia. Valencia: Fundación Bancaja, 2008.

Valencia de Don Juan 1898
Valencia de Don Juan, Juan Bautista Crooke y Navarrot. *Catálogo histórico-descriptivo de la Real Armería de Madrid.* Madrid: Fototipias de Hauser y Menet, 1898.

Venice 1993
Eredità dell' Islam: Arte islamica in Italia. Exh. cat., Palazzo Ducale, Venice. [Milan]: Silvana, 1993. Catalogue edited by Giovanni Curatola.

Vickers 1978
Vickers, Michael. "Some Preparatory Drawings for Pisanello's Medallion of John VIII Palaeologus." *Art Bulletin* 60, no. 3 (September 1978), pp. 417–24.

Vienna 1983
Die Türken vor Wien: Europa und die Entscheidung an der Donau 1683. Sonderausstellung 82. Exh. cat., Historischen Museums der Stadt Wien, Künstlerhaus, and Sonderausstellungsraum des Historischen Museums der Stadt Wien, Vienna. Vienna: Eigenverlag der Museen der Stadt Wien, 1983.

Vienna 1996
Weihrauch und Seide: Alte Kulturen an der Seidenstrasse. Exh. cat., Kunsthistorisches Museum, Vienna. Milan: Skira; Vienna: Kunsthistorisches Museum, 1996.

Viré 1986
Viré, F[r]. "Lamt." In *Encyclopaedia of Islam, New Edition,* edited by C[lifford]. E[dmund]. Bosworth, E. van Donzel, B[ernard]. Lewis, and Ch. Pellat, vol. 5, pp. 651–52. 2nd ed. Leiden: Brill, 1986.

Von Leyden 1982
von Leyden, Rudolf. "Indian Playing Cards." *Orientations* 13, no. 10 (October 1982), pp. 14–23.

Wadsworth and Sherby 1979
Wadsworth, Jeffery, and Oleg D. Sherby. "On the Bulat: Damascus Steels." *Bulletin of the Metals Museum* (The Japan Institute of Metals) 4 (1979), pp. 7–23.

Walker 1998
Walker, Daniel. "Talismanic Shirt." In "Recent Acquisitions, A Selection: 1997–1998." Special issue, *MMAB,* n.s., 56, no. 2 (Autumn 1998), p. 12.

Ward 1990
Ward, Rachel. "Goldsmiths' Work at the Court of Süleyman the Magnificent." *Jewellery Studies* 4 (1990), pp. 29–34.

Washington, D.C. 1981–82
The Imperial Image: Paintings for the Mughal Court. Exh. cat., 1981–82. Washington, D.C.: Freer Gallery of Art, Smithsonian Institution, 1981. Catalogue by Milo Cleveland Beach.

Washington, D.C. 1985–86
Islamic Metalwork in the Freer Gallery of Art. Exh. cat., 1985–86. Washington, D.C.: Freer Gallery of Art, Smithsonian Institution, 1985. Catalogue by Esin Atıl, W. T. Chase, and Paul Jett.

Washington, D.C. 1991–92
Circa 1492: Art in the Age of Exploration. Exh. cat., 1991–92. Washington, D.C.: National Gallery of Art; New Haven: Yale University Press, 1991. Catalogue edited by Jay A. Levenson.

Washington, D.C. 2009
The Art of Power: Royal Armor and Portraits from Imperial Spain/El arte del poder: Armaduras y retratos de la España imperial. Exh. cat., National Gallery of Art, Washington, D.C. [Madrid]: Sociedad Estatal para la Acción Cultural Exterior; Patrimonio Nacional; Tf Editores, 2009. Catalogue edited by Alvaro Soler del Campo.

Washington, D.C., Chicago, and New York 1987–88
The Age of Sultan Süleyman the Magnificent. Exh. cat., National Gallery of Art, Washington, D.C.; Art Institute of Chicago; and MMA, New York, 1987–88. Washington, D.C.: National Gallery of Art; New York: H. N. Abrams, 1987. Catalogue by Esin Atıl.

Washington, D.C., and Los Angeles 1989
Timur and the Princely Vision: Persian Art and Culture in the Fifteenth Century. Exh. cat., Arthur M. Sackler Gallery, Smithsonian Institution, Washington, D.C.; and Los Angeles County Museum of Art. Los Angeles: Los Angeles County Museum of Art, 1989. Catalogue by Thomas W. Lentz and Glenn D. Lowry.

Washington, D.C., and other cities 1966–68
Art Treasures of Turkey: Circulated by the Smithsonian Institution, 1966–1968. Publication 4663. Exh. cat., National Gallery of Art, Washington, D.C., and nine other venues, 1966–68. Washington, D.C.: Smithsonian Institution, 1966.

Washington, D.C., and other cities 1981–82
Renaissance of Islam: Art of the Mamluks. Exh. cat., National Museum of Natural History, Smithsonian Institution, Washington D.C., and six other venues, 1981–82. Washington, D.C.: Smithsonian Institution Press, 1981. Catalogue by Esin Atıl.

Washington, D.C., and other cities 1982–83
Patterns and Precision: The Arts and Sciences of Islam. Exh. cat. for "The Heritage of Islam," National Museum of Natural History, Smithsonian Institution, Washington, D.C., and other U.S. venues, 1982–83. Washington, D.C.: National Committee to Honor the Fourteenth Centennial of Islam, 1982. Catalogue by Holly Edwards.

S. Welch 1976
Welch, Stuart Cary. *A King's Book of Kings, The Shah-nameh of Shah Tahmasp.* New York: MMA, 1976.

S. Welch 1978
Welch, Stuart Cary. *Imperial Mughal Painting.* New York: George Braziller, 1978.

S. Welch and Swietochowski 1983
Welch, Stuart Cary, and Marie Lukens Swietochowski. "Dagger." *The Metropolitan Museum of Art: Notable Acquisitions, 1982–1983,* 1983, p. 12.

Wigington 1992
Wigington, Robin. *The Firearms of Tipu Sultan, 1783–1799: A Survey and Record.* Hatfield, U.K.: John Taylor Book Ventures, 1992.

A. Williams 2002
Williams, Alan [R]. *The Knight and the Blast Furnace: A History of the Metallurgy of Armour in the Middle Ages and the Early Modern Period*. History of Warfare 12. Leiden: Brill, 2002.

B. Williams 2001
Williams, Brian Glyn. *The Crimean Tatars: The Diaspora Experience and the Forging of a Nation*. Brill's Inner Asian Library 2. Leiden: Brill, 2001.

Williamstown and other cities 1978–79
The Grand Mogul: Imperial Painting in India, 1600–1660. Exh. cat., Sterling and Francine Clark Art Institute, Williamstown, Mass.; Walters Art Gallery, Baltimore; Museum of Fine Arts, Boston; and Asia House Gallery, New York, 1978–79. Williamstown, Mass.: Sterling and Francine Clark Art Institute, 1978. Catalogue by Milo Cleveland Beach with contributions by Glenn D. Lowry and Stuart Cary Welch.

Wills 1972
Wills, Geoffrey. *Jade of the East*. New York: Weatherhill; Hong Kong: Orientations, 1972.

Winkler 1930
Winkler, H[ans]. A[lexander]. *Siegel und Charaktere in der muhammedanischen Zauberei*. Edited by C. H. Becker. Studien zur Geschichte und Kultur des Islamischen Orients 7. Berlin and Leipzig: De Gruyter, 1930.

Wittgenstein 2001
Wittgenstein, Ludwig. *Philosophical Investigations/ Philosophische Untersuchungen*. Translated by G. E. M. Anscombe. 3rd ed. Oxford, U.K., and Malden, Mass.: Blackwell, 2001. First pub. 1953.

Woods 1976
Woods, John E. *The Aqquyunlu: Clan, Confederation, Empire: A Study in 15th/9th Century Turko-Iranian Politics*. Studies in Middle Eastern History 3. Minneapolis: Bibliotheca Islamica, 1976.

Woods 1999
Woods, John E. *The Aqquyunlu: Clan, Confederation, Empire*. Rev. ed. Salt Lake City: University of Utah Press, 1999.

Wright 1848
Wright, Thomas, ed. *Early Travels in Palestine, Comprising the Narratives of Arculf, Willibald, Bernard, Sæwulf, Sigurd, Benjamin of Tudela, Sir John Maundeville, de la Brocquière, and Maundrell*. London: Henry G. Bohn, 1848.

Yogev 1978
Yogev, Gedalia. *Diamonds and Coral: Anglo-Dutch Jews and Eighteenth-Century Trade*. New York: Leicester University Press, 1978.

Yücel 1964–65
Yücel, Ünsal. "Türk kilic ustalari" [Turkish sword masters]. *Türk ethnografya dergisi* [Turkish ethnography journal] 7–8 (1964–65), pp. 59–99.

Yücel 1988
Yücel, Ünsal. *Al-Suyuf al-Islamiyah wa-sunna'uha* [Islamic swords and swordsmiths]. Kuwait: Munazzamat al-Mu'tamar al-Islami, Markaz al-Abhath lil-Tarikh wa-al-Funun wa-al-Thaqafah al-Islamiyah, 1988.

Yücel 2001
Yücel, Ünsal. *Islamic Swords and Swordsmiths*. Istanbul: O. I. C. Research Centre for Islamic History, Art and Culture, IRCICA, 2001.

Zacharov 1935
Zacharov, A[leksei]. A[lekseevich]. "Beiträge Zur Frage Der Türkischen Kultur Der Völkerwanderungszeit." In *Studia levedica: Archäologischer Beitrag zur Geschichte der Altungarn im IX. Jh./Studia levedica: Régészeti adatok a magyarság IX. századi történetéhez*, pp. 6–47. Archaeologica Hungarica 16. Budapest: Magyar Történeti Múzeum, 1935.

Zebrowski 1983
Zebrowski, Mark. *Deccani Painting*. London: Sotheby Publications; Berkeley: University of California Press, 1983.

Zebrowski 1997
Zebrowski, Mark. *Gold, Silver and Bronze from Mughal India*. London: Alexandria Press in association with Laurence King, 1997.

Zeller and Rohrer 1955
Zeller, Rudolf, and Ernst F. Rohrer. *Orientalische Sammlung Henri Moser-Charlottenfels: Beschreibender Katalog der Waffensammlung*. Bern: Kommissionsverlag von K. J. Wyss Erben, 1955.

Zygulski 1968
Zygulski, Zdzislaw. "Choragwie tureckie w Polsce na tle ogólnej problematyki przedmiotu." *Studia do dziejów Wawele* 3 (1968), pp. 363–446.

Zygulski 1972
Zygulski, Zdzislaw. "Turkish Trophics in Poland and the Imperial Ottoman Style." In "Numero speciale per il 6° Congresso dell'Associazione Internazionale dei Musei d'Armi e di Storia Militare, Zurigo, 15–20 maggio 1972." Special issue, *Armi Antiche*, 1972, pp. 25–66.

Zygulski 1978
Zygulski, Zdzislaw. "Karabela i szabla orla/The Karbela and the Eagle Sabre." *Studia do dziejów dawnego uzbrojenia i ubioru wojskowego/Studies in History of Old Arms and Uniforms* 7 (1978), pp. 17–37.

Zygulski 1979
Zygulski, Zdzislaw. "Islamic Weapons in Polish Collections and Their Provenance." In Elgood 1979, pp. 213–38.

Zygulski 1979–80
Zygulski, Zdzislaw. "The Battle of Orsha." In *Art, Arms and Armour, An International Anthology*, edited by Robert Held, vol. 1, pp. 108–43. Chiasso: Acquafresca Editrice, 1979–80.

Zygulski 1982
Zygulski, Zdzislaw. *Stara broń w polskich zbiorach*. Warsaw: Krajowa Agencja Wydawnicza, 1982.

Zygulski 1983
Zygulski, Zdzislaw. *Broń wschodnia: Turcja, Persja, Indie, Japonia*. Warsaw: Krajowa Agencja Wydawnicza, 1983. Reprinted 1986.

Zygulski 1992
Zygulski, Zdzislaw. *Ottoman Art in the Service of the Empire*. New York: New York University Press, 1992.

Index

Page numbers in **bold** refer to catalogue entries. Page numbers in *italics* refer to figures.

Photograph Credits

Fig. 1: Royal Collection Trust/© Her Majesty Queen Elizabeth II, 2015; fig. 2: © The Wallace Collection; figs. 3, 25: Courtesy of Richard Green Gallery, London; fig. 4: from New York 1883, p. 85; fig. 22: © The Trustees of the British Museum; fig. 24: © Musée de l'Armée/Dist. RMN-Grand Palais/Art Resource, NY; figs. 27, 34, 42–43: © Victoria and Albert Museum, London; fig. 29: from Hauser and Wilkinson 1942, fig. 45; fig. 37: Courtesy of the Stair Sainty Gallery; fig. 41: bpk, Berlin/Museum für Islamische Kunst, Staatliche Museen/Georg Niedermeier/Art Resource, NY; fig. 44: from *The Sultan's Portrait: Picturing the House of Osman*. Exh. cat., Topkapı Sarayı Museum, Istanbul (Istanbul: İşbank, 2000), p. 222